The New Painting
Impressionism 1874-1886

LUX VITAE

BURTON

SOCIÉTÉ ANONYME

DES ARTISTES PEINTRES, SCULPTEURS, GRAVEURS, ETC.

PREMIÈRE

EXPOSITION

1874

35, Boulevard des Capucines, 35

CATALOGUE

Prix : 50 centimes

L'Exposition est ouverte du 15 avril au 15 mai 1874,
de 10 heures du matin à 6 h. du soir et de 8 h. à 10 heures du soir.
PRIX D'ENTRÉE : 1 FRANC

PARIS

IMPRIMERIE ALCAN-LÉVY

61, RUE DE LAFAYETTE

1874

The New Painting
Impressionism 1874-1886

An exhibition organized by
The Fine Arts Museums of San Francisco
with the
National Gallery of Art, Washington

Directed and coordinated by
Charles S. Moffett
with the assistance of
Ruth Berson
and
Barbara Lee Williams
Fronia E. Wissman

Richard Burton SA, Publishers
1 place de la Taconnerie,
1204 Geneva, Switzerland

Exclusive distributors for the
United States of America and Canada:
University of Washington Press, Seattle.

The New Painting
Impressionism: 1874–1886

National Gallery of Art, Washington
17 January–6 April 1986

The Fine Arts Museums of San Francisco
M. H. de Young Memorial Museum
19 April–6 July 1986

Published in 1986 by Richard Burton SA, 1 place de la Taconnerie,
Geneva, Switzerland.

Exclusive distributor for the United States of America and Canada:
University of Washington Press.

Translations of extracts from a review by Louis Leroy in *Le Charivari*,
25 April 1874, appearing with cat. nos. 7, 9, 15, and 17, are from
John Rewald, *The History of Impressionism.* © 1946 by The
Museum of Modern Art, New York, and renewed in 1973. All rights
reserved. Reprinted by permission of The Museum of Modern Art
and John Rewald.

Photo Credits: Reproductions of works in the exhibition are by per-
mission of the lenders, who supplied the color transparencies except for
the following:
A. C. Cooper, Ltd., London 29; D. James Dee 1; Photo Routhier,
Paris 136; Eric Pollitzer, New York 10, 43, 62; Schopplein Studio,
San Francisco 107; Malcolm Varon, New York 152.

Library of Congress Cataloging in Publication Data
Main entry under title:
The New Painting: Impressionism 1874–1886.
Exhibition held National Gallery of Art, Washington, 17 January–
6 April 1986, and The Fine Arts Museums of San Francisco,
M. H. de Young Memorial Museum, 19 April–6 July 1986.
Bibliography: p. 497
Includes index.
1. Impressionism (Art)–France–Exhibitions. 2. Painting, French–
Exhibitions. 3. Painting, Modern–19th century–France–
Exhibitions. I. Moffett, Charles S. II. The Fine Arts Museums of
San Francisco. III. National Gallery of Art (U.S.)
ND547.5.I4N38 1986 759.4'074'0153 85–24537
ISBN 2–88216–000–3 (Burton)
ISBN 0–295–96367–0 (University of Washington Press)

Front cover: Claude Monet, *La Seine à Argenteuil*, 1875.
Detail. Cat. no. 30

Back cover: Gustave Caillebotte, *Rue de Paris: Temps de pluie*, 1877.
Detail. Cat. no. 38

Frontispiece: Cover of the catalogue for the First Impressionist
Exhibition.

Note to the Reader

The catalogue section of this book is divided into eight parts, representing the original eight Impressionist exhibitions. Each part contains an essay, a reproduction of the original exhibition catalogue, and color plates of works in the present exhibition. The works exhibited in *The New Painting* have been identified as accurately as possible as works that appeared in the original exhibitions.

Identification of Works

Annotations to the reproductions of the original catalogues, which follow each essay, document these identifications. The full citations for the annotations appear in the Appendix under Abbreviated References. Contributions by scholars and other authorities, including the authors of these essays, are noted.

Catalogue Entries

In addition to the catalogue numbers for works in this exhibition, works that were in the original exhibitions are identified by a two-part number. A Roman numeral designates the original show, I through VIII, in which the work appeared. An accompanying Arabic number is the same one by which works were listed in the original exhibition catalogue. Thus, our cat. no. 39, Caillebotte's *Le pont de l'Europe*, also bears the number III–2, indicating that it was no. 2 in the Third Impressionist Exhibition in 1877. Works that were neither numbered nor listed in an original catalogue, but which were shown in an original exhibition, are referred to as HC (*hors catalogue*). Abbreviations of selected references for identification, found

beneath the color plates of these works, are arranged as follows: catalogue raisonné, institution catalogue, and recent exhibition catalogues or other references, in chronological order. These selected references have been chosen to direct the reader to the most recent sources of complete cataloging and bibliographical information. Full citations for these references are also located in the Appendix under Abbreviated References.

Titles

Works in *The New Painting* retain the titles they were given in the original exhibitions. Beneath color plates of these works are English translations of the original titles. If there is an alternate, current title, it is noted as well.

Figure captions for the essays also include in parentheses the works' current titles, in English, if they vary from the original title. No English title is given, however, in cases where an owner in an English-speaking country retains a French title.

Quotations from Reviews

Contemporary journalism and art criticism have been especially important in the identification of works in the original exhibitions. The color plates in this catalogue are accompanied by translations of relevant quotations from the nineteenth-century reviews and criticism of the original exhibitions. Spelling, capitalization, and punctuation have been standardized, and other minor errors have been corrected, except where noted. Full citations for these reviews, organized by exhibition, are found in the Appendix under Contemporary Reviews.

Contents

Acknowledgments

This exhibition could not have been done without the assistance and cooperation of scores of individuals both in this country and abroad. Words are inadequate to express my thanks and appreciation, and I hope that the future will bring an opportunity to repay their extraordinary kindness and generosity.

I am particularly grateful to the members of the team at The Fine Arts Museums of San Francisco. The quality and speed of their work are admirable, and I am particularly indebted to Ruth Berson, Associate Curator; Barbara Lee Williams, Assistant Curator; Fronia E. Wissman, Assistant Curator; Ann Heath Karlstrom, Publications Manager; Karen Kevorkian, Editor; Eileen E. McKeon, Coordinator; Paula March, Registrar; Norma Schlesinger, Research Assistant; Maura Nolan, Administrative Assistant; Secretaries: Eileen Petersen, Michael Byrne, Joan Perlman, and Andrei Glassey; Jane Scott, Photo Coordinator; Translators: Rhonda Honorat, Felicia Miller, and Joanna O'Connell; Proofreaders: Deborah Bruce, Barbara L. Mount, and Susan Stearns; Interns: Ann Bornstein, Jane Dini, Catherine de Heer, and Molly March. I would like also to extend my deepest thanks to Leonard Kingsley, Chairman of the Board (1982–1985); Mrs. W. Robert Phillips, Chairman of the Board (1985–1988); Ian McKibbin White, Director; F. Whitney Hall, Chief Administrative Officer; Thomas K. Seligman, Deputy Director for Education and Exhibitions; Debra Pughe, Exhibitions Manager; Kristin Hoermann, Paintings Conservator; Robert F. Johnson, Curator in Charge, Achenbach Foundation for Graphic Arts; Robert Futernick, Conservator in Charge, Western Regional Paper Conservation Laboratory; Jane Gray Nelson, Librarian; James Forbes, Deputy Director for Development; Antonette DeVito, Development Associate; Susan M. Singer, Corporate and Foundation Relation Manager, Development; Max Chance, Exhibition Architect; Ron Rick, Senior Graphic Designer; William White, Technician Coordinator; Michael Sandgren, Packer; Couric Payne, Bookshops Manager; Georgette Lynch, Management Assistant to the Departments of Operations and Education and Exhibitions; Laurie Goldman, Administrative Assistant to the Director;

Lauren Ito, Executive Office Secretary; Brian Marston, Accounting; and Linda Graham, Research Assistant.

In addition, I have benefited enormously from the advice, assistance, cooperation, and support of my colleagues at the National Gallery of Art. I owe my sincerest thanks to all of them, especially J. Carter Brown, Director, and the entire staff of the Office of the Director; John Wilmerding, Deputy Director; Al C. Viebranz, Assistant to the Director for Corporate Relations, Development; D. Dodge Thompson, Chief, Exhibition Programs; Joseph J. Krakora, External Affairs Officer; Charles F. Stuckey, Curator of Modern Painting; Gaillard F. Ravenel, Chief, Design and Installation; Frances P. Smyth, Editor-in-Chief; Florence E. Coman, Assistant Curator, Modern Painting; Ann M. Bigley, Exhibitions Officer; Cheryl A. Hauser, Exhibitions Assistant; Carolyn E. Amiot, Deputy Information Officer, Department of Public Information; Lamia Doumato, Reference Librarian; Stephanie T. Belt, Head, Department of Loans and the National Lending Service; Ruth E. Fine, Curator of Graphic Arts.

Special thanks are also due Alice Martin Whelihan, Indemnity Administrator, United States Government Indemnification Office, National Endowment for the Arts; Gabriel P. Weisberg, formerly Assistant Director, Division of General Programs for the Museum Program, National Endowment for the Humanities; Kenneth P. Todd, Division Manager, Public Relations, AT&T Communications; James Brunson, Corporate Vice President, AT&T; Mary Delle Stelzer, formerly Corporate Advertising Manager, AT&T; Ralph Zachary Manna, Corporate Advertising Manager, AT&T; Jacquelyne Byrne, Advertising Supervisor, AT&T; and Elizabeth A. C. Weil, Vice President, Rogers and Cowan, Inc., Washington Office.

It is impossible to express adequately my appreciation to the ninety-four lenders for their extraordinary generosity, but I offer my heartiest and most enthusiastic thanks to all. I am especially grateful to the directors and curators of the three institutions that, together, lent one-quarter of the works in the exhibition: Michel Laclotte, Inspector General of the French National Museums, Director of the Musée d'Orsay, and Curator in Chief,

Department of Paintings, Musée du Louvre; Philippe de Montebello, Director, The Metropolitan Museum of Art, New York; Sir John Pope-Hennessy, Consultative Chairman, Department of European Paintings, The Metropolitan Museum of Art, New York; James N. Wood, Director, and Richard Brettell, Searle Curator of Paintings, The Art Institute of Chicago. In addition, I would like to thank Laughlin Phillips, Director, The Phillips Collection, for permitting us to include Renoir's *Un déjeuner à Bougival* (*The Luncheon of the Boating Party*), cat. no. 130.

I am also deeply indebted to numerous libraries and archives for the use of their resources and their continuous assistance throughout the course of the project: Durand-Ruel Archives, Paris; The Frick Art Reference Library, New York; Thomas J. Watson Library, The Metropolitan Museum of Art, New York; New York Public Library; Greene Library and the Art Library, Stanford University, Palo Alto; Doe Library, University of California, Berkeley; Library of Congress, Washington, D.C.; Library of the National Gallery of Art, Washington, D.C.; Library of the Phillips Collection, Washington, D.C.; Library of the Achenbach Foundation for Graphic Arts and Library of The Fine Arts Museums of San Francisco; San Francisco Public Library; The Pierpont Morgan Library, New York; Fondation Custodia (Collection Frits Lugt), Institut Néerlandais, Paris; Bibliothèque Nationale (Imprimés, Périodiques, Manuscrits, Estampes), Paris; Bibliothèque d'Art et d'Archéologie (Fondation Jacques Doucet), Paris; Bibliothèque des Arts Décoratifs, Paris; Bibliothèque Sainte-Geneviève, Paris; Bibliothèque de l'Arsenal, Paris; Documentation, Musée d'Orsay, Paris; The Witt Library, Courtauld Institute (University of London); and The British Library, London.

Finally, I would like to express my deepest appreciation to the many individuals who provided valuable assistance with loans and documentation. Without them, we would have had neither an exhibition nor a catalogue: William Acquavella, Acquavella Galleries, New York; Thierry d'Allant, Paris and San Francisco; Susanna Allen, William Beadleston, Inc., New York; Roseline Bacou, Curator in Chief, Cabinet des Dessins, Musée du Louvre, Paris; George Berry, Account Executive, Rogers and Cowan, Inc., Washington Office; Jean C. Boggs, Special Advisor to the Minister of Communications, Government of Canada; Michael Botwinick, Director, Corcoran Gallery of Art, Washington, D.C.; Philippe Brame, Galerie Brame-Lorenceau, Paris; Lillian Browse, London; Timothy S. Bathurst, David Carritt, Ltd., London; Colin Bailey, Paris; His Grace the Duke of Beaufort, Marlborough Gallery, London; Béatrice de Boisseson, Service Photographique, Réunion des Musées Nationaux, Paris; Mlle Bouché, Musée des Arts des Africains et Océaniens, Paris; Allan J. W. Braham, Deputy Director

and Keeper, The National Gallery, London; Professor Jean-Paul Bouillon, Paris; Alan Bowness, Director, The Tate Gallery, London; Harry Brooks, Wildenstein and Company, New York; Emilie Beauchamp, Fondation Wildenstein, Paris; Richard Burton, BCK Graphic Arts, Geneva; Daniel Boorstin and staff, Library of Congress, Washington, D.C.; Françoise Cachin, Curator of Paintings, Musée d'Orsay, Paris; Beverly Carter, Washington, D.C.; Mme J. Chagnaud-Forain; Charavay, Paris; Jacques Chardeau, Paris; Pat Coman, Thomas J. Watson Library, The Metropolitan Museum of Art, New York; Lili Couvée-Jampoller, Amsterdam; Desmond Corcoran, The Lefevre Gallery, London; Marie-Christine de Croocq, Fondation Wildenstein, Paris; Alain Clairet, Paris; Candace Clements, New Haven; John Dabrey, Phillips, London; France Daguet, Durand-Ruel et Cie, Paris; François Delestre, Paris; the late Charles Durand-Ruel, Paris; Ann Distel, Curator, Musée d'Orsay, Paris; Jacqueline Derbanne, Paris; Douglas Druick, Prince Trust Curator of the Department of Prints and Drawings, The Art Institute of Chicago; John Elderfield, Director, Department of Drawings, Museum of Modern Art, New York; Robert Ellsworth, New York; M. et Mme J. Erwteman, Brussels; Marianne Feilchenfeldt, Zurich; Stuart P. Feld, Hirschl and Adler, New York; Joyce Fano, Hirschl and Adler, New York; Professor Alicia Faxon, Simmons College, Boston; Sara Ferguson, BCK Graphic Arts, London; Barbara S. Fields, Los Angeles; Michael Findlay, Christie's, New York; Hanne Finsen, Director, Ordrupgaardsamlingen, Charlottenlund, Denmark; Jacques Fischer, Paris; Erich Frantz, Bielefeld, Federal Republic of Germany; Raymond Gallois-Montbrun, President, Académie des Beaux-Arts de l'Institut, Paris; Marc Gerstein, Toledo Museum of Art; Denise Gazier, Librarian, Bibliothèque d'Art et d'Archéologie (Fondation Jacques Doucet), Paris; Ann Gilkerson, Boston; Caroline Godfroy, Durand-Ruel et Cie, Paris; Ludovic Ginguay de Beaugendre, Service Photographique, Réunion des Musées Nationaux, Paris; Stephen Hahn, New York; Professor Robert L. Herbert, Yale University, New Haven; Henry Hopkins, San Francisco Museum of Modern Art; Professor John House, Courtauld Institute (University of London); Ay Wang Hsia, Wildenstein and Company, New York; Suzanne d'Huart and the staff of the Archives Nationales, Paris; Ann van der Jagt, Fondation Custodia (Collection Frits Lugt), Institut Néerlandais, Paris; Marie Jeune, Musée des Beaux-Arts et de la Céramique, Rouen; Paul Josefowitz, London; Samuel Josefowitz, Lausanne; Isabelle Julia, Direction des Musées de Province, Musées Nationaux, Paris; Mr. and Mrs. George M. Kaufman, Norfolk, Virginia; Frances Keech, Publications, Museum of Modern Art, New York; Chantal Kiener, Paris; Ellen Melas Kyriazi, London; Myron Laskin, Curator of Paintings, The J. Paul Getty Museum, Malibu; Thomas P. Lee, Uvalde, Texas;

Sir Michael Levey, Director, The National Gallery, London; Suzanne G. Lindsay, Research Associate, National Gallery of Art, Washington, D.C.; Christopher Lloyd, The Ashmolean Museum of Art and Archeology, Oxford; Bernard Lorenceau, Galerie Brame-Lorenceau, Paris; Laura Luckey, Assistant Director for Collections and Programs, The Shelburne Museum, Inc., Shelburne, Vermont; John Lumley, Department of Impressionist Paintings, Christie's, London; James Medley and Joseph McDonald, Photography, The Fine Arts Museums of San Francisco; Edda Maillet, Musées de Pontoise; Magne Malmanger, Keeper of Paintings, Nasjonalgalleriet, Stockholm; Jonathan Mason, Registrar, The Tate Gallery, London; Dr. Nancy Mowll Mathews, Williams College, Williamstown, Massachusetts; Caroline Matthieu, Musée d'Orsay, Paris; Marcelline McKee, Coordinator for Loans, The Metropolitan Museum of Art, New York; Geneviève Monnier, Paris; Richard Nathanson, David Carritt, Ltd., London; Edward Nygren, Curator of Collections, Corcoran Gallery of Art, Washington, D.C.; Martha Parrish, Hirschl and Adler, New York; Mrs. Rose Pearlman, New York; Laughlin Phillips, Director, The Phillips Collection, Washington, D.C.; Sir David Piper, Director, The Ashmolean Museum of Art and Archeology, Oxford; Dr. Earl A. Powell III, Director, Los Angeles County Museum of Art; Robert Rainwater, Keeper of Prints, New York Public Library; John Rewald, New York; Jean Dominique Rey, Paris; Joseph Rishel, Curator, Philadelphia Museum of Art and The John G. Johnson Collection, Philadelphia; Andrew Robison, Senior Curator and Curator of Graphic Arts, National Gallery of Art, Washington, D.C.; Allen Rosenbaum, Director, The Art Museum, Princeton University; Cora Rosevear, Museum of Modern Art, New York; Alex Ross, Stanford University Library; Clément Rouart, Paris; Yves Rouart, Paris; William Rubin, Director, Department of Painting and Sculpture, Museum of Modern Art, New York; Guy Sainty, Stair Sainty Matthiesen, New York; Helen Sanger, Frick Art Reference Library, New York; Bertha Saunders, New York; Scott Schaefer, Curator of Paintings, Los Angeles County Museum of Art; Robert Schmit, Paris; the staff of the Service Photographique, Réunion des Musées Nationaux, Paris; George T. M. Shackelford, Assistant Curator, European Art, Museum of Fine Arts, Houston; Hermann Shickman, New York; Barbara Stern Shapiro, Assistant Curator, Department of Prints and Drawings, Museum of Fine Arts, Boston; Marc Simpson, Curator of American Paintings, The Fine Arts Museums of San Francisco; Paul Smith, London; Theodore Stebbins, John Moor Cabot Curator of American Paintings, Museum of Fine Arts, Boston; Lewis W. Story, Associate Director, The Denver Art Museum; Michel Strauss, Department of Impressionist and Modern Paintings, Sotheby's, London; Martin Summers, The Lefevre Gallery, London; Peter Sutton, Baker Curator of European Paintings, Museum of Fine Arts, Boston; John L. Tancock, Department of Impressionist and Modern Paintings, Sotheby's, New York; Patricia Tang, E. V. Thaw and Company, New York; Richard Teitz, Director, Denver Art Museum; Eugene V. Thaw, E. V. Thaw and Company, New York; Richard Thomson, University of Manchester; Gary Tinterow, Assistant Curator, Department of European Paintings, The Metropolitan Museum of Art; Professor J. Kirk T. Varnedoe, Institute of Fine Arts, New York University; John J. Walsh, Jr., Director, The J. Paul Getty Museum, Malibu; Roger Ward, Curator of European Paintings, Nelson-Atkins Museum of Art, Kansas City; Dr. and Mrs. John C. Weber, New York; Daniel Wildenstein, Wildenstein and Company, New York; Mark Wilson, Director, Nelson-Atkins Museum of Art, Kansas City; Michael M. J. Wilson, Deputy Keeper, The National Gallery, London; and Susan Wise, Associate Curator of European Painting and Sculpture, The Art Institute of Chicago.

C.S.M.

Lenders to the Exhibition

The Art Institute of Chicago
The Ashmolean Museum, Oxford
Civica Galleria d'Arte Moderna, Raccolta Grassi, Milan
Sterling and Francine Clark Art Institute, Williamstown
The Cleveland Museum of Art
Corcoran Gallery of Art, Washington
Denver Art Museum
Mr. and Mrs. Ray Dolby
Dr. Sharon Flescher
Galleria d'Arte Moderna, Florence
Galleria d'Arte Moderna Ricci Oddi, Piacenza
The J. Paul Getty Museum, Malibu
Robin Burnett Harrison
Simone and Alan Hartman
The Robert Holmes à Court Collection,
Perth, Western Australia
Joseph E. Hotung
John G. Johnson Collection, at the Philadelphia
Museum of Art
Josefowitz Collection
Joslyn Art Museum, Omaha
Mr. and Mrs. George M. Kaufman
Mr. and Mrs. David Lloyd Kreeger
Leeds City Art Gallery
Mr. and Mrs. Alexander Lewyt
Mr. Giuliano Matteucci
Mr. and Mrs. Paul Mellon
Memphis Brooks Museum of Art
The Metropolitan Museum of Art, New York
Montreal Museum of Fine Arts
Musée des Beaux-Arts de Rennes
Musée de Cambrai
Musée Fabre, Montpellier
Musée du Louvre, Cabinet des Dessins, Paris
Musée Marmottan, Paris
Musée Municipal de Pau

Musée d'Orsay (Galerie du Jeu de Paume), Paris
Musée du Petit Palais, Paris
Musées de Pontoise
Museum of Art, Carnegie Institute, Pittsburgh
Museum of Fine Arts, Boston
The Museum of Fine Arts, Houston
The Museum of Modern Art, New York
Národni Galeri v Praze, Prague
Nasjonalgalleriet, Oslo
The National Gallery, London
National Gallery of Art, Washington
National Gallery of Victoria, Melbourne
The National Museum of Western Art, Tokyo
The Nelson-Atkins Museum of Art, Kansas City
Ohara Museum of Art, Kurashiki
The Joan Whitney Payson Gallery of Art, Westbrook
College, Portland, Maine
The Peabody Institute of the City of Baltimore
The Henry and Rose Pearlman Foundation
Petit Palais, Geneva
Philadelphia Museum of Art
The Phillips Collection, Washington
John and Marcia Price
Rijksmuseum Kröller-Müller, Otterlo
San Francisco Museum of Modern Art
Shelburne Museum, Shelburne, Vermont
Smith College Museum of Art, Northampton
Stanford University Museum of Art
Szépmüvészeti Múzeum, Budapest
The Toledo Museum of Art
Wheelock Whitney & Company, New York
Mrs. John Hay Whitney
E. J. van Wisselingh & Co., Naarden
Anonymous lenders

Directors' Preface

The New Painting: Impressionism 1874–1886 celebrates the extraordinary contribution to the history of modern art made by the eight group shows known as the Impressionist exhibitions. One hundred years ago the final exhibition of that historic series was held on the second floor of 1 rue Laffitte, a building at the corner of the boulevard des Italiens, then famous as the site of the restaurant La Maison Dorée. Shortly before the show opened, the Compagnie Jablochkoff proposed the installation of electric lights in the exhibition space, evidence of the rapid changes that were taking place in Parisian life midway through the second decade of the Third Republic.

By 1886 much of the art considered scandalous at the time of the first Impressionist group show (1874) had gained the respect of influential critics, and the role of commercial galleries had begun to assume an importance rivaling that of the officially sanctioned exhibitions known as the Salons; but the shows independently organized by the avant-garde remained significant and controversial statements about contemporary art. Although Monet, the artist whose paintings were synonymous with the term Impressionism, as well as Renoir and Caillebotte, chose not to exhibit in the eighth exhibition, the work of the leading Neo-Impressionists Seurat and Signac was well represented. Impressionism, the new painting of the 1870s and early 1880s, was in the midst of the final phase of the transition to Post-Impressionism and Symbolism, the new painting of the later 1880s and 1890s. Moreover, the experimental styles of the early eighties had begun to mature, and the work of younger artists had begun to emerge with an integrity of its own. The heyday of classic Impressionism was over, but it had given rise to an equally vibrant and exciting new movement.

The New Painting: Impressionism 1874–1886 is the first exhibition to concentrate on a selection of works actually included in the eight landmark group shows held during the critical twelve-year period that is the crucible of Modernism. It presents the new art of the 1870s and the 1880s as a rich mélange of styles and differing approaches to subjects from modern life. Its diversity will undoubtedly surprise viewers accustomed to thinking of Impressionism as an art concerned almost exclusively with plein-air painting and feathery brushwork. *The New Painting: Impressionism 1874–1886* illustrates the movement as a wide-ranging phenomenon, with both major and minor participants. We have included famous works as well as many that are often ignored and overlooked, but above all we have tried to provide a view of avant-garde art of 1874–1886 that approximates the experience of the visitors to the original eight exhibitions.

In 1874 the term Impressionism was used primarily to refer to the small group of artists interested in effects of color and light. Their loose brushwork and bright palette were sufficiently similar to suggest the presence of a new school, which a contemporary critic sarcastically labeled Impressionism, but the renegade exhibitions also served the needs of such artists as Degas who thought of themselves as Realists. For this reason, the subject of our exhibition is avant-garde art of the 1870s and 1880s. Our title, *The New Painting*, borrows the term advanced in 1876 by the critic Edmond Duranty in order to draw attention to the full spectrum of the modern movement without subjecting it to the descriptive limitations of one or another "ism."

Among those who saw the final exhibition was Vincent van Gogh. He had arrived in Paris only a few weeks before the opening and during the next two years was exposed to the work of virtually every important contemporary artist in Paris. Later, in letters written from Arles in 1888 and 1889, he used Impressionism as a synonym for the art of the avant-garde. Clearly the word had become a generic term for the Modernism of the 1870s and 1880s. Like van Gogh, we use Impressionism to refer to the movement in its broadest sense, but especially to refer to the new styles, attitudes, and perceptions that signal a break with the past. Impressionism was, more than anything else, the art of the new, and it is the goal of this exhibition to come to terms with that newness in the form in which it was first encountered.

We would like, first of all, to express our appreciation to Charles S. Moffett, Curator of Paintings, The Fine

Arts Museums of San Francisco, who selected and organized the exhibition. The idea for *The New Painting* originated with a lecture titled "Impressionism: A Redefinition" that he delivered at a symposium at the Smithsonian Institution in December 1974. During the course of the next decade he collected information about works included in the eight group shows. Three years ago he determined that there were sufficient works of high quality available to mount an effective exhibition, and shortly thereafter The Fine Arts Museums of San Francisco and the National Gallery of Art agreed to pursue the project together.

During the last two years many other individuals in San Francisco and Washington have contributed enormously to the exhibition, and special thanks are due to the following: Thomas K. Seligman, Deputy Director for Education and Exhibitions, The Fine Arts Museums of San Francisco; D. Dodge Thompson, Chief, Exhibition Programs, National Gallery of Art; Charles F. Stuckey, Curator of Modern Painting, National Gallery of Art; Ann Heath Karlstrom, Publications Manager, The Fine Arts Museums of San Francisco; Gaillard Ravenel, Chief of Design and Installation, National Gallery of Art; Max Chance, Exhibition Architect, The Fine Arts Museums of San Francisco; Debra Pughe, Exhibitions Manager, The Fine Arts Museums of San Francisco; Ann M. Bigley, Exhibitions Officer, Department of Exhibitions, National Gallery of Art.

We would also like to take this opportunity to express our profound gratitude to AT&T for the financial support that has made the exhibition possible. The outstanding record of this company as a corporate contributor to the arts is well known to audiences throughout this country, and we would like particularly to thank the following individuals for their interest in *The New Painting*: C. L. Brown, Chairman of the Board; Edward M. Block, Senior Vice President; James L. Brunson, Corporate Vice President; Charles Marshall, Executive Vice President; and Mary Delle Stelzer, formerly Corporate Advertising Manager.

In addition, we are most appreciative of the Indemnity granted the exhibition by the Federal Council on the Arts and Humanities, and of the support given The Fine Arts Museums of San Francisco by the National Endowment for the Arts. At the National Gallery, where the exhibition receives federal as well as private sector support, we thank those responsible not only for helping this presentation, but also for the funding that has made possible the construction of a new suite of galleries that this exhibition inaugurates. They now complete the construction of the main floor of the original Gallery building given the nation by Andrew Mellon.

Finally, words are inadequate to express our profound thanks to the ninety-four lenders to the exhibition. Institutions and private collectors in this country and abroad have graciously consented to be without some of their most important works for more than six months, and we are exceedingly grateful. We particularly appreciate the exceptional generosity of the Musée d'Orsay, Paris; The Metropolitan Museum of Art, New York; and The Art Institute of Chicago for loans that are crucial to this undertaking.

Ian McKibbin White
Director
The Fine Arts Museums of San Francisco

J. Carter Brown
Director
National Gallery of Art

The New Painting
Impressionism 1874-1886

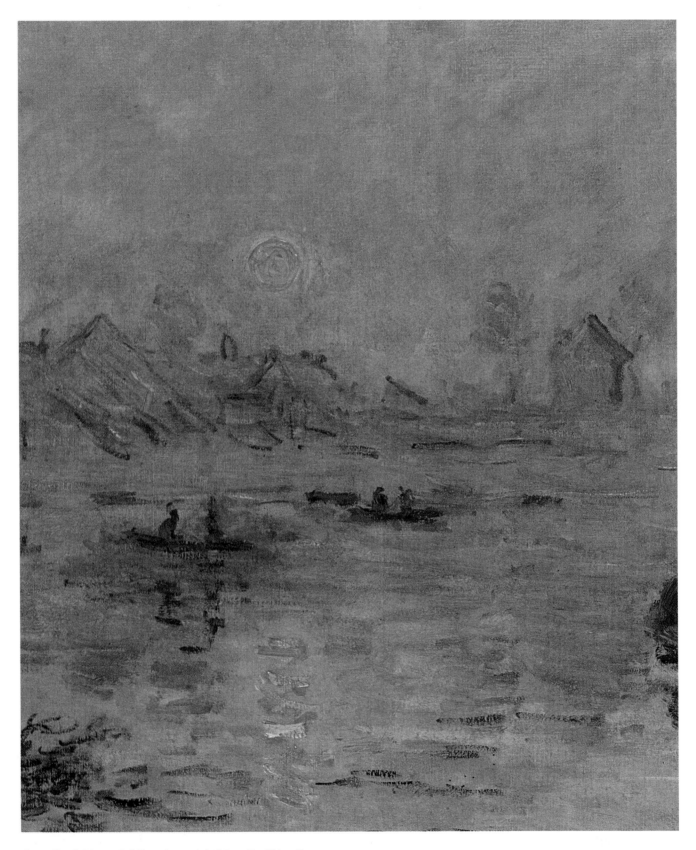

fig. 5 Claude Monet, *Soleil couchant, sur la Seine, effet d'hiver (Sunset on the Seine at Lavacourt, Winter Effect*, VII–62), 1880. Detail. Oil on canvas, 39⅜ x 59⅞ in. (100 x 152 cm). Musée du Petit Palais, Paris

Introduction

Charles S. Moffett

In 1867 Frédéric Bazille wrote to his family and described the frustrated plans of "a group of young people" to organize exhibitions of their own work independent of the officially authorized, juried exhibitions known as the Salons.[1] Although he did not name the members of the group, they were most probably Monet, Renoir, Sisley, Pissarro, Cézanne, Fantin-Latour, Manet, Guillemet, Degas, Morisot, Félix Bracquemond, Guillaumin, and, of course, Bazille himself.[2] The project collapsed shortly thereafter because of a lack of money.

In addition, the group initially encountered steadfast opposition from the academic establishment. According to Mallarmé,

In 1867 a special exhibition of the works of Manet and some few of his followers gave the semblance of a party to the then nameless school of recent painting which thus grew up, and party strife grew high. The struggle with this resolute intruder was preached as a crusade from the rostrum of each school. For several years a firm and implacable front was formed against its advance. . . .[3]

Two years later, Bazille announced to his parents that a "dozen talented people" had decided to rent a space in order to hold non-juried exhibitions of their own work as well as that of others by invitation.[4] It is very likely that the revitalized project had resulted from the efforts of, among others, the group portrayed in Fantin-Latour's *A Studio in the Batignolles Quarter* (fig. 1). However, before an exhibition could be organized, the Franco-Prussian War (1870–1871) broke out and was followed by the disastrous civil upheaval known as the Commune (1871).

Nevertheless, the idea of the independent exhibitions remained alive. In an article published in the 5 May 1873 issue of *L'Avenir National*, the critic Paul Alexis encouraged the formation of an "artistic corporation" to counter the iniquitous shortcomings of the Salon system.[5] He also alluded to earlier plans for such a "syndicate" and recalled discussions at the Café Guerbois of "projects of annual or monthly contributions put forward in certain groups, of statutes outlined, of societies for exhibitions and sales ready to be founded."[6] He specifically mentioned plans for an arrangement whereby "each member would have contributed five francs every month and been entitled to show two of his works for permanent exhibition and sale; no preliminary inspection, no exclusions. . . ."[7]

The 12 May edition of *L'Avenir National* included a letter from Monet to Alexis announcing the formation of an association of artists similar to that described the week before by the critic:

A group of painters assembled in my home has read with pleasure the article you have published in L'Avenir National. *We are happy to see you defend ideas which are ours too, and we hope that, as you say,* L'Avenir National *will kindly give us assistance when the society that we are about to form will be completely constituted.*[8]

In a note following the letter, Alexis reported that, in addition to Monet, the group included "several artists of great merit," among whom were Pissarro (the only artist who was to participate in all of the eight group shows), Jongkind, Sisley, Béliard, Amand Gautier, and Guillaumin.[9] He also pointed out the diversity of the organization, observing that

these painters, most of whom have previously exhibited, belong to that group of naturalists which has the right ambition of painting nature and life in their large reality. Their association, however, will not be just a small clique. They intend to represent interests, not tendencies, and hope for the adhesion of all serious artists.[10]

From the beginning, then, the group was broadly based and encompassed a wide range of "interests." As a result, it eluded a simple definition and seemed to exist principally for the purpose of providing an alternative to official exhibitions.

The association held the first of eight jointly organized shows in the spring of 1874. The last took place almost exactly twelve years later. Between 1874 and 1886 the critics used many labels to refer to the group. The artists were known variously as Independents, Impressionists, Intransigents, phalangists, and radicals, and were occasionally characterized as lunatics, maniacs, and worse (a caricaturist suggested that pregnant women risked miscarriage at the sight of the new art).[11] In retrospect, it is

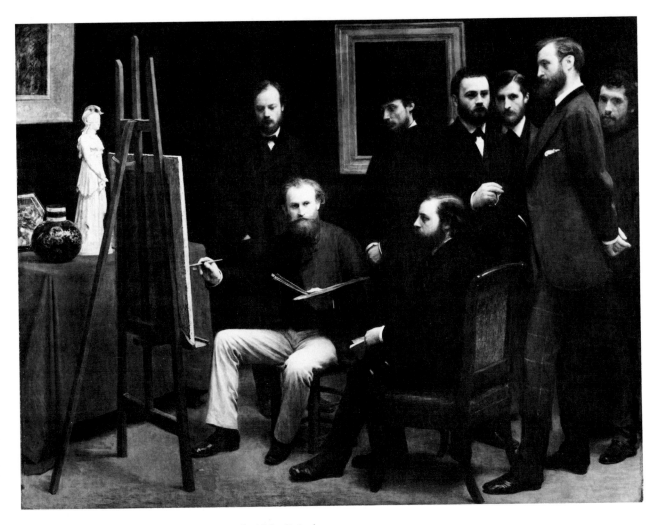

fig. 1 Henri Fantin-Latour, *Un atelier aux Batignolles* (*A Studio in the Batignolles Quarter*), 1870. Oil on canvas, 68 ½ x 82 in. (174 x 208.3 cm). Musée d'Orsay (Galerie du Jeu de Paume), Paris

evident that few individuals, including some of the most astute artists and critics, had a thorough understanding of the movement. Furthermore, the identity and philosophy of the group were unclear because the participating artists wished to avoid a name for the association that denoted a specific style. During the course of the planning for the first show, Degas proposed that they call themselves La Capucine (The Nasturtium), and Renoir later referred to his own fear of a title signifying a "new school."[12] Evidently the need for a neutral title was recognized by most members, because in 1874 they chose *SOCIETE ANONYME des artistes peintres, sculpteurs, graveurs, etc.* (frontispiece). In today's vernacular, they would have called themselves [A Group of] Artists, Painters, Sculptors, Printmakers, etc., Inc. The band of renegades recognized its own diversity, but the name initially adopted belied the extraordinary richness and complexity of the fledgling movement.

The title page of the catalogue of the second group show (1876) refers only to "la 2ᵉ EXPOSITION de peinture" and omits *SOCIETE ANONYME.* . . .[13] Nevertheless, according to at least one critic, the artists had already begun to call themselves Impressionists.[14] Furthermore, the title of Mallarmé's essay, "The Impressionists and Edouard Manet," indicates that in 1876 the word was widely used and bore none of the pejorative connotations intended by the critic who made the term popular in connection with the group two years earlier. Although the title page of the catalogue for the third exhibition (1877) also identifies the show only by number and fails to give the name of a sponsoring organization, during the planning for the show the participants agreed to bill it as an "Exposition des Impressionnistes."[15] Degas, who opposed the move, proposed in 1879 that they hold the fourth group show under the auspices of "un groupe d'artistes indépendants, réalistes, et impressionnistes."[16]

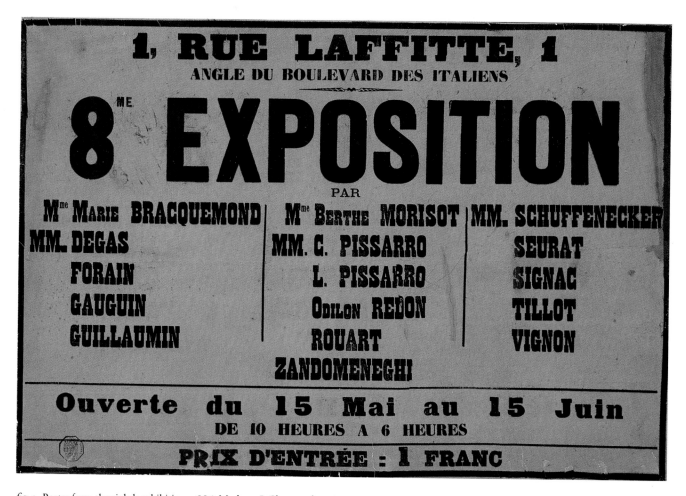

fig. 2 Poster from the eighth exhibition, 1886. Madame J. Chagnaud-Forain, Le Chesnay, France

However, only the phrase "Group of Independents" proved acceptable to the general membership. It seems clear that the avant-garde itself insisted upon the recognition of Impressionism as only one thread in the increasingly complex fabric of the modern movement. For the fifth (1880), sixth (1881), and seventh (1882) shows, they apparently continued to bill themselves as Independents (Moffett, "Disarray," fig. 2). But in 1886 they dropped the word Independent because of possible confusion with the newly formed Groupe des Artistes Indépendants;[17] both the exhibition poster (fig. 2) and the catalogue cover tell us only that it was the eighth exhibition. In short, the loose confederation that began as a Société anonyme ended its series of exhibitions without any name at all.

The eight group shows were in fact "umbrella" exhibitions for a diverse and complex association of avant-garde artists whose constantly changing membership obviated the ongoing usefulness of a term such as Impressionism. Degas's proposal in 1879 that the artists use "Independents, Realists, and Impressionists" seems, in retrospect, quite reasonable, but the strong factionalism within the group prevented it. Choosing terminology that accurately describes the complex phenomenon reflected by the eight shows remains a problem, but the present exhibition proposes a solution based on the title of an essay published in 1876 by the novelist and critic Edmond Duranty, *The New Painting: Concerning the Group of Artists Exhibiting at the Durand-Ruel Galleries*, published as a pamphlet shortly after the opening of the second exhibition.[18] During the course of his discussion of the emerging movement, Duranty carefully avoided the use of any term that implied stylistic exclusivity. Although his essay reflects his bias as a Realist/Naturalist, it is the first cogent effort to deal comprehensively with the new art. The text reflects his strong

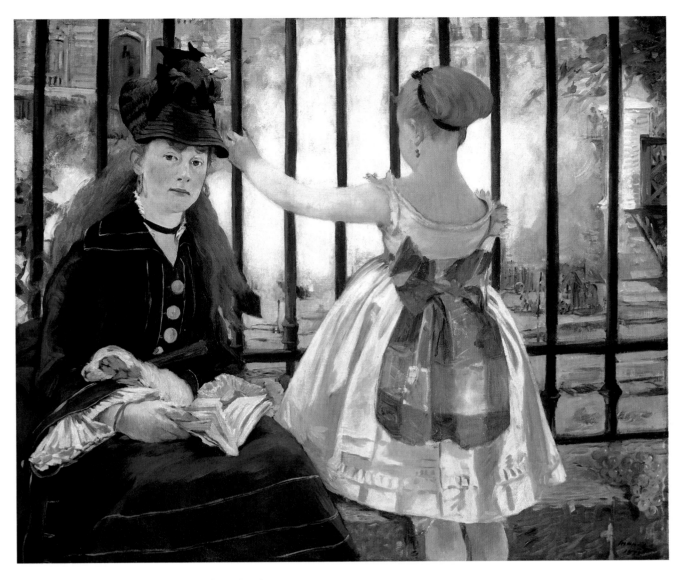

fig. 3 Edouard Manet, *Gare Saint-Lazare (The Railroad)*, 1872–
1873. Oil on canvas, 36½ x 45 in. (92.7 x 114.3 cm). National Gallery
of Art, Washington. Gift of Horace Havemeyer in memory of his
mother, Louisine W. Havemeyer, 1956

interest in the work of his friend Degas, but he attempted
to describe the main characteristics of the movement
without insisting that it adhere to one or another stylistic
formula. Like Mallarmé, he recognized that art was
undergoing fundamental changes and would never be the
same again, and that the new styles and the innovative
treatments of a wide range of subjects from modern life
signaled the beginning of a new esthetic order. However,
he resisted the use of an "ism" to describe it. The word
Impressionism does not appear in his essay.

The phrase "the new painting" accurately describes
the main thrust of each of the group shows that have
been known for more than a century as the Impressionist
exhibitions, but the title of the present exhibition com-
bines Duranty's phrase with the word Impressionism
because the latter term will unquestionably remain syn-
onymous with French avant-garde painting of the 1870s
and 1880s. It is one of many similarly imprecise art his-
torical terms that suggest an extremely limited range of
stylistic possibilities and thereby distort our view of a
particular period or school. However, by borrowing
from the title of Duranty's essay, we hope to draw atten-
tion to the so-called Impressionist movement as more
than the introduction of plein-air painting, feathery
brushwork, and a new understanding of color and light.
During the 1870s and 1880s artists turned to new sub-
jects and developed new styles appropriate to them.
Modern life provided a new iconography that demanded

fresh approaches and a new expressiveness. In addition, although the new art evolved as a logical consequence of Realism and Naturalism, it soon led toward an art that quickly exhausted the possibilities of imagery concerned principally with the appearance of things as they are. Paradoxically, it also grew increasingly abstract.[19] Furthermore, as Richard Shiff shows, the new painting was directly and indirectly influenced by new theories of perception that affected both the understanding and the purpose of art.[20]

The New Painting: Impressionism 1874–1886 honors the spirit and diversity of the eight original exhibitions. It is a selection of one hundred and sixty paintings and other works that are, in effect, a ninth group show. With the advantage of hindsight, the work of major figures has been emphasized, but examples by many lesser participants have also been included. The catalogue presents a detailed art-historical exegesis of each of the eight group shows, while the exhibition offers a unique opportunity to experience a large assemblage of works actually shown in the landmark exhibitions. During the last century there have been many exhibitions devoted to Impressionism, but this is the first to concentrate on the pictures that the artists themselves chose to bring before the public and the critics in order to establish the viability of their new art. Only in the case of Seurat's contribution to the eighth show has it proven necessary to make significant substitutions.

The present exhibition proposes a view of the modern movement of the 1870s and 1880s that acknowledges its strengths as well as its weaknesses. The "new painting" challenged and overcame long established traditions and the institutionalized control of standards and taste, but it also passed through a transitional phase in the late seventies and early eighties that is often referred to as a crisis, or the period of the so-called crisis styles.[21] In addition, key participants defected to the Salon and were replaced by others whose work was, in varying degrees, inappropriate. For example, in 1880 Monet exhibited at the Salon, but Raffaëlli was invited to participate in the fifth exhibition and showed more work than any other artist. Furthermore, his contribution was lauded by the critics, many of whom recognized that his work was out of place. That year the situation was particularly confusing and was made more so by Degas, who failed to exhibit eagerly awaited works listed in the catalogue and made last-minute substitutions.[22]

Nevertheless, the group shows remained the principal means through which the public and the critics experienced avant-garde art during the 1870s and 1880s. Despite ongoing organizational problems, internal rifts, disloyalty, hostile critics, and an uncertain membership of artists of widely varying ability and stylistic tendencies, the jointly organized exhibitions did in fact represent much of what was new in art. Moreover, they

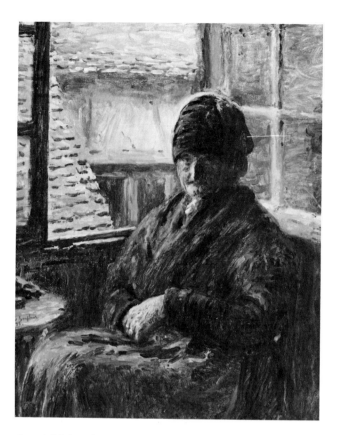

fig. 4 Adolphe-Félix Cals, *La mère Boudoux* (*La mère Boudoux à sa fenêtre*, III–13), 1876. Oil on canvas, 23⅞ x 19 in. (60.6 x 48.3 cm). The Dixon Gallery and Gardens, Memphis

provide us with a window onto the uneven, often exciting, but occasionally disappointing machinations of the avant-garde, and remind us that the actual evolution of art seldom describes the smooth trajectory that art historians, critics, and the public often attempt to impose on modern art in the effort to understand it and predict its course.

If the group shows had been more perfectly orchestrated events, contemporary audiences might have seen such works as Manet's *The Railroad* (*fig.3*) in one of the exhibitions. However, instead of appearing in the first show, it was exhibited at about the same time in the Salon of 1874. As a view of a scene near the Gare Saint-Lazare, it would have been particularly interesting in the context of the third exhibition, which included several views by Monet of the interior and the exterior of the Gare Saint-Lazare (cat. nos.51, 52, and 54), as well as Caillebotte's view of the nearby Pont de l'Europe (cat. no.39). Although numerous critics cited Manet as the leader of the avant-garde, he repeatedly refused invitations to participate in the shows organized by his friends and colleagues, preferring instead to submit to the Salon.[23] It is extremely likely that he did not want to participate in the Independent exhibitions because they

included the work of secondary and tertiary figures (e.g., Adolphe-Félix Cals's *La Mère Boudoux*, fig. 4). For an artist who had sought, since 1859, the kind of official recognition and public acclaim possible only as the result of success at the Salon, there can be no question that he preferred not to have his work exhibited under the auspices of a group that seemed unable to distinguish between the accomplishments of serious avant-garde artists and paintings by others of questionable competence. Although he was recognized in the press as a leader of the modern movement, he carefully avoided having his pictures associated in the public mind with those of mediocre artists whose shortcomings were less apparent in the context of an exhibition of avant-garde art.

Today, it is not difficult to understand why he chose to try to maintain an identity separate from that of the group that included such artists as Attendu, Béliard, Bureau, Cals, Colin, Cordey, Debras, Guillaumin, Lamy, Latouche, Lebourg, Lepic, Levert, Meyer, de Molins, Mulot-Durivage, Auguste-Louis-Marie and Léon-Auguste Ottin, Raffaëlli, Léopold Robert, Somm, Tillot, Vidal, Vignon, and others. Indeed, as the present exhibition was being organized, Manet's reluctance to formally associate with many of those artists became increasingly understandable. The work of certain artists (e.g., Levert and Mulot-Durivage) has virtually disappeared because it has never merited serious attention, while that of many others is decidedly inferior. Moreover, the work of Cals, Forain, Lebourg, Somm, Tillot, and other secondary figures suffers markedly in comparison to that of Monet, Pissarro, Cézanne, and Degas.

Of the 1,755 entries listed in the eight catalogues published in connection with the group shows, there is a large complement of art that can be considered negligible. It obscured the work of the more important artists and lowered the overall quality of the group shows. Nevertheless, the eight exhibitions unquestionably played an important role as vehicles for exciting new work by such key figures as Boudin, Caillebotte, Cassatt, Cézanne, Degas, Gauguin, Monet, Morisot, Pissarro, Redon, Renoir, Seurat, Signac, and Sisley. They also included interesting, sometimes innovative, works by such less well-known artists as Félix and Marie Bracquemond, de Nittis, Rouart, Desboutin, Forain, Legros, Raffaëlli, Schuffenecker, and Zandomeneghi. Moreover, it is significant that from the beginning the shows were popular. They were well attended and attracted the enthusiastic attention of a large audience. In addition, they were widely reviewed and carefully scrutinized by leading critics. Although much of the contemporary commentary is extremely hostile and often obtuse, one senses a profound interest in the exhibitions. Critics may not have admired much of what they saw, but they could not ignore the shows. Even Albert Wolff, who stated in his vitriolic review of the fifth exhibition that the show was not worth the trouble to see or to discuss, admitted that the work of three artists—Degas, Morisot, and Raffaëlli—was exceptional. Like many of his colleagues, by the late 1870s and early 1880s Wolff had begun to recognize the merit of certain aspects of the new movement. However, the fact that most critics greatly admired Raffaëlli's contribution to the fifth and sixth exhibitions, as opposed to that of, for instance, Degas, indicates how imperfectly they understood contemporary art.

Nevertheless, *The New Painting: Impressionism 1874–1886* is deeply indebted to the critics of the 1870s and 1880s. Their descriptions of individual works have permitted identification of many of the works actually included in the exhibitions. In certain instances they have provided the evidence with which to verify the existing record, and in others they have yielded facts that allow us to augment and/or correct it. For example, Paul Tucker has convincingly identified the version of *Impression, soleil levant* (Tucker, fig. 15) that was included in the first group show, and we now know that Degas's *Petites filles spartiates provoquant des garçons* (Moffett, "Disarray," fig. 5) was not exhibited in the fifth show although it is listed in the catalogue. Furthermore, the reviews make it apparent that the titles listed under Degas's name in the catalogues are often very inaccurate.

However, much remains to be done. For example, we have failed to positively identify any of the works that Lebourg exhibited. Many of his works have the same title, and few are dated. Rather than guess wildly, we await the catalogue raisonné currently being prepared by Rodolphe Walter. In addition, numerous works by such leading artists as Cézanne are yet to be identified; we have included the landscape from the Philadelphia Museum of Art (cat. no. 3), but we have done so only on the basis of the subject, the date, and Venturi's qualified assertion.[24] Although we can be reasonably certain that the picture represents the type of landscape that the artist exhibited as *Etude: Paysage à Auvers*, there is no hard documentary evidence to verify the identification. In addition, the sole work by Redon in our exhibition (cat. no. 151) is also only a strong candidate; it is one of two possibilities suggested by descriptions in reviews. However, like the Cézanne from Philadelphia, we are sure that it is of the type that the artist exhibited. Regarding the works shown by Seurat in the eighth exhibition, we have taken a bolder step. In addition to one painting (cat. no. 152) and one drawing (cat. no. 153) actually included in 1886, several substitutions have been made to adequately represent his enormous impact. However, all of the works substituted are paintings of 1885 or 1886 that the artist exhibited in group shows sponsored by the Groupe des Artistes Indépendants in 1886 or 1887.[25] In short, although they were not included in any of the so-called Impressionist Exhibitions, they were shown in analogous avant-garde exhibitions.

In addition, other surrogates and alternates have been sparingly used. For example, Monet's *Boulevard des Capucines* (cat. no.7) has long been thought to have been included in the first exhibition, but certain authorities believe the work shown then is the version now in the Pushkin Museum, Moscow. Also, the version of Renoir's *Bal du Moulin de la Galette* in the Musée d'Orsay, as opposed to the example in the present show (cat. no.62), is generally accepted as the painting actually included in the third exhibition.

It should also be pointed out that although many prints were exhibited in the group shows, none are included here. Early in the course of the organization of this exhibition, it became evident that the prints ought to be treated as the subject of an independent project. They form an important component of the group shows, but in the context of an exhibition devoted principally to paintings it was felt that a few isolated examples would prove inadequate and ineffective.

Finally, *The New Painting: Impressionism 1874–1886* is an exhibition about eight exhibitions, but it also addresses the processes through which art redefines and renews itself. The works in this exhibition represent conscious decisions on the part of numerous artists who created the foundations of the esthetic that continues to dominate attitudes toward art. Whether an artist was invited to participate in any of the eight group shows, and whether he or she chose to participate, is undeniably significant, but *what* an artist decided to send to the exhibitions is all important. For this reason, *The New Painting: Impressionism 1874–1886* focuses on precisely those pictures that the artists themselves chose to have seen by their contemporaries. In this connection, a letter of 8 March 1880 from Monet to the critic Théodore Duret provides an important insight into the artists' decision-making processes.[26] In the letter Monet explains that he realizes he will have to compromise if one of the two works he intends to submit to the Salon is to be accepted, and he knows that another painting he is working on is "too Monet" to consider sending. The tamer work was in fact accepted (Isaacson, *fig.7*),[27] but it is of more than passing significance that *Les glaçons* (cat. no.120), the painting rejected in 1880 by the Salon jury, was later exhibited in the seventh group show.[28] Clearly the independent exhibitions served precisely the purpose intended by the artists when they were inaugurated: they obviated the censorship of style and subject imposed by the Salon jury and considerably broadened the scope of modern art in the public mind.

Notes

All translations by the author unless otherwise noted.

1. Paul Tucker, "The First Impressionist Exhibition in Context," in this catalogue, and John Rewald, *The History of Impressionism*, 4th rev. ed., 2d printing (New York, 1980), 172.

2. Rewald, 172–173. Of the artists mentioned, all participated in at least one of the group shows except Bazille (who was killed in the Franco-Prussian War), Fantin-Latour, and Manet.

3. Stéphane Mallarmé, "The Impressionists and Edouard Manet," *The Art Monthly Review and Photographic Portfolio* 1, no. 9 (January 1876), 117, and in this catalogue.

4. Tucker, and Rewald, 173.

5. P[aul] Alexis, "Paris qui travaille, III, Aux peintres et sculpteurs," *L'Avenir National*, 5 May 1873, as cited and trans. Rewald, 309.

6. Rewald, 213.

7. Rewald, 213.

8. Monet to Alexis, 7 May 1873; the original text, as it appeared in the 12 May 1873 edition of *L'Avenir National*, is reprinted in Daniel Wildenstein, *Claude Monet, Biographie et catalogue raisonné*, 4 vols. (Lausanne and Paris, 1974–1985), 1:428, letter 65. This translation is from Rewald, 309.

9. Alexis, *L'Avenir National*, 12 May 1873.

10. As cited and trans. Rewald, 309.

11. Caricature by Cham, *Le Charivari* (16 April 1877): 3. "Madame! cela ne serait pas prudent. Retirez-vous!"

12. Rewald, 313.

13. The original catalogue for each exhibition is reprinted in this catalogue following the appropriate essay. For a discussion of the dissolution of the Société anonyme as a legal entity, see Tucker.

14. Bernadille review in *Le Français*, 21 April 1876, as cited in Adolphe Tabarant, *Manet et ses oeuvres*, 3d ed. (Paris, 1947), 285; also see Rewald, 366.

15. Rewald, 390.

16. Rewald, 421.

17. See Rewald, 500: "During the spring of 1884 . . . Paris had been the scene of new turmoil in the art world. Because the Salon jury once more attempted to strangle unorthodox efforts—despite its new, more liberal rules—hundreds of rejected artists had come together and founded a *Groupe des Artistes Indépendants*, consciously or not usurping the name under which, at Degas's request, the impressionists had exhibited for several years. But this new group was not constituted by kindred spirits; to the contrary, it was pledged to admit anybody wishing to join. Its first exhibition, which opened on May 15, 1884, in a barrack in the Tuileries gardens that had been set up as the temporary headquarters of a post office, presented a conglomeration of highly dissimilar works. The participants were not all artists rejected by the jury, since many who had not tried to gain admission to the Salon now showed with the new group."

18. Edmond Duranty, *La nouvelle peinture: A propos du groupe d'artistes qui expose dans les galeries Durand-Ruel* (Paris, 1876). The essay is reprinted in English and French in this catalogue.

19. Robert Goldwater, "Symbolic Form: Symbolic Content," *Acts of the Twentieth International Congress of the History of Art, Studies in Western Art*, 4 vols., *Problems of the 19th & 20th Centuries* (Princeton, 1963), 4:114–116.

20. Richard Shiff, "The End of Impressionism," in this catalogue.

21. See Goldwater, 111–121, and Joel Isaacson, *The Crisis of Impressionism*, exh. cat. (Ann Arbor: University of Michigan, Museum of Art, 1980), 2–42.

22. Charles S. Moffett, "Disarray and Disappointment," note 43, in this catalogue.

23. See Charles S. Moffett, "Manet and Impressionism," *Manet 1832–1883*, exh. cat. (New York: Metropolitan Museum of Art, 1983), 29–35.

24. Lionello Venturi, *Cézanne, son art, son oeuvre*, 2 vols. (Paris, 1936), no. 157.

25. See note 16.

26. Monet to Duret, 8 March 1880; reprinted in Wildenstein, 438, letter 173. Also, see Moffett, "Disarray," notes 3 and 4 and appropriate text, in this catalogue.

27. Moffett, " Disarray," in this catalogue.

28. *Les glaçons* was apparently also included in Monet's one-man show in June 1880 at La Vie Moderne, the gallery operated on the premises of the magazine of the same name; see Théodore Duret, *Le peintre Claude Monet*, exh. cat. (Paris: La Galerie du Journal Illustré de la Vie Moderne, 1880), 14, no. 1, *Les glaçons: Hiver de 1879–80*; and Rewald, 479, note 14.

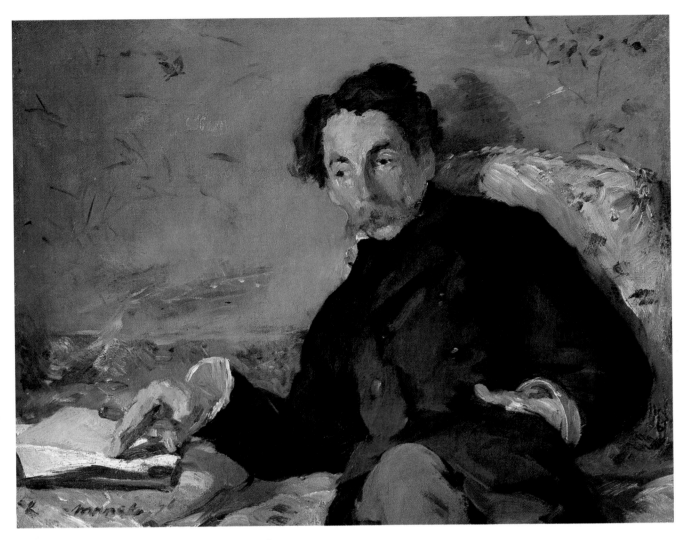

Edouard Manet, *Portrait de Stéphane Mallarmé*, 1876. Oil on canvas,
10⅝ x 14⅛ in. (27 x 36 cm). Musée d'Orsay (Galerie du Jeu de
Paume), Paris. Photo: Cliché des Musées Nationaux

The Impressionists and Edouard Manet

Stéphane Mallarmé

This reprint of "The Impressionists and Edouard Manet" will make generally available a key critical work in the history of French avant-garde painting of the 1870s. The article first appeared in the 30 September 1876 issue of The Art Monthly Review and Photographic Portfolio, *a periodical published in London.[1] We know that the poet Arthur O'Shaughnessy arranged with George T. Robinson, the director of the review, to have the essay published, because Robinson wrote a letter of confirmation, dated 19 July 1876, to Mallarmé:*

Our mutual friend Mr. Arthur O'Shaughnessy told me that you will kindly write an article for me on the views and aims of the Impressionists, and especially those of Manet. I will allocate to you two or three double-columned pages. . . . Please express your opinion and your account or critique very frankly. Speak to the public as you would speak to friends—straightforwardly and without too much discussion, but not too short.[2]

A second letter from Robinson to Mallarmé, dated 19 August 1876, reveals that the essay is a translation: "I made a translation of your article—it is in the hands of the printer, and in two or three days you will have proofs."[3] In a letter written to O'Shaughnessy exactly two months later, Mallarmé expressed his satisfaction with the translation and noted confidentially that he had made some corrections:

Thank you one last time for [your assistance with] the article on the Impressionists. Mr. Robinson was charming about everything; and, except for some easily rectified mistranslations (this is between us!) his excellent translation did my prose honor and rendered the work presentable. It goes without saying that the payment was generous and punctual.[4]

Although "The Impressionists and Edouard Manet" is unquestionably a translation, Mallarmé's satisfaction with the published text is important because the original French manuscript apparently no longer exists. Moreover, minor peculiarities of sentence construction, syntax, and diction suggest that Mallarmé may have done more than address mere problems of translation. In this connection, it is noteworthy that Mallarmé's command of fluent English is indisputable; following a trip to Lon-don in 1863 to learn the language in order to read the work of Edgar Allan Poe (1809–1849), he began a thirty-year career as a teacher of English in French schools.[5]

Mallarmé's early poetry was published in 1862, but he did not become well known until the 1870s when he published his translation of Poe's The Raven (1875) and his own L'après-midi d'un faune (1876), both of which were illustrated by his good friend Manet. In the 1880s he emerged as the central figure in the Symbolist movement in literature, which, like Impressionism, emphasized not things themselves but the effects produced by things (peindre non la chose mais l'effet qu'elle produit).[6] Furthermore, the Tuesday evening gatherings in his apartment on the rue de Rome, which began in 1880, played an exceedingly important role in the development of late nineteenth- and early twentieth-century French literature.

"The Impressionists and Edouard Manet" is an appreciation, explanation, and defense of his friend's work; it is also valuable as a general statement about the Impressionist movement of which Manet, willingly or not, was the acknowledged leader.[7] Manet repeatedly refused invitations to participate in the group shows, but numerous critics, including Mallarmé, cited him as "the head of the school of Impressionists, or rather the initiator of the only effective movement in this direction." In his essay, Mallarmé, like Duranty in The New Painting, *attempts to come to terms with the movement as a phenomenon and to give it the broadest possible definition. He associates it with the rise of Realism, in both literature and painting, and notes that in the late 1860s it was "a nameless school" that was not without "party strife." He goes on to observe that by the mid-seventies the public had begun to show measurable interest in "those then styled the Intransigeants, now the Impressionists."[8]*

In addition, he points out the characteristics of both subject and style that distinguish the emerging group. Manet's work will, he believes, "educate the public eye" and render "the graces which exist in the bourgeoisie . . . as worthy models in art." Mallarmé identifies the other

members of the group as artists whose primary interests are landscape painting and "subtle and delicate changes in nature." Underscoring their new treatment of light, space, and air the critic draws attention to the growing acceptance of the principles of Manet and his colleagues: There is indeed no painter of consequence who during the last few years has not adopted or pondered over some of the theories advanced by the Impressionists, and notably that of open air, which influences all modern artistic thought.

Mallarmé's essay also places the modern movement in a broad historical context: "Impressionism is the principal and real movement of contemporary painting. The only one? No. . . ." Equally important, he perceives the period to represent a wide-ranging transition "from the old imaginative artist to the energetic modern worker." And with remarkable clarity and foresight, he identifies the inexorable rise of new social, political, and esthetic orders: The participation of a hitherto ignored people in the political life of France is a social fact that will honour the whole of the close of the nineteenth century. A parallel is found in artistic matters, the way being prepared by an evolution which the public with rare prescience dubbed, from its first appearance, Intransigeant, which in political language means radical and democratic.

c.s.m.

Without any preamble whatsoever, without even a word of explanation to the reader who may be ignorant of the meaning of the title which heads this article, I shall enter at once into its subject, reserving to myself either to draw my deductions, new from an art point of view, as the facts I relate present themselves, or leave them to ooze out when and as they may.

Briefly, then, let us take a short glimpse backward on art history. Rarely do our annual exhibitions abound with novelty, and some few years back such years of abundance were still more rare; but about 1860 a sudden and a lasting light shone forth when Courbet began to exhibit his works. These then in some degree coincided with that movement which had appeared in literature, and which obtained the name of Realism; that is to say, it sought to impress itself upon the mind by the lively depiction of things as they appeared to be, and vigorously excluded all meddlesome imagination. It was a great movement, equal in intensity to that of the Romantic school, just then expiring under the hands of the landscape painters, or to that later one whence issued the bold decorative effects of Henri Regnault; and it then moved many on a new and contemporaneous path. But in the midst of this, there began to appear, sometimes perchance on the walls of the Salon, but far more frequently and certainly on those of the galleries of the rejected, curious and singular paintings—laughable to the many, it is true, from their very faults, but nevertheless very disquieting to the true and reflective critic, who could not refrain from asking himself what manner of man is this? and what the strange doctrine he preaches? For it was evident that the preacher had a meaning; he was persistent in his reiteration, unique in his persistency, and his works were signed by the then new and unknown name of EDOUARD MANET. There was also at that time, alas! that it should have to be written in the past tense, an enlightened amateur, one who loved all arts and lived for one of them. These strange pictures at once won his sympathy; an instinctive and poetic foresight made him love them; and this before their prompt succession and the sufficient exposition of the principles they inculcated had revealed their meaning to the thoughtful few of the public many. But this enlightened amateur died too soon to see these, and before his favourite painter had won a public name.

That amateur was our last great poet, Charles Baudelaire.

Following in appreciative turn came the then coming novelist Emile Zola. With that insight into the future which distinguishes his own works, he recognized the light that had arisen, albeit that he was yet too young to then define that which we to-day call Naturalism, to follow the quest, not merely of that reality which impresses itself in its abstract form on all, but of that absolute and important sentiment which Nature herself impresses on those who have voluntarily abandoned conventionalism.

In 1867 a special exhibition of the works of Manet and some few of his followers, gave to the then nameless school of recent painting which thus grew up, the semblance of a party, and party strife grew high. The struggle with this resolute intruder was preached as a crusade from the rostrum of each school. For several years a firm and implacable front was formed against its advance; until at length vanquished by its good faith and persistency, the jury recognised the name of Manet, welcomed it, and so far recovered from its ridiculous fears, that it reasoned and found it must either declare him a self-created sovereign pontiff, charged by his own faith with

the cure of souls, or condemn him as a heretic and a public danger.

The latter of these alternatives being now-a-days definitively adopted, the public exhibition of Manet's works has of late taken place in his own studio. Yet, and notwithstanding all this, and in spite of concurrent Salons, the public rushed with lively curiosity and eagerness to the Boulevard des Italiens and the galleries of Durand Ruel in 1874 and 1876, to see the works of those then styled the Intransigeants, now the Impressionists. And what found they there? A collection of pictures of strange aspect, at first view giving the ordinary impression of the motive which made them, but over beyond this, a peculiar quality outside mere Realism. And here occurs one of those unexpected crises which appear in art. Let us study it in its present condition and its future prospects, and with some attempt to develop its idea.

Manet, when he casts away the cares of art and chats with a friend between the lights in his studio, expresses himself with brilliancy. Then it is that he tells him what he means by Painting; what new destinies are yet in store for it; what it is, and how that it is from an irrepressible instinct that he paints, and that he paints as he does. Each time he begins a picture, says he, he plunges headlong into it, and feels like a man who knows that his surest plan to learn to swim safely, is, dangerous as it may seem, to throw himself into the water. One of his habitual aphorisms then is that no one should paint a landscape and a figure by the same process, with the same knowledge, or in the same fashion; nor what is more, even two landscapes or two figures. Each work should be a new creation of the mind. The hand, it is true, will conserve some of its acquired secrets of manipulation, but the eye should forget all else it has seen, and learn anew from the lesson before it. It should abstract itself from memory, seeing only that which it looks upon, and that as for the first time; and the hand should become an impersonal abstraction guided only by the will, oblivious of all previous cunning. As for the artist himself, his personal feeling, his peculiar tastes, are for the time absorbed, ignored, or set aside for the enjoyment of his personal life. Such a result as this cannot be attained all at once. To reach it the master must pass through many phases ere this self-isolation can be acquired, and this new evolution of art be learnt; and I, who have occupied myself a good deal in its study, can count but two who have gained it.

Wearied by the technicalities of the school in which, under Couture, he studied, Manet, when he recognised the inanity of all he was taught, determined either not to paint at all or to paint entirely from without himself. Yet, in his self-sought insulation, two masters—masters of the past—appeared to him, and befriended him in his revolt. Velasquez, and the painters of the Flemish school, particularly impressed themselves upon him, and the wonderful atmosphere which enshrouds the compositions of the grand old Spaniard, and the brilliant tones which glow from the canvasses of his northern compeers, won the student's admiration, thus presenting to him two art aspects which he has since made himself the master of, and can mingle as he pleases. It is precisely these two aspects which reveal the truth, and give the paintings based upon them living reality instead of rendering them the baseless fabric of abstracted and obscure dreams. These have been the tentatives of Manet, and curiously, it was to the foreigner and the past that he turned for friendly council in remedying the evils of his country and his time. And yet truth bids me say that Manet had no pressing need for this; an incomparable copyist, he could have found his game close to hand had he chosen his quarry there; but he sought something more than this, and fresh things are not found all at once; freshness, indeed, frequently consists—and this is especially the case in these critical days—in a co-ordination of widely-scattered elements.

The pictures in which this reversion to the traditions of the old masters of the north and south are found constitute Manet's first manner. Now the old writers on art expressed by the word "manner," rather the lavish blossoming of genius during one of its intellectual seasons than the fact fathered, found, or sought out by the painter himself. But that in which the painter declares most his views is the choice of his subjects. Literature often departs from its current path to seek for the aspirations of an epoch of the past, and to modernise them for its own purpose, and in painting Manet followed a similarly divergent course, seeking the truth, and loving it when found, because being true it was so strange, especially when compared with old and worn-out ideals of it. Welcomed on his outset, as we have said, by Baudelaire, Manet fell under the influence of the moment, and, to illustrate him at this period, let us take one of his first works, "Olympia"; that wan, wasted courtesan, showing to the public, for the first time, the non-traditional, unconventional nude. The bouquet, yet enclosed in its paper envelope, the gloomy cat, (apparently suggested by one of the prose poems of the author of the "Fleurs du Mal,") and all the surrounding accessories, were truthful, but not immoral—that is, in the ordinary and foolish sense of the word—but they were undoubtedly intellectually perverse in their tendency. Rarely has any modern work been more applauded by some few, or more deeply damned by the many, than was that of this innovator.

If our humble opinion can have any influence in this impartial history of the work of the chief of the new school of painting, I would say that the transition period in it is by no means to be regretted. Its parallel is found in literature, when our sympathies are suddenly awakened by some new imagery presented to us; and this is what I like in Manet's work. It surprised us all as something

long hidden, but suddenly revealed. Captivating and repulsive at the same time, eccentric, and new, such types as he gave us were needed in our ambient life. In them, strange though they were, there was nothing vague, general, conventional, or hackneyed. Often they attracted attention by something peculiar in the physiognomy of his subject, half hiding or sacrificing to those new laws of space and light he set himself to inculcate, some minor details which others would have seized upon.

Bye and bye, if he continues to paint long enough, and to educate the public eye—as yet veiled by conventionality—if that public will then consent to see the true beauties of the people, healthy and solid as they are, the graces which exist in the bourgeoisie will then be recognised and taken as worthy models in art, and then will come the time of peace. As yet it is but one of struggle —a struggle to render those truths in nature which for her are eternal, but which are as yet for the multitude but new.

The reproach which superficial people formulate against Manet, that whereas once he painted ugliness now he paints vulgarity, falls harmlessly to the ground, when we recognise the fact that he paints the truth, and recollect those difficulties he encountered on his way to seek it, and how he conquered them. "Un Déjeuner sur l'Herbe," "L'Exécution de Maximilien," "Un Coin de Table," "Des Gens du Monde à la Fenêtre," "Le Bon Bock," "Un Coin de Bal de l'Opéra," "Le Chemin de Fer," and the two "Canotiers"—these are the pictures which step by step have marked each round in the ladder scaled by this bold innovator, and which have led him to the point achieved in his truly marvellous work, this year refused by the Salon, but exhibited to the public by itself, entitled "Le Linge"—a work which marks a date in a lifetime perhaps, but certainly one in the history of art.

The whole of the series we have just above enumerated with here and there an exception, demonstrate the painter's aim very exactly; and this aim was not to make a momentary escapade or sensation, but by steadily endeavouring to impress upon his work a natural and a general law, to seek out a type rather than a personality, and to flood it with light and air: and such air! air which despotically dominates over all else. And before attempting to analyse this celebrated picture I should like to comment somewhat on that truism of to-morrow, that paradox of to-day, which in studio slang is called "the theory of open air" or at least on that which it becomes with the authoritative evidence of the later efforts of Manet. But here is first of all an objection to overcome. Why is it needful to represent the open air of gardens, shore or street, when it must be owned that the chief part of modern existence is passed within doors? There are many answers; among these I hold the first, that in the atmosphere of any interior, bare or furnished, the reflected lights are mixed and broken and too often discolour the flesh tints. For

instance I would remind you of a painting in the salon of 1873 which our painter justly called a "Rêverie." There a young woman reclines on a divan exhaling all the lassitude of summer time; the jalousies of her room are almost closed, the dreamer's face is dim with shadow, but a vague, deadened daylight suffuses her figure and her muslin dress. This work is altogether exceptional and sympathetic.

Woman is by our civilisation consecrated to night, unless she escape from it sometimes to those open air afternoons by the seaside or in an arbour, affectionated by moderns. Yet I think the artist would be in the wrong to represent her among the artificial glories of candlelight or gas, as at that time the only object of art would be the woman herself, set off by the immediate atmosphere, theatrical and active, even beautiful, but utterly inartistic. Those persons much accustomed, whether from the habit of their calling or purely from taste, to fix on a mental canvass the beautiful remembrance of woman, even when thus seen amid the glare of night in the world or at the theatre, must have remarked that some mysterious process despoils the noble phantom of the artificial prestige cast by candelabra or footlights, before she is admitted fresh and simple to the number of every day haunters of the imagination. (Yet I must own that but few of those whom I have consulted on this obscure and delicate point are of my opinion.) The complexion, the special beauty which springs from the very source of life, changes with artificial lights, and it is probably from the desire to preserve this grace in all its integrity, that painting—which concerns itself more about this flesh-pollen that any other human attraction—insists on the mental operation to which I have lately alluded, and demands daylight—that is space with the transparence of air alone. The natural light of day penetrating into and influencing all things, although itself invisible, reigns also on this typical picture called "The Linen," which we will study next, it being a complete and final repertory of all current ideas and the means of their execution.

Some fresh but even-coloured foliage—that of a town garden—holds imprisoned a flood of summer morning air. Here a young woman, dressed in blue, washes some linen, several pieces of which are already drying; a child coming out from the flowers looks at its mother—that is all the subject. This picture is life-size, though this scale is somewhat lower in the middle distance, the painter wisely recognizing the artificial requirements forced upon him by the arbitrarily fixed point of view imposed on the spectator. It is deluged with air. Everywhere the luminous and transparent atmosphere struggles with the figures, the dresses, and the foliage, and seems to take to itself some of their substance and solidity; whilst their contours, consumed by the hidden sun and wasted by space, tremble, melt, and evaporate into the surrounding atmosphere, which plunders reality from the figures, yet

seems to do so in order to preserve their truthful aspect. Air reigns supreme and real, as if it held an enchanted life conferred by the witchery of art; a life neither personal nor sentient, but itself subjected to the phenomena thus called up by science and shown to our astonished eyes, with its perpetual metamorphosis and its invisible action rendered visible. And how? By this fusion or by this struggle ever continued between surface and space, between colour and air. Open air:—that is the beginning and end of the question we are now studying. Æsthetically it is answered by the simple fact that there in open air alone can the flesh tints of a model keep their true qualities, being nearly equally lighted on all sides. On the other hand if one paints in the real or artificial half-light in use in the schools, it is this feature or that feature on which the light strikes and forces into undue relief, affording an easy means for a painter to dispose a face to suit his own fancy and return to by-gone styles.

The search after truth, peculiar to modern artists, which enables them to see nature and reproduce her, such as she appears to just and pure eyes, must lead them to adopt air almost exclusively as their medium, or at all events to habituate themselves to work in it freely and without restraint: there should at least be in the revival of such a medium, if nothing more, an incentive to a new manner of painting. This is the result of our reasoning, and the end I wish to establish. As no artist has on his palette a transparent and neutral colour answering to open air, the desired effect can only be obtained by lightness or heaviness of touch, or by the regulation of tone. Now Manet and his school use simple colour, fresh, or lightly laid on, and their results appear to have been attained at the first stroke, that the ever-present light blends with and vivifies all things. As to the details of the picture, nothing should be absolutely fixed in order that we may feel that the bright gleam which lights the picture, or the diaphanous shadow which veils it, are only seen in passing, and just when the spectator beholds the represented subject, which being composed of a harmony of reflected and ever-changing lights, cannot be supposed always to look the same, but palpitates with movement, light, and life.

But will not this atmosphere—which an artifice of the painter extends over the whole of the object painted—vanish, when the completely finished work is as a repainted picture? If we could find no other way to indicate the presence of air than the partial or repeated application of colour as usually employed, doubtless the representation would be as fleeting as the effect represented, but from the first conception of the work, the space intended to contain the atmosphere has been indicated, so that when this is filled by the represented air, it is as unchangeable as the other parts of the picture. Then composition (to borrow once more the slang of the studio) must play a considerable part in the aesthetics of a

master of the Impressionists? No; certainly not; as a rule the grouping of modern persons does not suggest it, and for this reason our painter is pleased to dispense with it, and at the same time to avoid both affectation and style. Nevertheless he must find something on which to establish his picture, though it be but for a minute—for the one thing needful is the time required by the spectator to see and admire the representation with that promptitude which just suffices for the connection of its truth. If we turn to natural perspective (not that utterly and artificially classic science which makes our eyes the dupes of a civilized education, but rather that artistic perspective which we learn from the extreme East—Japan for example)—and look at these sea-pieces of Manet, where the water at the horizon rises to the height of the frame, which alone interrupts it, we feel a new delight at the recovery of a long obliterated truth.

The secret of this is found in an absolutely new science, and in the manner of cutting down the pictures, and which gives to the frame all the charm of a merely fanciful boundary, such as that which is embraced at one glance of a scene framed in by the hands, or at least all of it found worthy to preserve. This is the picture, and the function of the frame is to isolate it; though I am aware that this is running counter to prejudice. For instance, what need is there to represent this arm, this hat, or that river bank, if they belong to someone or something exterior to the picture; the one thing to be attained is that the spectator accustomed among a crowd or in nature to isolate one bit which pleases him, though at the same time incapable of entirely forgetting the abjured details which unite the part to the whole, shall not miss in the work of art one of his habitual enjoyments, and whilst recognizing that he is before a painting half believes he sees the mirage of some natural scene. Some will probably object that all of these means have been more or less employed in the past, that dexterity—though not pushed so far—of cutting the canvas off so as to produce an illusion—perspective almost conforming to the exotic usage of barbarians—the light touch and fresh tones uniform and equal, or variously trembling with shifting lights—all these ruses and expedients in art have been found more than once in the English school, and elsewhere. But the assemblage for the first time of all these relative processes for an end, visible and suitable to the artistic expression of the needs of our times, this is no inconsiderable achievement in the cause of art, especially since a mighty will has pushed these means to their uttermost limits.

But the chief charm and true characteristic of one of the most singular men of the age is, that Manet (who is a visitor to the principal galleries both French and foreign, and an erudite student of painting) seems to ignore all that has been done in art by others, and draws from his own inner consciousness all his effects of simplification, the whole revealed by effects of light incontestably novel.

This is the supreme originality of a painter by whom originality is doubly forsworn, who seeks to lose his personality in nature herself, or in the gaze of a multitude until then ignorant of her charms.

Without making a catalogue of the already very considerable number of Manet's works, it has been necessary to mark the successive order of his pictures, each one of them an exponent of some different effort, yet all connected by the self-same theory; valuable also as illustrating the career of the head of the school of Impressionists, or rather the initiator of the only effective movement in this direction; and as showing how he has patiently mastered the idea of which he is at present in full possession. The absence of all personal obtrusion in the manner of this painter's interpretation of nature, permits the critic to dwell so long as he pleases on his pictures without appearing to be too exclusively occupied by one man; yet we must be careful to remember that each work of a genius, singular because he abjures singularity, is an artistic production, unique of its kind, recognisable at first sight among all the schools of all ages. And can such a painter have pupils? Yes, and worthy ones; notably Mademoiselle Eva Gonzales, who to a just understanding of the master's stand-point unites qualities of youthfulness and grace all her own.

But his influence as from friend to friend is wider spread than that which the master exercises over the pupil, and sways all the painters of the day; for even the manner of those artists most strongly opposed in idea to his theory is in some degree determined by his practice. There is indeed no painter of consequence who during the last few years has not adopted or pondered over some one of the theories advanced by the Impressionists, and notably that of the open air, which influences all modern artistic thought. Some come near us and remain our neighbours; others, like M. Fantin-Latour and the late M. Chintreuil, painters without any common point of resemblance, while working out their own ideas have little by little attained to results often analogous to those of the Impressionists, thus creating between this school and that of academic painting a healthy, evident, true, and conjunctive branch of art, at present upheld even by the generality of art lovers. But the Impressionists themselves, those whom cosy studio chats and an amicable interchange of idea have enabled to push together towards new and unexpected horizons, and fresh-formed truths, such as MM. Claude Monet, Sisley and Pizzaro [*sic*], paint wondrously alike; indeed a rather superficial observer at a pure and simple exhibition of Impressionism would take all their works to be those of one man—and that man, Manet. Rarely have three workers wrought so much alike, and the reason of the similitude is simple enough, for they each endeavour to suppress individuality for the benefit of nature. Nevertheless the visitor would proceed from this first impression,

which is quite right as a synthesis, to perceiving that each artist has some favourite piece of execution analogous to the subject accepted rather than chosen by him, and this acceptation fostered by reason of the country of his birth or residence, for these artists as a rule find their subjects close to home within an easy walk, or in their own gardens.

Claude Monet loves water, and it is his especial gift to portray its mobility and transparency, be it sea or river, grey and monotonous, or coloured by the sky. I have never seen a boat poised more lightly on the water than in his pictures or a veil more mobile and light than his moving atmosphere. It is in truth a marvel. Sisley seizes the passing moments of the day; watches a fugitive cloud and seems to paint it in its flight; on his canvass the live air moves and the leaves yet thrill and tremble. He loves best to paint them in spring, "when the yonge leves on the lyte wode, waxen al with wille," or when red and gold and russet-green the last few fall in autumn; for then space and light are one, and the breeze stirring the foliage prevents it from becoming an opaque mass, too heavy for such an impression of mobility and life. On the other hand, Pizzaro [*sic*], the eldest of the three, loves the thick shade of summer woods and the green earth, and does not fear the solidity which sometimes serves to render the atmosphere visible as a luminous haze saturated with sunlight. It is not rare for one of these three to steal a march on Manet, who suddenly perceiving their anticipated or explained tendency, sums up all their ideas in one powerful and masterly work. For them, rather are the subtle and delicate changes of nature, the many variations undergone in some long morning or afternoon by a thicket of trees on the water's side.

The most successful work of these three painters is distinguished by a sure yet wonderfully rapid execution. Unfortunately the picture buyer, though intelligent enough to perceive in these transcripts from nature much more than a mere revel of execution, since in these instantaneous and voluntary pictures all is harmonious, and were spoiled by a touch more or less, is the dupe of this real or apparent promptitude of labour, and though he pays for these paintings a price a thousand times inferior to their real value, yet is disturbed by the afterthought that such light productions might might be multiplied *ad infinitum*; a merely commercial misunderstanding from which, doubtless, these artists will have still to suffer. Manet has been more fortunate, and receives an adequate price for his work. As thorough Impressionists, these painters (excepting M. Claude Monet, who treats it superbly) do not usually attempt the natural size of their subjects, neither do they take them from scenes of private life, but are before everything landscape painters, and restrict their pictures to that size easiest to look at, and with shut eyes preserve the remembrance of.

With these, some other artists, whose originality has distanced them from other contemporary painters, frequently, and as a rule, exhibit their paintings, and share in most of the art theories I have reviewed here. These are Degas, Mademoiselle Berthe Morizot [*sic*], (now Madame Eugène Manet,) and Renoir, to whom I should like to join Whistler, who is so well appreciated in France, both by critics and the world of amateurs, had he not chosen England as a field of his success.

The muslin drapery that forms a luminous, ever-moving atmosphere round the semi-nakedness of the young ballet-dancers; the bold, yet profoundly complicated attitudes of these creatures, thus accomplishing one of the at once natural and yet modern functions of women, have enchanted M. Degas, who can, nevertheless, be as delighted with the charms of those little washerwomen, who fresh and fair, though poverty-stricken, and clad but in camisole and petticoat, bend their slender bodies at the hour of work. No voluptuousness there, no sentimentality here; the wise and intuitive artist does not care to explore the trite and hackneyed view of his subject. A master of drawing, he has sought delicate lines and movements exquisite or grotesque, and of a strange new beauty, if I dare employ towards his works an abstract term, which he himself will never employ in his daily conversation.

More given to render, and very succinctly, the aspect of things, but with a new charm infused into it by feminine vision, Mademoiselle Berthe Morizot [*sic*] seizes wonderfully the familiar presence of a woman of the world, or a child in the pure atmosphere of the sea-shore, or green lawn. Here a charming couple enjoy all the limpidity of hours where elegance has become artless; and there how pure an atmosphere veils this woman standing out of doors, or that one who reclines under the shade of an umbrella thrown among the grasses and frail flowers which a little girl in a clean dress is busy gathering. The airy foreground, even the furthermost outlines of sea and sky, have the perfection of an actual vision, and that couple yonder, the least details of whose pose is so well painted that one could recognise them by that alone, even if their faces, seen under the shady straw hats, did not prove them to be portrait sketches, give their own characteristics to the place they enliven by their visit. The air of preoccupation, of mundane care or secret sorrows, so generally characteristic of the modern artist's sketches from contemporary life, were never more notably absent than here; one feels that the graceful lady and child are in perfect ignorance that the pose unconsciously adopted to gratify an innate sense of beauty is perpetuated in this charming water-colour.

The shifting shimmer of gleam and shadow which the changing reflected lights, themselves influenced by every neighbouring thing, cast upon each advancing or departing figure, and the fleeting combinations in which these dissimilar reflections form one harmony or many, such are the favourite effects of Renoir—nor can we wonder that this infinite complexity of execution induces him to seek more hazardous success in things widely opposed to nature. A box at a theatre, its gaily-dressed inmates, the women with their flesh tints heightened and displaced by rouge and rice powder, a complication of effects of light—the more so when this scene is fantastically illuminated by an incongruous day-light. Such are the subjects he delights in.

All these various attempts and efforts (sometimes pushed yet farther by the intrepid M. de Césane [*sic*]) are united in the common bond of Impressionism. Incontestably honour is due to these who have brought to the service of art an extraordinary and quasi-original newness of vision, undeterred by a confused and hesitating age. If sometimes they have gone too far in the search of novel and audacious subjects, or have misapplied a freshly discovered principle, it is but another canvass turned to the wall; and as a set off to such an accident they have attained a praiseworthy result, to make us understand when looking on the most accustomed objects the delight that we should experience could we but see them for the first time.

If we try to recall some of the heads of our argument and to draw from them possible conclusions, we must first affirm that Impressionism is the principal and real movement of contemporary painting. The only one? No; since other great talents have been devoted to illustrate some particular phrase or period of bygone art; among these we must class such artists as Moreau, Puvis de Chavannes, etc.

At a time when the romantic tradition of the first half of the century only lingers among a few surviving masters of that time, the transition from the old imaginative artist and dreamer to the energetic modern worker is found in Impressionism.

The participation of a hitherto ignored people in the political life of France is a social fact that will honour the whole of the close of the nineteenth century. A parallel is found in artistic matters, the way being prepared by an evolution which the public with rare prescience dubbed, from its first appearance, Intransigeant, which in political language means radical and democratic.

The noble visionaries of other times, whose works are the semblance of worldly things seen by unworldly eyes (not the actual representations of real objects), appear as kings and gods in the far dream-ages of mankind; recluses to whom were given the genius of a dominion over an ignorant multitude. But to day the multitude demands to see with its own eyes; and if our latter-day art is less glorious, intense, and rich, it is not without the compensation of truth, simplicity and child-like charm.

At that critical hour for the human race when nature desires to work for herself, she requires certain lovers of

hers—new and impersonal men placed directly in communion with the sentiment of their time—to loose the restraint of education, to let hand and eye do what they will, and thus through them, reveal herself.

For the mere pleasure of doing so? Certainly not, but to express herself, calm, naked, habitual, to those newcomers of to-morrow, of which each one will consent to be an unknown unit in the mighty numbers of an universal suffrage, and to place in their power a newer and more succinct means of observing her.

Such, to those who can see in this the representative art of a period which cannot isolate itself from the equally characteristic politics and industry, must seem the meaning of the manner of painting which we have discussed here, and which although marking a general phase of art has manifested itself particularly in France.

Now in conclusion I must hastily re-enter the domain of aesthetics, and I trust we shall thoroughly have considered our subject when I have shown the relation of the present crisis—the appearance of the Impressionists—to the actual principles of painting—a point of great importance.

In extremely civilized epochs the following necessity becomes a matter of course, the development of art and thought having nearly reached their far limits—art and thought are obliged to retrace their own footsteps, and to return to their ideal source, which never coincides with their real beginnings. English Præraphaelitism, if I do not mistake, returned to the primitive simplicity of mediæval ages. The scope and aim (not proclaimed by authority of dogmas, yet not the less clear), of Manet and his followers is that painting shall be steeped again in its cause, and its relation to nature. But what, except to decorate the ceilings of saloons and palaces with a crowd of idealized types in magnificent foreshortening, what can be the aim of a painter before everyday nature? To imitate her? Then his best efforts can never equal the original with the inestimable advantages of life and space.—"Ah no! this fair face, that green landscape, will grow old and wither, but I shall have them always, true as nature, fair as remembrance, and imperishably my own; or the better to satisfy my creative artistic instinct, that which I preserve through the power of Impressionism is not the material portion which already exists, superior to any mere representation of it, but the delight of having recreated nature touch by touch. I leave the massive and tangible solidity to its fitter exponent, sculpture. I content myself with reflecting on the clear and durable mirror of painting, that which perpetually lives yet dies every moment, which only exists by the will of Idea, yet constitutes in my domain the only authentic and certain merit of nature—the Aspect. It is through her that when rudely thrown at the close of an epoch of dreams in the front of reality, I have taken from it only that which properly belongs to my art, an original and exact perception which distinguishes for itself the things it perceives with the steadfast gaze of a vision restored to its simplest perfection."

Notes

1. Stéphane Mallarmé, "The Impressionists and Edouard Manet," *The Art Monthly Review and Photographic Portfolio, a Magazine Devoted to the Fine and Industrial Arts and Illustrated by Photography* 1, no. 9 (30 September 1876): 117–122. The article also has been reprinted in Carl Paul Barbier, *Documents Stéphane Mallarmé*, vol. 1 (Paris, 1968), 66–86. For discussions of the text, see Jean C. Harris, "A Little-Known Essay on Manet by Mallarmé," *The Art Bulletin* 46, no. 4 (December 1964): 559–563, and Barbier, 59–65 and 87–91.

2. Barbier, 65: "Notre ami mutuel Mr Arthur O'Shaughnessy m'a dit que vous aura [*sic*] la bonté de m'écrire un article sur les vues et les aims [*sic*]des impressionistes et surtout les vues de Manet. Je vous donnera deux ou trois pages de deux colonnes. . . . Exprimez votre opinion et votre récit ou critique toute franchement, je vous prie. Parlez au public comme vous parlerez [?] aux amis—nettement pas trop discussion mais non trop court."

3. Barbier, 65: "J'ai fait une traduction de votre article—il est sous les mains des imprimeurs et en deux ou trois jours vous aurez les épreuves."

4. Barbier, 94: "Merci une dernière fois de l'article sur les Impressionistes. M. Robinson a été charmant de tout point; et, à part quelques contre-sens faciles à redresser (ceci bien entre nous!) son excellente traduction fait honneur à ma prose, et rend ce travail passable. Paiement large et exact. etc; inutile même à moi de le dire."

5. Wallace Fowlie, *Mallarmé* (Chicago and London, 1953/1970), 11.

6. Fowlie, 12.

7. See Charles S. Moffett, "Manet and Impressionism," *Manet: 1832–1883* exh. cat. (New York: Metropolitan Museum of Art, 1983), 29–35.

8. For a discussion of the term *Intransigeant*, see Stephen Eisenmann, "The Intransigent Artist," in this catalogue.

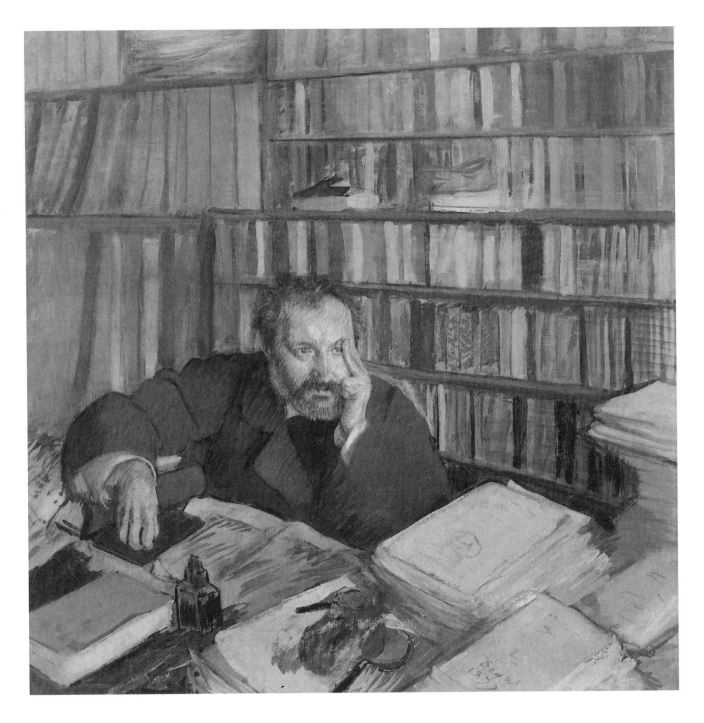

Edgar Degas, *Portrait de M. Duranty*, 1879 (IV–58). Tempera and
pastel on canvas, 39⅜ x 39⅜ in. (100.6 x 100.6 cm). The Burrell
Collection, Glasgow Art Gallery and Museum.

The New Painting:
Concerning the Group of Artists Exhibiting at the Durand-Ruel Galleries[1]

Louis Emile Edmond Duranty

Louis Emile Edmond Duranty (1833–1880), who was rumored to have been the illegitimate son of Prosper Merimée (1803–1870), emerged in French literary circles in 1856 as the editor of Réalisme, *a review that failed the following year after six issues were published. After the demise of this periodical Duranty channeled his interest in and support of Realism into the closely related Naturalist movement in literature. During the 1860s he wrote novels and short stories that are dogmatically Realist-Naturalist in approach, but stylistically rather dry. His fiction met with only limited success and was soon overshadowed by that of such major Naturalist writers as Emile Zola (1840–1902) and Gustave Flaubert (1821–1880).*

Duranty's reputation as an author depends primarily on the essay reprinted here, The New Painting: Concerning the Group of Artists Exhibiting at the Durand-Ruel Galleries. *It was originally published in 1876, at about the time of the Impressionists' second group show, as a thirty-eight-page pamphlet. This study has often been hailed as the first cogent attempt to deal with the salient characteristics of avant-garde painting as a whole during the 1870s. Interestingly, Duranty avoided the use of the word Impressionism and any other overly restrictive terms. In addition, he did not give the names of the artists whose work he cites in the course of the essay. He seems to have wanted to achieve the broadest, least prejudicial definition of the modern movement. Nevertheless, in 1878 when the Italian critic Diego Martelli requested a copy of* The New Painting, *Duranty wrote in the margins of the pamphlet the names of the artists cited (see note 2). In our reprint, we have included the artists' names in brackets.*

The New Painting *begins with a refutation of a recent article by Eugène Fromentin (1820–1876), who had attacked new tendencies in painting and defended the principles of academicism (see note 3). In his essay Duranty explores the origins of the new art and defines its position vis-à-vis the principles advocated by the Ecole des Beaux-Arts. While his art history may have serious*

shortcomings, he recognized that art was changing profoundly as a result of avant-garde innovations and attitudes. However, as has been recognized by Reuterswürd, Nochlin, and Reff, Duranty's point of view is predictably prejudiced in favor of Realist thinking and seems to have been influenced by the example of his friend Degas. In Reff's words,

In his well-known pamphlet *The New Painting* (1876) . . . [Duranty] discusses Degas's contribution to recent art in detail. . . . Without naming him . . . Duranty insists that "the series of new ideas was formed above all in the mind of a draftsman . . . a man of the rarest talent and rarest intellect." These ideas consist above all in establishing an intimate rapport between the figure in a work of art and its setting, which must be characterized as carefully as the figure itself. . . .

However, Duranty's essay cannot be reduced to a mere exercise in Realist-Naturalist theory with strong positivist overtones (see note 2), or to a manifesto about avant-garde art that is principally of value in dealing with Degas's art.

The New Painting *impresses upon us in a general way the viability and worthiness of subjects from modern life, and the new stylistic approaches appropriate to them. Although Duranty's prose style as a critic is often as uninspiring as that of his fiction, we feel his sense of discovery when he writes, "I am less concerned with the actual exhibition [the second Impressionist group show] than its* cause *and* idea." *Moreover, he knows that a fundamental change is at hand: "The idea, the very first idea, was to eliminate the partition separating the artist's studio from everyday life, and to introduce the reality of the street that shocks the writer in the* Revue des Deux Mondes *[Fromentin]." And, finally, there is no mistaking the excitement of an individual as he draws our attention to esthetic advances of enormous magnitude: "This extraordinary man [Diderot] is at the threshold of everything that the art of the nineteenth century would like to accomplish."*

C.S.M.

A painter [Eugène Fromentin],[2] eminent among those whose talent we do not admire, and who moreover has the gift and good fortune to be a writer, recently stated in the *Revue des Deux Mondes*:[3]

The so-called doctrine of Realism[4] has no more important basis than a true and sound observation of the laws of color. Still we are forced to acknowledge that there is some merit in the Realists' ambitions, and that if they knew more and painted better, some of them would paint very well indeed. In general, they have an exacting eye and a particularly refined sensitivity. Yet strangely enough, the other aspects of their craft are not as good. It seems they possess that most rare ability of lacking what should be the most common, so much that their eye and their sensitivity, which are of great value, are wasted because they are not properly employed. They appear to be revolutionary by pretending to accept only half of the requisite truths. As a result, they come close yet fall far short of the whole truth. Open air, diffused light, and real sunlight have today assumed greater importance in painting than ever before, and which, quite frankly, they do not deserve. . . .

Painting today is never bright enough, never sharp enough, never explicit enough, never crude enough. . . .

What the mind once imagined is now held to be artifice, and every artifice—by which I mean every convention—is prohibited in an art that should be nothing but convention. From all of this, as can be well imagined, controversies have erupted in which these students of nature have the majority on their side. They have scornfully labeled all opposing practices vieux jeu,[5] *meaning it is an antiquated, doddering, and outdated manner of perceiving nature by putting some of oneself into it. But their choice of subject, draftsmanship, and palette all contribute to an impersonal manner of perceiving and depicting the world. Here we are far from traditional practices indeed—or at least, from the traditional practices of forty years ago. Then the bitumen flowed freely from the palettes of the Romantic painters and passed for the representative color of the ideal. These trends are flaunted annually at a specific time and place, our spring exhibitions.[6] If one keeps at all current with the new trends presented there, he notices that the goal of the new painting is to assail the eyes of the public with striking and literal images, easily recognizable in their truthfulness, stripped of all artifice, and to recreate exactly the sensation of what is seen in the street. The public is only too ready to celebrate an art that so faithfully depicts its own costumes, faces, customs, tastes, habits, and spirit. But what about history painting, one asks? Can one even be certain that a school of history still exists, at the rate things are going? Even if this old term from the* ancien régime *still applied to those traditions so brilliantly championed but so little followed, one must not be fooled into thinking that history painting will*

escape this fusion of genres or resist the temptation to enter the mainstream.

Look closely at the changes that are taking place from year to year. Without examining them in depth, consider only the color of the paintings: from dark, the colors are becoming light, black is turning to white, the deep moves to the surface, the fluid becomes rigid, glossy turns to matte, and chiaroscuro gives way to the effects of Japanese prints. Then you will see enough to realize that there is a spirit here that is changing direction, and that the atelier is opening itself to the light of the street.

These observations were made with caution, courtesy, irony, and even a touch of melancholy.

But they are curious when one considers the influence this artist-writer exerts over the new generation just produced by the Ecole des Beaux-Arts.

The observations are even more curious when one considers that this same person—who believes that the faithful depiction of the costumes, faces, and customs of our contemporaries is a mark of mediocrity—devotes his own efforts to depicting the costumes, faces, and customs of—whom? *Contemporary Arabs.* Why does he persist in hindering the colonization of Algeria? No one knows. And why should contemporary Arabs seem to him the only ones worthy of the preoccupation of the painter? Indeed, no one knows that either.

Returning to Paris from the Sahel,[7] our artist ran into a fellow artist [Gustave Moreau]—a tormented and sensitive soul nurtured on ancient poetry and symbology. Perhaps this artist is even the greatest lover of myths on this earth, as he spends his life interrogating the Sphinx. Together, they inspire these new groups of young artists, bottle-fed on official and traditional art. A strange system of painting has resulted, limited on the south by Algeria, on the east by mythology, on the west by ancient history, and on the north by archaeology. Truly this is the confused painting of an era of criticism, curio-hunting, and pastiche.

The young artists make every effort to blend into this art all styles and manners. Their odious and washed-out figures sprawl against cloth colors lifted clumsily from the Venetians. The colors are heated until they glare, or diluted until they fade away [Jacques Fernand Humbert]. They borrow—one should really say they seize—Delacroix's backgrounds, cooling and souring them [either Emile Lévy or Henri Leopold Lévy]. They whip together a mixture of Carpaccio, Rubens and Signol, perhaps mixing in a little Prud'hon and Lesueur [Fernand Cormon], and serve up a strange ragout, meager and fermented, a salad of impoverished lines, angular and jolting. It is a dish of clashing colors, too faded or too acid, and confused forms, thin, awkward, turgid, and sickly. It is only a certain degree of strangeness achieved by the investigations of an evolving archaeology that give some piquancy to this negative and muddled art.

Archaeology, however, is not their field; they should leave that to the archaeologists. If an art is indeed impersonal, it is not the one so designated by our painter-author, but rather the art of the Ecole des Beaux-Arts. All conventions meet in it, it is true, but the result lacks everything that is part of man—his individuality and his spirit.

Do these artists of the Ecole really believe that they have created great art because they have rendered helmets, footstools, polychrome columns, boats, and bordered robes according to the latest archaeological decrees? Do they believe they succeed because in their figures they scrupulously respect the most recently accepted prototype of the Ionian, Dorian, or Phrygian race? Finally, do they think they are successful because they have hunted down, overwhelmed, and consigned to hell the monster "Anachronism"? They forget that every thirty years this same archaeology sheds its skin, and that the latest word in erudite fashion—the Boeotian skullcap with its nose and cheekguards, for example—will end up on the scrap heap along with David's great helmet of Léonidas,[8] in its day the ultimate expression of an erudite familiarity with antiquities.

They do not realize that it is by the flame of contemporary life that great artists and learned men illuminate these ancient things. Veronese's *Wedding at Cana*[9] would have failed pathetically without his Venetian gentlemen. M. Renan did not hesitate to compare Pontius Pilate to a prefect of Basse-Bretagne,[10] or M. de Rémusat to Saint-Philotée.[11] As a very observant artist said to me the other day, the strength of the English in art comes from the fact that Ophelia is always a *lady* in their minds.[12] What is it, then, this world of the Ecole des Beaux-Arts, even taken at its best? One sees reflected in it the melancholy of those who sit without appetite at a table laden with wonderful things. Deprived of the capacity for pleasure themselves, they do not enjoy the banquet, but find fault with those who do.

They are melancholy because they sense that their efforts are not great. In fact, it is they who limit themselves. On one hand they perfect the bedding of Antiquity and restore Homeric bric-a-brac, and on the other they fraternize with the *chaouchs* [Algerian lackeys] and the *biskris* [Arab peasants]. They have taken their black-bearded model down from his studio platform and stuck him on a camel before the Portail de Gaillon. They have cloaked him in a woolen bedspread borrowed from the butcher next door because this fraternizing with Arabs has made them blood-thirsty. Finally, they have added the *secar la cabeza* of the *sabir* jargon of the swarthy natives in the province of Oran to their Italian vocabulary brought back from Rome.

And that's that. After this little voyage, they will go happily off to posterity.

Yet, could they have gone any farther, given the strange education of their youth, so well described by the drawing master M. Lecoq de Boisbaudran,[13] whose simple and exact account is crueler than any joke:
Naturally, the young people who prepare for the competition direct all their efforts toward obtaining its prizes. Unfortunately, the path that generally seems to them the surest and easiest is the imitation of those previously honored works, those which are unfailingly exhibited with all due honor and pomp, as if offered as the means to success. Can anyone fail to understand the full significance of such incentives when most candidates abandon their own inspirations to follow slavishly the path recommended by the Ecole, and who, consequently, are, blessed by success. With rare exceptions, a student is admitted to the grand competition, that is, the atelier of the Prix de Rome,[14] only after long study devoted exclusively toward this goal. It is the sheer duration of this unnatural study that renders so hazardous the preservation of any originality. Those students who linger on end up resembling certain baccalaureate candidates who are more concerned with acquiring diplomas than true knowledge.

There are two requirements for them to meet—a sketch or composition on a given subject and a figure painted from a model. This preparation becomes the sole preoccupation of these young pupils. They seek no other course of study than the daily repetition of these banal figures and sketches, always executed with the dimensions, time-constraints, and customary style of the competition.

After entire years devoted to such exercises, what can possibly remain of the most valuable qualities? What becomes of the naive, the sincere, and the natural? The exhibitions of the Ecole des Beaux-Arts demonstrate their loss only too well.

Occasionally, candidates might imitate the style of their master or that of a famous artist. Others might seek their inspiration from former prize-winners of the Ecole, from the latest successes at the Salon, or from a work that has greatly impressed them. These various influences might give an appearance of variety to some of the exhibitions, but this appearance is far from the true diversity and original character that comes from individual inspiration.

Well! Gentlemen! As artists you have nothing to be proud of in receiving an education that only turns out a race of sheep, for you will be called the Dishley-Merinos[15] of art.

Nevertheless, it would appear that you are disdainful of the endeavors of an art that tries to capture life and the modern spirit, an art that reacts viscerally to the spectacle of reality and of contemporary life. Instead, you cling to the knees of Prometheus and the wings of the Sphinx.

And do you know why you do it? Without suspecting it, what you really want is to ask the Sphinx for the secret

of our time and Prometheus for the sacred fire of the present age. No, you are not as disdainful as you appear.

You are made uneasy by this artistic movement that already has lasted for a long time, which perseveres despite the obstacles and despite the little sympathy shown it.

But despite all that you know, ultimately you would like to be individuals. You begin to be disgusted by this mummification, this sickening embalming of the spirit. You start to look over the wall into the little garden of these new painters, perhaps just to throw stones into it, or perhaps simply to see what is going on there.

Come now, tradition is in disarray; your efforts to build on it prove this only too well. You feel you must let in that light from the street that fails to satisfy your guide, that honorable and clever painter-author, so courteous, so ironic, and so cynical in his speech. You, too, would very much like to come out into the world.

Tradition is in disarray, but tradition is tradition, representing as it does the ancient and magnificent formulas of the preceding ages. Like feudal serfs you are bound to the land of official art by the legitimists, while these new painters are considered artistic revolutionaries. The battle is really between you and them. Among their adversaries, you are the only ones they esteem. You deserve liberation. They will bring it to you. But before that, perhaps, it might be brought to you by women. By women? Why not.

"Isn't it curious," I read in a letter from that same observant painter who already has provided me with one interesting reflection, is it not curious indeed that *A sculptor or a painter has a wife or a mistress who is slim, light, and lively, with a turned-up nose and small eyes. He loves these things in her, even with their faults. Perhaps he even went through a passionate affair to win her. Now, this woman—who is the ideal of this artist's heart and mind, who has aroused and revealed his true taste, sensitivity, and imagination because he has discovered and chosen her—is the absolute opposite of the* feminine ideal *that he insists on putting into his paintings and statues. Instead he keeps returning to Greece, to women who are somber, severe, and strong as horses. In the morning he betrays the turned-up nose that delights him at night, and straightens it. Consequently, he either dies of boredom or brings to his work all the gaiety and effort of* thought *of a box-maker who is skilled at gluing and who wonders where he will go to* have some fun *after he has finished work.*

Someday, perhaps, the living woman with her turned-up nose will evict that Greek Venus of marble with her straight nose and heavy chin. She has embedded herself in your brain like debris from an ancient frieze that the mason has built into a wall, the excavation over. On that day, the real artist, latent beneath the shell of the deft box-gluer, will quicken into life.

Besides, your Greek woman looks quite ill, judging from the way you always depict her: haggard, tottering, either livid or sallow, with empty, sunken eyes. She has been brought to the Ecole de Rome so many times that she has caught *mal'aria*.

In the meantime, come and have a look into the little garden of the people here. You will see that they are trying to create from scratch a wholly modern art, an art imbued with our surroundings, our sentiments, and the things of our age.

A commonplace idea is just as likely to be easily expressed, varied, and modified in all its tones as a new idea is subject to being stuttered when first expressed.

The advantage, both material and rhetorical, has been on the side of the quai Malaquais[16]—it would be childish to deny it. That's a far cry, however, from saying that the people of the quai Malaquais are correct.

The strength of Renaissance artists and the pre-Renaissance primitives came from the fact that under the guise of Antiquity—or one should simply say the label of Antiquity—they described the customs, costumes, and decors of their own age, revealing their private lives and recording an era. They did it simply and naturally, without criticism or debate, and without having the need, as we have, to distinguish the right path from the wrong ones.

In literature we have succeeded—laboriously and thanks to brilliant examples—in putting this subject beyond dispute.[17] Like literature, current serious art criticism is Realist, affecting the most varied forms and techniques. The present author of these lines has contributed to the establishment of this movement, for which he was one of the first to provide a clear esthetic definition nearly twenty years ago.[18]

Painting, too, must enter this movement. Artists of great talent have attempted to do so ever since Courbet. Like Balzac, they have blazed the trail enthusiastically. Painting must enter it because, however conventional one might wish it to be, painting is the least conventional of all the arts. It is the only art that successfully *recreates* figures and objects, which *fixes* figures, costumes, and backgrounds, leaving nothing to doubt or ambiguity, which *imitates*, *depicts*, and *sums up* life better than any other art, in spite of all artifice and technique.

As for the groups of artists who work outside of the Ecole des Beaux-Arts, yet remain tied to its influence, they are hybrids.

Some of them come from that universal studio of anecdotal archaeology [Jean-Léon Gèrôme] where they turn out costumes ranging from the Roman gladiator's helmet down to the Premier Consul's little hat. They have sure methods of execution [Jean Vibert], a manner of modeling established once and for all, and they turn out a contrived and sententious carnival of characters. They have outdone their master and asked actors to show them

theatrical grimaces for the faces—invariably the same—of their little marquis, their eccentrics, their pages, monks, and archers, conscientiously copied according to the wishes of the patron, whom they dress up in cheap finery, too faded or too new. Their figures parade about always with conviction, like characters dressed up for Mid-Lent coming out of a laundry.[19]

Others, their rivals, follow the footsteps of Fortuny.[20] They have discovered shimmering iridescences, brilliant highlights, and scintillating contrasts. They turn out a virtuoso pageant of arpeggios, trills, chiffons, and crepons derived without benefit of observation, thought, or the desire to examine. They have dressed up, made up, and prettied up Nature, covering her with curls and frills. Like hairdressers, they have coiffed and styled her as if for an operetta. Profit and commerce play far too important a role in their work.

When I add to these the painters who have attached themselves to the *Etat-major*,[21] who pass their time between the bugle and the drum, the count will be complete. One reproaches these painters for being too facile and lacking profundity. They are neither true painters nor true draftsmen, nor are they determined, although some of them mean well and have some spirit.

Thus the battle really is between traditional art and the new art, between old painting and the new painting. The *idea* on exhibit in the Durand-Ruel galleries has its sole adversaries at the Ecole and the Institut. It is there that the movement can, and must, seek its converts. However, it is only there, at the Ecole and Institut, that it has been treated with any justice.

Ingres and his principal students admired Courbet. Flandrin greatly encouraged that other realistic painter[22] now established in England, who had a passion for contemporary religious scenes in which he was able to express both naivete and grandeur, whether in his paintings or in his powerful etchings.

In effect the movement already has its roots. It was not born only yesterday, but at least the day before. It was little by little that it evolved and abandoned the old approach in order to reach the open air and real sunlight. Little by little it rediscovered originality and spontaneity. That is to say, it discovered real character in its subjects and in its composition. Little by little it developed a penetrating draftsmanship, consonant with the character of modern beings and things. With great sagacity and perception it revealed their mannerisms, professional behavior, and the gestures and sentiments appropriate to their class and rank.

In order to speak of a movement, I have combined discrete artistic efforts and temperaments, but ones that are similar in their endeavors and aims.

The origins of these efforts and the first manifestations of these temperaments can be found in the atelier of Courbet in such works as *L'enterrement d'Ornans*[23] and *Les demoiselles du village*.[24] They are in the work of the great Ingres and Millet, those pious and ingenuous spirits, those men of powerful instinct. Ingres sat on the ivory footstool with Homer and was among the crowd who watched Phidias work on the Parthenon, but he brought back from Greece only respect for nature, returning instead to spend his life with the Famille Robillard, as well as the comte Molé and the duc d'Orléans.[25] He never hesitated or cheated when confronted with modern forms, and executed portraits of such simplicity and truth that they were rigorous, bold, and strange, and would not have been out of place in the Salon des Refusés. Millet, that Homer of the modern countryside, gazed at the sun until he was blinded by it. He depicted the laboring peasant as a simple animal among the oxen, swine, and sheep. He adored the *land*, which he depicted as infinitely simple, noble, and rustic, yet bathed in radiant light.

The roots of the new painting lie also in the work of the great Corot and his disciple Chintreuil,[26] that man who was always *searching*, and whom Nature seems to have loved because she revealed so many of her secrets to him. They appear next among some of the students of a certain drawing master, whose name in particular is linked to the so-called method of *l'éducation de la mémoire pittoresque*,[27] but whose principal merit lies in allowing the originality and individual inclinations of his students to develop, rather than leading them along the beaten path under the yoke of inviolable technique.

Simultaneously, the origins of the new painting are visible in the work of the Dutch painter of perfect tonalities who veiled his windmills, steeples, and ship masts in shimmering and delicate grays and violets [Johan Barthold Jongkind]. They also lie with another painter from Honfleur who carefully observed and analyzed the ocean skies, rendering the essence of the seascape [Eugène Boudin]. Both contributed their share to this enthusiastic expedition that sees itself setting sail, searching out new passageways as it navigates Art's Cape of Good Hope.

These daring and determined explorers first appeared at the Salon des Refusés in 1863.[28] Since then several of them have won medals or found fame and fortune in London or Paris.

I have already mentioned the painter of *L'ex-voto* [Alphonse Legros],[29] the work that appeared in 1861. This painting was quite modern, yet had the ingenuousness and grandeur of fifteenth-century works. What, then, did it depict? Just some old, *ordinary* women, dressed in *ordinary* clothes. But that quality of rigidly mechanical dullness produced by the painful and narrow life of the humble springs from these lined and withered faces with a profound intensity. All that is striking in human beings, all that holds the attention, all that is significant, concentrated, and unexpected in life radiates from these old creatures.

Three years ago, in these same Durand-Ruel galleries, another painter, an American [James Abbott McNeill Whistler], exhibited remarkable portraits and paintings with color variations of infinite delicacy—dusky, diffused, and vaporous tints that belong to neither night nor day. A third painter [Henri Fantin-Latour] created a highly personal palette, subtly rich and harmonious, and became the most marvelous flower painter of our time. He united contemporary artistic and literary figures in a curious series of group portraits, introducing himself as a remarkable painter of characters, which should become even more evident in the future. Finally, another painter [Edouard Manet] repeatedly produced the most daring innovations, and carried on an impassioned fight. He did not let in only a crack of light, but flung wide the windows and advanced into the open air and real sunlight. Time and time again he placed himself at the forefront of the movement. With a candor and courage linking him to men of genius, he offered the public the most innovative works, works fraught with flaws yet full of fine qualities, works full of depth and originality standing apart from all others, works whose strength of expression inevitably clashes with the hesitancy of an almost entirely new feeling that does not yet have the means to express itself fully.

I have not named these artists, because they are not exhibiting here this year. However, in the years to come, perhaps they will not be afraid to exhibit where their banners already are raised and their battle cries written on the walls.

Also associated with this movement at one time was the painter of kitchen scenes [Théodule Augustin Ribot], as was the painter of cauldrons and fish [Antoine Vollon]. The former, however, has returned to the *vieux jeu* and the latter has sought a refuge, a fortress, in the use of lampblack. They seemed more open before, disposed to a nature that is bright and smiling, surrounded by a rainbow, softened by reflected light, and embellished by the prismatic iridescence of the air.

A Belgian painter [Alfred Stevens] of great talent who has not exhibited for a long time, but who was called the man of *modernity* by his compatriots, also was part of this movement and still is today. Another painter we must include is that young portraitist of sound and solid yet unsophisticated technique, whom success no longer abandons [Charles Auguste Emile Carolus-Duran]. He set out with this movement, was a brother in art, a mate of those I mentioned earlier. He preferred, however, to return to a firmly established approach to execution, and was content to occupy the top rung of art's middle class. Now he dabs no more than the tip of his finger into that original art in which he was born and bred, and in which he once was immersed, right up to his neck.

Last, Meryon the engraver also was part of this movement, as was that other painter, engraver, and draftsman [Félix Bracquemond] who was such a remarkable portraitist in the manner of Holbein, but who now spends his time decorating faience. We must include as well that young Neapolitan painter [Giuseppe de Nittis] who loves to depict the street life of London and Paris.

These, then, are the artists who exhibit in the Durand-Ruel galleries, in association with those who preceded them and those who accompany them. They are isolated no longer. It would be a mistake to consider them as drawing alone upon their own resources.

I am less concerned with the present exhibition than its *cause* and *idea*.

What, then, do this cause and idea bring us? What does the movement contribute? And, consequently, what do these artists contribute, these artists who wrestle with tradition, admire it, and simultaneously want to destroy it, these artists who acknowledge that tradition is great and powerful and who attack it for that very reason?

Why, then, are people interested in them? Why are they forgiven for too often producing—and with a touch of laziness—nothing but sketches, abbreviated summaries of works?

The real reason is that, in an age like ours, when there seems nothing left to discover, when previous ages have been analyzed so much, and when we suffocate under the weight of the creations of past centuries, it is a great surprise to see new ideas and original creations suddenly burst forth. A new branch emerges on the trunk of the old tree of art. Will it bear leaves, flowers, and fruit? Will it spread its shade over future generations? I hope so.

What, then, do these painters contribute?

A new method of color, of drawing, and a gamut of original points of view.

Some of them limit themselves to transforming tradition, striving to translate the modern world without deviating too far from the superannuated and magnificent formulas that served earlier eras. Others cast aside the techniques of the past without another thought.

In the field of color they made a genuine discovery for which no precedent can be found, not in the Dutch master, not in the clear, pale tones of fresco painting, nor in the soft tonalities of the eighteenth century.

They are not merely preoccupied by the refined and supple play of color that emerges when they observe the way the most delicate ranges of tone either contrast or intermingle with each other. Rather, the real discovery of these painters lies in their realization that strong light mitigates color, and that sunlight reflected by objects tends, by its very brightness, to restore that luminous unity that merges all seven prismatic rays into one single colorless beam—light itself.

Proceeding by intuition, they little by little succeeded in splitting sunlight into its rays, and then reestablishing its unity in the general harmony of the iridescent color that they scatter over their canvases. With regard to

visual subtleties and delicate blending of colors, the result is utterly extraordinary. Even the most learned physicist could find nothing to criticize in these painters' analysis of light.

In this connection, some speak of the Japanese, and maintain that these new painters do nothing more than imitate the color of Japanese prints.

Indeed, I said earlier that they had set off to round Art's Cape of Good Hope. Was it not, then, in order to travel to the Far East? For if the same instincts of the Asian peoples, who live in the perpetual daze of the sun, impels these painters to render the sensation that continually strikes them—specifically, that of clear, matte tones, amazingly live and light, and of its luminous quality distributed almost equally everywhere—then why not investigate such an instinct, placed as it is for observation at the very sources of the sun's brilliance?

Was there not, in the proud, melancholy eye of the Hindus, in the great, languorous, contemplative eye of the Persians, and in the lively, narrowed eye of the Chinese and the Japanese a masterful ability to blend exquisite harmonies of delicate, soft, neutral tones with bold, bright colors?

Although the Venetians had glimpsed these facts about light, the Romantics knew absolutely nothing about them. As for the Ecole des Beaux-Arts, it never made it its concern, as there they only copy old paintings, everyone having rid himself of nature.

The Romantic artist, in his studies of light, knew nothing but the orange-tinted band of the setting sun over somber hills, or the white impasto tinged with chrome yellow or rose lake, which he threw across the opaque bitumen of his woods. No light could exist without bitumen, without ivory black, or Prussian blue, without the contrasts that were said to make the tone appear warmer, to heighten it. He believed that light colored and awakened tone, and was persuaded that it could not exist unless surrounded by shadow. A cellar pierced by a bright ray issuing from a narrow opening—such was the ideal that ruled the Romantic. Even today, landscape is everywhere treated as if it were the back wall of a chimney or the back room of a shop.

And yet everyone has crossed seventy-five miles of countryside in the middle of summer, and seen how the hillsides, meadows, and fields disappear, as it were, into a single luminous reflection that they share with the sky. For such is the law that engenders light in nature—in addition to the particular blue, green, or composite ray of light that each substance absorbs, it reflects both the spectrum of all light-rays and the tint of the vault that curves above the earth. Moreover, for the first time painters understand and reproduce these phenomena, or try to. In certain canvases you feel the vibration and palpitation of light and heat. You feel an intoxication of light, which is something of no merit or importance for those painters trained outside of nature and in opposition to it. It is something much too bright and distinct, much too crude and explicit.

Turning to drawing, it is well understood that among these new painters as elsewhere, the inevitable differences between colorists and draftsmen persist. Thus, when I speak of color, you should only think of those who primarily are colorists. And, when I refer to drawing, you should only envision those who primarily are draftsmen.

In his *Essay on Painting* on the Salon of 1765, the great Diderot established the *ideal* of modern drawing—that is, drawing from nature, based on observation: *We say of a man passing in the street that he is a poor specimen. Measured in terms of our wretched little rules, yes. But in terms of nature, it is a different matter. We say of a statue that its proportions are beautiful. Yes, following our wretched little rules, but in terms of nature . . . !*

Were I initiated into the mysteries of art, perhaps I would know how much the artist ought to submit to the accepted rules of proportion, and I would tell you. But what I do know is that these rules cannot compete against the omnipotence of nature, and that the age and condition of the subject predicate compromise in a hundred different ways. I never have heard a figure accused of being poorly drawn as long as it convincingly demonstrated through its external appearance its age, bearing, and the ability to carry out its everyday activities. For this determines both the overall size of the figure and the correct proportions of the limbs, as well as whether they fit together. From these characteristics emerge the child, the grown man, and the old man; the savage or civilized man; the magistrate, the soldier, and the stevedore. If there is a figure difficult to envisage, it would be that of a twenty-five-year-old man, created instantly from the raw clay, who never had done anything. Such a man, however, is only a figment of the imagination.

What we seek at present is neither a calligraphic technique for features or contours, nor decorative elegance in lines, nor an imitation of the Greek figures of the Renaissance. The same Diderot, describing the figure of a hunchback, said, "Cover this figure, and show nothing but the feet to Nature, and Nature will tell you without hesitation: 'These are the feet of a hunchback'."

This extraordinary man is at the threshold of everything that the art of the nineteenth century would like to accomplish.

And what drawing wants in terms of its current goals is just to know nature intensely and to embrace nature with such strength that it can render faultlessly the relations between forms, and reflect the inexhaustible diversity of character. Farewell to the human body treated like a vase, with an eye for the decorative curve. Farewell to the uniform monotony of bone structure, to the anatomical model beneath the nude. What we need are the

special characteristics of the modern individual—in his clothing, in social situations, at home, or on the street. The fundamental idea gains sharpness of focus. This is the joining of torch to pencil, the study of states of mind reflected by physiognomy and clothing. It is the study of the relationship of a man to his home, or the particular influence of his profession on him, as reflected in the gestures he makes: the observation of all aspects of the environment in which he evolves and develops.

A back should reveal temperament, age, and social position, a pair of hands should reveal the magistrate or the merchant, and a gesture should reveal an entire range of feelings. Physiognomy will tell us with certainty that one man is dry, orderly, and meticulous, while another is the epitome of carelessness and disorder. Attitude will reveal to us whether a person is going to a business meeting, or is returning from a tryst. "A man opens a door, he enters, and that is enough: we see that he has lost his daughter!" Hands kept in pockets can be eloquent. The artist's pencil will be infused with the essence of life. We will no longer simply see lines measured with a compass, but animated, expressive forms that develop logically from one another. . . .

But drawing is such an individual and indispensable means of expression that one cannot demand from it methods, techniques, or points of view. It fuses with its goal, and remains the inseparable companion of the idea.

Thus, the series of new ideas that led to the development of this artistic vision took shape in the mind of a certain draftsman [Edgar Degas], one of our own, one of the new painters exhibiting in these galleries, a man of uncommon talent and exceedingly rare spirit. Many artists will not admit that they have profited from his conceptions and artistic generosity. If he still cares to employ his talents unsparingly as a *philanthropist* of art, instead of as a businessman like so many other artists, he ought to receive justice. The source from which so many painters have drawn their inspiration ought to be revealed.

The very first idea was to eliminate the partition separating the artist's studio from everyday life, and to introduce the reality of the street that shocks the writer in the *Revue des Deux Mondes*. It was necessary to make the painter come out of his sky-lighted cell, his cloister, where his sole communication was with the sky—and to bring him back among men, out into the real world.

Now these new painters have demonstrated a fact of which that writer was totally unaware. Our lives take place in rooms and in streets, and rooms and streets have their own special laws of light and visual language.

For the observer there is a complete logic to the color and drawing associated with an image, which depends on the hour, the season, and the place in which it is seen. This image is not expressed and this logic is not determined by throwing Venetian cloth together with Flemish background, or by making old sideboards and vases shine in the light of the atelier.

If one wants to be truthful, one must neither conflate time and place, nor confuse the time of day and the source of light. The velvety shadows and golden light of Dutch interiors resulted from the structure of their houses, the small, multi-paned, leaded windows, and the misty streets beside steaming canals. Here, in our homes, tonal values vary infinitely, depending on whether one is on the first floor or the fourth, whether a home is heavily furnished and carpeted, or whether it is sparsely furnished. An atmosphere is created in every interior, along with a certain personal character that is taken on by the objects that fill it. The number, spacing, and arrangement of mirrors decorating an apartment and the number of objects hung on the walls—these things bring something to our homes, whether it is an air of mystery or a kind of brightness, that can be achieved no longer with Flemish methods and harmonies, even by adding Venetian formulas, nor by using any imaginable combination of daylight and composition in the best-equipped studio.

Suppose, for example, that at a given moment we could take a colored photograph of an interior. We would have a perfect match, a truthful and real representation, with every element sharing the same feeling. Suppose then that we waited, and when a cloud covered the sun, we immediately took another picture. We would have a result analogous to the first. It is up to observation to compensate for these instantaneous means of execution that we do not possess, and to preserve intact the memory of the images they would have rendered. But what if we were to take some details from the first photograph and combine them with some of the detail from the second, and to create a painting? Then homogeneity, harmony, and the truth of the impression will have disappeared and have been replaced by a false and inexpressive note. Every day, however, that is what painters do who do not look but instead rely on ready-made formulae provided by paintings already done.

And, as we are solidly embracing nature, we will no longer separate the figure from the background of an apartment or the street. In actuality, a person never appears against neutral or vague backgrounds. Instead, surrounding him and behind him are the furniture, fireplaces, curtains, and walls that indicate his financial position, class, and profession. The individual will be at a piano, examining a sample of cotton in an office, or waiting in the wings for the moment to go onstage, or ironing on a makeshift table. He will be having lunch with his family or sitting in his armchair near his worktable, absorbed in thought. He might be avoiding carriages as he crosses the street or glancing at his watch as he hurries across the square. When at rest, he will not be merely pausing or striking a meaningless pose before the

photographer's lens. This moment will be a part of his life as are his actions.

The language of an empty apartment must be clear enough to enable us to deduce the character and habits of its occupant. The passersby in a street should reveal the time of day and the moment of everyday life that is shown.

In real life views of things and people are manifested in a thousand unexpected ways. Our vantage point is not always located in the center of a room whose two side walls converge toward the back wall; the lines of sight and angles of cornices do not always join with mathematical regularity and symmetry. Nor does our point of view always exclude the large expanse of ground or floor in the immediate foreground. Sometimes our viewpoint is very high, sometimes very low; as a result we lose sight of the ceiling, and everything crowds into our immediate field of vision, and furniture is abruptly cropped. Our peripheral vision is restricted at a certain distance from us, as if limited by a frame, and we see objects to the side only as permitted by the edge of this frame.

From indoors we communicate with the outside world through windows. A window is yet another frame that is continually with us during the time we spend at home, and that time is considerable. Depending on whether we are near or far, seated or standing, the window frames the scene outside in the most unexpected and changeable ways, providing us with constantly changing impromptu views that are the great delights of life.

For example, if in turn one considers a figure, either in a room or on the street, it is not always in a straight line with two parallel objects or at an equal distance from them. It is confined on one side more than on the other by space. In a word, it is never in the center of the canvas or the center of the scene. It is not shown whole, but often appears cut off at the knee or mid-torso, or cropped lengthwise. At other times the eye takes it in from up close, at its full height, and relegates to perspectival diminution others in a street crowd, or a group gathered in a public place. It would be an endless task to detail every cut or to describe every scene—the railways, notion shops, construction scaffolds, lines of gaslights, benches on the boulevards and newspaper kiosks, omnibuses and teams of horses, cafés with their billiard-rooms, and restaurants with their tables set and ready.

The new painters have tried to render the walk, movement, and hustle and bustle of passersby, just as they have tried to render the trembling of leaves, the shimmer of water, and the vibration of sun-drenched air—just as they have managed to capture the hazy atmosphere of a gray day along with the iridescent play of sunshine.

But there are so many things that the art of landscape has not yet dreamed of expressing. Almost all landscape artists lack a feel for the *structure* of the land itself. If the hills are of a certain shape, the trees are sure to be grouped in a certain way, the houses nestled together in a certain fashion among the fields, and the riverbanks given a certain shape. Thus the character of the countryside takes form. No one yet has discovered how to capture the essence of the French countryside. And as we have made so much of bold color, now that we have had a little fling with intoxicating color, it is time to call *form* to the banquet.

At the very least, it seems preferable to paint the whole landscape *in situ*, and not from a sketch brought back to the studio, because one gradually loses the first impression. With very few exceptions, one must admit that everything in this new movement is new or wants to be free. Print-making, too, torments itself over technique.[30]

Here it takes up the dry point and uses it like a pencil, attacking the plate directly and tracing the work in a single stroke [Marcellin Desboutin]. There it uses the burin to unexpectedly accent the etching. Now it changes each impression—lightening, shading it in mystery, literally painting by a clever manipulation of the ink at the moment of printing [Viscount Ludovic Napoléon Lepic].

At last the subject matter of art includes the simple intimacies of everyday life in its repertoire, in addition to its generally less common interests.

Twenty years ago I wrote the following about subjects in painting:

I have witnessed a whole society, a wide range of actions and events, professions, faces, and milieux. I have seen dramatic gestures and faces that were truly paintable. *I have observed the comings and goings that are predicated upon the relations between people as they met at different times and places—church, dining room, drawing room, cemetery, parade-ground, workshop, Chamber of Deputies—everywhere. Differences in dress played a large role in these scenes and coincided with differences of physiognomy, manner, feeling, and action. Everything seemed to me arranged as if the world were created expressly for the delight of painters, for the delight of the eye.*[31]

I imagined painting attempting a vast series about society people, priests, soldiers, workers, and merchants. In such a series characters would differ in their individual roles, yet be linked by those scenes common to all, especially those scenes that happen *frequently* and thus accurately express the everyday life of a country—marriages, baptisms, births, successions, celebrations, and family scenes.

I thought that a painter who had been seduced by this great spectacle might end by working with strength, calm, certainty, and broad-mindedness—perhaps of a like possessed by no contemporary man—and gaining great superiority of execution and feeling.

But where, you will ask, is all this?

All this has been achieved, some of it here and some of it abroad, while some lies just on the horizon. All this

exists in works already painted, as well as in sketches, projects, dreams, and discussions. Art does not struggle in this fashion without some confusion.

Rather than acting as a group who share the same goal and who arrive successively at this crossroads where many paths diverge, these artists above all are people of independent temperaments. They come in search of freedom, not dogma.

Originality in this movement coexists with eccentricity and ingenuousness, visionaries exist with strict observers, and ignorant naïfs with scholars who want to rediscover the naivete of the ignorant. There are voluptuous delights in painting for those who know and love it, and there are unfortunate attempts that grate on the nerves. An idea ferments in one's brain while almost unconscious audacity spills from another's brush. All of this is interrelated.

The public is bound to misunderstand several of the leading artists. It only accepts and understands correctness in art, and, above all, it demands finish. The artist, enchanted by delicacy or brilliance of color, or by the character of a gesture or a grouping, is much less concerned with the finish and the correctness, the *only* qualities valued by those who are not artists. If, among our own, the new painters, there are those for whom freedom is an easy question and who would be pleased if beauty in art were to consist of painting without inconvenience, difficulty, and pain, such pretentiousness will be dealt with appropriately.

But for the most part, what they want is to work without ceremony, cheerfully and without restraint.

Besides, it matters very little whether the public understands. It matters more that the artists understand. For them one can exhibit sketches, preparatory studies, and preliminary work in which the thought, intention, and draftsmanship of the painter often are expressed with greater speed and concentration. In this work one sees more grace, vigor, strength, and acute observation than in a finished work. It would astonish many, even many students of painting, to learn that things they believe to be mere daubs embody and reveal the highest degree of grace, strength, and acuity of observation, as well as the most delicate and intense feeling.

Laissez faire,[32] *laissez passer.*[33] Do you not see the impatience in these attempts? Do you not see the irresistible need to escape the conventional, the banal, the traditional, as well as the need to find oneself again and run far from this bureaucracy of the spirit with all its rules that weigh on us in this country? Do you not see the need to free your brow from this leaden skullcap of artistic routine and old refrains, to abandon at last this common pasture where we all graze like sheep?

They have been treated like madmen. They may be madmen, but the little finger of a fool is assuredly worth more than the entire head of a banal man.

And they are not so crazy as has been insinuated.

To our time you might apply some of Constable's curious and beautiful thoughts, which certain of our own new painters seem to share with him:
The execution of my pictures, I know, is singular, but I like that rule of Sterne's, 'Never mind the dogmas of school, but get at the heart as you can.'[34]

Whatever may be thought of my art, it is my own.[35]

In art, there are two modes by which men aim at distinction. In the one, by a careful application to what others have accomplished, the artist imitates their works, or selects and combines their various beauties; in the other, he seeks excellence at its primitive source, nature. In the first, he forms a style upon the study of pictures, and produces either imitative or eclectic art; in the second, by a close observation of nature, he discovers qualities existing in her which have never been portrayed before, and thus forms a style which is original. The results of the one mode, as they repeat that with which the eye is already familiar, is soon recognized and estimated, while the advances of the artist in a new path must necessarily be slow, for few are able to judge of that which deviates from the usual course, or are qualified to appreciate original studies.[36]

It is in this way that public ignorance encourages laziness among artists and pushes them to imitation. The public gladly applauds pastiches painted after the great masters and ignores any work that is a new and daring interpretation of nature. That is a closed subject.[37]

Lord Bacon says, [Duranty dropped, "Cunning is crooked wisdom"] "Nothing is more hurtful than when cunning men pass for wise. [This is mannerism in painting.] The mannerists are cunning people: and the misfortune is, the public is unable to discriminate between their pictures and true painting.[38]

When I sit down, [Duranty added, "pencil or brush in hand"] to make a sketch from nature, the first thing I try to do is, to forget that I have ever seen a picture.[39]

I have never seen an ugly thing in nature. [Diderot wrote, " . . . there is nothing ugly; I never saw an ugly thing in my life."[40]]
(For his part, Diderot wrote that nature never makes an incorrect thing.)
Certain critics exalt painting to a ridiculous degree. They end up by giving it such high esteem that it seems as if nature had nothing better to do than to acknowledge herself defeated and ask artists for lessons.[41]

The landscape painter must walk in the fields with an humble mind. No arrogant man was ever permitted to see nature in all her beauty.[42]

The new painters also can claim as their own the following words of Emile Zola concerning one of their leaders, their boldest exponent:[43]
For the masses, there is an absolute ideal placed just beyond the artist's reach. In other words, there is an ideal

of perfection toward which each aspires and that each achieves to a greater or lesser degree. Thus there is a common standard that is the Beautiful itself, a standard that is applied to every work created. Depending on how near to or far from this standard it is, a work is said to have greater or lesser merit. But as circumstances would have it, that chosen standard is the Greek ideal of beauty. The result is that judgments passed on every work created by humanity are derived from the degree to which that work resembles Greek works.

What interests me, as a person, are the roots of my being. What touches and enchants me among human creations and works of art is rediscovering in each an artist— a brother who shows me a new side of nature with all the power or gentleness of his temperament. This work, viewed in this light, tells me the story of a heart and a body; it speaks to me of a civilization and a land. . . .

All problems must be reexamined. Science requires solid foundations, and it has returned to the precise observation of facts. And this thrust occurs not only in the scientific realm but in all fields of knowledge; all human works seek the reality of solid and definitive principles . . . art itself strives toward certainty.[44]

However, when I see these exhibitions, these attempts, I, too, become somewhat disheartened, and say to myself, where are these artists going—who are almost all my friends, whom I watched with pleasure as they set off on an unknown path, who have partially achieved the goals defined in our youth? Will they increase their endowment and preserve it?

Will they become the founders of a great artistic resurgence? Will their successors, relieved of the preliminary difficulties of sowing the seeds, reap a great harvest? Will they have the respect for their precursors that sixteenth-century Italians had for the *quattrocentists*?[45]

Or will they simply be cannon fodder? Will they be no more than the front-line soldiers sacrificed by marching into fire, whose bodies fill the ditch to form the bridge over which those following must pass? The fighters, or rather the swindlers, for in Paris, in all the arts, there are a goodly number of clever people lying in wait with lazy and cunning minds, but busy hands. In the naive world of inventors—some of whom are wildly successful—they reenact the fable of the chestnuts snatched from the fire and those scenes in natural history that occur between ants and aphids. With great agility they snatch the ideas, research, techniques, and subjects that their neighbor has painstakingly created with the sweat of his brow and considerable nervous energy. They arrive fresh and alert and, with an adroit flick of the wrist, neat and clean, they abscond with all or part of the property of the poor other fellow, making fun of him in the bargain. The comedy is really rather amusing. And the poor other fellow can only retain the consolation of saying, "So, my friend, you take what's mine!"

In France, especially, the inventor is eclipsed by the one who perfects and patents the invention—virtuosity takes precedence over naive clumsiness and the popularizer reaps the reward of the innovator.

But then, no one is a prophet in his own country. That is why our painters are far more appreciated in England and Belgium, lands of independent spirit, where no one is offended at the sight of people breaking the rules, and where they neither have nor create academic canons. In these countries, the present efforts of our friends to break the barrier that imprisons art—sometimes scholarly, brilliant, and successful, and sometimes disorderly and desperate—seem straightforward and worthy of praise.

But then why, you still ask, do they refuse to send their works to the Salon? Because theirs is not a painting exam, and because we must abolish official ceremony, the distribution of school-boy prizes, the university system of art. If we do not begin to extricate ourselves from this system, we will never convince other artists to abandon it either.

And now, I wish fair wind to the fleet—let it carry them to the Hesperides of Art.[46] I urge the pilots to be careful, determined, and patient. The voyage is dangerous, and they should have set out in bigger, more solid vessels. Some of their boats are quite small and narrow, only good for coastal painting.

Let us hope, however, that this painting is fit for a long voyage.

Notes

1 The original French text is reprinted in the Appendix.

2. In the published version of the essay, Duranty did not provide the names of any of the artists cited. However, in 1878 he sent an annotated copy of *The New Painting* to the Italian critic Diego Martelli (1839–1896); in the margins he inscribed the names of the artists intended, and at the end of the text he wrote: "Les noms en marge sont écrits de ma main. Duranty. Le 9 Septembre 1878" ["The names in the margin are written in my hand. Duranty. 9 September 1878."]. These are the names included in brackets.

Martelli's copy of *The New Painting* is now in the Biblioteca Marucelliana, Florence (Legato Martelli, Misc. 1201/4). For a discussion of the annotated copy see Oscar Reuters,ward, "An Unintentional Exegete of Impressionism; Some Observations on Edmond Duranty and his 'La nouvelle peinture,'" *Konsthistorisk Tidskrift*, 4 (1949): 111–116.

3. Eugène Fromentin, in *Revue des Deux Mondes*, 15 February 1876, 795–797, and again in *Les maîtres d'autrefois: Belgique-Hollande* (Paris, 1876), 283–287.

4. The term *Realism*, as used by Fromentin, refers to a broad spectrum of artists that includes Gustave Courbet and his followers as well as the emerging Impressionist circle.

5. *Vieux jeu* means literally [the] old game. Here, it refers to traditional, i.e. old-fashioned, techniques.

6. In other words, the officially sanctioned, conservatively juried, annual exhibitions known as the Salons.

7. The Sahel is a region that borders the Sahara.

8. The helmet cited here appears on the head of Léonidas in Jacques-Louis David's *Léonidas at Thermopylae*, 1814, Musée du Louvre, Paris.

9. The version of Paolo Veronese's *The Wedding at Cana* is undoubtedly that of 1562–1563 in the Musée du Louvre, Paris.

10. Ernest Renan (1823–1892), a philosopher, historian, author, and scholar of religion who held the chair of Hebrew at the Collège de France, was exceedingly well known during the late nineteenth century as the result of the publication of his *Vie de Jésus* (1863). Suspended from his position the year before because during his opening lecture he referred to Christ as "an incomparable man," in the *Vie de Jésus* he argued that Christ was merely an exceptional human being and attributed the development of Christianity to the popular imagination.

Basse-Bretagne is western Brittany.

11. Count François Marie Charles de Remusat (1797–1875), author and politician, is best known for his *Essai sur la nature de pouvoir* [*Essay on the Nature of Power*] and a refutation of de Lamennais's *Essai sur l'indifférence* [*Essay on Indifference*]. He was Undersecretary of State in Molé's cabinet (1836–1837); allied with Thiers, he was a cabinet member in 1840. During the Second Empire he was exiled.

12. Possibly a reference to one of the most famous Pre-Raphaelite paintings, John Everett Millais's *Ophelia*, 1855, National Gallery, London.

13. Horace Lecoq de Boisbaudran (1802–1897), a professor at the so-called Petite Ecole de la rue de l'Ecole de Médecine, placed a strong emphasis on drawing, both from memory and from life, as the foundation of an artist's education. See Horace Lecoq de Boisbaudran, *Education de la mémoire pittoresque, application aux arts de dessin*, 2d ed., enlarged (Paris, 1862).

14. Each year advanced students at the Ecole des Beaux-Arts competed for a prize known as the Prix de Rome, in effect a grant for travel to Italy and unrestricted study at the Academy of France in Rome. See Albert Boime, *The Academy and French Painting in the Nineteenth Century* (London, 1971), 19–20: "At its highest level, the Ecole curriculum assumed a more complex form as a series of competitions, the apex of which was the *Prix de Rome*. These contests were entirely supervised by the Academy and its member-professors. An innovation of the seventeenth century, the *Prix de Rome* embodied the quintessence of Academic philosophy and its ideal of historical painting. The subjects for this contest were selected from the Bible and classical literature. . . . The voyage to Rome represented the glory of the French art student and was essentially a scholarship awarded to the *Prix-de-Rome* winner."

15. Possibly a reference to Ignacio Merino (1818–1876), who exhibited at the Salon from 1850 through 1875, and/or one of a hardy breed of sheep with long, fine, silky wool, originally from Spain.

16. The north side of the Ecole des Beaux-Arts faces the Seine and runs almost the full length of the quai Malaquais.

17. Duranty alludes to the Naturalist movement in literature, of which Emile Zola was the leading proponent. See Theodore Reff, *Degas: The Artist's Mind* (New York, 1977), 119: "Duranty, a pioneer in the Naturalist movement whose career was later eclipsed by the fame of Flaubert and Zola, was often as bitter and withdrawn as he appears in *The Banker* [The Metropolitan Museum of Art, New York], his 'countenance soft, sad, and resigned. . . . His whole life was written, as it were, in the sometimes painful grin of his mouth' [Armand Silvestre, *Au pays des souvenirs*, Paris, 1887, pp. 174–175]."

18. Duranty edited the review *Réalisme* during its brief existence in 1856–1857.

19. Mid-Lent, the fourth Sunday in Lent, also known as Simnel Sunday or Mothering Sunday, the day when people customarily visit their parents to give and/or receive presents.

20. The reputation of Mariano Fortuny y Carbo (1838–1874), a Spanish academic Realist whose history and genre paintings sold for record prices, was near its zenith when Duranty wrote *The New Painting*.

21. *L'état major* is a military term designating the general staff. Presumably Duranty has in mind such successful painters of military subjects as Edouard Détaille (1848–1912), Etienne-Prosper Berne-Bellecoeur (1838–1912), and Karl Girardet (1813–1871).

22. Although Duranty did not inscribe the artist's name in the margin of the annotated copy of *The New Painting* that he sent to Diego Martelli (see above, note 2), Alphonse Legros (1837–1911) is undoubtedly the artist intended. Hippolyte-Jean Flandrin (1809–1864), one of the most successful followers of Ingres, painted official portraits and mural decorations for churches.

23. Gustave Courbet, *L'enterrement d'Ornans* (*The Burial at Ornans*), 1849–1850, Musée du Louvre, Paris.

24. Gustave Courbet, *Les demoiselles du village* (*The Young Ladies of the Village*), 1851–1852, The Metropolitan Museum of Art, New York.

25. Jean-Auguste-Dominique Ingres (1780–1867) included among his friends and clients duc Ferdinand-Philippe d'Orléans (1810–1842), comte Louis-Matthieu Molé (1781–1855), and members of the Robillard family; all were significant figures in the political and social life of Paris during the first half of the nineteenth century. Duranty's point is that although Ingres received a traditional training, spent long periods in Rome, and admired classical art, he lived the life of a modern Parisian and devoted much of his work to the depiction of his contemporaries in characteristic attitudes, dress, and surroundings.

26. Antoine Chintreuil (1816–1873) was Corot's best-known student. His landscapes follow Corot's manner closely, yet are distinguished by his personal style.

27. Lecoq de Boisbaudran. See above, note 13.

28. In 1863 the Salon jury rejected approximately 2,800 works submitted by about 2,000 artists. Following a vehement protest, the artists whose works had been refused were invited to show the rejected paintings in a special exhibition known as the Salon des Refusés. Among the fewer than half who participated were Manet, Pissarro, Whistler, Fantin-Latour, and Cézanne.

29. Alphonse Legros, *L'ex voto*, 1861, Musée des Beaux-Arts, Dijon.

30. Printmaking was an integral aspect of the new art. Degas and Pissarro, for example, often exhibited prints and other works on paper with their paintings in the group shows of 1874–1886. Furthermore, the group shows also included works by numerous individuals known principally as graphic artists, such as Marcellin Desboutin and Félix Bracquemond.

31. Presumably, Duranty refers to one of his own contributions to *Réalisme*, the review he edited in 1856–1857.

32. *Laissez faire* means let [one] do [as he wishes]. It is the doctrine or practice of non-interference with regard to individual freedom of choice or action. In the eighteenth century the term was used to designate the policies of French economists who objected to government control of industry.

33. *Laissez passer* means let [one] pass. The term often applies to documents permitting an individual to cross a regulated frontier without hindrance or to attend an event that requires a ticket.

34. See C. R. Leslie, *The Memoirs of John Constable, Composed Chiefly of His Letters* (London, 1951), 128.

35. Leslie, 280.

36. Leslie, 179.

37. The exact source for this quote is uncertain. It may be a paraphrase of Leslie's criticism of Mannerism, 300, perhaps with a reference to 97.

38. Leslie, 274.

39. Leslie, 279.

40. Leslie, 280.

41. A paraphrase of Leslie, 323.

42. Leslie, 327.

43. Edouard Manet.

44. Duranty quotes from Emile Zola, "Une nouvelle manière en peinture," *L'Artiste: Revue du XIX^e Siècle*, 1 January 1867. These passages are taken from the first section, "L'homme et l'artiste." A few months later the essay was revised and reprinted as a pamphlet: Emile Zola, *Ed. Manet, Etude biographique et critique, accompagné d'un portrait d'Ed. Manet par Bracquemond et d'une eau-forte d'Ed. Manet, d'après Olympia* (Paris [Dentu], 1867); the passages cited by Duranty are located on pages 19, 21, and 26–27, but minor changes in the text indicate that Duranty's source was the essay as printed in *L'Artiste: Revue du XIX^e Siècle*. The text of the version published by Dentu appears in the more readily accessible Emile Zola, *Oeuvres complètes*, ed. Henri Mitterand (Paris [Cercle du Livre Précieux], 1969), 12: 829, 830, and 833.

45. *Quatorze centistes* (literally: fourteen hundredists) refers to the artists of the fifteenth century, the early Renaissance.

46. In Greek mythology the Hesperides (Iles-Fortunées) are the islands at the western end of the world where nymphs, the daughters of Hesperus, the evening star, were fabled to guard a garden of golden apples.

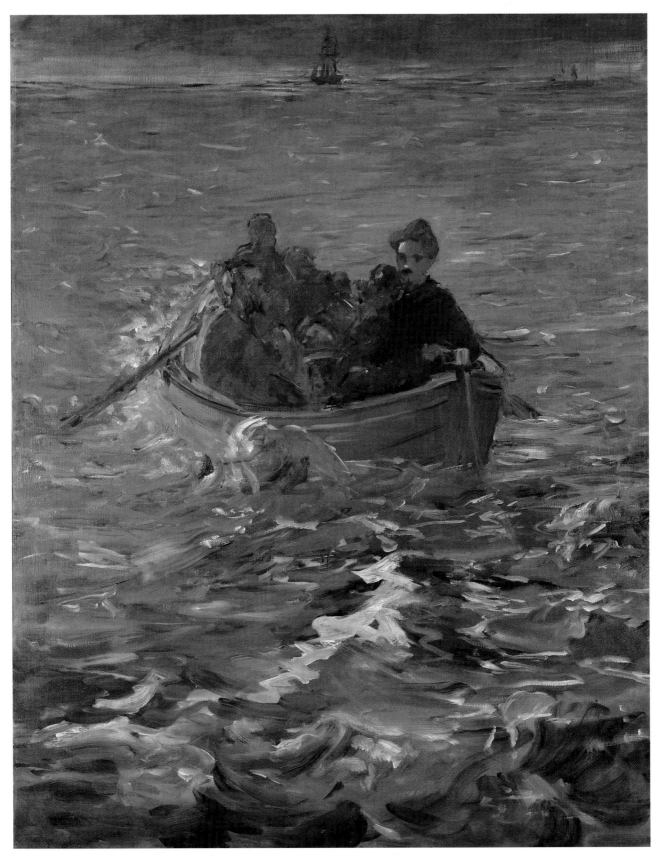

fig. 1 Edouard Manet, *The Escape of Rochefort*, 1880–1881. Oil on canvas, 57½ x 45¾ in. (146 x 116 cm). Kunsthaus, Zurich

The Intransigent Artist *or*
How the Impressionists Got Their Name

Stephen F. Eisenman

Most histories of Impressionism provide an account of how the movement got its name; the formula is as follows.[1] On 15 April 1874 there opened at the Paris studios of the photographer Nadar an exhibition billed as the *Première exposition* of the *Société anonyme des artistes peintres, sculpteurs, graveurs, etc.*[2] Thirty artists participated, including Claude Monet, who submitted a painting entitled *Impression, soleil levant.*[3] Within a week, the terms "impression," "effect of an impression," and "quality of impressions" were employed in press accounts of the exhibition, in particular referring to the paintings of Monet, Renoir, Sisley, Degas, Pissarro, and Cézanne.[4] Louis Leroy was apparently the first to speak of a school of "Impressionists" in his now famous satirical dialogue published in *Le Charivari* on 25 April, while it was Jules Castagnary who described "Impressionism" for readers of *Le Siècle* on 29 April.[5] The name apparently stuck, and three years later, in February 1877, the *Société* itself accepted the sobriquet, voting to call its imminent third exhibition the *Exhibition of Impressionists.*[6] The organization went on to have five more exhibitions (the last in 1886), and its members to remain in loving art historical memory simply as the Impressionists.

Two aspects of this story of origins concern me. First, the basic accuracy of the account—how common was the term *Impressionism* in the period between April 1874 and February 1877, and why did the Société anonyme adopt a name that apparently had been used in derision? Second, what was at stake in naming the new art? Why did the artists and their critics attach such importance to the matter? My answer to these questions is intended as a contribution both to the history of an art movement narrowly conceived, and to the ongoing debate over Modernism itself, of which Impressionism constitutes a signal moment.

The term *Impressionism* derives from impression, a word of considerable antiquity denoting a physical mark upon a surface or the immediate effect of an experience or perception upon the mind. This latter definition underlay a school of British epistemology, sometimes called "Impressionism," of which David Hume was the spokesman. In his *Essay on Human Understanding* of 1742 he wrote,

By the term impression, I mean all our more lively perceptions, when we hear, or see, or feel, or love or hate, or desire, or will. . . . Impressions are distinguished from ideas, which are the less lively perceptions of which we are conscious, when we reflect on any of those sensations or movements above mentioned.[7]

Hume's description of the sensual immediacy of impressions was echoed by the French physiopsychologists of the mid-nineteenth century, Hippolyte Taine, Théodule Ribot, and Emile Littré, who understood impressions as the middle term between subject and object or the self and non-self.[8] In his great *Dictionnaire* of 1866 Littré explicitly severed any ties between perception and cognition by defining impression as "the more or less pronounced effect which exterior objects make upon the sense organs."[9]

The word *impression* entered the vocabulary of art criticism at about the same time that the French positivists were undertaking their studies of perception. Charles Baudelaire, for example, in 1863 described the "impression produced by things on the spirit of M.G. [uys]."[10] Other texts could be cited, but the recent studies of Richard Shiff and Charles Stuckey permit a generalization to be made at once. By 1870 it had become clear that any art based upon impressions, that is, upon unmediated sensory experience, must resemble the colored patchwork that it was believed constituted unreflective vision, what Ruskin had earlier called "the innocence of the eye."[11] In that year Théodore Duret said of Manet,

He brings back from the vision he casts on things an impression truly his own. . . . Everything is summed up, in his eyes, in a variant of coloration; each nuance or distinct color becomes a definite tone, a particular note of the palette.[12]

Duret thus detected two aspects in Manet's Impression(ism): first, its utter individuality, and second, its structure of discrete color "notes" juxtaposed against, but not blended with, their adjacent tone. The dual nature of Impressionism also underlay Castagnary's celebrated usage of 1874, cited above in part. "They are

Impressionists in the sense that they render not the landscape but the sensation produced by the landscape. . . . [The Impressionists] leave reality and enter into full idealism."[13] By "Idealism," as Shiff has shown, Castagnary meant to signify the individualism of the artists, an individualism that corresponded to their technique of laying down a mosaic of colors and forms, which was determined by the impression of the exterior world upon their sense organs.[14]

Impressionism in 1874 thus connoted a vaguely defined *technique* of painting and an *attitude* of individualism shared by an assortment of young and middle-aged artists unofficially led by Manet. Yet if the word *Impressionism* offered only the merest coherence to the exhibition at Nadar's, it had one significant advantage over any other. Serving as a description of unbridled individualism, Impressionism assured politically moderate critics that the new art had both broken with increasingly discredited salon conventions, and remained unsullied by any troubling radical affiliations. "Does it constitute a revolution?" asked Castagnary of Impressionism. "No . . . it is a manner. And manners in art remain the property of the man who invented them. . . ."[15] To such supporters of the Third Republic as Castagnary, individualism was deemed an essential instrument for the emancipation of citizens from debilitating ties to former political, economic, or religious dogma. Individualism would be necessary in the massive work of reconstructing France after the disasters of the Franco-Prussian War and Commune.[16] We may conclude that the combination of painterly daring and political discretion suggested by the word *Impressionism* helps account for the surprisingly positive reception given the new art by many critics.

Not all critics, however, were sanguine about the political moderation of the new art. Indeed, *Impressionist* was not the only name given to the artists who exhibited at Nadar's studio in April 1874. The word *Intransigent* also appeared, and continued to gain in popularity until the Impressionists' self-naming in 1877. A critic for *Le Figaro*, writing two weeks after Leroy, described the "brutality of the Intransigents."[17] Jules Claretie commented that "the skill of these Intransigents is nil," while Ernest Chesneau noted that "this school has been baptised in a very curious fashion with the name of the group of Intransigents."[18] Before citing other critical articulations, it is necessary to outline the derivation and meaning of this curious word *Intransigent*.

The French word *intransigeant*, like the English *Intransigent*, is derived from the Spanish neologism *los intransigentes*, the designation for the anarchist wing of the Spanish Federalist Party of 1872.[19] The Intransigents were opposed to the compromises offered by the Federalist *Benevolos* (Benevolents), led by Pi y Margal, believing instead that the Spanish constitutional monarchy led by

the Savoy Prince Amadeo could best be toppled by mass armed resistance and a general strike.[20] When in fact Amadeo's fragile coalition finally collapsed in February 1873, the Intransigents pressed their claims for Cantonal independence against the newly empowered Benevolent Republicans. The dispute soon would escalate into civil war.

The French government led by President Thiers had in the meanwhile been watching the events in Spain with concern. The perception was widespread that the newly hatched Spanish Republic might degenerate into a radical Commune. Indeed the links between the two were direct, as it had been the Commune that helped inspire the Federalist challenge in Spain.[21] In addition, many Communards had found refuge there (including Karl Marx's son-in-law Paul Lafargue), precipitating the belief in France that Communard agitators were responsible for destabilizing the Spanish executive. In late February 1873 the correspondent for *Le Temps* sought to quash rumors that a contingent of Communards had arrived in Spain. "As for those Communards who would come to Madrid seeking an audience for their new exploits, let them not doubt that they will receive here the welcome they deserve."[22] The ex-Orleanist minister Marquis de Bouillé refused to recognize the new Benevolent Republic, and amid reports that the French might militarily intervene if the Intransigents gained control, the correspondent for *Le Temps* assured his readers that Spain remained stable. An attempted Intransigent coup in July 1873 ignited civil war, but without support of the International, the major Spanish cities, or France (its conservatism strengthened by the May election of Marshal MacMahon), the rebels were routed. The last Intransigent stronghold, Cartagena, submitted to the increasingly conservative Republic in January 1874. By the end of the year the Republic itself had been defeated and the Spanish Bourbons restored to power.

With the destruction of Intransigentism in Spain, the word *Intransigent* entered the political and cultural vocabulary of France. In the March 1875 preface to a catalogue for an auction of Impressionist paintings, Philippe Burty described the landscapes of the new group, "who are here called the Impressionists, elsewhere the Intransigents."[23] By 1876, the name Intransigent had grown considerably in popularity. In his April 3 review of the Second Impressionist Exhibition, Albert Wolff wrote, "These self-proclaimed artists call themselves the Intransigents, the Impressionists. . . . They barricade themselves behind their own inadequacy."[24] At the same time Armand Silvestre spoke of Manet and "the little school of Intransigents among whom he is considered the leader," while the Impressionist painter and patron Gustave Caillebotte composed a last will and testament that stipulated, "I wish that upon my death the necessary sum be taken to organize, in 1878, under the best conditions

possible, an exhibition of works by the painters called Intransigents or Impressionists."[25] A more ominous note was sounded in the *Moniteur Universel*. Responding to a favorable review by Emile Blémont in the radical *Le Rappel*, an anonymous critic wrote,

Let us profit from this circumstance to understand that the "Impressionists" have found a complacent judge in Le Rappel. *The Intransigents in art holding hands with the Intransigents in politics, nothing could be more natural.*[26]

The assertion that the Impressionists had joined hands with the Intransigents in politics was given further support by Louis Enault in *Le Constitutionnel*. In his review of the second "Exposition des Intransigeants," he recalled the origins of the word *Intransigent*:

If our memory is faithful, it is to Spain that we owe this new word whose importation is more recent than mantilles *and less agreeable than* castagnettes. *It was, I believe, the Republicans from the southern peninsula who for the first time employed this expression whose meaning was not perfectly understood at the beginning. . . . The political Intransigents admit no compromises, make no concession, accept no constitution. . . . The terrain on which they intend to build their edifice must be a blank slate.*[27]

The Intransigents of paint, Enault proceeds, similarly wished to begin with a clean slate, unburdened by the lines that the great draftsmen used to mark the contours of figures, or by the harmonious colors that offered such "delicacies to the eyes of dilettantes."

A critic for *La Gazette [des Etrangers]*, Marius Chaumelin, was more precise about the politics of Intransigent art and the appropriateness of its name:

At first they were called "the painters of open air," indicating so well their horror of obscurity. They were then given a generous name, "Impressionists," which no doubt brought pleasure to Mlle Berthe Morisot and to the other young lady painters who have embraced these doctrines. But there is a title which describes them much better, that is, the Intransigents. . . . *They have a hatred for classical traditions and an ambition to reform the laws of drawing and color. They preach the separation of Academy and State. They demand an amnesty for the "school of the daubs [taches]," of whom M. Manet was the founder and to whom they are all indebted.*[28]

Chaumelin claimed that the principles of the new art—reform of the laws of color and design, "separation of Academy and State," and amnesty for daubers—were derived from the principles of the political Intransigents, that is, the radicals who had gained some thirty seats in the March 1876 elections to the Chamber of Deputies. Among the radical leaders was Georges Clemenceau representing Montmartre, whose campaign platform included reform of electoral laws, separation of church and state, and amnesty for imprisoned or exiled Commu-

nards.[29] This latter issue of giving amnesty, highlighted by Chaumelin, was particularly controversial as it implied that the 1871 Commune had been a legitimate political contest between classes and not, as conservatives or moderate Republicans claimed, a criminal insurrection whose brutal suppression was deserved. Chaumelin offered his readers little help, however, in determining just how political turned into artistic Intransigence, preferring like Enault to treat them both as largely nugatory affairs.

Not all the evaluations of the new art as Intransigent came from the political right, however. Indeed, it was no less a critic than Stéphane Mallarmé who described with the greatest clarity as well as the greatest subtlety the link between radical, or Intransigent, art and politics. Mallarmé perceived the new art as an expression of working-class vision and ideology. His essay, long forgotten but now justly celebrated, was published in English in an issue of *The Art Monthly Review* of September 1876. Toward the end of the essay, Mallarmé wrote,

At a time when the romantic tradition of the first half of the century only lingers among a few surviving masters of that time, the transition from the old imaginative artist and dreamer to the energetic modern worker is found in Impressionism.

The participation of a hitherto ignored people in the political life of France is a social fact that will honor the whole of the close of the nineteenth century. A parallel is found in artistic matters, the way being prepared by an evolution which the public with rare prescience dubbed, from its first appearance, Intransigent, which in political language means radical and democratic.[30]

Mallarmé argued that, as Romantic fantasy and imagination characterized the art of the first half of the century, the new Impressionist art marked a significant new stage in social evolution. The Impressionist artist became the eyes of the "energetic modern worker" and assisted him in his drive for a radical republic. Thus the individualism that some critics perceived in Impressionism may have been valuable to Mallarmé, but a collectivist impulse too was celebrated. He wrote

Rarely have three workers [Manet, Sisley, and Pissarro] wrought so much alike and the reason of the similitude is simple enough, for they each endeavor to suppress individuality for the benefit of nature. Nevertheless the visitor would proceed from this first impression . . . to perceiving that each artist has some favorite piece of execution analogous to the subject accepted rather than chosen by him. . . .[31]

Impressionism was a movement with a radical cooperative program, Mallarmé believed, and the currency of the name Intransigent signaled to him the widespread perception of that fact.

Mallarmé offered a set of homologies between Impressionist art and working-class, or radical, vision. As did

Enault and Chaumelin, Mallarmé began by noting that Intransigent art or politics stripped away outmoded principles, seeking a blank slate upon which to write a new cultural or political agenda. Yet, unlike these critics, Mallarmé suggested that this radical erasure was itself a positive style, akin to the popular art commonly supposed indigenous to the working classes. The key term in Mallarmé's dialectic was "the theory of the open air," by which academic formulas were jettisoned in favor of a greater truth. He noted that "contours, consumed by the sun and wasted by space, tremble, melt and evaporate into the surrounding atmosphere, which plunders reality from the figures, yet seems to do so in order to preserve their truthful aspect." Mallarmé continued,

Open air:—that is the beginning and end of the question we are now studying. Aesthetically it is answered by the simple fact that there in open air alone can the flesh tints of a model keep their true qualities, being nearly equally lighted on all sides. On the other hand if one paints in the real or artificial half-light in use in the schools, it is this feature or that feature on which the light strikes and forces into undue relief, affording an easy means for a painter to dispose a face to suit his own fancy and return to by-gone styles.[32]

Open-air painting thus provides an objective justification for the discarding of academic traditions or individualist caprice. Yet Mallarmé further claims that the Impressionists' stripping away results in a pictorial clarity and flatness that mimics the look of the simple, popular art forms favored by the rising class of workers and petit bourgeois: "But today the multitude demands to see with its own eyes; and if our latter-day art is less glorious, intense and rich, it is not without the compensation of truth, simplicity and child-like charm."[33] The poet's analysis of Manet's sea-pictures illuminates this vaunted simplicity, revealing how the artist's technique of cropping reiterates pictorial flatness. Mallarmé most likely referred to Manet's *Alabama and Kearsarge* (John F. Johnson Collection, Philadelphia), but *The Escape of Rochefort* (fig. 1) serves as well. By placing the boat containing Rochefort and his comrades in the center of a vertical sea, Manet denies the traditional and essential metonymy that prevails between horizontal sea pictures and horizontal seas. Nor has Manet compensated for this elimination of lateral extension by providing a deep space. The even tonal value between fore-, middle-, and background and the numbing repetition of comma-shaped brushstrokes preclude extending the vision along the line of sight. Indeed, the juxtaposition of Rochefort's boat to the tiny ship at the top (no doubt inspired by the relationship between the two vessels in Géricault's *Raft of the Medusa*), merely caricatures the convention that diminution in size indicates flight into pictorial space. Similarly, Mallarmé wrote that "the function of the frame is to isolate [the picture]," thereby excluding from

its concerns all that is non-pictorial.[34] One is reminded here of Renoir's remarks to Ambroise Vollard concerning Manet's simplicity:

He was the first to establish a simple formula, such as we were all trying to find until we could discover a better. . . . Nothing is so distracting as simplicity. . . . You can imagine how those [Barbizon "dreamers" and "thinkers"] scorned us, because we were getting paint on our canvases, and because, like the old masters, we were trying to paint in joyous tones and carefully eliminate all "literature" from our pictures.[35]

Both Mallarmé and Renoir assert that the Impressionist followers of Manet remained loyal to the simple or popular character of his art. Indeed, Renoir's own *Etude* (cat. no. 35), reviled by Albert Wolff in 1876 as a "mass of decomposing flesh," perfectly exemplifies the "theory of the open air." The anatomy of the figure is dissolved by the dappled light produced by irregular brushwork, oddly shaped and ordered patches of pink, and shadows composed of the collision between warm and cool tones of yellow, orange, or purple, and green, gray, or blue. The face of Renoir's nude does not permit the imputation of character, or "literature." Eyes are unfocused, lips are unresolved, and the nose is articulated solely by rough daubs of green at the nostrils and bridge. Nevertheless, simple contours are created through the conformity of hair to shoulders and the vertical scumblings bordering the figure. To borrow the language of 1960s Modernism, the torso "stamps itself out" as a simple shape set amid a shallow pictorial space.[36] Indeed, this clarity, simplicity, and formal self-regard are the positive features that Mallarmé perceived in the Impressionist art of erasure. Mallarmé's ideal Impressionist painter proclaims in conclusion, "I have taken from [nature] only that which properly belongs to my art, an original and exact perception which distinguishes for itself the things it perceives with the steadfast gaze of a vision restored to its simplest perfection."[37] Here Mallarmé anticipates the late Modernist credo of medium purity. Clement Greenberg has written that

Manet's paintings became the first Modernist ones by virtue of the frankness with which they declared the surfaces on which they were painted. The Impressionists, in Manet's wake, abjured underpainting and glazing, to leave the eye under no doubt as to the fact that the colors used were made of real paint that came from pots or tubes. Cézanne sacrificed verisimilitude, or correctness, in order to fit drawing and design more explicitly to the rectangular shape of the canvas.[38]

To both Mallarmé and Greenberg, Impressionism was a method of dispensing with all the artistic conventions fatally compromised by academicism. Mallarmé, however, believed that the Modernist art that resulted would be favored by a working class whose own visual culture it resembled. He could not have foreseen what Greenberg

brilliantly described, that is, the growth of mass culture or kitsch. In the decades after 1870, the European and American working classes were provided with an administered culture which did indeed borrow the superficial forms that became characteristic of Modernism but now turned them into shallow receptacles for fashion, entertainment, and economic consumption. Far from becoming an instrument of working-class ideology, Modernism would narrow its audience and its range of expression nearly into extinction.

Faced with the conflicting interpretations of such formidable writers as Castagnary and Mallarmé, the reader must by now be wondering whether the new art, between 1874 and 1877, was in fact Impressionist or Intransigent, that is, affirmative and individualist, or radical and democratic. The answer must be that it was neither and both. The essence of the new art was its insistent indeterminacy, or, put another way, its determined position between those polarities Impressionist/Intransigent. As such, the new art must be understood as a signal instance of Modernist dialectics. On the one hand, works that primarily explore their own physical origins or constituents (Renoir's "simple formula," Mallarmé's "simplest perfection," or Greenberg's "frankness") are Intransigent rebukes to a society that seeks to tailor all culture to its own interests. On the other hand, the apolitical self-regard of Modernist art creates an environment favorable to the eventual industrial appropriation of the works. The "free space" desired by Modernism also is valuable to a culture industry that relies for its vitality upon the public generation of new desires. Yet there have been times when this latter process of appropriation has been sufficiently slowed that a semblance of autonomy (what Adorno has called "the duty and liberty of [the mind's] own pure objectification") has been achieved.[39] Such was the case between 1874 and 1877 when the new art was definable only by the uncertainties in critical language.

The opposition between Impressionist and Intransigent art is unresolved in the criticism of Claretie, Chesneau, Burty, Wolff, Silvestre, Blémont, Enault, Chaumelin, and Mallarmé. Indeed, even those critics who worked hardest to claim Impressionism for the moderate Republic were strangely compelled to call attention to its Intransigent alter-ego. Thus Emile Blavet writes in the conservative *Le Gaulois* of 31 March 1876,
Let us consider the artists who for the second time are calling on the public directly; are they rebels as some are pleased to call them when they are not stupidly called Communards? Certainly not. A few dissidents have simply come together to show to the public the several styles and varieties of their work in finer exhibition conditions than the Salon can offer.[40]
Blavet went still further in his effort to rescue Impressionism from the left, claiming that the new art represented

"the fruitful renovation of the French School, the affirmation, in a word, of a principle of art whose results may be considerable." But once again the critic resurrects the radical bogey by suggesting that the new art offered the young Republic a chance to demonstrate its magnanimity, just as Courbet offered a chance to an earlier republic: "When the *Burial at Ornans* appeared it was in fact [the academician] Flandrin who was the first to exclaim: 'What beauty! What grandeur! What truth!' . . . In a Republic there are no pariahs." If the new art, as we have seen, embodied a "theory of the open air," so too did its criticism, often seeming to "tremble, melt and evaporate" into ideological unease, the critics on the left proving no more confident than those on the right. This uncertain art criticism was thus wholly appropriate to the ambiguities of the new art. May we suppose that the artists took *deliberate* steps to cultivate a zone of esthetic autonomy that could remain free from the political polarizations disfiguring the art of the previous decades? The selection of the group's name in 1874 as the neutral Société anonyme suggests a high degree of premeditation. Renoir later explained,
The title failed to indicate the tendencies of the exhibitors; but I was the one who objected to using a title with more precise meaning. I was afraid that if it were called the "Somebodies," or "The So-and-Sos," or even "The Thirty-Nine," the critics would immediately start talking of a "new school," when all that we were really after, within the limits of our abilities, was to try to induce painters in general to get in line and follow the Masters, if they did not wish to see painting definitely go by the board. . . . For in the last analysis, everything that was being painted was merely rule of thumb or cheap tinsel— it was considered frightfully daring to take figures from David and dress them up in modern clothes. Therefore it was inevitable that the younger generation should go back to simple things. How could it have been otherwise? It cannot be said too often that to practice an art, you must begin with the ABCs of that art.[41]
Indeed, Renoir's rejection of a name encouraged critical uncertainty over the new art, thereby prolonging the period during which it remained between ideological antinomies. Such a stance was considered by Renoir as part of the tradition of "the Masters," essential if painting was not to "definitely go by the board," that is, be absorbed into the "cheap tinsel" or academicism that predominated in the Salon.

The success of the new art in evading either academicism or political tendentiousness is thus attributable both to the refusal of a proper name and the articulation of a new style; it was apparently Renoir who was responsible for the former and Manet who, despite his refusal to join the Société, set the standard for the latter. If Romanticism had vested artists with the power symbolically to breach the Enlightenment fissure between subject and

object or word and thing, Manet instead chose to expose these scissions through an art that called attention to its status as fiction; the refusal of tonal modeling and perspective, the purposeful cultivation of visual ambiguity, and the disrespectful highlighting of revered art historical sources are all the well-known devices by which Manet refused academic closure. Yet it is equally well known that in rejecting Romantic symbolism, Manet did not adopt what may be called the Jacobin tradition—art as the purposely tendentious iteration of a predetermined political position. On the contrary, as T. J. Clark has shown in his study of Manet's *Argenteuil, les canotiers* what we most often find in Manet's work is an avoidance of the explicit signs of politics or class achieved through blankness of human expression and an odd unreadability of gesture, posture, and physical place. Yet Manet has not thereby given in to abstraction, to the willful effacement of the norms of anatomy and composition, but instead offers a different kind of rationality based upon the consonance between the flatness of the canvas, the flatness of those vertical and horizontal stripes of paint that comprise a woman's dress or a man's *chemise*, and a flatness actually perceived in the world—in the peculiar mass-produced costumes and places of urban entertainment or suburban leisure. Clark claims that *Argenteuil, les canotiers*

. . . is massively finished; it is orderly and flawless, and the word "restrained" applies to it as much as the word "natural": it is not offered the viewer as something already made and self-evident, there to be looked at and not questioned (this is true of landscape and figures alike). What Manet was painting was the new look of a new form of life—a placid form, a modest form, but one with a claim to pleasure. . . . This woman looks out circumspectly from a place that belongs to people like her. How good it is, in these places, to find a little solitude on Sundays! How good, how modern, how right and proper.[42]

Manet's art, it may generally be said, elided the oppositions that comprised contemporary ideology: work/leisure, city/country, artifice/authenticity, public/private—in short a whole rhetoric of binaries that seemed to assure political and class stability. Manet questioned this stability and did so with a Modernist style that compelled conviction. His painting revealed an undeniable finish, solidity, composure, and simple rationality *that signaled a real knowledge*, a knowledge that could not be overlooked by a people who took so seriously their own reasonableness. Now it seems to me that the Impressionist followers of Manet similarly succeeded in eliding ideological oppositions while still offering something that could approach knowledge. The evidence of that knowledge is in the pictures, for example, in the decomposition of figures and their resurrection as shapes; the evidence of the new painters' success in eliding comforting social oppositions provide the aporias that dominated criticism of the new art, that is, the free space between Impressionist and Intransigent.

What I have described as the evasive posture of the new art began to erode after 1876. The polarization in that year, between radicals such as Clemenceau and so-called Opportunists (who sought a more opportune time for the granting of amnesty) such as Léon Gambetta, made it difficult for artists to find any ideological free space to cultivate for themselves. Merely to seek such a posture was to be Intransigent. Was the Société anonyme attempting to discourage Intransigent interpretations of its art when in early 1877 they decided to designate their upcoming group show an Exhibition of Impressionists? Charles Bigot, writing on 28 April 1877 in *La Revue Politique et Littéraire* believed so:

The public baptised them the "Intransigents," and the name did not appear to be repugnant to them: they have undoubtedly discovered, however, that recent political events have rendered this name compromising; they have definitively adopted the name "Impressionists."[43]

Indeed, it was only in 1877 that the Impressionists pushed forward with their plan, originally announced in 1874, of publishing a journal through which their art would be publicized and their views articulated. Renoir's friend Georges Rivière was entrusted with the task of writing and editing *L'Impressionniste*. It was the third number of this journal, dated 21 April, that contained the Impressionists' own account of their choice of a name, the account from which all others derive:

Some journalists . . . have been asking for fifteen days why the artists showing on the rue le Peletier have taken the name Impressionists. It is very simple. They have finally put the word Impressionist over the entrance door to their exhibition in order to avoid being confused with any other group and because the word clearly and forcefully represents them before the public. . . . This name reassures the public because the "Impressionists" are sufficiently well known so that no one will be fooled about the manner of works on display. . . . All these artists, I assure you, are sincere; if what they create is bad, it is not their fault because they could not make it either better or different. "Impressionists" they are, and their works are the result of sensations they have experienced. I can hardly understand it when artists can doubt, even for an instant, the sincerity of the works shown on the rue le Peletier.[44]

Rivière's explanation of the naming of the Impressionists was an effort to protect the group from academic imitators by claiming that their style was the ineluctable result of individual sensations, and at the same time to shield them from charges of political subversion. In the same issue of *L'Impressionniste*, Rivière directed remarks "Aux Femmes":

But you have a husband. . . . Your husband, who is per-

haps a Republican, enters into a rage against those revolutionaries who sow discord in the camp of the artist. . . . He rails against political routine and against administrative routine . . . but he looks at painting through the prejudicial routine of old canvases.[45]

Rivière and Renoir apparently had it in their minds to direct their words and pictures at a very particular Republican audience. In early 1877, Renoir made a pilgrimage to the offices of *La République Française*, the Opportunist journal edited by Léon Gambetta, in order to plead for the insertion of a notice favorable to the group. Rivière later recounted how Renoir, unable to find Gambetta in his office, made his request to Challemel-Lacour, co-founder of the journal, who answered by exclaiming, "What! You ask me to speak about some Impressionists in our journal! That's impossible, it would be scandalous! Do you forget, you are revolutionaries?" Renoir was apparently discomfited by this response and left without saying another word. Immediately, however, he ran into Gambetta, who asked him the reason for his visit. Rivière wrote, "When Renoir repeated to him the remarks of Challemel-Lacour, Gambetta laughed and said, 'You, one of the revolutionaries. Ah, well, and us, what then are we?' "[46] Renoir's appeal and Gambetta's mocking response suggest that Renoir had largely succeeded in putting distance between himself and Intransigent politics, and that Gambetta was ready to accept the artist into the camp of Opportunism. Gambetta was no longer a radical and neither then wasRenoir. The ground was being prepared for the assimilation of Impressionism into the mainstream of French culture.

The subsequent critical fortunes of Impressionism fall beyond the limits of the paper, but a kind of epilogue is in order. In January 1882 President Gambetta's Minister of Art, Antonin Proust, awarded Edouard Manet the Legion of Honor. Shortly thereafter, a columnist for the popular *L'Illustration* wondered at the effect the election would have upon the "irreconcilables of the brush" and the "Bellevillois of the canvas." The author continued,
It is the triumph of the Nouvelles-Athènes *over the School of Rome. The* Intransigents *of painting have triumphed. Ah, but not quite! They have knitted their brows, passed their fingers through their beards. Manet*

decorated is no longer Manet. . . . The painter Degas one day remarked, "He is better known than Garibaldi." "Manet," exclaimed a nouvel athénien *who was not the young Forain, "Oh well, may he rest in peace! He is only an Opportunist with color!"*[47]

Here indeed was Gambetta's and Proust's triumph. Manet the Intransigent, Manet the Communard, was now Manet the Opportunist. The award to Manet was followed up by other liberal initiatives, including the acquisition of five paintings from the estate of Courbet, and a plan by Proust to "democratize" the Ecole des Beaux-Arts by eliminating the Rome prize and replacing the "autocratic" heads of the three painting ateliers, Gérôme, Cabanel, and Lehmann, with a rotating group of ten or twelve instructors, among them Manet.[48] The Impressionists had by now adopted the name Independents, perhaps, as Joel Isaacson suggests, to paper over serious personal and political divisions within the group, but also to promote a stance of artistic purity.[49] This combination of political retreat and estheticist celebration is revealed most clearly in a letter of early 1882 from Renoir to Durand-Ruel concerning plans for a new group exhibition:
To exhibit with Pissarro, Gauguin and Guillaumin would be the same as exhibiting with a Socialist. What is more, Pissarro would probably invite the Russian Lavroff, or some other revolutionary. The public does not like what it feels is political, and I do not want, at my age, to be a revolutionary. . . . Free yourself from such people and show me artists such as Manet, Sisley, Morisot, etc., and then I will be yours because then there will no longer be politics, only pure art.[50]

What had once been an art whose simultaneous reductiveness and rationality signified the elision of esthetic traditions, now embraced *l'art pour l'art*. What had once been an art that explored a dynamic free space between conflicting ideologies now sought an apoliticism that was in fact deeply political. The autonomy of 1874 became by 1882 the estheticism that affirmed an Opportunist status quo. The pattern of this transformation—from autonomy to affirmation—is by now a familiar part of twentieth-century art history, but its origins may be traced to the burial of the Intransigent and the birth of the Impressionist.

Notes

For their insightful criticisms and generous suggestions, my sincerest thanks extend to David James, Occidental College; Richard R. Brettell, The Art Institute of Chicago; Fronia E. Wissman, The Fine Arts Museums of San Francisco; John H. Smith, University of California, Irvine; Thomas Crow, Princeton University; and M. Lee Hendrix, The J. Paul Getty Museum.
All translations are the author's except where otherwise indicated.

1. Three examples: Théodore Duret, *Histoire des peintres impressionnistes* (Paris, 1939), 20; Lionello Venturi, *Les archives de l'impressionnisme*, 2 vols. (Paris-New York, 1939), 1: 22; John Rewald, *The History of Impressionism*, 4th rev. ed. (New York, 1973), 336–338.

2. Paul Tucker has recently recounted the facts of the First Impressionist Exhibition, and the implicit nationalism of Monet's *Impression, soleil levant* in "The First Impressionist Exhibition and Monet's *Impression, Sunrise*: A Tale of Timing, Commerce and Patriotism," *Art History* 7, no. 4 (December 1984): 465–476. Also see Anne Dayez et al., *Centenaire de l'impressionnisme*, exh. cat. (Paris: Grand Palais, 1974).

3. The identity of this painting remains in doubt. See Tucker, 470–471, and Rewald, 339, note 23.

4. Cited by Jacques Lethève, *Impressionnistes et symbolistes devant la presse* (Paris, 1959), 64–69.

5. These reviews are reprinted in *Centenaire*, 259–261; 264–265. Tucker cites nineteen reviews of the exhibition: "Six were very positive; three were mixed, but generally positive; one was mixed but generally negative; four were negative; five were notices or announcements." Tucker, 469, 475–476, note 20.

6. Rewald, 390. The author does not document his suggestion that the name was definitively adopted in February. Also see Barbara Erlich White, *Renoir, His Life, Art and Letters* (New York, 1984), 74. The phrase "Exposition des impressionnistes" does not appear on the title page of the accompanying catalogue, but was placed above the door of the entrance to the galleries on the rue le Peletier. See G. Rivière, "Explications," *L'impressionniste* (21 April 1877): 3; cited in Venturi, 2: 322.

7. David Hume, *Essay Concerning Human Understanding, Original Ideas* (1817), 2:16; cited in *The Oxford English Dictionary*, ed. James A. H. Murray (Oxford, 1978), 5: 110.

8. Richard Shiff, *Cézanne and the End of Impressionism* (Chicago, 1984), 19, 239, note 24.

9. Emile Littré, *Dictionnaire de la langue française* (Paris, 1866), 2: 36; cited in Charles F. Stuckey, "Monet's Art and the Act of Vision," *Aspects of Monet*, eds. John Rewald and Frances Weitzenhoffer (New York, 1984), 120; also cited in Shiff, 18.

10. Charles Baudelaire, *Oeuvres complètes*, ed. Claude Pichois (Paris, 1976), 2: 698.

11. John Ruskin, *The Complete Works*, eds. E. T. Cook and Alexander Wedderburn (London, 1904), 15: 27; cited in Stuckey, 108.

12. Théodore Duret, "Salon de 1870," *Critique d'avant-garde* (Paris, 1885), 8; cited in Shiff, 22.

13. Dayez et al., 265.

14. Shiff, 4.

15. Dayez et al., 265.

16. Tucker, 474.

17. Lethève, 72.

18. Jules Claretie, "Salon de 1874 à Paris," *L'art et les artistes français contemporains* (Paris, 1876), 260; Ernest Chesneau, "Le plein air, Exposition du boulevard des Capucines," *Paris-Journal*, 7 May 1874; cited in Dayez et al., 268.

19. E. Littré, *Dictionnaire de la langue française: Supplement* (Paris, 1897), 204; Centre National de la Recherche Scientifique, *Trésor de la langue française: Dictionnaire de la langue de XIXᵉ et XXᵉ siècle, 1789–1960* (Paris, 1983), 10: 490; *The Oxford English Dictionary*, 5: 435. The following account of Intransigentism is largely based upon C. A. M. Hennessy, *The Federal Republic in Spain: Pi y Margal and the Federal Republican Movement, 1868–74* (Oxford, 1962). Also see Frederick Engels, "The Bakunists at Work: Notes on the Spanish Uprising in the Summer of 1873," in Marx, Engels, Lenin, *Anarchism and Anarcho-Syndicalism* (New York, 1978), 128–146.

20. The Intransigents' platform was never very clear, although it may generally be said to have been based upon a separation of church and state, land reform, direct democracy, price controls, nationalization of banks, and Cantonal independence. The Benevolents, however, were equally unable to draft a precise social program (much to the chagrin of their supporters in the International, Marx, Engels, and Lafargue), with the result that neither faction was able to claim leadership of the growing revolutionary movement. Hennessy asserts that the bulk of Intransigent support came from the proletariat of Madrid and Cartagena but that its leadership was mixed in its class and political backgrounds, including the moderate general Contreras, the socialists Córdoba y López and Luis Blanc, and the anti-socialist Roque Barcia (152).

21. "The Commune's aim is not an unrealizable utopia, but simply the autonomy of the Commune," *La Redención Social* (9 April 1871) in Hennessy, 149.

22. *Le Temps*, 23 February 1873. See the subsequent report (24 February) that ex-Communards were reported to be arriving in Spain in the guise of journalists. Also see Hennessy, 181.

23. Cited in Venturi, 2: 290.

24. Albert Wolff, "Le calendrier parisien," *Le Figaro*, 3 April 1876.

25. Armand Silvestre, "Les deux tableaux de Monsieur Manet," *L'Opinion Nationale*, 23 April 1876; cited in Françoise Cachin et al., *Manet*, exh. cat. (New York: The Metropolitan Museum of Art, 1983), 32; Marie Berhaut, *Caillebotte, sa vie et son oeuvre* (Paris, 1978), 251.

26. *Le Moniteur Universel*, 8 April 1876; cited in Lethève, 79.

27. Louis Enault, "Mouvement artistique: L'exposition des intransigeants dans la galerie de Durand-Ruelle[*sic*]," *Le Constitutionnel*, 10 April 1876. "Si nos souvenirs sont fidèles, c'est à l'Espagne que nous devons ce vocable nouveau, dont l'importation est plus récente que celles des mantilles, et moins agréable que celle des castagnettes. Ce sont, je crois, les républicains du midi de la péninsule qui employèrent pour la première fois, cette expression, dont on ne comprit pas parfaitement la valeur tout d'abord. . . . Les intransigeants politiques n'admettent aucun compromis, ne font aucune concession, n'acceptent aucun tempérament. . . . Le terrain sur lequel ils entendent élever leur monument doit leur offrir l'image d'une table rase."

28. Marius Chaumelin, "Actualités: L'exposition des intransigeants," *La Gazette [des Etrangers]*, 8 April 1876. "On les a d'abord appelés 'les peintres du plein air', ce qui indique assez bien qu'ils ont horreur de l'obscurité. On les a décorés du doux nom 'd'impressionnistes', pour faire plaisir, sans doute, à Mlle Berthe Morisot et aux autres jeunes peintresses qui ont embrassé leurs doctrines. Mais il y a un titre qui leur convient beaucoup mieux: celui d'*intransigeants*. . . . Ils ont en haine les traditions classiques et ambitionnent de réformer les lois du dessin et de la couleur. Ils prêchent la séparation de l'Académie et de l'Etat. Ils réclament l'amnistie pour 'l'école des taches' dont M. Manet fut le fondateur et d'où ils sont tous sortis."

29. Jack D. Ellis, *The Early Life of Georges Clemenceau* (Lawrence, Kansas, 1980), 64. Clemenceau's Radical program, fully articulated during his election campaign of 1881, was an expansion of the celebrated "Belleville Program" of Léon Gambetta from 1869. Clemenceau's text is translated and reproduced in Leslie Derfler, *The Third French Republic: 1870–1940* (Princeton, 1966), 121–123. Also see R. D. Anderson, *France: 1870–1914, Politics and Society* (London, 1977), 88–99, as well as his extensive bibliography, 187–208. The internecine Republican struggles of 1876 are described in J. P. T. Bury, *Gambetta and the Making of the Third Republic* (London, 1973), 263–327.

30. Stéphane Mallarmé, "The Impressionists and Edouard Manet," *Documents Stéphane Mallarmé*, ed. C. P. Barbier (Paris, 1968), 84, and in this catalogue.

31. Mallarmé, 79–80, and in this catalogue.

32. Mallarmé, 74–75, and in this catalogue.

33. Mallarmé, 84. Also see the remarks of Renoir to Ambroise Vollard, *Renoir, An Intimate Record* (New York, 1934), 47. "You realize then that for us the great task has been to paint as simple as possible; but you also realize how much the inheritors of tradition—from such men as Abel de Pujol, Gérôme, Cabanel, etc., with whom these traditions, which they did not comprehend, were lost in the commonplace

and the vulgar, up to painters like Courbet, Delacroix, Ingres – were bewildered by what seemed to them merely the naive efforts of an *imagier d'Epinal*. Daumier is said to have remarked at the Manet exhibition, "I'm not a very great admirer of Manet's work, but I find it has this important quality: it is helping to bring art back to the simplicity of playing cards." On the continuing affinity between Modernist art and popular culture see Thomas Crow, "Modernism and Mass Culture in the Visual Arts," in *Modernism and Modernity*, eds. S. Guilbaut and D. Solkin (Halifax, 1983). Also see T. J. Clark, *The Painting of Modern Life: Paris in the Art of Manet and His Followers* (New York, 1984), 205–258.

34. Mallarmé, 77, and in this catalogue.

35. Vollard, 66.

36. Michael Fried, "Shape as Form: Frank Stella's New Paintings," in *New York Painting and Sculpture: 1940–1970*, ed. Henry Geldzahler (New York, 1969), 403.

37. Mallarmé, 86, and in this catalogue.

38. Clement Greenberg, "Modernist Painting," in *Modern Art and Modernism: A Critical Anthology*, eds. Francis Frascina and Charles Harrison (New York, 1982), 6.

39. Theodor Adorno, "Commitment," in *Aesthetics and Politics*, ed. Ronald Taylor (London, 1980), 177.

40. Emile Blavet, "Avant le Salon: L'exposition des realistes," *Le Gaulois*, 31 March 1876. "Les artistes qui, pour la seconde fois, en appellent directement au public, sont-ils des révoltés, comme on se plaît à le dire, quand on ne les traite pas idiotement de communards? Non, certes. Des dissidents, tout au plus, groupés, associés afin de montrer au public l'ensemble de leurs tendances et la variété de leur oeuvre dans d'excellentes conditions de place et de lumière que le Salon ne saurait leur offrir."

41. Vollard, 62–63.

42. Clark, 172–173.

43. Charles Bigot, "Causerie artistique: L'exposition des 'impressionnistes'," *La Revue Politique et Littéraire* (28 April 1877): 1045. "Le public les avait baptisés les 'intransigeants,' et le nom ne paraissait pas leur répugner: ils auront trouvé, sans doute, que les derniers incidents de la politique en avaient rendu la qualification compromettante; ils ont définitivement adopté le nom 'd'impressionnistes'."

44. Venturi, 2: 322–324. "Des journalistes . . . demandant depuis quinze jours pourquoi les artistes qui exposent rue Le Peletier ont pris le titre d'impressionnistes. C'est bien simple. Ils ont mis à la porte de leur exposition le mot impressionniste afin de ne pas être confondus avec d'autres et parce que ce mot les désignait d'une façon fort claire pour le public. . . . Ce titre rassure le public, les 'impressionnistes' sont suffisamment connus pour que personne ne soit trompé sur la qualité des oeuvres exposées. . . . Tous les artistes, je le soutiens, sont sincères; ils donnent toujours dans leurs oeuvres leur valeur exacte; si ce qu'ils produisent est mauvais, il n'y a pas de leur faute, ils ne sauraient ni faire mieux, ni faire autrement. Les 'impressionnistes' sont ainsi, leurs oeuvres sont le résultat des sensations qu'ils ont éprouvées, et je conçois peu que des artistes puissent mettre en doute un seul instant la sincerité des oeuvres exposées rue le Peletier."

45. Venturi, 2: 322. "Mais vous avez un mari. . . . Votre mari, qui est peut-être républicain, entre en fureur contre un révolutionnaire qui sème la discorde dans le camp artistique. . . . Il crie contre la routine politique, contre la routine administrative . . . mais il regarde la peinture à travers les vieux tableaux."

46. G. Rivière. *Renoir et ses amis* (Paris, 1921), 89–90. On Challemel-Lacour, see M. Prevost and Roman D'Amat, *Dictionnaire de biographie française* (Paris, 1959), 8: 210–211.

47. Perdican, "Courrier de Paris," *L'Illustration*, 7 January 1882. "C'est le triomphe de la *Nouvelle Athènes* sur l'Ecole de Rome. Les *intransigeants* de la peinture devraient triompher. Eh! bien, non, pas du tout. Ils ont froncé le sourcil, passé leurs doigts dans leur barbe. Manet décoré n'est plus Manet. . . . disait, un jour, le peintre Degas: 'Il est plus connu que Garibaldi!' – 'Manet,' s'est ecrié un *nouvel athénien* qui n'est pas le jeune Forain, 'Alloas! *Requiscat*! Ce n'est qu'un opportuniste de la couleur!'" Degas's sarcastic comparison between Manet and Garibaldi also is reported by Jacques-Emile Blanche, *Manet* (Paris, 1924), 37; cited in Clark, 82.

48. Henry Houssaye, "Le Ministère des Arts," *Revue des Deux Mondes* 49 (1 February 1882): 619–620.

49. Joel Isaacson, *The Crisis of Impressionism: 1878–1882*, exh. cat. (Ann Arbor: The University of Michigan, Museum of Art, 1980), 18.

50. Venturi, 1: 122. "Exposer avec Pissarro, Gauguin et Guillaumin, c'est comme si j'exposais avec une sociale quelconque. Un peu plus, Pissarro inviterait le Russe Lavroff ou autre révolutionnaire. Le public n'aime pas ce qui sent la politique et je ne veux pas, moi, à mon âge, être révolutionnaire. . . . Débarassez-vous de ces gens-là et présentez-moi des artistes tels que Monet, Sisley, Morisot, etc., et je suis à vous, car ce n'est plus de la politique, c'est de l'art pur." The anarchist Lavroff had been deported to London on 10 February 1882 on the order of Prime Minister Charles Freycinet.

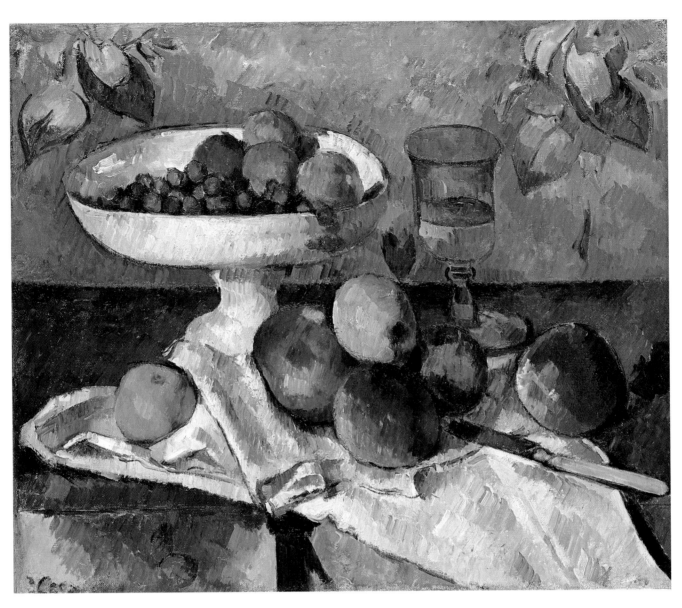

fig. 6 Paul Cézanne, *Still Life*, ca. 1880. Oil on canvas, 15 ¾ x 21 ⅝ in.
(40 x 55 cm). Private collection. Photo: Malcolm Varon, N.Y.C.

The End of Impressionism

Richard Shiff

This essay argues for a reorientation in thinking about the development of French impressionism, particularly regarding its "end." In English, the word *end* signifies two closely related but decidedly different notions: a termination or final moment, and a goal or purpose. French avoids this ambiguity. It has two words for end, making the distinction obvious: *la fin* (termination), *le but* (goal). Often scholars have conceived of the end of impressionism as its passage from an art of mere visual observation to one of emotional expression; thus impressionism is said to end when it accepts, implicitly, the tenets of an emerging symbolism. In this familiar historical account, it is as if the two senses of end—chronological and teleological—were exchanged or confused.[1] We easily lose sight of the fact that artists, critics, and theorists of the nineteenth century associated expressive, subjective content with impressionist art from its very inception. If, indeed, a kind of symbolist expressiveness always characterized impressionism, the movement cannot be said to have terminated by passing into or becoming dominated by symbolism. Subjectivity did not mark the chronological end of impressionism, but was instead one of its initial, defining features; to a great extent, subjectivity motivated the impressionist project and marked a different kind of end, a purpose.[2]

The Subjectivity of Impressionism

In 1874 Jules Antoine Castagnary, a champion of naturalism, reviewed the independent show of paintings that came to be known as the First Impressionist Exhibition. He directed most of his attention to a number of younger artists among the diverse group—Pissarro, Monet, Sisley, Renoir, Degas, and Morisot. These painters, as well as a few others, he wrote, should be characterized by the "new term *impressionists.* They are *impressionists* in the sense that they render not the landscape, but the sensation produced by the landscape."[3] Castagnary's statement seems to have been the first serious attempt to define impressionism by a critic who was both favorably disposed to it and familiar with its technical, philosophical, and psychological dimensions.[4] He recognized that

his own preferred term, *naturalist,* did not quite apply to this new art. The definition he was pursuing was not easy for him to articulate, nor is it for us. Castagnary alluded to a distinction between a natural world, a landscape that exists independently of any human perception or experience, and the "sensation produced" by this landscape. Obvious questions must follow. Is this sensation of nature universal, available to all? Or is the landscape by necessity seen differently by different viewers? Would variation among painters' styles be attributable to alternative renderings of a constant sensation or to variation in the sensation itself?

Scholars who have sought to define the impressionist project with the aid of early critical commentaries (Castagnary's and others') have emphasized the goal of "accurate" or verifiable observation—if not of nature, at least of the painter's sensation of light. They have described this light as if it existed for all to see.[5] Such an assessment of impressionism as an art of "true" visual appearances misses the point of Castagnary's "new term." The bold and direct painting of Courbet could be taken as an appropriate standard of an informed and inspired "naturalism"; the new art of 1874 was yet another matter. Although Castagnary's review is largely favorable, his reservations perhaps do more than his praises to reveal the distinct character of "impressionism." The critic's cryptic definition, which seems to hinge on distinguishing nature from sensation, is significantly qualified by a remark he adds almost immediately: "[the impressionists] leave reality and enter into full idealism." The reference here to the "ideal" is potentially quite confusing. For Castagnary, to enter the world of idealism is not to discover universal principles underlying the appearances of material reality, but rather to entertain *individual* ideals, sensations, and imaginative visions.

Castagnary associated idealism of this sort with the aims of earlier romantic artists, from whom the impressionists seemed to differ only technically in their exaggeration of sketchlike effects. As one who advocated art that reflected society in a rather direct manner, Castagnary was no admirer of the extremes of romantic imagination.[6] Accordingly, he expressed his greatest reservation

fig. 1 Jean Béraud, *The Church of Saint-Philippe-du-Roule*, 1877. Oil on canvas, 23⅜ x 31⅞ in. (59.4 x 81 cm). The Metropolitan Museum of Art. Gift of Mr. and Mrs. William B. Jaffe, 1955

about those among the exhibitors of 1874 who "pursue[d] the impression to excess," those whose technical idiosyncrasies were most pronounced (he had Cézanne, in particular, in mind):

From idealization to idealization, they will arrive at that degree of romanticism without bounds, where nature is no more than a pretext for dreams, and the imagination becomes incapable of formulating anything other than personal subjective fantasies, without any echo in general knowledge, because they are without regulation and without any possible verification in reality.[7]

Castagnary's "impressionism" thus represented a kind of intensely subjectified naturalism, a tenuous objectivity that threatened to be eroded, as it were, by a flood of subjectivity.

How representative was Castagnary's view? Certainly, many artists and critics of the late nineteenth century spoke of impressionism as an accurate depiction of nature and modern life, but they also repeatedly spoke of it as an intensely personal art, not to be judged by the familiar standards applied to conventional academic paintings as well as to seemingly automatic photographs. For many artists and critics, impressionist painting seemed *both* objective and subjective. How this could be so is not well understood today, nor, consequently, is the relationship between impressionism and symbolism. For many, symbolism—the art of Gauguin, van Gogh, Denis, Bernard, and others—embodied an extreme of subjectivity; it was an art of extended idealization and fantasy, exactly what Castagnary could never approve. Received opinion tells us that symbolism arose in opposition to impressionism in order to reintroduce both subjectivity and rigor into painting. This is, in fact, opinion we have received not only from a number of historians, but from the symbolists themselves; yet it is only a part of their total view. Impressionism had its own kind of

subjectivity and idealization, as Castagnary and many others, including the symbolists, once understood. If we recognize the special sense of such subjectivity, we gain access to a central, but neglected, realm of meaning in impressionist painting.

If impressionism dominated the art world of the 1870s and 1880s, symbolism prevailed during the 1890s.[8] To a great extent the inherited historical evaluation of impressionism is a symbolist product of the 1890s, impressionism seeming to have run its course by that time. For historians, the art of the 1890s marks a watershed since it appears to lead directly to modern abstraction. It may be that we have not yet departed from the principles established in that decade of post-impressionism. Any present study of impressionism thus demands not only knowledge of the romantic and realist origins of the style, but also an understanding of how it was viewed and transformed in the eyes of the symbolists.

Despite the shift in orientation that so many artists and critics proclaimed, symbolism and impressionism, as understood around 1890, were hardly antithetical, especially if the term *impressionism* is to signify the art of Monet, Renoir, Pissarro, Cézanne, and others closely related to them. These painters were rarely the object of the symbolist attack, which was directed against artists whose concern for the material world ruled over their creativity. Albert Aurier, the first critic to champion Gauguin and van Gogh and to offer a definition of "symbolism in painting," actually praised those he called the "impressionists"—specifically, Manet, Degas, Cézanne, Monet, Sisley, Pissarro, and Renoir. They were to be admired for their "attempts at expressive synthesis." Aurier rudely dismissed a different group, among them the popularly successful Jean Béraud, a painter of *la vie moderne* (*fig.1*); Bouguereau, known for his lifelike figure groups (*fig.2*); Detaille, who rendered military scenes (*fig.3*); and Detaille's honored master, Meissonier, a fastidious recorder of detail (*fig.4*).[9] Such painters, who received institutional support and praise at that time, did not present the generalized, ennobling subjects that their present label of "academics" suggests. Instead, they particularized their images, noting the incidental aspects of a scene and often giving to an allegorical type the character of individual portraiture. They belonged, then, to the very broad category of naturalists and realists (even "impressionists") as conceived by symbolists. To symbolist critics their works lacked emotion and were limited by both conventional technique and the materialistic goal of imitating nature. Impressionists such as Monet and Renoir, in contrast, were regarded as having developed a much more liberated technical procedure, one that allowed for personal emotional expression. Accordingly, Monet and the symbolist Gauguin could share mutual literary friends and admirers; and Gauguin was,

in effect, the pupil of Pissarro and Cézanne. Furthermore, symbolists and impressionists alike saw themselves as appropriating aspects of the French romantic tradition; both groups appreciated the works of Delacroix, Stendhal, and Baudelaire. (To be sure, in sensing romanticism in the impressionism of 1874, Castagnary hit upon a critical issue of lasting importance.)

To many eyes, impressionism seemed to merge so readily into symbolism that symbolist elements could be detected in what might, from an earlier historical vantage point, appear a pure impressionism.[10] Indeed, a number of studies have demonstrated that during the 1890s Monet's nominally impressionist art was often viewed from a symbolist perspective.[11] Cézanne's painting, like Monet's, was regarded in both impressionist and symbolist terms—seen, on the one hand, as an art of naturalism and the individualized expression of the painter's temperament, and, on the other hand, as an art of intense emotionalism directed toward the expression of primary, universal truths. Although in Monet's case one could

fig.2 William-Adolphe Bouguereau, *Bathers*, 1884. Oil on canvas, 79 x 50¾ in. (200.7 x 129 cm). Courtesy of The Art Institute of Chicago. A. A. Munger Collection

fig. 3 Jean-Baptiste-Edouard Detaille, *En reconnaissance*, 1876. Oil on canvas, 46 x 78⅜ in. (117 x 199 cm). Yale University Art Gallery. Gift of C. Ruxton Love, Jr., B.A. 1925

claim that it was exclusively his recent work—the brilliantly colored series paintings with their radically simplified compositions, for example, *Les meules (fig. 5)*—that elicited the symbolist response, the same cannot be said in the case of Cézanne *(fig. 6)*. The judgment by some of Cézanne as an impressionist, while he became for others a symbolist, was based on familiarity with the whole range of his work from his formative years in the 1860s onward. Because he was an obscure figure whose painting had received almost no significant comment before the 1890s, critics were inclined to regard his oeuvre in its entirety rather than to highlight recent developments, and perhaps contrast them with earlier achievements. It can be argued that Cézanne considered the whole body of his art, his life's work, as the product of impressionist "sensation."[12] Yet during the 1890s, it clearly served as a model for the symbolists.

In 1896 André Mellerio published a brief study entitled *Le mouvement idéaliste en peinture*. He discussed the circle of the symbolists and drew on Aurier for his general theoretical remarks. Mellerio cited Cézanne as "highly honored" by the younger generation. Although emphasizing the artist's link with idealism (that is, symbolism), the critic described his painting in terms related to *both* impressionist and symbolist concerns:

With Cézanne there is something of the naive and the refined all together; he presents nature according to a vision particular to himself, where the juxtaposition of colors [and] a certain arrangement of lines make his very direct painting like a synthesis of colors and forms in their intrinsic beauty. One might say that he wished to restore intact to each object, in its primitive force unattenuated by the practices of art, its true and essential radiance.[13]

Mellerio's description of Cézanne is two-faced in a positive sense; it serves two points of view. The particularity of the artist's vision can be related to the impressionist concept of individual temperament; the "juxtaposition

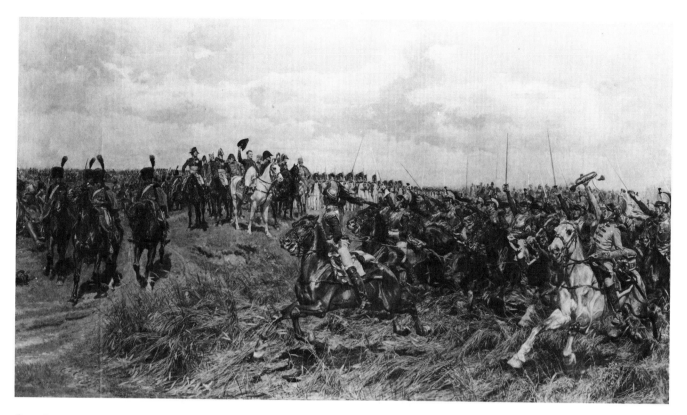

fig. 4 Jean-Louis-Ernest Meissonier, *Friedland 1807*, 1875. Oil on canvas, 53½ x 95½ in. (135.9 x 242.6 cm). The Metropolitan Museum of Art. Gift of Henry Hilton, 1887

of colors" was well known as the basic impressionist technical device. However, an "arrangement of lines" and "synthesis of colors and forms" would be more readily associated with symbolism, as would, of course, the aim of revealing the essence of an object. Significantly, Mellerio also referred to a simultaneous naivete and refinement, which both impressionists and symbolists would appreciate—Pissarro, for example, likened Cézanne to a "refined savage."[14] And both impressionists and symbolists consciously sought the same freedom from the conventional "practices of art" that Cézanne (according to Mellerio) attained. In fact, Mellerio credited the impressionists with having been pioneers in the "liberation of the artistic personality oppressed by restrictive rules and a limiting teaching." In turn, he lauded the symbolists for extending and building upon the impressionists' achievement.[15]

Passages of criticism in which the appropriate terminologies and even the practices of impressionism and symbolism are conjoined can be found in the writings of many others of the period; they reveal the extent to which the aims of the impressionist painter were seen as approaching those of the symbolist. Gustave Geffroy's introductory essay to the exhibition of Monet's *Les meules* of 1891 is a striking example. Geffroy, a personal friend of the artist, spoke of Monet's colors and forms as analogous to emotionally expressive gestures; he implied that the paintings revealed symbolic content. Yet he noted that, like an impressionist, Monet "gives the sensation of the ephemeral instant" and is the "anxious observer of minutes." He is a "subtle and strong painter," Geffroy concluded, "instinctive and delicately expressive—and he is a great pantheistic poet." In other words, this painter reveals the spirit or emotion of the totality of nature; he captures universal, permanent truths as well as particularized, transient ones. Furthermore, Geffroy's Monet, like Mellerio's Cézanne, is described as simultaneously naive and refined, lacking conventional training, yet a master of technical procedure.[16]

In 1892, the young critic Georges Lecomte, a close associate of Geffroy and a good friend of Pissarro, set such complex evaluations of Monet, Cézanne, and the other major impressionists into a general historical context when he spoke of an "impressionist evolution." Lecomte argued that the impressionists had sought initially to render specific sites and atmospheric conditions, but "gradually, they withdrew themselves from reality . . . they made compositions, distanced from nature, in order to realize a total harmony." The critic viewed this development as very natural, demanding no radical reorientation: "The evolution on which [the symbolists] pride

fig. 5 Claude Monet, *Haystack, Winter, Giverny*, 1891. Oil on canvas, 26 x 36⅝ in. (66 x 93 cm). Courtesy of The Art Institute of Chicago. Mr. and Mrs. Martin A. Ryerson Collection

themselves had begun long before with the first impressionists."[17] In contrast to Lecomte and many others of his generation, most recent historians have failed to see the passage from impressionism to symbolism (or "post-impressionism") as so natural an occurrence; instead they have viewed it as traumatic, maintaining that during the 1880s impressionism underwent a "crisis."[18] Lecomte, however, in speaking of a *natural* transition, specifically noted the same complex of stylistic changes that recent historians have found problematic in the impressionist art of the 1880s. He observed that Cézanne and Pissarro develop a decorative simplification of color and linear design; Renoir becomes involved with "linear beauty and the modeling of human anatomy"; and, to an ever greater degree, Monet "abstracts from manifold appearances the lasting character of things, as he accentuates meaning and decorative beauty with a more synthetic and reflective rendering." According to Lecomte, the younger symbolists took their cues from Monet's developing style and, much more so, from Cézanne's

"syntheses and simplifications of colors." It was impressionism that begat symbolism. Impressionism itself was no mere copy of material reality or its unfiltered appearance, but was an art that expressed "intimate emotions of an intellectual order."[19]

I do not wish to argue that the impressionists themselves either did or did not perceive the decade of the 1880s as a period of crisis or radical transition. There is much evidence this was for them a time of deep self-criticism.[20] I wish, rather, to discuss impressionism and symbolism in terms of fundamental principles, which may clarify the relationship between the two artistic styles. In this way it should become evident that impressionism, even in its initial form, was never free of the concerns later associated with symbolism. Although the two styles may be opposed in some senses, the extent of their commonly defined ground may be of equal or greater import. As critics such as Lecomte and Mellerio indicated, impressionism—ostensibly a study of an external

fig. 7 Jean-Baptiste-Camille Corot, *La route de Sin-Le-Noble*, 1873. Oil on canvas, 23⅝ x 31⅞ in. (60 x 81 cm). Musée du Louvre. Photo: Cliché des Musées Nationaux

nature—could lead into a more abstract and subjective symbolism. This would not have surprised Castagnary.

Both impressionist and symbolist art exemplified ways of investigating the world, of discovering the real or the true, of experiencing life. The mode of perception, of vision, was of greater consequence to the impressionist or symbolist artist than the view seen or the image presented. In this respect both impressionists and symbolists placed themselves in opposition to what they regarded as "academic" art that valued the object of its own creation more than the process that brought it into being. The conception of "impressionism" that motivated Monet, Cézanne, and others centers on a particular kind of experience—at once objective and subjective, simultaneously physical, sensory, and emotional. This experience had been widely discussed during the eighteenth and earlier nineteenth centuries and went by the name *impression*. The perceived impression, as an image or an object

of vision, was not the end of impressionist art, but the means to that end, the means to an experience through which the true could be apprehended in an act of seeing.

Defining *Impressionism*

Who, precisely, was creating the new "impressionist" manner of painting? In seeking to identify the genuine "impressionist," both earlier and later commentators considered one or more of the following: (1) the social group to which the artist belonged; (2) the artist's subject matter; (3) style or technique; and (4) the artistic goal or purpose. Each category presents its own difficulties.

First, the social group: An artist might be labeled a genuine impressionist in recognition of his having voluntarily united with others. In effect, he demonstrated that he considered himself an impressionist by participating in one or more of the eight independent exhibitions

called "impressionist" by the press and by the artists themselves. The title "impressionist" was conferred on anyone who associated with the group; reciprocally, such an individual's style (unless radically deviant) became exemplary of the group style. Given a strict application of this criterion of professional affiliation and personal sympathy, Degas remains an impressionist, even though some nineteenth-century critics claimed that his style necessarily excluded him; and Cézanne must be included, though for many twentieth-century viewers his style appears antithetical to impressionism. Acknowledging how problematic these two cases always have been, one might argue, at the very least, that the emergence of the loosely organized exhibiting group provided a focus for the original definition of the impressionist position. "Impressionism," however, also existed outside this social boundary, even within the elite society of the "Salon," the annual government-sanctioned presentation of works for public viewing. Ironically, it appeared there in the person of the elderly Corot, who gave moral support to the young independent painters but continued to exhibit among the officially honored and privileged. On the basis of elements of both subject matter and style, Corot (fig.7) was described in 1875 as a superior, poetic kind of "impressionist."[21] And he was not alone in introducing aspects of the "new" art to the Salon audience. In 1877 a critical review bearing the title "L'impressionnisme au Salon" discussed an extensive movement with almost no reference to members of the independent group.[22] A somewhat later review distinguished members of two parallel movements, the impressionists of the Salon and the "pure impressionists of the independent exhibitions."[23] During the 1870s and 1880s, much of what could be seen in Monet, Pissarro, or Degas apparently could also be seen elsewhere. Categorization based on membership in an exhibiting group could never have been definitive as from the very start this category was confused by independent considerations of subject matter and style. Once named, "impressionism" seemed more embracing than selective.

Second, subject matter: Definitions of impressionism determined by subject matter, just as those based on social affiliation, lead to awkward inclusions and exclusions. Critics and historians alike have stressed the impressionists' direct observation of a range of plein-air subjects, extending from grand vistas even into confined interiors—from the seacoast, the rural landscape and the city street, to the *vie moderne* of Parisian cafés. By this standard, however, one would be forced to include a number of artists who at the Salon of 1872 exhibited views of the environs of Paris notable for their simple and direct execution.[24] One of them, Stanislas Lépine (*fig.8*), showed later with the independent impressionists; the others did not. But even Lépine is today only rarely discussed as a genuine impressionist, for he lacks a major

stylistic feature—juxtapositions of unconventionally bright colors.[25]

Third, style or technique: If some painters of plein-air subjects revealed no clear technical commitment to impressionism, other painters of diverse orientations exhibited the bright color and sketchlike finish that seemed to identify an impressionist concern. In response to the classifier's dilemma, some nineteenth-century critics attempted to define impressionist color more precisely, linking it to the elimination of effects of chiaroscuro; but such considerations led to the exclusion of Degas (cat. no.26) from the impressionist camp.[26]

Fourth, artistic goal or purpose: It might seem consequently that an adequate definition of impressionism would have to be more comprehensive and synthetic, the result perhaps of a determination of the artistic aim behind the formation of a group of artists who (along with others) shared an interest in a certain kind of subject matter and certain stylistic innovations. The definition of the goals of impressionist art may indeed inform more purposeful distinctions in the other areas of investigation, but one must take into account the fact that early observers who knew the impressionist painters—among them Castagnary, Théodore Duret, and Georges Rivière—either insisted that the aims of these artists were not unique at all or spoke hardly a word about aims. Instead, technique often became the focus of their commentary. Castagnary, for example, discussed the impressionist paintings exhibited in 1874 from the perspective of technical innovation: "the object of art does not change, the means of translation alone is modified"; furthermore, impressionism should be noted for its "material means," not its "doctrines."[27] Similarly, in writings of the late 1870s, Duret and Rivière, who were on close terms with the independent group of artists, stressed the technical innovations of the radically sketchlike surface, and noted especially the juxtapositions of touches of unusually bright color. While Castagnary warned of the danger of such technique becoming idiosyncratic and "idealized," Duret and Rivière implied that it had simply been necessitated by the concern for a more accurate observation of nature. In their different manners, both Duret and Rivière allowed for variation in an individual's sensation of nature, but emphasized that impressionist color was in fact derived from a nature directly observed, a nature that everyone could experience. In this sense impressionist color was more "natural" or "true to nature." Neither critic explained openly how the notion of individualized sensation could be reconciled with that of an objective naturalism.[28] Even now this question remains largely unresolved, usually even unasked. An answer is of central importance to an understanding of both impressionism and symbolism.

How does one resolve the apparent contradiction implicit in the notion of an art of specific and perhaps

fig. 8 Stanislas Lépine, *The Seine near Paris ("La Seine à Bercy")*, ca.
1866–1872. Oil on canvas, 12 x 21 in. (30.5 x 53.4 cm). National
Gallery of Scotland, Edinburgh

innovative techniques, which seems nevertheless to lack
goals particular to itself? In investigating the aim or pur-
pose (the end) of impressionism, we encounter in the
early critical comments a substitution of means for ends.
Critics distinguished impressionist art for the *manner* in
which it attempted to render nature, or, more specifi-
cally, to render the "impression." Of course, this manner
or style was directed at something, the expression of a
fundamental truth, the *vérité* so often mentioned in the
theoretical and critical documents of the period. When
impressionism was seen in the most general terms, as a
naturalistic art aiming at truth, its purpose could hardly
be considered new, as Castagnary and others recognized.
The independent artists' preoccupation with the
"impression," however, seemed to set them apart, so that
their technical devices for rendering the impression—
sketchlike brushwork, lack of conventional drawing as
well as modeling and composition, and, especially,
unconventionally bright, juxtaposed hues—were
described as if they were sought as ends. They were seen
as effects difficult to achieve, having meaning in them-
selves. These effects often were found in the work of
naive or untrained artists, yet they could be praised

as the product of a most scrupulous and "advanced"
observation of nature, especially if seen in the context of
an exhibition of "naturalistic" painting. As Emile Zola
wrote of Jongkind's art in 1868, "one must be particu-
larly knowledgeable in order to render the sky and the
land with this apparent disorder . . . here . . . everything
is true."[29]

In summary: if the art for which the term *impression-
ist* now usually is reserved can be defined with precision,
this art must be understood in view of specific technical
devices having been applied to a very general problem of
both discovery and expression, a problem so fundamen-
tal to the art of the late nineteenth century that it often
went unstated. The problem is that of the individual's
means of arriving at truth or knowledge and the relation
of this individual (or private) truth to a universal (or pub-
lic) truth. Impressionists and symbolists shared this tra-
ditional concern. The impressionist artists distinguished
themselves in the way they conceived and responded to
the issue. For the impressionist, as the name implies, the
concept of the "impression" provided the theoretical
means for approaching the relation of individual and
universal truth. The artists' characteristic technical

devices, such as accentuated ("spontaneous") brush-work and bright color, are signs of their practical application of the theory of the impression.

The *Impression*

The term *impression* can bear very physical signification, as when it is synonymous with *imprint*. It suggests the contact of one material force or substance with another, resulting in a mark—the trace of the physical interaction that has occurred. Photographs are referred to often as impressions, as are the images of one's own vision. In both cases the term *impression* evokes a mechanistic account of the production of images by means of light; light is conceived as rays or particles that leave their marks or traces upon a surface, whether it is the photographic film's chemical coating or the eye's retina. The impression is always a surface phenomenon—immediate, primary, undeveloped. Hence, the term was used to describe the first layer of an oil painting, the first appearance of an image that might subsequently become a composite of many such "impressions."[30]

Primary and spontaneous, the impression could be associated with particularity, individuality, and originality. Accordingly, any style, if regarded as the sign or trace of an individual artist, could also be the impression left by that artist's true nature upon any surfaces with which he came into contact. By such reasoning, Emile Deschanel (in 1864) explained that the word *style* derived from *stylus*, the writing tool that leaves a characteristic mark corresponding to the personal touch of the individual, and he could then consider style a true impression: "Style is . . . the mark of the writer, the impression of his natural disposition in his writing."[31] In Deschanel's usage, the term *impression*, which one might first regard as a reference to a very concrete external event (one object striking another), is extended into the more internalized realm of character, personality, and innate qualities.

The impression, then, can be both a phenomenon of nature and of the artist's own being. Albert Boime defines the concept as it came to be used by painters and their critics during the nineteenth century, and stresses its dual association with an "accurate" view of nature and an individualized or "original" sensation belonging to a particular artist. Boime notes the importance of the parallel concept of the "effect" (*effet*). He states that the term *impression* was nearly interchangeable with *effect*. Consequently, a painting entitled *Effect of Sunrise* might also be labeled *Impression of Sunrise*; but, as Boime writes, "the distinction is this: the impression took place in the spectator-artist, while the effect was the external event."[32] Boime proceeds to ask why impressionists such as Monet tended to describe their works as impressions rather than effects: "The answer resides in the subjective connotation of this term."[33] The impressionist, that is,

wished to call attention to the particularity or originality of *his* sensation of nature. It was his sensation; yet, as Boime writes, it was considered to represent the external effect with "accuracy." Boime's discussion raises two perplexing questions: To what extent can the rendering of an admittedly subjective impression be thought of as revealing an external effect? And how can the "accuracy" of the presentation of this effect (and the artistic sincerity and originality associated with it) ever be evaluated by a critical observer? To deal with the first question entails an investigation of the concept of the impression as it is found outside artistic circles, in the field of psychology; to approach the second involves a consideration of the concept of "truth" (*vérité*) among painters and their critics.

It was not until the nineteenth century that psychology, the study of sensation, emotion, and thought, came to be commonly regarded not merely as a branch of metaphysics but as a natural science, an area of empirical research into the physiology of perception.[34] Terms such as *physiologie psychique*, *psychophysiologie*, and *psychophysique* gained currency. One of the standard definitions of the word *impression*, in accord with the thinking of such eighteenth-century figures as Hume and Condillac, was of direct relevance to the new psychologists: the impression is the "effect produced on the bodily organs by the action of external objects" or, more specifically, the "more or less pronounced effect that external objects make upon the sense organs."[35] The latter quotation is from the dictionary written by Emile Littré, the noted positivist who was himself involved with studies in the new psychology. In 1860 he published a general statement on the problem of perception and knowledge of the external world. For Littré, an external object cannot be known; only the individual's impression of it is known as real or true. Thus, one can never have absolute knowledge of the external world in the manner that one does have absolute knowledge (or experience) of an impression; one's view of the world is induced from one's experience of impressions and is necessarily relative.[36] The significance of Littré's argument for artistic issues lies in the implication that the most personal impression, if somehow presented publicly (say, by means of a painting), would reveal as much truth about the world as would any other genuine impression. As a result, the rendering of an impression could be an accurate expression of both the artist and his natural environment.

Littré put special emphasis on the primacy of the impression:

Yes, there is something that is primordial, but it is neither the [internal] subject nor the [external] object, neither the self nor the nonself: it is the impression perceived. A perceived impression does not in any sense constitute the idea of the subject or of the object, it is only the element of these ideas [which develop] only when the external

impression [i.e., physical resistance or contact] and the internal impression [i.e., pleasure or pain] are repeated a certain number of times.[37]

The impression, in other words, is the embryo of both bodies of one's knowledge, subjective knowledge of self and objective knowledge of the world; it exists prior to the realization of the subject/object distinction. Once that distinction is made, the impression is defined as the interaction of a subject and an object. An art of the impression, the primordial experience, could therefore be seen as both subjective and objective.

Littré's position on the significance of the impression was by no means unusual. Many French psychologists, as well as their British counterparts, held similar views. Among them, some (including Littré himself) tended to equate the impression with sensation. But others distinguished sensations as those impressions that were actually felt, rather than subliminal.[38] Hence, Littré, as if aware of this possible difference, spoke of the "perceived" impression, one actually sensed or noticed. In the early critical commentary on impressionism the phrases *l'impression perçue* and *l'impression reçue* appear frequently.

In 1904, a number of years after critics had begun to discuss specific impressionist works in terms associated with symbolist art, Fernand Caussy published an article entitled "Psychologie de l'impressionnisme." He identified impressionism as an art of rendering the first impression but made a basic distinction between Manet's "visual realism" and the "emotional realism" of Monet and Renoir. As Castagnary had done thirty years earlier, Caussy stated that Monet and Renoir presented a distorted idiosyncratic image in accord with their own emotional responses to nature. For him, as for Castagnary, this would lead to a subjective "idealism." In other words, Manet's rendering of the impression was objective, whereas Monet's was subjective. Nevertheless, Caussy argued, the two arts are intimately related, and differ only in that one is the product of an inactive nervous system that records visual observations passively, whereas the other is the product of irritability and attendant strong emotion.[39] In Caussy's overextended analysis, we see the full implications of Castagnary's original comment: "[These artists] are *impressionists* in the sense that they render not the landscape, but the sensation produced by the landscape."

We can draw a broad conclusion from the writings of Castagnary, Deschanel, Littré, Caussy, and other figures of the time: an art of the impression (or of sensation) may vary greatly from artist to artist, in accord with the individual's physiological or psychological state or, in other terms, with his temperament or personality. Whatever truth or reality is represented must relate to the artist himself as well as to nature. Indeed, we might say that the artist paints a "self" on the pretext of painting "nature."

Impressionism, Truth, and Positivism

In French art criticism of the nineteenth century, the word *vérité*, truth, had a double sense. On one hand, it referred to a fidelity or truth to nature. On the other hand, it referred to the artist's own temperament or emotions. In the latter sense, the word often would be used in conjunction with *naïveté* or *sincérité*. Sometimes the two meanings of *vérité*, objective and subjective, were clearly distinguished; at other times, not.[40] As I have indicated, impressionist art often was seen to be related to both kinds of truth.

In his "Salon of 1859," Charles Baudelaire chose to contrast the two kinds of truth as the respective aims of two kinds of art—"realist" or "positivist," and "imaginative":

The immense class of artists . . . can be divided into two quite distinct camps: one type, who calls himself "réaliste" . . . and whom we, in order to characterize better his error, shall call "positiviste," says: "I want to represent things as they are, or as they will be, supposing that I do not exist." A universe without man. And the other type, "l'imaginatif," says: "I want to illuminate things with my intellect [esprit] and project their reflection upon other minds."

Here Baudelaire oversimplified the theory of positivism in order to emphasize the difference between the truth of a mechanical realism (associated with the photograph) and that of a human, emotional encounter with nature.[41]

Other critics who, like Baudelaire, formulated generalizations on the state of modern French art referred to virtually the same categories. In 1876, Eugène Fromentin complained that much contemporary painting sought to represent the "absolute truth" of an external reality rather than the fantasies of the imagination. He associated recent landscape painting in particular with the mechanical reproductions of the photograph. In this type of art, he wrote, "any personal interference on the part of sensibility is too much."[42] About a decade later, Georges Lafenestre applied the same distinction, specifically to the art of the impression, referring to the great body of naturalistic painting then being produced throughout Europe. Lafenestre chose to link the truth of the impression with the *vérité* of fresh air and sunlight, the observation of the external environment. Just as Fromentin before him, he opposed this to the neglected art of the "imagination."[43] And in 1895, Roger Marx described the truth of naturalism as "literal, external, immediate truth," requiring retinal sensitivity and manual dexterity, but not "the intervention of the intellect . . . [;] art becomes a mirror."[44]

These three critics need not have conceived of naturalism (or the impression) in so narrow a fashion. Baudelaire himself, when writing about Constantin Guys, the "painter of modern life," took a more flexible position,

referring to the "impression produced by things upon the mind of M. G[uys]." And Baudelaire, in several different passages, would admit that "realism" could be justified by a strict adherence to

what [the artist] sees and . . . what he feels. He must be truly faithful to his own nature. He must avoid like the plague borrowing the eyes and the feelings of another man, however great that man may be; for then the productions he would give us would be, in relation to himself, lies and not realities.[45]

Following the manner of another seems here a more serious fault than that of a weak or relatively inactive imagination; as long as the artist is true to himself, his vision, even in its banal realism, will bear the redeeming imprint of his own subjectivity.

If indeed some critics who surveyed French art during the 1870s and 1880s decided that an objective truth, a fidelity to an external nature, was the aim of painters both academic and independent, they may have been influenced in part by some of the supporters of impressionism itself. Armand Silvestre, for example, wrote that Monet's renderings of water were of "une vérité absolue"; and Théodore Duret claimed that for Pissarro a landscape was the "exact reproduction of a natural scene and the portrait of a corner of the world that really exists."[46] Most of those who commented directly on impressionism, however, seemed to believe that a subjective truth was involved at least as much as an objective one, if not more. Duret himself was ambivalent when he wrote on Manet in 1870:

he brings back from the vision he casts on things an impression truly his own; no one more than he has the sense of the values *and of the accent in the coloring of objects. Everything is summed up, in his eyes, in a variant of coloration; each nuance or distinct color becomes a definite tone, a particular note of the palette. . . .*[47]

Here it is not clear whether Manet's rendering of the impression yields a truth of nature that he more than anyone else is capable of seeing, or a truth that is his vision and his alone. Duret seemed to feel that both truths were involved. Manet's art is seen, in either case, to depend on his eyes. It is this observation, made repeatedly during the late nineteenth century, that refers us back to the physiological psychology of the time.

Many critics of the period attributed artistic vision first to the artist's eye and only second to his whole person, his temperament or personality. But as each eye was different from any other, so each temperament or personality—the sum product of *all* physiological "facts" in an individual—would be unique and original. Applying such reasoning, Emile Zola set an immediate precedent for Duret by arguing for the acceptance of Manet's unconventional painting on the grounds of its subjective truth. Zola repeatedly asserted that Manet painted things "the way he sees them." Zola's emphasis in such

statements obviously is meant to be on the subject who sees, not the object seen. In 1867 he wrote: "[Manet's] whole personality consists in the manner in which his eye is organized: he sees blond, and he sees in [broad] masses." Accordingly, Zola could offer an explanation of the painter's unconventional style—Manet sees this way by nature; he is true to himself, sincere. "This daring man who is ridiculed has a well-disciplined technique, and if his works have an individual appearance, they owe that only to the entirely personal manner in which he sees and translates objects."[48]

Zola's acceptance of subjective truth put him in an odd position as a critic. He found himself necessarily open to all artistic manners, since any one might reveal a truth as individualized as the vision of reality he discovered in Manet:

I accept all works of art in the same way, as manifestations of human genius. And they interest me almost equally, they all possess genuine beauty: life, life in its thousand expressions, ever changing, ever new.[49]

Such universal receptivity, however, might lead to an ineffectual anarchy of artistic communication. And so, for some others, such as Castagnary, subjective individualism was not always acceptable, even if thoroughly authentic. As if in agreement with Zola, Castagnary found in 1874 that "Manet paints as he sees, he reproduces the sensation that his eye brings him: he is above reproach with regard to sincerity." But the critic added an important qualification, consistent with "naturalism" as he preferred it: Manet's immediate "summary sensation," although true on a personal, subjective level, would have to be transformed into a public, objective truth if it were to have social significance.[50]

Given the attention that early critics directed to the eye (both figurative and literal) of Manet and other naturalistic artists, art historians have often brought philosophical positivism to bear on their interpretation of impressionism. This has led to, or rather reinforced, some serious misconceptions.

Positivist doctrine was in wide circulation during the period of impressionism; it advocated direct observation as the primary means to valid knowledge. D. G. Charlton provides a general definition of philosophical positivism in France, one based not only on the theories of Auguste Comte, the founder of the positivist movement, but also on the beliefs of others, such as Littré, who were stricter than Comte himself in adhering to the core of positivist tenets. Charlton writes that for the positivist, outside of knowledge of logical and mathematical systems,

science provides the model of the only kind of knowledge we can attain. All that we can know of reality is what we can observe or can legitimately deduce from what we observe. That is to say, we can only know phenomena and the laws of relation and succession of phenomena,

and it follows that everything we can claim to know must be capable of empirical verification.[51]

Obviously, a positivist might argue, just as an impressionist, that unprejudiced eyes would reveal new truths. However, the most prominent positivistic thinkers believed that the direct observation and recording of external phenomena were the tasks of the scientist, whereas the artist should instead apply his *imaginative* vision to this world of fact. According to both Comte and Littré, art has its origin in fact but departs from it; the artist must imaginatively "idealize" and "perfect" what he observes. Thus art becomes inspirational and leads to the betterment of society. As Comte wrote, "art is always an ideal representation of what exists, destined to cultivate our instinct for perfection."[52]

One can detect elements of positivism in Castagnary;[53] but if anyone qualifies as a genuinely positivist art critic, it is Pierre Petroz, who published regularly in the journal edited by Littré, *La Philosophie Positive*. Petroz followed Comte's reasoning and stated that art should involve the "act of the mind through which it conceives the things of the physical and intellectual world under a form more perfect, more essentially true than that which they have in nature." The critic contrasted such an idealized art to one of simple, direct realism and thus recognized a dichotomy similar to Baudelaire's, even though Baudelaire himself associated positivism with the same banal realism to which Petroz objected. Like Baudelaire, Petroz stated that Delacroix's art was exemplary, revealing genius and imagination. Where Petroz diverged from Baudelaire—and from supporters of a subjective impressionism, such as Zola—was in his assertion that art should reveal general physical and intellectual laws.[54] Such a goal was in accord with the positivist's concern for the development of society as a whole. Baudelaire and Zola, on the contrary, were much too committed to individual expression to consider such an artistic aim valid.[55]

Recent scholars often have neglected the element of idealization figured into the Comtean sense of artistic creation, mistaking it for a simple process of recording observations.[56] Similarly, there has been much confusion in distinguishing paintings of the impressionist period that represent subjective truths from those that represent objective truths. It is likely that Baudelaire would have classified Monet's painting on the side of the imaginative (or subjective), not the positivist (or, in his system, objective). If so, he would have been recognizing what other critics of his time identified as the subjective truth of an immediate impression, as opposed to the objective truth of a contemporary subject that one might actually observe. In other words, an internalized reality or experience was to be differentiated from an externalized one. This distinction leads us to understand what separated the independent impressionist (a Monet or Renoir) from

his academic counterpart (a Detaille or Jean Béraud). The work of the former emphasized subjective experience of nature and denied itself the kind of observational detail often associated with the photograph. In contrast, the work of the latter stressed an objective external observation, and because of its precision or focus, often was said to resemble the photograph (for better or worse). Obviously, a whole range of representations, from subjective to objective, would be possible. For a number of critics, the relatively detailed works of some of the impressionists (especially Degas and Morisot) seemed to represent a mean, a union of subjective and objective truths. In contrast, the more fully detailed pictures of a "realist" (Detaille, for example) might seem limited to material objectivity; Monet's art, at the other extreme, might seem imprecise, fanciful, and simply too subjective.[57]

Although the surviving statements by the impressionists themselves often seem ambivalent, there is much evidence that they conceived of their art as essentially personal and subjective. Monet, for instance, once wrote that he "always worked better in solitude and according to [his] very own impressions"; and Pissarro, when he noted the similarity between his own work and Cézanne's over a period of years, added that "each one kept the only thing that counts, his own 'sensation'."[58]

Whatever confusion and ambiguity about subjective and objective truth has remained through the years cannot be blamed entirely on the points of failure of modern scholarship. Much of the confusion is built into the topic itself. The physiological psychologists, as well as many other nineteenth-century theorists, contributed to the breakdown of the distinction between subject and object, especially through their emphasis on the *experience* of the observer. Reality came to be equated with consciousness and, as so many maintained, the primordial *act* of consciousness was to perceive an impression. The impression was neither subject nor object, but both the source of their identities and the product of their interaction.

The Subject/Object Distinction, Critical Evaluation, and Technical Procedure

Littré identified the elemental experience or the primordial event with the impression, that which gives rise to the distinction between subject and object. This sense of the impression belonged also to Hippolyte Taine—philosopher, historian, critic, and perhaps the most influential figure within French intellectual life of the late nineteenth century. In his fundamental psychological study *De l'intelligence* (1870), Taine conflated the notions of subject and object. He spoke of an elemental unitary sensation (that is, the impression) that appeared simultaneously under two irreducible aspects,

as both conscious intellectual force and material substance. For Taine reality consisted neither of mind (subject) nor of matter (object) but of conscious experience, which manifests itself under both these dependent aspects of reality.[59]

Taine's thinking was associated with positivism, and his contemporaries often justifiably labeled him a materialist and determinist. Yet his notion of an essential interaction and unity of subject and object could be shared by critics who seemed to shift from a naturalist or materialist esthetic to a symbolist or spiritualist one. Jules Laforgue, for example, wrote in 1883 of the new impressionist painting as others would later write of symbolism.

Object and subject [that is, either nature and impressionist artist, or impressionist painting and viewer] are . . . irretrievably in motion, inapprehensible and unapprehending. In the flashes of identity between subject and object lies the nature of genius.[60]

In this way Laforgue presented the union of subject and object as an aim or ideal of art (and, in doing so, he considered himself allied with Schopenhauer and German philosophy, not with Taine). The impressionist was in a position to achieve this aim because he sought the impression itself, the most immediate perception, the moment at which subject and object are one. Later, during the 1890s, Maurice Denis would argue repeatedly that the end of art must be a synthesis of object and subject; eventually he would praise Cézanne for accomplishing a "reconciliation between the objective and the subjective."[61]

We associate both Laforgue and Denis with the theories of symbolism, yet they could at times speak warmly of impressionism because they recognized (to varying degrees) its integration of perceiving subject and perceived object. This was a very common concern. At an earlier date, the theorist Eugène Véron, who was no champion of the new independent art movements, also called for an art of both subject and object. Véron's *L'esthétique*, published in 1878, was very much a product of its age. It rejected metaphysical and theological speculation, as did the writings of Comte and Littré, and it advanced determinism and a theory of national and racial expression, as did Taine. *L'esthétique* described three paths open to the artist. First, the "imitation of an anterior art" or the "academic method": Véron rejected such derivation of art from antecedent art because its product seemed conventionalized and unoriginal. Second, the "copying of real things" or the "realist theory": This mode claimed objectivity in its recording of phenomena, but would reduce the artist to a machine. Véron argued that it was in any case an impossibility because the artist cannot be a perfect realist—he always adds something of himself, "his emotion, his personal impression." The third available path, the "manifestation of

individual impressions," involved both object and subject, the natural effect and its impression, "l'effet et l'impression": In this case, the artist might be stimulated by nature, but would paint colors that are "those of his own nature, of his temperament, of his personality." Véron referred to this last route as "l'art personnel"; it was the only true way.[62] His concern for an originality associated with individuality led him to an art that represented man's nature as well as external nature. He conceived of man's nature as endlessly variable, revealed through a work of art as the artist's unique temperament.

The notion of "temperament" was central for a great many theorists of the nineteenth century, who held that an individual's physiological constitution, the source of his temperament, was the cause of a necessary subjectivity of vision. In 1864, Emile Deschanel, who cited both Taine and Stendhal as authorities, defined "temperament" as the "particular state of the physical constitution of each person, caused by the diverse proportion of elements that enter into the composition of his body."[63] One might observe broad distinctions in constitution or temperament corresponding to racial differences, and subtler distinctions among individuals produced by variation in the domestic environment and even diet. Accordingly Stendhal, for example, had argued that if there are five races of men, there must be five "ideal" beauties: "I strongly doubt," he wrote, "that the inhabitant of the coast of Guinea admires the truth of Titian's color."[64] If there are five races, then there are innumerable individuals. And so, Delacroix stated that for an artist, "everything is a subject; the subject is yourself; it is your impressions, your emotions before nature."[65] Anything observed might be suited to artistic representation, and art might appear in virtually any style. As a result, no predetermined standard of objective realism or of universal beauty would ever prove adequate.[66]

Emile Zola inherited these aspects of romantic and realist theory and applied them to the criticism of an emerging impressionism, a manner of painting that made these issues more apparent than ever before. Symbolist critics usually credited Zola with the common notion of individual temperament as a source of authenticity and truth in art; they frequently cited his dictum that "a work of art is a bit of nature seen through a temperament." With such an inherently eccentric principle to guide him, Zola could describe Manet's art (*fig.9*) in terms of Manet's own personal vision: the artist simply painted "as he saw." This was Manet's achievement, to be true to his own unique impressions, to express his temperament. For Zola, the favorable evaluation of a work of art entailed the recognition of an artistic temperament, the discovery of the artist's own being. In his first extended essay on the painting of his day, he made a vigorous pronouncement:

I wish that one should be alive, that one create with

originality, outside of all, according to his own eyes and his own temperament. What I seek above all in a picture is a man and not a picture. . . . A work of art is never other than the combination of a man, the variable element, and nature, the fixed element. . . . Make something true [to nature] and I applaud, but above all make it individual and living, and I applaud more strongly.[67] Here we are reminded again of Castagnary's distinction between the "landscape"—in Zola's terms, the fixed truth—and the "sensation produced by the landscape"—Zola's infinitely variable truth. The latter was "alive" in individual artists, unconventionalized and evolving, subject to no fixed terms of evaluation. "The ridiculous common standard," Zola wrote, "no longer exists." Accordingly, the young critic stated that he was "displeased" by the word *art*, which seemed to suggest some absolute beauty that lived on through the ages, insensitive to the passing but penetrating glance of individual personalities.[68]

Zola stated unambiguously that he would apply no preconceived standards to his critical evaluations, and he repeatedly lauded Manet and the impressionists for their independence. This was a kind of negative judgment, the result of a comparison in which the new painting showed itself to be incommensurable with the old academicism. Yet, as if realizing that a judgment appears to lack full conviction if it makes no reference to a positive principle, Zola retained a concern for what he had called the "fixed element," the truth of nature. He praised Manet and others for their faithfulness to natural effects and the recording of relationships of hue and value. In essence, Zola evaluated aspects of artistic technique as if they were neither entirely original nor idiosyncratic. Manet as an individual might tend to "see blond," but he also observed a "law of values," a set of relationships that corresponded to relationships in nature. Zola noted that this same law had been profitably employed by many other painters.[69] The implication is that Manet recorded his unique and original vision within a framework established in the tradition of painting.

It may be that Zola's mode of technical analysis was cursory, even superficial. Nevertheless, he seems to have performed some objective inspection of qualities of color, value, spatial illusion, and the like, even as he experienced the works of the man he trusted implicitly. Although Zola might know the man (either personally or by reputation) and might respect his sincerity and be predisposed to accept his art, the structure of his arguments suggests the reciprocal procedure: a critic first judges a body of work *technically* and only then judges the artist.

Zola spoke of the painter's procedure as if it were subject to evaluation by comparison, if not with the technical results visible in other works of art, at least with some established sense of the appearance of nature. The often unacknowledged standard could be either an art of

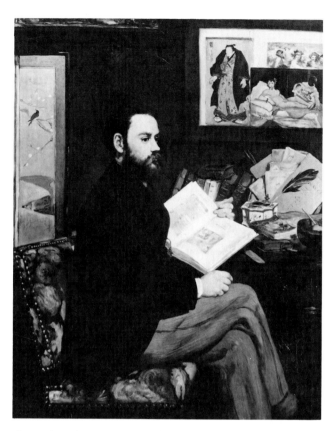

fig. 9 Edouard Manet, *Portrait of Emile Zola*, 1868. Oil on canvas, 57½ x 44⅞ in. (146 x 114 cm). Musée d'Orsay (Galerie du Jeu de Paume). Photo: Cliché des Musées Nationaux

nature or nature itself. At the same time, Zola emphasized that an accomplished technique that met this objective standard rendered nothing more concrete than the individual's subjective impression. Just as contemporary psychologists defined the impression as both objective and subjective, external and internal, Zola considered the naturalist or impressionist painting as representing both object and subject, nature and man. The work of art revealed, in effect, a special relationship between man and nature, a particular manner of perceiving the world, an artistic manner that yielded both objective and subjective truth. The artist's attention to the rendering of his original and spontaneous impression insured both fidelity to nature and the expression of his own temperament.

In Zola's most contentious critical writings, his Salons of 1866 and 1868 and his essay on Manet of 1867, he offered relatively little discussion of artists' efforts to develop appropriate technique, and stressed instead the significance of original and subjective vision. In his later, somewhat less polemical writings, he more readily acknowledged the need of any artist to attain a technique that will enable him to achieve his specific ends. Still, the "sincere" painter would have no use for academic training. In a manner that seems more stubborn than eloquent

or convincing, Zola repeatedly attempted to reconcile the subjective impression and an objective rational technique by insisting that proper technique can come only with study, but independently, without traditional schooling or the imitation of the styles of others who have themselves attained similar goals. He discredited "impressionists" of academic background (Bastien-Lepage and Gervex) who were technically competent but had acquired their skills by imitating "naives" (Manet).[70] For Zola and others, to accept the *possibility* of employing a studied yet independent or unconventional technique to render the spontaneous impression is fundamental to the critical analysis of impressionism. Without the concern for technique, even the ill-defined procedure of which Zola spoke, critical evaluation of impressionist painting would be reduced to questions of personal integrity; and one would be inclined to advocate that artists abandon any active search for the elusive "means of expression," merely to become receptive, attending passively to their most immediate physical sensations.

Zola's two commentaries on Jongkind (1868 and 1872; cf. *fig. 10*) exemplify the change in tone that distinguishes his earlier from his later critical essays. In 1868 he wrote of Jongkind's very personal vision and of his equally original manner of rendering this vision by means of a striking simplicity. He presented his reader with an image of the artist working quickly to capture both an objective truth of nature revealed in the "first impression" and, more significantly, a subjective emotional experience of nature, the artist's "sensation," over a period of time. In 1872 Zola republished these same statements almost verbatim, but added an important qualifying remark: "The truth is that the artist works slowly [*longuement*] on his canvases, in order to arrive at this extreme simplicity and unprecedented refinement."[71] Thus, in his later version, Zola linked the rendering of the spontaneous impression to a lengthy and deliberate process of painting. Similarly, in his Salon review of 1880, he defined impressionism in terms of seizing "nature in the impression of a minute." But, he added, "it is necessary to fix this minute on the canvas for all time, by a technique [*facture*] well studied." To capture the impression entails observing the light of the open air—"easy enough to say," Zola wrote, "but the difficulties begin with the execution." Indeed, when he evaluated Monet and the other independent impressionists with an eye to their technical accomplishments, he found them wanting. He reminded Monet, who seemed pressed to produce and sell his paintings hastily, that "it is study that makes solid works"; and he concluded that none of the impressionists was master of his chosen form of art.[72]

Zola did not argue that the impressionists' technical failure was due to a lack of sincerity. Monet, Pissarro, Cézanne, and the others were indeed expressing their individual temperaments but, Zola would claim, not

with the depth and mastery that could come only with further developments in execution. He made a clear distinction, then, between *what* was expressed and *how* it was expressed, between something deemed subjective and idiosyncratic, and something perhaps inventive and original yet still subject to objective evaluation and criticism. Although sketchlike effects, bright color, and a simplification of drawing and composition were evidence of the artist's concern for rendering the impression, the mere presence of these technical devices did not guarantee that the attempt, however sincere it might appear, would be judged successful.

During the nineteenth century it was quite common to distinguish, as Zola did, between the technical procedure that could be studied and the spontaneous expression of impressions and emotions that it made possible. Baudelaire wrote at length on this matter and quoted Delacroix as having stated that the artist needs to be "armed in advance" with the technical means of translating his impression of nature.[73] Manet, too, apparently thought of technical mastery as prerequisite to an art of "spontaneity"—his term, according to his friend Antonin Proust, for an art of the impression.[74] Another of Manet's intimates, Stéphane Mallarmé (who appreciated both impressionism and symbolism), described Manet's technique as one of skilled artifice calculated to give the *appearance* of spontaneity. For Mallarmé, as for the later Zola, there was nothing inconsistent in working thoughtfully and deliberately to achieve the expression of the momentary. Nor should one expect traditional technical devices to be completely abandoned in the new art. Mallarmé wrote (in a text that exists now only in this ineloquent English translation):

As no artist has on his palette a transparent and neutral colour answering to open air, the desired effect can only be obtained by lightness or heaviness of touch, or by the regulation of tone. Now Manet and his school use simple colour, fresh, or lightly laid on, and their results appear to have been attained at the first stroke. . . .

But will not this atmosphere—which an artifice of the painter extends over the whole of the object painted—vanish, when the completely finished work is as a repainted picture?

Mallarmé answered his own question in a way reminiscent of Zola. He noted that Manet avoided traditional composition and perspective, regarding it as unnatural. However, the painter still maintained a coherent pictorial unity, in particular by means of Japanese "perspective" and the cropping of figures to suggest an instantaneous directed glance. Mallarmé concluded:

Some will probably object that all of these means have been more or less employed in the past, that dexterity—though not pushed so far—of cutting the canvass off so as to produce an illusion—perspective almost conforming to the exotic usage of barbarians—the light touch and

fig. 10 Johan-Barthold Jongkind, *The Church of Overschie*, 1866. Oil on canvas, 18 x 20 in. (45.7 x 50 cm). Courtesy of The Art Institute of Chicago. Mr. and Mrs. Martin A. Ryerson Collection

fresh tones uniform and equal, or variously trembling with shifting lights—all these ruses and expedients in art have been found more than once, in the English school, and elsewhere. But the assemblage for the first time of all these relative processes for an end, visible and suitable to the artistic expression of the needs of our times, this is no inconsiderable achievement in the cause of art, especially since a mighty will has pushed these means to their uttermost limits.[75]

Here, Manet's artistic effects are regarded one by one and the critic admits that there are precedents for each of them. They are neither the results of an empirical study of nature nor of an entirely instinctive and "sincere" self-expression. Instead, they derive from a relatively internalized study of the painter's discipline. Such a study (at least for Mallarmé) would be worthy of a symbolist as well as an impressionist.

Baudelaire, Zola, Mallarmé, and others who evaluated either romantic or impressionist art had to face the issue of the communication of personal, individualized sensation. They found it necessary to speak of technical devices drawn from tradition or accumulated knowledge,

even while they were advocating an unconventional art of emotional immediacy. The artist's technique, his means of expression, was seen as translating the particular and idiosyncratic into terms of general understanding. As Gustave Geffroy wrote in his "Histoire de l'impressionnisme" (1894), the impressionists could never be genuinely "naive," for they knew well what past masters had accomplished in the field of painting.[76] Another critic, Charles Bigot, as he confronted the issues raised by impressionism, linked the success of this individualistic art with its conformity to a preexisting although not necessarily manifest ideal. Bigot reached this position through his consideration of Bastien-Lepage (*fig. 11*), whose style he discussed in the familiar terms of naturalism: the capturing of plein-air effects, the use of a simplified palette, the expression of a subject simply as the painter "saw" it. Bigot felt that Bastien-Lepage succeeded where the more radical impressionists failed because of his superior technical powers. Like many critics of his generation, Bigot concluded that every painter has his own vision and must use color accordingly, but those who succeed are those whose use of color conforms

fig. 11 Jules Bastien-Lepage, *Les foins (Grain)*, 1877. Oil on canvas, 70⅞ x 76¼ in. (180 x 195 cm). Musée d'Orsay (Galerie du Jeu de Paume). Photo: Cliché des Musées Nationaux

to some generally recognizable sense of harmony: the individual must strike a universal chord.[77] For the symbolists, the question to follow upon such reasoning was this: under what circumstances will an expression of a particular temperament result in an art of universal import? When does the subjective truth of the individual's impression or sensation become an objective truth known to all?

Subjective and Objective Distortion

A full comparison of the impressionist and symbolist conceptions of artistic expression demands consideration of the expressive device of distortion (*déformation*), the departure from accepted norms for rendering natural effects. Two kinds of distortion were to be seen in nineteenth-century painting: subjective, in the sense of idiosyncratic or spontaneous, and objective, in the sense of universally expressive.

It must be emphasized that "distortion" in impressionist or symbolist art was conceived in a rather sophisticated way, as deviation from *convention*, but not necessarily from nature. In its unorthodox turn distortion might actually reveal *truths*, either of external nature or of the artist's own nature, truths otherwise masked by a conventional rendering. Obvious distortions of form, color, or perspective, awkwardness in handling, and any other stylistic barbarisms were often taken as signs of the artist's sincerity. Throughout the nineteenth century, critics argued that awkwardness could be attributed to the direct and unattenuated manner in which a painter

expressed his immediate emotional response to his subject.[78] The symbolist Maurice Denis was thus applying common wisdom when he wrote that "awkwardness [*gaucherie*], for the moderns, consists in painting objects according to the consciousness one has of them naturally, instead of painting according to a preconceived idea of the picturesque or the esthetic."[79] Denis also remarked, "I call awkwardness this sort of maladroit affirmation through which the personal emotion of an artist is translated outside of accepted formulas."[80]

In these statements Denis seems to imply, elsewhere clearly indicating,[81] that awkwardness or distortion results from an inadequacy in technical procedure, however commendable that may be regarding the sincerity of the effort toward artistic expression. Such distortion Denis labeled "subjective," for it was the product of an attempt at expressing an individual emotional response to nature and was in accord with the "doctrine of . . . Nature seen through a temperament."[82] Here Denis referred to Zola's famous formulation of naturalist and impressionist art; and he regarded impressionism itself as a case of "subjective distortion." He also spoke of the second type of distortion, which he called "objective"; it was generated not by the artist's idiosyncracies but by his search for a valid technique, for the immutable laws of visual expression. Denis associated this type of distortion primarily with the symbolist artists who sought "laws of expression" both in the traditions of past art and in the advanced sciences of physics and mathematics. Symbolism, according to Denis, affirmed the "possible expression of emotions and human thoughts by esthetic [more specifically, visual] correspondences" that could be comprehended by all and were, in this sense, "objective."[83]

Albert Aurier, who seems to have been the source of many of Denis's formulations, discussed the issue of distortion a few years in advance of his younger colleague. In essays of 1890 and 1891 he reiterated the distinction that Castagnary had made in 1874, arguing that the impressionists did not render the natural object itself but its "perceived form"; their aim was the "translation of instantaneous sensation with all the distortions of a rapid subjective synthesis." As Denis would do, Aurier drew on Zola's notion of "nature seen through a temperament" to justify his position that an artist does not represent nature's truth, but "his truth, his own"—the "distortion [is] variable according to the [artists'] personalities." Aurier concluded that the resultant work of art, "distorted by a temperament," became the "visible sign of this temperament," its "symbol." Here, he is essentially in agreement with Zola, who would seek "the man" in the work of art; but he pushed his argument further, forcing what Zola seems to consider subjective and personal to become objective and universally meaningful. There was in art, Aurier wrote, a language of the correspondences between ideas and essences and their

sensual manifestations. The symbolists had studied this language, which enabled them to go beyond the expression of nature distorted by a temperament to the expression of a more permanently meaningful abstraction, "a particular idea, a dream, a thought." The apparent distortion of natural forms—to be seen, for example, in the art of Gauguin—might have been generated not only by "personal subjectivity" but also by the "needs of the Idea to be expressed."[84]

In effect, Aurier, like Denis after him, argued that distortion need not arise spontaneously as a product of temperament but could be used deliberately as a means of self-conscious artistic expression: the distorted formal elements of line and color become the means of converting a particular sensation or emotion into a concretely manifest idea (to use Aurier's term), a realized image of generalized meaning. For the symbolist, an artist's success is clearly linked to a technical procedure, itself subject to critical evaluation. The artistic process that Aurier described is the same one the symbolist poet Gustave Kahn conceived when he wrote in 1886 that "the essential goal of our art is to objectify the subjective (the exteriorization of the Idea) instead of subjectifying the objective (nature seen through a temperament)."[85] Kahn's thought is quite compact. He is setting symbolists against naturalists or impressionists: the symbolist aims to express his most profound intuitions in order to form a world of universal (objectified) knowledge, whereas the impressionist represents his own internalized experience of a mundane world that everyone already knows. The one renders the private and mysterious more accessible, while the other seems to convert what is public into a more private or personal form. Despite this apparent opposition, the antithetical effects that Denis, Aurier, Kahn, and others called subjective and objective distortion fuse whenever the artist's personal vision, his impressionist "ideal," is in immediate correspondence with an image of universal expressive power, the symbolist "Idea." The individual artist would at that moment feel and express (as it were, *spontaneously*) what all can feel and come to know. And at that moment, the art of the individual impression would merge with the art of the universal symbol.

Impressionism and Symbolism as Modes of Artistic Expression

The symbolist writers Aurier and Kahn seem to conceive of the "Idea" (*Idée*) as an objective essence to be discovered and expressed by the artist, an abstraction that bears universal significance. But this is at once the artist's own idea, perhaps known by introspection, as well as an Idea belonging to all. Romantics and impressionists had spoken of the related artistic "ideal" (*idéal*), the external objectification of the artist's own subjective sense (or

idea) of the world, and the public expression of a personal view. To idealize was to render the world in conformity with one's own view of it. In this sense of the word Castagnary wrote in 1874 that the impressionists would move from "idealization to idealization." Previously, in 1863, this same critic had defined the ideal almost as one might define the impression, not as something remote and never to be fully realized, but as the present and immediate product of human experience: "The ideal is the free product of each person's consciousness put in contact with external realities, in consequence an individual conception which varies from artist to artist."[86]

Hippolyte Taine offered an account of the relation of an "ideal" to an "idea" in one of the courses that he conducted at the Ecole des Beaux-Arts, where he was appointed professor of esthetics in 1864. Taine stated that the artist forms an idea of the essential character of his subject, and when he renders that subject in conformity with this idea, the subject (in its artistic representation) becomes ideal. Indeed, this was for Taine the goal of art—to render "real objects" ideal: "things pass from real to ideal when the artist reproduces them in modifying them according to his idea."[87] The statement is ambiguous since Taine does not specify whether the expressed character of the represented subject is a product of the artist's own particular experience or somehow the essence of that subject itself.

Before Taine issued his decree on the interrelation of the artistic subject (the "real" model in nature) and the artistic object (the artist's representation, his "end," his "ideal"), Baudelaire had stated that any work of art necessarily embodies elements proper to both artist and model. "An ideal is the individual [model] reflected by the individual [artist]."[88] In other words, the temperaments or characters of both the perceived and the perceiver will be expressed in any artistic rendering. In his formulation Baudelaire typically emphasized individuals. Taine would stress instead the general society, its material climate and spiritual atmosphere. He had an ingenious way of preserving artistic individuality within a world conceived as demanding conformity. While he clearly acknowledged that individual temperament plays a role in determining an artistic ideal, Taine added that a *great* artist possesses no ordinary temperament, but rather one especially marked by all that defines the essence of his culture. Thus, what distinguishes an artistic genius is a temperament that is indeed singular, but eccentric only in its being so *normal*, or normalizing. With the great artist, the personal ideal comes into correspondence with the ideal to be derived from any real object in the environment. Such an artist, expressing himself (his nature), expresses the universal truths or conditions of his society.[89] What a symbolist might regard as universally meaningful content in the work of a past master would be for Taine an expression of the high

nobility of the artist's own temperament that brought forth emotions with which all men could sympathize.

Although the expressed ideal was identified as a product of the artist's temperament, it seemed to gain in stature as it moved away from the domain of the individual to that of the general society. Such an observation allowed a potential *social* value to be reserved for the products of even the most eccentric geniuses. And this social significance, according to one of Taine's close associates, owed its life to esthetics—that is, the work of art created a social bond not otherwise fully manifest. The point was made in 1883 by Armand Sully-Prudhomme, known as the "positivist poet," a man committed to "l'esthétique par la psychologie." Sully-Prudhomme held the common belief that art was expressive simply in that it represented the "temperament of the artist, his ideal." In accord with its psychological foundation, artistic expression took its proper form as it established the correspondence between sensations and the emotions they arouse. Formal (technical) elements would serve as the vehicle of these correspondences, a universal language. One's appreciation of another's artistic expression would increase proportionately to the strength of the recognition that the artist's personal vision could also be one's own. In sum, Sully-Prudhomme wrote:

To enjoy a work of art is to experience, by means of formal elements [au moyen de la forme], *the delight of sympathizing with the ideal of another. . . . When this ideal is also our own . . . the enjoyment is for us that of a revelation, because the artist gives body to our ideal which was floating amorphously in our own imagination.*[90]

Hence, in the case of the greatest art, the expressed ideal would be universally recognized; such an ideal, subjectively generated, would appear as a revealed objective truth. To repeat: in the great work of art, the subjective (individual) becomes objective (universal).

It should be apparent that this pattern of reasoning was not confined to "positivists," such as Taine or Sully-Prudhomme. It was appropriated by symbolists who might be labeled idealists in that they thought of themselves as Platonists and Neoplatonists. Maurice Denis noted the double aspect of the ideal when he wrote of the precursors of the symbolist painters (Cézanne and others):

What they expressed was surely their ideal, their vision of life, their emotion in the face of things, but they expressed it only through pictorial means [i.e., through elements of visual sensation (line and color) rather than through choice of "literary" subject matter]. This was their virtue: they transposed their sensations into Beauty.[91]

Denis here called "sensations" what others were calling "impressions," both terms referring to the vision that actualizes a *personal* ideal. And when Denis spoke of the "Beauty" that may result from vision represented by

purely "pictorial means," he referred to an eternal and *universal* ideal. The symbolist is praising a group of painters for their conversion of personal vision into universal art.

Did the impressionist artist seek a goal analogous to the symbolist's? He also made manifest an ideal, although Zola and other critics usually emphasized this ideal as a sign of individuality, not universality. Yet there is also the impressionist's "effect" (*effet*) to consider, the objectification of his impression of nature (see above, "The 'Impression' "). Supposedly, the effect was true to nature, something anyone would be able to see if his vision were liberated from the constraints of convention and prejudice. While the impressionist's ideal varied with the individual personality, his representation of nature—the effect—paradoxically assumed a universal validity. In this sense, impressionist art, during the period of its currency, was interpreted as *both* subjective and objective. The truth of the ideal depended (so it seemed) on the artist's intangible sincerity, whereas the truth of the effect depended on his science. Consequently, in the writings of Zola and others, critical evaluations of technique were at times directed toward establishing proof of the artist's sincerity (by way of references to spontaneity, awkwardness, avoidance of academic convention, and other general qualities), and at other times directed toward establishing proof of his fidelity to nature (by way of references to bright color, atmospheric unity, and other specific features). In either case, the nature of the impressionist's expression, like the symbolist's, was known by way of his technical procedure. Impressionism and symbolism shared an end, but reached it by different technical means.

The relationships among the most important concepts that have been discussed thus far can be translated into a simplified graphic form to illustrate the manner in which they were regarded by both impressionists and symbolists. The concepts are these: temperament (*tempérament*), nature (*nature*), emotion (*émotion*), impression (*impression*), technique or means of expression (*les moyens d'expression*), ideal (*idéal*), effect (*effet*).

In the diagram, the arrows indicate that both emotion and impression were considered as products of the interaction of temperament and nature, self and world (or, in Littré's terminology, self and nonself). Temperament and nature usually were regarded as preexisting givens, fundamental entities, subject and object (although if known only in their interaction, their "preexistence" becomes

problematic). Emotion and impression exist in the realm of human experience. Both the impression and its attendant emotion—for Taine, the priority could be reversed—appear immediately or spontaneously to the individual. They cannot be separated one from the other.[92] They appear as the truths of immediate personal experience and are otherwise known by a single term, *sensation*. Sensation signifies both emotion and impression.

In the graphic representation, technique or the "means of expression" occupies the central or mediate position, serving as the means to the end. Impressionism and symbolism may be conceived as analogous theories or modes of expression, differing primarily in the role they assign to mediation, to technique. Clearly, both impressionists and symbolists employ technique to perform expression. The artist's technique or means of expression was regarded as a system of signs, perhaps merely a collection, capable of translating, expressing, or making manifest the immediate truths of emotion and impression.[93] The arrows indicate that artistic expression takes the dual form of ideal and effect, both of which constitute the work of art, or the (conventionalized) communication. One can discover universal truth in both the ideal and the effect: the ideal is verified through intuition (all may respond to it), and the effect is verified through attending to the empirical (all may observe it).

In the diagram, the top group of elements—temperament, emotion, ideal—are "internal" and constitute an image of the self; they relate to mental, psychic, or imaginative activity. The bottom group of elements—nature, impression, effect—are "external" and form an image of the world; they relate to physical or sensory activity.[94] The elements located "before" the means of expression—emotion and impression—are individual, subjective, and private; those located "after"—ideal and effect—are (if the work of art is optimally successful) universal, objective, and public.

Relationships between elements in the diagram hold true for both impressionists and symbolists, with differences only of emphasis. For both groups, the distinction between internal and external was of great significance: while impressionists tended to regard their impressions of nature as the primary source of their art, symbolists looked to their internal emotional experience as the origin and stressed an expression of the ideal, often belittling the significance of the effect.

The symbolists' concentration on emotion and internalized psychic life led them often to criticize impressionist art as materialistic because of its apparent concern with the pure impression, the sensory response to the external environment. Characteristically, however, the symbolists excluded from their harshest criticism independent impressionists such as Monet and Cézanne, for they recognized in them a sympathetic subjectivity. In any event, the artist to be condemned beyond all others

was he who simply registered natural phenomena like a photographic plate—his "impression" was not a felt, human one but mechanical, the result, as it were, of an external process. "In art," the symbolist poet Charles Morice wrote in 1889, "there is no external truth." The work of art begins, Morice argued, with the departure from external appearances,

according to the predilections of [the artists'] temperaments . . . [according to] the feeling of the artist, the personal impression he receives of universal nature. . . . [Things] have truth only in him, they have only an internal truth [vérité interne].

Morice linked internalized experience to an abstracted style and a visionary art.[95] We can see nonetheless how closely both the language and the import of his formulation accord with impressionist theory.

The liberating, internalized experiences that the symbolists sought included dreams, mystical visions or revelations, and the apperception of universal principles or harmonies underlying all significant sensation. For the symbolist the dream was as real as anything else, perhaps more intensely real because of its seeming independence from other phenomena of experience. At any rate it was, as Gustave Kahn wrote, "indistinguishable from life." Kahn explained that the symbolists wished to replace the naturalistic examination of the environment with the study of "all or part of a brain." The artist's psychological reality, rather than the assumed reality of an external world, was to be the subject matter of symbolist art.[96] The symbolists therefore emphasized the expression of emotion generated primarily from within, whereas the impressionists, *to the extent to which they were directly associated with "naturalism,"* were identified with an impression generated from without, albeit emotionally charged and varying according to the individual temperament. Indeed, this was the essence of the argument Aurier made in 1891 in order to distinguish Gauguin as symbolist from the impressionists with whom he often was linked: the label "impressionist" should be applied only to those concerned to render "an exclusively sensory impression," not to those seeking to present internalized "ideas" by way of external manifestations of correspondence or analogy.[97] And with regard to the dream, Aurier asked this confounding question, "Is a literature of the dream not a literature of true life, of real life, as much as is realism?"[98]

Aurier was well versed in those contemporary theories of psychology and physiology (temperament) that contributed to the formulation of both the impressionist and symbolist positions. Of particular interest to symbolists were studies of abnormal states of consciousness, which empirical psychologists regarded as invaluable guides to normal psychic life. One investigated dreams and various states of illusion to uncover aspects of the mind not manifest under ordinary circumstances. Ironically, the most

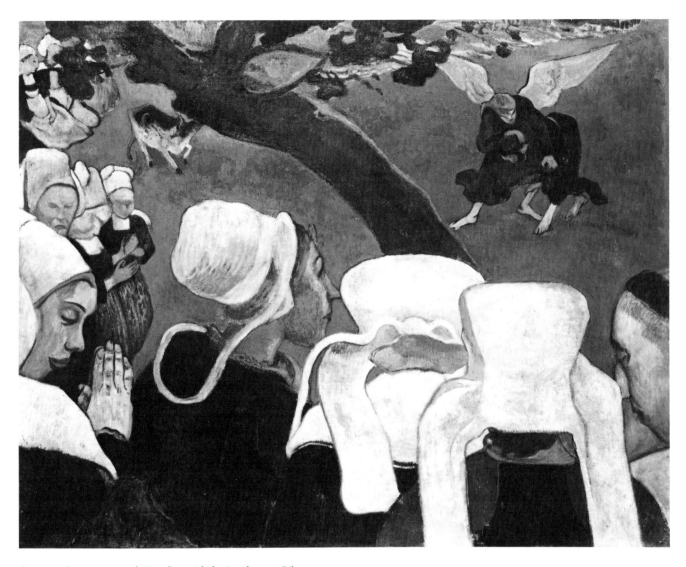

fig. 12 Paul Gauguin, *Jacob Wrestling with the Angel*, 1888. Oil on canvas, 28¾ x 36¼ in. (73 x 92 cm). National Gallery of Scotland, Edinburgh

influential account of abnormal psychological states came from Hippolyte Taine, whom the symbolists vilified for the deterministic views expressed elsewhere in his work. In *De l'intelligence*, Taine sought to demonstrate that a dream or illusion, in terms of the physiology of psychology, was just as real as any other conscious experience. He argued that perception had three components: (1) a mental image, labeled the "hallucination," (2) an antecedent sensation or activation of the nervous system; and (3) a more remote antecedent, an external object corresponding to the hallucinated image. His crucial observation was that the external object need not exist—sensation and a resultant hallucination could be generated from within. Taine stated that subjects are capable of sensation or feeling without the presence of

that which they imagine themselves to feel, and yet such a sensation seems no less vivid than any other. In the case of most everyday experiences, actual objects or events correspond to one's conscious "hallucinations," and such "true" hallucinations can be verified through continuing contact with the external world. But "false" hallucinations, generated, say, by dreams or hypnosis, are not subject to verification. Yet these two kinds of perception, *as immediate experience*, are indistinguishable. Taine chose his terms in such a way as to call attention to the unsettling fact that all consciousness is hallucinatory and that distinctions between normal and abnormal states of consciousness are not immediately apparent: "Our external perception is an internal dream which is found in harmony with external things; and instead of

saying that hallucination is a false external perception, it is necessary to say that external perception is a *true hallucination.*"[99] In sum, the "positivist" Taine presented an image of a world in which dream and reality seemed to merge in the mind, much as the "idealist" Gustave Kahn did later when he asserted that the dream was "indistinguishable from life."

Albert Aurier criticized Taine's method of analyzing art and yet treated perception in a manner reminiscent of the "determinist."[100] His defense of Gauguin is typical in this respect. Aurier noted that when the public would be confronted by works such as *La lutte de Jacob avec l'ange* (which he himself described as an imaginary "vision" called up by a priest's oratory, *fig. 12*), it would accuse Gauguin of painting "impressions that no one could ever have experienced." The critic argued that the public's mistake was to assume that artistic expression must be generated by material reality. Instead, the greatest art always expresses an inner mystical vision—Gauguin should not be compared to impressionists in search of a transient external reality, but to an "inspired hallucinated" mystic, Swedenborg.[101]

In referring to Swedenborg's hallucinatory vision, Aurier may have reflected back on the hallucinations of Taine's *De l'intelligence*, but he also raised the issue of the correspondences that the mystic had sought to discover, the immutable relationships between abstract ideas, human emotions, and expressive sensory phenomena (sounds, colors, smells, etc.). If such absolute correspondences existed, they would be the foundation of an ideally expressive artistic technique that would provide the desired bridge between an individual emotion or impression and an ideal or effect of universal significance. Here, the relationship between sign and "meaning" would not be arbitrary and conventional, but natural and originative. And through the conception of the search for the necessary technique or means of expression, we encounter another broad area in which impressionists and symbolists show related, but differing, concerns.

The impressionist sought a technique or means of expression that would convey his own spontaneity, originality, and sincerity; above all he wished to avoid traditional academic conventions because they would link his art to a communal school rather than to a unique temperament. Through his radical naturalism he could express his individuality; painting in outdoor light was itself considered an unconventional undertaking for which there were few predetermined rules of procedure. If impressionist technique, judged by comparison of one painting to another, appeared inconsistent or haphazard, little was lost—this could be taken as a further indication of the idiosyncrasies of the spontaneous impression. Artistic truth might be guaranteed more by the suggested sincerity of the technical procedure than by any claim

fig. 13 Gustave Moreau, *Salomé*, 1876. Oil on canvas, 56⅝ x 41 in. (143.8 x 104.1 cm). The Armand Hammer Foundation

that technique might have to accuracy of representation or precision of communication.

The symbolists, on their part, concentrated much more on the character of the final artistic expression and on its potential for communication; this is why they criticized their impressionist predecessors for a thoughtless choice of subjects and an incoherent manner of rendering them. They believed that the expressive power of technique was crucial, and this concern led them to oppose symbol to allegory. In their view, an art of the symbol was one of style and expressive *form*, whereas allegorical expression remained bound to the use of conventionalized subject matter. Allegory could neither be as personal as the symbol (because it was conventional rather than individual) nor could it be as universal (because it demanded acquired knowledge of the particular cultural tradition to which the allegorical figure belonged). Hence, Denis, for example, would exclude Gustave Moreau (*fig. 13*) from the ranks of the true symbolists, even though scholars today often interpret his imagery as characteristic of symbolism. For the French symbolists of 1890, Moreau worked in an allegorical

fig. 14 Vincent van Gogh, *Portrait of Eugène Boch*, 1888. Oil on canvas, 23⅝ x 17¾ in. (60 x 45 cm). Musée d'Orsay (Galerie du Jeu de Paume). Photo: Cliché des Musées Nationaux

directness—yet another aspect of their concern for an unconventional rendering of the spontaneous impression. And like the symbolist, the impressionist thought of his painting in terms of the elements of perception, especially color, out of which a whole would be formed. He never focused on discrete objects, nor observed their color merely to represent them in isolation. He regarded nature *in its entirety* as a stable reference that supplied a sense of permanent universal content; the painter would achieve an individualized image of this external world, "nature seen through a temperament." The symbolists, however, believed that the permanent reference was the human spirit itself, not something outside it. They often conceived of this human spirit as integral with a universal world-spirit, and any feelings common to all humankind (and to the world) commanded more importance for them than those attributed only to specific individuals. For the symbolists, the means of expression (the objective means of communication) was the universal language to which all minds could respond. To repeat one of their most significant points: their language was one of formal elements rather than of the complex images of either realism or allegory.

In the search for direct and elemental expression, impressionist and symbolist techniques might seem to converge. Thus, Aurier could argue that subjective distortion (the mark or form of a temperament) appeared itself as a kind of symbol—it referred directly to and revealed an essence, the state of being of the artist's mind.[106]

A Critical Impasse and a Convergence of Ends

Regardless of the number of fine distinctions that can be drawn between the impressionist and symbolist conceptions of artistic expression and the points of their intersection that can be defined, the issue of their relation remains perplexing. I believe the artists themselves were often confused, not so much about their actual practice but in their ancillary theorizing. In 1888, for example, van Gogh wrote that he

should not be surprised if the impressionists soon find fault with my way of working, for it has been fertilized by Delacroix's ideas rather than by theirs. Because instead of trying to reproduce exactly what I have before my eyes, I use color more arbitrarily, in order to express myself forcibly. Well, let that be, as far as theory goes. . . . Van Gogh went on to discuss three portraits that he wished to paint as he "felt" them—with unusually bright colors (cf. *fig. 14*).[107] Should we conclude that he chose to stress his emotion rather than his impression?

Van Gogh's commentary raises two significant problems. First, both impressionists and symbolists conceived of the artistic process very much as Delacroix did, van

mode and could only be regarded as an interesting predecessor who had broken away from the more traditional academic themes. Moreau's form remained in the shadow of his subjects.[102]

Artists and critics repeatedly described the formal language of expression that the symbolists sought as if it were to be truly universal and elemental. As universal, it would be both ubiquitous and eternal—found in the past through tradition, as well as in the present through empirical psychophysical research.[103] As elemental, it would appear in things simple or primitive. Accordingly, the symbolist painter Paul Sérusier spoke of "creating a language by purely formal means [of line and color], or rather rediscovering the universal language," the expressive means of past cultures, including the primitive ones.[104] Similarly, Gauguin, in an elaborate metaphor, compared his art to a primitive Oceanic tongue: in such a language elements common to all languages were plainly discernible, unlike the modern European languages, where the roots of words were obscured.[105]

The impressionists may not have seemed to employ a basic formal code, but they, too, admired simplicity and

fig. 15 Claude Monet, *Haystack in Winter*, 1891. Oil on canvas, 25¾ x 36⅛ in. (65.4 x 92.3 cm). Courtesy, Museum of Fine Arts, Boston. Gift of the Misses Aimee and Rosamond Lamb in Memory of Mr. and Mrs. Horatio A. Lamb

Gogh appears to have exaggerated the extent to which the impressionists ever thought they could either render nature exactly or eliminate personal expression from their work. Second, one must wonder how van Gogh could differentiate his own emotional expression from the mere reproduction of what he saw—if indeed an individual's vision, as both impressionists and symbolists held, expresses his individual temperament. Perhaps van Gogh, in aiming for expression, only reached an end to which impressionism itself would lead.

The writer and critic Octave Mirbeau had this problem of expression in mind when he published an article on van Gogh in 1891, not long after the artist's death. Mirbeau associated art with artifice, and he stressed the fact that van Gogh seemed to have imposed his will on nature instead of merely experiencing nature. He made a distinction similar to the one symbolist critics made between subjective and objective distortion, the former passive and automatic, the latter active and willful. He wrote that van Gogh, who accentuated his stylistic elements "to the point of signifying the symbol,"

did not allow himself to become absorbed into nature. He had absorbed nature into himself; he had forced her to bend to his will, to be molded to the forms of his thought, to follow him in his flights of imagination, to submit even to those distortions [déformations] *that specifically characterized him. Van Gogh had, to a rare degree, what distinguishes one man from another: style . . . that is, the affirmation of the personality.*[108]

In the same month that he published his article on van Gogh, in praise of a personal expressive style, Mirbeau wrote analogously of his intimate friend Claude Monet (*fig. 15*), but referred in this case to the expression of a pantheistic dream-vision: "The landscapes of Claude Monet are, so to speak, the illumination of the states of consciousness of the planet, and the supersensible forms

of our thoughts." With Monet, as with van Gogh, expression takes precedence over representation and, in Mirbeau's words, "dream becomes reality."[109]

The paintings that van Gogh and Monet produced around 1890 have their own special character and may well evoke a description of formal elements different from that to be drawn from impressionist works of the 1870s. Yet it seems that Mirbeau arrived at his critical station not by way of a discerning vision, but by following the shortest route left open in a continuing discussion of artistic expression. The debate that enmeshed Mirbeau was perennial; it had its modern origin in the question of romantic subjectivity and its somewhat skewed restatement in Zola's definition of naturalism and impressionism. By 1890 any short routes through the critical maze were no longer easy to discover. To complicate matters and to make final distinctions difficult, impressionist painters and critics had usually spoken of expressing *emotions* as well as impressions.[110] And, as Aurier wrote as if in a state of exasperation, insurmountable obstacles would face the critic who attempted to determine whether a particular artist had represented external nature with objective accuracy; nor did the hypothetical artistic act seem at all possible.[111] Indeed, for Aurier and his contemporaries, artists *could not fail* to be subjectively expressive, even if only passively so.

Yet art was also always objective since some communicable purpose was presumed to underlie the artist's choice of technical procedure. Nineteenth-century critics (including both Zola and Aurier) recognized that technique can never be entirely uninformed or unintended; it cannot be found, but must be made. Although the visual evidence of an impressionist work might lead a critic to judge the painter "innocent" of most of the conventions of his inherited cultural tradition, such an evaluation would result only if the critic were convinced that the artist had indeed taken a radically naive approach to representing his impression of nature. But the impressionist would have worked actively to give the appearance of this kind of passivity. To attain his goal, he would have depended on the skillful use of his technique to convey his intention, an intention to convey no intention, to have no preconceptions, perhaps even to be "absorbed by nature." The painter's expression of innocence or naivete would have to be *technically proficient*.

Hypothetically, any genuinely innocent or radically original artist works independently of others, perhaps as removed from the institutions of a modern society as a naive or a primitive. He is thus in a position to render truths that he alone can know; others, not sharing his experiences, may not be able either to discover these truths or to comprehend them. But if others do comprehend, if wholly effective communication is achieved, the artist who claims a naive and original vision—the impressionist—through an independent struggle to express himself, to paint "what he sees," comes in effect to express universal truths, truths recognized by all others. Such an artist is a symbolist. The impressionist, while not sharing the symbolist's initial aim, might be seen as attaining the symbolist's end. Conversely, the fact that Monet—or van Gogh—may appear as a symbolist does not preclude his remaining an impressionist. By this reasoning, the distinctions between impressionism and symbolism do not become irrelevant; but in some, even many, cases, these general categories converge or simply collapse.

Notes

A note on capitalization: This essay investigates the *concept* of impressionism across the fields of several discourses, including criticism, esthetics, and psychology. My use of the terms *impressionism/impressionist* most often extends beyond identification with specific individuals. Because I wish to stress this aspect of my study, I have chosen not to distinguish between the use of these terms as proper or common nouns. The same decision applies to words such as *symbolist, naturalist, realist,* and *romantic.*
All translations are author's unless otherwise noted.

1. A third meaning of *end*, "result," conveys aspects of both termination and purpose. For a refined version of the traditional account of impressionism's shift from observation to expression, see George Heard Hamilton, *Claude Monet's Paintings of Rouen Cathedral* (London, 1960), 13. The period of impressionism's end usually is defined as the late 1880s.

2. Two earlier versions of this essay have appeared: as "The End of Impressionism: A Study in Theories of Artistic Expression," *Art Quarterly,* n.s. 1 (Autumn 1978):338–378; and, considerably expanded, as chapters 1–5 of *Cézanne and the End of Impressionism* (Chicago, 1984). In the present version I have attempted to make the main line of argument all the more apparent by eliminating a number of secondary issues. I have kept references to recent art-historical literature to a minimum and have deleted most citations to supporting primary sources from the endnotes. Such material can be found in the corresponding sections of *Cézanne and the End of Impressionism.*
During the past decade, a number of art-historical studies have independently offered perceptive accounts of the symbolist qualities evident in later impressionism. However, the extent to which such qualities must also be brought to bear on the interpretation of *early* impressionism remains largely unrecognized. Critics and historians have persisted in contrasting early styles to late ones and have, at the same time, endorsed the notion of an artistic evolution from materialism to spiritualism. They appear reluctant to give up such formulaic appreciations, and this tendency has been reinforced by a number of broad surveys of intellectual history relating the demise of French positivism. One very significant exception (unknown to me in 1978) is Philippe Junod, *Transparence et opacité* (Lausanne, 1976). Junod exposes the false character of the conventional dichotomy realism/idealism (or naturalism/symbolism) within the modern history of the visual arts.

3. Jules Antoine Castagnary, "L'exposition du boulevard des Capucines: Les impressionnistes," *Le Siècle,* 29 April 1874, reprinted in Hélène Adhémar and Sylvie Gache, "L'exposition de 1874 chez Nadar (rétrospective documentaire)" in *Centenaire de l'impressionnisme,* exh. cat. (Paris: Grand Palais, 1974), 265.

4. Louis Leroy, who had published a satirical review of the exhibition four days previously in *Le Charivari*, generally is credited with having introduced the term *impressionist* in print.

5. See Lionello Venturi, "The Aesthetic Idea of Impressionism," *The Journal of Aesthetics and Art Criticism* 1 (Spring 1941):34–45; John Rewald, *The History of Impressionism* (New York, 1961), 338. Venturi and many others call upon the opposition of appearance to reality. This is only of limited usefulness; see Richard Shiff, "Review Article," *The Art Bulletin* 66 (December 1984):686–687.

6. According to Castagnary, art should allow a society to become consciously aware of its own nature, aims, and accomplishments. Romantic art could not aid in this project; often it was "somnambulistic." Naturalist art, however, was "truth in balance with science." See Jules Antoine Castagnary, "Salon de 1863," *Salons,* 2 vols. (Paris, 1892), 1:102–104.

7. Castagnary, "Les impressionnistes," 265.

8. On the development of French symbolist art, see John Rewald, *Post-Impressionism from van Gogh to Gauguin* (New York, 1962); and Sven Loevgren, *The Genesis of Modernism* (Bloomington, 1971). For a brief account, see Shiff, *Cézanne and the End of Impressionism,* 5–7.

9. Albert Aurier, "Les peintres symbolistes" [1892], "Meissonier et Georges Ohnet" [1890], *Oeuvres posthumes* (Paris, 1893), 306, 297, 322.

10. See Maurice Denis, "Le Salon du Champ-de-Mars; L'exposition de Renoir" [1892], *Théories, 1890-1910: Du symbolisme et de Gauguin vers un nouvel ordre classique* (Paris, 1920; 1912), 19.

11. The most significant among them are Pierre Francastel, *L'impressionnisme: Les origines de la peinture moderne de Monet à Gauguin* (Paris, 1937); Steven Z. Levine, *Monet and His Critics* (New York, 1976); Grace Seiberling, *Monet's Series* (New York, 1980).

12. See Shiff, *Cézanne and the End of Impressionism,* 162–219.

13. André Mellerio, *Le mouvement idéaliste en peinture* (Paris, 1896), 13, 26.

14. Pissarro to his son Lucien, 21 November 1895, in Camille Pissarro, *Lettres à son fils Lucien,* ed. John Rewald (Paris, 1950), 390. Emile Bernard also referred to an ideal combination of the naive and the refined; see his "De l'art naïf et de l'art savant," *Mercure de France,* n.s. 14 (April 1895):86–91.

15. Mellerio, 65, 67.

16. Gustave Geffroy, "Les meules de Claude Monet" [1 May 1891], *La vie artistique,* 8 vols. (Paris, 1892-1903), 1:26–29.

17. Georges Lecomte, "Des tendances de la peinture moderne," *L'Art Moderne* [Brussels] 12 (21 February 1892):58; *L'art impressionniste, d'après la collection privée de M. Durand-Ruel* (Paris, 1892), 260–261. Lecomte's interpretation of the historical development of impressionist painting may represent his critical formulation of some of Pissarro's views.

18. The most significant exceptions are Pierre Francastel (*L'impressionnisme,* esp. 92–94), Robert Goldwater ("Symbolic Form: Symbolic Content," in *Problems of the 19th and 20th Centuries: Acts of the XX International Congress of the History of Art* [Princeton, 1963], 4:111-121), and Philippe Junod (*Transparence et opacité*).

19. Lecomte, "Des tendances de la peinture moderne," 58; *L'art impressionniste,* 261.

20. See Loevgren, chap. 1.

21. Théodore Véron, *Salon de 1875: De l'art et des artistes de mon temps* (Paris, 1875), 35.

22. Frédéric Chevalier, "L'impressionnisme au Salon," *L'Artiste* (1 July 1877):32–39.

23. Henry Houssaye, "Le Salon de 1882," *Revue des Deux Mondes,* 3d ser. 51 (1 June 1882):563.

24. See Paul Mantz, "Salon de 1872," *Gazette des Beaux-Arts,* 2d ser. 6 (July 1872):45.

25. Théodore Duret excluded Lépine for just this reason; Théodore Duret, *Histoire des peintres impressionnistes* (Paris, 1906), 42–43.

26. See Charles Bigot, "La peinture française en 1875," *La Revue Politique et Littéraire,* 2d ser. 8 (7, 15 May 1875):1062–1068, 1088-1093; Houssaye, 561–586. For a detailed account of the theory and practice of impressionist technique, see Shiff, *Cézanne and the End of Impressionism,* 70–123, 162–174, 187–219.

27. Castagnary, "Les impressionnistes," 265.

28. Théodore Duret, "Les peintres impressionnistes" [1878], *Critique d'avant-garde* (Paris, 1885), 64–69; Georges Rivière, "L'exposition des impressionnistes," *L'Impressionniste, Journal d'art* (6 April 1877):3, 5. Rivière (5) offered this gloss on one of Monet's images of the Gare Saint-Lazare: "In viewing this magnificent painting, one is seized by the same emotion as before nature, and this emotion is perhaps even stronger, because the painting bears that of the artist in addition."

29. Emile Zola, "Mon Salon" [1868], *Mon Salon, Manet, écrits sur l'art,* ed. Antoinette Ehrard (Paris, 1970), 160. Cf. Duret, "Les peintres impressionnistes," 65–66.

30. See François-Xavier de Burtin, *Traité théorique et pratique des connaissances qui sont nécessaires à tout amateur de tableaux* (Valenciennes, 1846; Brussels, 1808), 45. The related technical definitions of the word *impression* from the fields of printing, dyeing, and photography also refer to primacy.

31. Emile Deschanel, *Physiologie des écrivains et des artistes, ou essai de critique naturelle* (Paris, 1864), 9.

32. Albert Boime, *The Academy and French Painting in the Nineteenth Century* (New York, 1971), 170. Cf. Félix Bracquemond, *Du dessin et de la couleur* (Paris, 1885), 139: "The effect is the single end of art. This word signifies sensation first of all, a perceived impression." (It is important to note that the effect could be associated with either the *natural* scene or the *painted* scene as an external object of one's vision.)

33. Boime, 172.

34. See the account given in Jules Lachelier, "Psychologie et méta-physique" [1885], *Du fondement de l'induction, Psychologie et méta-physique, Notes sur le pari de Pascal* (Paris, 1916), 104–107.

35. Pierre Larousse, *Grand dictionnaire universel de XIX^e siècle* (Paris, 1873), 9:604; Emile Littré, *Dictionnaire de la langue française* (Paris, 1866), 3:38.

36. Emile Littré, "De quelques points de physiologie psychique" [1860], *La science au point de vue philosophique* (Paris, 1876), 312, 314.

37. Littré, 315.

38. See Georges Guéroult, "Du rôle du mouvement des yeux dans les émotions esthétiques," *Gazette des Beaux-Arts*, 2d ser. 23 (June 1881):537.

39. Fernand Caussy, "Psychologie de l'impressionnisme," *Mercure de France*, n.s. 52 (December 1904):628–631. Caussy considered the entire oeuvres of Monet and Renoir, not just the later works.

40. The two senses correspond roughly–but by no means entirely comfortably–with the traditional distinction between the *vrai* and the *vraisemblable*, the true and the seeming-true (probable, credible). There is correspondence also with the traditional distinction between the mechanistic "copy" (*vrai*) and the inventive, composite, idealized "imitation" (*vraisemblable*). See entries for *vérité* and *vrai* in Antoine Joseph Pernety, *Dictionnaire portatif de peinture, sculpture et gravure*, 2 vols. (Paris, 1781), 2:421–422, 433. For examples of the critical use of such terms, see Etienne Delécluze, "Exposition du Louvre, 1824," *Journal des Débats* (12 December 1824):3; Henri Delaborde, "Salon de 1859," *Mélanges sur l'art contemporain* (Paris, 1866), 133. On the "imitation" and the "copy," see Richard Shiff, "The Original, the Imitation, the Copy, and the Spontaneous Classic," *Yale French Studies*, no. 66 (1984):27–54.

41. Baudelaire spoke also of a third type of artist, neither "réaliste" nor "imaginatif," who simply conforms to established conventions and produces a false art. Charles Baudelaire, "Salon de 1859," *Ecrits sur l'art*, ed. Yves Florenne, 2 vols. (Paris, 1971), 2:36–37.

42. Eugène Fromentin, *Les maîtres d'autrefois* (Paris, 1876), 284–285.

43. Georges Lafenestre, "Le Salon de 1887," *Revue des Deux Mondes*, 3d ser. 81 (1 June 1887):604–606, 638–639.

44. Roger Marx, "Les Salons de 1895," *Gazette des Beaux-Arts*, 3d ser. 13 (May 1895):354–355.

45. Baudelaire, "Le peintre de la vie moderne" [1863], "Salon de 1859," *Ecrits*, 2:155, 25 (emphasis omitted).

46. Armand Silvestre, preface to *Galerie Durand-Ruel, recueil d'estampes gravées à l'eau-forte* (Paris, 1873), 23; Duret, "Salon de 1870," *Critique d'avant-garde*, 8. (Silvestre's essay was never actually distributed publicly.) Cf. also Edmond Duranty, *La nouvelle peinture: A propos du groupe d'artistes qui expose dans les Galeries Durand-Ruel*, ed. Marcel Guérin (Paris, 1946; 1876), 39–40, and in this catalogue.

47. Duret, "Salon de 1870," 41.

48. Zola, "Edouard Manet" [1867], *Ecrits*, 101–102. Georges Rivière similarly applied physiology and temperament to justify the impressionists' technical innovations: "In painting each one should have a particular coloring according to the eye he possesses"; Rivière, "Explications," *L'Impressionniste, Journal d'Art* (21 April 1877):3. For one of Zola's immediate precedents, cf. Deschanel, 249–250.

49. Zola, "Edouard Manet," 99. Zola's position seems to have been inspired, at least in part, by Hippolyte Taine; see Emile Zola, "M. H. Taine, artiste" [1866], *Mes haines* (Paris, 1879), 212–213.

50. Castagnary, "Salon de 1874," *Salons*, 2:179–180.

51. D. G. Charlton, *Positivist Thought in France during the Second Empire, 1852–70* (Oxford, 1959), 4–5.

52. Auguste Comte, *Discours sur l'ensemble du positivisme* (Paris, 1848), 276ff. Cf. Emile Littré, "Culture morale, scientifique, esthétique et industrielle" [1849], *Conservation, révolution, et positivisme* (Paris, 1852), 138–139. The views of Pierre-Joseph Proudhon are very similar; see James Henry Rubin, *Realism and Social Vision in Courbet & Proudhon* (Princeton, 1980), 90–99.

53. See Castagnary, "Salon de 1857," *Salons*, 1:4–11.

54. Pierre Petroz, *L'art et la critique en France depuis 1822* (Paris, 1875), 335–339.

55. See Zola's arguments against Taine on this issue: "M. H. Taine, artiste," 224–225.

56. See Linda Nochlin, *Realism* (Harmondsworth and Baltimore, 1971), 43; H. R. Rookmaaker, *Gauguin and Nineteenth Century Art Theory* (Amsterdam, 1972), 86; George Heard Hamilton, "The Philosophical Implications of Impressionist Landscape Painting," *Museum of Fine Arts, Houston, Bulletin* 6 (Spring 1975):2–17.

57. Thus, reviewers often treated Degas and Morisot more gently than Monet and Pissarro; see Roger Ballu, "L'exposition des peintres impressionnistes," *La Chronique des Arts et de la Curiosité* (14 April 1877):147. Despite the commonplace association of photography with excessive detail, within photographic commentary itself critics distinguished relatively subjective ("artistic") images from relatively objective ("documentary") ones, according to the same criteria applied to paintings.

58. Monet to Durand-Ruel, 12 January 1884, reprinted in Daniel Wildenstein, *Claude Monet, biographie et catalogue raisonné*, 3 vols. (Lausanne, 1974–1979), 2:232; cf. also Monet to Bazille, December 1868, Wildenstein, 1:425–426; Pissarro to his son Lucien, 22 November 1895, in Pissarro, *Lettres à son fils Lucien*, 391; cf. also the letter of 21 November 1895, 388.

59. Hippolyte Taine, *De l'intelligence*, 2 vols. (Paris, 1880; 1870), 1:7, 2:4–5. For a recent evaluation of Taine's influence, see Hans Aarsleff, "Taine and Saussure," *From Locke to Saussure* (Minneapolis, 1982), 356–371.

60. Jules Laforgue, "L'impressionnisme" [1883], *Mélanges posthumes, Oeuvres complètes* (Paris, 1919), 3:140–141.

61. Denis, "Préface de la IX^e exposition des peintres impressionnistes et symbolistes" [1895], *Théories*, 29; Maurice Denis, "Cézanne," *L'Occident* 12 (September 1907):120.

62. Eugène Véron, *L'esthétique* (Paris, 1878), xiv, xxiii–xxv.

63. Deschanel, 81–82; cf. also 10–11. On the basic temperaments, see Johann Caspar Lavater, *Essai sur la physiognomonie*, 4 vols. (The Hague, 1781], 1:262, 3:85–117; Stendhal [Marie-Henri Beyle], *Histoire de la peinture en Italie*, 2 vols. (Paris, 1929; 1817), 2:55.

64. Stendhal, 2:31. Cf. Deschanel, 242.

65. From Delacroix's notes; see Achille Piron, *Eugène Delacroix, sa vie et ses oeuvres* (Paris, 1865), 421.

66. Eugène Delacroix, "Questions sur le beau," *Revue des Deux Mondes*, 2d ser. 7 (1854):306–315, esp. 313.

67. Zola, "Mon Salon" [1866], *Ecrits*, 60. For Zola's definition of art in terms of nature and temperament, see his "Proudhon et Courbet" [1866] and "M. H. Taine, artiste," *Mes haines*, 25, 229. See also Zola to Valabrègue [1864], reprinted in *Correspondance 1858–71*, ed. M. Le Blond (Paris, 1927), 248. For a fuller account of the motivation behind Zola's evaluation of Manet, see Shiff, *Cézanne and the End of Impressionism*, 93–97.

68. Zola, "Edouard Manet," "Mon Salon" [1866], *Ecrits*, 99, 60.

69. Zola, "Edouard Manet," "Mon Salon" [1868], *Ecrits*, 100–103, 109, 142.

70. Zola, "Le naturalisme au Salon" [1880], *Ecrits*, 340, 342ff.

71. Zola, "Mon Salon" [1868], "Jongkind" [1872], *Ecrits*, 160, 192.

72. Zola, "Le naturalisme au Salon," *Ecrits*, 335–341.

73. Baudelaire, "L'oeuvre et la vie d'Eugène Delacroix" [1863], *Ecrits*, 2:291.

74. Antonin Proust, "Edouard Manet," *Revue Blanche* 12 (June 1897):427.

75. Stéphane Mallarmé, "The Impressionists and Edouard Manet," *The Art Monthly Review* 1, no. 9 (30 September 1876):119, 120, and in this catalogue.

76. Geffroy, "Histoire de l'impressionnisme" [1894], *La vie artistique*, 3:21.

77. Charles Bigot, "Jules Bastien-Lepage" [1885], *Peintres français contemporains* (Paris, 1888), 160–161, 175–176. (The critic seems here to reflect Hippolyte Taine's *Philosophie de l'art* [1865–1869].) Bigot's approval of Bastien-Lepage had its limits; he wrote that *Les foins* (fig.11) and other works failed to establish "a harmony between the human characters and the natural environment surrounding them" (182).

78. Sully-Prudhomme, for example, regarded awkward execution as a "guarantee of sincerity"; Armand Sully-Prudhomme, *L'expression dans les beaux-arts (1883)*, *Oeuvres de Sully-Prudhomme, vol. 5, Prose* (Paris, 1898), 22.

79. Maurice Denis, entry for 15 April 1903, *Journal*, 3 vols. (Paris, 1957–1959), 1:197.

80. Denis, "Aristide Maillol" [1905], *Théories*, 242.

81. Denis, "Cézanne" [1907], *Théories*, 254–255.

82. Denis, "A propos de l'exposition d'A. Séguin" [1895], *Théories*, 23.

83. Idem. Cf. also Denis, "De Gauguin et de van Gogh au classicisme" [1909], *Théories*, 267–268.

84. Aurier, "Le symbolisme en peinture: Paul Gauguin" [1891], "Les isolés: Vincent van Gogh" [1890–1892], "Les peintres symbolistes," *Oeuvres posthumes*, 208, 211, 215, 260, 297–298, 302.

85. Gustave Kahn, "Réponse des symbolistes," *L'Evénement*, 28 September 1886, quoted in Loevgren, 83–84.

86. Castagnary, "Les impressionnistes," 265; "Salon de 1863," *Salons*, 1:102.

87. Hippolyte Taine, "De l'idéal dans l'art" [1867], *Philosophie de l'art*, 2 vols. (Paris, 1893; 1865–1869), 2:258.

88. Baudelaire, "Salon de 1846," *Ecrits*, 1:199.

89. Cf. Hippolyte Taine, preface to second edition [1866], *Essais de critique et d'histoire* (Paris, 1892), vii–xxxii.

90. Sully-Prudhomme, *Oeuvres de Sully-Prudhomme*, vol. 5, 29, 31, 410–411.

91. Denis, "A propos de l'exposition d'A. Séguin," *Théories*, 23.

92. On this point, cf. Sully-Prudhomme, 31.

93. This is stated as if from within the system of beliefs that rendered such artistic "expression" efficacious. Elsewhere I argue that late nineteenth-century French painting "represented" its own expressive powers rather than actually attaining them. See Shiff, *Cézanne and the End of Impressionism*, 55–123.

94. The impression is conceived as external in relation to its attendant emotion. It is also readily conceived as external if specifically distinguished from a felt or perceived impression (cf. above, "The 'Impression'.")

95. Charles Morice, *La littérature de tout à l'heure* (Paris, 1889), 165–167.

96. Kahn, "Résponse des symbolistes," quoted in Loevgren, 83–84.

97. Aurier, "Le symbolisme en peinture: Paul Gauguin," *Oeuvres posthumes*, 208–209.

98. From an interview with Albert Aurier [1891], as quoted in Jules Huret, *Enquête sur l'évolution littéraire* (Paris, 1891), 132.

99. Taine, *De l'intelligence*, 2:7–13.

100. For Aurier's criticism of Taine, see his "Essai sur une nouvelle méthode de critique" [1892], *Oeuvres posthumes*, 176–195.

101. Aurier, "Le symbolisme en peinture: Paul Gauguin," *Oeuvres posthumes*, 205, 208–211.

102. See Denis, "Définition du néo-traditionnisme" [1890], "Le Salon du Champ-de-Mars; L'exposition de Renoir," *Théories*, 9–10, 17; and "L'époque du symbolisme," *Gazette des Beaux-Arts*, 6th ser. 11 (March 1934):174.

103. Denis made this point; see his "A propos de l'exposition d'A. Séguin," *Théories*, 23.

104. Statement by Paul Sérusier in Charles Morice, "Enquête sur les tendances actuelles des arts plastiques," *Mercure de France*, n.s. 56 (15 August 1905):544.

105. Gauguin to August Strindberg, 5 February 1895, published in *L'Ermitage* 15 (January 1904):79–80.

106. Aurier, "Les peintres symbolistes," *Oeuvres posthumes*, 298.

107. van Gogh to Theo, V. W. van Gogh, ed., *The Complete Letters of Vincent van Gogh*, trans. J. van Gogh-Bonger and C. de Dood, 3 vols. (Greenwich, Connecticut, 1959), 3:6–7.

108. Octave Mirbeau, "Vincent van Gogh," *L'Echo de Paris*, 31 March 1891, 1.

109. Octave Mirbeau, "Claude Monet," *L'Art dans les Deux Mondes* (March 1891), quoted in Levine, 118. Cf. Geffroy's similar commentary in "Les meules de Claude Monet," *La vie artistique*, 1:22–29. If Monet and Cézanne both experienced the critical fortune of being absorbed into a symbolist discourse, they differed in respect to the type of critic they attracted. Monet's inner circle of commentators was composed largely of literary figures who shared the artist's political liberalism and secular "pantheism." (Cf. Robert L. Herbert, "The Decorative and the Natural in Monet's Cathedrals," *Aspects of Monet*, ed. John Rewald and Frances Weitzenhoffer (New York, 1984), 160–179.) In contrast, Cézanne's major critics were painters (Emile Bernard and Maurice Denis) who were politically conservative and called for a return to traditional religious beliefs.

110. See Rivière, "L'exposition des impressionnistes," 5.

111. Aurier, "Les isolés: Vincent van Gogh," *Oeuvres posthumes*, 260.

The First Exhibition *1874*

fig. 15 Claude Monet, *Impression, Soleil levant (Impression, Sunrise, 1–98)*, 1873. Oil on canvas, 19 x 24⅜ in. (48 x 63 cm). Musée Marmottan, Paris. Photo: Routhier, Paris

The First Impressionist Exhibition in Context
Paul Tucker

In early May of 1867 Frédéric Bazille, the tall, bearded Impressionist from Montpellier, wrote to his parents with some disappointing news. "In one of my last letters," he said,

I told you about the plan of a group of young people to have their separate exhibition. With each of us pledging as much as possible, we have been able to gather the sum of 2,500 francs, which is not enough. We must therefore abandon our desired project. We will have to re-enter the bosom of the administration whose milk we have not sucked and who disowns us.[1]

Two years later, in 1869, after having one picture accepted to the annual Salon and one rejected, Bazille wrote his parents once more. "I will never send anything again to the jury," he declared. "It is really too ridiculous for a considerably intelligent person to expose himself to administrative caprice, especially if medals and prizes hold absolutely no interest." He claimed a "dozen talented people" agreed with him and that they had decided *that each year we will rent a large studio where we will exhibit our works in as large a number as we wish. We will invite any painters who wish to send us work. Courbet, Corot, Diaz, Daubigny and many others . . . have promised to send work and heartily support our idea. With these people, and Monet, the best of all of them, we are certain of success. You will see how much attention we will get.*

Anticipating raised eyebrows from his haute-bourgeois parents, he added, "Don't be concerned, I assure you I am being very reasonable. We are certainly in the right, and this is nothing more serious than a student revolt."[2]

Unfortunately, Bazille would never see this idea realized. The following year the Franco-Prussian War broke out; he enlisted and was killed at the battle of Beaune-la-Rolande on 28 November 1870. Four years later, what for his parents he could call a simple student revolt actually became one of the most famous events of modern art history. Organized by Pissarro, Monet, Renoir, and Degas, and presented under the auspices of a cooperative they founded entitled the "Société anonyme des artistes peintres, sculpteurs, graveurs, etc.," the "première exposition," as the catalogue described it, opened on 15 April 1874 at 35 boulevard des Capucines, in the former studios of the notorious photographer Nadar (*fig. 1*).

This First Impressionist Exhibition, as it soon would be called, only ran for a month. But when it closed on 15 May, history had been made. For the first time artists had banded together to show their work to the public directly without the sanction of the government or the judgment of a jury. Defying tradition and the authority of the administration, the participating artists quickly were recognized as the avant-garde, and their show became the touchstone for all such future Modernists' efforts.[3]

There are a few practical aspects to the exhibition to consider, and a number of questions that seem appropriate, particularly given the show's later notoriety. First, it

fig. 1 Nadar's Studio, 35 boulevard des Capucines, site of the First Impressionist Exhibition. Photo: Bibliothèque Nationale, Cabinet des Estampes

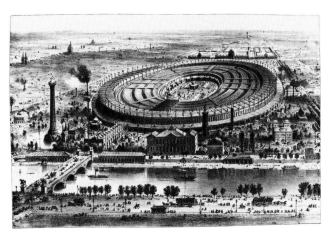

fig. 2 Provost, Universal Exhibition of 1867. The Champ de Mars seen from the Trocadéro, 1867. Lithograph. Photo: H. Roger Viollet

is interesting to note that seven years elapsed between the first idea for the exhibition and its realization. Why, we may want to ask, did it take so long; why did the idea even arise in 1867, and why did it come to fruition in 1874? Second, the idea seems to have been prompted by a shared disgust with the Salon and jury system. How widespread was the feeling, who shared it, and for what reasons? Also, was it the only or even the primary motivation for the show? Third, Bazille had suggested that established Barbizon artists and Courbet were to participate in 1867. Why didn't they in 1874? The catalogue for the show that year lists a host of other names that have long been forgotten. Indeed, the Impressionists who participated—Pissarro, Monet, Renoir, Degas, Sisley, Cézanne, and Morisot—were in the minority. Why was that the case and who were the other people? Finally, the show received a lot of critical abuse. Although some of it was typical Salon criticism—the artists could not draw, compose, or apply color—many negative remarks were so damning and so fraught with anger that they have become as famous as the artists and their work. More critics liked the show than not—a fact we tend to overlook—but why did some of them react so vehemently? Did it have something to do specifically with what they were looking at? Or was it also because of the time and place?

These are some of the points to explore, first by examining the origins of the show and the Impressionists' relation to the Salon, then by looking at the exhibition's historical context—what France and Paris were like in the early 1870s after the Franco-Prussian War of 1870–1871, and the ensuing Commune insurrection and civil war. It is then worth analyzing the criticism of the show particularly in relation to this context. For, as will become apparent, a familiarity with "l'année terrible," as Victor Hugo described the time between the outbreak

of the Franco-Prussian War and the bloody suppression of the Commune, is essential to understanding the First Impressionist Exhibition and the problems of French painting in the 1870s.

Bazille's first mention of an independent show, in 1867, came at a moment of considerable artistic activity in Paris. In addition to the Salon, which had become an annual event just three years earlier, the city was hosting a universal exhibition that was the first since the inaugural one in France in 1855. Visitors from around the world poured into the capital to view the exhibits of the dozens of participating countries (*fig.2*). They also would have been able to see a major exhibition of Ingres's work that had been mounted in the Ecole des Beaux-Arts. And beginning in the middle of May, they would have been able to take in Manet's and Courbet's one-man shows in the pavilions they had built near the Champs de Mars, the site of the World's Fair. Art dealers were staging special exhibitions in their galleries; two of them, Hagerman and Latouche, even showed recent works by Monet.

It is hardly surprising, therefore, that Bazille and his friends were interested in organizing an independent exhibition that year. They were part of a general trend, sparked particularly by the World's Fair and the thousands of tourists it attracted.

It so happens, however, that Bazille was rejected from the Salon of 1867 as were Monet, Renoir, Pissarro, Sisley, and Cézanne. Only Degas was accepted. Manet and Morisot had chosen not to send anything. The idea of a separate show, therefore, was equally tied up with the official apparatus for obtaining notice in the art world, as Bazille's letters implied, and for using such notice to sell work.

To justify their idea they could point not only to Manet and Courbet, but, as Albert Boime has made clear, to the Salon des Refusés of 1863.[4] As the first crack in the Salon system, it gave vent to important issues of individuality and independence, in terms not only of style and subject matter, but also of the artist's right to exhibit his work and to enter the art market. They also could point to the Salon des Arts Unis which had been mounted in 1861 by a number of accepted, conservative artists, Ingres among them, and to the time-honored practice of artists opening their studios to the public.[5]

But none of these matched up with what they envisioned, an exhibition open to all artists with the number of works limited not by jury or an administration, but by the size of the available space and the number of participants. Most important, perhaps, although no one would be excluded, those representing the latest developments in French avant-garde art would be the nucleus of the show.

It was a bold idea; at stake were their reputations and

fig. 3 Claude Monet, *Mouth of the Seine at Honfleur*, 1865. Oil on
canvas, 35¼ x 59¼ in. (89.5 x 150.5 cm). The Norton Simon
Foundation, Pasadena

their livelihoods. The fact that other artists such as Corot
and Daubigny, the leading landscape painters of the day,
supported the idea and were willing to lend pictures
undoubtedly was reassuring. They would give the show
breadth and credibility, but they could not guarantee its
success. Hope for such a result had to come from the art-
ists themselves through their works or, more specifically,
from their work in relation to what else was being
exhibited.

In 1867, however, the artists had enough confidence
to proceed with their plans, and with some justification.
All of them except Cézanne had been accepted to pre-
vious Salons, albeit inconsistently, and some had
received favorable notices. In 1865, for example, Paul
Mantz, writing on the Salon for the *Gazette des Beaux-
Arts*, was struck by Monet's *Mouth of the Seine at Hon-
fleur* (fig.3):

*The taste for harmonious color schemes, the feeling for
values, the striking point of view of the whole, the bold
manner of seeing things and of forcing the attention of
the spectator, these are qualities which M. Monet already
possesses in high degree. His* Mouth of the Seine *stopped
us abruptly and we shall not forget it. From now on we
shall certainly be interested in following the future
efforts of this sincere marine painter.*[6]

Even at the Salon des Refusés of 1863, Pissarro's land-
scapes could be singled out for praise by Jules Castag-
nary who four years later also called Degas "remarkably
gifted"; Degas's *Two Sisters* in the Salon of 1867 indi-
cated to Castagnary that the artist "has an exact feeling
for nature and life."[7]

There was some interest in the artists' work among
collectors as well, to be sure not a great deal, but perhaps
enough to nurture realistic hopes for a developing mar-
ket. Monet, for example, sold his 1866 Salon submission
of *The Woman in a Green Dress* to Arsène Houssaye, an
Inspector of Fine Arts and editor of *L'Artiste*, while
Renoir found a patron in the Le Coeur family of archi-
tects and artists.[8]

All of this contributed to their sense of self-worth and
allowed them to feel equal if not superior to their con-
temporaries at the Salon. They were not by any means
alone in this regard. Dozens of artists since the Salon des
Refusés of 1863 had sent letters to the Minister of Fine
Arts protesting their rejection and demanding either
another such Salon or permission to set up their own
shows.[9] In 1867 some artists protested so vehemently
about the selection of works for the Universal Exhibition
that complaints against them were filed with the Prefect
of Police in the area of the Palais de l'Industrie where the

annual Salon was being held. The protests came to naught, however, as the Superintendent of Fine Arts, the comte de Nieuwerkerke, refused all requests for counter-exhibitions.

Even those who did not get involved in formal action could be angered by the Salon jury. Cézanne's geologist-painter friend Fortuné Marion, for example, became so upset in 1866 that he suggested organizing a "rival exhibition" that would be "deadly competition for all those half-blind idiots."[10]

Those "idiots" came from the ranks of power in the system. In the 1860s, a quarter to a third of them were appointed by the government; the others were elected by artists who already had won medals or honors at previous Salons. They headed what in essence, therefore, was an insular, patronizing system that easily drew disdain.[11]

But what annoyed artists even more was the unpredictability of the jury. To be accepted one year and rejected the next, as in the case of Bazille and his friends, was extremely frustrating. On one level, the game had rules that were rigidly enforced; on another it appeared to have none at all. And on top of that, it was the only game in town and everyone, regardless of orientation, wanted to be part of it, even the Impressionists. Indeed, as Boime has pointed out, if some official system of Refusés shows had been permitted in conjunction with the Salon, the First Impressionist Exhibition might never have taken place. There would have been less need for it.

But that was not the case, and in 1868 they all returned to the Salon, this time with resounding success. Everyone except Cézanne, who would have to wait until 1882 to get in, had at least one painting accepted. Perhaps encouraged by these strides, they tried again in 1869

fig. 4 Eugène Médard, *The Deliverance, The Entrance of the Army into Paris, 21 May 1871.* Location unknown. Photo: The Witt Library

with mixed results. Monet, Sisley, and Cézanne were rejected outright; Degas, Pissarro, Renoir, and Bazille got in with one painting each; Morisot abstained. It was then that Bazille resolved never to send works again, although he broke his promise the following year, 1870. Once more he was accepted with everyone, except Cézanne who did not submit, and Monet whose rejection caused Daubigny as a member of the jury that year to resign in protest.

The Salon of 1870 barely had closed on 14 July when Napoléon III, goaded by Otto von Bismarck of Prussia and the famous Ems telegram into believing that a Hohenzollern German might be pushed onto the vacant Spanish throne, ordered French troops to arms. Bismarck did the same the following day. Five days later, on 19 July 1870, the Franco-Prussian War began. Defeat came swiftly to France—in a mere six months. But the memory of the humiliation haunted the country for decades and the conservative backlash that it produced played an important role in the critical reception of the Impressionists' exhibition. It is to that story, therefore, that we now turn.

At the outbreak of the war, Monet and Pissarro left for England, Sisley remained with his family in Louveciennes, Cézanne went into hiding in the south, Renoir was drafted into the cavalry, and Bazille enlisted in the Zouaves. Degas and Manet were beyond the legal age for military service but both of them later volunteered and went into the National Guard.

On 2 September, after having suffered one setback after another, Napoléon's army was defeated at Sedan, the last major field battle of the war. Napoléon was captured and the Prussians marched on Paris where from the surrounding hills they laid siege to the city for the next four months. It all ended on 18 January 1871, when William, King of Prussia, crowned himself Emperor of Germany in the Hall of Mirrors in the palace of Versailles, and ten days later forced France to sign a humiliating armistice in the same hallowed hall.

Seven weeks after that, on 18 March 1871, the country was torn from within. Insurgents in Paris, feeling the government had betrayed the nation, executed two army generals and established a radical Republican government that they called the Commune of Paris.

Their reign lasted only two months. In May 1871, from their base at Versailles, the former government's troops swept into Paris and with brutal force reclaimed the city under the watchful eyes of the Prussians (*fig. 4*).[12]

Without a doubt, the war, the Commune, and the resulting civil war were the most painful events in modern French history. There had been greater destruction, loss of life, and greater capital expenditures, but nothing in the past had so damaged the French psyche.[13] The apparent advances of the Second Empire since its founding in

fig. 5 The rue de Rivoli, May 1871. Photo: H. Roger Viollet

fig. 6 The railroad bridge at Chatou destroyed during the Franco-Prussian War, 1870. Photo: H. Roger Viollet

1852 – the growth of industry, the massive rebuilding of Paris, the rise in the standard of living, the accumulation of wealth, and the influence of French culture – were put into chilling perspective; it was as if they had been for naught. Although many Frenchmen were happy to see the end of what they felt was the decadence of the Empire, few would have traded it for the humiliation of the war. The decadence they could have improved; the humiliation was irreversible and could never be forgotten.

The cost of the defeat was staggering as set out in the terms of the treaty signed in Frankfurt on 10 May 1871. France had to pay Germany a five-billion-franc indemnity, absorb the expense of a German occupation army for three years, surrender two of her richest departments, Alsace and Lorraine, and allow the German troops to conduct a triumphal march through Paris.

The first two penalties were almost unfathomable; the latter were loathsome, excruciating, cold-blooded, and unforgivable. Little wonder that France would force Germany to sign the armistice for the First World War in the very Hall of Mirrors where her humiliation began.

After the civil war of the same year, it also was not surprising that one journalist could assert in a New Year's Day editorial of 1872 that

the year that has just ended will be for France one of the saddest and most painful. You have to go back five centuries in our history to find a year as ill-fated. . . . 1360 could be a match. . . . the treaty of Brittany to the treaty of Versailles.[14]

The analogy with the horrors of the Hundred Years' War, in which Britain brought France to her knees, was appropriate indeed.

Nothing seemed to have escaped the war or the Commune unscathed, particularly in Paris. "Destruction

everywhere," wrote one observer. "From the Châtelet to the Hôtel de Ville, all was destroyed."[15] He was not over-stating the case, as a view of the rue de Rivoli taken in 1871 reveals (*fig. 5*). And this was only part of the story. In addition to the Hôtel de Ville, lying in ruins were the Palais des Tuileries, the Conseil d'Etat, the Gobelins, the Bibliothèque du Louvre, the Ministère des Finances, the Préfecture de Police, the Cour des Comptes, the Palais de la Légion d'Honneur, the Théâtre-Lyrique, and parts of the Palais de Justice and the Palais Royal.[16] Bridges in and around the capital had been blown up (*fig.6*) while acres of the Bois de Boulogne had been stripped of their trees, as had long stretches of the newly planted boulevards. Outside the city, railroad stations and farmland had been destroyed, homes occupied, indemnities extracted, and people terrorized. Saint-Cloud had been particularly hard hit with its park ravaged and the royal château burned (*fig.7*). Everywhere shrapnel was more plentiful than meat, and prices of food and drink reflected post-war shortages.

"A silence of death reigned over these ruins," wrote Théophile Gautier in 1871. "In the necropolis of Thebes or in the shafts of the pyramids, it was no more profound. No clatter of vehicles, no shouts of children, not even the song of a bird. . . . An incredible sadness invaded our souls."[17]

It would take years to clear the rubble, lay the foundations, and raise the scaffoldings; years more, in some cases, to decide what to do; and decades to purge the French soul of its sadness – facts which must be kept in mind when considering the First Impressionist Exhibition.

But the country dug in and began the process with surprising speed and commitment, so much so that one

fig.7 A street in Saint-Cloud bombed by the Prussians, 1871. Photo: H. Roger Viollet

journal could optimistically assert in 1871 that, despite the destruction,

Paris is still Paris. It can revive and grow by the power of wisdom just like France as a whole. . . . By the end of the year, most of the damage [blessures] done to our monuments, our houses, and our buildings by the Prussians and the Commune will be hardly visible.[18]

That would not be the case, however. "We are far from being able to appear anything but a city partially destroyed and slowly rebuilding," wrote one observer a year later.

Besides the Tuileries, the Hôtel de Ville and other great buildings in Paris that have remained in the same or almost the same condition since the day after the Commune, you can still find destroyed houses and abundant proof of the extent of the damage. Can we efface this evidence quickly? We don't think so.[19]

Still, he had to admit that progress was made. A great deal of rubble had been removed throughout the city. The rue Royale, the rue Saint-Martin, and the avenue Victoria had been rebuilt. Part of the Palais de Justice had received a new roof, as had the Palais de l'Industrie, and the Palais de la Légion d'Honneur was on its way as well to being completely reconstructed.

The most impressive accomplishment, perhaps, was the fact that the country was able to pay the Germans the five-billion-franc indemnity in just two-and-a-half years, half the time the treaty had anticipated. The money came from the pockets of all Frenchmen in response to two bond issues floated by the government, the first in summer 1871, the second in spring 1872. The first was oversubscribed by two-and-a-half times the amount necessary, the second by thirteen times.

Despite this outpouring and the reconstruction that continued unabated in Paris, the capital contained ample

evidence of the recent disasters when the Impressionist show opened in 1874. Indeed, a tourist in April could take a tour of the city suggested by the *Gazette des Etrangers* and not see one monument or area that did not bear some witness to the war or the Commune.[20]

At the Louvre, for example, where one began, masons and painters were at work on the Galerie des Tuileries in the Pavillon de Flore, which had been burned when the Versailles army retook the city. The restoration of the Jean Goujon sculptures on the Pavillon de l'Horloge had recently been completed and new water reserves had just been installed underground by the front door of the museum, a precaution against any future incendiary attempts.

The Arc de Triomphe du Carrousel, which was being cleaned, was covered with scaffolding, as was the Vendôme column, the next stop on the tour (*fig.8*). The latter was being completely reconstructed, the government hoping to have it completed in May for a dedication ceremony on the 24th, the day three years earlier that the Communards had pulled it down. Then it was on to the Place de la Concorde where the statue of Strasbourg was draped with wreaths in memory of its loss to the Prussians with the department of Alsace. The tourist would have walked up the Champs-Elysées past newly planted saplings and a pavilion containing a panorama of the siege of Paris by the military painter Félix Philippoteaux. At the top of the avenue, the Arc de Triomphe was being cleaned and repaired, Rude's sculptures having suffered also during the storming of the capital by the Versailles troops. The next stop, the Bois de Boulogne, left little doubt about what had occurred several years earlier, as an army of gardeners was at work restoring it to its prewar beauty. And so the days would go, with the tour appropriately concluding with the ruins of the Tuileries Palace.

In addition to repairs, there were numerous plaques and monuments erected throughout the city in response to the disasters of 1870–1871. Perhaps the most prominent was the equestrian statue of Joan of Arc by Emmanuel Frémiet that was raised in the Place des Pyramides on 19 February 1874, two months before the Impressionists' show opened. The medieval heroine, dressed for battle and wielding a ten-foot-long staff, rode not insignificantly towards the ruins of the Tuileries on the other side of the street (*fig.9*). Individuals who had died in the war and the Commune also were recognized. Generals Lecomte and Clément Thomas, who had been executed by the insurgents in 1871, were given special tombstones in Père Lachaise a month after the Joan of Arc dedication. One month after that, on 25 April 1874, ten days after the Impressionist show opened, a monument was erected at the Ecole des Beaux-Arts to Henri Regnault, one of the most celebrated artists to be killed during the war.[21]

fig. 8 [Charles Marville], *The Vendôme Column during its Reconstruction, 1874*. Photo: La Bibliothèque Historique de la Ville de Paris

fig. 9 Drawing after Emmanuel Frémiet. *The Statue of Jeanne d'Arc in the place des Pyramides, 1874*. Photo: *Le Journal Illustré* (1 March 1874): 72

Outside the city, monuments dotted the suburbs; hundreds were erected throughout France between 1871 and 1874. Several even went up in Switzerland where French troops had taken refuge in the winter of 1870. Like Le Havre, some cities that had escaped destruction raised statues in thanks for their good fortune. Others, like Verdun, recovered the cannons used in battle and set them up in the squares in front of the town halls. One of the more ambitious undertakings was a national subscription for a huge lion that the sculptor Bartholdi offered to do for Belfort, a project that had not been realized by April 1874.[22]

Foreigners likewise were moved by France's misfortunes and responded. Americans held dinners during the war to raise money for their former ally and contributed thousands of dollars during the early seventies. In 1872 the Englishman Richard Wallace donated one hundred drinking fountains to Paris, many of which are in use today. And the following year John Wilson, the Paris-based art dealer, gave the Louvre its first paintings by Constable.[23]

The largest, longest, and most expensive project after the war was the construction of the basilica of the Sacré-Coeur. Royalists who had won a majority of seats in the

Assembly in the national elections of February 1871 pushed through a bill in mid-1873 that gave the Archbishopric of Paris the crest of Montmartre as the site for the church on the grounds of public utility.[24]

The competition for the building's design opened in February 1874. In July just after the annual Salon closed, eight hundred and ninety drawings by the seventy-seven entrants went on exhibition at the Palais de l'Industrie on the Champs-Elysées. Paul Abadie, the winner, was chosen by the end of the month and ground was broken. It took more than three decades and millions of francs raised primarily by the Church to complete the eclectic white structure, an extended labor and financial sacrifice that kept the war a continuing presence in the minds and pockets of devout French Catholics.

Sacrifice, of course, was what the church was all about, as Catholic clergy and laymen felt that the war and insurrection were God's punishment for the decadence of the Second Empire. Excessive concern for materialism and worldly power, in their opinion, had led the country from its proper Christian path. Everyone, now, was to rededicate himself to the sacred heart of Jesus and return to a strict morality. Such connections between recent events and undertakings in the arts should once

again be kept in mind when we come to the Impressionists' exhibition.

There was considerable opposition to this project, however, as many members of the Assembly and the public felt it improper for the government to be so closely aligned with the Church, and that "superstitious gestures" such as this were a "humiliation to the pride of a great people."[25] But many agreed that France had lost the war either because the government was corrupt, as Zola's *La Débâcle* continued to assert twenty years later, or because of flaws in the French character that the extravagances of the Second Empire had allowed to flourish. An editorial in *Le Siècle* of January 1872 noted that

1871 saw all of the consequences of the Empire unfold: Paris capitulating after a heroic resistance and our last forces conquered; France signing a peace treaty that wrenched two provinces from her and cost her 3 [sic] billion francs; a part of our soil condemned to suffer three entire years of occupation by the victors. And after the war? Civil war. Paris thrown back into a blood-bath . . .

fig. 10 Gill, *The Raft of the Medusa*, 1872. Photo: *L'Eclipse* (9 June 1872): 1

everywhere intrigue and discord, bearing witness to the moral ruin of the country and the debasement of souls.[26]

The dangers of this state had been noted in the late 1860s and warnings had been made about the possible ramifications. The war, of course, confirmed the worst fears. In the early 1870s many claimed that these same weaknesses were responsible for a host of disturbing problems.

In mid-1872, for example, the government published statistics about the fitness of young men called up for military service. Of the 325,000 who had reported in the last three years, only 108,839 were acceptable. "More than a quarter of the population," cried one conservative observer, "is composed of the handicapped and sickly bags of bones." Nature, in his opinion, was not just to blame; "public habits count a great deal in this sad situation."[27]

The seriousness of the problem was not to be underestimated, given the physical strength of the Germans and their greater numbers. Indeed, studies conducted in the early 1870s (and on through the nineties), which were always tellingly compared to similar studies done in Germany showing the opposite, showed an alarming drop in France's population.[28] Again, demographers had spoken about this situation in the 1860s. After the war, however, their figures took on a particular urgency and were seen, by conservatives at least, as further evidence of the country's moral decline.

Perhaps not surprisingly, given the physical destruction of the war, the Commune, and the evident need to reconstruct, there was a widespread appeal in the years after the armistice for a return to seriousness, diligence, morality, and patriotism. This call to order cut across political lines, although the ways of actually establishing such a state, and the form of government that France should have, remained a bitterly contested issue. Political caricaturists could satirize the struggle using the herald images of France's great artists (*fig. 10*), but the situation was real and led most people to believe that a commitment to honorable principles was critical to the health and future of the country. Indeed, only through a change of ways and a profound stock-taking, as the editor of *Le Siècle* insisted, could the nation pull itself out of the ruins of its recent past, recover, and advance.[29]

Everything was affected or colored by this effort. There were plays in 1872 like the musical *Paris chez lui en 1869* that portrayed the capital at the end of the Second Empire as the Babel that brought on the fall. There was a major crackdown on prostitution in Paris; in the last six months of 1871 the police arrested twice as many *coquettes* as they did during any year of the previous decade. There were innumerable books and poems published on the war, its aftermath, and what needed to be done. Many of these, like the articles in the popular press, were colored with chauvinism. In the case of one of

the most outspoken nationalists—Paul Déroulède, whose *Nouveaux chants du soldat* appeared in January 1872 and went through forty-nine editions by 1878—there were even outright calls for revenge.[30]

The fine arts were affected as well. Indeed, in many circles the arts were called upon to play an active role in the recovery process. Even the editor of the prestigious *Gazette des Beaux-Arts* could write the following in the first issue of the magazine after it resumed publication in 1871:

Today, called by our common duty to revive France's fortune, we will devote more attention to . . . the role of art . . . in the nation's economy, politics, and education. . . . We will continue to back the cause of beauty so closely aligned with the causes of truth and good. And we will struggle for the triumph of those teachings which will help the arts rebuild the economic, intellectual, and moral grandeur of France.[31]

He was not alone in his ambitions or in his view of art's role in the recovery. "Art is a soldier," wrote one critic in 1872. "It too has its battles to wage like the army. It should vie to regenerate spirits and to make France vigorous and strong once more."[32]

The mixture of nationalism, militarism, and esthetics was not at all uncommon in the early 1870s. One could hardly avoid it, given art's long-standing significance to France. "The country is wounded," observed one writer in late 1871, but "it is by the miracles of art that she will console herself. Nothing will be able to alter her domineering power over the souls of men because France will always be the first nation when it comes to the human spirit."[33]

Art, in fact, was the one thing that the country despite its ruinous condition could point to as unscathed and incontestably superior to that of other European countries. Indeed, Napoléon III's famous dictum, "A country is only as strong as the number of men it can put into uniform," would be considerably altered after the war. "A good book and a good museum do more for civilization than an army of a hundred thousand men," asserted one writer six weeks before the First Impressionist Exhibition opened.[34] The brass-buttoned jackets and tailored pants of the military were impotent, temporarily at least, so confidence had to come from other sources. And art was one of the most important.

The government recognized this and took appropriate measures. It first reviewed and reorganized the Fine Arts administration. The comte de Nieuwerkerke, the "Surintendant des Beaux-Arts et directeur général des musées nationaux" under Napoléon III, was replaced by the moderate Republican Jules Simon whose title was changed to "Ministre de l'Instruction publique, des Cultes et des Beaux-Arts." Charles Blanc, author and editor of the *Gazette des Beaux-Arts* and "Directeur de l'Administration des Beaux-Arts" between 1848 and

1852, was appointed "Directeur des Beaux-Arts" until December 1873 when conservative factions forced him to resign. He was succeeded by the aristocratic Philippe de Chennevières, who occupied the post for nearly a decade. In his first weeks on the job Chennevières established a Fine Arts Commission to advise him on a wide range of questions. Together they planned a reorganization of the administration of the national museums, which went into effect in March 1874. Two months later in May they ordered an inventory of the riches of France, an ambitious attempt to document every art object owned by the government throughout the country. At the same time in Paris, dozens of engravers were set to work copying paintings and sculptures in churches and public buildings in the city.[35]

In April 1874 Chennevières succeeded in getting permission to decorate the restored Palais de la Légion d'Honneur with history paintings that "would allow France to regain the level in the genre that it knew in the past." He was also responsible for an even larger project—the decoration of the Panthéon, one of the city's most important buildings. Here again, his intentions were nationalistic as he proposed subjects that would treat the religious history of France and the legend of Sainte Geneviève, the patron saint of Paris who had brought the city through the siege by the Huns in ancient times and, many claimed, watched over it during the recent attack by the Prussians. Not surprisingly, his proposal was widely praised despite the claims of one opposition paper that the building and French society were basically irreligious. On 6 March 1874, just as the Impressionists were attending to last-minute details on their show, Chennevières's proposal was approved and the selection of specific artists and subjects ensued.[36]

These projects were only part of a larger desire on the part of everyone in the fine arts to see France's hegemony reestablished. In order to accomplish this, however, many felt that art had to have certain characteristics: "Art must produce virile and grand works, worthy of the task in front of us, styles worthy of the terrible times we have come through and of the future that awaits us."[37]

Chennevières and others recognized that this kind of art was not just going to appear; it would be the result of study and hard work and, as one critic suggested, would stand in contrast to that of the previous decade:

Let's hope that with characters rebuilt by patriotism and with the fine arts renewed by long study, we will witness the production of elevated works unlike that which occurred under the Empire whose lush lifestyle threatened our complete downfall.[38]

This hope was tinged with the fear that the decadence of the Second Empire might linger and corrupt art at the very moment that the country needed moral leadership. *L'Artiste*, one of the leading contemporary art journals, was one of the most vocal organs for this fear. While

expressing confidence about France's artistic abilities, it explored in numerous articles the problems of making art in an age of materialism in the years just after the war. The basic assumption was that no great artist and no great work had emerged, despite the fact that France "possesses the most sophisticated tools, the willingness and the powers of execution."[39]

Once again, this problem had been discussed before the war. Critics then had held up various people, like Meissonier and Gérôme, as candidates for the title of "great artist," but it still was widely believed that French painting had failed to produce someone who could replace the recently deceased Delacroix and Ingres, to say nothing of David.

Explanations for the lack of great artists were not terribly imaginative, most returning to questions of rules and training. It was asserted that the ideal and quest for beauty, hard work, and perfection were not being sufficiently instilled or followed. The same reasoning was part of post-war explanations too, although the recent catastrophes had caused some conservative writers to assert that religion or the lack of it also was responsible. Comparing contemporary French art with the efforts of the ancient Greeks, for example, the critic Edouard L'Hôte in September 1871 felt the former was inferior because of contemporary atheism. The Greeks, in his opinion, "wanted to see and live with their gods. They imagined them to be pure and perfect," and thus created pure and perfect art. The atheism of the present, however, only produced "laziness, corruption, and degeneration."[40]

Less extreme and more complicated was the notion that art would be corrupted because it would respond too much to its market:

If mercantile instincts carry over into the feeling for the beautiful, if art comes to be no more than a courtesan interested in the crowd, if those who cultivate it consent to work on it more as bungling laborers than artists, then our decadence will be without remedy.[41]

The difficulty here was the fact that the artist had to have clients in order to survive, but that the clients having the money were, it seemed to many, negatively influencing production.

One of the most vigorous assertions of this point of view was made by Jules Fleuricamp in his discussion of the Salon of 1872. "The nineteenth century," he observed,

has no religious or historical aspirations. The kings of the era are the bankers, the businessmen, the head ministers, engineers, and architects, the secretaries of state, master masons, and subcontractors. They demand an art that is going to be like their art, the art of building railroads, stations, ballast beds, steam engines, miles of telegraph posts and wire.[42]

This did not mean that they wanted pictures that focused on these industrial products. It was more subtle than that. "These kings of the period," Fleuricamp asserted, "want to master the material not the spirit" and as such "approve only of those things that fall under their sense of the world," which in his opinion was not very elevated. "A beautiful woman. A beautiful farm. Stews of color." This was the taste of the "Medici of the Madeleine" and according to Fleuricamp it had dominated the art market for twenty years, allowing nothing to change except the homes of this elite where walls gradually disappeared behind works by Regnault, Lefèvre, Daubigny, Laurens, and Breton.

For Fleuricamp and others it was sad to see this continue in 1872 and to have it evident in the Salon, the first to be held after the war. As critics of all persuasions understood, this Salon was the first opportunity to reassert the powers of French art and "to show jealous Europe all that the genius of France could produce in the aftermath of its defeat."[43] The administration of the fine arts understood this too and tried to insure its brilliance by tightening the admissions policies. Those who had earned *hors concours* status from prevous Salons were no longer admitted automatically. Only two submissions per person were allowed, down from the three of the Salon of 1870. And instead of being able to elect the entire jury from its ranks, participating artists could only vote for a minority of members, all of whom had to have been medal, honor, or Prix de Rome winners at past Salons.[44] The majority of the jury after the vote, not surprisingly, were members of the Institute, and the number of works in the show was less than half those in the Salon of 1870.

As usual, there were diverging opinions about the show, but no one could write about it without relating it to the war, or judge its success without using some post-war criteria. Those who liked it did so not so much because it was filled with great works, but because they were relieved to see art again, remembering under what conditions it had been made. Jules Simon summed up this attitude in his awards ceremony speech at the close of the Salon. "More than one of these beautiful works was conceived under a shower of shells, in the ruins of a house that one loved, or next to a grave. We work, and we think, therefore we are alive."[45]

This was not enough for most critics, however. "It absolutely lacks virility," wrote Georges Puissant in *L'Avenir National*. "Ideas are nil and thoughts mediocre. . . . In the heap, not a man, not a revelation, not even the promise of individuality . . . a lot of talent but once again not a heart that beats, not a soul that believes, not even a misled vanity!"[46] This was all the more disappointing given the moment. "Coming after the war and the terrible events of the past year," wrote Jules Castagnary, "the show should have had an original and gripping makeup." But, like Puissant, he claimed it was

fig. 11 Alphonse Muraton, *Faith in the Future*, Salon of 1872. Photo: *L'Univers Illustré* (20 June 1872): 452

"totally devoid of character. . . . You can walk around there without knowing what country you're in or what date it is."[47]

This was not completely true. A large portrait of President Thiers hung in the first room where one also could find scenes drawn from the war. In addition there were dozens of genre paintings that related to the events of the year before, scenes from the lost territory of Alsace, for example, or Alphonse Muraton's picture of a monk on his knees praying in the snow for "faith in the future" as the title indicates (*fig. 11*).[48] In order to get to the paintings, you had to walk through the sculpture garden which was filled with French heroes, heroines, and saints. And at regular intervals, patriotic music drifted over the arena provided by the Paris military band.

What annoyed Castagnary, however, was the fact that the show "didn't have the soul or the life of France." Leadership, in other words, was in question, and the source of a needed confidence was seriously compromised. Castagnary, like other critics, also noted that "one could hardly dare say if it's the Republic which reigns or the Empire that continues," as if recent history had not changed the look of art as it somehow or other was

supposed to. More conservative critics felt they could detect signs of transition. Paul de Saint Victor, pointing to the work of Henri-Michel Lévy, Jules-Elie Delaunay, François-Emile Ehrmann, and others, said, "It would be puerile to search the new Salon for the complete change that we are hoping for."[49]

The Salon lost some of its contemporary edge when Charles Blanc, acting on the wishes of President Thiers, removed from the show half-a-dozen paintings and one piece of sculpture already accepted and put on view. The government felt they "touched too directly or too energetically on the events of the last war" and could affect negotiations with the Prussians,[50] a poignant indication of the influence art was thought to have.

But according to critics, this action did not really address the problem. The Salon did not reflect the moment, as Fleuricamp implied, because artists were guarding their market; if they changed in any way, they might lose their clientele. It was the dealers, one writer suggested, who were partly responsible for this attitude. They "dictate the whims of her majesty the public to the artist, regulate the dimensions of a canvas, assign to each genre its venial value and fix at so much percent the superiority of 'la peinture gourmande' over 'la peinture idéale'." To solve this problem, artists had to be "more independent and focus attention less on what would make them money and more on what would make their name immortal."[51]

Such calls for austerity or improvement were directed only at painters, as most writers felt sculptors in the Salon preserved the honor of French art. It was evident in their choice of subjects, their aspirations towards perfection, and the time as well as labor they put into their work. They had an advantage, one writer claimed; they could not just dash things off like a painter. In addition their market was limited. With rare exceptions they received commissions only from the state, the church, or local governments. This curbed wanderings from accepted norms and, in theory at least, forced them to think on higher levels.[52] Had the painters a leader, many critics believed, were they "an army guided by a chief, saluting a flag which represents the country," then perhaps they could pull themselves out of their rut.[53]

Charles Blanc and Jules Simon thought they had a solution to the problem. They wanted to increase the number of Prix de Rome awards and oblige some of the winners to copy great works in museums throughout Europe. These copies and others that the two would commission would be brought back to Paris where they would be housed in a new museum for all to study.[54] The project was approved in December 1872 and one-and-one-half years later, 15 April 1873, exactly one year before the first Impressionist show, the museum opened in the Palais de l'Industrie with a collection of one hundred and twenty-one works.

As Albert Boime has shown, the museum soon became a source of controversy. There were allegations of misappropriated funds, overspending, and esthetic misjudgment. Why spend time and money on copies, cried artists and critics, when originality was the problem? Wouldn't that only continue the servile repetition that so plagued contemporary painting? Worst of all, as it took up so much space in the Palais de l'Industrie, would it not cut down on the number of works that could be included in the Salon? The latter didn't prove to be the case, as the Salon of 1873 contained two thousand one hundred and forty-two works, seventy more than the previous year. But because the administration had tried to diffuse anti-Salon activity by allowing artists to submit three works instead of two, there were many rejections. Artists suffering that fate pointed to Le Musée des Copies and clamored for equal space.

There had been similar protests the year before, as Blanc had begun gathering his copies in the Palais early, hoping to open his museum as soon as possible. (Artists, critics, and the administration actually were admitted in November; the public had to wait five months more.) One of the many letters Blanc received that year demanding a Salon des Refusés was signed by twenty-six artists, among them Manet, Renoir, Pissarro, Cézanne, Fantin-Latour and Jongkind.[55] But Blanc held firm and, even over the advice of Jules Simon, denied all such requests.

In 1873, the museum officially open, with critics like Castagnary joining the artists' outcry, he had no choice. The Salon des Refusés opened on 15 May with 477 participants.[56] Many of those who had been rejected from the official Salon had chosen not to join the alternative. They did not want to be labeled "refusés," claimed one critic sympathetic with their plight:

Look at the number of years that we didn't allow this to happen. Every time we did, we found out why we shouldn't have. . . . We couldn't get the public to come as they only know the Salon, the one and only.[57]

That was not the only problem. Refusés risked having whoever did come to the show confirm the jury's decision. If that happened, there would be little hope of attracting buyers.

It was these very questions of judgment and taste that made Charles Blanc in 1872 argue for two Salons, one organized by the state and one by the artists. As with the copies museum, this would be another way for him to set standards and improve the arts.[58]

The idea was not exclusive to the administration, of course; it was inherent in all of the requests for Refusés shows since 1863. It also was specifically voiced in 1870 by Bracquemond, another future participant in the First Impressionist Exhibition, and by various artists and critics in the years thereafter.[59]

Blanc, however, continued to press the case himself, most notably in a series of articles that he wrote for *Le Temps* in April 1874. "If the government exhibitions were not supermarkets," he argued, "if the state organized its own leaving the artists free to organize theirs, we would have a select, well-spaced show."[60] Although Blanc had been dismissed as Director of Fine Arts several months earlier and was therefore writing as a private citizen, it seemed clear that something had to change. The organizers of the First Impressionist Exhibition understood that very well. Their show opened a week after his first article appeared.

They had been actively planning their show for well over a year, although in many ways it had been in the making since Bazille's letter to his parents in 1867. By April 1873, preparations had advanced far enough for Monet to ask Pissarro "if we are getting ready to gather together again to bring things to a close."[61] As it turned out, they were not. Two weeks later, however, on 5 May, the opening day of the Salon, an article appeared in *L'Avenir National* that spoke about the general dissatisfaction with the Salon and the various efforts to do something about it. It was written by a friend of the Impressionists, the socialist art critic Paul Alexis, whose anti-government politics coincided with the artists' anti-Salon stance. His article called for the abolition of the jury system and the establishment of artists' syndicates that would organize their own individual exhibitions. "This powerful idea, the idea of association, is growing," Alexis claimed, "and it is beginning to inject new blood into the anemic old world."[62]

Almost immediately afterwards, Monet wrote Alexis a letter that the journalist published on 12 May. "A group of painters assembled in my home have read with pleasure the article which you have published," wrote Monet. "We are happy to see you defend the ideas which are ours too and we hope that, as you say, *L'Avenir National* will kindly give us assistance when the society which we are about to form is completely constituted."[63]

Alexis took the opportunity to give his readers some more information about this group. He included "several artists of great merit . . . Pissarro, Jongkind, Sisley, Béliard, Amand Gautier, and Guillaumin." These painters, he continued, "most of whom have previously exhibited at the Salon, belong to that group of Naturalists that has the right ambition of painting nature and life in their larger reality. Their association, however, will not be just a small clique. They intend to represent interests, not tendencies, and hope all serious artists will join them."

It would take all summer and fall for Pissarro and his friends, with these principles in mind, to pound out the articles of their association, but on 27 December 1873 their "Société anonyme coopérative d'artistes-peintres, sculpteurs, etc." was officially constituted.[64] The charter, based on one for a baker's union in Pissarro's hometown of Pontoise, was quite democratic. Membership was

open to anyone who contributed sixty francs a year, payable at a rate of five francs per month. All members had equal rights and would elect a governing board of fifteen members, one-third of whom would be replaced each year. Hanging positions would be determined by lot, ten percent of all sales going to the society's operating budget. The number of works a member could submit theoretically was governed by the amount he paid, two works per sixty francs. This rule was not enforced, however, as everyone in the 1874 exhibition showed more than two works, although no one paid more than the basic membership fee.

The joint stock company (the "Société anonyme") had three purposes: the organization of free exhibitions where each person could show his work without jury or honorary awards; the sale of exhibited work; and the publication as soon as possible of a journal exclusively related to the arts.

Although some confusion surrounds the exact number of founding members, sixteen seem certain. Monet, Pissarro, Degas, Renoir, Sisley, and Morisot all were members. In addition there were the landscape painter Armand Guillaumin; Pissarro's friend Edouard Béliard; the sculptor Auguste Ottin, who had contributed to the Medici Fountain in the Jardin du Luxembourg; Auguste de Molins, known for his hunting scenes; and three friends of Degas's: the vicomte Ludovic-Napoléon Lepic, a lawyer turned student of Gleyre and Cabanel, a regular at the Salon and founder of the museum at Aix-les-Bains; the landscape painter Jean-Baptiste Léopold Levert; and the industrialist, collector, and accomplished amateur Stanislas-Henri Rouart. There was also the enamelist Alfred Meyer, and two people who subscribed but did not exhibit in April, the landscape painter François-Nicolas-Augustin Feyen-Perrin and Louis Mettling, both of whom served on the group's administrative committee.[65]

It was Degas who had argued for including artists who had earned reputations at the Salon, feeling that they would give the group credibility and perhaps attract visitors and favorable reviews. Others like Pissarro felt this compromised the group's integrity, but Degas won out. By the time the show opened five months later, many more such people had joined the founders. Most of their names have been forgotten and their works lost, but with the other, more traditional, members, they actually constituted the majority of the participants. They were people like Antoine-Fernand Attendu, who specialized in still lifes; Louis Debras, a genre and portrait painter; and Léon-Auguste Ottin, son of Auguste. Most of them had exhibited regularly at the Salon and some, like Debras and de Molins, were in their fifties.

In addition to what they may have been able to do for the public image of the show, these more traditional artists at least helped to defray some of the costs, made the show numerically substantial, and made the Impressionists' advances clear.

Recruiting them was a problem, however, as Monet explained to Pissarro. "It's very difficult to ask people to join who don't know you, no less those who are not completely sympathetic."[66] Even those who did know them frequently had excuses. Henri-Michel Lévy, for example, whom Monet had approached, was "scared of compromising himself"; someone else did not want to oppose the state because he was not a French citizen. The biggest disappointments were Manet and Fantin-Latour. Like Lévy, Duret, and others, they felt the battle for recognition should be fought in the Salon and so refused to join.[67]

Given the number of Salon artists who did participate, it is surprising not to find Daubigny, Corot, and Courbet, who had been willing to lend pictures and support in 1867, according to Bazille's letter. There is no explanation for Corot's absence. As a frequent member of the Salon jury, he had fought for the younger artists over the previous decade; perhaps he felt joining them would compromise his ability to continue that struggle. According to later recollections by Monet, Corot not only refused to participate but commended others for doing the same. Again there is no hard evidence to support this contention, just as there is no verifiable reason for Courbet's absence. The latter at the time, however, was in exile in Switzerland due to his participation in the Commune and the destruction of the Vendôme column. Some may have thought the show would be radical enough without him; although, as with Corot, his recent work had not greatly appealed to many of the Impressionists.[68]

As the eventual slate of thirty artists began to take shape, the organizers did a lot of groundwork for their opening. They were able to get the *Chronique des Arts* to announce their formation and publish their charter on 17 January 1874.[69] A week later on 25 January, two other leading journals did the same.[70] By 15 April there had been nearly a dozen pieces on the group and their show in various Paris publications.[71] Degas was encouraged. "Already the notices in the newspapers begin to contain more than just announcements," he wrote, trying to convince Tissot to join, "and while they do not dare yet devote an entire column with a special article, they appear willing to give us more space."[72]

Degas and his friends may have been helped by the fact that in January they had done remarkably well in an auction of their work at the Hôtel Drouot. One of Monet's pictures made five hundred and fifty francs, a Sisley brought five hundred and seventy-five, two Pissarros reached seven hundred and nine hundred and fifty, and a Degas, an astonishing eleven hundred. "The reactions from the sales are making themselves felt as far as Pontoise," Pissarro wrote to the critic Théodore Duret. "People are very surprised that a canvas of mine could go for as much as nine hundred and fifty francs."[73]

Duret was pleased for Pissarro but he placed his friend in a difficult position soon after the auction by urging him not to participate in the Impressionist show: *You still have one step to take, that is to succeed in becoming known to the public and accepted by all the dealers and art lovers. For that purpose there are only the auctions at the Hôtel Drouot and the big exhibition in the Palais de l'Industrie. You now have a group of art lovers and collectors who are devoted to you and support you. . . . But you must take one more step and become widely known. You won't get there by these exhibitions of private societies. The public doesn't go to these exhibitions, only the same nucleus of artists and patrons who already know you. . . . Among the 40,000 people who, I suppose, visit the Salon, you will be seen by fifty dealers, art lovers, critics who would never otherwise seek you out and discover you. Even if you only achieve that, it would be enough. But you will gain more because you are now in a special position in a group that is being discussed and that, with reservations, is beginning to be accepted. . . . I urge you to exhibit; you must succeed in making a noise, in defying and attracting criticism, in coming face to face with the great public. You can't achieve all that except at the Palais de l'Industrie.*[74]

With his wife expecting their fourth child and the future looking as bright as Duret painted it, Pissarro undoubtedly did not want to hear such advice; it sounded too right. For despite the widely recognized problems of the Salon, it still had the weight of history and attracted huge crowds. It thus remained an important place to make a name and sell work. But perhaps because he had some financial stability and could see a market developing outside the official realm, perhaps also because of his Socialist belief in smaller collectives and his role in founding the "Société anonyme," Pissarro, to his enduring credit, stuck with his commitment to the group and in fact, unlike the other participants, was the only one to be in all eight of the Impressionist shows.

With the Salon their obvious challenge, the Impressionists decided to have their exhibition run simultaneously, but to have it open two weeks before the government's. The intelligence of this maneuver was equaled by their choice of location, as Nadar's former studios were well known in Paris and the boulevard des Capucines was an active commercial and tourist street.[75] To capitalize on the location, they kept the show open from ten until six and from eight until ten at night. They charged one franc to get in and fifty centimes for a catalogue and they offered a ten percent discount on works bought from the show.

The works were not cheap, however. Perhaps encouraged by the Hôtel Drouot auction, Pissarro was asking one thousand francs for his *Le verger* (cat. no. 14), and

Monet, the same amount for his *Impression, soleil levant.*[76]

These prices also may have reflected the relationship that the Impressionists had established with the dealer Paul Durand-Ruel, whom Monet and Pissarro had first met in London during the war. In 1872 he began buying their works so enthusiastically that by the end of 1873 he had spent more than seventy thousand francs on them.[77] For the first time, with the exception of Renoir who received only about a thousand francs, everyone could live comfortably, or at least without the constant worry of the previous decade. This was another reason why they felt they could go ahead with an independent show. If a major dealer was investing so much in them, there must be a market developing for their work, something the Drouot auction would have suggested as well.

With the catalogue printed and the more than two hundred works hung on the flocked, reddish-brown walls, the show opened on 15 April, ironically the day after the Ministre de l'Instruction Publique, des Cultes et des Beaux-Arts had left Paris for his vacation house in the Dordogne. About two hundred people came the first day, and about half that each day thereafter. Although this was nothing in comparison to the Salon, which attracted over 4,000 people on weekdays and ten times that on Sundays and holidays when it was free, the total of 3,500 for the Impressionists' show was not to be dismissed.[78]

What the visitors would have seen was a strikingly eclectic collection of traditional and new works in all media. There were paintings, prints, pastels, watercolors, and sculpture in marble, terracotta, and plaster, representing every kind of subject. There were even copies after other paintings. In its diversity, it was not unlike a Salon, but what distinguished it from all previous shows was the more than fifty entries by the core of seven Impressionists. Focusing primarily on landscape, portraiture, and scenes of modern life, these paintings, although constituting only a quarter of what was on view, stood out from the rest on account of their stronger color, bolder brushwork, and contemporary subjects. Most reviewers noted the contrast, and few spoke at any length about the more traditional works.

The show received considerable press coverage, with more than fifty notices or articles appearing in Paris publications. Some critics had scathing things to say, but the majority liked it. Even some of the more abusive reviewers like Louis Leroy found aspects of the show appealing. Pissarro's sarcastic comments to Duret, therefore, were not completely true. "Our exhibition goes well," he wrote in early May. "It's a success. The critics are devouring us and accusing us of not studying. I'm returning to my work—this is better than reading their comments. One learns nothing from them."[79]

Contrary to this assertion, nearly every reviewer commended the artists for their efforts, a fact which should

fig. 12 Pierre-Auguste Renoir, *La Loge* (*The Theater Box*, 1–142), 1874. Oil on canvas, 31½ x 25 in. (80 x 63.5 cm). Courtauld Institute Galleries, London (Courtauld Collection)

be emphasized, as it reveals how much the show was filling a recognized gap. Some did not like what was in it, such as Emile Cardon, who felt that "the Salon des Refusés was a Louvre in comparison to this show." However, he could claim the show "represents not just an alternative to the Salon but a new road . . . for those who think art needs more freedom in order to develop than that granted it by the administration."[80]

The administration, the Ecole des Beaux-Arts, the Salon, and academic painters were frequently chided. Emile d'Hervilly, in his review in the radical *Le Rappel*, which appeared two days after the show opened, called the administration and the Salon jury "the two cripplers of French art. . . . Instead of the rhetoric taught at the Ecole des Beaux-Arts," the Impressionists' show, in his opinion, was filled with "fresh, gripping," works whose "generous exaggerations are even charming and consoling when one thinks of the nauseating banalities of the academic routine. . . . One cannot encourage this daring undertaking too much," he concluded, an event he claimed critics and amateurs had been recommending for a long time.[81]

D'Hervilly's review was followed by eight more in the next six days, all but one of which expressed support for the show and praised many of the works. "What pleases us," wrote Edouard Drumont in *Le Petit Journal*, "is the initiative taken by these artists who, without recriminations, protests, or polemics, opened a room and said to the crowds, 'We see like this, we understand art in this way, come on in, look, and buy if you like'."[82]

The most comprehensive discussion of the works came from the pen of Armand Silvestre, who had already written favorably about Monet, Pissarro, and Sisley in Durand-Ruel's catalogue of gallery artists the year before. From that catalogue Silvestre excerpted a section that sensitively distinguished the differences among the three Impressionists: Monet was "the cleverest and the most daring," Sisley "the most harmonious and the most timid," and Pissarro "the most real and the most naive." His support in 1874 was not unreserved. He was uneasy, for example, with their exclusive pursuit of the impression and their apparent belief that everything in the world was beautiful and worth rendering. But at the same time, he felt "their vision, which does not resemble any master of the past, is affirmed with a conviction that cannot be slighted," that "their pleasant colors and charming subjects will extend their influence," and most important, that the

means by which they seek their impressions will infinitely serve contemporary art. . . . It is the range of painting's means that they have restored. . . . And don't believe that this makes the palette a banal percussion instrument as one might initially think. . . . You need special eyes in order to be sensitive to the subtlety of their tonal relations, which constitutes their honor and merit.[83]

The suggestion that this new art would advance French painting is very important. Although no one linked it directly with the post-war calls for an art that would lead, at least three critics in addition to Silvestre—Philippe Burty, Jean Rousseau, and Ernest Chesneau—appreciated the Impressionists' work for its leadership potential, feeling like other writers that the Impressionists had powers that the academics lacked. Rousseau, though more reticent than the others, still asserted that "it would be necessary to bless all the brutalities of the Impressionists if they delivered us from the insipid perfection of Bouguereau." Burty claimed the Impressionists had "already conquered those who love painting for itself," while Chesneau "willingly predicted that in a very few years the typical paintings at the Salon will be like theirs."[84]

Chesneau was the most vocal spokesman for the group, publishing no less than six pieces on the show after having written the catalogue for the Hôtel Drouot auction in January.[85] He had some hesitation about the efforts of this new "école de plein air," as he called them in one of his articles; the more traditional artists should not have been included in the show. For example, Monet should have brought his *Boulevard des Capucines* (cat. no.7) to a more finished state, and

their way of painting is sometimes so incomplete and so disturbing to eyes that have been blinded by routine that, in the public's way of thinking, it would have been more consistent for the critics to have blasted the show.[86]

"But," he could ask, "isn't it necessary to think also of the public of tomorrow?" His answer was a decided yes. Monet's *Boulevard des Capucines* was "a masterpiece" that went a "long way into the future"; Renoir's *La loge* (fig. 12) had "the most remarkable qualities of observation and color," and Sisley's *La Seine à Port Marly* (fig. 13) "surpassed any work of the past or present in its ability to evoke the physical sensation of 'plein air' atmosphere."[87] There was no doubt in his mind that the Impressionists were doing the most important work of anyone at the time. "There are elements of renewal and progress in their paintings that are so potent," he claimed, "that their influence is already evident in the work of artists who are used to assimilating the advances of others."[88]

It is only with these many positive reviews and the claims of renewal and progress in mind that we can turn to the negative blasts of the less sympathetic critics, as the Impressionists clearly were not misunderstood nor unappreciated. What, then, did these others find so irksome? First, the unfinished qualities of the paintings, the fact that they appeared to be just sketches. "Looking at the first rough sketch and rough is the right word," wrote the critic for *La Patrie*, "you simply shrug your shoulders; seeing the lot you burst out laughing, but with the last ones you finally get angry. And you are sorry you did not

fig. 13 Alfred Sisley, *La Seine à Port-Marly* (*The Seine at Port-Marly*, 1–163), 1873. Oil on canvas, 17¾ x 25½ in. (45 x 64.5 cm). Ny Carlsberg Glyptotek, Copenhagen

give the franc you paid to get in to some poor beggar."[89] Why did this bother him so much? Obviously, he felt he had wasted time and money and that he had been insulted by what he had seen. What he had wanted to see were works in which forms were more harmoniously arranged and more clearly defined in terms of traditional modeling. Rather than revealing time, labor, and training, these paintings, in his opinion, were ones "which Manet had rejected."

Emile Cardon put it bluntly; they were "quite simply the negation of the most elemental rules of drawing and painting. . . . The scribblings of a child have a naivete and sincerity that make you smile; the debaucheries of this school are nauseating and revolting." To Marc de Montifaud, it seemed that they painted with the wrong end of the brush, a lack of sophistication that Etienne Carjat noted as well; "a worker in this case," he claimed, "could even replace the artist."

Not only did these so-called artists scoff at the

principles of painting but, as Cardon told his readers, they also "look with an air of supreme pity on works that we are accustomed to admire, slighting everything that study taught us to love." This was a serious affair, Cardon pointed out, especially as "the artists themselves take it all very seriously." Carjat asked, "What do we see in the work of these men? Nothing but a defiance, almost an insult to the taste and intelligence of the public."[90]

What is striking about these comments is their obvious contrast with Chesneau's and those of the other positive reviewers. Everything that the latter admired or forgave, these critics condemned. Clearly, they were protecting older values, ones that actually had recently been attacked by Courbet and Manet. The latter was conspicuously absent from the show, but because he was "le chef de file," as Chesneau called him in one of his reviews, he was not far from the critics' minds.[91] In fact, he served in many reviews as a touchstone for judgments on value and quality. He was what the Salon des Refusés of 1863

had been all about, for example, or in Louis Leroy's infamous dialogue in *Le Charivari*, he was the head of a body politic.[92] "Stupid people who are finicky about the drawing of a hand," says the crotchety academic M. Vincent in Leroy's satire, "don't know anything about 'l'art impressif,' and Manet would chase them out of his republic." Almost all of these references come in negative reviews and contribute to the negative tenor of the piece. This is not surprising; Manet could easily upset conservative critics. Indeed, in 1874, one writer accused him not only of trying to "shock the middle class" (*épater la bourgeoisie*) but also of being led by "esthetic disorder to dreams" of "moral disorder."[93]

Castagnary and others reviewing the Impressionists' show went to some lengths to point out that this was not a protest exhibition or an anti-Salon, and that the artists were not a group of radicals bent on bringing down the system. Castagnary could even make fun of such a suggestion:

Irony! These are four [sic] *young men and a woman who for five or six years made the jury tremble! Barring their path for all that time, the jury became more and more ridiculous, compromising itself so much before the public that there is hardly a man in France who dares speak in its favor. Let's see then a little of what these terrible revolutionaries, so monstrous and subversive of the social order, have in store for us.*[94]

It is difficult to know whether the Impressionists would have seen themselves in the same ironic way. Except for Pissarro, none of them were particularly inclined towards revolutionary action. Yet they had organized an exhibition that clearly subverted the Salon system and had shown paintings that they knew would be controversial. They were, of course, trying to promote their own work in terms of sales as well as style. "The Realist movement no longer needs to fight with others," Degas tried to assure Tissot in early 1874. "It is, it exists, it has to show itself separately. There has to be a Realist Salon."[95]

This must have seemed all the more true in 1874, when two official Salons and one Refusés had failed to produce the great painter or paintings that the critics and the public sought. The Impressionists must have felt that they could fill that void. In fact, they hardly could have conceived of the show then without paying some thought to its place in post-war France and the nationalistic rhetoric. Even just the initiative, which so many critics praised, could be seen as patriotic. "Initiative doesn't exactly run in our streets," observed one critic writing on the show. "When you see it, you have to doff your hat and follow it with appreciation."[96]

Most of the Impressionists had a patriotic streak. Degas, it will be recalled, had volunteered for the National Guard. And even though Monet and Pissarro had gone to England to avoid the war, both expressed concern about their country. Pissarro was particularly direct in a letter to Duret written in London in 1870. *I am only here for a very little time. I plan to return to France as soon as possible . . . it is only when you are abroad that you realize how beautiful, grand, and hospitable France is. What a difference here! . . . Oh how I hope everything will be all right and that Paris recovers her supremacy!*[97]

When Monet returned to France in late 1871, he painted more than half-a-dozen pictures, such as *The Bridge under Repair* (fig. 14), that speak about the country after the war rebuilding its bridges, reopening its lines of communication, regenerating its industries, and restoring its pride. In fact, his *Impression, soleil levant* (fig. 15) can be seen in the same light. It shows the industrial port city of Le Havre with its ocean-going clipper ships, packboats, and smoke-filled sky. Combining the evidence of industrial-commercial activity with the beauties of nature, the appearance of spontaneity with the conviction of forethought, this painting too can be seen as Monet's vision of a new day dawning for a revivified France.[98]

However, despite the thoroughly French subject matter of most of the Impressionists' paintings in the show and any possible patriotic motivations, despite also the irony of Castagnary's characterization, the Impressionists still could be perceived by conservative critics as subversive, given the climate of opinion after the war. They simply were not preserving "the science of painting, the construction of groups, the arrangement of draperies, the beauty of effects, and the artfulness of their means," which Marc de Montifaud asserted was at the heart of French art.[99] French painting, in contrast to the "feverishness of the Italians and the dogmatism of the Germans" was "fresh, precise, serious, tempered *d'un éclat doux*."[100] The Impressionists' paintings appeared to be the opposite. In addition, they clearly broke accepted hierarchies. Hierarchies were as important to society as they were to art. "To abolish them in society is to create chaos," wrote one conservative critic at the Salon of 1874, "to do so in art is to discourage elevated aspirations," precisely what the Impressionists seemed to be doing.[101]

Some of these problems were brought specifically to bear on the show by Etienne Carjat. He had actually supported Monet, Pissarro, and Cézanne in the late sixties, defending "them tooth and nail against the stupid mockeries of the young upstarts in Cabanel, Picot, and others' studios. . . . Their progress seemed certain and we were happy to see them get onto a truly revolutionary track." But after the war his opinion had changed. They disdained form and patient laborious study, they did not understand effects, and their color was "fausse, lourde et commune."

What the masters called a tone, they call a blob. It's

fig. 14 Claude Monet, *The Bridge at Argenteuil under Repair*, 1872.
Oil on canvas, 21¼ x 28¾ in. (54 x 73 cm). Private collection,
Marseilles

*no longer a question for them of broken tints based on
a desired harmony, but flat multicolored touches
juxtaposed haphazardly with all of the garishness of
the palette.*
Perhaps to cover his past error, he suggested that they
could "conquer their place at the top . . . with a little
energy, perseverance, and firm commitment to learning
all that they lacked." If they did not apply themselves
with this Charles Blanc or Chennevières-like work ethic,
however, they would end up as "sign painters working
for coal dealers and moving men."[102]

Carjat's concern with class and the status of the artist
begins to suggest the real problem: there was no place for
this kind of crass, unelevated art in a country that needed
discipline and leadership. The war and the Commune,
though three years in the past when the Impressionist
show opened, were far from forgotten. "Alas," cried one
critic reviewing the Salon of 1874, "the muscle is still

vibrating, the wound is still open."[103] The physical
reminders, as we have seen, were everywhere in Paris—
from the ruins, to the rebuilding, to the monuments and
plaques. They also were present in everyone's minds.

As one writer put it in 1874 in a review of a book on
the siege of Paris,
*Millions of human beings recall and will recall with
unspeakable emotion during their entire lives the sad day
when the enemy armies arrived, took up positions
around Paris, "the palpitating heart of France," and
formed this awful circle of iron and fire, vainly to con-
sume and crush the glorious, heroic, and unhappy city.*[104]

There was a joke going around that wounded city in
April 1874, precisely on this point. "Do you know why
those wonderful Prussians carried off a rather large num-
ber of watches, clocks, and chronometers?" the joke
went. "It's not, as you could suppose, in order to prevent
us from ever hearing the hour of our revenge ring; no,"

went the response, "it's in the hope of paralyzing this vengeance by never allowing us to have the moment to vent it."[105]

The idea of revenge in its most blatant militaristic form would brew in the minds of most conservative Frenchmen for years to come, occasionally boiling over in the 1880s and 1890s until finally becoming a possibility in 1914. And in the early seventies, the military began their preparations. They underwent considerable soul searching and then internal reorganization. Their budget was increased by nearly ten million francs a year between 1872 and 1874. New weapons were developed after two years of research and testing began, ironically, in early 1874. Plans for defending Paris and the new border with Germany were designed and, coincidentally again, they were approved by the National Assembly four days before the Impressionists' show opened. By late April 1874 the military was acquiring land for new forts and defensive constructions. They also received permission sometime after the war to have military instruction be part of all lycée and college curricula. Enough schools had introduced such courses for military officers from

fig. 16 Alfred Le Petit, *Le réveil (The Awakening)*, 1873. Photo: *Le Grélot* (28 September 1873): 1

Paris to begin on-site inspections throughout the country, coincidentally once more, in May 1874.[106]

The need for these expenditures, training, and development was brought into focus not only by the loss of the war but also because the Prussians, according to the provisions of the treaty, were to occupy twenty-one departments of France for three years, or any time up to that date if the indemnity was not paid off. It was therefore not until September 1873, when the last payment was made, that "the enemy" began evacuating. It was not actually until late November that the last left French soil. All of this, of course, was followed in the Paris press, the troops' departure prompting great relief and images such as *Le réveil* (fig. 16), which speaks in clear metaphors about the new day for "la belle France."

The pain would continue, however. Just a week before the Impressionists announced their charter, the Germans placed their last indemnity hoard of sixty million thalers in a mountain cache and shortly thereafter seated the first deputies from Alsace and Lorraine in the Reichstag in Berlin. The day they arrived, the new delegates placed a motion before the legislature that would have required the government to consult with the people of Alsace and Lorraine on all matters concerning their annexation. The motion was hotly debated the following day and turned down.[107]

The very day the Impressionist show opened, a reporter learned that German authorities in the city of Landau had taken a statue of Louis XIV down from the city's triumphal gate and sent it off to Hohenschwangau. "Every day," he wrote, "some sad detail reminds us—if we have forgotten—of the unfortunate facts of the recent war." The Germans were going to destroy the gate on which appeared the inscription "Nec pluribus impar" [None are better]. "God wants that inscription," the reporter said, "to be as fatal for them as it was for us."[108]

Alsace and Lorraine were very much on the minds of Parisians in 1874, as they so frequently would be until the Great War. Refugees, particularly from Alsace, had been streaming into the capital since the end of the fighting. Some 80,000 passed through Nancy in 1872 on their way westward.[109] At some point it was decided that many could start new lives in the French colony of Algeria. In 1874, to raise money for their transport and living expenses, the comte d'Haussonville and the Corps Législatif organized a huge exhibition of works of art from the best private collections in Paris. It was a staggering show with nearly every major master from Raphael to Ingres represented. It rightfully attracted a lot of press and huge crowds, five thousand people a day. This patriotic gesture opened on 28 April, just after the Impressionists' show.[110]

When the Salon opened two days later, there were reminders in abundance of "l'année terrible." Military paintings by Detaille, Clairin, Dupray, and Pille

dominated the Grand Salon, and others could be found throughout the show. Genre paintings like Gustave Brion's *Une noce en Alsace* and Auguste Masse's *Les funérailles d'un drapeau* touched sensitive chords, while Paul Morlon's *Alsace! En appelant à Dieu du sort de la patrie, fièrement elle espère et fervent elle prie* poetically but wrenchingly expressed popular sentiments.[111]

The most heralded work in the show, however, was Antonin Mercié's *Gloria Victis* (fig. 17). Exhibited the previous year in the Salon of 1873 where it caused a huge sensation, it was brought back for an unprecedented second time because it so effectively translated defeat into glory and spoke so powerfully about timely issues of pride and revenge.

There likewise were two German painters in the show and they did not go unnoticed. One critic pointed out that, according to the catalogue, one was born in Prussia but was a naturalized Frenchman. The other, he said, was simply described as born in Berlin. "In exchange for the hospitality that the French exhibition gave him," the critic wrote,

he could have said he was Prussian. . . . What's the story with these enervating people who begin to talk about how art doesn't have a country! I still maintain that to play Richard Wagner in France and to have Prussians in our exhibition is a bad thing. That's my opinion and I stand behind it ready and waiting.[112]

He was not alone. A few months earlier, a well-known singer actually came to Paris to protest newspaper reports claiming she had accepted an engagement in Berlin. "I am Belgian," she told a reporter, "but I am French at heart. Though I was sent to Prussia, I simply did a tour of Holland."[113]

Conservative criticism at the Salon could be equally chauvinistic. Standing in front of Louis Barria's funeral monument and Ernest Hiolle's *Allegorical Homage to the Children of Cambrai*, the critic for *L'Univers Illustré* could assert, "In the middle of our sadness, it is a consolation to think about these works of art that are going to maintain the sacred fire of patriotism in all corners of France and protest against prescription and forgetting."[114]

It was Mercié's *Gloria Victis*, however, that prompted his most passionate response. It was "a vision that repairs and consoles while we await the supreme reparation and the immortal consolation." So important was this piece for him that he felt the Grand Medal of the Salon which Mercié had won was not enough. He wanted

the President of the Republic and the President of the National Assembly to gather delegates of all opinions and of all parties around this sublime group. They would show them this broken sword, this wound that bleeds,

fig. 17 Antonin Mercié, *Gloria Victis*, 1873. Musée d'Orsay. Photo: Cliché des Musées Nationaux

this person who is going to die, this guardian angel of the country who changes disaster into triumph, the black wooden cross into a rainbow, death into immortality, and they would say "Now, continue to quarrel if you have the courage!"[115]

It is hardly surprising that neither he nor his colleague on *L'Univers Illustré* went to the Impressionists' show. Those who did, however, and who felt like him, clearly heard a quarrel continuing. And with "our recent disasters being too close,"[116] there was no room for it. Conservatives like these writers made their voices heard. Indeed, they still resound today. But happily, they were contradicted by more open minds who saw in this First Impressionist Exhibition the initiative France needed to move forward and the painting on which it would build its future. As history has shown, they were not to be disappointed.

Notes

All translations are author's unless otherwise indicated. I would like to thank Leah Kharibian, Sophie Monneret, Paul Smith, and William D. Tucker, Jr. for reading this essay and making many valuable suggestions. I would also like to thank Fronia Wissman and Ruth Berson for their research assistance and the American Council of Learned Societies and the Florence Gould Foundation for their support.

1. Bazille to his parents, [May] 1867, as cited in G. Poulain, *Bazille et ses amis* (Paris, 1932), 208, and trans. J. Patrice Marandel, *Bazille and Early Impressionism*, exh. cat. (Chicago: The Art Institute of Chicago, 1978), 180.

2. Bazille to his parents, [May] 1869, as cited in Poulain, 207–208, and trans. Marandel, 180.

3. All studies of the First Impressionist Exhibition, indeed, of Impressionism as a whole, are indebted to John Rewald's pioneering *The History of Impressionism* (New York, 1946) and its subsequent editions. I refer to the 4th rev. ed., published in 1973. Other important studies include: Hélène Adhémar and Sylvie Gache, "L'exposition de 1874 chez Nadar," *Centenaire de l'impressionnisme*, exh. cat. (Paris: Grand Palais, 1974), 221–270; Albert Boime, "The Salon des Refusés and the Evolution of Modern Art," *Art Quarterly* 32 (Winter 1969):411–426; Ralph T. Coe, "Claude Monet's *Boulevard des Capucines* After a Century," *The Nelson Gallery and Atkins Museum Bulletin* (February 1976):5–16; Ian Dunlop, "The First Impressionist Exhibition," *The Shock of the New* (New York, 1972), 54–87; William Hauptman, "Juries, Protests and Counter-Exhibitions before 1850," *Art Bulletin* 67 (March 1985):95–109; Joel Isaacson, *The Crisis of Impressionism 1878–1882*, exh. cat. (Ann Arbor: The University of Michigan, Museum of Art, 1980), 2–4; Jacques Lethève, *Impressionnistes et symbolistes devant la presse* (Paris, 1959), 59–70; Steven Z. Levine, *Monet and his Critics* (New York, 1976), 13–22; Roy McMullen, *Degas: His Life, Times, and Work* (Boston, 1984), 243–249; Sophie Monneret, *L'impressionnisme et son époque*, 4 vols. (Paris, 1978–1981), 3:145–148; Carol Osborne, "The Impressionists and the Salon I," *The Impressionists and the Salon (1874–1886)*, exh. cat. (Riverside: University of California Gallery, 1974), n.p.; Scott Schaefer, "Impressionism and the Popular Imagination," *A Day in the Country*, exh. cat. (Los Angeles: Los Angeles County Museum of Art, 1984), 330–339; Ralph E. Shikes and Paula Harper, *Pissarro, His Life and Work* (New York, 1980), 103–137; Paul Tucker, "Monet's *Impression, Sunrise* and the First Impressionist Exhibition: A Tale of Timing, Commerce and Patriotism," *Art History* 7 (December 1984):465–476; Lionello Venturi, *Les archives de l'impressionnisme*, 2 vols. (Paris, 1939), 2:255–256; Harrison C. and Cynthia A. White, *Canvases and Careers: Institutional Changes in the French Painting World* (New York, 1965), 148–154; Daniel Wildenstein, *Claude Monet: Biographie et catalogue raisonné*, vol. 1 (Paris and Lausanne, 1974), 65–70; I am also indebted to Carl Baldwin, "The Salon of 1872," *Art News* 71 (May 1972):20f.

4. Boime, 411–426.

5. On the Salon des Arts Unis, see Charles Blanc, "Le Salon des arts unis," *Gazette des Beaux-Arts* 9 (February 1861):189–192.

6. Paul Mantz, "Salon de 1865," *Gazette des Beaux-Arts* 18 (July 1865):26.

7. Castagnary, "Salon de 1867," reprinted in *Salons* (Paris, 1883), 1:246–247, and on Pissarro, "Salon des Refusés," 175–176.

8. On Monet's sales, see Wildenstein, 148, 425, and 445. On Renoir's relations with the Le Coeur family, see John House et al., *Renoir*, exh. cat. (London: Hayward Gallery, 1985), 185–186, and Douglas Cooper, "Renoir, Lise and the Le Coeur Family: A Study of Renoir's Early Development–I. Lise, II. The Le Coeurs," *Burlington Magazine* 101 (May 1959): 163–171, and (September-October 1959):322–327.

9. Boime, 411–426.

10. McMullen, 243, from a letter to Marion's friend, Morstatt, 12 April 1866. The letter is worth quoting as it provides a good idea of contemporary attitudes. ". . . ce refus en masse [of Cézanne and others from the Salon of 1866], cet exil immense est une victoire. Il ne nous reste plus qu' à exposer nous-mêmes et faire une concurrence mortelle à tous ces vieux idiots borgnes. Ce moment est une période de lutte, et ce sont les jeunes qui combattent vis-à-vis des vieux; le jeune homme contre le vieil homme; le présent tout plein des promesses de l'avenir contre le passé, ce noir pirate. La postérité, c'est nous et l'on dit que c'est la postérité qui juge. Nous espérons nous dans l'avenir. Nos adversaires ne peuvent guère espérer que dans la mort. Nous avons de la confidence. Ne désirons qu'une chose, produire. Avec la production le succès nous est sûr." See Alfred Barr, "Cézanne, d'après les lettres de Marion à Morstatt, 1865–1868," *Gazette des Beaux-Arts* 17 (January 1937):37–59.

11. Some of the strongest language against the jury came from Emile Zola, whose Salon articles in *L'Evénement* between 27 April and 20 May 1866, reprinted in *Mes haines* (Paris, 1867), caused such protest among the paper's readers that he was forced to curtail his reviews. See Emile Zola, *Salons*, ed. F. W. J. Hemmings and Robert J. Niess (Geneva, 1959), 53–60.

12. My thanks to Leah Kharibian for Medard's painting, which comes from her doctoral dissertation on the image of Paris between 1850 and 1880.

13. On the Franco-Prussian War and the Commune, see for example: Robert Baldick, *The Siege of Paris* (London, 1964); Jules Claretie, *Paris assiégé. Tableaux et Souvenirs* (Paris, 1871); Aimé Dupéry, *1870–1871. La guerre, la Commune, et la presse* (Paris, 1959); Théophile Gautier, *Tableaux de siège. Paris 1870–1871* (Paris, 1871); Alistaire Horne, *The Fall of Paris. The Siege and the Commune, 1870–1871* (London, 1965); and Michael Howard, *The Franco-Prussian War* (London, 1961). Absolutely essential are G. M. Carrol, *French Public Opinion and Foreign Affairs 1870–1914* (New York, 1931); Claude Diego, *La crise allemande de la pensée française, 1870–1914* (Paris, 1959); and Commandant Palat, *Bibliographie générale de la guerre de Paris, 1870–1871* (Paris, 1896).

14. Daléria, "1871," *L'Opinion Nationale*, 1 January 1872.

15. Edwin Child, as quoted in Horne, 402.

16. See Jan-Karl, "Les ruines de la Commune," *L'Univers Illustré* (13 January 1872):27; Th. de Langeac., "Bulletin," *L'Univers Illustré* (16 March 1872):166, and (27 April 1872):262.

17. Gautier, as cited and trans. Horne, 420.

18. "Chronique," *L'Artiste* (September 1871):302–303.

19. J. A., "Travaux de Paris," *L'Univers Illustré* (2 November 1872):698–699.

20. See "Une semaine à Paris," *La Gazette des Etrangers*, April 1874.

21. On the Regnault monument, see *L'Univers Illustré* (25 April 1874):262. Ingres was also honored with a half-length statue at the Ecole. Installed just after the war, it showed him carrying a scroll on which was inscribed, "Le dessin est la probité de l'art." See *L'Univers Illustré* (28 March 1872):182. On the Frémiet statue, see *L'Univers Illustré* (28 February 1874):132, and (10 June 1874):18–19.

22. On the Belfort monument, see Th. de Langeac., "Bulletin," *L'Univers Illustré* (25 April 1874):259–262. Beginning on 15 April 1874, ironically, all subscribers were sent photographs of Bartholdi's model. On the Verdun cannons, see *L'Univers Illustré* (14 February 1874):102; and for Le Havre's statue, see *L'Artiste* (October 1873):210. For the monuments in Switzerland, see *L'Univers Illustré* (16 November 1872):726, and (23 November 1872). Falguière even did one; see *L'Univers Illustré*, (4 July 1874):422. The French government also commissioned Jules-Clément Chaplain to do a medal commemorating the siege of Paris; it was deposited at the Monnaie in early 1874; see *La Renaissance Littéraire et Artistique* (25 January 1874):19.

23. On John Wilson's donation, see *La Chronique des Arts* (21 March 1874):118, and (4 April 1874):135. On Richard Wallace's gift, see *L'Univers Illustré* (6 April 1872):214. In thanks for America's aid during the war, Meissonier and the Director of the Ecole des Beaux-Arts, M. Guillaume, organized a sale of contemporary French painting in New York, the proceeds to aid victims of the recent Chicago fire; see *Moniteur des Arts*, 1 December 1871. Richard Wallace also gave a lot of money to France during the war; see, for example, Adriani, "Courrier," *Moniteur des Arts*, 9 September 1870.

24. John McManners, *Church and State in France, 1870–1914* (New York, 1972), 40. Also see Paul Lessourd, *La Butte Sacré, Montmartre des origines au XXᵉ siècle* (Paris, 1937), 323–360, and H. Rohault de Fleury, *Histoire de la Basilique du Sacré-Coeur*, 3 vols. (Paris, 1903–1907).

25. McManners, 40. On the exhibition of the proposed designs, see Léon de Lora, "Concours pour la construction de l'église de Montmartre," *L'Artiste* (August 1874):131.

26. Charles Bigot, "Paris–31 Décembre 1871," *Le Siècle*, 1 January 1872.

27. Gérôme, "Courrier de Paris," *L'Univers Illustré* (8 June 1872): 354–355.

28. See, for example, Raudot, "La Population de la France en 1872," *Le Correspondant* 59 (10 April 1874):189–214.

29. Bigot.

30. With titles for his poems like "Vive la France" and "Vae Victoribus" and a dedication to his mother and father, "who taught me to love my country," Paul Déroulède's sentiments were far from subtle; but they were popular. His *Nouveaux chants du soldat*, which appeared in 1873, went through 93 editions by 1883. For the crackdown on prostitution, see C. J. Lecour, *La prostitution à Paris et à Londres 1789–1871*, 2d ed. (Paris, 1872), 338. On the musical "Paris chez lui en 1869," see Gérôme, "Chronique," *L'Univers Illustré* (23 March 1872):179.

31. Emile Galichon, "A nos lecteurs," *Gazette des Beaux-Arts* 4 (October 1871):281–283, as quoted and trans. Baldwin, 20f.

32. A. Delzant, "Salon de 1872," *Courrier de France*, 9 July 1872.

33. "Chronique," *L'Artiste* (September 1871):228.

34. René de Laferté, introduction to "Histoire officielle de l'art au XIXᵉ siècle," *L'Artiste* (March 1874):164. Similar ideas are found in Evariste Bavoux, "Les monuments de Paris," *L'Artiste* (August 1874):105–115.

35. On the copying project, see *Le Monde Artiste* (7–14 March 1874). On the inventory, see Philippe de Chennevières's report of 15 May 1874 in *Moniteur des Arts*, 22 May 1874, and Chennevières, *Circulaires relatives à l'Inventaire générale des richesses d'art de France, 20 mai 1874 and 14 août 1876* (Paris, 1877); and *Inventaire générale des richesses d'art de la France. Rapport à M. le Ministre de l'Instruction publique, des Cultes et des Beaux-Arts* (Paris, 1877). On the reorganization of the national museums and administration, see *Arrêtés* of 4 and 6 March 1874 in *Journal Officiel* (29 April 1874). On Chennevières, see his *Souvenirs d'un Directeur des Beaux-Arts* (Paris, 1879).

36. On the decoration of the Pantheon, see Chennevières's letter to Jules Simon in "Chronique," *L'Artiste* (April 1874):291–293, and his *Rapport sur l'Administration des arts depuis le 23 décembre 1874 jusqu'au 1ᵉʳ janvier 1878* (Paris, 1878), 4–9. Opposition was voiced by *La Renaissance Littéraire et Artistique* (5 April 1874):144. On the decoration of the Palais de la Légion d'Honneur and Chennevières's quote about history painting, see *La France*, 21 May 1874, and *Le Patriote Français*, 24 May 1874.

37. Delzant.

38. Comtesse d'Orr, "Petite Gazette," *L'Artiste* (November 1871).

39. Edouard L'Hôte, "De l'enseignement supérieur des Beaux-Arts," *L'Artiste* (September 1871):313–330.

40. L'Hôte, 329.

41. H. N. de Buffon, "De la décadence des arts," *L'Artiste* (December 1872):194–200. Also see Marc de Montifaud, "Salon de 1873," *L'Artiste* (May 1873):190, and Théophile Silvestre, "Salon de 1874," *Le Pays*, 8 May 1874.

42. Jules Fleuricamp, "Causerie sur le Salon," *L'Artiste* (May 1872):271–276. My thanks to Marilyn Brown for this reference.

43. Claudius Stella, "Salon de 1872," *L'Opinion Nationale*, 11 May 1872.

44. Blanc's Salon rules can be found in "Règlement de l'exposition nationale des ouvrages des artistes vivants pour 1872," *Moniteur des Arts*, 22 December 1871. Also see *L'Artiste* (May 1872):225.

45. E. F., "Distribution des récompenses aux exposants du Salon," *Moniteur des Arts*, 5 July 1872.

46. Georges Puissant, "Le Salon de 1872," *L'Avenir National*, 22 May 1872.

47. Jules Castagnary, "Salon de 1872," *Le Siècle*, 11 May 1872. Surprise and regret about the show not reflecting the moment were widely expressed. See, for example, A. Delzant, "Salon de 1872," *Courrier de France*, 21 May 1872, or Jules Claretie, "La Sculpture," *L'Artiste* (June 1872):263–270.

48. Other such telling genre paintings include: Gustave Brion's *(Gullertanz) Danse du coq, souvenir d'Alsace*; Jean Richard Goubie's *Du boeuf à Paris (Décembre 1870)*; Frédéric Lix's *Adieux à la patrie*; Raymond Balze's *Elégie nationale*; Emile Betsellère's *L'oublie!*; Jules Saintin's *2 Novembre 1871*; Narcisse Chaillou's *Un marchand de rats*; Marie Eline Ortès's *Le trésor de l'alsacienne*; Auguste Laurens's *Veuve!*; Camille Pabst's *Un intérieur d'Alsace (1871)*; Théophile Schuler's *Le berceur; Souvenir d'Alsace*; and Léonie Dusseuil's *Jeune alsacienne*. François Feyen-Perrin, who would participate in the First Impressionist Exhibition, sent a painting entitled *Le printemps de 1872* that was accompanied by a patriotic verse by Armand Silvestre. Two of the more lasting images from the show were Puvis de Chavannes's *Espérance* and Gustave Doré's *L'Alsace!*

There were also over three dozen military paintings or scenes of destruction from the war or the Commune. One of the most telling must have been Louis Hanmot's *In hoc signo vinces. La France, la religion, la liberté et la justice. – Deux figures symbolisant la démagogie et le despotisme sont submergées dans un fleuve de sang. – Dieu bénit la France et ceux qui sont morts pour elle.*

President Thiers's portrait was framed by two seascapes, two landscapes, and a scene illuminated by moonlight, an apparent attempt to suggest his calm nature and ability to bring order to France. It led one critic, however, to observe that he had his feet in the water, his hands in the branches, and his head in the sky. See *L'Avenir National*, 12 May 1872.

49. Paul de Saint Victor, "Les tableaux de style au Salon," *L'Artiste* (June 1872):247–254.

50. Adriani, "Chronique," *Moniteur des Arts*, 10 May 1872. Also, see About, "Deux refusés qui n'ont rien dit," *L'Artiste* (May 1872):220–221. The works in question were numbers 72, 507, 1127, 1428, 1469, and 1839. Unfortunately, they were also removed from the Salon catalogue. About named two of the artists—Detaille and Ulmann—but the others and all the works remain unidentified.

51. A. de Pontmartin, "Salon de 1872," *L'Univers Illustré* (6 July 1872):422–424. Also see A. de C., "Le Salon de 1874," *La Gazette des Etrangers*, 3 May 1874, and Emil Bergerat, "Le Salon et les marchands de tableaux," *Journal Officiel* (21 April 1874).

52. de Pontmartin, "Salon de 1874," *L'Univers Illustré* (27 June 1874):406–407. Also see Frances Aubert, "Salon," *La France*, 10 May 1874, and Armand Silvestre, "Salon de 1873, sculpture," *L'Opinion Nationale*, 22 June 1873. This important evaluation of sculpture's position after the war is set out by Ruth Butler, "Rodin and the Paris Salon," *Rodin Rediscovered*, exh. cat. (Washington, D.C.: National Gallery of Art, 1981), 24–28, 47, and note 1.

53. de Pontmartin, "Salon de 1872," 422–424.

54. On the Museum of Copies, see Albert Boime, "Le Musée des Copies," *Gazette des Beaux-Arts* 64 (October 1964), 237–274; Henri Delaborde, "Le Musée des Copies," *Revue des Deux Mondes* (May 1873):209–216; Th. de Langeac., "Bulletin," *L'Univers Illustré* (17 January 1874):34; Chennevières, *Souvenirs*, 96–97; and Charles Blanc, "De l'état des Beaux-Arts en France à la veille du Salon de 1874, I, peinture," *Le Temps*, 7 April 1874. As Blanc and Chennevières point out, the museum was actually originally conceived by Thiers in the 1830s.

55. Boime, "The Salon des Refusés," 421–422 and note 53–57. The petition addressed to Jules Simon and dated May 1872 is in the Archives Nationales F²¹ 535. Another future participant in the First Impressionist Exhibition, Auguste Ottin, wrote a pamphlet in 1870 that backed the idea of Refusés salons, but proposed an alternative system whereby separate groups of artists would mount shows that the government would support with funds and exhibition space. He even suggested that various artists had already formed groups of this kind "prononcés sur la nécessité absolue de sortir de cette état d'instabilité." A. Ottin, *Organisation des arts du dessin* (Paris, [1870]), 5, in Archives Nationales F²¹ 301, Dossier: "M. Ottin," and Boime, 420 and note 46.

56. For more on the Salon and the Refusés section, see *Moniteur des Arts*, 20 June 1873. On Castagnary's protests, see "Le Salon de 1873" in *Le Siècle*, 10 May 1873. Reprinted in *Salons, 1872–1879* (Paris, 1892), 2:43–49. Also see Boime, 422 and notes 59–61, and Rewald, 304.

57. Ernest Fillonneau, "Questions du jour—une expérience décisive," *Moniteur des Arts*, 4 July 1873. He voiced similar hesitations the following year in "Questions du jour–à propos du prochain Salon," *Moniteur des Arts*, 5 January 1874. Castagnary felt the same way; see "Le Salon de 1873," 62–63. Strong support for the Salon came from many people, most notably Bergerat. On the number of works in the

Salon and the Refusés section, see *Moniteur des Arts*, 20 June 1873.

58. Ch. Blanc, "Rapport au Ministre de l'Instruction publique, des Cultes et des Beaux-Arts sur l'exposition nationale du 1872," in catalogue to *Salon de 1872* (Paris, 1872), cxxiii–cxxviii.

59. On Bracquemond's proposal, see the unpublished letter in *Archives Nationales*, Fichier Charavay, "Bracquemond," Paris, 1870. My thanks to Fronia Wissman for this reference.

60. Blanc, "De l'état des Beaux-Arts," 2–3. So strong was the belief in this eventuality that Charles Clément could assert the following month that the Salon of 1874 was "the last that will be held under the auspices of the Fine Arts Administration. From now on, the artists will be free to do it themselves." See Charles Clément, "Exposition de 1874," *Journal des Débats* (5 May 1874):1–2. It was also in 1874 that Chennevières revived the idea of forming an "Académie nationale des artistes français," which in 1870 had received widespread support. Four hundred artists that year (Manet, Millet, Vollon, and Lepic among them) had signed a document that set out the statutes of this new academy. Instead of the forty members of the long-standing "Académie," this new organization would be open to all artists who had received medals at the Salon, the Grand Prix de Rome, the Legion of Honor, or the 4th class of the Institute. Although under the Minister of Fine Arts, members would be able to elect their own jury and have full control over exhibitions. The idea never materialized. See René de Laferté, "L'Académie nationale des artistes français," *L'Artiste* (February 1874):96–99.

61. Monet to Pissarro, 22 April 1873, as cited in Wildenstein, 428. Also see letters of 12 September, 30 November, 5 and 11 December 1873, 429.

62. Paul Alexis, "Paris qui travaille, III, aux peintres et sculpteurs," *L'Avenir National*, 5 May 1873.

63. Monet to Alexis, 7 May 1873, as cited in Wildenstein, 428, and in Paul Alexis, "Aux peintres et sculpteurs, une lettre de M. Claude Monet," *L'Avenir National*, 12 May 1873. Several months earlier, Monet and Renoir had been cited as artists to watch by a writer for *L'Artiste*. "Renoir et Monet, deux jeunes peintres recommandés à leur début par *L'Artiste*, deviennent des artistes de marque. Nous les étudierons à l'exposition dans les oeuvres hors ligne. Ces deux artistes sont des réalistes non comme Courbet mais comme Rembrandt, c'est-à-dire qu'ils sont à la vraie école de la nature." See Pierre Dax, "Chronique," *L'Artiste* (February 1873):368.

64. See the founding charter published in "Société anonyme coopérative d'artistes-peintres, sculpteurs, etc., à Paris," *La Chronique des Arts et de la Curiosité* (17 January 1874):19. John Rewald happily found three other versions of the charter among Pissarro's papers and published them in the French version of *The History of Impressionism* (Paris, 1955), 358–364.

65. For more information on these and other participants in the show, see Monneret, Adhémar and Gache, and Rewald, 311–316. On the founding members, see the chapter by Adhémar and Gache, and Rewald, 313.

66. Monet to Pissarro, 5 December 1873, as cited in Wildenstein, 429.

67. Wildenstein, 429. The foreigner Monet referred to was probably the Spanish painter, Ricardo de los Rios, a student of Pils. See Monneret, 2:63.

68. Monet told Louis Vauxcelles that Corot had praised Guillemet's decision not to join the Impressionists, saying, "You have done well to escape that gang." See L. Vauxcelles, "Un après-midi chez Claude Monet," *L'Art et les Artistes* (December 1905):87, and Rewald, 316. However, this was more than thirty years after the fact and thus open to question.

69. "Société anonyme coopérative d'artistes-peintres, sculpteurs, etc., à Paris," 19.

70. "Gazette des Beaux-Arts," *La Renaissance Littéraire et Artistique* (25 January 1874):20. Also see Armand Silvestre, 25 January 1874. See First Exhibition review list in Appendix for complete citation of this and other reviews.

71. See review list. Mention of the group and references to specific members also appear in Jean Dolent, *Petit manuel d'art* (Paris, 1874), an indication of how well known they may have been in 1874. My thanks to Paul Smith and Leah Kharibian for this previously unknown source. It should be noted that, while research for this essay in nearly 100 periodicals of the period turned up many more notices and reviews

than formerly known, more undoubtedly exist; a survey conducted by the Minister of the Interior in April 1874 showed 282 periodicals being published in Paris alone. See *L'Univers Illustré* (2 May 1874):278.

72. Degas to Tissot, February-March 1874, as cited and trans. in *Degas's Letters* (Oxford, 1947), 38–40, and Rewald, 313.

73. Pissarro to Duret, January-February 1874, as cited in A. Tabarant, *Pissarro* (Paris, 1924), and trans. Rewald, 301. For prices in the January action, see *La Chronique des Arts et de la Curiosité* (17 January 1874):18–19. Also, see M. Bodelsen, "Early Impressionist Sales, 1874–94, in light of some unpublished 'procès-verbaux'," *The Burlington Magazine* 110 (June 1968):330–349.

74. Duret to Pissarro, 15 February 1874, as cited in L. Venturi and L. R. Pissarro, *Camille Pissarro, son art, son oeuvre* (Paris, 1939), 1:33–34 and trans. Rewald, 310.

75. In addition to the Grand Hôtel at 12 boulevard des Gapucines, which was a big institution on the street, and the well-known gallery Maison Giroux at 43, which according to the *Moniteur des Arts*, 29 December 1871, had a monopoly on elegant "objets d'étrennes"—painting, furniture, bronzes, toys, and books—there was an important "salle des conférences" at 39 that frequently hosted lectures and classes in the evening. It was an added incentive, perhaps, for the Impressionists to have kept their exhibition open from eight to ten. The topics were timely; on 30 April 1874, for example, there was a lecture on Flaubert's newest book, *The Temptation of Saint Anthony*. See *La Semaine Parisienne*, 23 April 1874. Also, Jules Simon and Republican delegates had their headquarters on the boulevard. See "Lettre de Paris," *Le Sémaphore de Marseilles*, 12 May 1874.

76. These prices come from an annotated copy of the exhibition catalogue that Claude Roger-Marx acquired. They are quoted in Adhémar and Gache, 224. In comparison to the tens of thousands of francs a Meissonier, for example, could command, these prices, and those attained at the January auction, might not seem that high. However, at a Drouot auction in February 1874, Canalettos only fetched 880 and 950 francs; a Jacob van Ruisdael, 810; a Tiepolo, 900; and a Titian, 960. These were some of the lowest prices at the sale, but for 2,000 to 3,000 francs one could acquire some exceptional pictures. See *La Chronique des Arts et de la Curiosité* (21 February 1874):70. Paintings by popular Barbizon artists in 1874, such as Corot, Rousseau, and Dupré, generally began around 4,000 or 5,000 francs, while some now completely forgotten painters like Florent Willems could get 7,000 francs for a lost work entitled *Le départ pour la promenade*. See *La Chronique des Arts et de la Curiosité* (28 February 1874):83. And then there were always the exceptions, like the Adriaen van Ostade, which brought 76,000 francs at the same auction. All of these figures, however, should be set against the fact that the yearly salary for an average middle-class family was about 5,000 francs, with doctors and lawyers making about twice that.

77. These figures are from Durand-Ruel's stock books and were tabulated by Shikes and Harper, 105.

78. The figures for the Impressionist show come from the detailed records they kept, which were among the documents Rewald found in Pissarro's papers. They also appear in the French version of *The History of Impressionism* (Paris, 1955), 366–367. Unfortunately, no attendance figures for shows at private galleries or dealers at the time have been found. But even today, 3,500 is far from a failure for avant-garde exhibitions. In fact, shows of some established and highly respected contemporary artists at important museums in large urban areas have attracted only between 15,000 and 25,000 people. On the Minister's departure, see *La Patrie*, 15 April 1874.

79. Pissarro to Duret, 5 May 1874, as cited and trans. Rewald, 331.

80. Emile Cardon review, 29 April 1874.

81. [Ernest d'Hervilly] review.

82. E. Drumont, "L'exposition du boulevard des Capucines," *Le Petit Journal*, 19 April 1874. See review list.

83. Armand Silvestre review, 22 April 1874.

84. Ernest Chesneau, "Au Salon," *Le Soir*, 9 May 1874; [Philippe Burty] review, 25 April 1874; Jean Rousseau, "Le Salon," *Le Figaro*, 11 May 1874.

85. See review list; also "Au Salon," *Le Soir*; "Chronique: Beaux-Arts," *Revue de France* 9 (February 1874):532, and 10 (April 1874):254–255; "Au Salon," *Paris-Journal*, 15 May 1874; and "A côté du Salon," *Le Soir*, 7 May 1874.

86. Ernest Chesneau, "A côté du Salon," review, and "Au Salon."

87. Chesneau, "A côté du Salon."

88. Chesneau, "Au Salon," *Paris-Journal.*

89. A. L. T., "Chronique," *La Patrie,* 21 April 1874, cited and trans. Dunlop, 78.

90. Etienne Carjat, "L'exposition du boulevard des Capucines," *Le Patriote Français,* 27 April 1874; Marc de Montifaud review, 307; Emile Cardon review, 29 April 1874.

91. Chesneau, "A côté du Salon."

92. Louis Leroy review. It is unfortunate that Leroy's satirical article has so long dominated ideas about the reception of the Impressionists' show. It was a serious spoof, but it was meant to be sarcastic and to make as much fun of the conservative painters of the Academy as of the Impressionists. The former is represented by "M. Joseph Vincent, landscape painter, student of Bertin, medaled and decorated under several governments." M. Vincent is crotchety, "rash," "Mephistophelian," and slightly touched. He is also amusingly inconsistent; Monet's *Impression, soleil levant* was no better than "wallpaper in an embryonic state," but his *Déjeuner* – which Vincent's companion "acknowledged without too much difficulty" contained "good bits of painting" – was too finished, a sacrifice "to the false gods of Meissonier!" The aging painter's cynical cries of anguish have an endearing quality to them. To his credit, Leroy was the first to call the group the "Impressionists." However, this title did not specifically derive from Monet's painting of *Impression, soleil levant,* as traditionally recounted. That painting was "Papa Vincent's favorite" and provoked plays on the word "impression," a word, it should be noted, that was quite common to the critical discourse on landscape painting. Monet's painting was "impressive," and it "impressed" Papa Vincent, but the word "Impressionist" does not appear in the article. Rather, it comes earlier between references to Monet's *Boulevard des Capucines,* Cézanne's *La Maison du Pendu, à Auvers-sur-Oise,* and a Boudin beach scene. It therefore should be recognized as more appropriately deriving from the group as a whole, a fact which is emphasized by M. Vincent's "Impressionist dance" at the end of the piece where he refers, not to *Impression, soleil levant,* but to Monet's street scene and to two Cézannes.

93. Frances Aubert, "Le Salon," *La France,* 26 May 1874.

94. Jules Castagnary review.

95. *Degas's Letters,* 38–40.

96. E. Lepelletier, "Chronique parisienne: L'exposition libre du boulevard des Capucines," *Le Patriote Français,* 19 April 1874.

97. Pissarro to Duret, June 1871, as cited in Tabarant, 20, and Rewald, 261.

98. For a further elaboration of this suggestion, see my "Monet's *Impression, Sunrise,*" 465–476.

99. Marc de Montifaud, "Le Salon de 1874," *L'Artiste* (May 1874):301.

100. de Montifaud, 301.

101. A. de Pontmartin, "Salon de 1874," *L'Univers Illustré* (16 May 1874):310–311.

102. Carjat.

103. de Pontmartin, "Salon de 1874."

104. J. M. G., "Histoire du siège de Paris en 1870–1871 par Edouard Heyde et Adolphe Froese," *Gazette de France,* 8 June 1874.

105. Hippolyte Briollet, "Au hasard de la Fourchette," *Le Tintamare,* 19 April 1874. Like most jokes, this one does not translate with all of its subtlety intact. It, therefore, is worth citing. "Savez-vous pourquoi ces excellents Prussiens ont emporté de chez nous chez eux une aussi grande collection de montres, d'horloges et de pendules? Ce n'est pas, comme vous pourriez le supposer, pour nous empêcher à jamais d'entendre sonner l'heure de la vengeance; non, – c'est dans l'éspoir de paralyser cette vengeance, en nous laissant *sans mouvement!*"

106. On the introduction and inspection of military instruction in curricula, see "Petites nouvelles," *La Patrie,* 3 May 1874; Th. de Langeac., "Bulletin," *L'Univers Illustré* (11 April 1874):234; and "Un dernier appel à l'Assemblée," *L'Avenir Militaire,* 11 August 1871. On the approval of new defense plans and the acquisition of land, see Th. de Langeac., "Bulletin," *L'Univers Illustré* (11 April 1874):234, and J. Bourgeois, "Les nouvelles fortifications de Paris," *Gazette de France,*

28–29 March 1874. On the military budget, see "Chronique l'annuaire de l'armée française pour 1874," *La Patrie,* 2 May 1874, and *L'Avenir Militaire,* 16 April 1873, 27 June 1872, and 7 June 1872. On the reorganization and soul-searching, see the many articles in *L'Avenir Militaire* beginning on 26 May 1871, particularly "Projet de Lois sur l'organization de l'armée active par M. le général de Cissey, Ministre de la Guerre," *L'Avenir Nationale,* 21 March 1873. Also see A. Clapeyron, *Etudes sur les causes de nos désastres et la réorganisation de l'armée* (Paris, 1871).

107. On the delegates and their motion, see *L'Univers Illustré* (28 February 1874):131–132. On the indemnity, see *L'Univers Illustré* (7 February 1874):87.

108. "Chronique," *La France,* 15 April 1874. The country's preoccupation with the war, the Commune, and reconstruction into 1874 is to be found in almost every contemporary periodical. One of the more poignant statements on the subject came from Charles de Mazade, one of the editors of the *Revue des Deux Mondes.* "La France est occupée depuis trois ans à résoudre le problème le plus difficile et le plus inexorable. Il s'agit pour elle de se relever, de reprendre son équilibre intérieur, de retrouver sa place et son rôle parmi les nations européennes. Elle le sait bien, si on l'oublie quelque fois pour elle. Ce n'est point l'affaire d'un jour, ni même d'une année, c'est l'affaire de tous les jours, de toutes les heures, et bien des années. C'est une oeuvre de temps, de patience, de raison prévoyante, de courageuse activité." See Ch. de Mazade, "Chronique de la Quinzaine," *Revue des Deux Mondes* (28 February 1874):220. It also was a concern of those in the arts. After the reorganization of *La Renaissance Littéraire et Artistique* in early 1874, the editors could state, "Espérons donc que l'année 1874 nous sera favorable, et que *La Renaissance Littéraire et Artistique* deviendra bientôt l'organe ferme et puissant de cette génération ardente de littérature et d'artistes qui a pour ambition de relever l'esprit et le coeur de la France, et de donner à la patrie les meilleurs des consolations permises après tant de désastres." See "Réorganisation de la *Renaissance,*" *La Renaissance Littéraire et Artistique* (18 January 1874):1–2. On the staff of the magazine were various supporters of the Impressionists: Philippe Burty, Ernest d'Hervilly, Mallarmè, and Catulle Mendès (who also wrote under the pseudonym of Jean Prouvaire for *Le Rappel;* see review).

109. Th. de Langeac., "Bulletin," *L'Univers Illustré* (19 October 1872):661.

110. See, among the many reviews of the show, Paul Demeny, "L'exposition du Corps Législatif," *Le XIXᵉ Siècle,* 25 April 1874. There were many other shows that went on at the same time as the Impressionists'. One of works by the recently deceased Chintreuil opened on 15 April; a huge Prud'hon show opened at the Ecole des Beaux-Arts on the first of May; it contained 518 works. In late April and early May, two new Chardins went on view at the Louvre together with a new bronze attributed to Michelangelo and the Rothschilds' collection of art and antiquities from Asia Minor. On 10 May, the Société française de photographie opened its tenth annual exhibition at the Palais de l'Industrie, and two days afterwards, Boulanger's four frescoes for the new opera house went on view also at the Ecole des Beaux-Arts.

111. Although fewer than in the Salon of 1872, there still were more than a dozen such genre paintings and more than two dozen military pictures. There were, likewise, more than a dozen pictures of sculpture that dealt with the war and its aftermath.

112. Maxime, "Salon de peinture, exposition de 1874," *Le Tintamare,* 24 May 1874.

113. "Petit journal de la semaine," *L'Europe Artiste,* 1 March 1874.

114. de Pontmartin, "Salon de 1874," *L'Univers Illustré* (27 June 1874):406–407.

115. de Pontmartin, 406–407. For similar raves about Mercie's statue, see, for example, E. Drumont, "Salon 74, XI," *Le Petit Journal,* 12 June 1874.

116. E. Pignet, "Le Salon de 1874," *L'Europe Artiste,* 9 August 1874.

3. *Présents*
Sharon Flescher,
New York
Intérieur, Musée
d'Evreux; no, per Flescher

SOCIÉTÉ ANONYME
DES ARTISTES PEINTRES, SCULPTEURS, GRAVEURS, ETC.

PREMIÈRE

EXPOSITION
1874
35, Boulevard des Capucines, 35

CATALOGUE

Prix : 50 centimes

L'Exposition est ouverte du 15 avril au 15 mai 1874,
de 10 heures du matin à 6 h. du soir et de 8 h. à 10 heures du soir.
PRIX D'ENTRÉE : 1 FRANC

PARIS
IMPRIMERIE ALCAN-LÉVY
61, RUE DE LAFAYETTE
—
1874

*Une fois les ouvrages rangés par grandeur, le sort décidera
de leur placement.*

(Extrait du règlement d'exposition.)

Exposition de 1874
—

CATALOGUE

ASTRUC (Zacharie)
5, rue d'Arcet (Batignolles), Paris.

1. Le Bouquet à la Pénitente.
 Aquarelle.

2. La Leçon du vieux Torrero.
 Aquarelle.

3. *Cadre de figures contenant* :
 Dames flamandes à leur fenêtre.
 Scène de Somnambulisme.
 Enfants flamands dans une serre.
 Poupées japonaises.
 Les Présents chinois (Londres).
 Intérieur parisien.
 Aquarelles.

4. *Cadre de paysages renfermant* :
 Estaminet dans les Flandres.
 Jardins de Schaerbeck.
 Intérieur d'estaminet.
 Étang de Saint Josse-ten-Noode (Flandres).

5. Les Poupées blanches (Japon).

6. Le Ménage mal assorti.

ATTENDU (Antoine-Ferdinand)

3, rue des Fossés-Saint-Jacques, Paris.

7. **Nature morte.**
 Appartient à M. A. Q.

8. Un fin Connaisseur.

9. Quelques réflexions (au XIII^e arrondissement).

10. Nature morte : *Musique.*
 Aquarelle.

11. Nature morte : *Cuisine.*

12. Id. id.
 Aquarelles. Appartiennent à M. J. D.

✳

BELIARD (E.)

Chez M. Martin, marchand de tableaux, rue Laffitte, 52.

13. Le Fort de la Halle.
 Appartient à M. D.

14. Saules.

15. Rue de l'Hermitage, à Pontoise.

16. Vallée d'Auvers.

✳

BOUDIN (Eugène)

31, rue Saint-Lazare, Paris.

17. Le Toulinguet, côtes de Camaret (Finistère).

18. Rivage de Portrieux (Côtes-du-Nord).

19. Id. id.

20. 4 Cadres (même numéro). Études de ciel.
 Pastels.

21. 2 Cadres (même numéro). Études diverses.
 Pastels.

22. 4 Cadres (même numéro). Plage de Trouville.
 Aquarelles.

✳

BRACQUEMOND (Félix)

11, Villa Brancas, à Sèvres, Seine-et-Oise.

23. Portrait.
 Dessin.

24. *Cadre d'eaux-fortes :*
 Portraits de MM. Robert.
 Meyer Heine.
 Hoschedé.
 Edwards.
 Aug. Comte.
 Ch. Kean.
 A. Legros.
 Meryon.

17. Perhaps Schmit 808 or
 809
18. Perhaps Schmit 964

24. *Robert,* Beraldi 94
 Heine, Beraldi 80
 Hoschedé, Beraldi
 63 or 64
 Edwards, Beraldi 38
 Comte, Beraldi 22 or 23
 Kean, Beraldi 66
 Legros, Beraldi 73
 Meryon, Beraldi 77 or 78
 Gauthier, Beraldi 50
 Tombeau, Beraldi 49
 Baudelaire, Beraldi 10, 11,
 or 12
 Granger, Beraldi 56

Portraits de MM. Th. Gauthier.
 Th. Gautier (le Tombeau).
 Baudelaire.
 Madame Granger.
 D'après Ingres.

25. *Cadre d'eaux-fortes :*
 La Locomotive.
 D'après Turner. (Planche non terminée.)
 Le Lièvre.
 D'après A. de Belleroy.
 Le Divan.
 D'après Manet.
 Le Tournoi.
 D'après Rubens.
 La Source.
 D'après Ingres. Étude de gravure.
 La Servante.
 D'après Leys.

26. *Cadre d'eaux-fortes.*
 Les Saules.
 Les Arbres de la manufacture à Sèvres.
 Les Charmes.
 Les Bouleaux.
 La Montée de Bellevue.
 Le Mur.
 Pointe sèche.
 Les Bachots.
 Pointe sèche.

27. *Cadre d'eaux-fortes :*
 Le Chemin du parc.
 Frontispice pour les *Fleurs de mal.*

Margot la critique.
Bois de Boulogne.
La Mort de Matamore (*Capitaine Fracasse*).

28. *Cadre d'eaux-fortes :*
 Portrait d'Erasme.
 D'après Holbein.
 Premier état.
 État définitif.

✳

BRANDON (Édouard)

77, rue d'Amsterdam, à Paris.

29. Première Lecture de la Loi.

30. Portrait de M. A. Z.
 Dessin.

31. Aquarelles.

32. Exposition du corps de Sainte-Brigitte à Rome, en 1392.
 Carton fusain.

32 (*bis*). Le Maître d'école.

✳

25. *Locomotive,* Beraldi 336
 Lièvre, Beraldi 277
 Divan, Beraldi 279
 Tournoi, Beraldi 274
 Source, Beraldi 275
 Servante, Beraldi 280

26. *Saules,* Beraldi 122 or 190
 Arbres, Probably Beraldi
 209 or 123
 Bouleaux, Beraldi 128
 Montée, Probably Beraldi
 120, perhaps 188 or 210
 Bachots, Beraldi 161

27. *Chemin,* Perhaps Beraldi
 208
 Frontispice [*sic*], Beraldi
 378
 Margot, Beraldi 113
 Bois, Beraldi 157, 158,
 or 159
 Mort, Beraldi 177

28. Beraldi 39

29. Philadelphia Museum of
 Art

32bis. Perhaps Cab. des Est.;
 may be a canvas

— 8 —

BUREAU (Pierre-Isidore)
59, rue de Turenne, Paris.

33. Le Clocher de Jouy-le-Comte.

34. Près de l'étang de Jouy-le-Comte.

35. Bords de l'Oise (Isle-Adam), Clair-de-Lune.

35 bis. Clair-de-Lune.

❊

CALS (Adolphe-Félix)
Chez M. Martin, rue Laffitte, 52, Paris

36. Portrait de Madame Ed. G.

37. Le bon père Pêcheur à Honfleur,
 Appartient à M. M....

38. Vieux Pêcheur.
 Appartient à M. R...

39. Paysage.
 Appartient à M. H...

40. Bonne Femme tricotant.

41. Fileuse.

❊

— 9 —

CEZANNE (Paul)
120, rue de Vaugirard, Paris

42. La Maison du Pendu, à Auvers-sur-Oise.

43. Une moderne Olympia.
 Esquisse. Appartient à M. le Dr Gachet.

44. Étude : Paysage à Auvers.

❊

COLIN (Gustave)
14, rue Fontaine, Paris

45. Haurra-Maria.

46. La Maison du Charpentier.

47. L'Étang aux poules d'eau.

48. Marchandes de poissons de Fontarabie (Espagne).

49. Entrée du port de Pasages (Espagne).

❊

— 10 —

DEBRAS (Louis)
18, rue de Chabrol, Paris

50. Un Paysan.
 Étude.

51. Une Nature morte.

52. San Juan de la Rapita (Espagne).
 Dessin.

53. Rembrandt dans son atelier.

❊

DEGAS (Edgard)
77, rue Blanche, Paris

54. Examen de danse au théâtre.
 Appartient à M. Faure.

55. Classe de danse.
 Appartient à M. Brandon

56. Intérieur de Coulisse.
 Appartient à M. Rouart.

57. Blanchisseuse.
 Appartient à M. Brandon.

58. Départ de Course.
 Esquisse. Dessin.

— 11 —

59. Faux Départ.
 Dessin à l'essence.

60. Répétition de ballet sur la scène.
 Dessin. Appartient à M. Mulbacher.

61. Une Blanchisseuse.
 Pastel. Appartient à M. Brandon.

62. Après le bain.
 Étude. Dessin.

63. Aux Courses en province.
 Appartenant à M. Faure.

❊

GUILLAUMIN (Jean-Baptiste)
120, rue de Vaugirard, Paris

64. Le Soir.
 Paysage.

65. Temps pluvieux.
 Paysage.

66. Soleil couchant à Ivry.
 Appartenant à M. le docteur Gachet.

❊

L A T O U C H E (Louis)
12, rue de La Tour-d'Auvergne, Paris

67. Clocher de Berck (Pas-de-Calais).

68. Vue des Quais (Paris).

69. La Plage, marée basse à Berck (Pas-de-Calais).

70. Sous bois.

❊

L E P I C (Ludovic-Napoléon)
46, rue de La Rochefoucauld, Paris

74. L'Arrivée de la marée à Cayeux.
Aquarelle.

75. La Pêche.
Étude en pleine mer. Aquarelle.

76. Golfe de Naples.
Aquarelle.

77. Le Départ pour la pêche du hareng.
Aquarelle.

78. L'Escalier du château d'Aix en Savoie.
Eau-forte.

79. César.
Portrait de chien. Eau-forte.

80. Jupiter.
Portrait de chien. Eau-forte.

❊

L E P I N E (Stanislas)
12, rue des Rosiers (Montmartre), Paris

81. Le canal Saint-Denis.
Appartient à M. Sporck.

82. La rue Cortot.
Appartient à M. Brullé.

83. Bords de la Seine.
Appartient à M. M...

❊

L E V E R T (Jean-Baptiste-Léopold)
Chez M. H. R..., rue de Lisbonne, 34, Paris

84. Bords de l'Essonne.

85. Le Moulin de Touviaux.

86. Près d'Auvers.

❊

77. Perhaps Musée de
Valenciennes
78. Cab. des Est.
79. Cab. des Est.
80. Cab. des Est.

83. Perhaps Musée d'Orsay

M E Y E R (Alfred)
5, rue de Dunkerque, Paris

87. Estienne Marcel, prévôt des marchands.
Émail.

88. Doña Maria Pacheco, épouse de Don Juan de Padilla,
chef de l'insurrection, qui avait pris le nom de
Sainte Ligue des communes sous Charles-Quint.
Émail.

89. Le Firmament.
D'après Émile Lévy. Émail.

90. Figure d'après Raphaël.
Émail.

91. Id. Id.
Émail.

91 bis. Idylle.
Dessin.

❊

DE MOLINS (Auguste)
Chez M. Marchand, 13, rue Neuve-des-Petits-Champs, à Paris,
et 17, route du Calvaire, à St-Cloud.

92. The Comming Storm.

93. Rendez-Vous de chasse.

94. Relai de chiens.

94 bis. Rendez-Vous de chasse.

❊

M O N E T (Claude)
A Argenteuil (Seine-et-Oise).

95. Coquelicots.

96. Le Havre : Bateaux de pêche sortant du port.

97. Boulevard des Capucines.

98. Impression, Soleil levant.

99. Deux croquis.
Pastel.

100. Deux croquis.
Pastel.

101. Deux croquis.
Pastel.

102. Un croquis.
Pastel.

103. Déjeuner.

❊

Mademoiselle MORISOT (Berthe)
7, rue Guichard, Passy-Paris

104. Le Berceau.

105. La Lecture.

106. Cache-Cache.
Appartient à M. Manet.

107. Marine.

94bis. Dayez et al.
95. Wildenstein 274, Musée
d'Orsay or 132
96. Wildenstein 296 or 126
97. Wildenstein 293, Nelson-
Atkins Museum or 292,
Pushkin Museum,
Moscow
98. Wildenstein 263, Musée
Marmottan
103. Wildenstein 132,
Städelsches Kunstinstitut,
Frankfurt

104. Bataille and Wildenstein
25, Musée d'Orsay
105. Bataille and Wildenstein
20, National Gallery of
Art, Washington
106. Bataille and Wildenstein
27, Mrs. John Hay
Whitney
107. Bataille and Wildenstein
17, National Gallery of
Art, Washington

— 16 —

108. Portrait de Mademoiselle M. T.
Pastel.

109. Un Village.
Pastel.

110. Sur la Falaise.
Aquarelle.

111. Dans le Bois.
Aquarelle.

112.
Aquarelle.

❊

MULOT - DURIVAGE
13, rue Neuve-le-Berry, au Havre (Seine-Inférieure)

113. Barques à plomb.
114. La Rampe.

❊

DENITTIS (Joseph)
64, avenue Uhrich, Paris

115. Paysage près de Blois.
116. Lever de lune. Vésuve.
117. Campagne du Vésuve.
118. Études de femme.
118 bis, Route en Italie.

❊

— 17 —

OTTIN (Auguste-Louis-Marie).
9, rue Vincent - Compoint (18ᵉ arrondissement), Paris.

119. Amour et Psyché.
Groupe marbre.

120. Acis et Galathée.
121. Jeune Faune.
122. Nymphe chasseresse.
Réductions en bronze des sculptures décoratives de la fontaine Médicis, au Luxembourg.

123. Jeune Femme portant un vase.
Terre cuite.

124. Id. id.
Terre cuite.

125. Buste.
Terre cuite.

126. Buste de Ingres.
Réduction en plâtre.

127. Le Dernier Mousse du Vengeur.
Plâtre.

128. Buste de M. B***.
Terre cuite.

❊

OTTIN (Léon-Auguste)
2, rue Bervic (18ᵉ arrondissement), Paris.

129. Après la messe à la campagne.
130. Au Château (Sannois).
131. La Butte Montmartre, versant sud.

❊

— 18 —

132. La Fête chez Thérèse.
Projet de rideau de théâtre. — Aquarelle

133. Une Bergerie sans moutons.
Lithographie.

134. At home.
Appartient à M. T. N.

135. Mariette.
Tête d'étude.

❊

PISSARRO (Camille)
26, rue de l'Hermitage, à Pontoise (Seine-et-Oise).

136. Le Verger.
137. Gelée blanche.
138. Les Chataigners à Osny.
139. Jardin de la ville de Pontoise.
140. Une Matinée du mois de juin.

❊

RENOIR (Pierre-Auguste)
35, rue Saint-Georges, Paris.

141. Danseuse.
142. La Loge.
143. Parisienne.

— 19 —

144. Moissonneurs.
145. Fleurs.
146. Croquis.
Pastel.

147. Tête de femme.

❊

ROUART (Stanislas-Henri)
34, rue de Lisbonne, Paris.

148. Ferme bretonne.
149. Levée d'étang.
150. Vue de Melun.
Appartient à M. J. D.

151. Village.
152. Forêt.
153. Route bretonne.
154. Ferme bretonne.
Aquarelle.

155. Maisons béarnaises.
Aquarelle.

156. Id.
Aquarelle.

157. Eau-forte.
158. Id.

❊

ROBERT (*Léopold*)

A Barbizon (Seine-et-Marne), et à Paris, 12, rue Linné.

159. Jeunes filles dans les foins en fleurs.

160. Cadre.

Aquarelles

SISLEY (*Alfred*)

2, rue de la Princesse, à Voisins-Louveciennes.

161. Route de Saint-Germain.

Appartient à M. Durand-Ruel.

162. Ile de la Loge.

Appartient à M. Durand-Ruel.

163. La Seine à Port Marly

164. Verger.

165. Port Marly, soirée d'hiver.

161. Perhaps Daulte 43
162. Daulte 21, Ny Carlsberg
 Glyptotek, Copenhagen
163. Perhaps Daulte 67, Ny
 Carlsberg Glyptotek,
 Copenhagen
164. Daulte 82, private
 collection, Paris
h.c. Sisley, *L'automne: Bords
 de la Seine près
 Bougival*, Daulte 94,
 Museum of Fine Arts,
 Montreal

h.c. Comtesse de Luchaire
 [pseud.], *Lieutenant de
 lanciers*

S'adresser

POUR TOUS LES RENSEIGNEMENTS

ET LA VENTE DES ŒUVRES EXPOSÉES,

au siége même de l'Exposition, 35, Boulevard des Capucines (au premier), de 10 heures du matin à 10 heures du soir.

PARIS. — IMPRIMERIE ALCAN-LÉVY, 61, RUE DE LAFAYETTE

1. Zacharie Astruc

1 – 3e

Les présents chinois (Londres)
The Chinese Gifts (London)

Signed lower right center: *Zacharie Astruc*
Watercolor on paper, 15 x 21¾ in. (38 x 55 cm)
Collection of Dr. Sharon Flescher, New York
REFERENCES: Astruc n.d., no. 143; Flescher 1978, 421–422, figs. 55, 56.

We would like to examine some of the remarkable works we saw, to admire the superior qualities of tone, directness, and vigor that prevail in them, to offer a learned opinion about specific shortcomings; but wouldn't we, then, too closely resemble those judges from whom the Société anonyme would like to distance itself? Let us limit ourselves to citing . . . the powerful watercolors of Zacharie Astruc. . . .
C. de Malte [Villiers de l'Isle-Adam], *Paris à l'Eau-Forte*, 19 April 1874

Zacharie Astruc has a whole collection of brilliant watercolors. Lively, bursting with color and light, they fix the attention of the visitors.
Léon de Lora [Félix Pothey], *Le Gaulois*, 18 April 1874

Z. Astruc paints brilliant and amusing watercolors.
[Philippe Burty], *La République Française*, 25 April 1874

2. Eugène Boudin

I — 18

Rivage de Portrieux (Côtes-du-Nord), 1874
The Coast of Portrieux (Côtes-du-Nord)

Now known as *Environs de Portrieux* (The Coast near
Portrieux, Brittany)
Signed, dated, and inscribed lower right: *E. Boudin
Portrieux 74*
Oil on canvas, 33½ x 58¼ in. (85 x 148 cm)
Private collection, England
REFERENCES: Schmit 1973, no. 964; Dayez et al. 1974, no. 2;
Sotheby's London, 28 June 1978, no. 4.

Let us say to the public that it will
find no works there already stig-
matized and compromised by
rejection. All are original and
have not appeared before any
jury. As a result, they have not
been subjected to dismissive judg-
ments. They stand virginal before
the *amateur*, who has complete
freedom to judge them for him-
self. But don't think these works
are poor or of little importance.
The catalogue lists 165 paintings,
watercolors, etchings, pastels,
drawings, and so on. Although
some of the artists exhibited are
still fighting to be recognized, a
certain number have commanded
respect for years. One of these is
Eugène Boudin, whose *beaches*
and *seascapes* are being fought
over at very high prices.
[Jules-Antoine] Castagnary,
Le Siècle, 29 April 1874

Boudin and Lépine, two artists
who are only remotely associated
with this tradition, have exhib-
ited seascapes. These paintings
could have been predicted from
their earlier work, and do not tell
us anything new about the artists.
Armand Silvestre, *L'Opinion
Nationale*, 22 April 1874

The more moderate but no less
courageous works by Colin,
Rouart, Boudin, Lépine, the
younger Ottin or de Nittis, and
the watercolors by Lepic, show
that we can expect a great deal
from this school.
[Philippe Burty], *La République
Française*, 25 April 1874

To have invited to exhibit
together both those painters who
lag at the very tail end of the latest
banalities of the official Salons
and those who show real talent,
but who work in a very different
direction—such as de Nittis, Bou-
din, Bracquemond, Brandon,
Lépine, and Gustave Colin—this
was a major error in logic and
strategy.
Ernest Chesneau, *Paris-Journal*,
7 May 1874

3. Paul Cézanne

I — 44

Etude: Paysage à Auvers, ca. 1873
Study: Landscape at Auvers

Now known as *Quartier Four, à Auvers* (Landscape, Auvers)
Oil on canvas, 18¼ x 21¾ in. (46.3 x 55.2 cm)
Philadelphia Museum of Art. The Samuel S. White, 3d, and
Vera White Collection. 67-30-16
REFERENCES: Venturi 1936, no. 157; Rishel 1983, no. 2.

Among the works that caught my eye, I was particularly struck by a remarkable landscape by Paul Cézanne, one of your compatriots from the South, a native of Aix, who shows great originality. Paul Cézanne, who has been struggling for a long time, unquestionably has the temperament of a great painter.
[Emile Zola], *Le Sémaphore de Marseille*, 18 April 1874

No audacity will raise our eyebrows. But where landscape is concerned, Cézanne will be glad we did not get as far as his *Maison du pendu* and his *Etude à Auvers*; there, we admit, we were left behind.
Marc de Montifaud [Marie-Amélie Chartroule de Montifaud], *L'Artiste*, 1 May 1874

Shall we mention Cézanne who, by the way, has his own legend? No known jury has ever, even in its dreams, imagined the possibility of accepting a single work by this painter, who came to the Salon carrying his paintings on his back, like Jesus Christ carrying his cross. An over-exclusive love of yellow has compromised Cézanne's future up to now. Nevertheless, because the jury is the jury, it has been wrong.
Jean Prouvaire [Pierre Toloza], *Le Rappel*, 20 April 1874

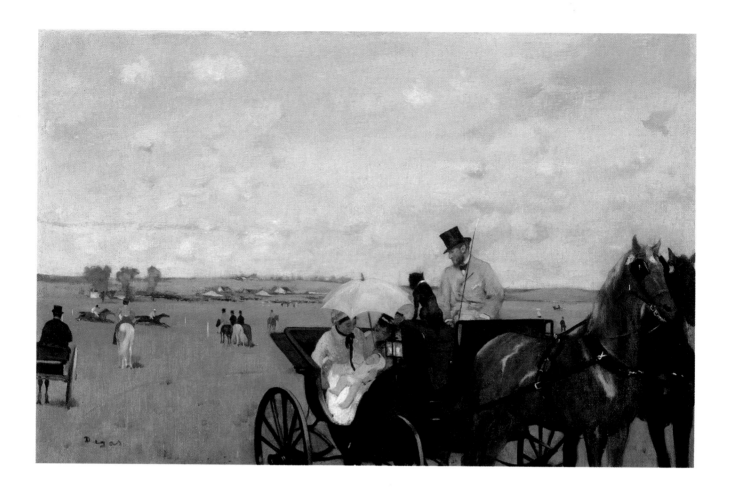

4. Edgar Degas

1–63

Aux courses en province, ca. 1872
At the Races in the Country
Now known as *Carriage at the Races*
Signed lower left: *Degas*
Oil on canvas, 14⅜ x 22 in. (36.5 x 55.9 cm)
Museum of Fine Arts, Boston. 1931 Purchase Fund. 26.790
REFERENCES: Lemoisne 1946, no. 281; Boggs 1962, 37, 46,
47, 92, pl. 72; Dayez et al. 1974, no. 13; Murphy 1985, 75.
NOTE: The occupants of the carriage are Paul Valpinçon, his
wife, and infant son Henri. Valpinçon was a childhood friend
of Degas who lived at this time at Ménil-Hubert in Normandy
where Degas visited him frequently. See Boggs, above.

In defending it too much, we might end up compromising this group, which is attacked with the same arguments that were used against Corot and many others. Might not Degas become classic some day? No one can express with a surer hand the feeling of modern elegance. He knows how to see and to make others see a horse race, the jockeys welded to their saddles, the excited crowd, the horses at the gate. . . . Moreover, this is a man whose capacity for observation, artistic subtlety, and taste reveal themselves in even his smallest works.
[Philippe Burty], *La République Française*, 25 April 1874

In general his color is a little muted, except for a small painting, *Aux courses en province*, which has exquisite color, draftsmanship, exactness of pose, and accuracy of execution.
Ernest Chesneau, *Paris-Journal*, 7 May 1874

Degas is strange and sometimes goes as far as being bizarre. Horses, ballerinas, and laundresses – these are his favorite subjects, and of all the things that surround him, they seem to preoccupy him exclusively. But what precision there is to his drawing, and what pleasing accord in his colors!
[Jules-Antoine] Castagnary, *Le Siècle*, 29 April 1874

5. Jean-Baptiste Armand Guillaumin

1 – 65

Temps pluvieux, 1871
Rainy Weather

Now known as *La Seine à Paris* (The Seine in Paris)
Signed and dated lower right: *AGuillaumin 71*
Oil on canvas, 49¾ x 71⅜ in. (126.4 x 181.3 cm)
The Museum of Fine Arts, Houston. John A. and Audrey Jones
Beck Collection. 71.5
REFERENCES: Serret and Fabiani 1971, no. 10; Wisdom 1981,
no. 184; Gray 1972, no. 24; Lee 1974, 48-49.

I have received no richer impressions than those from *Temps pluvieux* by Guillaumin.
Armand Silvestre, *L'Opinion Nationale,* 22 April 1874

6. Stanislas Lépine

I – 83

Bords de la Seine, 1869
Banks of the Seine

Now known as *Paysage* (Landscape)
Signed and dated lower right: *S. Lépine. 69.*
Oil on canvas, 11 13/16 x 23 in. (30 x 58.5 cm)
Musée d'Orsay (Galerie du Jeu de Paume), Paris. Eduardo
Mollard Bequest, 1972. R.F. 1972-26
REFERENCES: Adhémar and Dayez-Distel 1979, 58, 161.

Bords de la Seine has lustrous waves that are a little cold, but of a fine color harmony, tending to green. Houses with gray roofs and white facades rise from the bank. The river, marbled by shadow near the banks, lightens toward the middle and flows quietly on its way. Lépine's palette has a healthy and peaceful quality that seems better suited to the trickling freshness of waters and reflected foliage than to the treatments of [subjects] "from the Scamander [river] to the tempestuous waves [of the Hellespont]."
Marc de Montifaud [Marie-Amélie Chartroule de Montifaud], *L'Artiste,* 1 May 1874

. . . Stanislas Lépine, who made a reputation on his finely handled *Bords de la Seine*
[Jules-Antoine] Castagnary,
Le Siècle, 29 April 1874

Lépine is a young landscape painter with a great future, a conscientious artist.
Emile Cardon, *La Presse,*
29 April 1874

7. Claude Monet

I–97

Boulevard des Capucines, 1873

Signed lower right: *Claude Monet*
Oil on canvas, 31¼ x 23¼ in. (79.4 x 59 cm)
The Nelson-Atkins Museum of Art, Kansas City, Missouri.
Acquired through the Kenneth A. and Helen F. Spencer
Foundation Acquisitions Fund. F72-35
REFERENCES: Wildenstein 1974, no. 293; Taggart and
McKenna 1973, 150; Dayez et al. 1974, no. 30.
NOTE: This picture is one of two versions, one of which was
shown in the first group exhibition. The other is now in the
Pushkin Museum, Moscow; see Wildenstein 1974, no. 292.

Monet has frenzied hands that work marvels. But to tell the truth, I never could find the correct optical point from which to look at his *Boulevard des Capucines*. I think I would have had to cross the street and look at the picture through the windows of the house opposite.
[Jules-Antoine] Castagnary, *Le Siècle*, 29 April 1874

The extraordinary animation of the public street, the crowd swarming on the sidewalks, the carriages on the pavement, and the boulevard's trees waving in the dust and light—never has movement's elusive, fugitive, instantaneous quality been captured and fixed in all its tremendous fluidity as it has in this extraordinary, marvelous sketch that Monet has listed as *Boulevard des Capucines*. At a distance, one hails a masterpiece in this stream of life, this trembling of great shadow and light, sparkling with even darker shadows and brighter lights. But come closer, and it all vanishes. There remains only an indecipherable chaos of palette scrapings. Obviously, this is not the last word in art, nor even of this art. It is necessary to go on and to transform the sketch into a finished work. But what a bugle call for those who listen carefully, how it resounds far into the future!
Ernest Chesneau, *Paris-Journal*, 7 May 1874

Unfortunately, I was imprudent enough to leave him too long in front of the *Boulevard des Capucines*, by the same painter.
"Ah-ha!" he sneered in Mephistophelian manner. "Is that brilliant enough, now! There's impression, or I don't know what it means. Only, be so good as to tell me what those innumerable black tongue-lickings in the lower part of the picture represent?"
"Why, those are people walking along," I replied.
"Then do I look like that when I'm walking along the boulevard des Capucines? Blood and thunder! So you're making fun of me at last?"
"I assure you, M. Vincent. . . ."
"But those spots were obtained by the same method as that used to imitate marble: a bit here, a bit there, slap-dash, any old way. It's unheard-of, appalling! I'll get a stroke from it, for sure."
Louis Leroy, *Le Charivari*, 25 April 1874

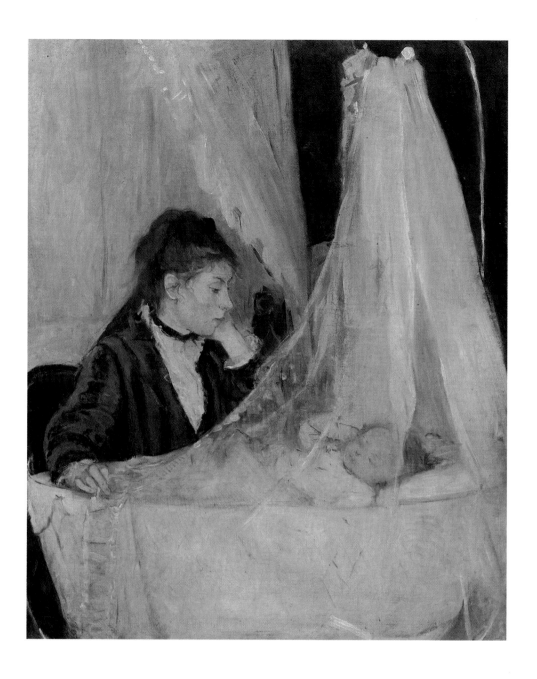

8. Berthe Morisot

1 – 104

Le berceau, 1872
The Cradle

Oil on canvas, 22 x 18 in. (56 x 46 cm)
Musée d'Orsay (Galerie du Jeu de Paume), Paris. R.F. 2849
REFERENCES: Bataille and Wildenstein 1961, no. 25; Dayez et al. 1974, no. 32; Adhémar and Dayez-Distel 1979, 81–83, 165.

Morisot sometimes leaves the fields and shores, and nothing is both more true and tender than the young mother – admittedly rather badly dressed – who leans over the cradle where a rosy child falls asleep, just visible through the pale cloud of muslin.
Jean Prouvaire [Pierre Toloza], *Le Rappel,* 20 April 1874

Morisot exhibited her *Mère près du berceau de son enfant* and *Femme assise dans un pré et lisant,* which also deserve praise.
Léon de Lora [Félix Pothey], *Le Gaulois,* 18 April 1874

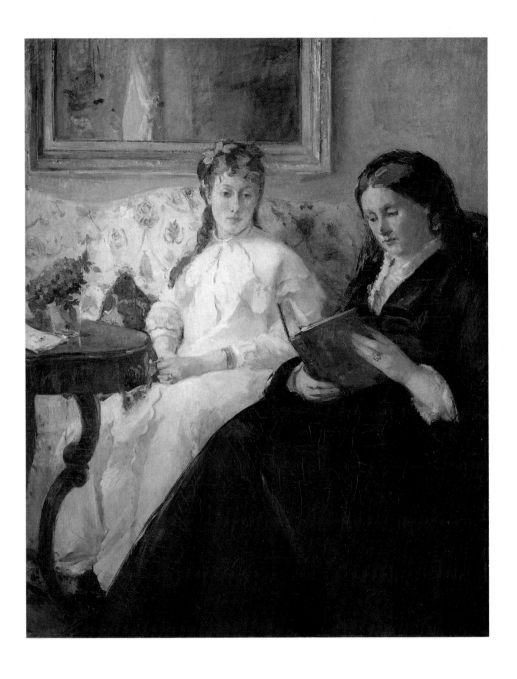

9. Berthe Morisot

1—105

La lecture, 1869—1870
Reading

Now known as *The Mother and Sister of the Artist*
Oil on canvas, 39¾ x 32¼ in. (101 x 81.8 cm)
National Gallery of Art, Washington. Chester Dale Collection.
1963.10.186
REFERENCES: Bataille and Wildenstein 1961, no. 20;
Washington 1965, no. 1850; Rewald 1973, 241—243; Walker
1975, no. 670.
Washington only

"Now take Mlle Morisot! That
young lady is not interested in
reproducing trifling details.
When she has a hand to paint, she
makes exactly as many brush-
strokes lengthwise as there are
fingers, and the business is done.
Stupid people who are finicky
about the drawing of a hand
don't understand a thing about
Impressionism, and great Manet
would chase them out of his
republic."
Louis Leroy, *Le Charivari* ,
25 April 1874

NOTE: Upon completion of this painting, Morisot asked her
brother-in-law, Edouard Manet, his opinion. Manet's reponse
was to retouch it himself; his brushstrokes are still evident
around the eye and mouth of Mme Morisot and on her dress.
See Walker, above.

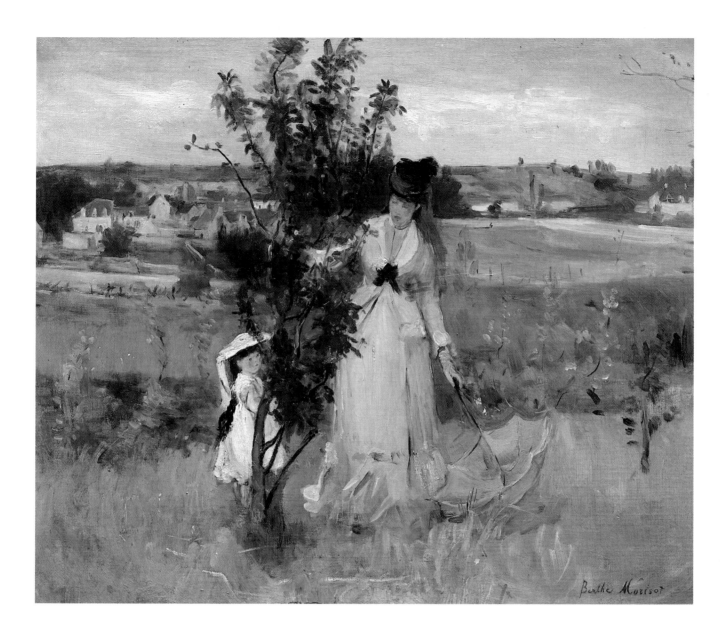

10. Berthe Morisot

I – 106

Cache-cache, 1873
Hide-and-Seek

Signed lower right: *Berthe Morisot*
Oil on canvas, 17¾ x 21⅝ in. (45 x 55 cm)
From the collection of Mrs. John Hay Whitney, New York
REFERENCES : Bataille and Wildenstein 1961, no. 27; Rewald
(Whitney) 1983, no. 17.
San Francisco only

An oil painting, of a young mother playing hide-and-seek behind a cherry tree with her little girl, is a work that is perfect in the emotion of its observation, the freshness of its palette, and the composition of its background.
[Philippe Burty], *La République Française*, 25 April 1874

Berthe Morisot has wit to the tips of her fingers, especially at her fingertips. What fine artistic feeling! You cannot find more graceful images handled more deliberately and delicately than *Berceau* and *Cache-cache*. I would add that here the execution is in complete accord with the idea to be expressed.
[Jules-Antoine] Castagnary, *Le Siècle*, 29 April 1874

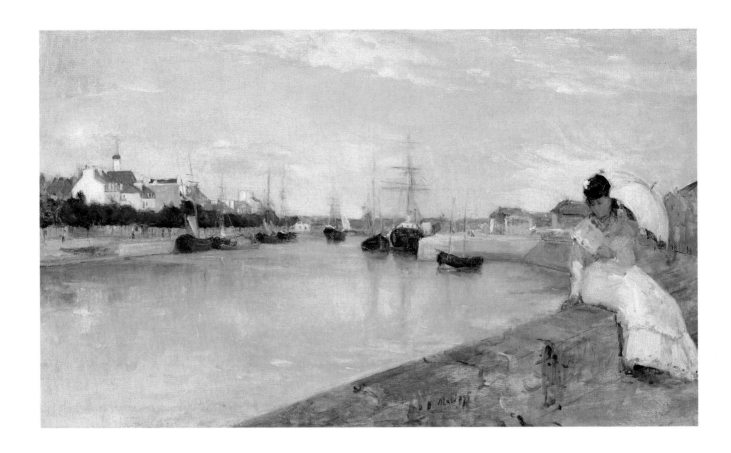

11. Berthe Morisot

Marine, 1869
Seascape
Now known as *The Harbor at Lorient*
Signed lower right: *B. Morisot*
Oil on canvas, 17½ x 28¾ in. (43.5 x 73 cm)
National Gallery of Art, Washington. Ailsa Mellon Bruce
Collection. 1970.17.48
REFERENCES: Bataille and Wildenstein 1961, no. 17; Rust
1978, 38, 39.
Washington only

Berthe Morisot is certainly not a
perfect artist. However, there are
many admirable instincts in the
way the pink border of a muslin
scarf is arranged next to a blue or
green umbrella, and what a lovely
vagueness [there is] in the dis-
tance at sea where the tiny points
of masts tilt!
Jean Prouvaire [Pierre Toloza],
Le Rappel, 20 April 1874

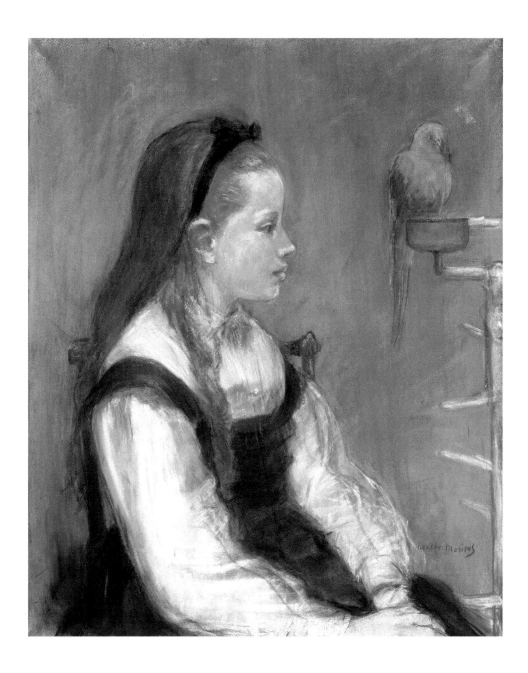

12. Berthe Morisot

I — 108

Portrait de Mademoiselle M. T., ca. 1873

Now known as *Portrait of Madeleine Thomas* or *Young Girl with a Parrot*
Signed lower right: *Berthe Morisot*
Pastel on paper, 23⅝ x 19⅜ in. (60 x 49.5 cm)
Private collection, New York
REFERENCES: Bataille and Wildenstein 1961, no. 426; Sotheby's London, 4 December 1974, no. 6.
NOTE: Madeleine Thomas was the sister of Gabriel Thomas, a patron and collector of Impressionist paintings, and a first cousin of Berthe Morisot, whose mother was born Marie-Joséphine Cornélie Thomas.

The masterpiece of Morisot, who belongs more directly to the new school, is a completely vigorous and charming pastel: *Le portrait de Mlle T. . . .*
Armand Silvestre, *L'Opinion Nationale*, 22 April 1874

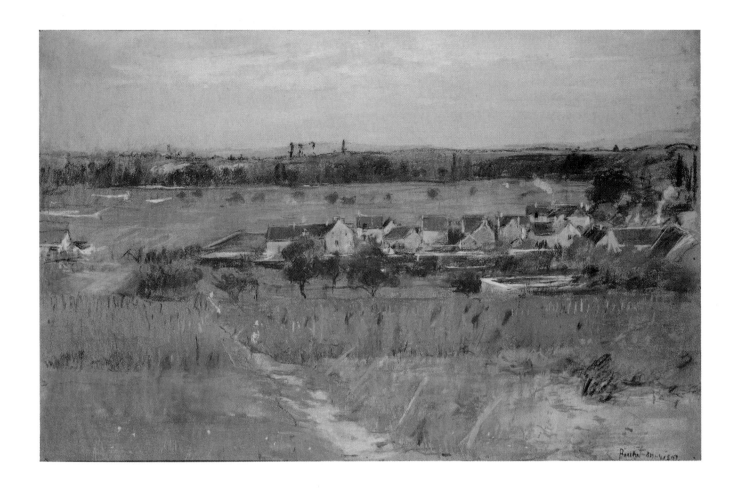

13. Berthe Morisot

I — 109

Un village

Now known as *Le village de Maurecourt*
Signed lower right: *Berthe Morisot*
Pastel on paper, 18½ x 28¼ in. (47 x 72 cm)
Private collection, New York
REFERENCES: Bataille and Wildenstein 1961, no. 424.
San Francisco only

Berthe Morisot is a gifted artist.
She shows pastels and watercol-
ors of touching grace.
[Philippe Burty], *La République
Française*, 25 April 1874

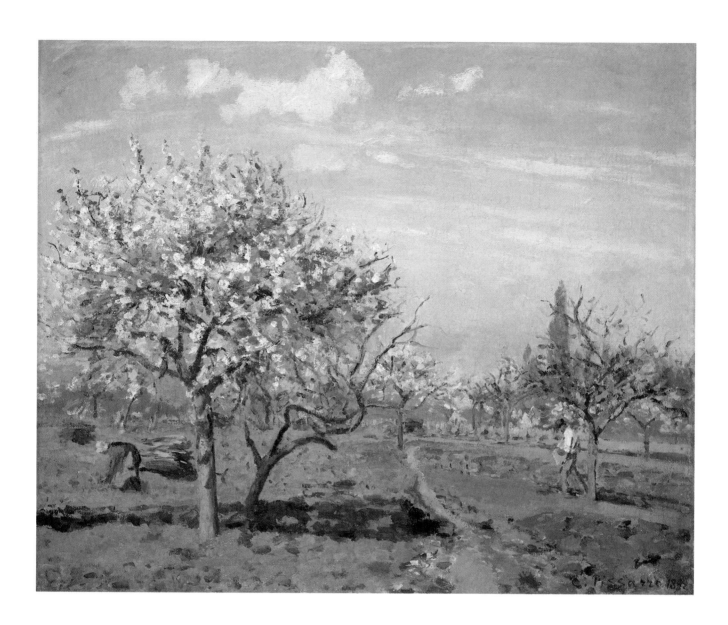

14. Camille Pissarro

1 – 136

Le verger, 1872
The Orchard
Now known as *Orchard in Bloom, Louveciennes*
Signed and dated lower right: *C. Pissarro 1872*
Oil on linen, 17¾ x 21⅝ in. (45.1 x 54.9 cm)
National Gallery of Art, Washington. Ailsa Mellon Bruce
Collection. 1970.17.51
REFERENCES: Pissarro and Venturi 1939, no. 153; Rust 1978,
18, 19.

He has a deplorable predilection
for market-gardens (*Le verger*)
and does not hesitate to paint
cabbage or any other domestic
vegetable. But these errors of
logic or vulgarities of taste do not
alter his beautiful qualities of
execution.
[Jules-Antoine] Castagnary,
Le Siècle, 29 April 1874

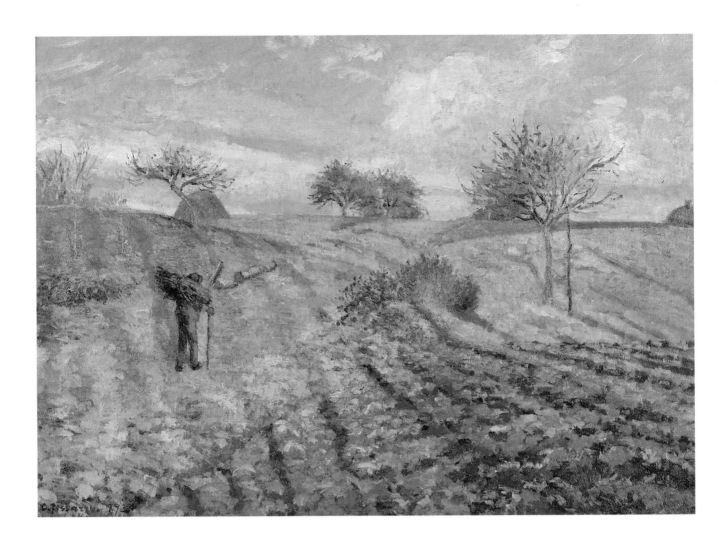

15. Camille Pissarro

I – 137

Gelée blanche, 1873
Hoarfrost

Signed and dated lower left: *C. Pissarro. 1873*
Oil on canvas, 25⅝ x 36⅝ in. (65 x 93 cm)
Musée d'Orsay (Galerie du Jeu de Paume), Paris. Eduardo
Mollard Bequest, 1972. R.F. 1972-27
REFERENCES: Pissarro and Venturi 1939, no. 203; Adhémar
and Dayez-Distel 1979, 88, 167; Dayez et al. 1974, no. 34;
Lloyd et al. 1981, no. 26; Shikes and Harper 1980, 109-110;
Brettell et al. 1984, no. 96.
NOTE: The subject of this picture has been identified as the
Ancienne route d'Ennery, Pontoise. See Lloyd et al., above.

Then, very quietly, with my most naive air, I led him before the *Ploughed Field* of M. Pissarro. At the sight of this astounding landscape, the good man thought that the lenses of his spectacles were dirty. He wiped them carefully and replaced them on his nose.
"By Michalon!" he cried. "What on earth is that?"
"You see . . . a hoarfrost on deeply ploughed furrows."
"Those furrows? That frost? But they are palette-scrapings placed uniformly on a dirty canvas. It has neither head nor tail, top nor bottom, front nor back."
"Perhaps . . . but the impression is there."
"Well, it's a funny impression!"
Louis Leroy, *Le Charivari*,
25 April 1874

One effect of *Gelée blanche*, by Pissarro, reminds us of Millet's best themes. We believe that he intentionally eliminates shadows, even though he merely selects those sunless, gently luminous days that leave the tones all their color values and soften planes. What we must demand is more precisely defined relief in the branches and tree trunks.
[Philippe Burty], *La République Française*, 25 April 1874

Pissarro is sober and strong. His synthesizing eye embraces at a glance the whole scene. He commits the grave error of painting fields (*Gelée blanche*) with shadows cast by trees placed outside the frame. As a result the viewer is left to suppose they exist, as he cannot see them.
[Jules-Antoine] Castagnary,
Le Siècle, 29 April 1874

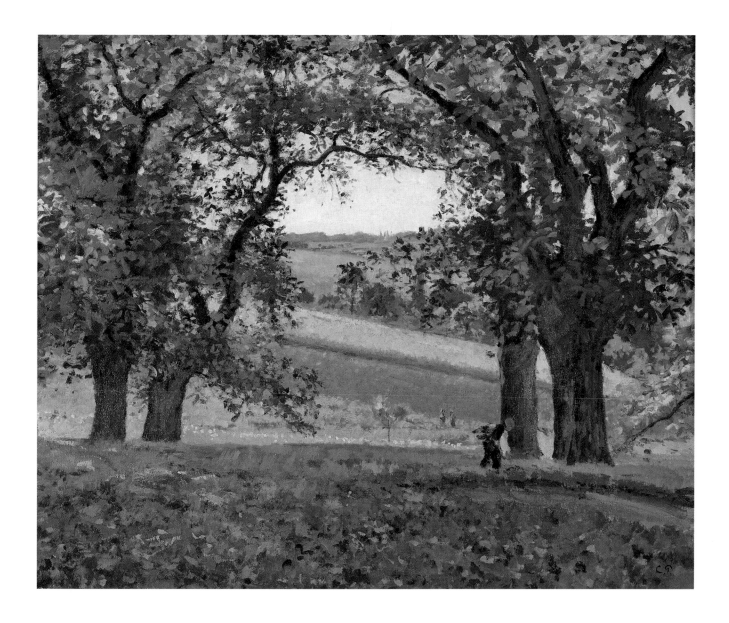

16. Camille Pissarro

1—138

Les châtaigniers à Osny, ca. 1873
The Chestnut Trees at Osny
Initialed lower right: *C.P.*
Oil on canvas, 25⅝ x 31⅞ in. (65 x 81 cm)
Private collection, New York
REFERENCES: Pissarro and Venturi 1939, no. 236; Shikes and
Harper 1980, 109, 111.

Les châtaigniers à Osny by Ca-
mille Pissarro is somewhat crude
in tone, but the lushly painted
fields indicate that serious inten-
tions lie beneath the persistently
coarse surface.
Marc de Montifaud [Marie-
Amélie Chartroule de Monti-
faud], *L'Artiste*, 1 May 1874

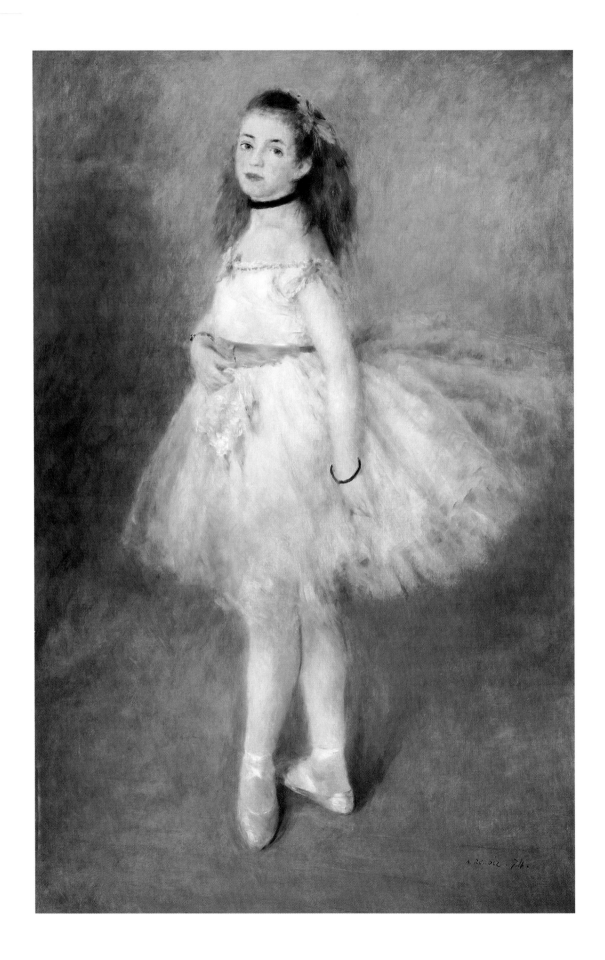

17. Pierre-Auguste Renoir

I – 141

Danseuse, 1874
Dancer
Signed and dated lower right: *A. Renoir. 74.*
Oil on canvas, 56⅛ x 37⅛ in. (142.5 x 94.5 cm)
National Gallery of Art, Washington. Widener Collection.
1942.9.72
REFERENCES: Daulte 1971, no. 110; Washington 1975,
no. 668; Guillaud et al. 1984, 34, fig. 32.

Renoir exhibited a *Danseuse,*
a young blond girl who lifts
her tulle skirts with a graceful
gesture
Léon de Lora [Félix Pothey],
Le Gaulois, 18 April 1874

His *Jeune danseuse* is a charming
portrait. With her dark red hair,
her too pale cheek, and too red
lips she reminds us of the "thir-
teen-year-old woman" whose
story was so cruelly told by Théo-
dore de Banville in the *Pari-
siennes de Paris.* Already, as a
result of work undertaken when
too young, her legs have grown
heavy, and her feet, in their pink
satin slippers, are not dainty
enough. But the long and spindly
arms are surely those of a child,
and below her boyish chest a blue
sash, a ribbon from first com-
munion, comes down and flutters
over the winged skirt of the balle-
rina. Still a little girl? Doubtless.
Already a woman? Perhaps. A
young girl? Never.
Jean Prouvaire [Pierre Toloza],
Le Rappel, 20 April 1874

Renoir's *Danseuses* [*sic*] and the
Parisienne are both sketches and
nothing more. The figure should
not be systematically treated in
this loose way. Despite this reser-
vation, the overall tone is attrac-
tive; the heads recall both English
painting and Goya, and the fab-
rics are only thinly painted and
have no depth or projection. It is
an attractive approximation, but,
at the most, it is a mere promise.
Nature finds deeper expression
than in such imperceptible
appearances. There is something
worse than taking reality for a
shadow, and that is taking the
shadow for reality. Despite these
criticisms, one would search our
official school in vain for a head
whose distinction, quality, and
reality of tone matched those of
the *Danseuse.*
Armand Silvestre, *L'Opinion
Nationale,* 22 April 1874

Upon entering the first room,
Joseph Vincent received an initial
shock in front of the *Dancer* by
Renoir.
"What a pity," he said to me,
"that the painter, who has a cer-
tain understanding of color,
doesn't draw better: his dancer's
legs are as cottony as the gauze of
her skirts."
"I find you hard on him," I
replied. "On the contrary, the
drawing is very tight."
Bertin's pupil, believing that I was
being ironical, contented himself
with shrugging his shoulders, not
taking the trouble to answer.
Louis Leroy, *Le Charivari* ,
25 April 1874

Considered from a distance, for
example, from the back of the
third room on the ground floor,
the *Danseuse* is an original con-
ception, a kind of fairy molded in
earthly forms. Nothing is more
alive than her bright and tender,
rosy skin. On this the heap of
gauze that makes up her dress
somehow delightfully blends
with her luminous and tender
tones. This is Realism of the great
school, the one that does not feel
forced to trivialize nature to
interpret it. You can apply to
Renoir these three lines of a son-
net written to characterize a witty
canvas:
*He knows how, oh Parisienne, to
give iridescence to your toilette
One sees flowers and cupids
spring from his palette
Eve in vine leaves, and Venus
without a corset.*
Marc de Montifaud [Marie-
Amélie Chartroule de Monti-
faud], *L'Artiste,* 1 May 1874

The *Danseuse* is true to life and
has a fine and nervous elegance in
its truth. However, everything
that is charming—the haziness of
the gauze skirts, the notes of color
on the head, breast, and legs—is
unfortunately lost in a vague,
entirely conventional
background.
Ernest Chesneau, *Paris-Journal,*
7 May 1874

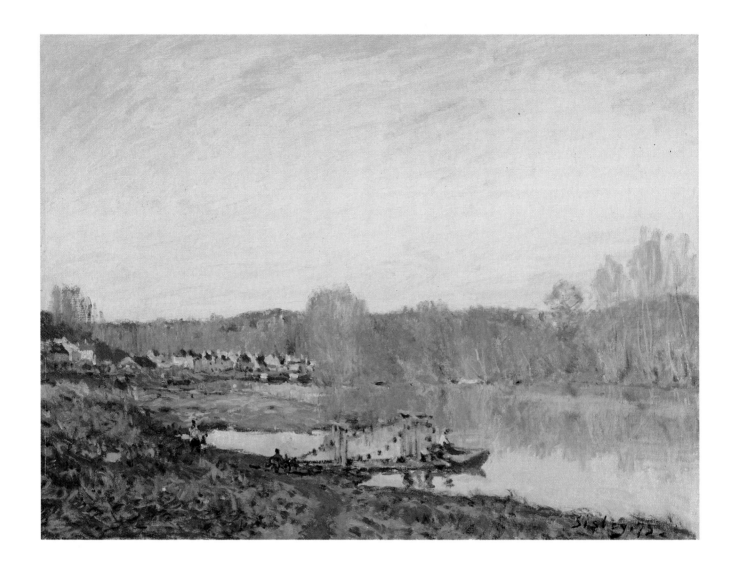

18. Alfred Sisley

I — HC

L'automne: Bords de la Seine près Bougival, 1873
Autumn: Banks of the Seine near Bougival

Signed and dated lower right: *Sisley. 73*
Oil on canvas, 18¼ x 24⁵⁄₁₆ in. (46 x 62 cm)
Montreal Museum of Fine Arts/Musée des Beaux-Arts
de Montréal.
Bequest of Miss Adaline Van Horne, 1945. 924
REFERENCES: Daulte 1959, no. 94; Montreal 1977, 107, fig.
71; Brettell et al. 1984, no. 60.

We confess that in general we only moderately admire Sisley's paintings. Finishing is difficult. Many people make sketches with finesse, but one must blame those among them who limit themselves to beginnings. But this time Sisley exhibits a charming work along with other mediocre canvases. We do not know its title, for the catalogue is not yet published. On the bank of water vaguely tinted by the reflection from a pale sky, some yellow and red autumn trees lean, sad yet golden. And on the opposite bank, in a sort of half-circle, small houses, some with red roofs, stretch toward a distant, deeper blue.
Jean Prouvaire [Pierre Toloza], *Le Rappel*, 20 April 1874

Landscape paintings are prominent in the Exhibition. Their defects also pierce the armor. Sisley is one of those making progress, but perhaps he sees too thin a section of nature.
Marc de Montifaud [Marie-Amélie Chartroule de Montifaud], *L'Artiste*, 1 May 1874

The Second Exhibition *1876*

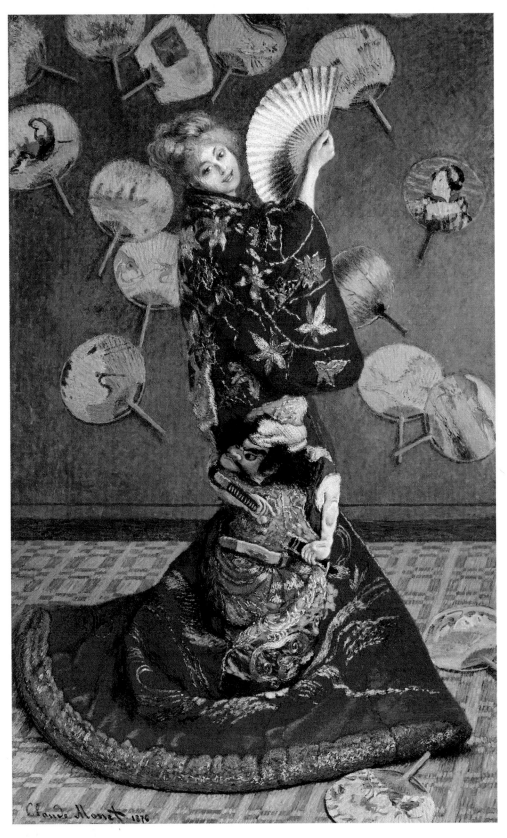

fig. 6 Claude Monet, *Japonnerie* (*La Japonaise*, II–153), 1876. Oil on canvas, 91 x 56 in. (231 x 142 cm). Museum of Fine Arts, Boston. 1951 Purchase Fund

A Failed Attempt

Hollis Clayson

By staging a second exhibition, the Independent artists of the disbanded Société anonyme effected an automatic shift in the public's view of their identity: overnight the one-time *cause célèbre* became an ongoing phenomenon, entrenching a small group with recognizable and consistent traits and practices. In other words, the series of Independent exhibitions actually began with the second show, not with the first.

The second exhibition attracted much more attention in the Parisian press than had the first, and a distinguished international roster of literary figures—Henry James, Stéphane Mallarmé, August Strindberg, and Emile Zola—wrote about the Independents in 1876 for foreign readers.[1] But one should mistake neither the notice paid by eminent vanguard *literati* nor the increased attention in the press for a sign of the show's critical success. On the contrary, there were as many negative as positive notices, despite the organizers' certain hope to succeed with the event which they had prepared in a sensible, businesslike fashion. They were not looking for controversy. They hoped to make money and to win critical and public approval, but despite the sobriety of the artists' pursuit of success, when the second exhibition was held in spring 1876, the artists were still on the defensive in the Paris art world.

In 1874 the initiative for the public formation of a group and an independent exhibiting organization came from the core of what was to be called the Impressionist group (Degas, Monet, Morisot, Pissarro, Renoir, and Sisley). Their motivation was strategic and economic in equal parts and hinged upon the relationship between their art and that welcomed by the Salon. They did not seek independence as a permanent status. They set out in 1874 to enact a career strategy: to forge a group identity and to gain the kind of visibility that just might have helped to secure eventual entrance into the Salon and have made them some money in the interim.[2] But by 1876 it seemed doubtful that the work of the Impressionist core would ever be welcome in the Salon, largely, as we shall see, because of what was perceived to be their works' lack of finish. Though their difficulties with the critics and the Salon juries were due primarily to the unacceptability of their painting styles, the renegade image was also an obstacle to their acceptance. Reputations and prices had suffered after the first show branded the exhibitors as Intransigents. But what developed into a stylistic dispute by 1876 had more complex and diverse roots. It is important to recall that the group's distinctive esthetic was based as much on material considerations and limitations as esthetic passions.

When some of the artists became acquainted and began to work together in the later 1860s, they wanted to produce works suitable for display in the Salon, but, as Charles Harrison argues, "this ambition was practically (and philosophically) in conflict with their aim to work out-of-doors and to represent subjects in specific lighting conditions."[3] These aims resulted in the sketchy handling and small scale of many of the paintings displayed in the Independent exhibitions: works conceived as studies were shown as finished paintings (e.g., Monet's *Les bains de la Grenouillère* [fig. 1], painted in 1869). The painters ended up making a virtue and an issue of what had initially been the by-product of technical and financial restrictions. They felt "increasingly confident in defending what might have been seen as lack of finish as the necessary means to preserve the integrity of their working procedure and the immediacy of their visual sensations."[4] The characteristic style of the members of the Impressionist core rose therefore out of the constraints of practice, including their determination to represent modern life in a new and forthright way, rather than proceeding directly from some esthetic parti pris.

Despite their joint development of the rationale of the sketched glimpse, these issues were not the principal reasons for exhibiting independently. While it was true that viewing conditions in the Salon galleries were appalling, it is even more important to note that the political and economic conditions of the early years of the Third Republic did not favor the support of independent artists. After the suppression of the Commune, the standards of the Salon juries became increasingly strict and narrow, meaning that prospects for support from the State had diminished. The post-1873 economic slowdown lessened the likelihood of help from the private

sector. For example, the Durand-Ruel Gallery, the dealer for most of the core group, suffered a lean period from 1874 to 1880. Furthermore, a test of support from the private sector in 1875 had proved disastrous.[5] Four members of the group (Renoir, Monet, Sisley, and Morisot) had staged a very unsuccessful auction sale of seventy-three of their works at the Hôtel Drouot in March 1875.[6] The poor showing at the auction certainly helped persuade them not to stage a second group show in spring 1875.

Nevertheless it is not surprising that the group decided to stage a second exhibition the following year.[7] In view of the economic and cultural difficulties of the 1870s, it seemed unlikely that their work could be seen, let alone sold, in any other way. The show ran during April 1876; at the same time Manet also was showing paintings in his studio, including the two rejected from the 1876 Salon. Three rooms of the centrally-located premises of Durand-Ruel at 11 rue le Peletier served as the showcase for the two hundred fifty-two works put on display on Thursday, 30 March. Unlike the first show where entries were mixed together, this time they were grouped by artist with each exhibitor's work arranged on its own panel. The exhibition bore an entirely neutral title, "La deuxième exposition de peinture par MM. . . ," although the terms Impressionist and/or Intransigent used in 1874 were widely employed again in 1876 to label and discuss the show in the press.

As had been the case in 1874, it was again found necessary and expedient to recruit exhibitors on a wider basis in order to put together a show of adequate size, to lend an air of professionalism and respectability (avoiding the impression that this was a Salon des Refusés), and to spread the financial responsibility. Much of the initial financial burden of the early days of the Impressionist group had been carried by the well-to-do Bazille, who had died in the 1870 Franco-Prussian War, and by Sisley's father, whose ruin was War-related.[8] Some of the well-respected artists recruited in 1874 defected. Astruc, Boudin, Latouche, de Nittis, and others withdrew, but Béliard, Bureau, Cals, Lepic, Levert, Ottin *fils*, and Rouart stayed with the project in 1876. Desboutin, François (a pseudonymous woman), Legros, J. B. Millet (*the* Millet's brother), and Tillot were new exhibitors. Cézanne and Guillaumin (neither handled by Durand-Ruel) sat out the second show as did Lépine, but Caillebotte joined up—a future financial supporter and new group stalwart, 1876 marking the first of his five appearances in the Independent efforts. There was a total of nineteen exhibitors where there had been thirty in 1874. Of the two hundred fifty-two works on display, less than half—ninety-five works—were exhibited by the core: Degas showed twenty-four works, Monet eighteen, Morisot seventeen, Pissarro twelve, Renoir fifteen, and Sisley nine.

The arrangement of the exhibition seems to have reflected its organizers' concern to blunt or at least postpone the impact of some of the most difficult pieces in the show.[9] Some of the easiest, most conventional paintings filled the first room of the gallery, while more difficult works—those of Renoir, Sisley, and Monet—were saved for the second room. The entries that angered many critics the most—Degas's and Pissarro's—were hung at the end of the show in the third room.

The first room contained Desboutin's six drypoint engravings, mostly portraits and figure studies, and his seven paintings, including his *Portrait de M. F. . . .* (cat. no.28), and *Le violoncelliste* (11–64), a larger version of which is illustrated (*fig.*2). Also in the first room were Legros's twelve prints, etchings and drypoints, mostly genre scenes and several portraits,[10] and Millet's ten watercolors and sepia drawings of rural motifs. Either at the end of the first room or at the beginning of the second were Lepic's thirty-six etchings and watercolors, mostly marines.

Although, as we have already indicated, the objects were organized by artist in this exhibition, some evidence suggests that Degas's and Morisot's exhibits were divided up by media between two rooms,[11] thereby reserving the first room of the exhibition for works on paper, except for Desboutin's paintings. Morisot's watercolors and pastels were apparently in the first room, and her oil paintings were in the second. Half of her works were landscapes, with and without figures (as in *West Cowes. [Ile de Wight.]*, [11–171], and *Un percher de blanchisseuse* [cat. no.33]) and the other half were figures. And it is possible that Degas's studies of dancers, with perhaps other subjects, were in the first room, with the balance of his exhibit installed at the end of the exhibition in the third room. Among these works are the *Portraits dans un bureau (Nouvelle-Orléans)* (cat. no.22), *Portrait de M* E. M. . . . (cat. no.23), *Portrait, le soir* (cat. no.24), and *Petites paysannes se baignant à la mer vers le soir* (cat. no.27) in the present exhibition. Degas's exhibit contained five or six works on the subject of dance, including the *Salle de danse* (cat. no.25) and the *Coulisses* (*fig.*3), and five *Blanchisseuses* (cat. no.26 and 11–41, 50, 54, and 59).[12]

The second room, called the Grand Salon, contained the fifteen works by Renoir including his *Portrait de M. M. . . .* (cat. no.36) and the *Etude* (cat. no.35), as well as the *Frédéric Bazille, peintre tué à Beaune-la-Rolande* (*fig.*4), lent to the exhibition by Manet. Six of the remaining twelve works by Renoir were lent by Victor Chocquet. Also in this room were Sisley's nine landscapes, including the frequently commended *Inondations à Port–Marly* (*fig.*5) and *L'abreuvoir de Marly, en hiver* (cat. no.37), and Monet's *Japonnerie* (*fig.*6), the largest piece in the room. In addition, of the seventeen landscapes by Monet, nine were lent by the opera star,

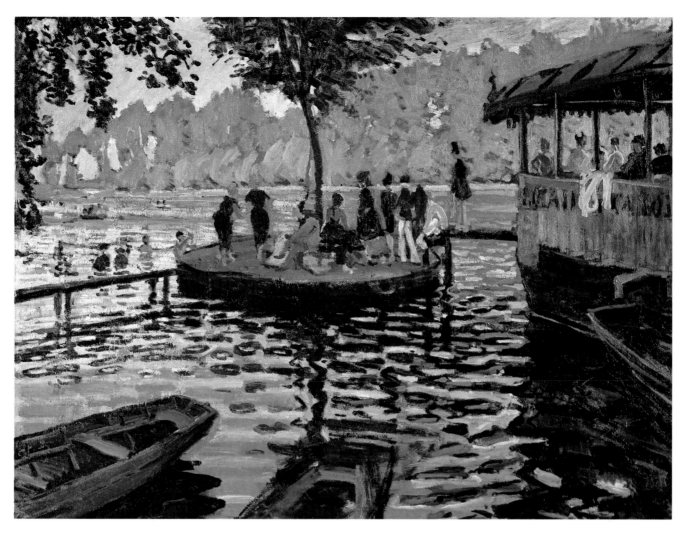

fig. 1 Claude Monet, *Les bains de la Grenouillère* (*La Grenouillère*, II–164), 1869. Oil on canvas, 29⅜ x 39¼ in. (74.6 x 99.7 cm). The Metropolitan Museum of Art. Bequest of Mrs. H. O. Havemeyer, 1929. The H. O. Havemeyer Collection

Faure, including *La plage à Sainte-Adresse* (cat. no.31), *La Seine à Argenteuil* (cat. no.30), *Le pont d'Argenteuil* (fig.7), and *La prairie* (fig.8). Also included was *La promenade* (cat. no.32), *Les bains de la Grenouillère* (fig.1), and *Panneau décoratif* (II–162). Another of the landscapes was lent by Chocquet. Caillebotte's eight canvases were in this room as well, including the two *Raboteurs de parquets* (cat. nos.19 and 20), the *Jeune homme à sa fenêtre* (cat. no.21), the *Jeune homme jouant du piano* (fig.9) and the *Déjeuner* (fig.10).

In addition to Degas's work, the third and final room contained eight landscapes by Tillot; three figure drawings and eight paintings by Cals that were mostly landscapes, including *Soleil couchant* (II–25); ten works by Rouart that were mostly landscape paintings; two figure paintings and six still lifes by François; eight landscapes by Béliard; fourteen landscapes by Ottin *fils*; and the

twelve landscapes by Pissarro, including *Neige. Coteaux de l'Hermitage (Pontoise)* (fig.11) and *Ferme à Montfoucault* (II–201). One of the remaining ten canvases was lent by Chocquet.

One cannot do justice in a brief essay to all of the criticism that appeared in 1876. But some facts emerged from the diverse texts. Monet's *Japonnerie* and Degas's *Portraits dans un bureau (Nouvelle-Orléans)* were found to be the show's key pieces: they drew the most comment—both pro and con. Pissarro's landscapes fared least well of the nineteen displays, while Caillebotte's participation was widely remarked and generally praised. Degas's well-known *L'absinthe* (Musée d'Orsay), long believed to have been part of this show as II–52, *Dans un café*, was not, I believe, in the exhibition after all, because even the most detailed comments on Degas's exhibit make no reference whatsoever to such a work.

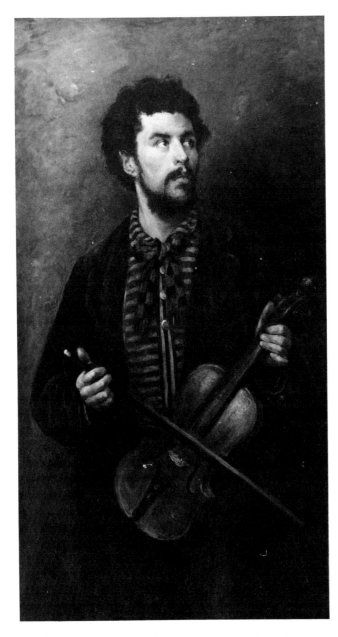

fig. 2 Marcellin Desboutin, *Le joueur de violon (The Violinist)*, 1874. Oil on canvas, 47¼ x 25⅝ in. (120 x 65 cm). Musée de Moulins

Before considering the critics' discussion of the exhibition, let us analyze three famous and ambitious essays written by literary-figures-turned-critics in 1876–those of Edmond Duranty, Emile Zola, and Stéphane Mallarmé. Although we now tend to think of these authors as analysts of Impressionist theory, as their articles were based on this early exhibition, their writings suggest the ways in which the art critical judgments leveled in 1876 could have various contexts.

Duranty's *La nouvelle peinture: A propos du groupe d'artistes qui expose dans les Galeries Durand-Ruel* was the very first substantial publication ever consecrated to the subject of Impressionism, although as is well known,

Duranty studiously avoided the term, perhaps owing to Degas's influence.[13] A thirty-eight page pamphlet, it was published at the author's expense in an edition of 750 copies. It *was* a review of the second exhibition, culminating in the author's endorsement of Degas's and Caillebotte's Naturalism, which was based on modern life, but it also featured an extended analysis of the new painting's relationship to the nineteenth-century Realist/Naturalist tradition that Duranty had championed twenty years earlier, and a presentation of what he had reckoned to be the distinctive new and important features of the group's work.

The first half of the essay concerns the new painting's history and parentage. Duranty argues that its relationship to nineteenth-century tradition is a complex one: "[they] wrestle with tradition, admire it, and simultaneously want to destroy it, . . . acknowledge that tradition is great and powerful and . . . attack it for that very reason." He mounts his defense, aware that the appearance of many of the works could wrongly suggest pictorial anarchy, as "too often [these artists produce] nothing but sketches, abbreviated summaries of works."

For Duranty, the Independent artists' works are innovative in four ways, in the uses of color, drawing, composition, and subject matter. The colorists of the group (the landscape painters) discovered that light "decolors" [*décolore*] tones, and they thereby represented the way nature appears to the eye. The draftsmen of the group (Duranty found a marked difference between the two contingents) perfected a new kind of *dessin* that disclosed the character of the motif in Balzacian fashion. "A back should reveal temperament, age, and social position."

He also stresses the importance of time- and place-specific observation, and of a painstaking inventory of material details. The first idea, he writes, "was to eliminate the partition separating the artist's studio from everyday life." To this end, he suggests, painting that imitates a rapidly-exposed (imaginary) color photograph would be ideal. Here he also gives away his belief that Degas and Caillebotte best achieved the new fact-based form of novel observation, for, in the list he provides of scenarios ripe for this kind of transcription, he includes figures that sit at a piano (Caillebotte's *Jeune homme jouant du piano*), examine a sample of cotton in the office (Degas's *Portraits dans un bureau [Nouvelle-Orléans]*), press an iron onto an ironing board (Degas's five *Blanchisseuses*), or dine with the family (Caillebotte's *Déjeuner* and Monet's *Panneau décoratif*). The connection between the new composition and the surprising appearance of things in life is the final formal element enumerated by Duranty: the new art reveals that things are often seen from pronounced angles and are glimpsed only partially. Need it be said that this observation corresponds to Degas's characteristic way of

composing? And Duranty's stress on the importance of the window as surprising framing recalls Caillebotte's *Jeune homme à sa fenêtre.*

Duranty's famous inventory of settings suitable for the new honest transcription was one of the first attempts to catalogue the iconography of urban Impressionism.[14] He did attempt to bring the two threads of his argument together by rejoining the observers of culture with the recorders of nature, but he clearly found the landscape contingent the weaker. His real passion—shaped by the enthusiasms of Courbet's Realist heyday—was for an art that recorded the diverse facets of modern life, and landscape painting was unimportant by comparison. However, even in 1856, his attachment to the panorama of modern life had been a thoroughly estheticized one. "Everything seemed to me arranged as if the world were created expressly for the delight of painters, for the delight of the eye."[15]

Zola's generally positive review of the 1876 show was written for Russian readers of *Le Messager de l'Europe.*[16] He was most optimistic about the future of the group, if less sanguine about the work of all of the artists involved:

One cannot doubt that we are witnessing the birth of a new school. In this group a revolutionary ferment is revealed which will little by little win over the Academy of Beaux-Arts itself, and in twenty years will transform the Salon from which today the innovators are excluded. We can say that Manet, the first, set the example.

The last phrase is consistent with Zola's earlier art critical position and echoes Duranty's ideas about the new art's genealogy.

To present the distinctive characteristics of group method and style, Zola quotes Duranty approvingly, concurring that the crucial issues were those of coloration, drawing, and choice of modern subject. Though sharing Duranty's ideas about the ingredients of the new style, he reaches different conclusions about the works in the exhibition. He discusses the work of eight exhibitors only (the core six plus Caillebotte and Béliard, a personal friend); he considers these artists to be "at the head of the movement."

To Monet went the most fervent praise (he is "incontestably the head of the group"), as Zola singles out his *Japonnerie* and *La prairie* for mention. Praise for the other landscape painters followed (Morisot, Pissarro, Sisley, Béliard) and for Renoir's portraits. The point at which he parts company with Duranty is in his judgment of Caillebotte's and Degas's work. He admires the three-dimensionality of Caillebotte's two canvases of *Raboteurs de parquets* and *Jeune homme à sa fenêtre*, but finds the work too precise: "Because of their precision, the paintings are entirely anti-artistic, clear as glass, bourgeois. The mere photography of reality is paltry when not enriched by the original stamp of artistic

fig. 3 Edgar Degas, *Coulisses (Dancers Preparing for the Ballet, II–47)*, ca. 1878 or 1880. Oil on canvas, 29⁹⁄₁₆ x 23³⁄₄ in. (74.1 x 60.3 cm). The Art Institute of Chicago. Gift of Mr. and Mrs. Gordon Palmer, Mr. and Mrs. Arthur M. Wood, and Mrs. Bertha P. Thorne

talent." In Degas's exhibit, Zola preferred the least finished works, mentioning a *Blanchisseuse* and a *Salle de danse*, and thought his best works were studies. Predictably, then, the New Orleans picture was roundly condemned as too finished and heavy-handed. "He spoils everything when he puts the last touches to a work." Disparagingly, he likened Degas's most finished works to fashion plates or images from illustrated newspapers.

While Zola shares Duranty's theory of the new art, he betrays his preference for the colorists over the draftsmen. Both writers, however, circumscribe the issues posed by the art of the new school within a purely artistic context. Indeed, for all the fame of their accounts, their comments are rather narrowly framed. Ironically, given the emphasis of the three men's own literary practice, it is Mallarmé's account that departs from this estheticized view of the significance of the new art.

Mallarmé's long piece, "The Impressionists and Edouard Manet," appeared in English in *The Art Monthly Review* in September.[17] Like Duranty and Zola, he wished to situate the Impressionists vis-à-vis their Realist/Naturalist predecessors, Courbet and Manet, but Mallarmé's analysis of Manet—the "preacher [who]

had a meaning"—was the centerpiece of his article, and he saw Manet's leadership of the Impressionists in both artistic and political terms. In his discussion of matters stylistic and in his selection of the significant artists, he appeared to echo the views of Duranty and Zola. Mallarmé cited the primacy of the "theory of open air," and the novelty of the new science of framing ("which gives to the frame all the charm of a merely fanciful boundary"). He found that the work of Monet, Sisley, and Pissarro could be mistaken for that of Manet because all suppressed individuality for the benefit of nature. He briefly mentioned Degas, Morisot, and Renoir, noting that they too "share in most of the art theories I have reviewed here."

But the arresting novelty of Mallarmé's analysis is his discussion of the most recent of Manet's work and that of the Impressionists in the arenas of pictorial innovation *and* political purpose. The poet-turned-critic argues optimistically that pure painting (painting "steeped again in its cause") can and will serve the needs of the multitude. He joins advanced art to democracy in the following way: the achievement of a self-referential, fully Modernist art will not compromise its usefulness to what Gambetta called, in a celebrated phrase, the *nouvelles couches sociales*. Therefore, the following excerpts from Mallarmé's text must be seen as complementary aspects of the same argument.

The participation of a hitherto ignored people in the political life of France is a social fact that will honour the whole of the close of the nineteenth century. A parallel is found in artistic matters, the way being prepared by an evolution which the public with rare prescience dubbed, from its first appearance, Intransigeant, which in political language means radical and democratic.

He adds the comments of an imaginary Impressionist: *I content myself with reflecting on the clear and durable mirror of painting. . . . [When I am] rudely thrown at the close of an epoch of dreams in the front of reality, I have taken from it only that which properly belongs to my art. . . .*

The latter quotation echoes Zola's and Duranty's confidence that Impressionism lacks a social dimension and is therefore purely an art of esthetic innovation and refinement. Mallarmé, however, if not Zola and Duranty, could at the same time align Impressionist painting with the social and political aspirations of the majority, an argument that may now appear to have been wildly optimistic, but which posed no problem for Mallarmé at the time.

The bulk of the published reviews of the second exhibition appeared, however, in the ordinary Parisian press. Jacques Lethève has pioneered the compilation and analysis of the workaday press criticism of Impressionism. Regarding the coverage of the 1874 show, he observed, "What certain papers approved of, especially

those who were favorable to the Republican regime, was the principle of the liberty of expression, the affirmation that art is free."[18] Our consideration of the art journalism of 1876 will put Lethève's formulation to the test: we will test the presumption of interrelationship between the esthetic and political ideologies of newspapers in their coverage of the Independent exhibitions. We shall discover that Lethève was generally correct, even though the conditions under which journalists operated during these years tended to blur the normal relations between ideas about art and ideas about politics. The Parisian press was subject to the caprices of government censorship from the time of the provisional declaration of the Republic in 1870 until the passage of the relaxed press law of July 1881; vigilance was especially tight during the *septennat* of Marshal MacMahon, 1873–1879.[19] Unlike earlier and later decades, there was no trenchant,

fig. 4 Pierre-Auguste Renoir, *Frédéric Bazille, peintre tué à Beaune-la-Rolande (Frédéric Bazille, Painter Killed at Beaune-la-Rolande,* II–224), 1867. Oil on canvas, 41 ⅜ x 29 in. (105 x 73.5 cm). Musée d'Orsay (Galerie du Jeu de Paume), Paris. Photo: Photographie Bulloz

politically critical paper on the left in the 1870s, with the exception of *La Lanterne*, the only successful radical organ of this period. It did not, in any case, review the 1876 exhibition.

The reviews almost invariably discuss extra-esthetic issues that would never have been brought up in a Salon review. However, the unusual exhibition tactics and theoretical position of the group called attention to themselves, and were therefore as subject to discussion and evaluation as the quality of the objects on display. Unsurprisingly, then, there were split reviews, depending on the issue under discussion: tactics or art.

We will analyze six of the most overtly hostile accounts against the six most clearly positive reviews. The characteristic terms of praise and derision will emerge, as will the correlations between the newspapers' political orientation and policies on the new art.

Of all the 1876 press accounts, Albert Wolff's tirade against the show published on 3 April in *Le Figaro*, the giant of the conservative press, is probably the most frequently excerpted and reproduced. The large circulation of *Le Figaro* justifies believing that it was an influential review, but its wild and irresponsible denunciations also have helped to build the myth of the completely misunderstood Impressionists.

Wolff calls the show a "cruel spectacle," and the exhibitors are termed "lunatics" and "hallucinated"; he proposes the show is tantamount to the negation of art and argues that the work betrays its authors' complete lack of artistic education. In other words, Wolff strains to persuade his readers that the work in no way represents the real world (they merely threw paint on the canvas), and deserves no consideration from the *cognoscenti* of real art. Attacked the most ferociously are Pissarro (for no understanding of color), Degas (for no understanding of drawing or color), and Renoir (because his torso of a woman in sunlight, exhibited as *Etude*, showed violet-colored putrefying flesh).[20]

Georges Maillard's review of 4 April in the Bonapartist *Le Pays* almost matches Wolff's for vitriol. He finds no doctrine, idea, or method underlying the work. He did see that they were generally Realist, but decides that this "small coterie of Independent, Intransigent painters" had only their avoidance of a jury in common. "As far as the revelation of a new art, a new formula, any sort of new procedure, the truth is there is no trace. . . . [There is only] originality and audacity that sometimes approaches savagery." Visitors, he said, will only experience bewilderment. The show is more laughable than a *Refusés*; these are "insanities of conception that are absolutely revolting."[21]

Emile Porcheron's piece on 4 April in *Le Soleil*, a paper of the center right, asks the question, "What is an Impressionist?" The answers: "One who is without talent, without training," "one who consecrates himself to

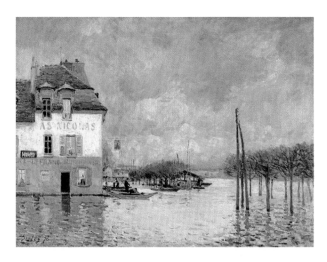

fig. 5 Alfred Sisley, *Inondations à Port-Marly* (*Flood at Port-Marly*, II–244), 1876. Oil on canvas, 23 5/8 x 31 7/8 in. (60 x 81 cm). Musée d'Orsay (Galerie de Jeu de Paume), Paris

the cult of the palette." Pick out any motif and render what you see in any fashion whatever, and "Impressionism will count one more follower." His denunciations of individual works are quite precise, and, despite the initial blanket disapproval, he discriminates between the works of the core group and others. In brief: Morisot cannot draw and stops painting before she has finished; Pissarro's work is laughable because everything is blue; Caillebotte's work is the worst of the show because it martyrs perspective; Monet's landscapes are unintelligible and *Japonnerie* merely plays a juggling game with screens; and Renoir's portraits are remarkable for their artificial eyes that seem to jump off the canvas. "One cannot," he concludes in part, "be tolerant toward painters who have neither talent nor have studied sufficiently." Desboutin and Lepic are also criticized, but François, Ottin, Tillot, Bureau, and Rouart are spared.[22]

The list of conservative journals denouncing the show continues with *La Revue Politique et Littéraire*'s publication on 8 April of Charles Bigot's sober review. A political analogy opens his lengthy discussion: "This is the revolutionary school, and France—which one accuses rightly or wrongly of loving revolutionaries—seems to me to like them less today than ever in art as in politics." Bigot's optimism about Marshal MacMahon's durability is thereby used as a metaphor for his understanding of the various camps of the art world (he also likens the art of the Intransigents to "le radicalisme Naquet" in politics). He singles out four artists as the representative painters of the group: Monet, Degas, Renoir, and Morisot.

In attempting a definition of the group's work, he understands it to have come from a "reaction against the black painting done in the studio, a reaction against the polite, labored, finished, and polished painting in which

the eye is mirrored." He looks back on early nineteenth-century art and sees each episode as a reaction to what came before. Not insensitively, he notes that to "express objects as they appear at a distance, express only the essential and characteristic note, such is the program of our new Realists."

In his comments on the individual exhibits, he avoids the scatter-gun attack style of Wolff, Porcheron, and Maillard. Monet has the talent of a true landscapist (*La prairie* and *Le printemps* [II–163] are singled out for praise while his other landscapes are severely criticized). But Bigot considers the notorious *Japonnerie* "un coup de pistolet," flawed by the contrast between the handling of the woman and the ornamented robe. He finds Sisley's *Inondations à Port-Marly* to be probably the best piece in the exhibition. In Bigot's view, Morisot's imperfect color sense shows that she is a victim of the system of this kind of painting.

Bigot senses that Degas observes his novel motifs as would a foreigner (owing in part to his mistaken belief that the artist was born in New Orleans). He finds that the inadequacies of his technique and his strange taste compel him to prefer the bizarre or ugly (e.g., the dancers and laundry women) to the gracious. The New Orleans picture is praised, but "unhappily, Degas does not have the eye of a colorist, nor always the hand of a drafts-man." Caillebotte deserves a place of honor, and polite-ness dictates silence concerning the work of Lepic, Renoir, and Béliard.

But finally it is what Bigot calls "the system" that is fatally flawed. He had been waiting, he claims, to see if a butterfly would emerge from the 1874 caterpillar. On the contrary, several artists even retreated (Pissarro and

Rouart). The problem is that their approach to painting results in failure. "Shadows are abused by being sup-pressed, colors are abused by being melted into one another and they suppress all connection between *les touches*." The heart of the problem is this:
They succeed in rendering the appearance of objects seen vaguely from afar, but art is not made of appearances and distant vistas alone. . . . Art requires retouching and finishing up. . .; for an artist, an esquisse *is not a* tab-leau. . . . *The new school suppresses the* tableau, *dispen-ses with work and offers the* ébauche *for public admiration.*
An antidote is suggested: they will all profit from follow-ing the example of Desboutin.[23]

We break the link between the press on the right and negative accounts of the exhibition by looking briefly at Marius Vachon's review of 4 April in the Republican paper, *La France.* In this very antagonistic and snide piece of journalism, Vachon finds no system, no theory whatsoever. Moreover, he thinks that the artists are all jokers and that "the *impressionnalistes* are people who have given themselves permission not to follow any rule, to do everything contrary to what others do, without worrying in the least about good sense or truth."[24]

Finally, we turn to the specialized publication, *L'Art* (the most expensive periodical in France), which pub-lished Léon Mancino's denunciation of the exhibition. Mancino's is the archetypal split review in his endorse-ment of the Independent exhibition strategy, and the condemnation of specific works on display. He praises the "virile and dignified stance of independence," but regrets that "unhappily the group has no quality other than its independent organization to recommend it to the public and draw the attention of the critic." There fol-lows a corrosive denunciation, among the most severe written in 1876. A typical sentence captures his tone:
We are simply dealing with a band of maddened and vain individuals who speculate audaciously on human folly to try to persuade [the public] of the talent of people of an incurable weakness, condemned by their crass ignorance to the perpetual production of endeavors lacking any creative thought, any science of composition, any trace of dessin, *the least notion of perspective, of any anatomi-cal knowledge, of any virtuosity of the brush.*[25]

The most positive reviews of the exhibition appears in Republican papers. *Le Rappel,* an Intransigent paper on the Republican left, is completely behind the Indepen-dent effort. The brief 2 April note by Ernest d'Hervilly (writing as "un passant") is breathlessly enthusiastic, and the longer piece by Emile Petitdidier (writing under the pen name Emile Blémont) on 9 April is a carefully designed encomium.[26] (When the *Moniteur Universel* ran an excerpt of Petitdidier's review on 11 April, it is archly prefaced: "The Intransigents of art joining hands with the Intransigents of politics–how completely natural.")

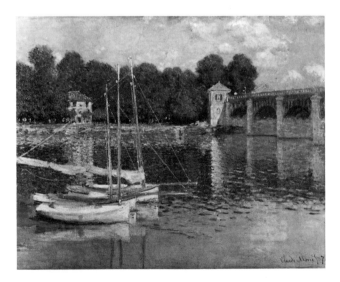

fig. 7 Claude Monet, *Le pont d'Argenteuil* (*The Bridge at Argenteuil,* II–156), 1874. Oil on canvas, 23 5/8 x 31 1/2 in. (60 x 80 cm). Musée d'Orsay (Galerie du Jeu de Paume), Paris. Photo: Lauros-Giraudon

fig. 8 Claude Monet, *La prairie* (*The Meadow*, II–154), 1874. Oil on canvas, 22½ x 31½ in. (57 x 80 cm). Nationalgalerie. Staatliche Museen Preussischer Kulturbesitz, West Berlin. Photo: Jörg P. Anders

Petitdidier broaches the question of defining Impressionism and provides, relative to most other critics, a thoughtful answer. The artists seem to have a common goal, "to render with absolute sincerity, without arrangement or mitigation, by simple and broad methods, the impression evoked in them by aspects of reality." "They are synthetists and not analysts," he claims, in order to suggest a subjective component in their transcription of nature. Furthermore, "they do not see the necessity of modifying their personal and direct sensation according to this or that convention."

This hearty endorsement is followed by an important qualification. Petitdidier finds that the work does not live up to the theory, but he anticipates its ripening with maturity and practice. In the actual review portion of the article, only rarely and circumspectly does he depart from a descriptive inventory of the exhibits and even then

dishes out only the most gingerly criticism: some hesitations about one of Desboutin's canvases, second thoughts about several of Monet's landscapes (but a warm appreciation of the *Japonnerie*); some worries about Degas's lack of finish; and doubts about Pissarro's abilities.

He stops short of any penetrating analysis ("One could criticize, and seriously criticize, the majority of works we have just enumerated"), because he wants to stress the importance of supporting "this enterprise of free initiative" in the hope that its existence and emulation might help undo the ridiculous state system.[27]

Philippe Burty proved himself a loyal and intelligent supporter of the Independent effort in his two reviews of the second exhibition—the first on 1 April in *La République Française*, a Republican paper (for which Burty was art editor), and the second on 15 April in the English-

fig. 9 Gustave Caillebotte, *Jeune homme jouant du piano* (*Young Man Playing the Piano*, 11–19), 1876. Oil on canvas, 31 ½ x 45 ⅝ in. (80 x 116 cm). Private collection, Paris. Photo: Routhier

language *The Academy* of London. It is not surprising, of course, that Burty would praise the exhibition. He had written the notice in the catalogue for the Hôtel Drouot auction in 1875, and a favorable and serious review of the 1874 show.[28]

In the French review, Burty sensibly observes that this was a better show than the first and rehearses his admiration for the strategy of the Independent group effort. A brief review of theory reminds that "the notion which dominates the group [is] the investigation of light and the effects of plein air, and the irisation of color." Proposing that the appreciation of the works requires a disengagement from hackneyed expectations, he recalls the examples of Delacroix and Courbet in their day. But there is no review of the works per se, merely a room-by-room inventory.

Burty's English review was in many ways a more forceful, even surprising account. He argues that the show was better received by the public than the first, which he explains with an extraordinary, Mallarmé-like proposition:

The public are fired with a kind of tender interest in this group of honest, earnest-minded, hard-working, original young artists, men yearly victimised by the majority who bear tyrannous rule over the official Salon, its entrance, and its awards. They regard this exhibition with favourable eyes, as being both a tribute to their judgement and to men chiefly poor, who, in a country, in a society, that has no notion of the advantages of material or moral co-operation, have succeeded in forming an association among themselves, for their mutual benefit.[29]

(Perhaps Mallarmé knew Burty's account before he wrote his own?) Burty is alone in suggesting a solidarity between members of the public and the down-trodden, hard-working Impressionist painters, whose alienated lot was brought about by the injustices of their society. His explanation of the controversy over the painters also is unusual:

That which makes these men the dreaded enemies of the academical system is their not remaining entirely impersonal, but introducing man, his passions, his allusions, his feelings, into the midst of this everlastingly impassive nature.[30]

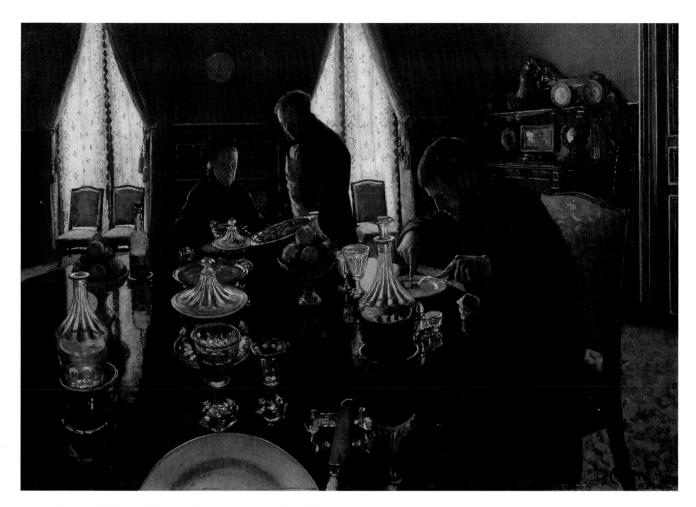

fig. 10 Gustave Caillebotte, *Déjeuner* (*Luncheon*, II–21), 1876. Oil on canvas, 20½ x 29½ in. (52 x 75 cm). Private collection, Paris. Photo: Routhier

He firmly believes, however, that their victory "is the assertion of Realism." His discussion of Caillebotte's work strikes a related note, one absent from his French review. The success of Caillebotte's pictures "is fair and honest and due to their faithful representation of life as it expresses itself in the working functions, and of the members as they come to look when modified by the constant pursuit of some one particular occupation"—an achievement not associated by Burty with Degas's *Blanchisseuses*, by the way. (Compare this to Louis Enault's opposite view of Caillebotte's subjects in his review in the Bonapartist *Le Constitutionnel*: the shirtless *raboteurs* were vulgar and badly rendered.[31]

None of the nineteen exhibitors—all mentioned—is criticized by Burty, but several receive especial praise: Renoir, Morisot, Caillebotte, and Pissarro ("the great high-priest of the Intransigents, a man of sober masculine talent"). Burty ends with a lengthy, congenial discussion of Degas's work, especially regarding the New Orleans picture, as the critic is otherwise concerned that too many of his works lack finish.

Armand Silvestre, writing on 2 April for *L'Opinion Nationale*, a paper on the Republican left, considers the second exhibition even more carefully than he has the first. He is quick to name the artists he is discussing (only the core six plus Desboutin and Caillebotte), and praises work by each of them. He argues that this group proceeds from a principle of simplification: "Little concerned about form, [the work] is exclusively decorative and colorist." Mind you, he finds this an incomplete ideal, but he writes sympathetically that "[the school] has discovered certain unexplored aspects of things, has analyzed them with an infinite subtlety, and has enlarged the field of pictorial research."[32]

Alexandre Pothey's review of 31 March in *La Presse*, a Republican paper, is sympathetic and well-informed. He finds the show "infinitely more interesting" than the first and mentions, unlike any other critic, that the exhibitors had studied painting for years—fifteen or twenty, he writes, a bit exaggeratedly. He praises the self-starting exhibition policy that "merits encouragement by all who love or are interested in the modern movement of the

fig. 11 Camille Pissarro, *Neige. Coteaux de l'Hermitage (Pontoise)* (*Snow at the Hermitage, Pontoise*, 11–200), 1874. Oil on canvas, 21½ x 25¾ in. (54.5 x 65.5 cm). Private collection

Beaux-Arts." In his most penetrating remark he notes that "for the most part, they depart from the traditions of *l'école*, the standard methods, the sacred formulas; but he who makes a canvas come to life, who shows a personal kind of *dessin*, a virile execution, and knows how to find a new kind of expression, is a painter."

His account of the works on display is unwaveringly positive. He mentions Monet, bothering to mention the location of his landscape motifs, "Petit-Gennevilliers or the environs of Argenteuil," discussing the *Japonnerie* at length; Lepic, mentioning the artist's practice of working five or six months a year from a moored boat; Morisot, comparing her works flatteringly to Manet's; Desboutin; Degas, praising the New Orleans picture and one of the *Blanchisseuses* ("strong and true like a Daumier"); Caillebotte's *Raboteurs*; Renoir's portraits; Sisley's landscapes; Pissarro, offering unusually strong praise for his work ("[landscapes] of which the uneven terrains are so well constructed"); and Legros. Wishing to show his ardent support for the entire project, he regrets not being able to discuss the "conscientious" work of the remaining exhibitors.[33]

Because Alfred de Lostalot's two favorable reviews did not appear in Republican organs, they really counted in 1876. His first appeared on 1 April in *La Chronique des Arts et de la Curiosité* (a paper, as Burty put it, "which is the organ of the purest academical doctrines. . . . a weekly flyleaf of the *Gazette des Beaux-Arts*"), and the second on 4 April in the conservative Republican paper, *Le Bien Public*.

The first review is somewhat mixed, but when Lostalot writes,
The present exhibition will produce in the public a com-

pletely different sentiment than had the preceding one: one encounters nothing in it which could reasonably provoke the laughter or indignation of the visitors, and it is not difficult, on the contrary, to discover very real talent in many of the works on display,[34]
he praises the Independents from a podium of entrenched institutional privilege.

The second review, owing perhaps to the change of venue, is less formal and more favorable, and includes the critic's reflections on the theory of the Independents' art. He asserts right away that Manet is the leader of this crew of Intransigents, but urges against both ridicule and excessive worshipfulness at the sound of his name. He tenders this view, in part, of the theory of the Manet-led group: "The intent of the new school is to fix the emotion and the impression of the moment—of things whose immaterial nature allows them to be rendered by the simplest means." There follows an unflattering account of their pictorial habits, but he then attributes an insightful remark to an imaginary Impressionist: "everything for the eye, nothing for the thought; to each his *métier*, we have no concern other than exercising the sense of vision [*le sens de la vue*]." Lostalot summarizes the objective of the school in a not insensitive way, noting it is "the pursuit of varied light effects in the atmospheric milieu, taking into consideration to a degree the animate and inanimate beings who frequent this milieu." His highest praise resides in his belief that the best of these artists, once they renounce their convictions, could make a good living returning to the beaten track. Evidence? He cites some "excellent morsels of painting," Monet's *Japonnerie*, Degas's ballet sketches, Renoir's female nude, and Morisot's female portrait. Lostalot had a discriminating eye. He noted that Caillebotte, Sisley, Cals, and Rouart were not devotees of the *tache*, and that Bureau, Lepic, Desboutin, Legros, and Millet could not upset "the most timid conservative."[35]

The final article to adduce is a piece that is in fact *hors concours* in the politics of criticism in 1876. Written by Georges Rivière, it appeared in the new journal of ideas, *Esprit Moderne*, on 13 April. (As is well known, so fervent was Rivière's support of the new school, that he founded *L'Impressionniste* in 1877.) However, the piece demonstrates that the most ardent support does not necessarily produce the most interesting criticism.

Rivière believes unflaggingly that the new work marks a turning point in art, and he endorses it with a bold if unanalytical pronouncement. "Today the Intransigents effect a revolution in art analogous to that of 1830, but even more violent and especially more universal." The balance of the review lists the exhibitors and heartily praises various of their works. Only in the cases of Desboutin and Ottin does he allow that their connection to the balance of the group is quite feeble. Although he perhaps wanted to justify his equal enthusiasm

for each and every exhibitor, his only attempt at describing a group style or policy was weak. "What this exhibition reveals, made by artists unified by the same idea, is a profound individuality not to be found in the Salon."[36]

On examining first the negative reviews, we find the six detractors to a man easily discriminate between the Intransigent art and the other work on display. In each case, the frame of reference is insistently stylistic: each commentator singles out for disparagement the technical inadequacies of the paintings. Wolff, Maillard, Porcheron, Vachon, and Mancino see, or find it expedient to see, only botched, incompetent work; none can accept that naturalistic description is being capably done. The most broad-minded attack is Bigot's: "an *esquisse* is not a *tableau*."

The positive reviewers also focus upon the work of the core group and each, save Rivière, mounts some discussion of the theoretical underpinnings of the Intransigents' displays, but they tend to focus on the Impressionists' commitment to a world of vision, rather than on their commitment to producing socially realistic pictures. As we have noted, Mallarmé and Burty are alone in 1876 in their attempt to attribute more complex goals to the artists.

Most of the reviewers, then, both pro and con, see through the differences between the works of the various exhibitors. The show appears homogeneous to almost no one, save certain stalwart supporters like Rivière who feigns seeing consistency in order not to dilute his praise for the enterprise. To most it is clear that six or seven of the artists are doing a new kind of work that has a certain coherence when considered as an ensemble, even with the differences between the *coloristes* and *dessinateurs*, and that most of the other exhibitors do not belong.

The conclusion we might draw from these reviews indicts the exhibition strategy of the group. We must ask whether it was a wise decision to pad the exhibition with diverse artists. Was it expedient, in the end, for the core group to surround itself with esthetic buffers? Did it not obscure certain qualities of the work that otherwise might have been discussed, at least by the group's supporters?

I would argue that the diversity of work on display tended to overemphasize the contrast of relative finish or workmanship between the work of the respectable artists and the paintings of the Intransigents. This issue dominated most of the critics' discussions, and explains the concentration on Degas's New Orleans picture and Monet's *Japonnerie* to the exclusion of any extended discussion of the correlation between the style and the subject matter of the new painting. In order to defend the sketchiness of the work, even the favorable texts had to emphasize its Modernist aspects, without giving much consideration to what was chosen for depiction. Is it

impossible to imagine, had the core group been able to show by itself, that the newness of the suburban subjects pioneered by Monet and Morisot, for example, might have been discussed: the stark new bridge in Monet's *Le pont du chemin de fer (Argenteuil)*, bourgeois recreation in Monet's *Les bains de la Grenouillère*, or the peasant laundresses on the fringes of Gennevilliers's encroaching modernity in Morisot's *Un percher de blanchisseuse*?[37] Might not a comparative discussion have been opened on the relationship between Caillebotte's and Degas's treatment of urban workers in the *Raboteurs de parquets* and the *Blanchisseuses*?[38] And might the critics have focused on the differences between the subjects of many of the Impressionist paintings and the sober historical themes being demanded in reviews of the annual Salons?[39] (But it must be admitted that it is still possible that the issue of casual workmanship or untenable sketchiness, given its significance in the esthetic discourse of these years, would have dominated the discussions even if the core group had been seen on its own.)

Another shortcoming of the criticism was most commentators' underestimation of the practicality of the goals of the Independent exhibitors. The artists were aware of the economic and social conditions of their enterprise, and mounted a second exhibition because it seemed the best way—perhaps the only way—to try to enhance their reputation and to make some sales. Even though the recruitment of the diverse artists incorporated in the exhibition seems to have prevented the critics from seriously discussing the Impressionists' distinctive interpretations of modern life, those artists were invited for practical reasons. Their inclusion seemed paradoxically vital to the success of the project. Of course the Independent artists produced and displayed art that embodied their esthetic convictions as well as their attitudes about modern life, but they believed that surrounding their untested goods with bona fide respectable wares was the necessary road to wider acceptance. And yet critics could wrongly believe that the Independent artists had no interest in what the public thought. Charles Bigot, for one, could write, "Might the critic hope to have any influence on these Intransigents? It is doubtful. When one is headstrong enough to show certain things to the public, it is certain that it is not what the public says that is going to affect you."[40]

This kind of critical response contributed to a mythology-in-the-making that has dogged the history of the Impressionist exhibitions for one hundred years. The down-to-earth goals of the Independent exhibitions have consequently been overlooked, and the artists have been falsely described as impractical esthetic fanatics. The probity of the artists' pursuit of material gain and a secure place in the Paris art world should not be overlooked when recounting the history of the early Independent efforts.

Notes

All translations are the author's unless otherwise noted.

1. My calculations suggest an approximate doubling of articles in the Parisian press in 1876 relative to 1874. (And see note 20.) Rewald has observed, however, that fewer visitors attended this exhibition than the first; see John Rewald, *The History of Impressionism*, 4th rev. ed. (New York, 1973), 368. Despite Strindberg's and James's literary fame, their 1876 articles are not discussed in this essay because of their peculiarities and, frankly, lack of interest. James argues that Impressionism was analogous to English Pre-Raphaelitism and that the French painters were cynics (Henry James, "Parisian Festivity: Cynical Artists," *New York Tribune*, 13 May 1876). Strindberg merely wrote a piece in what he considered an Impressionist literary style (see Rewald, 372). Moreover, although Strindberg saw some related works at the Durand-Ruel Galleries in 1876, he did not visit the Independent exhibition (August Strindberg, "Från Café de l'Ermitage till Marly-le-Roi [impressionisterna, 1876]," reprinted in Strindberg, *Kultur-historiska studier* (Stockholm, 1881), 108–110, 112–113).

2. The best discussion of these aspirations is found in Harrison and Cynthia White, *Canvases and Careers: Institutional Change in the French Painting World* (New York, 1965).

3. Charles Harrison et al., *Impressionism and Degas; Arts: A Third Level Course, Modern Art and Modernism, Block II, Units 5–6* (Milton Keynes, U.K., 1983), 13.

4. Harrison et al., 15. And see Edmond Duranty's recognition of this in his *La nouvelle peinture: A propos du groupe qui expose dans les Galeries Durand-Ruel* (Paris, 1876), 33; in this catalogue.

5. As Rewald reports, one definite benefit of the auction was meeting Victor Chocquet, soon-to-be patron of Cézanne, Pissarro, Renoir, and Monet, and active promoter of the 1876 exhibition. See Rewald, 354–355, 364–366. And two men who would write favorable pieces on the 1876 exhibition also patronized the 1875 sale, Ernest d'Hervilly and Emile Petitdidier.

6. See Rewald, 351, 354; M. Bodelsen, "Early Impressionist Sales, 1874–1894 in the light of some unpublished 'procès-verbaux,'" *The Burlington Magazine* 110 (June 1968): 331–348; and Jacques Lethève, *Impressionnistes et symbolistes devant la presse* (Paris, 1961), 74–75. Renoir tried unsuccessfully to get into the Salon in 1875. This disappointment might have helped influence him to work on organizing a second exhibition for 1876, especially because the government did not decide to sponsor a Salon des Refusés in 1875 as it had in 1873.

7. It is not entirely clear who the principal organizers were, but Renoir and Rouart drafted Caillebotte's invitation (J. Kirk T. Varnedoe, *Gustave Caillebotte: A Retrospective Exhibition*, exh. cat. [Houston: Museum of Fine Arts, 1976], 44, note 12), and Degas wrote at least a follow-up letter to Morisot in April 1876 regarding the delivery of her work to the gallery. See Denis Rouart, ed., *The Correspondence of Berthe Morisot* (New York, 1959), 97.

8. Financially, things did work out better in 1876. The show finished in the black. After expenses were paid, each exhibitor was repaid his or her initial contribution of 120 francs along with a dividend of 3 francs. See M. Desboutin's letter to Mme de Nittis, 20 April 1876, in Mary Pittaluga and Enrico Piceni, *De Nittis* (Milan, 1963), 358, and Ralph E. Shikes and Paula Harper, *Pissaro: His Life and Work* (New York, 1980), 132. And the financial coup of the event was Monet's sale of *Japonnerie* for 2,000 francs.

9. The following reconstruction of the gallery installation is based on several reviews that covered the show room by room. For complete citations see review list for the Second Exhibition in Appendix for these and other reviews: [Philippe Burty], *La République Française*; Ph. Burty, *The Academy*; and Emile Blémont [Emile Petitdidier]. No one, however, mentioned the placement of Levert's work.

10. Two of Legros's exhibits (11–81 and 83) contained seven prints each, so Legros showed twenty-four prints altogether. See *Catalogue de la 2e Exposition de peinture par MM. . . .*

11. Burty reported this division (see note 9). Emile Porcheron also wrote that Morisot's drawings were in the first room; see his review.

12. It has proven quite difficult to determine exactly which *Blanchisseuses* were in the exhibition. Several critics referred to a *Blanchisseuse* in which one woman yawned while the other ironed. It seems likely

then that at least one of the laundresses shown in 1876 was reworked later by Degas and was therefore either Lemoisne 686 or 687 (both dated ca. 1882) or 785 or 786 (both dated ca. 1884); *Degas et son oeuvre*, 4 vols. (Paris, 1946).

13. Duranty, *La nouvelle peinture*. See this catalogue. All direct quotations of Duranty's words are taken from this text.

14. Duranty, *La nouvelle peinture*. "The railways, notion shops, construction scaffolds, lines of gaslights, benches on the boulevards and newspaper kiosks, omnibuses and teams of horses, cafés with their billiard-rooms, and restaurants with their tables set and ready." It goes without saying that some of these subjects had not been painted in 1876.

15. Duranty quoted his own words written in 1856 for the review *Réalisme*.

16. Emile Zola, "Lettres de Paris: Deux expositions d'art au mois de mai," *Le Messager de l'Europe* [Saint Petersburg, June 1876], reprinted from Russian in Gaëtan Picon, ed., *Le bon combat de Courbet aux impressionnistes. Anthologie d'écrits sur l'art* (Paris, 1974), 172–186.

17. See this catalogue for Stéphane Mallarmé, "The Impressionists and Edouard Manet," *The Art Monthly Review and Photographic Portfolio*, 1, no. 9 (30 September 1876). For the circumstances of this essay's publication, see Jean C. Harris, "A Little-Known Essay on Manet by Stéphane Mallarmé," *The Art Bulletin* 46 (December 1964): 559–563. For its translation back into French, see Philippe Verdier, "Stéphane Mallarmé: 'Les Impressionnistes et Edouard Manet,' 1875–1876," *Gazette des Beaux-Arts* 86 (November 1975): 147–156. The most interesting and important recent analyses of Mallarmé's essays are to be found in Thomas Crow, "Modernism and Mass Culture in the Visual Arts," in *Modernism and Modernity: The Vancouver Conference Papers*, Benjamin H. D. Buchloh et al., ed. (Halifax, 1983), 216–217; and T. J. Clark, *The Painting of Modern Life: Paris in the Art of Manet and His Followers* (New York, 1985), 10–11, 267–268. Crow and Clark seem to disagree, however, about the central emphasis of Mallarmé's account.

18. Lethève, 61.

19. This and all other information in this essay concerning the politics of Parisian journalism in the 1870s is taken from the following sources: Lethève; Claude Bellanger et al., *Histoire générale de la presse française, 1871–1940*, vol. 3 (Paris: PUF, 1969); Philippe Jones, *La presse satirique illustrée entre 1860 et 1890* (Paris, 1956); Lethève, *La caricature et la presse sous la IIIe République* (Paris, 1961); and Raymond Manévy, *La presse de la IIIe République* (Paris, 1955).

20. Albert Wolff review. The essay is reproduced in Lethève, *Impressionnistes et symbolistes*, 76–77; Rewald, 368–370; and Gustave Geffroy, *Claude Monet: Sa vie, son oeuvre*, 2d ed. (Paris, 1924), 65. But even *Le Figaro*'s witheringly negative notice was in some ways good for the Independents. It was at least a positive blow struck in the realm of public recognition since it indicated the group was no longer to be overlooked by the arbiters of good taste. Along with *Le Figaro*, the *Revue des Deux Mondes* and the *Revue Bleue* (the *Revue Politique et Littéraire*) had boycotted the first show, but covered the second.

21. Georges Maillard review.

22. Emile Porcheron review.

23. Charles Bigot review.

24. [Marius Vachon], *La France* review. Oscar Reuterswärd identifies the author as Vachon in his still indispensable *Impressionisterna inför publik och kritik* (Stockholm, 1952), 261. Vachon's negative review was not the only one to violate the correlation between journalism on the right and a dislike of the exhibition. Another extremely snide and derogatory review written by Punch (identified by Reuterswärd as Gaston Pérodeaud aka Gaston Vassy), appeared in *L'Evénement*, an Intransigent paper that was trying to become the Republican *Le Figaro* (see review list). Some of the most contemptuous and nonserious reviews appeared in politically diverse or unclassifiable papers: e.g., Bertall's [Charles-Albert d'Arnoux's] three reviews in *Paris-Journal*, *Les Beaux-Arts*, and the tiny Republican paper *Le Soir*; and Louis Leroy's two reviews in *Le Journal Amusant* and *Le Charivari*. (Once political, *Le Charivari* was no longer by the 1870s.)

25. Léon Mancino review.

26. Un passant [Ernest d'Hervilly] review.

27. *Le Moniteur Universel* review.

28. Burty, *Catalogue des tableaux et aquarelles par Claude Monet, Berthe Morisot, A. Renoir, A. Sisley et dont la vente aura lieu Hôtel*

Drouot etc. (Paris, 1875), iii–vi; [Burty], "Exposition de la Société anonyme des artistes," *La République Française*, 25 April 1874.

29. [Burty], *La République Française* review.

30. Burty, *The Academy* review.

31. Louis Enault review.

32. Armand Silvestre review.

33. Alex[andre] Pothey review.

34. A. de L. [Alfred de Lostalot], *La Chronique des Arts et de la Curiosité* review.

35. A. de L., *Le Bien Public* review.

36. Georges Rivière, "Les intransigeants de la peinture," *L'Esprit Moderne* (13 April 1876): 7–8, reprinted in Pierre Dax, *L'Artiste* review.

37. See the following for important recent analyses of the significance of these paintings in view of their subjects: On Monet's *Le pont du chemin de fer (Argenteuil)*, see Clark, *The Painting of Modern Life*, 190; Paul Tucker, "Monet and the Bourgeois Dream," in *Modernism and Modernity*, 23–25; Paul Tucker, *Monet at Argenteuil* (New Haven and London, 1982), chap. 3. On Morisot's *Un percher de blanchisseuse*, see Clark, 161–162. On Monet's *Les bains de la Grenouillère*, see Richard Brettell et al., *A Day in the Country: Impressionism in the French Landscape*, exh. cat. (Los Angeles: Los Angeles County Museum of Art, 1984), no. 14; Clark; Crow in *Modernism and Modernity*, 216–217; and Harrison et al., *Impressionism and Degas*, 13–15.

38. In fairness to the critics writing in 1876, there was some discussion of Degas's handling of the laundress theme. See reviews by Pothey, Porcheron, Zola, Leroy, and Enault.

39. See, for example, the issues raised in Charles Bigot's Salon review in *La Revue Politique et Littéraire* (13 May 1876): 462, and the discussion of the issue in Emile Bergérat, "Revue artistique: Les impressionnistes et leur exposition," *Le Journal Officiel de la République Française* (17 April 1877): 2917–2918.

40. Bigot, 8 April 1876 review.

CATALOGUE

DE LA 2ᵉ

EXPOSITION

DE PEINTURE

PAR MM.

Béliard — Legros — Pissaro — Bureau
Lepic — Renoir — Caillebotte — Levert — Rouart
Cals — Millet (J.-B.) — Sisley — Degas — Monet
(Claude) — Tillot — Desboutin — Morisot (Berthe)
François (Jacques) — Ottin fils

De 10 heures à 5 heures
11, RUE LE PELETIER, 11,
PARIS

Avril 1876

PARIS. IMPRIMERIE ALCAN-LÉVY, 61, RUE DE LAFAYETTE.

*References for identifications
and present locations*

DÉSIGNATION

BÉLIARD (E.)
A Etampes (Seine-et-Oise)

1. Perhaps Musée Municipal
 d'Estampes

1 — Bords de l'Oise.

2 — Fabriques au bord de l'Oise.

3 — Rue de village.

4 — La rue de Chaufour à Etampes. Effet
de neige.

5 — Port de Granville.

6 — Rue de l'Hermitage, à Pontoise.

7 — Rue Dorée, à Pontoise.

8 — Promenade des Fossés, à Pontoise.

BUREAU (Pierre-Isidore)
31, rue de Turenne

9 — Route de Champagne, près l'Isle-Adam.

10 — Jouy-le-Comte, clair de lune.

11 — Château de Valmondois.

12 — Entrée de village à Champagne, près l'Isle-Adam.

13 — Meules au clair de lune.

14 — Entrée de Nesles.

15 — Avoines dans la plaine de Champagne.

16 — Usine à Pacy-sur-Eure.

CAILLEBOTTE (Gustave)
77, rue Miroménil

17 ⧸ Raboteurs de parquets.

18 — Raboteurs de parquets.

19 — Jeune homme jouant du piano.

20 — Jeune homme à sa fenêtre.

21 — Déjeuner.

22 — Jardin.

23 — Jardin.

24 — Après déjeûner.

CALS (Félix-Adolphe)
70, rue Rochechouart

25 — Soleil couchant.

26 — Ferme de Saint-Siméon, Printemps.

27 — Sous les arbres.

28 — Madelaine.

29 — Femme allaitant son enfant.

30 — A la Ferme de Saint-Siméon.

31 — Cour à Honfleur.

32 — La Leçon.

33 — Portrait de Mme X... (Dessin).

34 — Les Enfants du pêcheur id.

35 — Le Repas frugal id.

DEGAS (Edgard)
77, rue Blanche

36 — Portraits dans un bureau (Nouvelle-Orléans).

37 — Examen de danse.
Appartenant à M. F...

38 — Portrait de Mr E. M...

17. Berhaut 28, Musée d'Orsay

18. Berhaut 29, private collection, Paris

19. Berhaut 30, private collection, Paris

20. Berhaut 26, private collection, New York

21. Berhaut 32, private collection, Paris

24. Berhaut 20

25. Perhaps Musée d'Orsay or Delestre, no. 17

36. Lemoisne 320, Musée Municipal de Pau

37. Lemoisne 397, private collection, New York

38. Perhaps Lemoisne 339, Joseph E. Hotung, Hong Kong or 392, Musée d'Orsay

40. Lemoisne 309, Ordrupgaardsamlingen, Charlottenlund

41. Perhaps Lemoisne 687, Norton Simon Museum, Pasadena or 686, 785, or 786, per Clayson

43. Lemoisne 271, National Gallery of Art, Washington

44–45. Lemoisne 340, Musée d'Orsay

47–48. Lemoisne 512, The Art Institute of Chicago

49. Lemoisne 356, Metropolitan Museum of Art

52. Previously thought to be Lemoisne 393, Musée d'Orsay

53. Perhaps Lemoisne 391

56. Lemoisne 377, private collection, Northern Ireland

57. Perhaps Lemoisne 371

62. Wheelock Whitney and Co., New York

66. Perhaps *Mme N. de C.*

67–72. M. Jacquemart
M. Goeneutte
Portrait du peintre M. R. (maybe Henri Rouart)
Le faiseur de cigarettes
Le dilettante

h.c. *Femme accoudée*

39 — Portrait de femme (ébauche).

40 — Cour d'une maison (Nouvelle-Orléans, esquisse).

41 — Blanchisseuses.

42 — Ebauche de portrait (pastel).

43 — Portrait, le soir.

44 — Salle de danse.

45 — id.

46 — Portrait.

47 — Coulisses.

48 — id.

49 — Blanchisseuse (silhouette).

50 — Blanchisseuse portant du linge.

51 — Divers croquis de danseuses.

52 — Dans un Café.

53 — Orchestre.

54 — Blanchisseuse.

55 — Femme se lavant le soir.

56 — Petites Paysannes se baignant à la mer vers le soir.

57 — Modiste.

58 — Portrait.

59 — Blanchisseuse (dessin).

DESBOUTIN
rue Breda, 21

60 — Chanteurs des rues.

61 — Etude d'Enfant.

62 — Portrait de M. F...

63 — Les Premiers pas.

64 — Le Violoncelliste.

65 — Tête d'Etude.

66 — Portrait.

67 — Portraits et Etudes. (Gravure à la pointe sèche).

68 — Portraits et Etudes. id.

69 — Portraits et Etudes. id.

70 — Portraits. id.

71 — Portraits. id.

72 — Portraits. id

81. If the following are prints:
Baigneuses, perhaps
Poulet-Malassis 69
Procession, perhaps
Poulet-Malassis 48, 49, or
57
Ambulance, perhaps
Poulet-Malassis 124
Promenade, perhaps
Poulet-Malassis 68
Tribunal, perhaps Poulet-
Malassis 123
Chantres, perhaps Poulet-
Malassis 59
82. Perhaps Poulet-Malassis
89
83. If the following are prints:
Vagabonds, perhaps
Poulet-Malassis 71
Cheminée, perhaps
Poulet-Malassis 116
*Lithographie, Leçon
d'électricité
d'Aurevilly*, Poulet-
Malassis 10
84. Perhaps Poulet-Malassis
61 or 62
87. Poulet-Malassis 34
88. *Femmes*, perhaps Poulet-
Malassis 80
89. Perhaps Poulet-Malassis
110
91. Perhaps Robin Burnett
Harrison, Oxford

134. Cab. des Est.

149. Perhaps Wildenstein 373,
Museum of Modern Art,
San Francisco
150. Wildenstein 389,
Albright-Knox Art
Gallery, Buffalo
151. Wildenstein 92, The Art
Institute of Chicago
152. Perhaps Wildenstein 279
153. Wildenstein 387, Museum
of Fine Arts, Boston
154. Wildenstein 341,
Nationalgalerie, West
Berlin
156. Perhaps Wildenstein 311,
Musée d'Orsay
158. Perhaps Wildenstein 291,
Mrs. John Hay Whitney,
New York

— 10 —

FRANÇOIS (Jacques)

73 — Raisins.
74 — Prunes.
75 — Estamo de tabacco à l'Alhambra.
76 — Portrait de M^me M . . .
77 — Le Dessert.
78 — Roses jaunes et Raisin.
79 — Raisin et Grenades.
80 — Raisin et Grenade.

LEGROS (Alphonse)

A Paris, chez M. Poulet-Malassis, 41, rue Mazarin
A Londres, westall villa Brook Green Hammersemth

81 — Les Baigneuses.
 La Procession.
 Ambulance.
 Promenade. (Pointe sèche.)
 Tribunal.
 Cours de Médecine.
 Chantres Espagnols.
82 — La Morte.(Premier état avant la pointe
 sèche.)

— 11 —

83 — Les Vagabonds.
 La Confrérie de la Sainte-Vierge.
 Près de la Cheminée.
 Paysage. (Pointe sèche.)
 Deux Lithographies.
 Portrait de M. Barbey d'Aurevilly.
84 — Lutrin.
85 — Portrait de petite Fille. (Pointe sèche.)
86 — Bonhomme Misère.
87 — Portrait de l'historien Carlysle. (Premier état.)
88 — Tête de Vieillard. (Pointe sèche.)
 Femmes de Boulogne.
89 — Grand Paysage, coup de vent.
90 — L'Homme au Mouton.
91 — La Communion.
92 — Paysage.

LEVERT

A Fontenay-sous-Bois, rue d'Alayrac, 53

93 — Vue de Portrieux.
94 — Plage de Portrieux.

— 12 —

95 — Port de Portrieux.
96 — La Jetée de Portrieux.
97 — Bords de l'Essonne.
98 — Maison à Vaulry (Limousin).
99 — La Ferme de Saint-Marc.
100 — Vue prise à Buttier.
101 — Le Chemin Vert à Noiseau.

LEPIC

25, rue Maubeuge

102 — L'Ile de Vachereu (clair de lune).
103 — Effet de brouillard en mer.
104 — Etude de bateaux.
105 — La Plage de Berck.
106 — Le Christ de la Plage de Berck.
107 — Bateaux de la baie de Somme.
108 — Un Brisant. (Etude.)
109 — La Plage de Hourdel.
110 — Le Beaupré.
111 — Forcé !

— 13 —

112 — Bateaux de la plage de Berck.
113 — La Bouée N° 2, baie de Somme.
114 — Clair de Lune en mer (Manche).
115 — Effet de Soleil (Manche).
116 — La Plage de Cayeux. (Effet de nuit.)
117 — Le Halage d'un bateau.
118 — Un Cabestan.
119 — Le Voilier.
120 — Bateau à sec.
121 — Le Charpentier.
122 — La Plage.
123 — Le Chantier de Cayeux.
124 — Pompeï. (5 Aquarelles d'après nature.)
125 — Le Quai Sancte Lucià à Naples. (Aquarelle.)
126 — Filets. (2 Aquarelles.)
127 — Barque échouée. (Baie de Somme.) (2 Aquarelles.)
128 — Falaises du Tréport. (Aquarelle.)
129 — Soleil en mer. id.

130 — L'Église de Cayeux. (Aquarelle.)
131 — Barque Napolitaine.　　id.
132 — Les Souterrains du port de Naples. (Aquarelle.)
133 — Fontaine à la Cava, près Naples. (Aquarelle.)
134 — La Ballade des Pendus. (Eau-forte.)
 Appartient à M. Arsène Houssaye.
135 — Croquis Hollandais. (2 Cadres. Eaux-fortes.)
136 — Canal en Hollande, lever de Lune. (Eau-forte.)
137 — Tête de Chien. Epreuve tirée sur plaque sans gravure.

MILLET (Jean-Baptiste)
9, rue Lepoulletier

138 — Femme gardant les Vaches. (Aquarelle.)
 Appartient à M. Brame.
139 — La Ferme. (Aquarelle.)
 Appartient à M. Haro.

140 — La Chaumière. (Aquarelle.)
 Appartient à M. Petit.
141 — Moulin à eau. (Aquarelle.)
 Appartient à M. Petit.
142 — Coin de Ferme.
143 — Ferme du Fays.
 Appartenant à M. Haro.
144 — Le Pré.
 Appartenant à M. Petit.
145 — Le Verger. (Sépia.)
146 — Le Labourage. (Sépia rehaussée.)
147 — La Fermière. (Aquarelle.)

MONET (Claude)
A Argenteuil

148 — Le Petit bras. (Argenteuil).
 Appartient à M. Faure.
149 — La Seine à Argenteuil.
 Appartient à M. Faure.
150 — Le Chemin d'Epinay. Effet de neige.
151 — La Plage à Sainte-Adresse.
152 — Le Pont du Chemin de fer (Argenteuil.
 Appartient à M. Faure.

153 — Japonnerie.
154 — La Prairie.
 Appartient à M. Faure.
155 — Le petit Genevilliers.
 Appartient à M. Faure.
156 — Le Pont d'Argenteuil.
 Appartient à M. Faure.
157 — La Berge d'Argenteuil.
 Appartient à M. Faure.
158 — Effet d'Automne.
 Appartient à M. Choquet.
159 — Les Dalhias.
160 — Les Bateaux d'Argenteuil.
 Appartient à M. Faure.
161 — La Promenade.
162 — Paneau décoratif.
163 — Le Printemps.
164 — Les Bains de la Grenouillère.
165 — Bateaux de pêche. (Etude.)

MORISOT (Berthe)

166 — Au Bal.
167 — Le Lever.

168 — La Toilette.
169 — Déjeûner sur l'herbe.
170 — Vue du Solent (Ile de Wight.)
171 — West Cowes. (Ile de Wight.)
172 — Le Bateau à vapeur.
173 — Plage de Fécamp.
174 — Un Chantier.
175 — Un Percher de Blanchisseuse.
176 — Vue d'Angleterre.
177 — Vue d'Angleterre.
178 — Figure de Femme.
179 — Avant d'un Yacht. (Aquarelle.)
180 — Entrée de la Midina. Ile de Wight. (Aquarelle.)
181 — Vue de la Tamise. (Aquarelle.)
182 — Trois dessins au pastel.

OTTIN fils (Léon-Auguste)
9, rue Vincent-Compoingt

183 — La Maison Bleue (Butte Montmartre).

159. Perhaps Wildenstein 383, Národni Galeri, Prague
160. Wildenstein 368, Sotheby's New York, 5 November 81 or 369, Fogg Art Museum, Cambridge
161. Wildenstein 381, National Gallery of Art
162. Wildenstein 285, Musée d'Orsay
163. Wildenstein 201, The Union League Club of Chicago or 205, Walters Art Gallery, Baltimore
164. Perhaps Wildenstein 134, Metropolitan Museum of Art or 136
h.c. *Springtime*, Wildenstein 205, Walters Art Gallery, Baltimore; may be No. 163

166. Bataille and Wildenstein 60, Musée Marmottan
167. Bataille and Wildenstein 73
168. Bataille and Wildenstein 61
169. Bataille and Wildenstein 47
170. Perhaps Bataille and Wildenstein 48, 52, or 53
171. Perhaps Bataille and Wildenstein 50, 52, or 55, Virginia Museum of Arts, Richmond
172. Perhaps Bataille and Wildenstein 53 or 56
173. Bataille and Wildenstein 30, Sotheby's London, 28 June 1976
174. Bataille and Wildenstein 39
175. Bataille and Wildenstein 45, Mr. and Mrs. Paul Mellon, Upperville, Virginia
176. Perhaps Bataille and Wildenstein 48 or 52
177. Perhaps Bataille and Wildenstein 50 or 53
178. Bataille and Wildenstein 59, private collection, Paris
179. Bataille and Wildenstein 630, Sterling and Francine Clark Art Institute, Williamstown
180. Bataille and Wildenstein 632, Fogg Art Museum, Cambridge
181. Bataille and Wildenstein 631

197. Perhaps Pissarro and
Venturi 336
198. Perhaps Pissarro and
Venturi 268, private
collection, Switzerland
199. Pissarro and Venturi 246
200. Pissarro and Venturi 238,
private collection
201. Pissarro and Venturi 274,
Musée d'Art et d'Histoire,
Geneva
202. Perhaps Pissarro and
Venturi 370,
Metropolitan Museum of
Art
203. Pissarro and Venturi 366

184 — Mont Cassin. Versant sud. (Butte
Montmartre.)
185 — En plein Soleil. Versant sud. (Butte
Montmartre.)
186 — Sur le Versant nord. (Butte Mont-
martre.)
187 — Le Plateau de la Butte.
188 — La Maison Lorcinier. (Butte Montm.)
Appartient à M. L.....
189 — La rue du Mont-Cenis. (Butte Mont-
martre.)
190 — Retraite de Russie. Versant ouest.
(Butte Montmartre.)
191 — La Maison Rouge, l'Abreuvoir. (Butte
Montmartre.)
192 — Petite rue Saint-Denis. (Butte Mont-
martre.)
193 — La Tour Solferino. (Butte Montm.)
Appartient à Mᵐᵉ O...
194 — Au Cimetière. (Butte Montmartre.)
195 — 7 pièces :
1° Le Sommet. Orage.
2° Le Sommet. Brouillard sur Paris.

3° Rue du Mont-Cenis.
4° L'Observatoire à 10 cent.
5° Village Kabyle.
6° D'un Balcon. Soleil couché.
7° Entre les rues des Carrières et
Marcadet.
196 — 3 pièces :
1° Le Parc.
2° Auvergne.
Appartient à M. And. Gill.
3° De la rue Ordener.

PISSARRO (Camille)
A Pontoise, rue de l'Hermitage

197 — Printemps. Soleil couchant.
198 — Un Etang à Montfoucault (Mayenne).
199 — Gelée blanche avec Brouillard.
Appartenant à M. Choquet.
200 — Neige. Coteaux de l'Hermitage (Pon-
toise).
201 — Ferme à Monttoucault.
202 — Les Coteaux du Choux.
203 — Le Berger.

212. Daulte 201, Musée
d'Orsay
213. Daulte 174, private
collection, New York
214. Daulte 175, Sammlung
Oskar Reinhart,
Winterthur or 176, Fogg
Art Museum, Cambridge
217. Daulte 167, private
collection, Paris
219. Daulte 187, The Art
Institute of Chicago
220. Perhaps Daulte 132,
Musée d'Orsay or 87, Mr.
and Mrs. Paul Mellon,
Upperville, Virginia
221. Daulte 305, The Art
Institute of Chicago
223. Daulte 141, Henry P.
McIlhenny, Philadelphia
224. Daulte 28, Musée d'Orsay
225. Daulte 111, The Frick
Collection
h.c. *Portrait de l'auteur*,
Daulte 157, Sterling and
Francine Clark Art
Institute

204 — Effet de neige à Pontoise.
205 — Effet de Neige. Coteaux d'Osny.
206 — Les Jardins de l'Hermitage.
207 — Paysanne.
208 — Village de l'Hermitage.

RENOIR (Pierre-Auguste)
35. rue Saint-Georges

209 — Femme et Enfant.
Appartient à M. Poupin.
210 — Sur la Terrasse.
Appartient à M. Choquet.
211 ≠ Portrait.
Appartenant à M. Choquet.
212 — Etude.
213 — Liseuse.
Appartient à M. Choquet.
214 — Tête d'Homme.
Appartient à M. Choquet.
215 — Portrait d'Enfant.
Appartient à M. Choquet.

216 — Tête d'Enfant.
Appartient à Choquet.
217 — Tête de Femme.
Appartenant à M. Dollfus.
218 — Portrait de Mˡˡᵉ S...
219 — Femme au Piano.
Appartient à M. Poupin.
220 — Portrait de M. M...
Appartenant à M. Dollfus.
221 — Déjeûner chez Fournaise.
222 — Portrait de Mᵐᵉ D...
223 — Portrait de jeune Fille.
Appartient à M. Legrand.
224 ♯ Frédéric Bazille, peintre tué à Beaune-
la-Rolande.
Appartient à M. Manet.
225 — La Promenade.
226 — Portrait de Mˡ H... (Pastel.)

ROUART (Stanislas-Henri)
34, rue de Lisbonne

227 — Chemin bordé d'Arbres. (Nor-
mandie.)

228 — Ancien Manoir.

229 — Vieille Ferme bretonne. (Etude.)

230 — Bords de l'Indre.

231 — Chemin des Fourneaux (Melun).

232 — Vue de Melun.

233 — Enfants bretons.

234 — Manoir de Graffard. (Encre de Chine.)

235 — Dans un Parc. (Sépia.)

236 — Chaumières.

SYSLEY

A Marly-le-Roy

237 — Effet de Neige.

Appartient à M. Martin.

238 — Avenue de l'Abreuvoir. Effet de Givre.

Appartient à Mᵐᵉ Latouche.

239 — Une Route aux environs de Marly.

Appartient à M. Martin.

240 — L'Abreuvoir de Marly, en hiver.

Appartient à M. Martin.

241 — Le Bord d'un Ruisseau. Environs de Paris.

Appartient à M. Durand Ruel.

242 — Le Chemin des Aqueducs.

Appartient à M. Durand.

243 — Route de Saint-Germain.

Appartient à M. Martin.

244 Inondations à Port-Marly.

Appartient à M. Legrand.

TILLOT (Charles)

7, rue Duperré

245 — Le Chaos de Villers.

246 — Vue prise des hauteurs du Chaos, à Villers.

247 — Falaises, à Villers.

248 — Falaises à Marée basse.

240. Perhaps Daulte 152, The Tate Gallery, London

242. Perhaps Daulte 133, The Toledo Museum of Art or 13, Sammlung Oskar Reinhart, Winterthur

244. Daulte 240, Musée d'Orsay

249 — Manoir de Graffard.

250 — Rochers et Plage à Villers.

251 — Plaine de Barbizon.

252 — Intérieur du Bas-Bréau.

Paris. Imprimerie Alcan-Lévy, 61, rue de Lafayette.

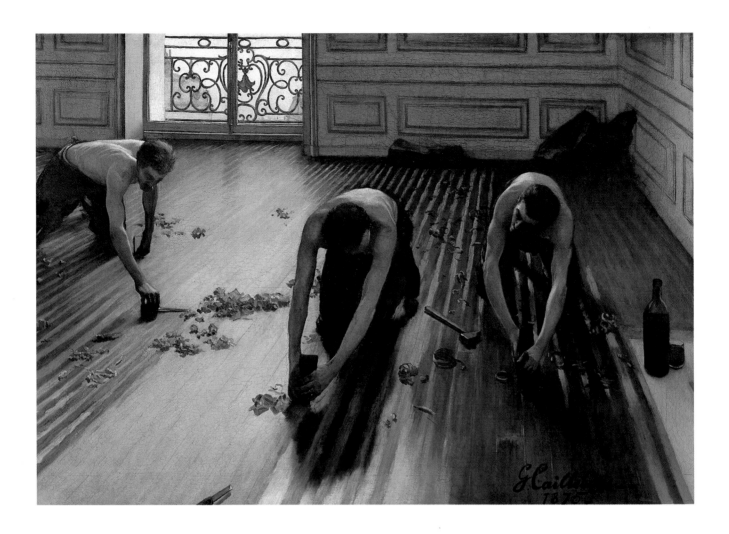

19. Gustave Caillebotte

II—17

Raboteurs de parquets, 1875
The Floor-scrapers

Signed and dated lower right: *G. Caillebotte/1875*
Oil on canvas, 39⅜ x 57¼ in. (100 x 145.4 cm)
Musée d'Orsay (Galerie du Jeu de Paume), Paris. R.F. 2718
REFERENCES: Berhaut 1978, no. 28; Adhémar and Dayez-Distel 1979, 19, 152; Varnedoe and Lee 1976, no. 8.

We will end this list and our necessarily abbreviated appreciation by pointing out to visitors . . . the remarkable *Raboteurs de parquets* by Caillebotte, *primus inter pares*.
L'Audience, 9 April 1876

Should I mention . . . Caillebotte, who, despite his best efforts, lags far behind Degas? His *Raboteurs*, ugly as they are, do not measure up to the *Blanchisseuses* of the master.
Arthur Baignères, *L'Echo Universel*, 13 April 1876

. . . then some *Racleurs de parquet* by Caillebotte, a beginner whose beginnings will create a sensation.
[Philippe Burty], *La République Française*, 1 April 1876

As for Caillebotte, his *Racleurs de parquets* are posed as sincerely as Courbet's fellows, and a great deal of observation is evident in the accessory details.
Such an approach was necessary to lend some interest to the subject.
Armand Silvestre, *L'Opinion Nationale*, 2 April 1876

Who knows Caillebotte? Where does he come from? In what school was he trained? No one has been able to tell me. All I know is that Caillebotte is one of the most original painters to have come forward in some time, and I am not afraid I shall compromise myself by predicting that he will be famous before long.
In his *Raboteurs de parquet*, Caillebotte shows himself to be a Realist as crude as but far more witty than Courbet, as violent as but far more precise than Manet.
Marius Chaumelin, *La Gazette [des Etrangers]*, 8 April 1876

That Gustave Caillebotte knows his craft is a matter that no one will wish to argue. There is certainly evidence of some skill in the two paintings he dedicates to the glory of these floor-scrapers, who perhaps did not expect such an honor. The subject is no doubt vulgar, but we understand why it might tempt a painter. Everyone who has had the pleasure or the bother of having something built will recognize the way these strapping fellows work. Having put aside encumbering clothing and wearing only the barest minimum, they offer to the artist who wants to do a nude study a torso and chest that cannot be freely exposed in any other line of work.
Caillebotte's floor-scrapers are certainly not badly painted, and the perspective has been worked out accurately. I only regret that the artist did not choose better models, or that, from the moment he accepted what reality offered, he did not make use of the right to interpret them generously—a right that he can be assured no one would begrudge him! The arms of the scrapers are too thin, and their chests are too narrow. Artists—do nudes, if the nude is what suits you. I am not prudish, and I would not be so petty as to find it offensive. But let your nude be beautiful, or leave the subject alone.
Louis Enault, *Le Constitutionnel*, 10 April 1876

The *Raboteurs de parquets*, who are seen from above, are strange and rather unpleasant.
G. d'Olby, *Le Pays*, 10 April 1876

A young man, Caillebotte by name, who makes his first appearance in this exhibition, has attracted a great deal of attention. His pictures are original in their composition, but, more than that, so energetic as to drawing that they resemble the early Florentines. These pictures would create a scandal in an official Salon amid the false and sinewless figures of the school, and we applaud the juries for their wisdom in keeping them out. Here it is a different matter. Their success is fair and honest and due to their faithful representation of life as it expresses itself in the working functions, and of the members as they come to look when modified by the constant pursuit of some one particular occupation. M. Caillebotte has sent *Des racleurs de parquet*, joiners bare to the waist scraping the parquet floor of a room with iron blades.
Ph[ilippe] Burty, *The Academy* [London], 15 April 1876

If he wanted, Caillebotte, who is known for scorning perspective, would be capable of doing it, just like anyone else. But he would sacrifice his originality, and he knows better than to make this mistake. In his *Déjeuner*, his *Gratteurs de parquet*, and his *Jeune pianiste* the intention is obvious. He knows perfectly well that this is how he will make a name for himself, and so be able to demonstrate that he has some talent. The little floor-scraper sitting in the background of his picture is evidence of this.
Bertall [Charles-Albert d'Arnoux], *Les Beaux-Arts*, 1876

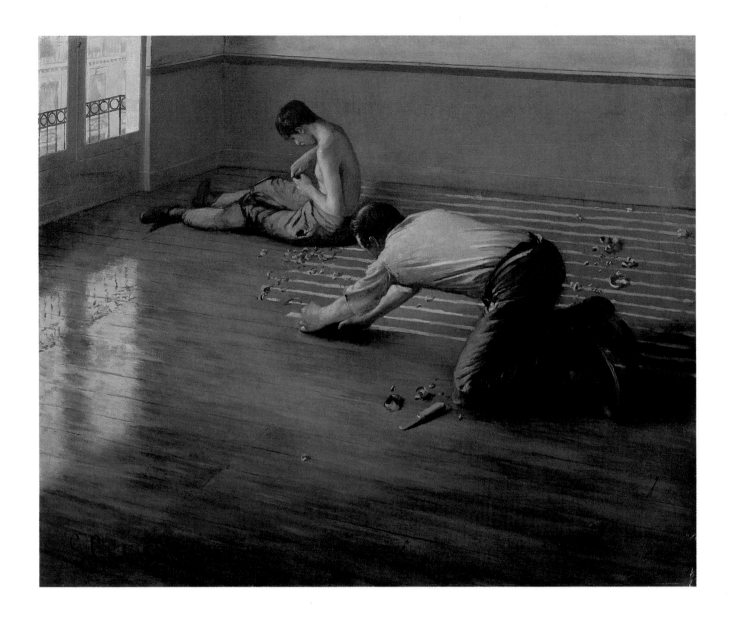

20. Gustave Caillebotte

11–18

Raboteurs de parquets, 1876
The Floor-scrapers

Signed and dated lower left: *G. Caillebotte 1876*
Oil on canvas, 31½ x 39⅜ in. (80 x 100 cm)
Private collection, Paris
REFERENCES: Berhaut 1978, no. 29; Varnedoe and Lee 1976,
no. 10; Maillet 1984, no. 3.

Two canvases representing *Gratteurs de parquet* are just too original. In one of them, one of these gentlemen has stopped working to give himself over to that kind of little hunt on himself that certain habits of cleanliness would make unnecessary. The good taste of this is doubtful.
Emile Porcheron, *Le Soleil*,
4 April 1876

. . . his *Rabotteurs de parquet* has an unquestionable stamp of originality.
Pierre Dax, *L'Artiste*,
1 May 1876

For additional quotations see previous page.

II—20

21. Gustave Caillebotte

Jeune homme à sa fenêtre, 1876
Young Man at His Window

Signed and dated lower left: *G. Caillebotte. 1876*
Oil on canvas, 45¾ x 31⅞ in. (116.2 x 81 cm)
Private collection, New York
REFERENCES: Berhaut 1978, no. 26; Varnedoe and Lee 1976, no. 11.
NOTE: The model is Caillebotte's younger brother René, who died that same year at the age of twenty-six. He is seen at a window in the family apartment at 77 rue de Miromesnil, overlooking the junction of the rue de Lisbonne and the boulevard Malesherbes.

Caillebotte showed *Les raboteurs de parquet* and *Un jeune homme à sa fenêtre*, paintings done in astonishingly high relief. But because of their precision, the paintings are entirely anti-artistic, clear as glass, bourgeois. The mere photography of reality is paltry when not enriched by the original stamp of artistic talent.
Emile Zola, *Le Messager de l'Europe* [Saint Petersburg], June 1876

The success of the exhibition seems to be a newcomer, Caillebotte. We will discuss four of the numerous works he is exhibiting: the *Pianiste*, the two paintings of the *Parqueteurs à l'ouvrage*, and the *Homme à la fenêtre*. The sum of Caillebotte's "intransigence" consists of the way he creates scenes using a bizarre perspective. As a painter and draftsman, however, he returns shamelessly to the conservative ranks of the good school, that of knowledge, where he will certainly find the warmest welcome.
A. de L. [Alfred de Lostalot], *La Chronique des Arts et de la Curiosité*, 1 April 1876

Caillebotte knows how to draw and condescends to paint. His *Jeune homme à la fenêtre*, his *Joueur de piano*, and his *Raboteur de parquet* are very entertaining pictures, full of light, and boldly carried off. But all this simply follows from the fact that Caillebotte has at some point made the effort to study, and thus can put a degree of skill at the service of his imagination. He has gone into the rebel camp on an impulse. Some day, the true artists will slay a fatted calf in their camp to celebrate the return of this prodigal son.
Simon Boubée, *La Gazette de France*, 5 April 1876

Caillebotte is a newcomer who will be given a warm welcome. His *Jeune homme à la fenêtre*, his *Jeune homme jouant du piano*, and his *Raboteurs de parquet* are strikingly modern and in certain passages are firmly modeled. They are full of truth, life, and of a simple and frank intimacy. One of the paintings Caillebotte shows us here was not admitted by the jury last year—a very bad mark for the official jury!
Emile Blémont [Emile Petitdidier], *Le Rappel*, 9 April 1876

22. Edgar Degas

II—36

Portraits dans un bureau (Nouvelle-Orléans), 1873
Portraits in an Office (New Orleans)

Now known as *Le bureau de coton à la Nouvelle-Orléans* (The
Cotton Exchange at New Orleans)
Signed and dated lower right: *Degas/Nlle Orléans/1873*
Oil on canvas, 28¾ x 36¼ in. (73 x 92 cm)
Musée Municipal de Pau, France. Purchased by the City
through the Noulibos bequest, 1878. 878.1.2
REFERENCES: Lemoisne 1946, no. 320; Comte 1978, no.
878.1.2; Dayez et al. 1974, no. 16; Guillaud et al. 1984, 42,
no. 2.

NOTE: In 1872, Degas visited New Orleans where his mother's
family lived. This painting of the Cotton Exchange depicts both
family and associates: Degas's brother Achille leans against an
open window on the left; their uncle Michel Musson is seated
in the foreground; Degas's other brother and Musson's son-in-
law, René, is reading the *Daily Picayune*; and another of
Musson's sons-in-law, William Bell, a broker for the Exchange,
shows cotton to a customer at the central table. Two of
Musson's associates are on the right, James Prestidge seated on
a tall stool behind René and John E. Livaudais examining a
ledger.

. . . and a series of paintings by Degas one wishes were more plentiful: *Magasin de cotons à la Nouvelle Orléans*, some *Blanchisseuses*, some *Danseuses de l'Opéra*, etc.
[Philippe Burty], *La République Française*, 1 April 1876

La boutique de marchand de coton, a scene from New Orleans, is a good painting that owes nothing to revolutionary methods.
A. de L. [Alfred de Lostalot], *La Chronique des Arts et de la Curiosité*, 1 April 1876

The *Portraits dans un bureau* is an utterly clever painting, and we could spend days in front of it.
Armand Silvestre, *L'Opinion Nationale*, 2 April 1876

Degas is a strange artist who tries to see new things. He was born in New Orleans [*sic*] and left there to live in Paris. One feels that he watches Parisian life as an observer who is new to its spectacles, not as one used to them since childhood. But it is unfortunate that his execution is always so inadequate and that his taste leads him to the bizarre or ugly, rather than to the graceful. He has an unfortunate weakness for pink-skirted dancers and yawning laundresses. However, there are some inarguably good qualities in a painting he calls *Un magasin de coton à la Nouvelle-Orléans*. The figure seated examining cotton in the foreground shows an immensely accurate sense of movement and is entirely absorbed in what he is doing. The same is true of the figure in the middle ground who is immersed in reading a large newspaper. Unhappily, Degas does not have the eye of a colorist nor always the hand of a draftsman.
Charles Bigot, *La Revue Politique et Littéraire*, 8 April 1876

I do not believe the 1876 Salon offers us many interiors as remarkably painted as Degas's *Portraits dans un bureau, à la Nouvelle Orléans*. There is nothing to say about the composition except that the figures are not posed. They are grouped – or rather scattered – just as you would see them in a wholesaler's shop on the rue du Sentier. The main figure is an old gentleman wearing a black frock coat and a top hat. He sits in the foreground, examining a piece of cotton through his glasses. This fellow lives. His bearing is so true that it is deceiving; his expression is indicated with extraordinary sensitivity. Behind him, an American smokes a cigarette and tilts back on his chair nonchalantly, reading the *Daily Telegraph* [*sic*]. To the right a bookkeeper standing in front of a table examines a register. In the background seven or eight other people are placed around a large table spread with cotton.
This is a subject that is in no way classic. The academicians can laugh all they want about it, but it will not disappoint those who love accurate, frankly modern painting, and who think that the expression of ordinary life and subtle execution ought to count. It is hard to explain why Degas, who in this picture seems to have wished to rival the Dutch painters in delicacy and distinctness, felt that he had to make concessions elsewhere to the school of spots [*taches*].
Marius Chaumelin, *La Gazette [des Etrangers]*, 8 April 1876

Degas, who has not been afraid to bore the public, exhibits no fewer than twenty canvases, all of about the same quality and showing the same unfortunate compositional preoccupations. This is Realism at its gloomiest and most unfortunate. I would like to make an exception, nevertheless, for the painting bearing the bizarre title of *Portraits dans un bureau*. The painting so designated, or disguised, is nothing more than a collection of cotton merchants examining the precious commodity that is one of the great opportunities for America. It is cold, it is bourgeois, but it is seen in an exact and accurate way, and what is more, it is rendered correctly.
Louis Enault, *Le Constitutionnel*, 10 April 1876

In a cotton merchant's office in New Orleans, Degas has grouped a number of portraits whose truth and individualism demand praise.
G. d'Olby, *Le Pays*, 10 April 1876

When he gives himself the time to complete and finish anything, he displays qualities which are analogous to those that distinguished the early Flemish painters. He has one such finished picture here, the interior of a cotton-warehouse in New Orleans, perfect alike as regards observation and rendering.
Ph[ilippe] Burty, *The Academy* [London], 15 April 1876

Degas is a masterful observer and the kind of impeccable draftsman rarely seen today. His painting of the *Cotonniers* is astonishing, accurately capturing the suffocating atmosphere of the office, summing up all of American civilization. The old gentleman examining the cotton, the employee bending over the books in the foreground, and the young man leaning on his elbows near the cashier's window are remarkably posed.
Pierre Dax, *L'Artiste*, 1 May 1876

This painter is very taken with modernity, life indoors, and everyday models. What is annoying, though, is the way he spoils everything as soon as he puts the finishing touches on a work. As a result, his best paintings are only sketches. As he completes his work, his draftsmanship becomes blurred and pathetic. He paints pictures like *Portraits dans un bureau (Nouvelle Orléans)*, halfway between a seascape and a plate from an illustrated journal. He has excellent artistic perceptions, but I'm afraid his brush will never be really creative.
Emile Zola, *Le Messager de l'Europe* [Saint Petersburg], June 1876

23. Edgar Degas

II–38

Portrait de Mʳ E. M. . . ,1874

Now known as *Portrait of Eugène Manet*
Signed lower left: *Degas*
Oil on canvas, 25⅝ x 31⅞ in. (65 x 81 cm)
Collection of Joseph E. Hotung, Hong Kong
REFERENCES: Lemoisne 1946, no. 339; Boggs 1962, 93, 122;
Christie's New York, 19 May 1981, no. 308.
NOTE: Eugène Manet, brother of Edouard Manet, married
Berthe Morisot in 1874. With Morisot, he was an early
supporter and organizer of the eighth group show in 1886.

Degas is a painter of extreme sensibility and of not less extreme boldness. He more often throws his sketches on to the canvas than takes time to finish them; but these in themselves are sufficient to prove the power of his imagination, his science, his intimate acquaintance with modern life, with the gestures, effect, the athletics peculiar to each of his subjects. . . .
Ph[ilippe] Burty, *The Academy*
[London], 15 April 1876

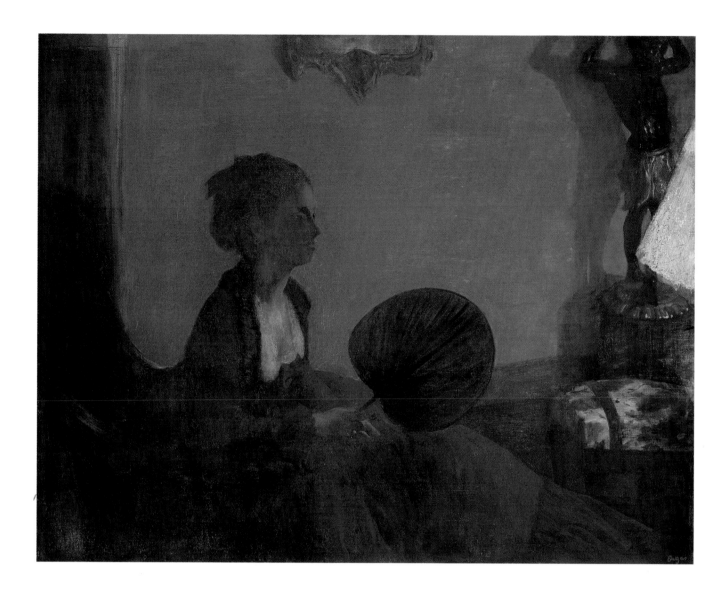

24. Edgar Degas

II—43

Portrait, le soir, 1869–1870
Portrait, Evening
Now known as *Madame Camus*
Atelier stamp lower right: *Degas* [Lugt no. 658]
Oil on canvas, 28⅝ x 36¼ in. (72.7 x 92.1 cm)
National Gallery of Art, Washington. Chester Dale Collection.
1963.10.121
REFERENCES: Lemoisne 1946, no. 271; Washington 1965,
no. 1785; Boggs 1962, 22, 26, 111, pl. 66; Guillaud et al. 1984,
24, fig. 25.
Washington only

Try, then, to bring Degas to rea-
son. Tell him that in art there are
some qualities that we can name:
drawing, color, execution, intent.
He will laugh in your face and
treat you like a reactionary.
Albert Wolff, *Le Figaro*,
3 April 1876

NOTE: Mme Camus, an accomplished musician, and her
husband, a physician, were friends of Manet and Degas; Dr.
Camus treated Degas. In 1869 Degas executed several sketches
and an additional finished portrait of Mme Camus, depicting
her at her piano (Lemoisne no. 207). See Boggs, above.

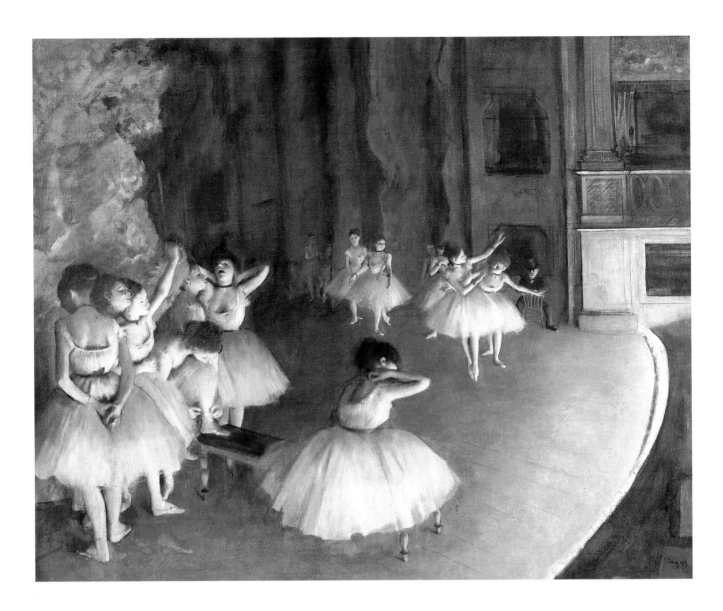

One cannot describe the *Danseuses* (among them, the photograph of a painting) or the *Blanchisseuses*; one must see them.
Pierre Dax, *L'Artiste*,
1 May 1876

The sketch in *grisaille* by the same painter, representing a dancer's foyer, stands out for its well-observed suggestion of movement and the composition of its groups. But these are merely suggestions—are they enough to make a painting?
G. d'Olby, *Le Pays*,
10 April 1876

25. Edgar Degas

Salle de danse, 1874
The Dance Class

Now known as *Répétition de ballet sur la scène* (The Dress Rehearsal)
Signed lower right: *Degas*
Oil on canvas (grisaille), 25⅝ x 31⅞ in. (65 x 81 cm)
Musée d'Orsay (Galerie du Jeu de Paume), Paris. Camondo Bequest, 1911. R.F. 1978
REFERENCES: Lemoisne 1946, no. 340; Adhémar and Dayez-Distel 1979, 35, 155; Pickvance 1963, 263, fig. 20.

NOTE: The *pentimenti* in this work indicate that Degas originally intended a duplication of the composition of *Répétition de ballet sur la scène* (Lemoisne, no. 400), now in The Metropolitan Museum of Art, New York. At some point the artist changed the scene from a classroom where the dancers are supervised by several figures to a more formal dress rehearsal on stage. See Pickvance, above.

174 THE NEW PAINTING

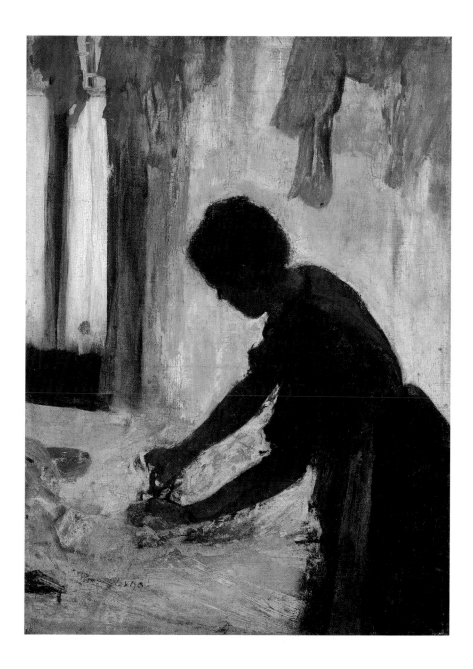

Degas presents some rapidly done silhouettes of laundresses and some more finished studies of dancers from the Opéra. There are some excellent passages in these latter paintings. One senses in Degas a better-trained artist than one might expect, and perhaps even more so than he might wish to appear.
A. de L. [Alfred de Lostalot], *La Chronique des Arts et de la Curiosité*, 1 April 1876

In the room at the back, Degas offers us, among other "delights," a laundress whose head and arms are almost black. The first thought the picture inspires is to make you ask yourself whether the coal seller is a laundress, or whether the laundress is a coal seller.
Emile Porcheron, *Le Soleil*, 4 April 1876

Despite Degas's accurate and firm draftsmanship, his *Blanchisseuses* will never get my business: the laundry that they are ironing is repulsively dirty.
Marius Chaumelin, *La Gazette [des Etrangers]*, 8 April 1876

26. Edgar Degas

II—49

Blanchisseuse (Silhouette), ca. 1874
Laundress (Silhouette)

Now known as *A Woman Ironing*
Signed lower left: *Degas*
Oil on canvas, 21 ⅜ x 15 ½ in. (54.3 x 39.4 cm)
Lent by The Metropolitan Museum of Art. Bequest of Mrs. H. O. Havemeyer, 1929. The H. O. Havemeyer Collection. 29.100.46
REFERENCES: Lemoisne 1946, no. 356; Sterling and Salinger 1967, 3: 77–78; Baetjer 1980, 1: 45.

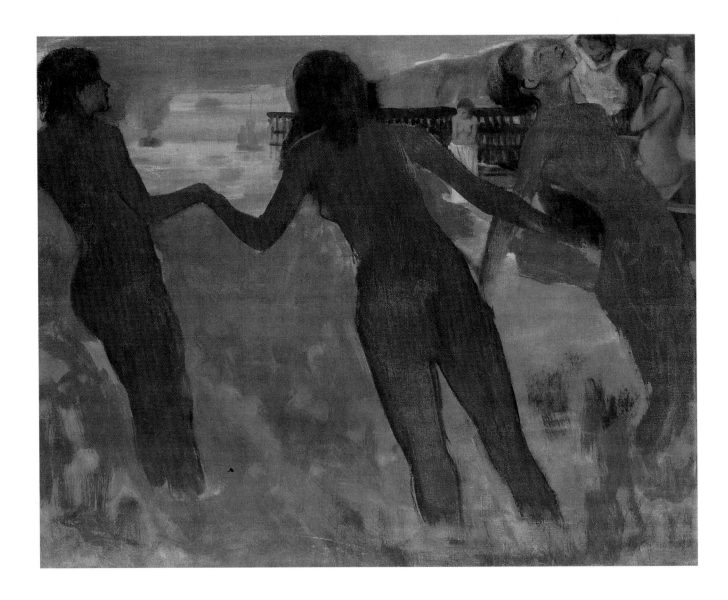

27. Edgar Degas

II–56
also III–51

Petites paysannes se baignant à la mer vers le soir,
1875–1876
Peasant Girls Bathing in the Sea at Dusk

Titled in the third exhibition *Petites filles du pays se baignant dans la mer à la nuit tombante*
Atelier stamp lower left: *Degas* [Lugt no. 658]
Oil on canvas, 25⅝ x 31⅞ in. (65 x 81 cm)
Private collection, Northern Ireland
REFERENCES: Lemoisne 1946, no. 377; Sotheby's London, 4 December 1984, no. 6.

In the third room are the works Degas sent. . . . But though we encountered some excellent sketches there, we did not see a truly finished painting . . .
Emile Blémont [Emile Petitdidier], *Le Rappel*, 9 April 1876

Edgar Degas is perhaps one of the most intransigent of this Intransigent company.
Louis Enault, *Le Constitutionnel*, 10 April 1876

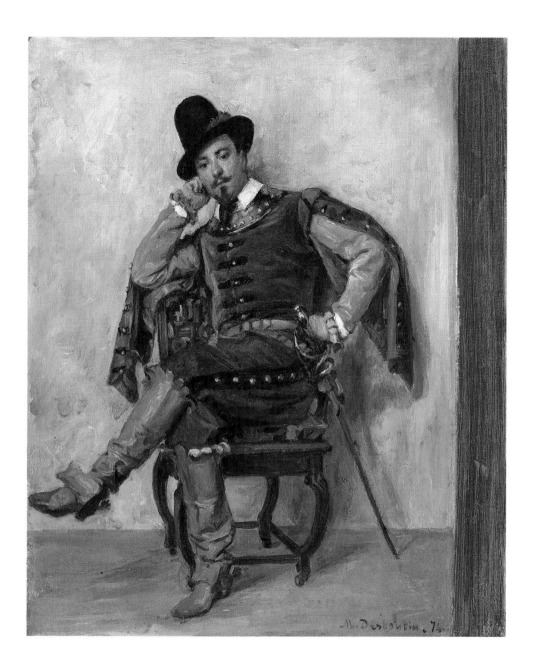

28. Marcellin Desboutin

II–62

Portrait de M. F. . . , 1874

Now known as *Portrait of Jean-Baptiste Faure*
Signed and dated lower right: *M. Desboutin.74.*
Oil on canvas, 18⅞ x 14¾ in. (40.8 x 32.7 cm)
Wheelock Whitney & Company, New York
REFERENCES: New York, Wheelock Whitney, 1983, no. 22.
NOTE: Jean-Baptiste Faure (1830–1914), a celebrated
baritone with the Paris Opéra, was an early patron of Manet,
later collecting works by Degas and Monet as well. He is seen
here in his role as de Nevers in Meyerbeer's opera *Les
Huguenots.*

Desboutin's drypoints seem more
truly felt than his paintings,
which in no way offend the ordi-
nary laws of honest and moderate
painting.
G. d'Olby, *Le Pays,*
10 April 1876

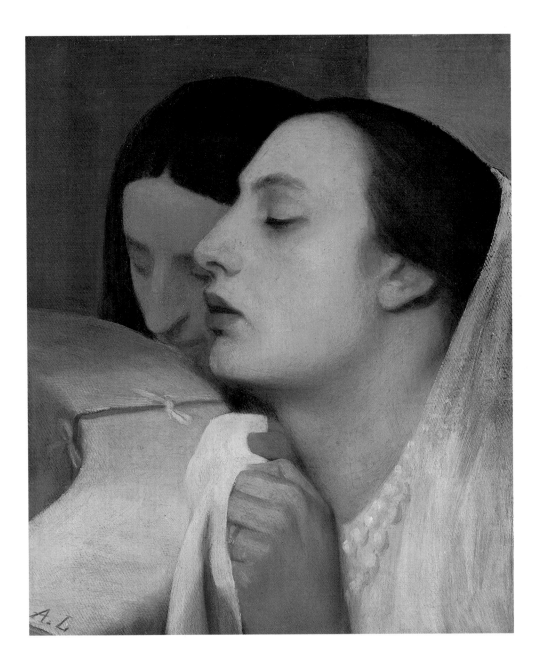

29. Alphonse Legros

II—91

La communion, ca. 1876

Initialed lower left: *A.L*
Oil on canvas, 14¼ x 12 in. (36 x 30.5 cm)
Collection of Robin Burnett Harrison, Oxford, England
REFERENCES: Phillips London, 27 March 1984, no. 86.

[Alphonse Legros] is a master little known to the public, although he has been held in the greatest esteem in artistic circles for a long time.
A. de L. [Alfred de Lostalot], *Le Bien Public*, 4 April 1876

Legros's work seems to reappear from the time of the old masters, as if seen by a man from another century, which gives his work a priceless Gothic flavor.
Pierre Dax, *L'Artiste*, 1 May 1876

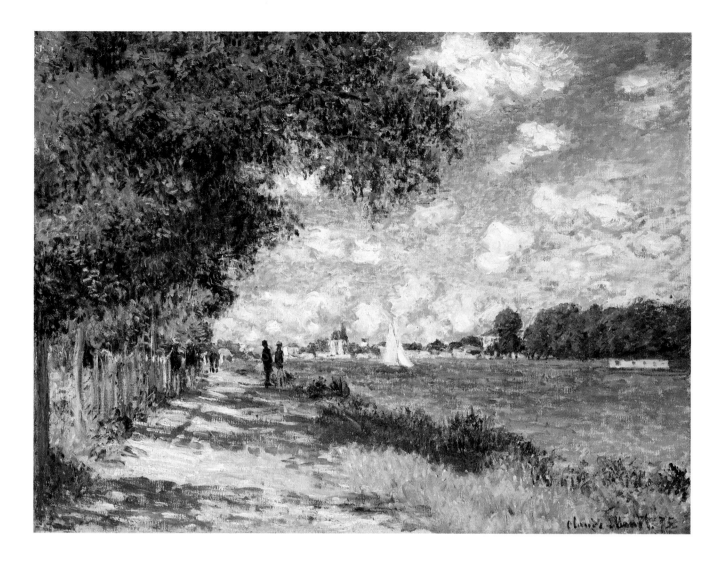

30. Claude Monet

II–149

La Seine à Argenteuil, 1875
The Seine at Argenteuil

Signed and dated lower right: *Claude Monet.75*
Oil on canvas, 23 ½ x 32 in. (59.7 x 81.3 cm)
San Francisco Museum of Modern Art. Bequest of Mrs. Henry
Potter Russell 74.4
REFERENCES: Wildenstein 1974, no. 373; duPont et al.
1985, 344.

Monet is exhibiting some land-
scapes: only one, number 149,
seems worthy of the name: a view
from the river's edge.
Emile Porcheron, *Le Soleil*,
4 April 1876

I do not want to predict what the
future holds for the artists of the
rue le Peletier; will they pass for
masters one day? They might;
then Degas will take the place
that Ingres holds now, while that
of Delacroix is saved for Claude
Monet, the dazzling colorist of
the group. Along with some gro-
tesque canvases, Monet exhibited
some remarkable landscapes,
among them the beach at Sainte-
Adresse and several views of the
Seine near Argenteuil. If only
Monet wanted to cure himself of
the sickness of Impressionism,
what a landscape painter we
would have! Few artists render
better than he the brilliance of
daylight, the purity of atmo-
sphere, and the blue of water
and sky.
Arthur Baignères, *L'Echo
Universel*, 13 April 1876

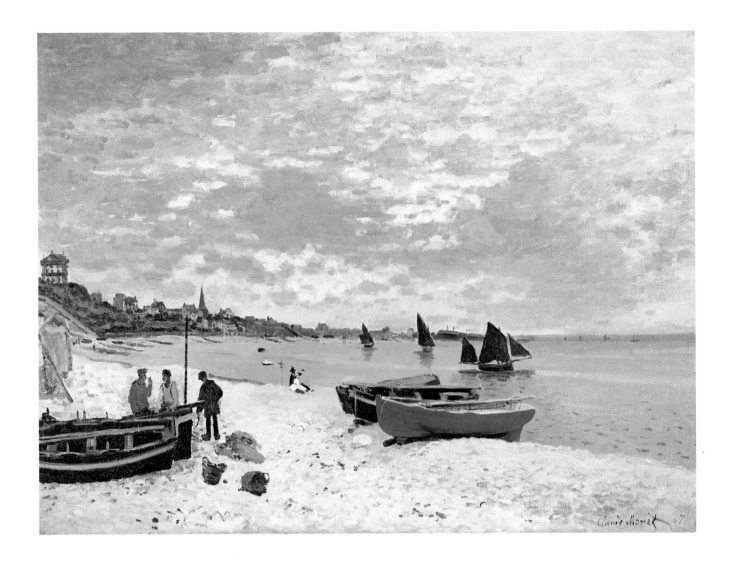

31. Claude Monet

II—151

La plage à Sainte-Adresse, 1867
The Beach at Sainte-Adresse

Signed and dated lower right: *Claude Monet 67*
Oil on canvas, 29¹³⁄₁₆ x 40⁵⁄₁₆ in. (75.8 x 102.5 cm)
The Art Institute of Chicago. Mr. and Mrs. Lewis Larned
Coburn Memorial Collection. 1933.439
REFERENCES: Wildenstein 1974, no. 92; Chicago 1961, 278,
318; Adhémar et al. 1980, no. 16bis; Brettell et al. 1984, no. 6.

Of the landscapes by this same artist, we noticed particularly the *Plage de Sainte-Adresse*, a seascape of solid tone and broad stroke.
Emile Blémont [Emile Petitdidier], *Le Rappel*,
9 April 1876

Monet's landscapes are very beautiful. A seascape with a blue boat on the beach is a masterpiece.
Pierre Dax, *L'Artiste*,
1 May 1876

And yet, when he wants, Monet knows perfectly well how to make the public understand him. All it takes is for him to give up speaking Japanese or Bengali, and to express himself in plain French, as he has done in painting the *Pont du chemin de fer à Argenteuil*, *Prairie*, and *Plage de Sainte-Adresse*. These three pieces would make a good showing at the official Salon. If the jury did not award them a medal, the connoisseurs certainly would like their frankness, originality, and their general brilliance.
Unidentified review in Gustave Geffroy, *Claude Monet*
(Paris, 1922), 70

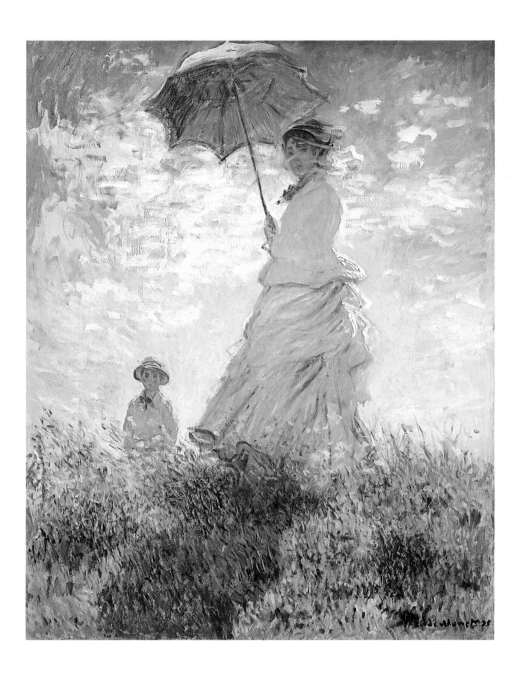

32. Claude Monet

II–161

La promenade, 1875

Now known as *Woman with a Parasol–Madame Monet and Her Son*
Signed and dated (at a later time) lower right: *Claude Monet 75*
Oil on canvas, 39⅜ x 32 in. (100 x 81 cm)
National Gallery of Art, Washington. Collection of Mr. and Mrs. Paul Mellon. 1983.1.29
REFERENCES: Wildenstein 1974, no. 381; Washington 1966, no. 85; Isaacson 1978, no. 54.

. . . [we noticed] a *Promenade*, where the figure of a woman stands out with rhythmic movement against a light sky.
Emile Blémont [Emile Petitdidier], *Le Rappel*, 9 April 1876

A young woman and a little boy on a hill surrounded by brambles and tall grasses gaze around while the wind pushes the clouds and the sun appears from behind them. This painting creates an effect that is both singular and extremely accurate.
Pierre Dax, *L'Artiste*, 1 May 1876

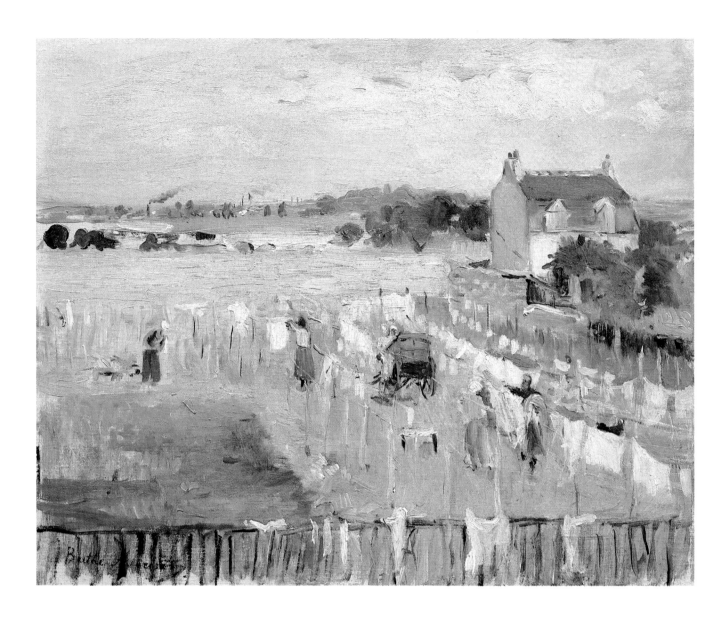

33. Berthe Morisot

II—175

Un percher de blanchisseuse, 1875
Laundresses Hanging Out the Wash

Now known as *Percher de blanchisseuses, Gennevilliers*
Signed lower left: *Berthe Morisot*
Oil on canvas, 13¾ x 17¾ in. (35 x 45 cm)
Collection of Mr. and Mrs. Paul Mellon, Upperville, Virginia
REFERENCES: Bataille and Wildenstein 1961, no. 45.

There is a woman in the group, as there is in all celebrated gangs. Her name is Berthe Morisot, and she is interesting to watch. Her feminine grace lives amid the excesses of a frenzied mind.
Albert Wolff, *Le Figaro,*
3 April 1876

Berthe Morizot [*sic*] was born with a real painter's talent. It would take very little for her color to really please. You could say that she particularly is the victim of the system of painting that she has adopted.
Charles Bigot, *La Revue Politique et Littéraire,* 8 April 1876

Given her delicate color and the adroitly daring play of her brush with light, it is a real pity to see this artist give up her work when it is only barely sketched because she is so easily satisfied with it.
A. de L. [Alfred de Lostalot],
La Chronique des Arts et de la Curiosité, 1 April 1876

Politeness makes it our duty to start with Morisot, the only woman to have exhibited at the rue le Peletier. She pushes the system to its extreme, and we feel all the more sorry about this as she has rare talent as a colorist.
Arthur Baignères, *L'Echo Universel,* 13 April 1876

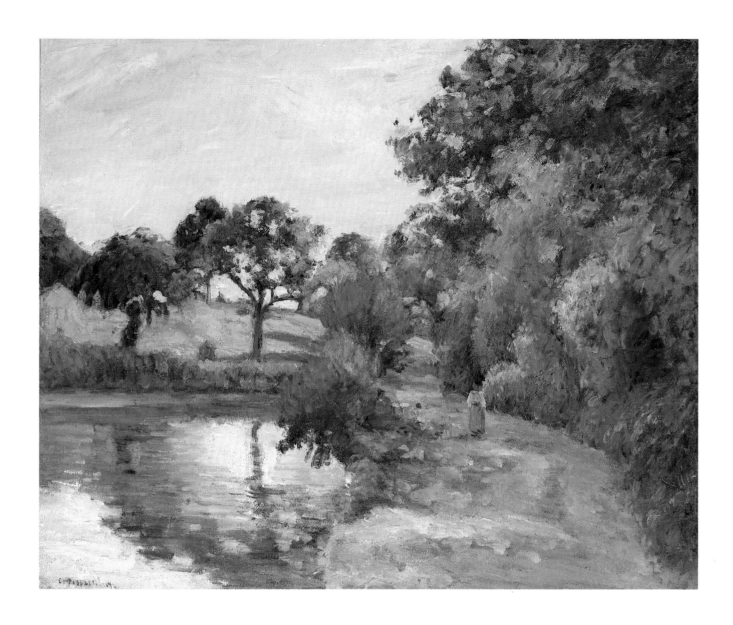

34. Camille Pissarro

II–198

Un étang à Montfoucault (Mayenne), 1874
Pond at Montfoucault (Mayenne)

Signed and dated lower left: *C. Pissarro.1874.*
Oil on canvas, 21 x 25¾ in. (53.5 x 65.5 cm)
Private collection, Switzerland. Courtesy of Ellen Melas
Kyriazi
REFERENCES: Pissarro and Venturi 1939, no. 268; Sotheby's
London, 29 November 1976, no. 7.
NOTE: The work was also previously signed lower right. This
signature disappeared when the picture was cleaned after the
1976 sale.

We are arriving at the only two
exhibitors who could truly justify
the title of Intransigents and ren-
ovators of art, Monet and Pisacco
[*sic*]. With them, there is no possi-
ble doubt, their palette evokes the
aggravated tones of the solar
spectrum in order to translate
impressions taken in a nature that
does not belong to this world.
G. d'Olby, *Le Pays*,
10 April 1876

Pissaro [*sic*] has a manner that
pleases us much less [than
Degas].
Emile Blémont [Emile
Petitdidier], *Le Rappel*,
9 April 1876

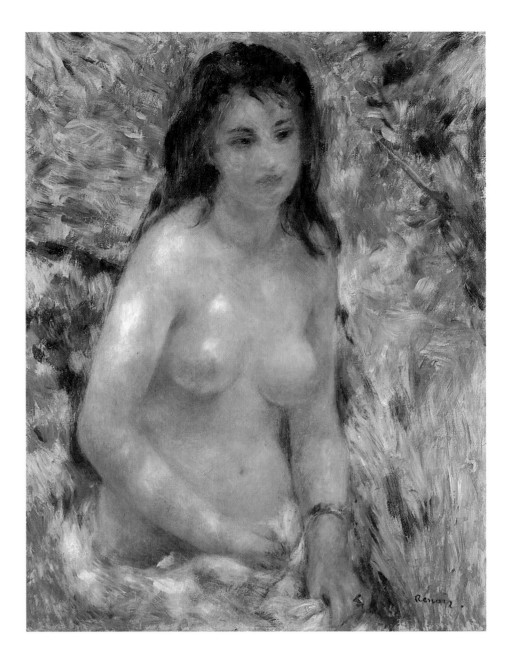

If only Renoir were in less of a hurry to finish the subject he begins, he would certainly have the makings of a distinguished painter. He exhibits here a female nude and a portrait of a young girl that testify to his very real talents.
A. de L. [Alfred de Lostalot], *La Chronique des Arts et de la Curiosité*, 1 April 1876

Go ahead and try to explain to Renoir that a woman's torso is not a mass of decomposing flesh with the purplish-green splotches that denote the final stage of putrefaction in a corpse!
Albert Wolff, *Le Figaro*, 3 April 1876

Let us throw a veil over [Renoir's] *Vénus*, which he should have hidden behind a screen.
Emile Porcheron, *Le Soleil*, 4 April 1876

Looking at his *Etude de femme nue*, I struggle in vain to tell whether that thing wriggling in the background is a piece of fabric, a cloud, or a fantastic beast.
Marius Chaumelin, *La Gazette [des Etrangers]*, 8 April 1876

In his studies, as in his portraits, Renoir may be making a bet with nature that he stands a good chance to lose. . . . A large study of a female nude is depressing—its flesh has the purplish tones of meat gone rank. It certainly would have been kinder to let her put on a dress. Where did the artist manage to find such a pathetic model? But this is not systematic hostility toward Renoir—no artist will ever reproach me with that.
Louis Enault, *Le Constitutionnel*, 10 April 1876

35. Pierre-Auguste Renoir

II—212

Etude, ca. 1876
Study
Now known as *Torse de femme au soleil* (Torso of a Woman in the Sunlight)
Signed lower right: *Renoir.*
Oil and canvas, 32 x 25½ in. (81 x 64.8 cm)
Musée d'Orsay (Galerie du Jeu de Paume), Paris. Gustave Caillebotte Bequest, 1894. R.F. 2740
REFERENCES: Daulte 1971, no. 201; Adhémar and Dayez-Distel 1979, 96, 169; White 1984, 38, 57, 58, 73, 74, 132, 228; House et al. 1985, no. 36.

NOTE: The model for this nude study has been identified as Alma Henriette Leboeuf (1856–1879), called Anna. See House et al., above.

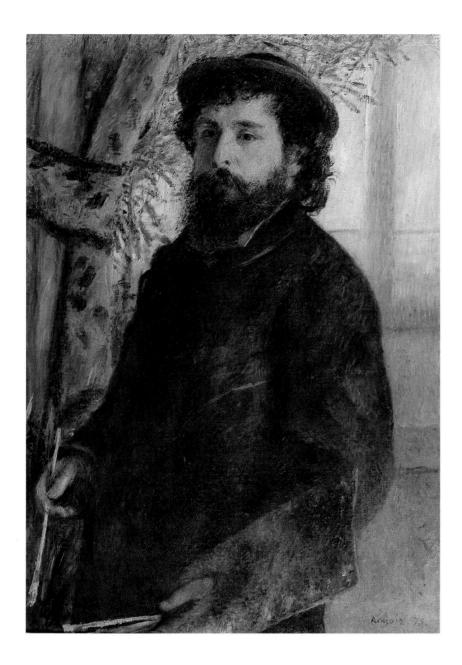

His portrait of Claude Monet is a strong piece that has been finished to perfection.
Emile Blémont [Emile Petitdidier], *Le Rappel*, 9 April 1876

Certain passages in Renoir's *Peintre* are those of a master.
Pierre Dax, *L'Artiste*, 1 May 1876

Renoir is a painter who specializes in human faces. A range of light tones dominates his work, the transitions between them arranged with superb harmony. His work is like Rubens, illuminated by the brilliant sunlight of Velásquez. He exhibits a very successful portrait of Monet.
Emile Zola, *Le Messager de l'Europe* [Saint Petersburg], June 1876

36. Pierre-Auguste Renoir

II–220

Portrait de M. M. . . , 1875
Now known as *Portrait de Claude Monet*
Signed lower right: *Renoir, 75.*
Oil on canvas, 33½ x 25⅝ in. (85 x 60.5 cm)
Musée d'Orsay (Galerie du Jeu de Paume), Paris. Bequeathed by M. and Mme Raymond Koechlin, 1931. R.F. 3666
REFERENCES: Daulte 1971, no. 132; Adhémar and Dayez-Distel 1979, 95, 168.

NOTE: This portrait is one of three possibilities for no. 220 in the second exhibition. The others are *Claude Monet lisant* (Daulte no. 85) in the Musée Marmottan, Paris, and *Portrait de Claude Monet* or *Le liseur* (Daulte no. 87) in the collection of Mr. and Mrs. Paul Mellon, Upperville, Virginia.

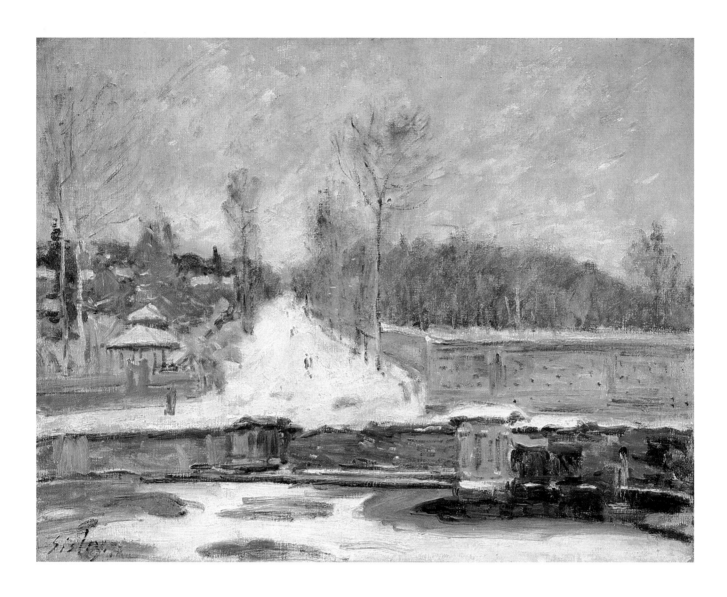

37. Alfred Sisley

II–240

L'abreuvoir de Marly, en hiver, 1875
The Watering Place at Marly in Winter

Signed and dated lower left: *Sisley. 7[5]*
Oil on canvas, 19½ x 25¾ in. (49.5 x 65.5 cm)
The Trustees of The National Gallery, London. 4138
REFERENCES: Daulte 1959, no. 152; Davies 1970, no. 4138.
NOTE: Daulte dates this work 1875 per an earlier reading of
the inscribed date. However, the pigment of the second
numeral has worn thin and thus the date can no longer be
confirmed by the inscription. See Davies, above.

All the good ones, those who have talent—Sisley, Cals, Rouart—are anxious to show their knowledge, I would even say their membership in the school, if I were not afraid to offend them.
A. de L. [Alfred de Lostalot], *Le Bien Public*, 4 April 1876

Sisley, whose paintings at the previous exhibition at the boulevard des Italiens made a scandal because of their strangeness, seems to wish to humanize himself and to see nature with an eye of less debatable sincerity.
G. d'Olby, *Le Pays*, 10 April 1876

Sisley is a landscapist of great talent who has more balanced means than Pissarro.
Emile Zola, *Le Messager de l'Europe* [Saint Petersburg], June 1876

The Third Exhibition *1877*

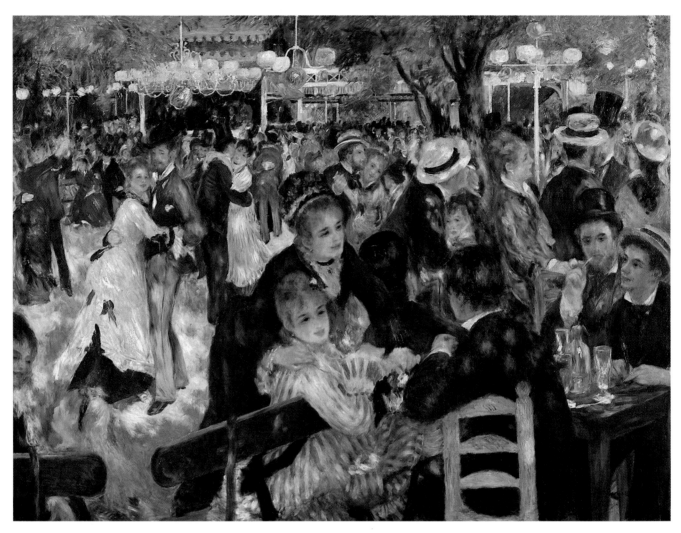

fig. 1 Pierre-Auguste Renoir, *Bal du Moulin de la Galette* (*Ball at the Moulin de la Galette*, III–186), 1876. Oil on canvas, 51½ x 69 in. (130.8 x 175.3 cm). Musée d'Orsay (Galerie du Jeu de Paume), Paris. Gustave Caillebotte Bequest, 1894. Photo: Cliché des Musées Nationaux

The "First" Exhibition
of Impressionist Painters

Richard R. Brettell

<div style="text-align: right">

Wednesday [1877]

</div>

My dear Pissarro,
Will you come to dinner at my house next Monday? I am
returning from London and would like to discuss certain
matters with you relative to a possible exhibition. Degas,
Monet, Renoir, Sisley, and Manet will be there. I count
absolutely on you.
Monday at seven o'clock.

<div style="text-align: right">

all my best
G. Caillebotte[1]

</div>

This undated letter from Gustave Caillebotte to Camille Pissarro, kept by its receiver throughout his life, is the only evidence of a dinner party—held sometime in January or February 1877—at which the third exhibition of the "Impressionists" was planned. I put "Impressionists" in quotation marks because, before the exhibition of 1877, the word was never used self-consciously by the artists themselves, and, as Stephen Eisenman has shown,[2] its selection as the group name was controversial both politically and esthetically. Thus, the third exhibition of the artists we now call Impressionists was technically their first as Impressionists. This name and, therefore, the "image" of the group surely was one of the major topics discussed at Caillebotte's dinner party.

How one would have loved to have been present that Monday evening early in 1877. In fact, if one were to make a list of the greatest French painters living at that moment, all but two were present—Corot and Millet were already dead; Courbet, the aging revolutionary, was living what was to be the last year of his life in exile in Switzerland; and Cézanne, the only genius of the younger painters whose work up to that point stands the test of time, was perhaps too controversial to have been invited and definitely too shy to have attended. Clearly, Caillebotte knew good painting as well as we do today, if not better, for not one minor painter was included for political or financial reasons. Also present was the great Manet, the dean of French avant-garde artists. There were no critics, no dealers, no wealthy amateurs, no decorative friends. This was arguably the most important dinner party of painters held in the nineteenth century.

Why was it necessary? What were Caillebotte's aims in constructing it so carefully? One thing is clear—that the dinner party was not merely ceremonial. There were only seven guests, all of whom could sit comfortably in one of Caillebotte's sitting rooms on the rue Miromesnil and continue their deliberations around a single table at dinner. Obviously, Caillebotte wanted to encourage intense conversation, to create a situation in which the future of French painting would be intelligently planned. He wanted to foster a "democratic" exhibition, but to exclude all but the most important from the decision-making process. His method worked, because there is little doubt that the exhibition planned by the group that evening was the most balanced and coherent of the eight Impressionist exhibitions. All major painters associated at that time with Impressionism were represented in quantity and by important works of art. Renoir's *Bal du Moulin de la Galette* (*fig. 1*), Monet's series of the Gare Saint-Lazare (cat. nos. 51, 52, and 54; and *fig. 2*), Caillebotte's *Rue de Paris: Temps de pluie* (cat. no. 38), Pissarro's *Le verger, côte Saint-Denis, à Pontoise* (*fig. 3*), Cézanne's first great still-life painting (e.g. *fig. 4*), and Degas's first monotypes, many of which were finished with pastel (*figs. 5* and *6*)—all of these competed for the attention of the thousands of viewers who attended the exhibition planned that Monday early in 1877.

It is probably fair to surmise that Caillebotte lost only one major battle that evening. Even with the aid of his friends he was unable to convince Edouard Manet to desert the Salon and join forces with the Impressionists. How one wishes that he would have succeeded! Indeed, the history of Impressionism would have been written rather differently had Manet been part of the group exhibitions that gave public definition to the most hallowed modern movement. It is easy to imagine an even greater exhibition with Manet's *Nana* (Kunsthalle, Hamburg) submitted to, but rejected from, the Salon of 1877. Emile Zola might then have written a more important, substantive review than the slight one he contributed, not to a Parisian newspaper, but to *Le Sémaphore de Marseilles*, had Manet decided to join the Impressionists.[3] And many other of Manet's paintings would have

corresponded perfectly to those submitted to the 1877 exhibition by the younger artists. The first version of his famous *Waitress Serving Beer* (National Gallery, London) would have been superb with the café scenes by Renoir and Degas. In addition, Manet's great *Gare Saint-Lazare* (National Gallery of Art, Washington), although already exhibited at the Salon of 1874, perhaps was the major source for paintings by both Monet and Caillebotte. Although each of the younger artists responded rather differently to Manet's example in their paintings of the same site, most of their work was shown in the exhibition planned at Caillebotte's dinner party in 1877.[4]

Gustave Caillebotte had one major reason for playing such a crucially formative role in the third group exhibition. He was then completing the most important paintings of his career and wanted an exhibition worthy of his efforts. In many ways, the Impressionist Exhibition of 1877 *was* Caillebotte's exhibition. He maneuvered skillfully among the strong, contrasting personalities of Degas, Monet, Renoir, and Pissarro—writing encouraging letters, meeting individually with single artists, and even purchasing paintings and pastels from each at this crucial time in the financial history of Impressionism. He loaned three works by Degas (including *figs. 5* and *6*), one by Monet (cat. no. 55), and three by Pissarro (cat. no. 60, 111–181, and *fig. 3*) to the exhibition. He effected the necessary compromise between the Socialist politics of Pissarro and the frankly bourgeois lifestyle of Monet, Renoir, and their respective patrons, the Hoschedé and Charpentier families. And he flattered each artist into believing that he was the crucial member of the group.

In fact, it was politics that nearly toppled the fragile tower of Impressionism in 1877. Pissarro, seen today as the artist most faithful to the movement and the only one who submitted work to all eight Impressionist exhibitions, was more than a little disenchanted with Monet and Renoir in 1876 and early 1877, and was perfectly ready to abandon the group. Together with his friends Paul Cézanne and Armand Guillaumin he had joined a frankly anti-bourgeois Union of artists founded by Alfred Meyer, with whose politics he sympathized. It was Cézanne who finally convinced Pissarro to withdraw from the Union exhibition and to join forces with the Impressionists, a decision that seems to have been made largely because the Union artists were not of a uniformly high standard. Pissarro, in turn, was brought back into the Impressionist fold by Caillebotte, whose insistent last sentence in the letter quoted above ("I count absolutely on you")[5] undoubtedly was written to assure the older artist of his central role in the "new" Impressionist group. Without Pissarro in the fold, it is doubtful that Cézanne would have exhibited with the group, and, in spite of the fact that he was not present at Caillebotte's dinner, the young Provençal painter was to be one of the stars of the exhibition planned that evening.

In orchestrating his dinner party, Caillebotte gave an important part to each of the painters, thus provoking them to create an exhibition that, in spite of its eventual size (two hundred and forty-one framed works), was more like chamber music than symphonic music. Virtually all the critics who wrote about the exhibition noticed its new focus and clarity. Many commented on the reduction in the number of artists (eighteen) from the 1874 (thirty) and 1876 (nineteen) exhibitions, and most of the criticism was confined to the work of seven or eight painters, most of whom were present at Caillebotte's party. Only Berthe Morisot (whose brother-in-law, Manet, was present) and Cézanne (whose teacher, Pissarro, was his surrogate) were among those not at the planning meeting whose work was singled out frequently for comment in exhibition reviews.

Thus the 1877 exhibition was preeminently an exhibition created by artists. Although it seems large by the standards of temporary exhibitions today, it was almost miniscule by comparison with the official Salon with which it vied for the attention of the public. In fact, the Salon of 1877 contained nearly two thousand works, almost eight times the size of the Impressionists' exhibition. And, rather than exhibiting one to five of the best paintings by each artist, the norm in the Salon, the Impressionists included a representative sample of the recent work of each major artist, following the practice set in their 1876 exhibition. Monet, the largest exhibitor, was represented by thirty paintings, most of which had been painted during the past year. Degas was second with twenty-five works, Pissarro—twenty-two, Renoir—twenty-one, Sisley—seventeen, and Cézanne—sixteen. In this way, the Impressionist Exhibition of 1877 was less an exhibition of individual paintings than of the work of individual artists. Only two minor artists, Guillaumin and Piette, were represented in any quantity and undoubtedly as a concession to their friend Pissarro. In spite of that, very few critics noticed their work.

The 1877 exhibition was brilliantly conceived, and Caillebotte was responsible for the subtle mechanics of its creation. Yet, if the process of preparation was exemplary, so was the exhibition itself. The Impressionist movement was in full maturity in 1877, and ready for such a carefully planned exhibition. The works in the exhibition ranged from enormous paintings seemingly scaled for the Salon to slight watercolors and monotypes. There were landscapes, genre scenes, portraits, and still lifes, each area represented sufficiently to make its presence felt. The viewer was able to compare the flowers by Renoir with those by Cézanne and Monet, or the portraits by Monet with those by Cézanne, Renoir, and Degas, or the domestic interiors by Morisot with those by Monet and Caillebotte. Everywhere was balance—the city, the suburb, and the country were almost equal in their representation; there were interiors and exteriors, figures and landscapes; there were large and small

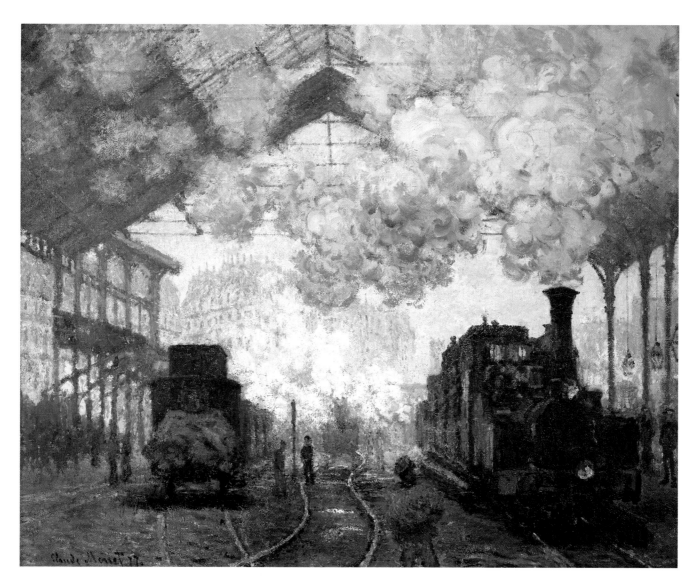

fig. 2 Claude Monet, *La Gare Saint-Lazare, arrivée d'un train (Saint-Lazare Station, Paris,* III–100), 1877. Oil on canvas, 32¼ x 39¾ in. (82 x 101 cm). The Fogg Art Museum. Bequest–Collection of Maurice Wertheim, Class of 1906

paintings. And all of these works were arranged not in a series of "galleries," but in the rooms of an apartment so that the viewer could easily imagine the works of art "at home."

The locale for the exhibition was arranged, like much else, by Caillebotte, who rented the apartment himself, to be repaid from exhibition admissions (fifty centimes, about five current dollars). Each of the previous exhibitions had been situated in a commercial gallery space, the first in Nadar's studio and the second in the galleries of the famous dealer Durand-Ruel. It seems that Durand-Ruel was not able to schedule the Impressionist Exhibition in his galleries, so the space used was secured by Caillebotte shortly before the exhibition opened.

Although this situation must have created certain logistical difficulties of security, admissions, and sales (each of which would have been efficiently handled by Durand-Ruel), there were also advantages that came from independence. Both the selection of a location and the installation of the galleries rested with the artists themselves. There was no one to blame for their failure, and no one to take false credit for their success.

Caillebotte chose a large (one reviewer said "immense") apartment on the second floor of a building at 6 rue le Peletier, across the street from Durand-Ruel's galleries where their 1876 exhibition had been held.[6] The entrance to the building was just off the boulevard Haussmann at the point where it intersected with the

boulevard des Italiens, and several exhibition rooms had views of the grand boulevards. Thus the Impressionists placed themselves directly in the center of "Nouveau Paris," not more than a five-minute walk from Garnier's Opéra. Again, as in 1874 and 1876, they chose to market themselves in a highly visible quarter filled with new shops, apartments, and other architectural evidence of a capitalist economy. Again, their choice of such a location was optimistic, especially so at a time when the French economy was still sufffering under the strains of Second Empire inflation combined with Franco-Prussian War reparations and Commune rebuilding debts. As Paul Tucker has shown in his recent study of Monet's contribution to the 1874 exhibition, the Impressionists were aggressively new and optimistic at a time when French self-esteem was at a low point.[7]

And the exhibition was very much a success. The critics, most of whom had done little but satirize the previous exhibitions, were by and large respectful, even if critical, of this one, and publications that included art magazines, small political newspapers, sports publications, satirical journals, and the big illustrated weeklies sent writers to the exhibition. In terms of public relations the Impressionists made a great leap forward in 1877. We learn from the critics that throughout the city there were banners advertising the exhibition, that the opening was filled with well-dressed people, and that as many as five hundred people per day visited the galleries on the rue le Peletier.[8] From this figure one can estimate a total attendance of about eight thousand people, assuming great attendance occurred only on weekends. Caillebotte's efforts had their effect, and the anti-Impressionist tirades of critics like Louis Leroy, whose two reviews appeared, as always, in the satirical journal Le Charivari, must have seemed rather pathetically predictable by the time of their third appearance in 1877.[9]

One must not gloss over the negative criticism. Indeed, some of the most often discussed and reproduced cartoons against the Impressionists were published with the 1877 exhibition. It was almost an honor to be so satirized; one was in the select company of the government, the railroad industry, the real estate tycoon, the department store, and other elements of the official and industrial worlds attacked by Cham, the greatest cartoonist of his age, who made eight cartoons about the 1877 exhibition alone.[10] In one, a pregnant woman is discouraged by the police from entering the exhibition in presumed deference, to not only the future taste, but the future health of her unborn baby. In another, an Impressionist artist is accused of painting a cadaver rather than a human being, to which he readily agrees, saying only that he has failed to capture the smell! In yet another, a battalion of Turkish soldiers, having bought a group of Impressionist paintings, takes them into battle where their antagonists flee at the sight of the paintings. Yet it is wrong to use these cartoons (and there were many more) as evidence of the general popular contempt and incomprehension of Impressionism. Using that logic, one could easily prove that the vast majority of Americans dislike Ronald Reagan from the evidence of political cartoons. In fact the cartoons, all of which appeared in the most widely read satirical journal in France, Le Charivari, are evidence of widespread public knowledge about the Impressionist movement.

The one subject that fascinates and eludes art historians is the actual appearance of the exhibition. What was hung where? What colors were on the walls? How were the paintings framed? Fortunately, Georges Rivière, a minor journalist and friend of Renoir, wrote a description of the installation in his four-part review of the exhibition in the journal L'Impressionniste. This magazine, developed as a more-or-less official exhibition rag, appeared in four issues on 6, 14, 21, and 28 April during the public run of the exhibition. After grappling in his first essay with what he considered to be the stupid reviews by such critics as "Baron Grimm," who wrote about the exhibition in the influential daily paper Le Figaro,[11] he got down to the business of describing and criticizing the exhibition itself.[12]

If Louis Leroy was, in certain ways, the major critic of the 1874 exhibition, and Edmond Duranty played the same role in 1876 from the opposite side of the ideological fence, Rivière was the dominating critical presence in 1877. Quite simply, he wrote four to five times more prose than any other critic about the exhibition, and can in many ways be considered the "house" critic of the movement in 1877. Unfortunately, Georges Rivière was not a great critic. After the cerebral analyses of Stéphane Mallarmé and Edmond Duranty, the gushy enthusiasm of Rivière is often too much to bear. At first endearing because he is so aggressively on the right side of history, Rivière rapidly annoys a careful reader. Even the description of the exhibition with which he begins his formal review is insufficient for a full reconstruction.

What do we learn about the installation from Rivière? First, there were five rooms, divided to an extent by panels that probably also served to close in the windows. The first room was hung with several paintings by Renoir, Monet, and Caillebotte. The second was focused on the large decoration by Monet and included several more paintings by Renoir as well as landscapes by Monet, Pissarro, Sisley, Guillaumin, Cordey, and Lamy; the latter two were friends of Renoir. The middle room centered on two paintings by Renoir and Pissarro and then was devoted to the work of Cézanne and Morisot. The fourth gallery was the largest and contained works by Caillebotte, Monet, Sisley, and Pissarro, and the last gallery, a small room at the back, was filled with works by Degas.

This description seems wonderfully rich, especially

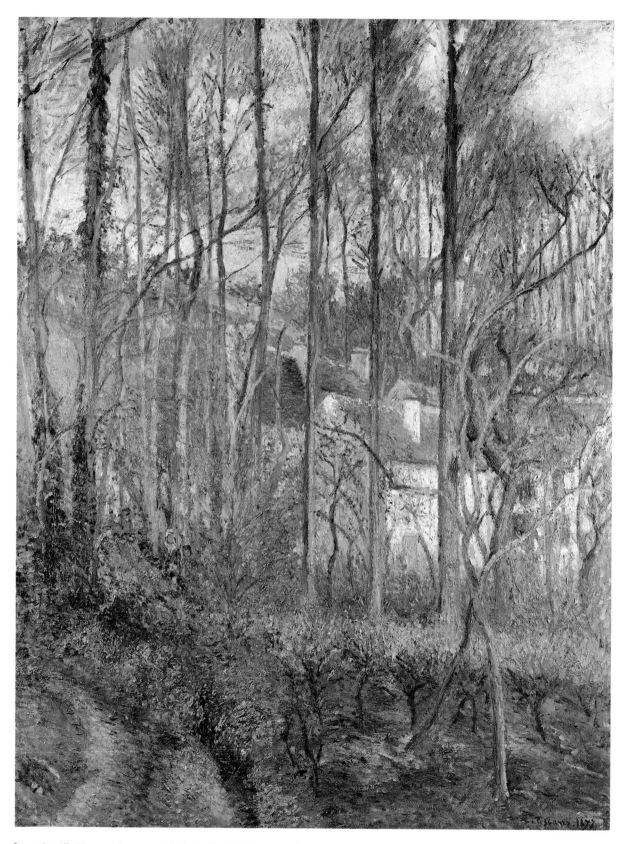

fig. 3 Camille Pissarro, *Le verger, côte Saint-Denis, à Pontoise (The Côte des Boeufs at l'Hermitage, near Pointoise*, III–164), 1877. Oil on canvas, 45¼ x 34½ in. (114.9 x 87.6 cm). The National Gallery, London

compared to our state of information about the appearance of other exhibitions. Yet in many ways it raises more questions than it answers. Where, for example, were the other minor artists? We hear only about Cordey and Lamy, but what of Piette, Rouart, Jacques-François, Maureau, or Levert? Were paintings by each artist separated in the galleries, as they had been in the 1876 installation,[13] or were they mingled? The latter at first seems likely, because so little effort was made in Rivière's description to indicate a separation of artists. Except for the small "Degas Gallery," one suspects that the paintings were not separated by artist. However, virtually every review treated each artist separately; that there is so little comparative discussion of works of art suggests that they were grouped by artist within each gallery.

The hanging committee was small, like the exhibition planning committee, and consisted of Renoir, Pissarro, Caillebotte, and Monet. Unfortunately, Manet was not enlisted to aid them again. Rivière stressed that the arrangement of pictures was "exquisite,"[14] which implies that formal or generally esthetic matters in addition to authorship were of paramount importance. This esthetic hanging might explain why paintings by Renoir, Monet, and Pissarro could be found in three galleries, while those by Caillebotte, Sisley, and Morisot were divided into two galleries. Only Degas was isolated in a gallery of small dimensions appropriate to his small oils, pastels, pastels over monotype, and monotypes.

From the evidence of Rivière's description, certain remarks in other reviews, and the works of art that have been identified thus far, the following reconstruction of the installation can be advanced. The first gallery, with

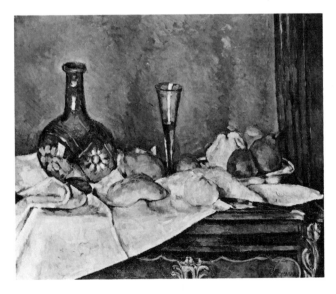

fig. 4 Paul Cézanne, *Nature morte* (*The Dessert*, III–17/19), 1877 or 1879. Oil on canvas, 23¼ x 28¾ in. (59 x 73 cm). Philadelphia Museum of Art. Mr. and Mrs. Carroll Tyson, Jr. Collection

its combination of paintings by Renoir (the dominant artist), Caillebotte, and Monet, evidently included no landscapes (Rivière carefully singled out the landscapes in other rooms), and thus was filled with figure paintings by those artists. These most likely would have been the two portraits (III–99 and 114) and possibly the *Intérieur d'appartement* (cat. no. 55) by Monet; the two small apartment interiors (III–4 and cat. no. 40) and possibly the large *Portraits à la campagne* (III–3) by Caillebotte; and the six portraits (III–187–192 and cat. no. 63) by Renoir. These sensibly could have been joined by the figure paintings produced by Cals, Jacques-François, and Rouart.

The second gallery is somewhat more difficult. Dominated by Monet's large decoration, *Les dindons* (cat. no. 53), and several paintings by Renoir, it was filled with a large number of landscapes by other artists. Rivière characterized the mood of the gallery as one of "inexpressible, almost musical gaiety,"[15] a mood in keeping with landscapes of parks, gardens, and unproblematic countrysides. One can imagine Guillaumin's various representations of *Le parc d'Issy* (III–62, 67, and 72); Monet's views of *Les Tuileries* (III–95, 105, and 119), *Le parc Monceaux* (cat. no. 50), and various private gardens; Pissarro's various paintings of blooming trees, panoramas of the countryside around Pontoise, and views of private gardens (cat. no. 58); and Renoir's paintings of gardens, flowers, and parks, one of which (III–204) was described by Rivière as a "splendid decoration, a large panel with magnificent red dahlias seen in a tangle of grass and vines."[16] Each artist would thus have contributed several paintings to this general pastoral theme, exemplified perfectly by Monet's large *Les dindons*.

The next room is quite simple to reconstruct because Rivière's description is so precise. The place of honor in this gallery was given to Renoir's *Bal du Moulin de la Galette* (fig. 1). If the 1877 exhibition had a single masterpiece, it was without doubt Renoir's *Bal*. Although not universally admired by the critics, it was omnipresent in their articles. No one could ignore it. The review by Renoir's friend Rivière, from which we have quoted so extensively, commenced with a beautiful and evocative descriptive analysis of this painting, which he called a true "history painting" and contrasted to the pathetic, medievalizing concoctions called "history painting" in the Salon.[17] Perhaps Rivière's only major omission in his discussion of Renoir's *Bal* was understandable: he failed to identify the figures in the painting, all of whom he knew and one of whom he was. And he failed as well to align Renoir's sensibilities with those of Watteau, whose *Embarcation from the Island of Cythera* in the Louvre had been similarly described by the Goncourt brothers in their famous essay on Watteau. Instead, Rivière linked Renoir to more virile—and even heroic—artists from the past, Velásquez and Hals.

Renoir's "history painting" was juxtaposed in the third gallery to what Rivière called "a large landscape by Pissarro."[18] The only logical candidate for this landscape is a painting called today *La côte des boeufs, Pontoise* (fig.3) and entitled *Le verger, côte Saint-Denis, à Pontoise* in the catalogue of the 1877 exhibition.[19] This painting and its even more brilliant companion from Caillebotte's collection (fig.7) never before have been identified as 1877 exhibition paintings because their present titles are so different from those under which they were exhibited in that year. However, there are no other paintings by Pissarro of the côte Saint-Denis from 1876–1877 or earlier, and no other was owned by Caillebotte (surely the "M.C." listed as the owner for III–163 in that exhibition catalogue). This great vertical landscape by Pissarro—with its scumbled, even tortured surface, its inaccessible jumble of vegetation, and its haunting peasant figures staring out at the viewer from the protection of the forest—is everywhere the opposite of Renoir's *Bal*. This contrast between two paintings, of a city dance in summer and a peasant landscape in winter, perhaps expressed the tensions within the Impressionist movement as clearly as one can imagine.

The remaining walls of the third gallery celebrated those tensions. One was devoted to the paintings of Paul Cézanne and the other to Berthe Morisot. More opposite sensibilities can scarcely be imagined, and it seems that each artist was given his and her own wall so that their achievements could be clearly presented in isolation. Cézanne was absolutely the dominating personality of the room, and many reviewers responded—mostly negatively—to his paintings. Although historians of art have long been able to identify Cézanne's paintings in the 1874 exhibition,[20] no attempt has yet been made to identify more than four of the sixteen works by Cézanne in the third exhibition. These are the *Tête d'homme: Etude* of Victor Chocquet (cat. no.44), *Les baigneurs: Etude, projet de tableau*, ex-Spingold collection (fig.8), the *Tigre* (Venturi 250), and the *Scène fantastique* ("The Fisherman") (Venturi 243, cat. no.42), which was not listed in the catalogue but was clearly described in Rivière's review of the exhibition as hanging over a door in the second or "pastoral" gallery.[21] In addition, John Rewald in his recent catalogue of *The Watercolors of Paul Cézanne* has suggested that the three watercolors in the 1877 exhibition were those owned by Chocquet (Rewald 8, 10, and 17), who also owned both the *Tigre* and *Paysage* ("The Fisherman").[22]

The remainder of the paintings by Cézanne in the exhibition were titled so generically (three were entitled *Nature morte*, two—*Etude de fleurs*, and four—*Paysage: Etude d'après nature*), and so few descriptions of them exist in the criticism, that precise identification has eluded all scholars. However, the clue provided by John Rewald is all that is needed to identify most of the

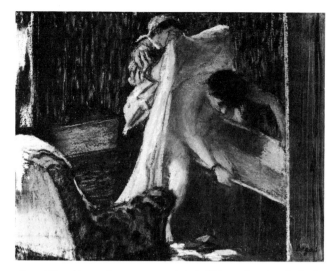

fig.5 Edgar Degas, *Femme sortant du bain* (*Woman Leaving the Bath*, III–45), ca. 1877–1879. Pastel over monotype, plate 6¼ x 8½ in. (16 x 21.5 cm). Musée d'Orsay (Galerie du Jeu de Paume), Paris. Gustave Caillebotte Bequest, 1894. Photo: Cliché des Musées Nationaux

remaining paintings. All of the remaining paintings in the exhibition except no. 28, *Figure de femme: Etude d'après nature*, which cannot be identified conclusively, were owned by Victor Chocquet, whose portrait dominated the group. Many modern accounts of the 1877 exhibition include the anecdotes first told by Duret,[23] and repeated in Rivière's book on Renoir, of Victor Chocquet's daily attendance at the 1877 exhibition.[24] Apparently the collector, having recently retired after years of service as a supervisor in the customs service, spent all his time at the exhibition, untiringly explaining the paintings to incredulous viewers, devoting much of his time to Cézanne.[25] He had already assembled the most important single collection of works by Renoir and Cézanne, purchasing most of the finished, signed paintings by the younger artist, all of which he had made accessible to the Impressionists and their exhibition.

Chocquet's collection, dispersed in a sale in 1899, was the first great Cézanne collection, and the fact that it also was exhibited in 1877 is of considerable importance to our modern understanding of Cézanne's Impressionism. Never before had Cézanne exhibited a still life in public, and the great still life currently entitled *Un dessert* in the Philadelphia Museum of Art (fig.4), together with its smaller companions (Venturi 196 and 207), show Cézanne's complete mastery of the genre. In their grave and intricate compositions, their interlocking masses and voids, their indirect but undeniable quotations from Chardin, these three small still lifes are among the most masterly of Cézanne's early years, and the fact that they were so prominently hung by a committee consisting of such diverse talents as Renoir and Pissarro is no surprise. Even Rivière, whose enthusiasms were so often without

substance, saw in these paintings a classical quality. For him Cézanne's still lifes were "so beautiful and so exact in the rapport of their tones as to be solemn and truthful."[26] And Zola, still faithful to his boyhood friend, called Cézanne "the colorist of the group" and condemned bourgeois taste for its rejection of Cézanne's mastery.[27] This mastery with color was perhaps seen most clearly in Cézanne's two floral still lifes (Venturi 181 and 182), the smaller and more brilliant of which was purchased by the great Russian collector Schoukine at the Chocquet sale and hangs now in the Pushkin Museum, Moscow, with many of the Russian collector's paintings by Gauguin and Matisse.

Of the four landscapes by Cézanne, two were painted in the vicinity of Pontoise and Auvers where the young painter worked with Pissarro (Venturi 171 and 173), and two in Provence where Cézanne painted in splendid isolation (Venturi 158 and 168). The first two, each of which is vertical, explore both sites and pictorial problems of interest to Pissarro; the larger of the two, *La côte des boeufs, Pontoise* (Venturi 173), represents exactly the same landscape in the same format as Pissarro's *Le verger, côte Saint-Denis, à Pontoise* (fig.3), the "large landscape" which hung in the same gallery. Of the southern landscapes, the one painted for Chocquet at L'Estaque in summer 1876 (*L'Estaque*, 1876, The Bernhard Foundation, New York) has become famous as an illustration to a passage in Cézanne's famous letter to Pissarro of 2 July 1876. There he talked of a landscape "like a playing card, red roofs against the blue sea."[28] The other, painted from inside the wall of his parents' house, the Jas de Bouffan (Venturi 158), is based clearly on compositional prototypes in Pissarro's oeuvre. However, Cézanne already had transcended his master in 1877, and the strength, even dominance, of his paintings led one unsuspecting critic to note the influence of Cézanne on the work of Pissarro, Sisley, and Monet.[29] While Pissarro would have admitted cheerfully the validity of this reversal of the usual master-student relationship, Monet —and probably Sisley—would have been horrified by Paul Sébillot's judgment. Strangely enough, there is more than a grain of truth in his assertion. Certainly, Cézanne's Impressionism is in serious need of reexamination.

The one painting by Cézanne that was most commented about was no. 26 in the catalogue, *Les baigneurs: Etude, projet de tableau*. While most critics found it laughable, others were moved by it, particularly Rivière. Number 26 generally has been identified as the large version of the composition once owned by Caillebotte that now is in the Barnes Foundation. Both the subtitle (*Projet de tableau*) and the fact that the Barnes Foundation picture was not owned by Chocquet, who owned the majority of the works by Cézanne in the third exhibition, suggest that no. 26, now called *Baigneurs en repos* (fig.8), is more likely the much smaller study for the

Barnes painting. This painting is without doubt a *Projet de tableau*, and the only reason to accept the Barnes painting as the correct candidate for no. 26 is that a drawing by Degas made from the central figure at the time of the exhibition is closer in detail to the Barnes picture. However, there are enough discrepancies between the Degas drawing and either of the other versions that it cannot be used itself as proof that one or the other was exhibited. If one follows the catalogue as well as some of the violently negative critical comments about the painting, the Spingold version is still the most likely candidate.

If the works by Cézanne seemed esthetically connected to the example by Pissarro in the same gallery, one could argue that Morisot's paintings corresponded to Renoir's *Bal du Moulin de la Galette*. In spite of all Morisot's canvases being of small dimension, like Cézanne's, their dedication to the clothed human form, particularly the woman, links them undeniably to Renoir. Most writing about Morisot stresses instead her relationship—pictorial and familial—with her brother-in-law and devoted friend, Edouard Manet. Yet her paintings are everywhere softer and more diaphanous in facture than his. In many ways the comparison with Renoir, suggested by the juxtaposition of the *Bal* with Morisot's smaller canvases, is fairer, and the hanging committeee recognized that fact.

The fourth gallery in the exhibition was also the largest, and in it undoubtedly were the two immense paintings of the place de l'Europe and its environs by Caillebotte and the series of paintings of the adjacent Gare Saint-Lazare by Monet. There was also ample room for many, many landscapes by Pissarro, Sisley, Guillaumin, and the assorted minor landscape painters. If one assigns paintings to this gallery by process of elimination, one finds a startling variety of subjects. Indeed, the gallery, even granted its size, was probably crammed with paintings, and the effect it might have conveyed was probably the opposite of that induced in the viewer by the second gallery of pastoral landscapes. In the large gallery, all was alive with movement. Boats sailed and trains steamed. Urban streets were filled with promenaders whose movement was unhampered by rain and inclement weather. Fields were harvested, clouds rushed through the sky, and wind skipped across the choppy waters of the Seine. If the pastoral paintings in the second gallery made landscapes of private gardens and private gardens of landscapes, the paintings in the large gallery were quintessentially public and, to a large extent, urban.

Here was the center of the Impressionist landscape, the Gare Saint-Lazare. Manet, as always, had been the first to essay this subject, but his followers were far from timid, and Caillebotte staked his reputation on his paintings of this new Paris. Virtually every critic noticed Caillebotte's two great paintings, and, by a happy coincidence of accident and plan, *Rue de Paris: Temps de pluie* and *Le pont de l'Europe* (cat. no.39) were nos. 1 and 2 of

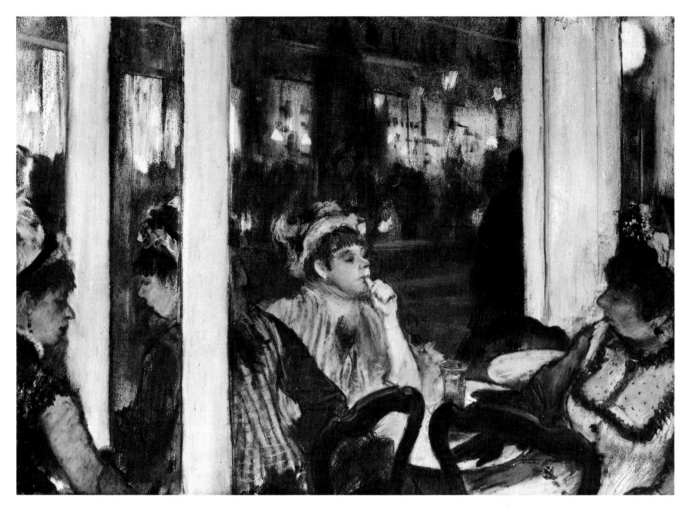

fig. 6 Edgar Degas, *Femmes devant un cafe, le soir* (*Women in Front of a Café, Evening*, III–37), 1877. Pastel over monotype, 16⅛ x 23⅝ in. (41 x 60 cm). Musée d'Orsay (Galerie du Jeu de Paume), Paris. Gustave Caillebotte Bequest, 1894. Photo: Cliché des Musées Nationaux

the 1877 catalogue. How magisterial they must have been in this large gallery, undoubtedly filling the centers of the two longest walls and thus anchoring the room. In fact, the largest paintings by Monet, Renoir, Pissarro, and Caillebotte played the key organizing roles throughout the installation. Surely it was no coincidence that these four artists were all members of a hanging committee of four. Again, as at Caillebotte's dinner party, the group dynamics were carefully controlled. Everywhere there was balance that resulted, inevitably, from compromise.

The question invariably raised today about Caillebotte's massive easel pictures of 1876–1877 is the extent to which they really are Impressionist. Their smoothly finished surfaces, immense scale, and completely logical perspectival construction separate them radically from the majority of the paintings with which they were hung in 1877. This disparity was not lost on the critics, the vast majority of whom admired Caillebotte's paintings. There were the inevitable criticisms: the asymmetry of his compositions, the fact that the main figures of *Rue de Paris* were cut by the edge of the picture so awkwardly, the yawning voids of Caillebotte's streets, and the fact that their scale was too "epic" for their subjects. Also, several reviewers of the official Salon exhibition included remarks about Caillebotte's paintings in the context of their Salon reviews. Already by 1877 the distinctions between "official" and "Impressionist" art were to a certain extent blurred. One review of the Salon exhibition was entitled "Impressionnisme au Salon," and many reviewers of the Impressionist exhibition made comparisons with the Salon. Caillebotte's heroically scaled and superbly finished paintings raise today, as they raised in the 1870s, the issue of the definition of Impressionism.

It is easy for us to label as Impressionist Monet's paintings of the Gare Saint-Lazare, which hung in the same

room as Caillebotte's masterpieces. Monet exhibited seven versions of this subject on which he had worked in 1876, which continued to interest him throughout 1877 and 1878. In many ways the paintings of the Gare Saint-Lazare were the first series in Monet's career, preceding by nearly fifteen years his exhibition of the haystack series in 1891. Although we do not know whether the paintings were hung together, and one presumes they were not, it is likely that they were all in the same room, several critics even using the word "series" to describe them. And, although they represented the same *quartier* of Paris as Caillebotte's paintings, they were everywhere the opposite.

Caillebotte's paintings were smoothly finished; Monet's were aggressively rough. Certain of Monet's canvases, particularly the great views of the interior of the station in the Musée d'Orsay and the Fogg (*fig.2*), are so thickly scumbled and so lacking in contour drawing that they offended many critics. More admired by critics was the rapidly executed *Arrivée du train de Normandie, Gare Saint-Lazare* (cat. no.51), a painting much more easily legible to a nineteenth-century viewer of oil sketches. Yet even this, arguably the most conservative in Monet's series, was absolutely different from the paintings by Caillebotte. In his choice of both technique and subject, Monet was interested in the immediacy of experience and in creating a "field of vision" in which forms dissolved in atmosphere. His selection of a visual world filled with smoke and steam was a natural one, and, as many have noticed, it was less the machines that interested Monet than the interaction of the steam with the light shining through the great glass roof of the train shed at the Gare Saint-Lazare. In many ways, Monet's paintings would have hung better next to Pissarro's superb *Côte Saint-Denis à Pontoise* (*fig.7*), with which they contrasted completely in subject, than next to Caillebotte's vast *Le pont de l'Europe*.

It is clear from many of the reviews of the Impressionist Exhibition of 1877 that the remainder of the paintings in the large gallery tended to crowd into the background of the mind. Caillebotte's paintings were remembered because of their size and skillful surfaces and Monet's paintings of the Gare Saint-Lazare because they were exhibited in series. The others—by Sisley, Pissarro, Guillaumin, and the minor artists—were both too numerous and too diverse to recall. As a consequence, many of the reviews of the exhibition discussed "the landscapists" as a single, unified group without any mention of specific paintings. Again this suggests that the gallery was not hung with all the paintings by one artist together, but grouped in a more or less esthetic manner around the central points of Caillebotte's large canvases.

It was perhaps in this central gallery that the viewer of the 1877 exhibition first encountered the white frames for which the Impressionists were to become famous. We know from several sources that Pissarro and Degas at least used white frames instead of the traditional gilded decorative frame on certain of their submissions to the 1877 exhibition.[30] Interestingly, however, only "Jacques" among the critics mentioned these frames, suggesting that, radical as they might have seemed, they were less shocking or noteworthy than the paintings they surrounded.

The last gallery of the exhibition was, by all accounts, very small and devoted to Degas. Although several drawings and watercolors by Morisot were included, all of Degas's entries seem to have been confined to that room, making it easier for viewers and critics to judge his art clearly. Degas was presented, quite simply, as Degas. He was not a "landscapist" or a figure painter or a follower or a teacher of anyone, and his works in the 1877 exhibition were almost universally admired. Perhaps only Renoir was the recipient of so much praise, but, unlike Renoir, who was also criticized on several occasions, Degas, with Morisot, appealed to many of the most hardened and conservative of critics. This is difficult for us to realize today because of the clear vulgarity of his subjects. Fat women getting in and out of bathtubs (*fig.5*) vied with prostitutes making obscene gestures in public (*fig.6*), and popular singers performed their titillating ditties to admiring audiences (111–43). Yet these mundane subjects were tempered by Degas's inclusion of a particularly beautiful and esthetically conservative portrait of a woman painted a decade earlier (cat. no.48), as well as several superb paintings, pastels, and pastels over monotype of ballet dancers.

Among these small paintings, pastels, and prints devoted almost exclusively to the nightlife of Paris, Degas placed two outdoor scenes devoted to two contrasting relationships between man and nature, *Bains de mer: Petite fille peignée par sa bonne* (*fig.9*) and *Petites filles du pays se baignant dans la mer à la nuit tombante* (also in second exhibition; cat. no.27). In the first and more famous of these, he explored a subject for which Monet, Boudin, and even Manet were better known, and this work has often been compared with their images. However, Degas had already included *Petites filles du pays* in the 1876 Impressionist catalogue, but here, juxtaposed against the *Bains de mer*, it acquired a new meaning. The naive or naturally liberated nudity of the country girls, whose agile bodies fill the picture surface of the oil painting, is in stark contrast to the confined, protected situation in which the city girl is placed in the large gouache, *Bains de mer*. The little bourgeois girl is shown lying fully clothed on the beach, safely away from the pictorial surface (and, hence, out of reach of the viewer) as her hair is combed by an adoring servant. Degas explored matters of class status and behavior with his customary clarity, paying absolute attention to clothing, posture, and gesture as they revealed class differences.

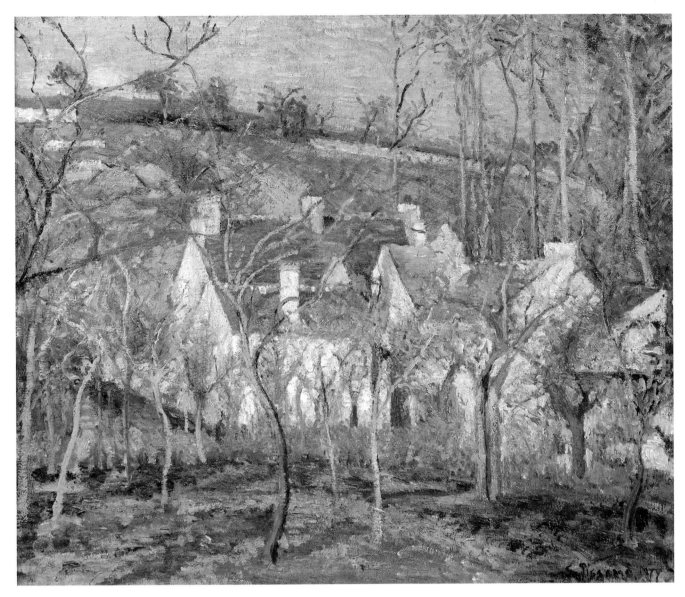

fig. 7 Camille Pissarro, *Côte Saint-Denis à Pontoise (Red Roofs*, III–163), 1877. Oil on canvas, 21 ½ x 25⅞ in. (54.5 x 65.6 cm). Musée d'Orsay (Galerie du Jeu de Paume), Paris. Gustave Caillebotte Bequest, 1894. Photo: Cliché des Musées Nationaux

Technically, the most novel works in the entire exhibition were the monotypes by Degas hung several to a frame in the last gallery. Interestingly, many of the pastels also in the exhibition were drawn over a monotype base, but, for the first time in 1877, Degas exhibited simple monotypes. Unfortunately, not a single critic mentioned these works individually, and therefore we are unable to identify them from the many surviving monotypes. However, that there were three framed groups of these monotypes, and that Degas clearly had already made monotypes of bathers, dancers, and café singers suggests that many of his monotypes currently dated as late as 1880 were probably made by April 1877. As many

Degas scholars have pointed out, the artist tended to work obsessively and rapidly in one or another mode or medium, and because he may have exhibited ten to fifteen monotypes with and without pastel in 1877 suggests that he selected these works from a much larger group.

The works included in *The New Painting* from the 1877 exhibition give an idea of their quality and variety. Yet it is difficult to identify many of the paintings, by Sisley for example, in the exhibition. In Sisley's case many of his titles have changed dramatically, and there has not been a careful study of the paintings since François Daulte's catalogue raisonné.[31] The same situation holds true for Guillaumin, whose work after 1880 is well

documented, but whose earliest and best painting has never been put into a clear order. In fact, the many paintings produced by Guillaumin in the region just southwest of Paris around Issy and Clamart that were exhibited in 1877 have never been studied; many of the precise titles recorded in the Impressionist exhibition catalogue have never been assigned to surviving paintings, which usually have generic titles. This task would produce a body of data that, although not of staggering art historical importance, would help very much in the proper identification of many of Cézanne's early works. (Cézanne worked as much in 1876–1877 with Guillaumin as he did with Pissarro, and the two painters shared a studio on the Ile Saint-Louis in 1876.)

Our modern understanding of Impressionism will benefit enormously from a complex analysis of the exhibition of 1877; a great many works never previously thought to have been exhibited there now have been identified with the help of a careful reading of both the contemporary criticism and the recent literature on landscape iconography. What remains to be done is to assess the interplay among the eight exhibitions and to measure the effect they had on the future work of each artist. This latter task can be accomplished only with a thorough study of the original objects, because it is clear that the Impressionists learned many technical lessons from each other, most of which have fascinating intellectual ramifications, but none of which can be measured from photographs.

There is, however, one central subject that can be dealt with at this point—a general analysis of the criticism. Researchers have isolated approximately fifty individual reviews of the exhibition produced during its one-month

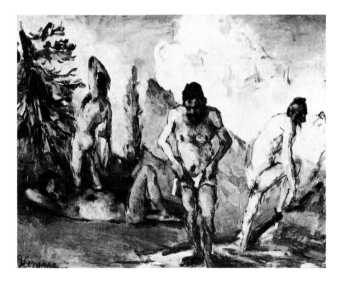

fig. 8 Paul Cézanne, *Les baigneurs: Etude, projet de tableau* (*Bathers at Rest*, III–26), ca. 1876–1878. Oil on canvas, 13¾ x 18 in. (35 x 45.7 cm). Ex–Spingold Collection, New York

run in April 1877. The most important of these have been read many times by earlier historians of Impressionism, and most of them have been familiar to John Rewald, the dean of Impressionist scholars, for more than a generation. However, several general points now can be made. First, although a minority of the reviews were completely favorable, the majority of them were fair and balanced. This seems especially true given the knowledge and taste of the critics, most of whom did not know the artists. Second, the figure painters were much more admired than the landscapists. The landscapists suffered, in some cases severely, because their works were not only hard to "read" as paintings, but were difficult to isolate for discussion. Third, the individual artists in the group were recognized clearly by the press and treated, for the most part, as individuals in their reviews. This was in clear distinction to criticism of the official Salon, in which works tended to be grouped by subject or stylistic tendency rather than by artist. Yet, if the artists were treated individually and judged in terms of their separate achievements, they were also assumed to be part of a coherent and real group, whether it was called Impressionist, Independent, or Intransigent. The entire issue of the name, discussed so brilliantly by Stephen Eisenman, is beyond the scope of this essay.[32] However, it must be said here that there was considerable discussion about both the meaning and the appropriateness of the word *Impressionist* in the critical reviews of the exhibition.

It is clear from any study of the formation of the eight Impressionist exhibitions that the artists did not agree very much on very many issues. In certain years the exhibition would be dominated by one artist and his followers, while in others two or three factions would become apparent. From this observation—and from a great deal of what has already been noted about the group—the idea emerges that the members of the group were strong individualists whose association was one of "Independent" artists. Yet, as the failure in 1877 of Meyer's alternative association, Union, made clear, there was more than a desire for "independence" that linked the artists who came, grudgingly, to call themselves "Impressionists." In spite of their differences in politics, social class, technique, and imagery, the "Impressionists" of 1877 had strong esthetic links, and this fact can be proven again by the criticism.

Over and over, the reviews of the 1877 exhibition began with a general characterization of the movement and its aims. Whether the critic hated the painters or was in profound sympathy with their aims, he tended to understand just what the movement was about. What linked the Impressionists in the mind of the contemporary press was what we would call today their Naturalism. Although very few reviewers sought any direct connections with contemporary Naturalist literature, the painters were characterized as artists interested in the

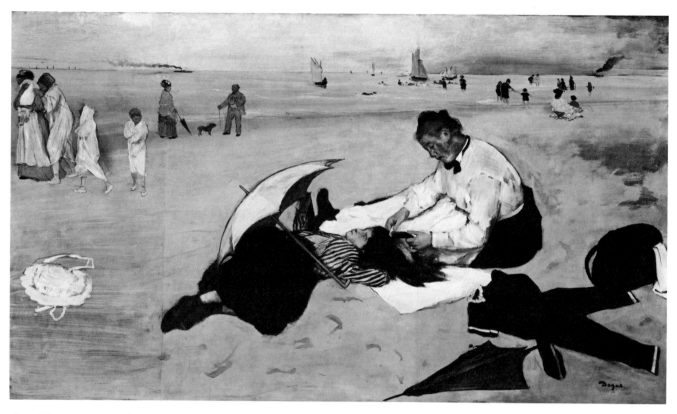

fig. 9 Edgar Degas, *Bains de mer: Petite fille peignée par sa bonne*
(*Beach Scene*, III–50), ca. 1877. Paper mounted on canvas, 18½ x
32½ in. (47 x 82.6 cm). The National Gallery, London

direct, unfettered representation of reality. The phrase
that was most commonly used in the reviews is the fol-
lowing: "The artists seek as a group to fix the general
aspect of things and beings apart from their conventional
character."[33] It is obvious that the ramifications of these
ideas–of the general rather than the literal character of
Impressionist paintings and of their unconventional
modes of representation–have been discussed many
times in the extensive literature on the meaning of
Impressionism. What is perhaps less well known is that
these broadly conceptual and esthetic issues were as
important to contemporary viewers, most of whom were
unsure of the future importance of the Impressionist
movement, as they are to us today.

Another general message the modern reader receives
from the contemporary critics is that Impressionism had
a very strong political dimension. Many writers, espe-
cially those concerned with the "Intransigent" status of
the artists,[34] that is, with the artists as rebels, talked
about painting as if it were, in a sense, subversive. We
have come to understand today that many of the most
important Impressionist painters were horrified by this
accusation of social radicalism and that many of them
chose to market themselves as Impressionists rather than
Intransigents or Independent painters so as to fight

against any radical political reading of their movement.
Yet, in our eagerness to study the political basis of
Impressionism, we must be careful not to rely too heavily
on the critics and their superficial accusations. Indeed, I
can think of no single discussion of an individual work of
art in all the reviews of the 1877 exhibition in which that
work is called subversive or political. Rather, it was the
rebel status of the artists, trying, as they were, to find a
secure niche for themselves outside the governmental
structures, that was subversive.

There is another theme that emerges from a reading of
the criticism in 1877, and this one, too, links the contem-
porary view of Impressionism with our modern idea of
the movement. For many critics–again from various
ideological positions–Impressionism was an art
obsessed with technique and theory. Rivière put it the
most bluntly in the topic sentence of a paragraph about
Renoir. "To treat a subject for the colors [*tons*] and *not
for the subject itself* [author's emphasis], that is what dis-
tinguishes the Impressionist from other painters."[35] Here
we have a sentence that, at its most basic level, antici-
pates Maurice Denis's famous statement about the artifi-
ciality, the essential flatness of painting. And, even by
critics less willing to concede so revolutionary a point,
the Impressionists were accused again and again of

adhering absolutely to certain theories of color and line. As if to predict Huysmans's now famous review of the Impressionist Exhibition of 1880,[36] many critics in 1877 accused the Impressionists of seeing incorrectly. "Blue again!" exclaimed the inimitable Louis Leroy on entering yet another gallery in 1877, the idea being that one was unable to see the subjects for the color.[37] This idea, expressed negatively on most occasions, nevertheless reveals the formal novelty of the Impressionist palette and method of dividing tone.

And Leroy was scarcely alone. In fact, a great many of the negative comments about the paintings in the 1877 exhibition never mention the particular painting, but characterize their technique. "On entering a gallery on the rue le Peletier," wrote Paul Sébillot, "the eye is immediately surprised and even scandalized by the violent, palpitating colors and also by the manner of execution for which these painters are known."[38] And the list of the many faults of the Impressionists in Bertall's lengthy review contains not one mention of their subjects, but instead of their "crude colors and tones, lack of modeling and contour," etc.[39] To read the reviews at a sitting, one would almost think that they were reviews of the 1905 exhibition at the Salon d'Automne at which the Fauves were first exhibited!

Caillebotte's exhibition, the third group exhibition, was in most senses a glorious, but short-lived success. In May 1877 a conservative backlash shook the government, and the French economy succumbed to depression in 1878. The sale of pictures, many of which came from the exhibition held by the group in late May at 6 rue le Peletier, was a comparative failure, and the general economic ill-wind of 1877–1878 blew strongly in the direction of the Impressionists. Never particularly strong, their optimism weakened, and the sense of group solidarity, so carefully fostered by Caillebotte in the months preceding the 1877 exhibition, gave way to bickering. After the exhibition, the group split apart again, each artist going his own way. The Independent artists of 1874, who had become rebel Intransigents in 1876 and Impressionists early in 1877, became Independent artists again by summer 1877. Another round of negotiations was necessary before the next exhibition was possible, and, of the seven artists at Caillebotte's dinner party, only five exhibited in the Fourth Exhibition of 1879.

Notes

All translations are the author's unless otherwise indicated.

1. Marie Berhaut, *Caillebotte, sa vie et son oeuvre* (Paris, 1978), 243.
2. Stephen F. Eisenman, "The Intransigent Artist," in this catalogue.
3. Emile Zola. See Third Exhibition review list in Appendix for complete citation for this and all other reviews.
4. In fact, Caillebotte himself was working on a particular painting of the Gare Saint-Lazare, now in the Kimball Museum, that owed a particularly strong debt to Manet's masterpiece. Unfortunately, he never finished the painting, which was clearly intended as part of the series for the 1877 exhibition.
5. Berhaut, 243.
6. Jules Robert review.
7. Paul Tucker, "The First Impressionist Exhibition and Monet's *Impression, Sunrise*: A Tale of Timing, Commerce, and Patriotism," *Art History* 7, no. 4 (December 1984): 465–476.
8. Refer to review list.
9. Louis Leroy reviews.
10. Cham reviews of 16, 26, and 28 April 1877, respectively.
11. Baron Grimm review.
12. Georges Rivière, "A.M. le rédacteur" review, 1–2.
13. Hollis Clayson, "A Failed Attempt," in this catalogue.
14. Rivière, "L'exposition," 6 April 1877 review, 2–6.
15. Rivière, "L'exposition," 6 April 1877 review, 2.
16. Rivière, "L'exposition," 6 April 1877 review, 4.
17. Rivière, "L'exposition," 6 April 1877 review, 3.
18. Rivière, "L'exposition," 6 April 1877 review, 2.
19. The côte Saint-Denis and côte des Boeufs are names for the same hillside, and the painting was given its present title by Pissarro when it was next exhibited in 1892 at Durand-Ruel's gallery.
20. Paul Tucker, "The First Impressionist Exhibition," in this catalogue.
21. Rivière, "L'exposition," 14 April 1877 review, 2.
22. John Rewald, *Paul Cézanne: The Watercolors* (Boston, 1983).
23. Théodore Duret, "Introduction," in *Vente Chocquet* (Paris, 1–4 July 1899).
24. Rivière, *Renoir et ses amis* (Paris, 1921).
25. John Rewald, *The History of Impressionism*, 4th rev. ed. (New York, 1973). It is possible that Chocquet purchased the paintings at the exhibition rather than loaned them from his collection.
26. Rivière, "L'exposition," 14 April 1877 review, 2.
27. Zola review.
28. Rewald, *Impressionism*, 374.
29. Paul Sébillot review.
30. Georges Lecomte, "Camille Pissarro," *Les hommes d'aujourd'hui* [pamphlet] (Paris, 1890), 3, and Jacques, *L'Homme Libre*, 12 April 1877 review.
31. François Daulte, *Alfred Sisley: Catalogue raisonné de l'oeuvre peint* (Lausanne, 1959).
32. Eisenman, "The Intransigent Artist."
33. Philippe Burty review.
34. Eisenman, "The Intransigent Artist."
35. Rivière, "L'exposition," 6 April 1877 review, 4.
36. Joris-Karl Huysmans, "L'exposition des indépendants en 1880," *L'art moderne* (Paris, 1883).
37. Louis Leroy reviews.
38. Paul Sébillot review.
39. Bertall review.

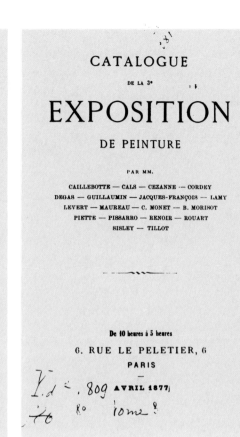

1. Berhaut 52, The Art
 Institute of Chicago
2. Berhaut 44, Petit Palais,
 Geneva
3. Berhaut 31, Musée Baron
 Gérard, Bayeux
4. Berhaut 53, private
 collection, Paris
5. Berhaut 54, Simone and
 Alan Hartman, New York
6. Berhaut 48, private
 collection, Paris

8. Perhaps John G. Johnson
 Collection, at the
 Philadelphia Museum
 of Art
13. The Dixon Gallery and
 Gardens, Memphis

17–19. Venturi 196; 197,
 Philadelphia Museum of
 Art; and 207, per Rewald
 1969 and Brettell
20–21. Venturi 179; 180;
 181; 182, Pushkin
 Museum, Moscow; or
 222, National Gallery of
 Art, Washington, per
 Rewald 1969; 181 and
 182, per Brettell
22–25. Venturi 158; 168;
 private collection,
 Switzerland; 171; or 464,
 per Rewald 1969; 158,
 168, 171, and 173 per
 Brettell

26. Previously thought to be
 Venturi 276, Barnes
 Foundation, Merion;
 Venturi 273, per Brettell
27. Venturi 250, Wildenstein,
 New York
29. Venturi 283, private
 collection, New York
30. Rewald 8, per Brettell
31. Rewald 10, per Brettell
32. Rewald 17, per Brettell
h.c. Venturi 243, *Scène
 fantastique*, private
 collection, New York

37. Lemoisne 419, Musée
 d'Orsay
38. Lemoisne 398, Corcoran
 Gallery of Art,
 Washington, D.C.
39. Perhaps Lemoisne 513,
 The Art Institute of
 Chicago, per Brettell
40. Perhaps Lemoisne 418,
 Musée d'Orsay
41. Lemoisne 421; previously
 thought to be 408,
 Metropolitan Museum of
 Art
43. Lemoisne 404, Corcoran
 Gallery of Art

44. Perhaps Lemoisne 405,
 Musée de Lyon
45. Lemoisne 422, Musée
 d'Orsay
46. Perhaps Lemoisne 423,
 Norton Simon Museum,
 Pasadena
47. Lemoisne 420, Musée
 d'Orsay
49. Lemoisne 373, Carnegie
 Institute, Museum of Art,
 Pittsburgh
50. Lemoisne 406, National
 Gallery, London
51. Lemoisne 377, private
 collection, Northern
 Ireland
53–54. Lemoisne 163, Musée
 d'Orsay
58–60. Lemoisne 547
61. Lemoisne 400,
 Metropolitan Museum
 of Art

h.c. *L'Absinthe*, Lemoisne
 393, Musée d'Orsay

63. Perhaps Serret and Fabiani
 32, City Museums and Art
 Gallery, Birmingham,
 England
64. Perhaps Serret and Fabiani
 34, The Art Institute of
 Chicago; no, per Brettell
71. Serrett and Fabiani 51,
 Musée d'Orsay

— 4 —

11 — Femmes effilant de l'étoupe.
12 — Le Coin du feu.
13 — La mère Doudoux.
14 — Femme couchée; Étude.
15 — Paysage; Soleil levant.
16 — Jeune femme; le matin.

———

CÉZANNE (Paul)
67, rue de l'Ouest.

17 — Nature morte.
18 — Id.
19 — Id.
20 — Étude de fleurs.
21 — Id.
22 — Paysage; Étude d'après nature.
23 — Id. Id.
24 — Id. Id.
25 — Id. Id.
26 — Les baigneurs; Étude, projet de tableau.
27 — Tigre.
28 — Figure de femme; Étude d'après nature.
29 — Tête d'homme; Étude.
30 — Aquarelle; Impression d'après nature.
31 — Id. Id.
32 — Aquarelle; Fleurs.

———

— 5 —

CORDEY (Frédéric)
14, rue Le Chapelais.

33 — Rue, à Montmartre.
34 — Le pont des Saints-Pères.
35 — Le Séchoir (Chantilly).
36 — Pêcheur (esquisse).

———

DEGAS (Edgar)
4, rue Frochot.

37 — Femmes devant un café, le soir; appartient à
 M. C...
38 — École de danse, appartient à M. H. H...
39 — Ballet.
40 — Danseuse, un bouquet à la main.
41 — Danseuses à la barre.
42 — Chanteuse de café-concert.
43 — Café-concert, appartient à M. Ch. H...
44 — Id. appartient à M. V...
45 — Femme sortant du bain, appartient à M. C...
46 — Femme prenant son *tub* le soir.
47 — Choristes, appartient à M. C...
48 — Classe de danse.
49 — Portrait de monsieur H. R...

— 6 —

50 — Bains de mer; Petite fille peignée par sa bonne,
 appartient à M. H. R...
51 — Petites filles du pays se baignant dans la mer à
 la nuit tombante.
52 — Coulisses de théâtre.
53 — Portrait.
54 — Id.
55 — Billard.
56 — Cabinet de toilette.
57 — Ballet.
58 — Dessins faits à l'encre grasse et imprimés.
59 — Id. Id.
60 — Id. Id.
61 — Répétition de ballet.

———

GUILLAUMIN (Armand)
13, quai d'Anjou.

62 — Le parc d'Issy en automne.
63 — Route de Clamart à Issy.
64 — Viaduc de Fleury.
65 — Rue de Saint-Cloud, à Clamart.
66 — Lavoir, à Billancourt.
67 — Le parc d'Issy.
68 — Le coteau de Meudon.
69 — Le Val Fleury.

———

— 7 —

70 — Rue de Trosy, à Clamart.
71 — Femme couchée.
72 — Le parc d'Issy.
73 — Rue, à Clamart.

———

JACQUES-FRANÇOIS

74 — Portrait de madame B...
75 — A Vêpres.

———

LAMY (Franc)
Chez M. Legrand, 22 bis, rue] Laffitte.]

76 — Une rue, à Évreux.
77 — Une place, à Évreux.
78 — Coucher de soleil à Montmartre.
79 — Plein soleil à Montmartre.

———

LEVERT (Jean-Baptiste-Léopold)
53, rue Dalayrac, à Fontenay-sous-Bois.

80 — Paysage du Limousin.

81 — Étude à Malesherbes.
82 — Route sur le plateau de Fontenay.
83 — Sablonnière, forêt de Fontainebleau.
84 — Étude de forêt.
85 — Moulin de Touviaux.

MAUREAU (Alphonse)
8, rue Couston.

86 — La place Pigalle.
87 — Bords de la Seine.
88 — Bords de la Seine.
89 — Animaux.

MONET (Claude)
à Argenteuil.

90 — La Prairie, appartient à M. H...
91 — La mare à Montgeron, appartient à M. H...
92 — Paysage d'automne, Id.
93 — Les Dalhias (Montgeron), Id.
94 — Dans la prairie, appartient à M. Duret.
95 — Les Tuileries, appartient à M. de Bellio.
96 — Paysage : le parc Monceaux. Id.

97 — Arrivée du train de Normandie, gare St-Lazare, appartient à M. H...
98 — Le pont de Rome (gare St-Lazare), appartient à M. de Bellio.
99 — Portrait d'enfant, appartient à M. H...
100 — La gare St-Lazare, arrivée d'un train, appartient à M. H...
101 — Les Dindons (décoration non terminée), appartient à M. H...
102 — Vue intérieure de la gare St-Lazare.
103 — La maison du passeur à Argenteuil, appartient à M. Manet.
104 — Marine (Argenteuil), appartient à M. Manet.
105 — Les Tuileries ; Esquisse.
106 — Corbeille de fleurs, appartient à M. Charpentier.
107 — La plaine de Gennevilliers.
108 — Effet d'automne à Montgeron, appartient à M. H...
109 — Le Châlet, appartient à M. H...
110 — Marine (Ste-Adresse), appartient à M. Duret.
111 — Le grand quai au Hâvre (Esquisse), appartient à M. Fromenthal.
112 — Un Jardin, appartient à M. H...
113 — Un Jardin.
114 — Portrait.
115 — Intérieur d'appartement, appartient à M. G. C.
116 — Intérieur de la gare St-Lazare, à Paris.
117 — Id. Id. Id.

118 — Intérieur de la gare Saint-Lazare, à Paris.
119 — Le Jardin des Tuileries.

MORISOT (Berthe)

120 — Tête de jeune fille.
121 — La Psyché.
122 — La Terrasse.
123 — Jeune femme à sa toilette.
124 — L'Amazone.
125 — Pastel.
126 — Vue de la Tamise (Pastel).
127 — Aquarelle.
128 — Id.
129 — Id.
130 — Dessin.
131 — Id.

PIETTE (Ludovic)
Rue Véron.

132 — Le marché de la place de l'Hôtel-de-Ville, à Pontoise.
133 — Marché de Pontoise, place du Grand-Martroy.

134 — Marché de Pontoise, place du Grand-Martroy.
135 — Marché aux porcs à Lassay (Effet de neige).
136 — Cour de l'hôtel de Cluny, à Paris.
137 — Marché aux volailles, au Mans.
138 — Marché aux légumes, à Pontoise.
139 — Fin de marché, à Lassay.
140 — L'arrivée au marché (Effet de neige).
141 — Fête de l'hermitage, à Pontoise.
142 — Vieilles halles, à Lassay.
143 — Fleurs.
144 — Fleurs.
145 — Marché aux vaches, place des Jacobins, au Mans.
146 — Prairie ; Crépuscule (Aquarelle).
147 — Rue, à Lassay ; Neige fondante Id.
148 — Fête des Fossés, à Pontoise Id.
149 — Cirque forain Id.
150 — Marché aux porcs, à Lassay Id.
151 — Vue de Cluny, à Paris Id.
152 — Vue de Pontoise Id.
153 — Jardin de la Ville, au Mans Id.
154 — Fête de l'hermitage à Pontoise. (Aquarelle).
155 — Fenaison. Id.
156 — Jardin. Id.
157 — Bois en automne. Id.
158 — Chute des feuilles. Id.
159 — Givre. Id.
160 — Battage du grain à la mécanique. Id.

87–88. Perhaps Galleria d'Arte Moderna, Florence

h.c. Wildenstein 448, Niedersächsische Landesgalerie, Hanover

91. Perhaps Wildenstein 419
92. Wildenstein 432
93. Wildenstein 417, private collection, Chicago
94. Wildenstein 405
95. Wildenstein 401, Musée Marmottan
96. Wildenstein 398, Metropolitan Museum of Art
97. Wildenstein 440, The Art Institute of Chicago
98. Wildenstein 442, Musée Marmottan
99. Wildenstein 434
100. Wildenstein 439, Fogg Art Museum, Cambridge
101. Wildenstein 416, Musée d'Orsay
102, 116–118. Wildenstein 438, Musée d'Orsay
103. Perhaps Wildenstein 329, destroyed
104. Perhaps Wildenstein 327
105. Wildenstein 403, Musée d'Orsay
107. Wildenstein 437, Acquavella Galleries, New York
108. Perhaps Wildenstein 431
110. Perhaps Wildenstein 94
111. Wildenstein 295
114. Wildenstein 436
115. Wildenstein 365, Musée d'Orsay
119. Wildenstein 402

120. Bataille and Wildenstein 67, Mr. and Mrs. Alexander Lewyt, New York
121. Bataille and Wildenstein 64, Thyssen-Bornemisza Collection, Lugano
122. Bataille and Wildenstein 37
123. Bataille and Wildenstein 63
125. Bataille and Wildenstein 434
126. Bataille and Wildenstein 431

132. Perhaps Musées de Pontoise
133–134. Perhaps Musées de Pontoise
153. Perhaps Christie's London, 4 December 1979, no. 209

163. Perhaps Pissarro and Venturi 384, Musée d'Orsay, per Brettell

164. Perhaps Pissarro and Venturi 380, National Gallery, London, per Brettell

165. Pissarro and Venturi 371, private collection, Paris

166. Pissarro and Venturi 349, Nelson-Atkins Museum of Art, Kansas City

167. Pissarro and Venturi 394 or 396, per Brettell

168. Perhaps Pissarro and Venturi 310, Kunstmuseum, Basel

169. Pissarro and Venturi 342 or 345, per Brettell

170. Pissarro and Venturi 344

171. Pissarro and Venturi 409, Rijksmuseum Kröller-Müller, Otterlo

175. Pissarro and Venturi 383, per Brettell

179. Perhaps Pissarro and Venturi 350, private collection, Paris, per Brettell

180. Pissarro and Venturi 364, Musée d'Orsay

181. Perhaps Pissarro and Venturi 282, private collection, Paris, per Brettell

185. Daulte 202, Musée d'Orsay

186. Daulte 209, Musée d'Orsay

187. Daulte 226, Musée d'Orsay

188. Daulte 178, private collection, New York

189. Daulte 163, Musée d'Orsay

190. Daulte 117, The Art Institute of Chicago

191. Daulte 229, Pushkin Museum, Moscow

192. Daulte 71, Mr. and Mrs. Charles Wohlstetter, New York

195. Musée d'Orsay

211. Perhaps Daulte 208, Metropolitan Museum of Art, per Brettell

212. Perhaps Daulte 211, on deposit at the Musée d'Art et d'Histoire, Geneva, per Brettell

213. Perhaps Daulte 219, per Brettell

214. Daulte 230, Musée du Petit Palais, Paris

— 12 —

161 — Fenaison. (Aquarelle.)
162 — Fauche des foins. (Aquarelle.)

PISSARRO (Camille)
à Pontoise, rue de l'Hermitage.

163 — Côte Saint-Denis à Pontoise, appartient à M. C...
164 — Le verger, côte Saint-Denis, à Pontoise.
165 — Sous bois, id. id.
166 — Jardin des Mathurins, à Pontoise.
167 — Coin du Jardin des Mathurins, à Pontoise.
168 — Sentier près les Mathurins, id.
169 — Verger de Montbuisson, à Pontoise.
170 — Vue de Saint-Ouen-l'Aumône, appartient à M. C...
171 — La plaine d'Épluches (Arc-en-ciel), appartient à M. H...
172 — Bord de l'Oise en automne, appartient à M. Ch...
173 — Bord de l'Oise, route d'Auvers.
174 — Place de l'hermitage à Pontoise.
175 — Grand poirier, à Montbuisson, appartient à M. H...
176 — Paysage avec ruine (Automne), appartient à M. H...

— 13 —

177 — Bord de l'Oise, marine.
178 — Basse-cour. Pluie.
179 — Vue de l'hermitage.
180 — La Moisson, appartient à M. C...
181 — Allée sous bois, à Montfoucault, appartient à M. C...
182 — Un friche, à Montfoucault.
183 — Paysage.
184 — La Plaine, à Pontoise.

RENOIR (Pierre-Auguste)
35, rue Saint-Georges.

185 — La Balançoire, appartient à M. C...
186 — Bal du moulin de la Galette.
187 — Portrait de madame G. C., appartient à M. G. Charpentier.
188 — Portrait de mademoiselle G. C., appartient à M. G. Charpentier.
189 — Portrait de madame A. D., appartient à M. A. D.
190 — Portrait de M. Sisley.
191 — Portrait de mademoiselle S...
192 — Portrait de M. S...
193 — Jeune fille.
194 — Femme assise.
195 — La Seine à Champrosay.
196 — La place Saint-Georges.

— 14 —

197 — Coucher de Soleil.
198 — Jardin.
199 — Id.
200 — Tête de jeune fille.
201 — Bouquet de fleurs des champs.
202 — Deux têtes.
203 — Id.
204 — Les Dalhias.
205 — Portrait d'enfant.

ROUART (Henri)
34, rue de Lisbonne.

206 — Bords de la Sédelle.
207 — Ferme bretonne.
208 — Portrait.
209 — Vallée de Cauterets.
210 — Quai des Fourneaux, à Melun.

SISLEY
à Marly-le-Roy.

211 — Le Chalet; Gelée blanche, appartient à M. H...
212 — Le Parc, appartient à M. H...

— 15 —

213 — Route, le soir, appartient à M. H...
214 — Scieurs de long, appartient à M. de Bellio.
215 — Rue de village, Id.
216 — Les Gressets, village aux environs de Paris, appartient à M. de Bellio.
217 — La Seine, au Pecq, appartient à M. Charpentier.
218 — Champ de foin, appartient à M. Charpentier.
219 — La machine de Marly, appartient à M. Duret.
220 — Le pont d'Argenteuil en 1872, appartient à M. Manet.
221 — Bords de la Seine. Coup de vent, appartient à M. Ch...
222 — L'Abreuvoir, à Marly.
223 — L'Auberge du Lion-d'Or.
224 — Village de Marly. (Effet de neige.)
225 — Le Lavoir, à Marly.
226 — La Terrasse, à Marly.
227 — Inondations.

TILLOT (Charles)
4, rue Fontaine-St-George.

228 — Forêt de Fontainebleau.
229 — Le Bas-Bréan et la plaine de Chailly.
230 — Plage de Villers.
231 — Rouen.

232 — Maison et atelier de J.-F. Millet, à Barbizon.
233 — La rue de Barbizon.
234 — Bout du village de Barbizon.
235 — Meules dans la plaine.
236 — Vue prise des hauteurs des Forges d'Apremont.
237 — Étude d'arbres.
238 — Vue prise à Villers.
239 — Fleurs.
240 — Tête de femme.
241 — Portrait de M. X...

FIN.

Paris. — Imprimerie E. Cappiomont et V. Renault, 6, rue des Poitevins.

219. Daulte 215, per Brettell
220. Daulte 30, Memphis Brooks Museum of Art, Memphis
221. Perhaps Daulte 228, per Brettell
227. Any one of Daulte 237–240, per Brettell

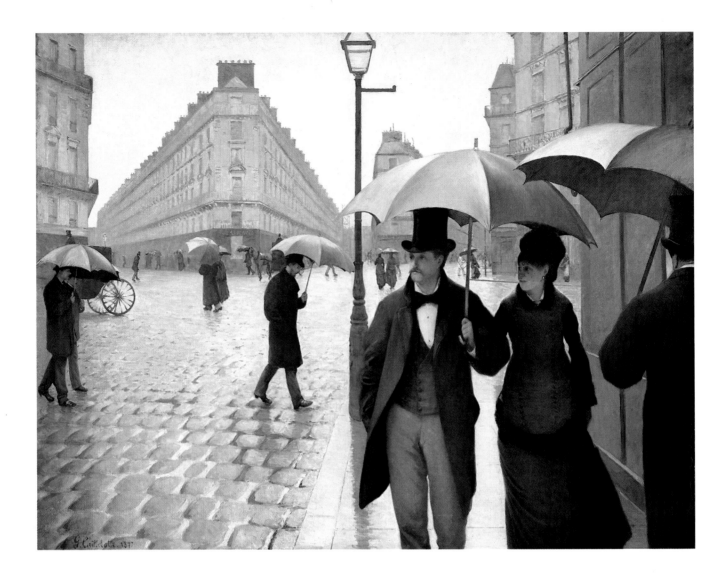

38. Gustave Caillebotte

III—I

Rue de Paris: Temps de pluie, 1877
Paris Street: A Rainy Day

Signed and dated lower left: *G. Caillebotte.1877*
Oil on canvas, 83½ x 108¾ in. (212.2 x 276.2 cm)
The Art Institute of Chicago. Charles H. and Mary F. S.
Worcester Fund. 1964.336
REFERENCES: Berhaut 1978, no. 52; Feldstein 1978, no. 53;
Varnedoe and Lee 1976, no. 25.

The other canvas shows the inter-section made by the rue de Turin and the rue de Moscou, seen on a rainy day. Again, this is very well drawn . . . only Caillebotte has neglected to provide any rain. That day the rain seems to have left no impression on him at all. *L'Evénement*, 6 April 1877

Here is Caillebotte and his huge painting: *Rue de Paris: Temps de pluie*. The catalogue describes it as rain, but my personal impres-sion is that it is snow. The open umbrellas give off white reflec-tions; nevertheless, there is not a single flake on people's clothing, and the very oddly laid-out pav-ing stones are smooth. The art-ist's impression must have been that the rain looked like snow. Caillebotte has genuine talent: his figures are firmly set down; the perspective is good; and his paint-ings have space, a great deal of it. Thomas Grimm [Pierre Véron], *Le Petit Journal*, 7 April 1877

The *Rue de Paris* by Caillebotte offers some bits of striking Realism: the houses are finely observed and convincingly drawn, and there are some subtle colors in the heads of the young woman and gentleman who are walking under their umbrella. But why does this streetlamp stretch its disagreeable perpendicular right into the middle of the picture? Why is this gentleman wearing a long overcoat, his body cut in half by the frame? With its disdain of composition and of proper technique, despite its unquestionable strengths, this painting amazes, but does not move you. It gives an idea of what photography will become when the means are found to reproduce colors with their full intensity and subtlety.
Paul Sébillot, *Le Bien Public*, 7 April 1877

Gustave Caillebotte is showing *Une rue de Paris* (in rainy weather) where the figures look like people walking around with umbrellas open an hour before the storm breaks.
La Petite Presse, 9 April 1877

Let us speak of Caillebotte. What a strange idea he had, to paint a streetcorner on a rainy day with life-sized figures! Some men in overcoats and dark couples with linked arms walk along under their umbrellas. The canvas is too big, the look is dull and sad. Treating the same subject, de Nittis would have made a very pleasant little painting. Caillebotte with more ambition has come up with a work that is excessive, and thus whatever qualities it may have are diluted.
Léon de Lora [Louis de Fourcaud], *Le Gaulois*, 10 April 1877

Caillebotte is an Impressionist only in name. He knows how to draw and paints more seriously than his friends. *Le pont de l'Europe* and *Une rue de Paris, par un jour de pluie* – although the latter would have gained in being scaled down – deserve all possible critical praises.
La Petite République Française, 10 April 1877

Caillebotte's painting *Rue de Paris par un temps de pluie* throws over all tradition. . . . The group in the foreground seems a bit magnified, given the closeness of the horizon. With the exception of the woman, the figures are weak and perhaps lack the desired definition. But the walk-ons in the distance are so alert, so complete, have such vitality – this whole group moves so easily through the vast intersection with its skillfully dampened, gray tonality – that I just do not have the heart to heap criticism on the principal actors.
Jacques [pseud.], *L'Homme Libre*, 12 April 1877

Caillebotte is less fortunate [than Sisley]; there are very few absurdities that have not been said of him. One critic has written that in *Temps de pluie* everything exists except the rain which you do not see fall. This is full of naiveté. The same gentleman was fed up by the sight of a little dog crossing the *Pont de l'Europe*.
Caillebotte, however, has some great qualities, and definitely does not indulge in what blind critics have called a "debauchery of colors." Is all criticism then to be biased? People have been unwilling to see in Caillebotte that noble, sincere, and very realistic drawing style that is the chief of his talents.
They also have refused to understand his study of atmosphere and light, a study that I agree brings a slight fading but which is no less near the truth.
In his painting the *Pont de l'Europe* there are some fine qualities and a successful arrangement of the subject on the canvas. The figures are drawn in a very intelligent and amusing manner. *Le temps de pluie* is a considerable effort, one not enough acknowledged. Those who criticized this painting had no idea of how difficult it was and what technique was needed to bring off a canvas of this size.
Georges Rivière, *L'Impressionniste*, 14 April 1877

Is Caillebotte an Impressionist, for example, in his large canvas entitled *Rue de Paris – Temps de pluie*? The open umbrellas are all of a uniformly silvery tint, yet the rain is nowhere to be seen. The painter was not able to produce that mist formed by falling raindrops. Instead, there is something that suggests a rather poor hand at drawing. Moreover, it is easy to see that Caillebotte considers the composition of a painting beneath his dignity: his figures are grouped haphazardly; the frame cuts in half, from head to foot, a figure of a man seen from the back.
Roger Ballu, *La Chronique des Arts et de la Curiosité*, 14 April 1877

Finally, I will name Caillebotte, a young painter who shows the finest courage, and who does not hesitate to treat modern subjects on a life-sized scale. His *Rue de Paris par un temps de pluie* shows some passers-by – above all a man and a woman in the foreground – who seem very real. Once his talent has become more supple, Caillebotte certainly will be among the boldest of the group.
[Emile Zola], *Le Sémaphore de Marseille*, 19 April 1877

The paintings *Peintres en bâtiment* and *Temps de pluie* show surprising aspects of the Parisian landscape. Caillebotte reduces the role of the ideal as much as possible, believing in muddy pavements, in wet umbrellas, and in ladies' boots dishonored by splashes. But his street corners are observed with care, and their effect of veiled light is accurate. It seems nevertheless as though Caillebotte could show more courage here and there: he submerges local tone a little too much into an overall harmony of slate gray. It's sweet, but not entirely authentic.
Paul Mantz, *Le Temps*, 22 April 1877

Is it true that Caillebotte is an "Impressionist"? Yes, if one looks at his *Pont de l'Europe*, and his *Portraits à la campagne*; no, if one looks at the other paintings he sent, above all his large bravura piece the *Carrefour de la rue de Moscou par un temps de pluie*. A half-dozen figures, life-sized, with open umbrellas, cross the intersection or walk along the sidewalks. The subject lacks interest, as do the figures, as does the painting. Caillebotte sees a gray and confused world. Nothing is more emptied of character and expression than these faces, and the drawing truly is insufficient. I would be embarrassed to say what kind of future Caillebotte could have as an artist. What he lacks most today is personality. He seems still to be looking for himself. In any case, you can promise him that it is not by painting maroon umbrellas stretched in a semi-circle on their struts that he will find himself.
Charles Bigot, *La Revue Politique et Littéraire*, 28 April 1877

[In] *Une rue de Paris pendant la pluie* all the umbrellas are open, and rain is no longer falling. What did fall is not rain, it is something like flour or powdered sugar that was sprinkled all over the pavement, umbrellas, everything, with equal and regular perfection. It is painted in a normal way, and is not without distinction. It is as big as life, as is demanded of a subject of such compelling interest.
Léon Mancino (quoting letter from P. Noël), *L'Art*, 1877

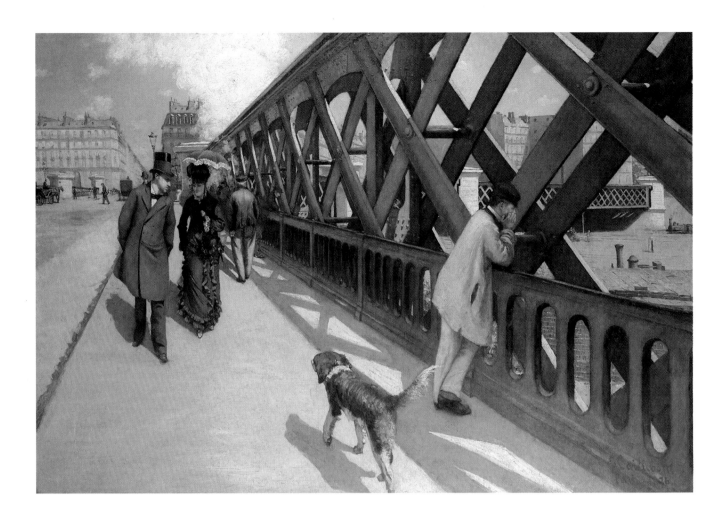

39. Gustave Caillebotte

III—2

Le pont de l'Europe, 1876

Signed, dated, and inscribed lower right: *G. Caillebotte/Paris 1876*

Oil on canvas, 49⅛ x 71⅛ in. (124.8 x 180.7 cm)

Petit Palais, Geneva. 111

REFERENCES: Berhaut 1978, no. 44; Daulte et al. 1968, 46, no. 13; Varnedoe and Lee 1976, no. 16.

Washington only

Nevertheless, I prefer a hundred times over his *Pont de l'Europe*, whose sober composition offers at once more truth and grace. The sky is blue, the clear air throws the shadows sharply into relief, and in the immense expanse that opens all the way to the Trinité, just discernible in the distance, two silhouettes demand attention. A young dandy walks past an elegant woman, exquisite beneath her flecked veil, a common little vignette that we have all observed with a discreet and benevolent smile. The figure of the worker leaning on the railing is an audacious touch: it stops the action. Nevertheless, it is a necessity. The painter could not leave the whole foreground of his painting empty. It took tact to understand this.

Jacques [pseud.], *L'Homme Libre*, 12 April 1877

The most remarkable works, without question, are by Gustave Caillebotte, a millionaire who paints in his free time. Let us especially point out two immense paintings, both too uniformly gray but very well drawn.

One of them offers a *Vue du pont de l'Europe*. The main figure is the painter himself, chatting with a very pretty woman close at hand (another portrait, no doubt). Our compliments, Caillebotte, . . . you must have had some very happy *impressions* that day.

L'Evénement, 6 April 1877

For additional quotations see previous page.

40. Gustave Caillebotte

III–5

Portraits, 1877

Now known as *Portraits dans un intérieur* (Portraits in an Interior)
Signed and dated lower right: *G. Caillebotte. 1877*
Oil on canvas, 18⅛ x 22 in. (46 x 56 cm)
Collection of Simone and Alan Hartman, New York
REFERENCES: Berhaut 1978, no. 54; Varnedoe and Lee 1976, no. 31; Milkovich 1977, no. 3; Sotheby's New York, 16 November 1984, no. 12.
NOTE: Mme Godard and Mme Davey (Davoye, per Varnedoe and Lee), friends of the Caillebotte family, are depicted in the drawing room of a residence in the rue de Miromesnil in Paris. See Berhaut, above.

Only one word about Caillebotte: he may have some talent, but if so it is unfortunate, for the talent of Caillebotte is not at all attractive. Some very honest people have confessed to agreeing with us. Therefore, to our regret, we have decided not to conclude this review by crying, "bravo" and "take courage."
Ch. Flor O'Squarr [Oscar-Charles Flor], *Le Courrier de France*, 6 April 1877

41. Adolphe-Félix Cals

III—8

Paysage, à Saint-Siméon, 1876
Landscape at Saint-Siméon

Now known as *Landscape with Figures*
Signed, dated, and inscribed lower right: *Cals Honfleur/1876*
Oil on canvas, 14⅜ x 24⅞ in. (36.5 x 63.2 cm)
John G. Johnson Collection, at the Philadelphia Museum of
Art. 909
REFERENCES: Milkovich 1977, no. 6; Isaacson 1980, no. 9.
NOTE: Since the 1840s, plein air painters had gathered at the
farm at Saint-Siméon in the hills above Honfleur, sometimes
called the "Barbizon of Normandy." The farm was known for
its panoramic view of the Seine estuary and its apple orchard,
both of which Cals painted frequently. This painting is
probably the work exhibited as no. 8 in the 1877 group
exhibition.

Cals, a consummate
practitioner. . . .
La Petite République Française,
10 April 1877

[Cals] has some feeling and a
rather rich technique and soon
will be sorry he strayed into the
Impressionist crossroads.
Léon de Lora [Louis de Four-
caud], *Le Gaulois,* 10 April 1877

I have so little room that I have to
return to Paris quickly, despite
my desire to stroll with Cals in the
streets of Honfleur.
Jacques [pseud.], *L'Homme
Libre,* 11 April 1877

42. Paul Cézanne

III–HC

Scène fantastique *or* **Les pêcheurs,** ca. 1873
Fantasy Scene *or* The Fishermen
Signed lower right: *Cezanne*
Oil on canvas, 21¼ x 32 in. (54 x 81.3 cm)
Private collection
REFERENCES: Venturi 1936, no. 243; Orienti 1972, no. 261.

Over a door in the second room, Cézanne has a painting representing a scene at the seaside. It is strikingly majestic and extraordinarily calm. It seems that the scene takes place in his memory while he turns the pages of his life.

A man in a black overcoat wearing a pointed hat hobbles forward in the bright sun, leaning on a large staff. . . . In front of this old man, a woman calls the ferryman with a gesture full of grandeur; and, in a small arm of the sea, a fishing boat with a high white sail is stopped. A sailor on the shore pulls nets from the water; another, an old salt in a red shirt standing in the boat, directs the maneuver. It is vast and sublime, like a beautiful memory; the landscape is imposing with large trees moving in the sea breeze, the blue, transparent water, and the clouds sparkling in the sun.
Georges Rivière, *L'Impressioniste,* 14 April 1877

Pissarro and Cézanne, who have supporters, together form a school apart, and even two schools within one. I recognize again their qualities of draftsmanship and even of composition, but their color is a different matter. In this chapter, I will spare myself from treating that subject. I acknowledge that I do not find these artists very comprehensible and I am wary of analyzing the merit that one attributes to them.
Jacques [pseud.], *L'Homme Libre,* 12 April 1877

However, paintings by Cézanne have the inexpressible charm of biblical and Greek antiquity. The movements of the figures are simple and grand like those in antique sculpture, the landscapes have an imposing majesty. . . .
Georges Rivière, *L'Impressionniste,* 14 April 1877

43. Paul Cézanne

III—22—25

Paysage: Etude d'après nature, ca. 1876
Landscape: Nature Study

Now known as *La mer à L'Estaque*
Signed lower right: *P. Cezanne*
Oil on canvas, 16½ x 23¼ in. (42 x 59 cm)
Private collection, Switzerland
REFERENCES: Venturi 1936, no. 168; Orienti 1972, no. 172;
Sotheby's London, 30 June 1981, no. 8.

Cézanne's *Impressions d'après nature* are not pleasing to look at; to me they resemble unscraped palettes.
Léon de Lora [Louis de Fourcaud], *Le Gaulois*,
10 April 1877

44. Paul Cézanne

III—29

Tête d'homme: Etude, 1876—1877
Head of a Man: Study

Signed lower left: *P. Cezanne*
Oil on canvas, 18 x 14½ in. (45.7 x 36.8 cm)
Private collection, New York
REFERENCES: Venturi 1936, no. 283; Rewald 1969, 48,
fig. 10; Rishel 1983, Addendum.
NOTE: Cézanne painted several portraits of Victor Chocquet
(1841—1891), one of the strongest early defenders of the
Impressionists. Chocquet is best known as a patron of
Cézanne, but he also collected works by Monet, Pissarro, and
Renoir. See Rishel, above.

Paul Cézanne is a genuine Impressionist. He sent to the rue le Peletier a series of paintings each more stupefying than the last. We noticed a *tête d'homme*, deliberately odd, that we have been assured his fellow Impressionists find very beautiful. He is a worker in a blue smock who has a face as long as if it had been sent through a rolling mill and as yellow as that of a dyer who has worked with ocher for a long time. He is framed by blue hair bristling from the top of his head.
La Petite Presse, 9 April 1877

Cézanne, a faithful Intransigent, requires special treatment. He has had such *visions* this year that corrective lenses have become indispensable for him. He risks making even the most enthusiastic of his friends gnash their teeth. Without mentioning his fabulous landscapes, stucco fruits, and zinc flowers, notable in his work are a *Tête d'homme* in red copper, and some *Baigneurs* in plaster who would cause the Messalinas of the world to swear forever to chastity. If nothing else, the artist has produced work of the highest morality.
La Petite République Française,
10 April 1877

Let us mention also *Tête d'homme*, which looks like Billoir [an infamous murderer] in chocolate.
L'Evénement, 6 April 1877

And now a piece of advice, dear reader. If you visit the exhibition with a woman in a delicate condition, go quickly past the portrait of a man by Cézanne. This head, the color of a boot-top, looks so strange that it might make too strong an impression on her and give yellow fever to the child still in her womb.
Louis Leroy, *Le Charivari*,
11 April 1877

45. Edgar Degas

III-38

Ecole de danse, 1873
The Dance School

Now known as *School of Ballet*
Signed lower right: *Degas*
Oil on canvas, 19¹/₁₆ x 24⁵/₈ in. (48.3 x 62.5 cm)
Corcoran Gallery of Art, Washington, D.C. William A. Clark
Bequest, 1926. 26.73
REFERENCES: Lemoisne 1946, no. 398; Robinson 1983, no.
41; Shackelford 1984, 43–45, fig. 2.1.
Washington only

Degas is a true artist. He is often very imperfect but occasionally exhibits the signs of a master. Some of his paintings, the *Danseuse, un bouquet à la main*, the *Ecole de danse*, and the *Ballerine qui salue le public* are among the strongest and most interesting works at the exhibition.
Paul Sébillot, *Le Bien Public*,
7 April 1877

I come now to Degas. The works he sent consist mainly of a series of paintings and watercolors showing café-concerts and backstage scenes. The movements of his little figures are piquant and accurate, and his color is brilliant. . . . But do not ask Degas for anything but approximations. He cares only for the pose, the contour enveloping his figures, their clothing, for such things and nothing else. Do you want to look at their features? Degas forbids it.
Léon de Lora [Louis de Fourcaud], *Le Gaulois*, 10 April 1877

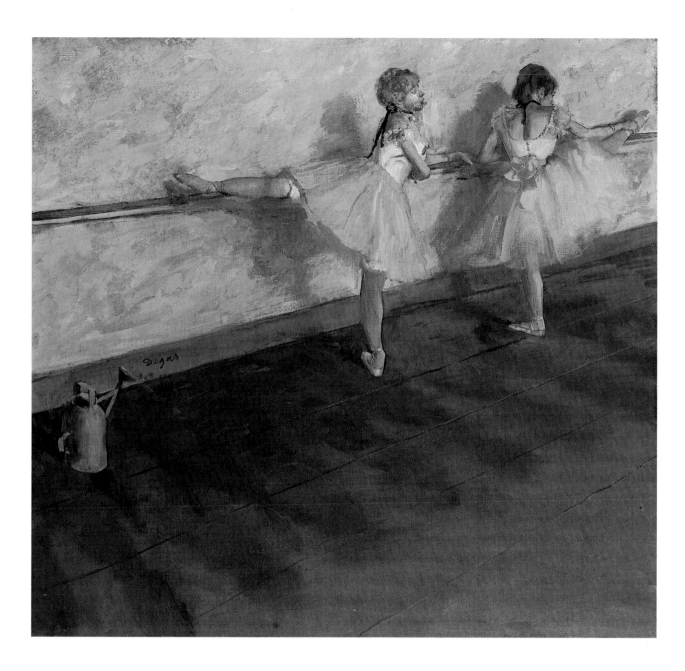

46. Edgar Degas

III—41

Danseuses à la barre, 1876–1877
Dancers at the Bar

Now known as *Dancers Practicing at the Bar*
Signed center left: *Degas*
Oil colors freely mixed with turpentine, on canvas, 29¾ x 32
in. (75.6 x 81.3 cm)
Lent by The Metropolitan Museum of Art. Bequest of Mrs.
H. O. Havemeyer, 1929. The H. O. Havemeyer Collection.
29.100.34
REFERENCES: Lemoisne 1946, no. 408; Sterling and Salinger
1967, 3: 78–81; Baetjer 1980, 1:45; Guillaud et al. 1984, 56,
58, fig. 142.

Degas is definitely the most original artist of the constellation. No one, including Gavarni and Grévin, has portrayed with such humor the worlds of backstage and the café-concerts: *Les femmes devant un café, le soir, Les danseuses au bouquet, Les choristes, Les bains de mer, Les danseuses à la barre* and *Le café-concert* are just so many little masterpieces of clever and accurate satire.
La Petite République Française,
10 April 1877

I imagine that Edgar Degas may not be a zealous Impressionist, but I am sure he is a man of sense. He is perfectly in charge of himself, and you may be sure that in coming to the rue le Peletier he has followed his own inclination. His studies of *Danseuses* assert a rare and original talent. The drawing is flawed in places, but how lively this artist is in his handling of color!
Roger Ballu, *La Chronique des Arts et de la Curiosité,*
14 April 1877

NOTE: This is one of two possibilities for no.41 in the 1877 group show. The other is Lemoisne no.421, present location unknown.

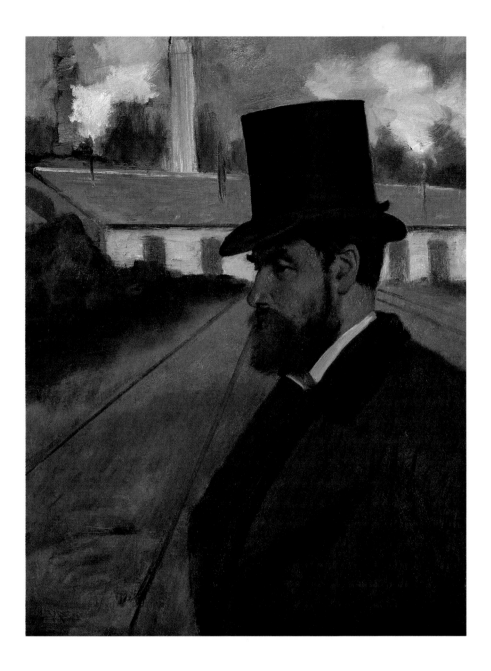

47. Edgar Degas

III—49

Portrait de Monsieur H. R. . . , ca. 1875

Now known as *Henri Rouart devant son usine* (Henri Rouart
in Front of His Factory)
Oil on canvas, 25 ⅝ x 19 ¾ in. (65 x 50 cm)
Museum of Art, Carnegie Institute. Acquired through the
generosity of the Sarah Mellon Scaife Family. 69.44
REFERENCES: Lemoisne 1946, no. 373; Boggs 1962, 45,
128–129.

NOTE: Henri Rouart (1833–1912) attended the Lycée Louis-
le-Grand with Degas, served as his captain during the Franco-
Prussian War, and was one of Degas's closest lifelong friends.
An engineer and industrialist by profession, Rouart was also a
collector and amateur painter who exhibited in all but the
seventh group exhibition. See Boggs, above.

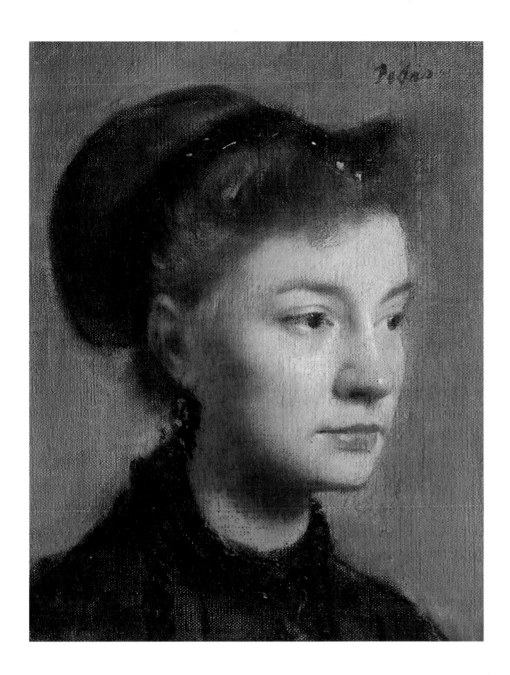

It is hard to understand exactly why Edgar Degas categorized himself as an Impressionist. He has a distinct personality and stands apart from the group of so-called innovators. Moreover, Degas does not seek to hide the origins of his talent and even gives us an autobiographical sketch. Presented on an easel and under a carefully chosen ray of light is the portrait of a woman that evidently was not painted for the good of the cause, as it is dated 1867. The work is serious, with some Italian reminiscences. Its individual character distinctly has been sought for: the modeling is simple and broad. We will not ask ourselves how the Florentine of ten years ago has become today's Impressionist. Proximity does not create kinship. Degas may be exhibiting near Pissarro and Sisley, Cézanne and Claude Monet, but he does not belong to the family. He is an observer, a historian perhaps.
Paul Mantz, *Le Temps*,
22 April 1877

48. Edgar Degas

III—53

Portrait, 1867
Now known as *Portrait de jeune femme* (Portrait of a Young Woman)
Signed upper right: *Degas*
Oil on canvas, 10⅝ x 8⅝ in. (27 x 22 cm)
Musée d'Orsay (Galerie du Jeu de Paume), Paris. R.F. 2430
REFERENCES: Lemoisne 1946, no. 163; Adhémar and Dayez-Distel 1979, 30, 154; Boggs 1962, 125.
NOTE: Lemoisne has identified this sitter as Rose Adelaide Aurore de Gas, the duchess Morbelli, sister of the painter's father. See Lemoisne, above. However, this has been refuted by Riccardo Raimondi. See Raimondi 1958, 264.

Degas is exhibiting a portrait in oil of a woman. The foolish admire it, thinking it has been carefully studied and seriously painted, instead of admiring his pastels full of amiable madness. But you are idiots! If the painter exhibits this portrait, it is to triumphantly show you the great strides he has made since he stopped drawing!
Louis Leroy, *Le Charivari*,
11 April 1877

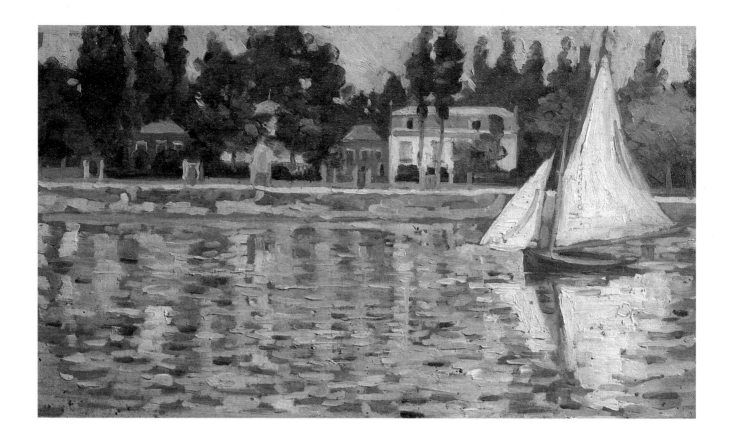

49. Alphonse Maureau

III—87 or 88

Bords de la Seine
Banks of the Seine

Signed center right, on sail: *Maureau*
Oil on canvas, 5¾ x 9½ in. (14.5 x 24 cm)
Galleria d'Arte Moderna, Florence. C. G. 268
REFERENCES: Rosenberg 1977, no. 163.
NOTE: According to O'Squarr, writing in *Le Courrier de France*, 6 April 1877, Maureau's entry no. 88 consisted of three small panels.

Maureau exhibits some beautiful studies. Their drawing is excellent, and they are solid, fresh, and luminous.
La Petite République Française, 10 April 1877

Alphonse Maureau shows some skillful studies from nature done on a small scale. The *Place Pigalle* and the *Bords de la Seine* are the work of an artist who is still inexperienced, but whose vision is sane and who has a fine sense of the variety and power of color.
Paul Mantz, *Le Temps*, 22 April 1877

There is a certain force and a genuine feeling for color in one or two of Maureau's little sketches (nos. 87 and 88).
Charles Bigot, *La Revue Politique et Littéraire*, 28 April 1877

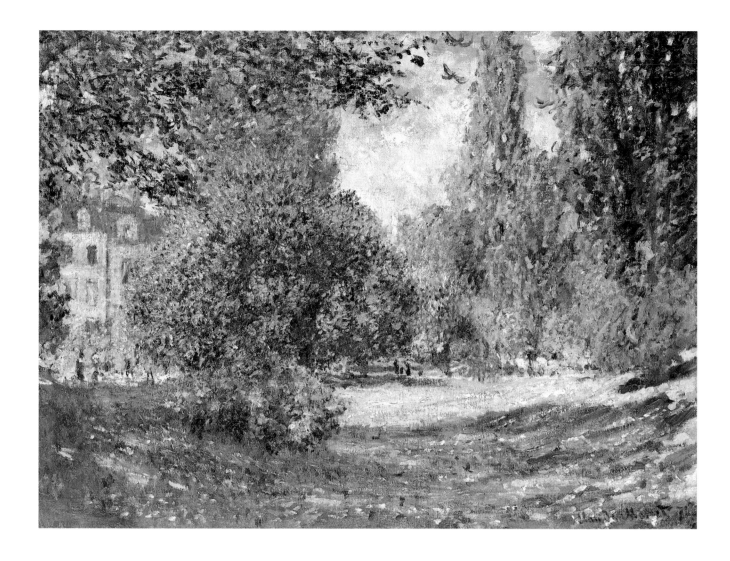

50. Claude Monet

III—96

Paysage: Le parc Monceaux, 1876
Landscape: Parc Monceaux, Paris

Signed and dated lower right: *Claude Monet 76*
Oil on canvas, 23 ½ x 32 ½ in. (59.7 x 82.6 cm)
Lent by The Metropolitan Museum of Art. Bequest of Loula D.
Lasker, New York City, 1961. 59.206
REFERENCES: Wildenstein 1974, no. 398; Sterling and
Salinger 1967, 3: 128–129; Baetjer 1980, 1:128.

Everyone knows that this group of eighteen artists was formed for a single purpose: to render the effect and the emotion that nature produces directly in the heart or spirit. Have they achieved this result? At times; but it is always pursued.

Thus, for example, Claude Monet, scorning to look for his themes in the *Book of Truth*, is smitten with everything that strikes his eye: a *Prairie*, the *Parc Monceaux*, a *Coin de jardin*, the *Gare Saint-Lazare*, a *Vue de Sainte-Adresse*, and an *Intérieur d'appartement* are all equally good to him.
A. P., *Le Petit Parisien*,
7 April 1877

[Previously] the painting of Monet appeared singular: along with some brutal qualities, it had some savor and intensity. Obedience to a school has changed everything. There is still something in his *Intérieurs de gare*, a picturesque subject for which Monet has given us many variations, but the sense of reality is completely lacking in the *Tuileries*, *Le parc Monceaux*, and other landscapes by this artist. The distances are muddled, the values become mixed together and everything is lost in an anarchic mess.
Paul Mantz, *Le Temps*,
22 April 1877

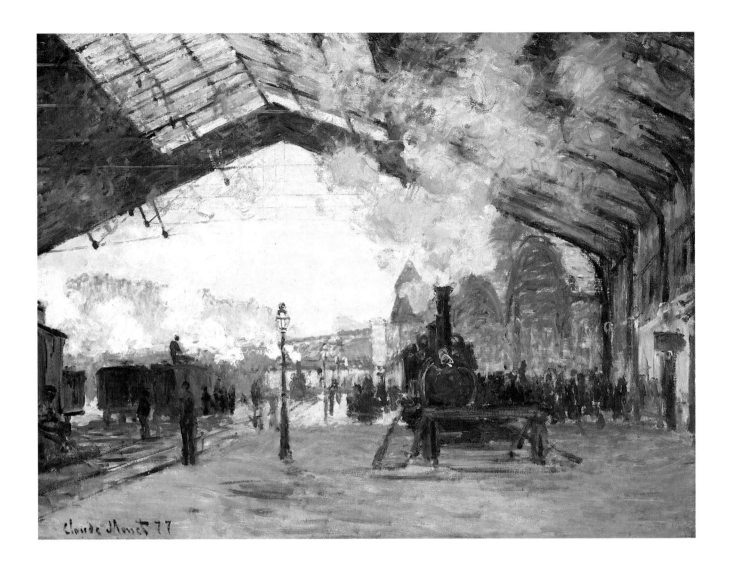

51. Claude Monet

III—97

Arrivée du train de Normandie, Gare Saint-Lazare, 1877
Arrival of the Normandy Train at the Gare Saint-Lazare

Signed and dated lower left: *Claude Monet 77*
Oil on canvas, 23 ½ x 31 ½ in. (59.6 x 80.2 cm)
The Art Institute of Chicago. Mr. and Mrs. Martin A. Ryerson Collection. 1933.1158
REFERENCES: Wildenstein 1974, no. 440; Chicago 1961, 279, 318–319; Brettell et al. 1984, no. 32.

Given the lack of space here, we will content ourselves by mentioning Monet's works *La prairie, La marine (Sainte-Adresse)*, an admirable study *La plaine de Gennevilliers*, and several *Intérieurs de gare*. One of the latter, *Arrivée du train de Normandie*, is one of the best things at the exhibition.
La Petite République Française, 10 April 1877

Valtravers (pausing in front of the Gare de l'Ouest): There—that is really ridiculous . . . why is this painting upside down? You cannot see anything.
Doctor [a specialist in mental illness]: You are wrong. It is right side up.
Valtravers: Are you sure?
Doctor: I swear. The painters themselves supervised the hanging.
Valtravers: How odd. I would have sworn. . . .
Louis Leroy, *Le Charivari*, 14 April 1877

The most prolific among these new masters exhaust their imaginations representing train stations. One of them shows us all the aspects of the Gare de l'Ouest. The artist wanted to create, in turn, the impression of a departing train, the impression of a train about to leave, and he tried, finally, to give us the disagreeable impression of many trains whistling at once. He has translated this into an abundance of smoke, which seems to be made out of cardboard.
Baron Grimm [Albert Millaud], *Le Figaro*, 5 April 1877

But in our quick walk, we have made a significant discovery – the most frequently treated subject is the *Vue de la Gare Saint-Lazare, arrivée d'un train*. One cannot guess the number of *vues de la Gare Saint-Lazare* that catch the public's eye. Should we see in this strange coincidence the sign manifest that there is some impression emitted by the Gare de l'Ouest that is irresistible to the painters of the new school?
L. G., *La Presse*, 6 April 1877

Monet, whose talent is vigorous, and who takes the trouble to draw, has turned himself into the customary painter of the Gare Saint-Lazare with all its ins and outs.
Baron Schop [Théodore de Banville], *Le National*, 8 April 1877

This year Monet is giving us a number of canvases showing locomotives, either by themselves or coupled to a line of cars in the Saint-Lazare station. These paintings are amazingly varied, despite the monotony and aridity of the subject. In them more than anywhere else can be seen that skill in arrangement, that organization of the canvas, that is one of the main qualities of Monet's work. In one of the biggest paintings the train has just arrived, and the locomotive is about to leave again. Like a spirited, impatient beast stimulated rather than fatigued by the long journey it has just finished, it shakes its smoky mane that billows against the glass roof of the vast hall. Men swarm around the monster like pygmies at the feet of a giant. On the other side, locomotives not in use wait, sleeping. And, in the background, the gray sky blanketing the tall pale houses closes the horizon. We hear the shouts of the workers, the sharp whistles of the engines blasting their cry of alarm, the incessant noise of scrap-iron, and the formidable panting of the steam.
We see the broad sweep and tumultuous movement in this train station where the ground shakes with every turn of the iron wheels. The pavements are damp with soot and the air is charged with the bitter odor of burning coal. Looking at this magnificent painting, we are gripped by the same emotion as before nature, and it is perhaps even more intense, because the painting gives us the emotion of the artist as well.
Georges Rivière, *L'Impressionniste*, 6 April 1877

Among the twenty-nine paintings [Monet] is exhibiting – for at the rue le Peletier each artist submits as many works as he pleases (and I am not complaining) – out of the twenty-nine, seven or eight are dedicated to showing us every aspect of the Gare Saint-Lazare. These various studies are certainly not uninteresting, and one of them seems excellent. It is the one exhibited closest to the window [of the gallery], at the bottom, that shows an interior of the train station. The number is missing from the frame, but I am told it is no. 97, *Arrivée du train de Normandie*, and belonging to M. Hoscedé [*sic*]. This piece gives an accurate, clear impression, is unpretentious, well done. I congratulate its lucky owner.
Charles Bigot, *La Revue Politique et Littéraire*, 28 April 1877

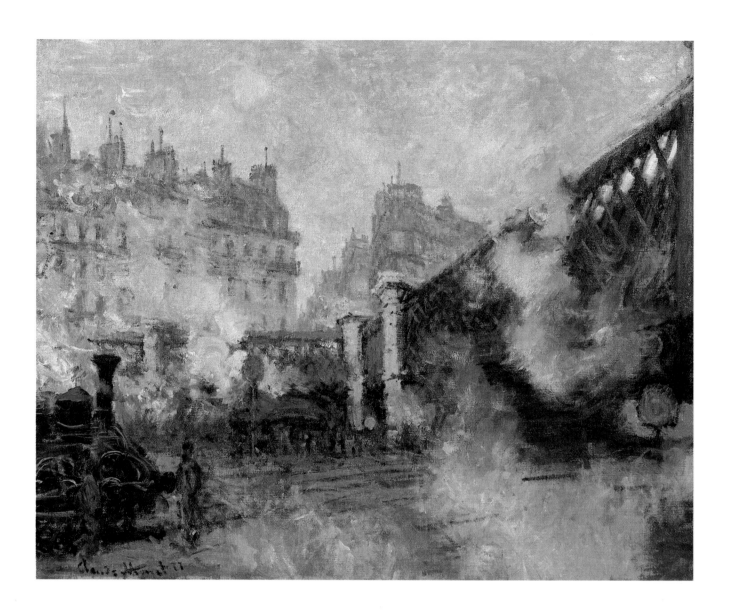

52. Claude Monet

III—98

Le pont de Rome (Gare Saint-Lazare), 1877
Now known as *Pont de l'Europe (Gare Saint-Lazare)*
Signed and dated lower left: *Claude Monet 77*
Oil on canvas, 25 ¼ x 31 ⅞ in. (64 x 80 cm)
Musée Marmottan, Paris. 4015
REFERENCES: Wildenstein 1974, no. 442; Adhémar et al.
1980, no. 57; Daulte et al. 1982, no. 19; Brettell et al. 1984, no.
30.
NOTE: This is a view from just outside the Gare Saint-Lazare
where the tracks are spanned by the Pont de l'Europe. See
Brettell et al. above.

Manet's scepter is now held by
Monet. Monet is fond of the Gare
Saint-Lazare, filled with smoke
through which trains and loco-
motives can be discerned. All this
shades to a vague troubled gray
that excites the enthusiasm of the
followers.
Bertall [Charles-Albert d'Ar-
noux], *Paris-Journal*,
9 April 1877

*For additional quotations see
previous page.*

If the last painter [Piette] has ded-
icated himself to markets, Claude
Monet has dedicated himself to
railroads. He gives us five or six
interior views of the Gare Saint-
Lazare, filled with black, pink,
gray, and purple smoke, which
makes them look like an illegible
scrawl. The *Pont de Rome*, where
passers-by look as the trains
come and go, is not without merit
but utterly lacks any attraction.
Léon de Lora [Louis de Four-
caud], *Le Gaulois*, 10 April 1877

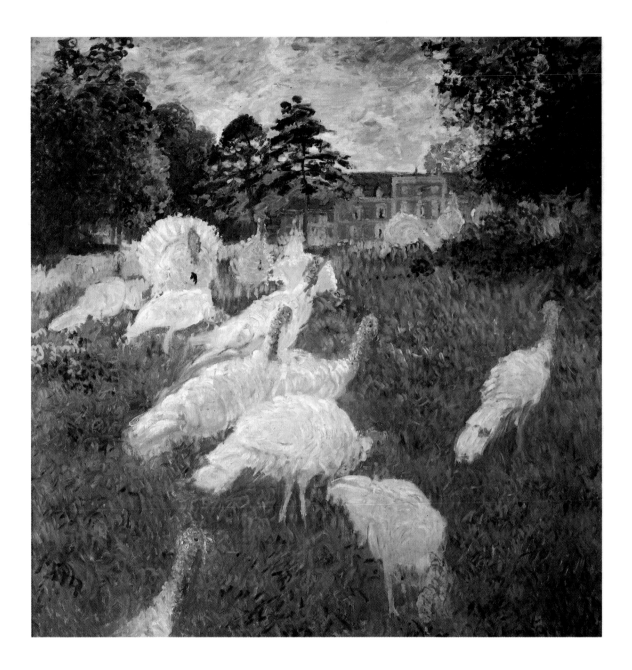

53. Claude Monet

III—101

Les dindons (décoration non terminée), 1877

The Turkeys (unfinished decoration)

Signed and dated lower right: *Claude Monet 77*
Oil on canvas, 68⅞ x 67¾ in. (175 x 172 cm)
Musée d'Orsay (Galerie du Jeu de Paume), Paris. Princess
Edmond de Polignac Bequest, 1944. R. F. 1944-18
REFERENCES: Wildenstein 1974, no. 416; Adhémar and
Dayez-Distel 1979, 74, 164; Adhémar et al. 1980, no. 61;
Daulte et al. 1982, no. 16.

NOTE: This painting is now complete, but it apparently was
exhibited although unfinished in both the 1877 group show
and in an 1889 exhibition at Georges Petit. After this time it
was reworked, signed, and dated 1877. See Adhémar et al.
above.

*For quotations from reviews see
next page.*

Should the new school transform art? I do not think so; to some extent it is the product of *japonisme*, which it has exaggerated. Already many of its followers have become very refined in their vision and in their technique. But it seems to me that only a decorative movement could emerge from such elements. Imagine a painting by Monet—the *Dindons*, for example—in a room with bright colors, subdued by the gold lavished around it. I believe that this painting, placed in a suitable environment, would no longer be shocking, at least as an element of color. It might even give pleasure, especially if the painter's disinterest in composition, perhaps intentional, could be underplayed a bit.
Paul Sébillot, *Le Bien Public*, 7 April 1877

One of the works most admired by those who have been convinced conveys the impression received by the artist at the sight of a flock of white turkeys, climbing all over each other, set in a vast field of endive. The impression produced by black turkeys, no doubt, would have been pathetic.
Bertall [Charles-Albert d'Arnoux], *Paris-Journal*, 9 April 1877

The famous *Dindons*, also by Monet, are the hit of this exhibition. The catalogue indicates that the canvas is unfinished. My God, what will it be like after the last brush stroke?
La Petite Presse, 9 April 1877

About the panel with the white turkeys clucking around on the loud green grass, I will say nothing, not knowing too well what to say. Monet's decorative sense cannot be denied, but the painter admits that this panel is not yet finished, and I agree completely.
Léon de Lora [Louis de Fourcaud], *Le Gaulois*, 10 April 1877

I come now to the *Dindons blancs*, no. 101. I am not afraid to announce that this is the last word in Impressionist art. These fowl have exquisitely irresolute form. Do not look at them from close up! One breath might send them floating away like feathers. Those fools who convulse with laughter at the sight of them obviously are unaware of the amount of courage it took for the artist to dare to throw to the wolves these creatures so completely outside the order of gallinaceous birds!
Louis Leroy, *Le Charivari*, 11 April 1877

Why join [*Les dindons*] to such a distinguished offering? According to the booklet, it was an unfinished decoration. Monet should have waited until it was done.
Jacques [pseud.], *L'Homme Libre*, 11 April 1877

Monet has painted an immense panel to serve as the decoration for a drawing room; one sees a flock of white turkeys involved in their affairs among the tall grasses of a green field. This field is a vision that evaporates, and these turkeys are as insubstantial as dreams. Monet has impressions of things—one must believe it—but he is so little concerned about being understood that he does not condescend to turn his stutterings into speech.
Paul Mantz, *Le Temps*, 22 April 1877

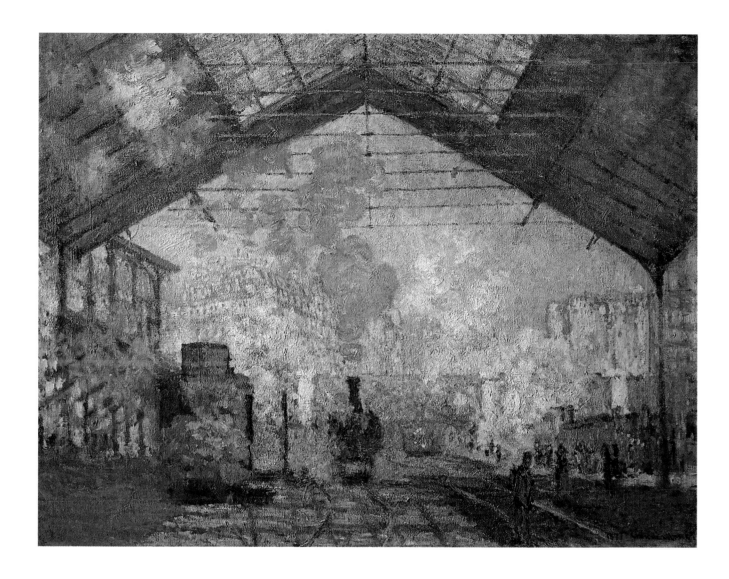

54. Claude Monet

III–102, 116, 117, or 118

Intérieur de la Gare Saint-Lazare, à Paris, 1877
Interior of the Gare Saint-Lazare, Paris

Now known as *La Gare Saint-Lazare*
Signed and dated lower right: *1877 Claude Monet*
Oil on canvas, 29¾ x 41 in. (75.5 x 104 cm)
Musée d'Orsay (Galerie du Jeu de Paume), Paris. Gustave
Caillebotte Bequest, 1894. R.F. 2775
REFERENCES: Wildenstein 1974, no. 438; Adhémar and
Dayez-Distel 1979, 72, 164; Adhémar et al. 1980, no. 56;
Brettell et al. 1984, no. 31.

[This painting] shows the arrival of a train in full sunlight. It is a joyous, lively canvas. People hurriedly get down from the cars, smoke puffs off into the background and rises upward, and the sunlight, passing through the windows, gilds the gravel of the tracks as well as the trains.
In some paintings, the irresistible, fast trains enveloped in light rings of smoke are engulfed in the platforms. In others, huge locomotives, immobile and widely scattered, await their moment of departure. In all of them, the same power animates these objects that Monet alone could render.
Georges Rivière, *L'Impressionniste*, 6 April 1877

Monet loves this station and he has presented it several times before, with less success. This time it is really wonderful. His brush has expressed not only the movement, color and activity, but the clamor; it is unbelievable. Yet this station is full of din—grindings, whistles—that you make out through the colliding blue and gray clouds of dense smoke. It is a pictorial symphony.
Jacques [pseud.], *L'Homme Libre*, 11 April 1877

55. Claude Monet

III—115

Intérieur d'appartement, 1875
Interior of an Apartment

Now known as *Un coin d'appartement* (Corner of an Apartment)
Signed and dated lower center: *Claude Monet 75*
Oil on canvas, 32⅛ x 23¾ in. (81.5 x 60.5 cm)
Musée d'Orsay (Galerie du Jeu de Paume), Paris. Gustave Caillebotte Bequest, 1894. R.F. 2776
REFERENCES: Wildenstein 1974, no. 365; Adhémar and Dayez-Distel 1979, 72, 164; Milkovich 1977, no. 14; Adhémar et al. 1980, no. 52.

Let us not forget no. 115 which shows a Prussian blue child with black legs that are unreasonably long.
L'Evénement, 6 April 1877

Monet, meanwhile, has submitted to the rue le Peletier a number of works that would be at home at the *Palais de l'Industrie* . . . [including] an *Intérieur d'appartement* full of flowers, in the middle of which a child materializes in a ray of blue light that passes through the glass of a large window.
La Petite Presse, 9 April 1877

The first painting I saw as I entered, and which genuinely charmed me, was by Claude Monet. It shows the interior of an apartment where the perspective is exaggerated. This painting could be called *Symphony in Blue*, for that color streams from the window across the floor in surprising abundance. I would not be surprised if a new kind of blue siccative under the brand name of Monet became the rage. Raphanel [*sic*] would turn over in his grave.
Louis Leroy, *Le Charivari*, 11 April 1877

[There is] an apartment interior that I barely like at all. Blue plays a disproportionate role, and I really had no idea that daylight, however late, would fill dining rooms and the young boy's eyes with such azure.
Jacques [pseud.], *L'Homme Libre*, 11 April 1877

56. Berthe Morisot

III—120

Tête de jeune fille, 1876
Head of a Girl

Now known as *Woman with Fan*
Signed lower right: *Berthe Morisot*
Oil on canvas, 24⅜ x 20½ in. (62 x 52 cm)
Collection of Mr. and Mrs. Alexander Lewyt, New York
REFERENCES: Bataille and Wildenstein 1961, no. 67;
Baltimore 1962, no. 83.

As we think of ourselves as being gallant to ladies, we have avoided mentioning Berthe Morisot's exhibition, which in the strangeness of its impressions, rivals Pissarro's—no mean feat!
L'Evénement, 6 April 1877

Too bad that Berthe Morisot has strayed among the Impressionists! Her initial studies miss, the drawing is off, but among these works, the tact and feeling for color cannot be denied.
Roger Ballu, *La Chronique des Arts et de la Curiosité*,
14 April 1877

Berthe Morizot [*sic*] is not without some talent, but she drowns herself in an excessive prejudice for white.
Baron Schop [Théodore de Banville], *Le National*, 8 April 1877

What Berthe Morizot [*sic*] has in her favor is that she can draw naturally when she wants to, and she uses color delicately. . . . Paint me young women in their slips admiring themselves in their mirrors, and similar subjects if you wish, but have the courage to paint them through to the end. A sketch will never be anything but a sketch.
Léon de Lora [Louis de Fourcaud], *Le Gaulois*, 10 April 1877

. . . then a bust of a pensive young girl dressed in black, who tilts her face slightly, her Japanese features of a fine and rosy texture.
Jacques [pseud.], *L'Homme Libre*, 12 April 1877

57. Ludovic Piette

III—132

Le marché de la place de l'Hôtel de Ville, à Pontoise, 1876
The Marketplace in Front of the Town Hall at Pontoise

Signed and dated lower left: *L. Piette 1876*
Oil on canvas, 43¾ x 73¼ in. (111 x 186 cm)
Musées de Pontoise. P.84.4
REFERENCES: Pontoise 1983, no. 27.

There is a great deal of light in the painting by Piette, even though his *Marché de la place de l'Hôtel de Ville* is rather dazzling. I prefer his *Marché aux vaches*, swarming with life and very fine, and his *Petit marché à Pontoise*, despite its disorderly composition. In short, Piette is a very serious artist who would do well not to exaggerate his *Impressionism*.
Paul Sébillot, *Le Bien Public*,
7 April 1877

Ludovic Piette is sometimes a little out of his element among the Impressionists. Among the canvases he is showing, we took note of a pretty *Marché à Pontoise*, on the place du Grand-Montroy. . . .
La Petite Presse, 9 April 1877

Piette is not just anyone, far from it. . . . There are, however, many weaknesses and mistakes among the numerous works he is showing.
Roger Ballu, *La Chronique des Arts et de la Curiosité*,
14 April 1877

Ludovic Piette is an artist who has captured the feeling of the swarming movement of a crowd. He is partial to the marketplaces. I have counted ten in his exhibition: a poultry market, a pig market, a cattle market, the arrival at the market, the departure from the market, etc. These paintings are picturesque and picaresque, when they are not too large and loose in technique. Perhaps one should object to their gaudy excess of colors.
Léon de Lora [Louis de Fourcaud], *Le Gaulois*, 10 April 1877

[Piette] has submitted thirty canvases, interesting for the profuse life you find there, the variety of characters, and the unusual accuracy of the sites. Among these he has included the *Marché de la place de l'Hôtel de Ville* in Pontoise.
Jacques [pseud.], *L'Homme Libre*, 11 April 1877

58. Camille Pissarro

III–166

Jardin des Mathurins, à Pontoise, 1876
Garden of Les Mathurins at Pontoise

Signed and dated lower right: *C. Pissarro. 1876*
Oil on canvas, 44⅜ x 65⅓ in. (112.7 x 165.4 cm)
The Nelson-Atkins Museum of Art, Kansas City, Missouri.
Nelson Fund. 60-38
REFERENCES: Pissarro and Venturi 1939, no. 349; Taggart and McKenna 1973, 163; Lloyd et al. 1981, no. 44.

Let us add to the list of works that deserve a serious look . . . *Jardin des Mathurins* by Camille Pissarro.
[Georges Lafenestre], *Le Moniteur Universel*, 8 April 1877

A room particularly furnished with the works of Pezzaro [*sic*], a primitive landscapist, is especially devoted to that particular blue that floats over the rest of the exhibition like a flag and a Masonic sign.
Bertall [Charles-Albert d'Arnoux], *Paris-Journal*, 9 April 1877

By Pissarro, the *Jardin des Mathurins à Pontoise* . . . and the *Moisson*, remarkable canvases.
La Petite République Française, 10 April 1877

59. Camille Pissarro

III–171

La plaine d'Epluches (Arc-en-ciel), 1877
The Plain of Epluches (Rainbow)

Now known as *De regenboog* (The Rainbow)
Signed and dated lower left: *C. Pissarro.1877*
Oil on canvas, 20⅞ x 31⅞ in. (53 x 81 cm)
Rijksmuseum Kröller-Müller, Otterlo. 615-19
REFERENCES: Pissarro and Venturi 1939, no. 409; Otterlo
1956, no. 560.

Let us also cite in the list of works that merit serious examination, the *Plaine d'Epenches* [*sic*]. . . . [Georges Lafenestre], *Le Moniteur Universel*, 8 April 1877

I will not list the Impressionist painters in order of merit, or I would have already mentioned Pissarro and Sisley, two landscape painters of great talent. In different ways, both exhibit some slices of nature that are strikingly true.
[Emile Zola], *Le Sémaphore de Marseille*, 19 April 1877

But Pissarro's landscapes cannot be deciphered either, nor are they less stunning [than Cézanne's]. Seen up close, they are incomprehensible and hideous; seen from a distance, they are hideous and incomprehensible. They are like a rebus that does not add up to any *word*.
Léon de Lora [Louis de Fourcaud], *Le Gaulois*, 10 April 1877

60. Camille Pissarro

III—180

La moisson, 1876
The Harvest

Now known as *La moisson à Montfoucault* (The Harvest at Montfoucault)
Signed and dated lower left: *C. Pissarro. 1876*
Oil on canvas, 25⅝ x 36⅜ in. (65 x 92.5 cm)
Musée d'Orsay (Galerie du Jeu de Paume), Paris. Gustave Caillebotte Bequest, 1894. R.F. 3756
REFERENCES: Pissarro and Venturi 1939, no. 364; Adhémar and Dayez-Distel 1979, 86–87, 89, 167; Lloyd et al. 1981, no. 45; Brettell et al. 1984, no. 97.

I am sorry to see Monet, Pisarro [*sic*], and Sisley overdo their own style. They seem to have decided to imitate Cézanne. However, I am happy to recognize the work of Pisarro [*sic*] in the *Moisson. . . .*
Paul Sébillot, *Le Bien Public,* 7 April 1877

61. Pierre-Auguste Renoir

III—185

La balançoire, 1876
The Swing
Signed and dated lower right: *Renoir. 76.*
Oil on canvas, 36¼ x 28¾ in. (92 x 73 cm)
Musée d'Orsay (Galerie du Jeu de Paume), Paris. Gustave
Caillebotte Bequest, 1894. R.F. 2738
REFERENCES: Daulte 1971, no. 202; Adhémar and Dayez-
Distel 1979, 96, 168–169; White 1984, 8, 73–74, 81, 132;
House et al. 1985, no. 39.

Unfortunately, placed next to
these pretty canvases is *La Balan-
çoire.* In it the effects of sunlight
are combined in such a bizarre
way that they exactly produce the
effect of grease stains on the fig-
ures' clothing.
L'Evénement, 6 April 1877

But I really think that his two
works, the *Balançoire* and his
Bal, are just mistakes. Renoir can
and should do better.
Paul Sébillot, *Le Bien Public,*
7 April 1877

Renoir is one of the prolific and
daring ones at the place.
I recommend his *Balançoire,* sub-
lime in its grotesqueness and in its
audacious impudence, and the
Bal du Moulin de la Galette,
which is in no way inferior to his
other work in its incoherence of
draftsmanship, composition, and
color.
Bertall [Charles-Albert
d'Arnoux], *Paris-Journal,*
9 April 1877

More blue! But this one is fright-
eningly intense. It has been
applied to the picture of a young
girl on a swing covered with azure
pom-poms. I hope you like pom-
poms, for the painter has scat-
tered them all over, in the sky, the
trees, and on the ground. And
everywhere the same ferocious
blue. This dizzying work was
signed by Renoir.
Louis Leroy, *Le Charivari*,
11 April 1877

The young girl of the *Balançoire*
is endlessly graceful in her spring-
time surroundings.
Jacques [pseud.], *L'Homme
Libre,* 12 April 1877

In his paintings *La balançoire* and *Le bal du Moulin de la Galette* . . . Renoir is engaged in slavishly presenting nature. At first glance, his canvases seem to have been in an accident during their shipment from his studio to the exhibition hall. They are flecked with round spots and are striped like a tiger here and there. On closer examination it is clear what the artist wanted to do: he is trying to render the effect of full sunlight falling through foliage onto figures seated beneath the trees. These round spots are supposed to look like the shadows cast by individual leaves. This is, I admit, a truly Impressionist enterprise, but in taking on such a struggle with nature, don't you expose yourself to an inexcusable and uninteresting defeat, because it is always ridiculous?
Roger Ballu, *La Chronique des Arts et de la Curiosité*, 14 April 1877

Valtravers: . . . (Pointing at the *Dame à la balançoire* by Renoir) What is that?
Doctor: Come on, let us go. The sight of these blue pom-poms is unhealthy.
Valtravers: I still would like to know what this painting represents.
Doctor: You would have to ask the painter, and still it is not clear that he knows.
Louis Leroy, *Le Charivari*, 14 April 1877

Renoir exhibits a large canvas showing the *Bal du Moulin de la Galette* on Montmartre. The painter has very accurately presented the boisterous and slightly disorderly scene at this open-air café with dancing, perhaps the last such café remaining in Paris. People are dancing in the spare small garden next to the mill. A great, brutal light falls from the sky through the green, transparent foliage, gilding blonde hair and pink cheeks, and tossing sparks onto the ribbons of the little girls. This light illuminates the painting all the way to the back with a joyful glow from which even the shadows take reflection. In the middle of all this light a crowd of dancers twists in the many postures of mad choreography. It is like the shimmer of the rainbow. You dream in front of this painting of that adorable Chinese princess of whom Henri Heine speaks, who had no greater pleasure than to tear fabrics of satin and silk into shreds with her fingernails polished to the luster of jade, and watch them as they swirled yellow, blue, pink, turning in the air like butterflies.
Ch. Flor O'Squarr [Oscar-Charles Flor], *Le Courrier de France*, 6 April 1877

. . . and because of our poor visual education we laugh blindly at *Les dindons* by Claude Monet, which resemble only puffs of smoke, and at the *Bal du Moulin de la Galette* by Renoir, where the figures dance on a floor that looks like those purple clouds that darken a stormy sky.
[Georges Lafenestre], *Le Moniteur Universel*, 8 April 1877

Do you like vibrant landscapes? I admit that I am unable to figure out what a vibrant landscape is, but since the Impressionist painters who opened their exhibition on the rue le Peletier the day before yesterday claim that they do vibrant work, so be it. It was necessary to find a surprising enough adjective to indicate such an unforeseen system. When you have done green hair, brick red flesh, turkeys like puffs of smoke and the dance floor at the Moulin de la Galette like a purple cloud, then you have done vibrant painting. Even if you cannot argue with taste, you at least can laugh at it, and this kind is really amusing. . . .
We spoke of the *Bal au Moulin de la Galette* by Renoir, and of the impression produced by its floor, a minor detail. What must be added is that, except for the search for peculiar tonalities, this painting has real value because of the skillful composition of its many figures.
La Petite Presse, 9 April 1877

A catalogue of 1869 informs us that Auguste Renoir is a student of Gleyre. We never would have guessed it. In his intelligent talks Gleyre used to tell his students that when Hercules was in love he spun wool at Omphale's feet, and about the terrors of Pantheus when the Maenads were after him. If he were still here, the master would be astonished that such teachings could have led Renoir to paint the *Bal du Moulin de la Galette*. But he would be even more surprised by the techniques of execution that his student has adopted.
Paul Mantz, *Le Temps*, 22 April 1877

The most important work, nevertheless, is the *Bal du Moulin de la Galette*. A dense crowd, some waltzing, the impetus of their whirling visible. Forming a line, others watch. Still others are drinking, happily seated at tables. Some nonchalant young girls, sitting where their laughing faces seem to lean outside the frame, amuse themselves by telling innocent trifles. In the shadow of a lightly sketched-in stage, the band plays and the luminous globes swing in the green leaves of the acacias. The clumps of leaves moving in the breeze break the horizon and set off the orchestra. These are humble female workers, good people of the suburbs enjoying themselves decently. Nothing unwholesome here. They are treating themselves to a day off and accept pleasure without a second thought. This, in an environment of lively, perfumed, clear tones—nothing excessive, no heaviness. This is the face of a corner of Paris in the nineteenth century that will endure.
Jacques [pseud.], *L'Homme Libre*, 12 April 1877

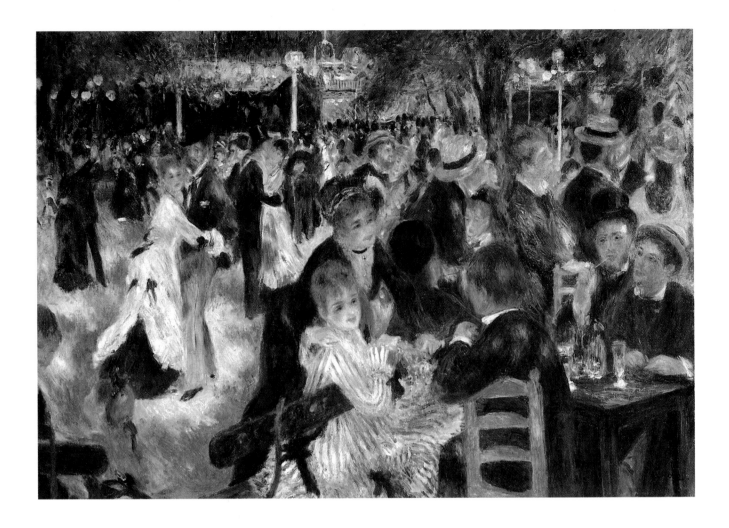

62. Pierre-Auguste Renoir

III—186

Bal du Moulin de la Galette, 1876
The Ball at the Moulin de la Galette

Signed and dated lower right: *Renoir./76*
Oil on canvas, 31 x 44½ in. (78.7 x 113 cm)
From the Collection of Mrs. John Hay Whitney, New York
REFERENCES: Daulte 1971, no. 208; Rewald (Whitney) 1983, no. 20; Kyoto 1980, no. 23.
Washington only
NOTE: The Moulin de la Galette, located on the Butte Montmartre at the base of the old windmill from which it took its name, was a popular open-air dancehall where young people gathered to waltz on Sunday afternoons. This is the smaller of two finished versions of this subject, the larger of which was probably exhibited as no. 186 in the third exhibition (now in the Musée d'Orsay [Galerie du Jeu de Paume], Paris, R.F. 2739). See Rewald, above.

Renoir is much more an Impressionist [than Degas]. In order to characterize him better, it would be necessary to call him a *Romantic Impressionist*. With his hypersensitive temperament he always fears to state too much. With a few well-placed touches in a painting like his *Bal à Montmartre*, he could highlight the stable elements—the chairs, benches, and tables. This would leave to the dancing or talking groups of people their truth of action, to the rays of sunlight their trembling splashes, and would impress the whole with that stamp of reality that is now missing.
Ph. B. [Philippe Burty],
La République Française,
25 April 1877

For additional quotations see previous page.

63. Pierre-Auguste Renoir

III–190

Portrait de M. Sisley, 1874

Now known as *Alfred Sisley*
Signed lower right: *Renoir*
Oil on canvas, 25¾ x 21⅜ in. (65.4 x 54.3 cm)
The Art Institute of Chicago. Mr. and Mrs. Lewis Larned
Coburn Memorial Collection. 1933.453
REFERENCES: Daulte 1971, no. 117; Chicago 1961,
395; Maxon 1973, no. 16; White 1984, 54, 74.

Some of Renoir's *Portraits* look
all right – at a distance – so that
you do not notice too much his
way of applying brushstrokes like
pastel hatchings and the peculiar
scratches that make his style seem
so painful.
Paul Sébillot, *Le Bien Public*,
7 April 1877

The series of portraits ends with
one of Sisley, one of the establish-
ment regulars. This portrait
achieves an extraordinary like-
ness and possesses great value as
a work.
Georges Rivière, *L'Impression-
niste*, 6 April 1877

64. Pierre-Auguste Renoir

III—195

La Seine à Champrosay, 1876

Now known as *Bords de Seine à Champrosay* (Banks of the
Seine at Champrosay)
Signed lower right: *Renoir*
Oil on canvas, 21 ⅝ x 26 in. (55 x 66 cm)
Musée d'Orsay (Galerie du Jeu de Paume), Paris. Gustave
Caillebotte Bequest, 1894. R.F. 2737
REFERENCES: Adhémar and Dayez-Distel 1979, 96, 168;
White 1984, 64, 73, 76—77.

La vue de la Seine à Champrosay
is a superb landscape, one of the
most beautiful ever done. No one
before has so strikingly given the
feeling of a windy autumn day.
Georges Rivière, *L'Impression-
niste*, 6 April 1877

I will be more reserved in my
praise of the *Seine à Champro-
say*, whose touch is quite brutal
despite its impression of truthful-
ness. It is the high grass of the
bank that ruins the river for me.
Jacques [pseud.], *L'Homme
Libre*, 12 April 1877

III–214

65. Alfred Sisley

Scieurs de long, 1876
Pit Sawyers
Signed and dated lower right: *Sisley. 76*
Oil on canvas, 19⅝ x 25⅝ in. (50 x 65.5 cm)
Musée du Petit Palais, Paris. 484
REFERENCES: Daulte 1959, no. 230.

Sisley is cold and a little pale. He lacks light and plastic strength. But one senses that he loves nature and makes an effort to produce sincere impressions of it. I recommend in his exhibition no. 214, titled the *Scieurs de long*.
Charles Bigot, *La Revue Politique et Littéraire*, 28 April 1877

Of those by Sisley . . . above all the *Scieurs de long*, a charming picture, of which we hope to see some companion pieces.
La Petite République Française, 10 April 1877

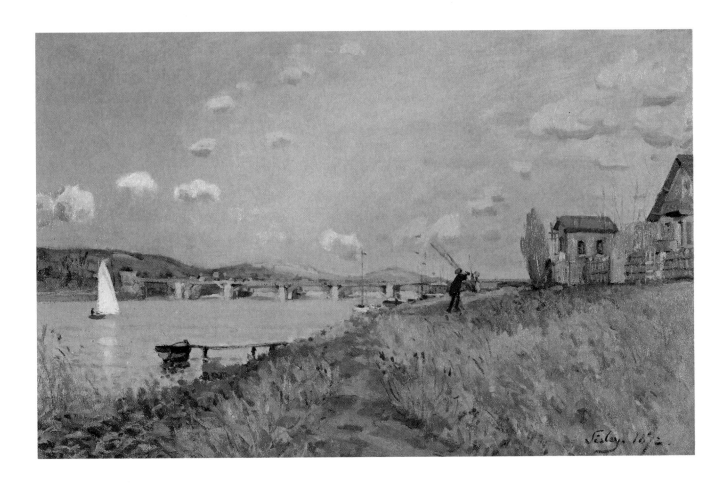

66. Alfred Sisley

III—220

Le pont d'Argenteuil en 1872
The Bridge at Argenteuil in 1872
Signed and dated lower right: *Sisley 1872*
Oil on canvas, 15¼ x 24 in. (38.5 x 60.9 cm)
Memphis Brooks Museum of Art, Memphis, Tennessee. Gift of
Mr. and Mrs. Hugo N. Dixon. 54.64
REFERENCES: Daulte 1959, no. 30; Thomason 1984, 113;
Milkovich 1977, no. 26; Lloyd 1985, no. 5.

This year, Sysley [*sic*] has more
paintings than last. Nevertheless,
he has not been prodigal with his
charming talent—there are ten
canvases at most. In all of them,
one finds the same taste, delicacy,
and tranquillity. . . .
Several landscapes of scenes
under overcast skies, some in
unsettled weather, some sunny
landscapes, and a very harmoni-
ous one creating snowy effects
complete Sysley's show.
Georges Rivière, *L'Impression-
niste*, 14 April 1877

The Fourth Exhibition *1879*

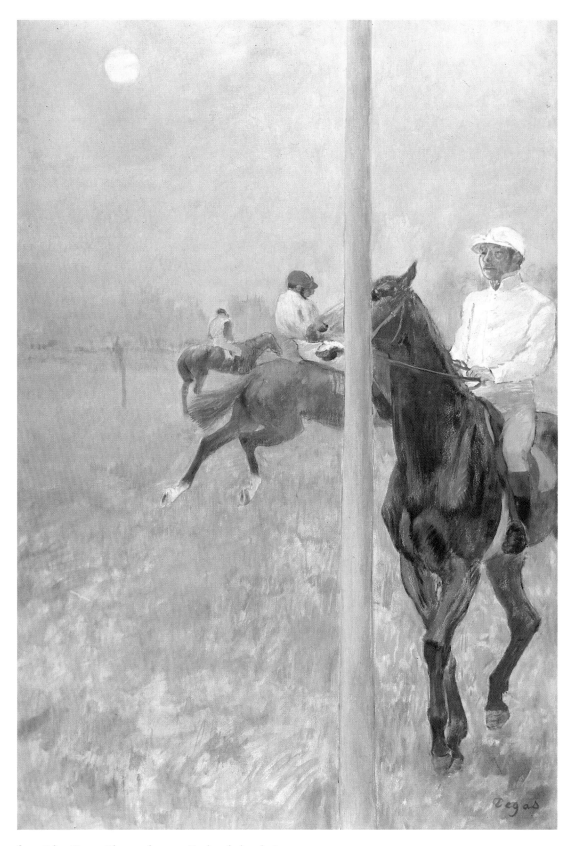

fig. 1 Edgar Degas, *Chevaux de course* (*Jockeys before the Race*,
IV–63), 1869–1872. Oil, essence, with touches of pastel on paper,
42⅛ x 28¾ in. (107 x 73 cm). The Barber Institute of Fine Arts, The
University of Birmingham

Contemporary Popularity
and Posthumous Neglect

Ronald Pickvance

While the fourth group exhibition may have lacked the trail-blazing bravado of the first, the substantial presence of the second, and the expansive panache of the third, it possessed many elements that give it a modest claim to historical significance. To a large extent, however, these have been obscured by decades of historians' neglect. A curious phenomenon surrounds the fourth show: later writers have seemed reluctant to delve more deeply into its history. No one has made any comment on the rooms chosen for the show at 28 avenue de l'Opéra (whereas Nadar's studio and Durand-Ruel's gallery have entered into Impressionist mythology). No one has attempted to reconstruct the hanging or the lighting of the show (whereas Rivière walked us through the galleries in 1877). And, given the scanty press reviews that have been quoted, whether in histories, monographs or catalogues raisonnés, it seems that no one has been interested in taking seriously the responses of the critics.[1]

There may also be the suspicion that without Renoir, Sisley, Cézanne, and Berthe Morisot, the fourth show was less adventurous, less brilliant, and less provocative than the previous three. And, retrospectively, it could be argued that slumps in standard, commitment, and group ethos, caused by secessions and compromises, characterized the show of 1879, and the shows of 1880 and 1881 as well.[2] They lacked the compact stylistic unity and weighty group presence of 1882, and the curiously piquant and heterogeneous styles of 1886.

Yet no exhibition that could boast Degas's *Portrait de M. Duranty* (in Duranty, "The New Painting") or his *Chevaux de course* (fig.1), Monet's two celebratory paintings—*La rue Montorgueil, fête du 30 juin* (fig.2) and *La rue Saint-Denis, fête du 30 juin* (fig.3), Pissarro's *Printemps. Pruniers en fleurs* (fig.4), Caillebotte's series of boating on the Yerres (e.g., cat. no.67), Mary Cassatt's set of women in theater boxes (e.g., cat. no.71), and—a distinctive feature—the many fans by Degas, Forain, and Pissarro (e.g., *figs.5* and 6), could be thought dull or second-rate. What has been in doubt is whether Degas, for example, actually included any but a small proportion of the twenty-five works listed in the catalogue.

In the critical reaction to the show, there appears to be nothing comparable to Edmond Duranty's brochure of 1876 or Georges Rivière's special periodical of 1877. Yet Caillebotte was able to send Monet some thirty reviews by 1 May.[3] An exhibition that tempted the formidable pens of not only Duranty (in what proved to be his last review), but also Diego Martelli (his only review), Philippe Burty, Armand Silvestre, and Ernest d'Hervilly (all regulars since 1874), the widely known Arsène Houssaye, and the lesser-known Alfred de Lostalot, Edmond Renoir, and Paul Sébillot, as well as the reactionary triumvirate of Charles-Albert d'Arnoux [Bertall], Louis Leroy, and Albert Wolff, cannot easily be dismissed. In re-evaluating the show, the contributions of some of these art critics need to be emphasized. Certainly, it is quite misleading to rely solely on the pronouncements of Joris-Karl Huysmans and Emile Zola in 1879.

Another reason for the relative neglect of the 1879 show may be that the events leading up to it have not been viewed in correct sequence. There was, for example, a serious and concerted effort to stage a show in 1878, the year of the International Exhibition in Paris. This has certainly been underplayed: even Théodore Duret's *Les peintres impressionnistes*, published in May 1878, could have been intended as a piece of accompanying propaganda had that attempt succeeded. By giving due weight to these ultimately abortive attempts in 1878, it is possible, for instance, to date convincingly an important letter by Mary Cassatt, to suggest a new order for Pissarro's letters of that year, and to offer some new observations on one of Degas's notebooks.[4]

An account of the events of 1878 is an essential prelude to a reconstruction, based largely on artists' letters, of the genesis of the fourth exhibition. An examination of the most significant press reviews will then be followed by an attempt to identify and to evaluate the works submitted by the five major artists—Caillebotte, Cassatt, Degas, Monet, and Pissarro. And finally, the achievement of the fourth group show will be considered afresh.

Caillebotte's own serious commitment to the organization of a group show in 1878 was already clear by the

end of 1876. In the first paragraph of his will, dated 3 November 1876, he announced,

It is my wish that there be taken from my estate the sum necessary to hold, in 1878, in the best possible conditions, the exhibition of the painters known as Intransigents or Impressionists. It is rather difficult for me to evaluate this sum today; it could go up to thirty, forty thousand francs or even more. The painters who will figure in this exhibition are: Degas, Monet, Pissarro, Renoir, Cézanne, Sisley, Mlle Morizot (sic). I name these without excluding others.[5]

The most obvious interpretation of Caillebotte's plan is that he was assuming that the Impressionist exhibitions would continue to take place every two years. Hence, after those of 1874 and 1876, 1878 would follow. However, it was already known by November 1876 that Paris would witness an International Exhibition (a world's fair) in 1878. Caillebotte was ensuring that his friends would have their own exhibition at that time. There is a further factor. Plans for a third group show in spring 1877 were already laid at least two months before Caillebotte made his will. To have taken a decision as early as September is unusual in the general pattern of each group exhibition's genesis.[6] (In 1876, and again in 1879, it was February before matters got moving.) Since the third show was assured when he wrote his will, Caillebotte demonstrates an even firmer and more determined stance against the official exhibition of 1878.

Events after the close of the third group show in May 1877 did not materially help the realization of his hopes. Sales from that show had been few. Less than a month later, four of the participants, Pissarro, Renoir, Caillebotte, and Sisley, decided to hold an auction of forty-five of their paintings. Caillebotte's was a token presence (he included only four works), supporting the far greater financial needs of Pissarro, Renoir, and Sisley. But prices were disastrously low.[7] A further blow to the artists' hopes followed in August 1877 with the bankruptcy of Ernest Hoschedé, one of their most important patrons since 1872. Duranty wrote to Zola, "The Hoschedé disaster will evidently disturb the camp of our Intransigent friends, but they are regaining some possibilities from Chocquet's side, whose wife—I am told—will some day have an income of 50,000 francs."[8] And in November 1877, Murer organized a lottery among his clients with a Pissarro painting as first prize.[9]

Myths of the Impressionists' penury and near destitution over a prolonged period have been exaggerated. But if material suffering had any substance in the decade of the 1870s, then it would seem to have had its greatest impact around 1878. This impression may be the greater because of the sudden abundance of surviving letters that year, many of them begging money, especially those of Monet and Pissarro.[10]

But the crisis of Impressionism was not just compounded of material difficulties. It also had a strong ideological basis. There were those artists who valued the exhibitions as a modest guarantee of getting their work seen—and who hoped for some sales; those who wanted a group identity, a narrowing of focus on shared aims and assured quality; those who conceived of the exhibitions as decisive alternatives to the Salon, so much so that they stipulated that those artists who submitted to the Salon should not be allowed to exhibit with the group; and those who were greatly tempted by the prospect of a return to the Salon. Allegiances, commitments, beliefs—all could change radically.[11]

But once 1878 arrived, neither a disappointingly poor public auction, nor a bankrupt patron, nor a small-time lottery, nor ideological differences could shake the resolution of a small coterie of artists to realize Caillebotte's wishes.

The earliest documented proof of their serious intent is, curiously enough, a letter from one American artist to another. On 10 March 1878, Mary Cassatt replied to J. Alden Weir's invitation to participate in the first exhibition of the Society of American Artists in New York:

Your exhibition interests me very much. I wish I could have sent something, but I am afraid it is too late now. We expect to have our annual exhibition here, and there are so few of us that we are each required to contribute all we have. You know how hard it is to inaugurate anything like independent action among French artists, and we are carrying on a despairing fight and need all our forces, as every year there are new deserters.[12]

The "new deserters" were potentially Renoir, Monet, Cézanne, and Desboutin. Degas had introduced a new condition, that no artist intending to exhibit with the group should send anything to the Salon. He referred to this when writing to Caillebotte, probably in late March:

I saw Mme Manet [i.e. Berthe Morisot] this morning. She renounces sending to the Salon. She had been told that Monet renounced, as did Renoir, etc. She had not received any notice of the meeting at Legrand's and was surprised. As to the date of 1 June, she, like me, finds that excellent. Naturally, we wish to stock our walls. I will go to see the apartment tomorrow.[13]

The important meeting at Legrand's was clearly designed to approve the Salon edict, to agree upon a list of participating artists, to decide on an opening date, and to begin looking in earnest for possible exhibition rooms.

This meeting took place on 25 March, as we learn in a letter from Cézanne to Zola. Early in March Cézanne left Paris for the South. On 28 March he wrote from L'Estaque, "There will probably be an Impressionist show; so would you please send in the still life you have in your dining room. In that connection, I received a convocation letter for the 25th of this month, rue Laffitte. Naturally, I wasn't there."[14]

It must have been in the wake of the group meeting

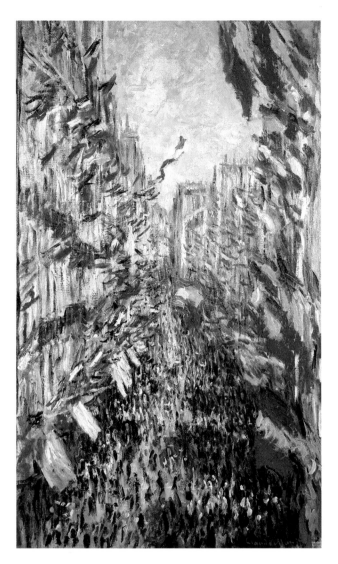

fig. 2 Claude Monet, *La rue Montorgueil, fête du 30 juin* (*Rue Montorgueil, Celebration of 30 June 1878*, III–145), 1878. Oil on canvas, 59¼ in. x 31½ (150.5 x 80 cm). Private collection, Paris

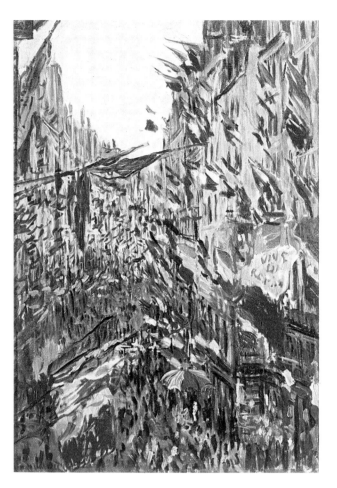

fig. 3 Claude Monet, *La rue Saint-Denis, fête du 30 juin* (*Rue Saint-Denis, Celebration of 30 June 1878*, IV–154), 1878. Oil on canvas, 29⅞ x 20½ in. (76 x 52 cm). Musée des Beaux-Arts, Rouen. Photo: Giraudon/Art Resource, New York

that Degas listed thirteen artists' names in his notebook. It read: "Caillebotte, Monet, Pissarro, Sisley, Degas, Mme Morisot, Cézanne, Guillaumin, Mlle Cassatt, Rouart, Tillot, Levert, Desboutin."[15] One notable absentee is Renoir. In the last week of March, he had evidently decided to desert and to submit work to the Salon. Cézanne's name, however, is present; as he told Zola on 28 March, he still wished to exhibit.

It must also have been in late March that Pissarro wrote to Caillebotte.

Like you, I think that, given the exceptional year, there would be no inconvenience in waiting until 1 June for our exhibition. We need men of talent—who are deserting us—we also need new pictures, but what I advise you is to warn the interested ones immediately so that they can set to work. M. Chocquet had announced to me that Cézanne would send to the Salon, failing an Impressionist exhibition. . . . I received a note from Cézanne asking me to send certain pictures of his to our exhibition. As for Zola, I have heard nothing of him. Zola perhaps is pushing Cézanne at the Salon, just as the Charpentiers are pushing Renoir. Couldn't we stage our exhibition alone? For we shall have to expect some defections. . . . I would like to see Monet on this subject—I regret it, I fear a complete disbandment later. You have heard Monet himself who is afraid of exhibiting. If the best artists slip away, what will become of our artistic union? Monet believes that this prevents us from selling—but I hear all the artists complaining, so that is not the cause. Let us make good pictures, let us not exhibit sketches, let us be

very disciplined with our pictures—that is better, don't you think? For the public's discouragement with the most beautiful sketches is a pretense.[16]

Pissarro's reference to a projected opening on 1 June puts this letter close in date to Degas's. The defections of Renoir and Cézanne were to be expected (though it is revealing that the Charpentiers were already pushing Renoir at the Salon of 1878). Monet, while not sending to the Salon, had clearly lost the conviction that a group exhibition was a worthwhile project. But Pissarro's letter —one of his best—demonstrates his own undivided commitment, his wholehearted concern about the possible dissolution of the group, and his emphasis on the need to produce and exhibit pictures (*tableaux*), not sketches (*esquisses*). Caillebotte's reply is lost.

Pissarro's enthusiasm increased after the opening of the International Exhibition on 1 May. He reported to Eugène Murer:

I saw Caillebotte this morning. He is excited about the idea of an exhibition, since his visit to the International Exhibition has persuaded him that ours could only gain from the comparison. I believe that the moment has never been more propitious, for it is shameful not to see a single master well represented.[17]

The notion of an opening on 1 June was still very much alive. But toward the middle of May, Pissarro told Caillebotte,

I have seen Degas. We talked of our affair; he doesn't think it impossible. He has nothing ready, but in one or two months he will have some new things to show. According to him, on the contrary, an exhibition now would be a flop, because all the crowds go to the Champ-de-Mars, but a moment will come when the Parisians will end by demanding something else. As for the foreigners, there are so few who are concerned about us, they would be by contrast very ready to come to see us, if only out of a feeling of curiosity. Our public, adds Degas, is always the same, a small nugget that is concerned about us. It will come back faithfully to our show; the autumn would be a favorable time.[18]

The proposed June opening was delayed and autumn was now suggested by Degas. Yet Degas had nothing ready for exhibition. Pissarro complained, "I don't understand, knowing the importance of an exhibition, that he hasn't the smallest drawing to show."[19]

Some encouragement for a June opening must surely have come from the publication of Duret's brochure, *Les peintres impressionnistes.* This slim volume appeared in May and could well have been conceived as an accompaniment to the projected exhibition. It is not known if Degas talked of Independents in 1878; but for Duret, at least, the artists were "Impressionists." And he confined the group to five artists—Monet, Renoir, Sisley, Pissarro, and Morisot. That it acted as a boost to the Impressionists was affirmed by Manet, writing to Duret that

summer, that "They need it badly, for the pressure is tremendous at the moment."[20]

But more discouragement followed. On 5–6 June 1878, the enforced sale of Hoschedé's collection, including some sixteen works by Monet, thirteen by Sisley, and nine by Pissarro, saw some disastrously low prices.[21] It is hardly surprising that nothing was heard of the exhibition project until August. And by then, even Pissarro had lost heart.

Useless to count on our exhibition, it would be a flop. At Durand-Ruel's, where there is a collection of masterpieces by our most famous masters, not a soul, the most complete indifference. People have had enough of this dreary art, of this exacting, stupid painting which demands some attention, some thought—all that is too serious.[22]

The combined efforts of Cassatt, Degas, Caillebotte, and Pissarro had been in vain; the project was abandoned.

By early February 1879 at least, plans, however vague, were afoot for a fourth exhibition. The Italian art critic, Diego Martelli, in an article written on 1 February, commented, "We will have this year, in March or April, an exhibition of the Impressionists richer than usual, although several of them, for reasons of convenience, are abstaining from participating."[23]

Presumably things did not move very quickly in February; we have no evidence of meetings or exchanges of letters. Certain matters were probably agreed upon, especially the principle of not submitting work to the Salon. Happily, the survival of some ten letters written between 10 March and 10 April affords glimpses of what happened in the month before the exhibition opened.

The first clear indication occurs in a letter of 10 March from a very discouraged Monet to de Bellio. "I am giving up the struggle as well as all hope; I don't have the strength to work any more under these conditions. I hear that my friends are preparing a new exhibition this year; I renounce taking part in it, not have done anything that is worth being shown."[24] Four days later, Sisley wrote to Duret,

I am tired of vegetating, as I have been doing for so long. The moment has come for me to make a decision. It is true that our exhibitions have served to make us known and in this have been very useful to me, but I believe we must not isolate ourselves too long. We are still far from the moment when we shall be able to do without the prestige attached to official exhibitions. I am, therefore, determined to submit to the Salon.[25]

After these despondent and negative responses, a more optimistic letter from Degas to Caillebotte sets the stage for negotiations. It is undated, but was probably written on 16 March:

Sisley declines. I saw Pissarro this morning; Cézanne is

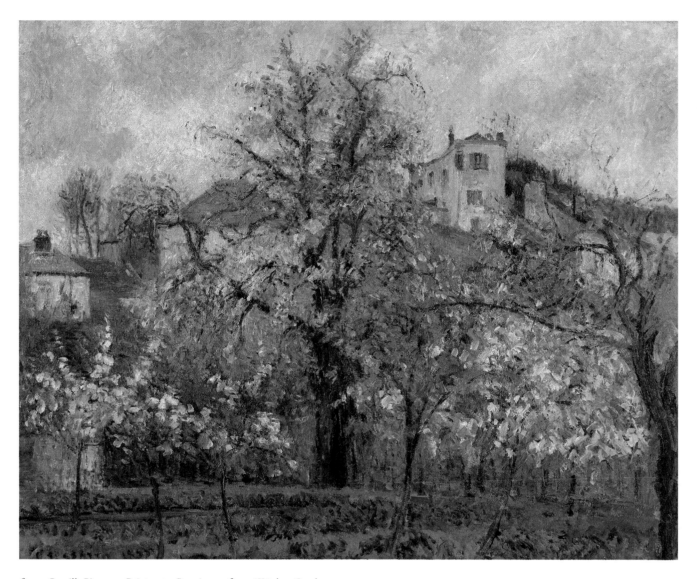

fig. 4 Camille Pissarro, *Printemps. Pruniers en fleurs* (*Kitchen Garden and Trees in Blossom, Spring, Pontoise*, IV–183), 1877. Oil on canvas, 25¾ x 31⅞ in. (65.5 x 81 cm). Musée d'Orsay (Galerie du Jeu de Paume), Paris. Gustave Caillebotte Bequest, 1894

going to arrive in several days, and Guillaumin will see him then. Monet still only knows one thing–that he is not sending to the Salon. Manet has persuaded a lady whose portrait Forain is painting that the place of Forain was not with us. . . . Amen for little Forain. Mlle Cassatt is seeing Mlle Morisot tomorrow and will know her decision. We are therefore almost certainly: Caillebotte, Pissarro, Mlle Cassatt, Mlle Morisot, Monet, Cézanne, Guillaumin, Rouart, Tillot, Levert, Raffaëlli, Zandomeneghi, Maureau, Bracquemond, Cazin, Degas, Mme Cazin. If you have the time, come and see me during the day tomorrow or, if you haven't the time, come to May's house tomorrow evening; we will talk. Write to Belloir, if you think we cannot have anything cheaper.[26]

Shortly before sending this letter to Caillebotte, Degas

made a list of artists' names on a page of his notebook.[27] It is virtually identical to the list he gave Caillebotte. But as things developed over the following weeks, he cancelled some names and added others, began a numbered list, then abandoned it, and spilled over with more names onto the adjoining page. It is clear proof of his wholehearted involvement with the preparations for the fourth show.

Also, it must have been around mid-March, soon after receiving Degas's letter, that Caillebotte wrote to Monet, trying to lift him from his mood of extreme despair and encouraging him to exhibit:
Try then not to discourage yourself like that. Since you are not working, come to Paris, you have time to collect all the possible pictures. I will take care of M. de Bellio. If

fig. 5 Edgar Degas, *Eventail (Fan Mount. The Ballet*, IV–77, cat. no.76) ca. 1879. Watercolor, india ink, silver, and gold on silk, 6⅛ x 21¼ in. (15.7 x 54 cm). The Metropolitan Museum of Art. Bequest of Mrs. H. O. Havemeyer, 1929. The H. O. Havemeyer Collection

there isn't a frame on the "Drapeaux," I will take care of it. I will take care of everything. Send me a catalogue [a list of works] immediately, or rather send it to M. Portier, 54 rue Lepic. Put down as many canvases as you can. I wager that you will have a superb exhibition. You get discouraged in a frightening way. If you could see how youthful Pissarro is! Come.—And your catalogue? You have no need to have seen all the owners of your pictures to make your catalogue. Simply give the list of those you wish to include. I will spend the week running around for you if you wish. . . . [28]

Caillebotte's enthusiasm and resolution raised Monet's morale—and persuaded him to change his mind. Monet announced to Murer on 25 March, "I should have refused to take part in our last exhibition, having nothing to show there: it is only reluctantly and in order not to be thought a slacker that I have relented." [29]

Monet's participation, however unwilling, was assured. But what of Cézanne and of Guillaumin, who, Degas wrote, would see Cézanne on his return to Paris? Cézanne had left Paris in March 1878, taking his mistress, Hortense Fiquet, and their young son to the South. He remained a year, mostly at L'Estaque, returning to Paris some time towards the end of March 1879. Evidently Pissarro then took it upon himself to try to persuade Cézanne to join the group. But Cézanne had

already submitted to the Salon; and since Degas had stipulated that no one exhibiting with the group should send work to the Salon, Cézanne wrote briefly to Pissarro on 1 April,

I think that amidst all the difficulties caused by my sending to the Salon, it will be more convenient for me not to take part in the exhibition of the Impressionists. I am sending you my greetings pending the moment when I can shake hands with you in person. [30]

And it must have been at this time that Guillaumin decided not to exhibit; perhaps he, too, had submitted to the Salon. His name, along with that of Cézanne, had been crossed out in Degas's notebook list.

Without Cézanne and Guillaumin, as well as Renoir and Sisley, the exhibition was fast running out of names—though Degas thought of Lhermitte, Destrem, and even Clairin. It was probably after receiving Cézanne's refusal—and also, possibly, Guillaumin's—that Pissarro consulted with Degas, and they decided to invite Paul Gauguin to join the group. Gauguin's reply is dated 3 April—a week before the exhibition was due to open.

I accept with pleasure the invitation which you and M. Degas were kind enough to send me and, of course, under these circumstances shall observe all the rules established by your association. In taking this decision, I hold my dues at your disposal. . . . [31]

In late March or early April, Diego Martelli wrote to
his artist-friend Francesco Gioli, in Florence, where Gioli
was organizing an exhibition in his studio,
*Here [in Paris], curious coincidence, opens on 10 April
the exhibition of the old Impressionists, who this year
have taken the more reasonable name of Independents.
This year, thanks to Degas, they have introduced an
innovation that replaces the question of the narrow char-
acter of a research into the manner of painting by the
more comprehensive one of each artist painting in his
own manner, outside the sphere of official protection and
favors. Thus, whoever exhibits with the Independents
must renounce the Salon. "The Salon, there's no such
thing," says Degas. A very fine first floor is already pre-
pared at 28 avenue de l'Opéra, and there will be about
200 works. Among the exhibitors will be: Mme Bracque-
mond, Mlle Morisot, Miss Cassatt, M. Bracquemond,
Degas, Caillebotte, Pissarro, Monet, Zandomeneghi,
Lebourg, Forain, etc. etc., Piette (deceased). The condi-
tion of not exhibiting at the Salon has provoked several
desertions, among them Renoir, Desboutin. . . . Degas
will send you the poster with the plea that you stick it on
your door, and if you send me yours it will be stuck on
their door. . . .*[32]

Martelli's list of exhibitors still included Berthe Mori-
sot. Morisot is often said to have refused to participate in
the show because of the birth of her daughter, Julie, in
November 1878. Clearly, her decision could not have
been as simple and clearcut as that. In his letter of mid-
March Degas told Caillebotte that Mary Cassatt would
see Mlle Morisot "tomorrow and will know her deci-
sion." In Degas's notebook list, where many names are
erased, hers is not. Martelli's mention of her name still
leaves the matter open. And writing to Bracquemond in
early April, Degas cajoled, "There is one room with *fans,*
do you understand Mme Bracquemond? Up to now, Pis-
sarro, Mlle Morisot, and I are depositing things there.
You and your wife should contribute too."[33]

What happened to the fans by Berthe Morisot? Her
name is not in the catalogue and her absence from the
walls of the exhibition was noticed by several critics. Did
she suddenly decide to withdraw her work—fans only,
presumably—at the last moment?

If Morisot did a *volte-face*, then so did Forain. Per-
suaded by Manet—according to Degas—not to exhibit,
and with his name erased in Degas's notebook list, Forain
nonetheless decided to join the group for the first time.
Other late additions, absent from Degas's notebook and

Martelli's letter, were Henri Somm and Adolphe-Felix Cals. Who invited them, and why, is uncertain. But Cals at least provided a spirited defense of his decision to contribute.[34]

When the exhibition opened on 10 April, there were sixteen exhibitors—Bracquemond, Mme Bracquemond, Caillebotte, Cals, Mlle Cassatt, Degas, Forain, Lebourg, Monet, Pissarro, Rouart, Somm, Tillot, Zandomeneghi, and Gauguin and Piette (both *hors catalogue*).[35]

It seems to have been a fairly rushed and often improvised affair, concluded in four weeks, with Degas, Caillebotte, and Pissarro the chief instigators, and we are left in the dark as to how certain decisions were arrived at. For instance, it is unknown how the premises at 28 avenue de l'Opéra were chosen. Presumably, something like this happened:

The little group of Independents bravely continues its peregrinations through the unoccupied entresols of Paris. Usually M. Degas leads the caravan. About February, he goes out to look, consulting the noticeboards and interrogating the concierges. – "Do you have a free apartment in the house?" – "Yes, sir." – "Would the proprietor consent to let it for a month?" If the proprietor agrees, M. Degas gives a sign to his companions. The interior decorator is informed immediately. As many works are collected as a drawing-room, a dining-room, two bedrooms, a bathroom and a kitchen could contain. A turnstile is installed in the ante-room and the day for the opening is fixed.[36]

The rooms that were rented at 28 avenue de l'Opéra were considerably grander than these. Martelli described them as "on the first floor, very beautiful, of a newly built house."[37] In fact, the avenue de l'Opéra had only just been created in 1877. A more prestigious locale could hardly have been found.[38] Degas made several quick plans of the apartment in his notebook. Not only was Belloir the "tapissier-décorateur" called in to prepare the rooms, but the Compagnie Jablochkoff[39] may have installed electric lighting—though no evening openings were advertised.

As for the poster, Degas made four drafts in his notebook.[40] He began tentatively: "4ᵉ Exposition/faite par/un groupe d'artistes." He then broadened the concept: "4ᵉ Exposition/faite par/un groupe d'artistes indépendan[ts]/réalistes/et/Impressionnistes/28 Av." He then removed "réalistes" and "Impressionnistes." His final draft read:

4ᵉ Exposition
faite par un
Groupe d'artistes Indépendants
28 Av. [enue de l'] Opéra
du

On 9 April, the day before the opening, "all the walls of Paris were covered with superb posters, where this title [Artistes Indépendants] shone in immense letters."[41] No

names of artists were displayed, just the title, venue, and dates. Having achieved this arresting image for the 1879 poster, Degas was furious when, the following year, Caillebotte insisted on including the artists' names. The colors used in the starkly simple poster of 1879 remain a mystery (in the 1880 poster they were bright red letters on a green ground). Unfortunately, no copy has survived.[42]

For his part, a relieved and buoyant Caillebotte wrote to Monet at the close of the exhibition's first day,
I am sending you some newspapers. I am excluding those where there are only some announcements. We are saved. By five o'clock this evening receipts were more than 400 francs. Two years ago on the opening day—which is the worst—we had less than 350. Tomorrow or the day after we will have an article in Le Figaro. There's no need to point out to you certain ridiculous circumstances. Don't think, for instance, that Degas sent his twenty-seven or thirty pictures. This morning there were eight canvases by him. He is very trying, but we have to admit that he has great talent. There are some marvelous things. I hope that you will come to Paris between now and the close and see the show.[43]

The press announcements that Caillebotte refrained from sending to Monet on 10 April were soon followed by the art critics proper. Their responses were by no means entirely hostile, derisory, or uncomprehending. Inevitably, Albert Wolff did his best to be all that and more in *Le Figaro*. In a brief, four-paragraph review, he denounced them as "furious madmen," always making sketches and never pictures, lambasting Monet as the author of these "pochades primesautières," Degas as being in the decline of his career, "always giving promises and nothing but that," and the group of Independents as "independent of all study, all science, all truth, and all good sense." He noted that the more gifted, Sisley, Renoir, and Morisot, had deserted; and that Manet had been wrongly called the chief of the Impressionists, he who has "more talent than the whole of the little church," and who had never wished to exhibit with the so-called Independents, thus showing how little he thought of their talent.[44]

In *Le Soleil*, also of 11 April, Emile Cardon predicted merely a "success of mad laughter." But unlike Wolff, Cardon did find some paintings "full of real qualities." In particular, he picked four paintings by Monet, as well as the work of Cals and the drawings of Lebourg.[45]

Three days later, Bertall wrote a long review for the *Paris-Journal*, which was subsequently reprinted in *L'Artiste* of June 1879. For Bertall, Manet, as the "first inspirer of this curious group," was "nothing but an opportunist." Formerly the incontestable leader, he had pushed out the boat that contained his disciples, and now M. Caillebotte took "with a firm hand the boat's tiller." M. Caillebotte, "a charming young man, and one of the

best brought up, has an income of a hundred thousand francs"—and that helped guarantee independence. Bertall then devoted three paragraphs to Caillebotte's paintings, followed by briefer mentions of Monet, Degas, Forain, Zaudomenechy [sic], Lebourg, and Cassatt—not a word on Pissarro. He dismissively summed up the show: "There reigns in this exhibition a gentle and amiable madness ["une folie douce et aimable"], which is not dangerous, and serves to keep alive frame-makers and canvas and color merchants."[46]

More serious, sympathetic, and, indeed, supportive reviews were composed during these first days of the show. Renoir's younger brother Edmond, for example, wrote warmly of it in *La Presse* of 11 April.[47] It contained, he asserted, a certain number of quite remarkable works by Monet (to whom Edmond Renoir devoted half his review), Degas, and Pissarro. To the briefest mention of Forain, Caillebotte, Rouart, and Cals was added a paragraph on Mary Cassatt, critical of her compositional gambits and colored frames. Nevertheless, the exhibition of "Impressionists"—Renoir never once called them "Independents"—"gave us the liveliest pleasure to visit."

Ernest d'Hervilly, writing in *Le Rappel* of 11 April, also headed his article "Impressionists," and made no play of "Independent."[48] Like Edmond Renoir, he gave particular praise to Monet ("landscapes having as much delicacy as accent"), and then picked out for brief mention the majority of the rest, including Pissarro and especially Cassatt.

A rather world-weary view characterizes Philippe Burty's piece in *La République Française* of 16 April.[49] He admires the tenacity of the artists in mounting a fourth show. But he doubts that it offers the same curiosity value as the previous three. This is not only due to the absence of Morisot, Sisley, and Renoir, but also because there are no really extreme paintings, neither "portraits en flammes de punch" nor "paysages acides comme des plats d'oseille." Burty is critical of Caillebotte's hastily brushed landscapes; he finds Pissarro's fans too coarse for women. Monet remains the gifted one; Degas (with only three works hung when Burty visited), "éminent, rare, spirituel, et grave." Cassatt's portraits are "worthy of serious attention," as is the work also of the Bracquemonds, Somm (*fig.7*), and Forain.

These early critical opinions virtually balance the camps "for" and "against." Armand Silvestre, like Burty, a well-seasoned and usually favorable and understanding critic who had witnessed all the previous shows, also wrote on 16 April in *L'Estafette*.[50] He briefly touched on Monet, Pissarro, Cassatt, Caillebotte ("le plus intransigeant, sans comparaison du groupe"), and Forain, before warmly praising the work of Degas. The public, Silvestre thinks, has become more accustomed to "this summary translation of external things" and is no longer much

surprised as it was at the earlier exhibitions. For himself, Silvestre concludes, "I am still in favor of what I have already said: 'If this is the alphabet of a new pictorial language, so much the better! If it is the whole language, so much the worse!' "[51]

Perhaps the most revealing review—certainly the longest—was that appearing in *Le Gaulois* of 18 April. The author was Montjoyeux, the pseudonym of Jules Poignard, compiler of "Chroniques Parisiennes" rather than art critic, whose small literary output included one novel and one play. His article combines a defense of the group against such attacks as Bertall's ("une folie douce et aimable") with a more positive attempt to characterize it, emphasizing that these are artists without grandiose ambitions or the desire to play roles, simple men who produce amazing works like the young Naturalists in literature. He discusses the financing of the show—the installation has cost eight to ten thousand francs; Belloir, the interior decorator, has not dreamed of asking for a sou, and Caillebotte, who is rolling in money, will not be needed, as the daily receipts are never below seven hundred francs. Most revealing, however, are Montjoyeux's pen-portraits of the four major artists—Degas, Monet, Pizzaro [sic], and Caillebotte:

Degas is a bachelor of forty-five years. The quietest man in the world who will certainly not pardon me for having included him in this melee. All the spirit that he has does not prevent him from having an antipathy bordering on horror for every kind of publicity. He does not imagine that the press can take hold of any man without inflicting on him the stigma of a third-rate actor. "We are not hams." It is not necessary to have spoken an hour with M. Degas to be aware of his favorite phrase. Weakness of a strong man, in short. But [in] this hour . . . put this talker on his own ground; speak painting to him. . . .

fig. 7 Henry Somm, *Calendrier de 1879* (*Calendar for 1879*, IV–229), ca. 1879. Drypoint. Photo: Bibliothèque Nationale, Paris

You will have heard the most brilliant, the most marvelous improvisation you have ever dreamed of. No one, up to now, has written a book that is worth a quarter of what he says. And what brio! What verve! This New Orleanist is the most brilliant lecturer in Paris. One recognizes the same man in conversation as one sees in his paintings. One finds the same originality. . . .

[Monet is] thirty-seven years old. Married and father of a family. He is a handsome dark-haired man, with a pretty beard made for pretty fingers to pass through. Having lived for a long time at Argenteuil, he has been for a year at Vétheuil, near la Roche Guyon.

One of the most exceptionally gifted painters. Artistic temperament, tense to breaking-point. The neurosis of the times has touched him. Capable of powerful enthusiasms, and subject to invincible disgusts. Floating now between the exaltations of triumph and the prostrations of defeat. He had his day of glory at the Salon with his Femme verte. *Since then, he has voluntarily retired from official ambitions. Manet, "le grand Manet," has called him the "Raphael of water."*

M. Pizzaro [sic] is older, although his energy belies his fifty years. Beautiful apostle's head, whitened in the unceasing fight for tomorrow. Married also, and father of many children, he divides his time between Pontoise and Paris. Integrity makes the man, and courage makes the artist. Contrary to Monet [he is] firm as a rock, not knowing either weariness or loss of belief. Surer of himself than the others, not asking more than to believe in good and dream of the future. Poor as Job and prouder than he.

Finally, M. Caillebotte, the youngest—hardly thirty years old. Former student of Bonnat, in whose studio he was still when, three years ago, he showed his Raboteurs *at Durand-Ruel's. . . . It caused a stir, if I remember, at least among the artists. . . . The Impressionists warmly welcomed him. . . . He entered into the melee like a spoilt child. Assured against misery, fortified with this double strength: will served by wealth. . . . His apartment in the boulevard Haussmann, which could be luxurious, has only the very simple comforts of a man of taste. He lives there with his brother, a musician.*[52]

None of the other exhibitors are even mentioned by Montjoyeux. But he does attempt an analysis of the nature of *The New Painting*, actually paraphrasing several chunks out of Duranty's *La nouvelle peinture*.[53] It was surely Caillebotte who helped prepare the article. And it was Caillebotte who wrote on 17 April, *Monsieur, I must thank you for your article of this morning, so much the more as you are the only one, this year, who has defended us, and you have done it very decisively. The press has perhaps recognized that the struggle would be long, for those who have supported us until now have disappeared or have abandoned us. . . . P.S. I much regret that you forgot Miss Cassatt and a word for*

this year's absentees: Cézanne, Renoir, Sisley, and Mlle Morizot [sic]. Thank you all the same.[54]

Montjoyeux spoke of "five large, high, well-lit rooms." But only one critic attempted a room-by-room review of the show, thus enabling one to reconstruct something of the hanging. The first room, according to Henry Havard's account in *Le Siècle* of 27 April, was badly lit ("obscure"). It contained Lebourg's *fusains*, Rouart's drawings, and Piette's watercolors. The second showed Mme Bracquemond's three cartoons for the large ceramic, *Les muses des arts*, shown at the Champ-de-Mars in 1878, Degas's pictures, and Forain's watercolors ("gouachées," adds Havard). In room three, all eleven works by Mary Cassatt were hung (Havard mentions no other artist in this room), and in room four, Tillot and Zandomeneghi. In the fifth and last room were the "grands prêtres de l'*impressionnisme*," Monet and Pissarro.[55]

In a postscript, Havard apologizes for not having mentioned Caillebotte. He does not say where Caillebotte's work was hung, only that it covered the walls and was spread on easels. He also omitted Cals, Lebourg's oils, Bracquemond, Somm, and Gauguin.

Havard is reasonably sympathetic and not irrationally uncomprehending. Monet and Pissarro he cannot accept ("impressions vagues et turbulentes"); he comments on the experiments of Degas—his technique, subjects, and framing; and he is guarded in his praise of Mary Cassatt. In trying to define Impressionism, or the "movement," or "the new school," he, too, as did Montjoyeux, takes his cue from Duranty, but from the Duranty who had recently reviewed the show himself, not the Duranty of *La nouvelle peinture*.[56]

Writing in *La Chronique des Arts et de la Curiosité*, the supplement to the *Gazette des Beaux-Arts*, on 19 April, Duranty was the only critic to give his article the same title that Degas had given the exhibition on the poster: *La Quatrième Exposition faite par un Groupe d'Artistes Indépendants*. He reminds himself and his cultivated readers that his position is difficult, as he may be suspected of parti pris (because of *La nouvelle peinture*) towards these artists. He quickly defines "indépendant" —as free of official organization, involving an undertaking not to show at the Salon. He applauds the existence of artists' societies (such as the newly founded Aquarellistes) that will accustom the public to exhibitions throughout the year and not just at the time of the Salon. And then, playing the art-critic's in-game, he confesses, *I will put myself first of all under the aegis of M. Paul Mantz, who, two years ago, devoted to the artists a very long and fairly benevolent article in the newspaper Le Temps. I hope then that if I follow his example in a short article, I shall not be anathematized.*[57]

This is not merely a salute (as it appears on the surface), however belated and apparently sincere, to

Mantz's review of the third group show. It is a deliberate reminder to those cultivated readers of *La Gazette des Beaux-Arts* of Mantz's scholarly articles on the Old Masters. And it could also carry a greater ironical sting. Mantz refused to review the fourth show for *Le Temps* because he found it of too little interest.[58] Duranty, it would seem, was well aware of Mantz's decision.

And Duranty, for his part, maintains a gentle, unpolemical, and generally conciliatory tone. He distinguishes between the Impressionists and the others. The majority of the Impressionists had tried the Salon this year, leaving only three: Monet, Pissarro, and Caillebotte. In spelling out the nature of Impressionism his general argument repeats elements he discussed in his section on color in *La nouvelle peinture*, for instance, on the decomposition of light.[59] He sees "this school of *plein soleil*" pursuing "arduous experiments which resemble the experiences of a chemist or a physicist."[60] And on their individual achievement: Monet is "very alive, very subtle, and very skillful," Pissarro "is gifted with a fine sensibility and great delicacy"; curiously, now, direct links exist between Monet and Théodore Rousseau, between Pissarro and Millet. Duranty does not explain further, nor does he name a single work by either of them. Caillebotte is criticized for his blue-violet excesses, but Duranty finds a certain cruel intensity of effect in some of the portraits.

Yet despite his impersonal, detached tone, Duranty is the one critic who takes the trouble to mention every artist, including Gauguin and his "small agreeable sculpture, the only sculpture in the show." He regrets the absence of Berthe Morisot, "whose painting much attracts M. Mantz." But he never refers to the fans exhibited by Degas, Forain, and Pissarro. Of Degas, he foretells his high place in a few years and reports the influence he has had on the success of at least twenty other painters. (His failure to mention his own portrait was not self-effacing, simply part of his strategy not to discuss specific works.) Mary Cassatt's portraits he finds very English in their elegance and distinction. Duranty's conclusion, after he had picked out trends and influences, defined characteristics, and alluded to affinities (e.g. Israels and Cals) is simply that there are four major artists in the show—Monet, Pissarro, Degas, and Cassatt.

Duranty trimmed his sails to suit his cultivated readership. Another former friend of Courbet's, Louis Leroy, did no such trimming. Still writing for *Le Charivari*, Leroy found no compulsion to pull his punches, nor, at the age of sixty-eight, to alter his opinions. His method remained the same: select a few pictures and gently mock or satirize them (he was a successful and facile popular playwright). Caillebotte—the butt of all critics, Burty and Duranty, as much as Bertall and Leroy—is savagely lampooned. Forain, Cassatt, and Degas (the last most useful for identifying some of his works) receive brief mentions;

Monet gets a paragraph; and among the "faux frères" Leroy puts Tillot, Cals, and, of all people, Pissarro![61]

Of more serious import is Alfred de Lostalot's review in *Les Beaux-Arts Illustrés* of 26 April. He devotes some space to arguing the esthetics of Impressionism and to summarizing intention and objective. (This may well have influenced the young Jules Laforgue.) De Lostalot also makes the highest claims for Degas *before* Huysmans's Salon review in *Le Voltaire*. He writes with sympathetic insight of Mary Cassatt, and he alone tells us of Antonin Proust's purchase of her *Femme lisant* (cat. no.72). He writes much less on Monet and Pissarro than his friend Duranty, but he too is critical of Caillebotte's "ferocity" and "unfortunate tendency to see everything in blue."[62]

Launched during the first week of the fourth group show and published by Charpentier, the weekly illustrated periodical *La Vie Moderne* might have been construed as a committed defender of the "new painting." Even so it found an old hand to do its work: Armand Silvestre reworked his piece in *L'Estafette* and it reappeared in *La Vie Moderne* of 24 April.[63] Far more interesting is a second article by Silvestre in the following number of 1 May. Here, he mentions that the exhibition has been enriched with some new works and by Degas's completing his submission. *Miss Lola, au Cirque Fernando* [sic] (cat. no.74) is then described and a new *Ecole de danse*.[64]

Also on 1 May a longer review appeared in *L'Artiste*. Although entitled "Salon de 1879," it was given over entirely to a review of the Independents; and although signed "F.-C. de Syène," there was little problem in decoding the pseudonym. It was no less than Arsène Houssaye, the same who had so stoutly defended Monet and Renoir in 1870, but had not written on them since. Houssaye had lost nothing of his zeal and parti pris. He still overtly lauds Monet, and has no "blue" or "violet" quarrels with Caillebotte; he applauds Degas and Cassatt, but sums up Pissarro in one brief sentence. Like Duranty, he runs through all the exhibitors, often at greater length and frequently citing individual works—though he fails to mention Gauguin. His review combines an attempt to analyze the new painting with the now familiar argument that it had influenced and penetrated the Salon.[65]

The exhibition closed on 11 May. At least two critics, each with germane things to say, went into print after that date. In *La Plume* of 15 May, Paul Sébillot wrote a relatively short but generally approving notice, which is also valuable for its observations on individual works by Degas, Monet, and Pissarro.[66]

A much longer contribution—an essay, in fact—appeared in *Revue des Deux Mondes*, also on 15 May. Dismissing the predominance of "ébauches" and "pochades," without naming Monet or Pissarro,

Georges Lafenestre was fiercely critical. He commented on the desertion of Renoir and Desboutin to the Salon (and was surprised to find the Bracquemonds), and defined the group as merely "a stray group of stragglers from the battalion of the *Realists*." And in what must have been a veiled critique of Duranty, Lafenestre asserts, *Our Independents are in reality only isolated late-comers, bursting through already-open doors, plaintiffs of won causes. They are not the only ones either to know how to make a subtle analysis of the phenomena of light, or to know how to place things in their true milieus. . . .*[67]

Both the latter were key points in Duranty's *La nouvelle peinture*. The only good Lafenestre could find was in the work of Degas and Cassatt.

Lafenestre's essay appeared two days before Huysmans's first review of the Salon in *Le Voltaire*. There, Huysmans reversed the argument, parading—disconcertingly for his readers—his dismissive contempt for the Salon and applauding unreservedly the achievement of Degas and Cassatt. (Was all this in turn a riposte to Lafenestre and a defense of Duranty?) Such in-fighting, where some measure of a critic's worth, judgment, and parti pris can be deduced, is outside the scope of this essay. So also are the critics' varied attempts to define the "movement," "group," or "school"; or their shifts and changes in response (were Burty and Silvestre less enthusiastic than in 1874?); or their wider views in the context of the Salon. The critics' reactions to *one* show have been synoptically presented. (And by no means have all reviews of 1879 been tracked down.)[69] Notwithstanding, their comments on the *work* exhibited by the five major artists prompt the question of how and why those artists chose the works they did.

In deciding on the nature and scale of their individual contributions, each artist was faced with a perplexing set of alternatives: whether to show a large "exhibition-picture," such as Monet's *Japonnerie* of 1876 (II–153) or Renoir's *Bal du Moulin de la Galette* of 1877 (cat. no.62), or to present as part of the selection a concentrated series of smaller pictures, such as Monet's Gare Saint-Lazare paintings; whether to concentrate exclusively on recently completed work, say of the previous year, or to offer a mixture of recent and older work, in some instances extending over fifteen years, so that something like a mini-retrospective might result (this could also involve the retouching of older canvases, as well as the inclusion of Salon-refused pictures such as Monet's *Déjeuner* in 1874 [I–103] or his *Les bains de la Grenouillère* in 1876 [II–164]); and whether to make a conscious distinction between "sketch" and "picture," as Pissarro exhorted Caillebotte in March 1878, "Let us make good pictures, let us not exhibit sketches. . . ."

Also facing each artist were the problems of whether

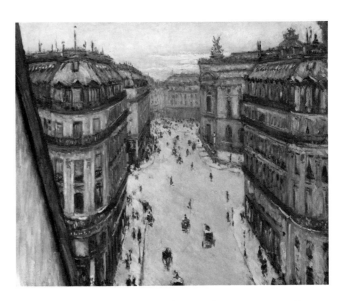

fig. 8 Gustave Caillebotte, *Rue Halévy, vue d'un sixième étage (Rue Halévy Seen from the Sixth Floor*, IV–14), 1878. Oil on canvas, 23 ½ x 28⅞ in. (59.7 x 73.3 cm). Photo: Courtesy of Wildenstein and Co.

to choose work from the studio, thinking in terms of potential sales, or to borrow from distinguished collectors (as Monet did from Faure in 1876), thus giving their work a certain prestige that might send other collectors to the studio; whether to base some of their selection on the idea of direct rivalry with fellow participants, or to agree beforehand on work that would blend with that of others (for instance, fans in 1879, etchings in 1880); and whether to show paintings exclusively, or to create variety by including pastels, gouaches, watercolors, graphics, and sculpture.

In facing these alternatives, some artists were more concerned than others. Monet left it entirely to Caillebotte. Cassatt, in her debut, was advised by Degas. Pissarro, above all, had to strike the right balance.

Caillebotte, on the other hand, with no financial problems, was more of a free agent. Nineteen paintings and six pastels were listed in the catalogue, a half dozen of the group borrowed from private collectors. Only his more recent work was selected; five paintings are dated 1877, eleven 1878.[70] He divided his pictures into three groups. First was a series on boating and bathing, taken not on the Seine at Argenteuil or Chatou, but south of Paris on the Yerres, near Montgeron, where both Hoschedé and Caillebotte's family had a country house. Second were three views of Paris, two of roofs seen from a studio window, the third a typically daring perspective exercise—a view of the rue Halévy seen from the sixth floor (*fig.8*). Finally, he made a group of eight portraits. Within this selection, Caillebotte included three large decorative panels, stimulated by the example of Monet's *Déjeuner* in the 1874 show and his *Les dindons* in that of 1877 (cat. no.53). These were meant to have the most arresting

CHEZ MM. LES PEINTRES INDÉPENDANTS, PAR DRANER.

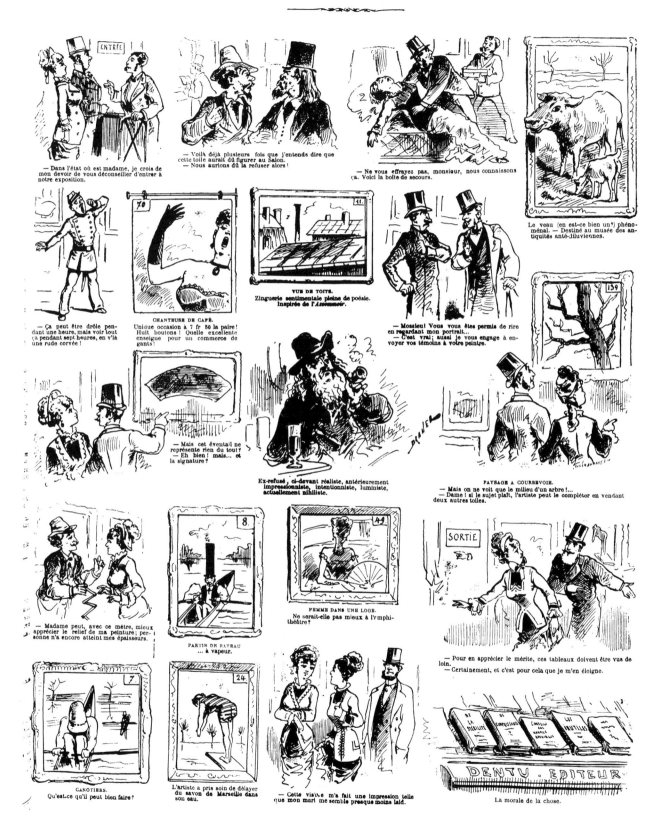

fig. 9 Draner [Jules Renard], "Chez MM. les peintres indépendants,"
Le Charivari (23 April 1879)

impact. As it turned out, few critics bothered even to mention them; none took them at all seriously; and Draner satirized the oil *Baigneurs* (IV–24; *fig.9*).

In fact, Draner and several critics were much more tempted by a large, curious, and unique painting in Caillebotte's oeuvre that showed a life-size cow and a goat in a field. Shown *hors catalogue*, it was universally scorned and ridiculed.[71] It no longer exists: perhaps in disgust Caillebotte destroyed it soon afterwards. Critical response to Caillebotte was largely hostile and uncomprehending. Even such allies of the movement as Burty and Duranty found the work difficult to take. Only Edmond Renoir (in a brief sentence), Silvestre, and Houssaye registered the slightest sympathy or appreciation. The critics' hostility towards Caillebotte must have affected his judgment of their coverage of the show as a whole.[72] He complained to Montjoyeux of their total lack of understanding. Despite this, he still sent Monet some thirty reviews. His final comment, however, was on the "malevolence of the press."[73]

Clearly Caillebotte had tried to follow Pissarro's injunction to make pictures, not sketches. It must have been especially galling to have Burty call his canvases hastily brushed, and consider it fatuous for him to present them as pictures.[74] But in effect, Caillebotte's exhibit in 1879 was the single most important one of his lifetime, both in terms of the number of works shown as well as their imposing scale.[75] Bertall mentioned some thirty-five works (all beautifully framed), Martelli approximately forty, while Havard described how they were shown on easels as well as hung on the walls. Not surprisingly, several critics decided that his display would have gained more from showing less.

Mary Cassatt showed no such indulgence or prodigality. It was her debut—although she had been part of the abortive plans for a show in 1878. And it remained an annus mirabilis that she would recall a quarter of a century later.[76] Her selection must have been made in consultation with Degas. Written in his hand on one of his notebook pages is a list of eleven works by Cassatt; on adjacent pages, he listed his own. Cassatt listed eleven works in the catalogue, and, according to Havard, she exhibited eleven. Yet the transitions from notebook to catalogue to exhibition walls were not smooth: changes in title, possible substitutions, and a probable addition make it difficult to suggest clear-cut identifications for every work.[77]

Cassatt exhibited two male protraits, an oil of her father, and a pastel of Moyse Dreyfus. She chose an outdoor scene, *Dans un jardin* (IV–56), described as a gouache by Degas, but called "couleur à la détrempe" in the catalogue and convincingly identified by Martelli.[78] She concentrated, however, on women and young girls in theater boxes: three such were catalogued, and a fourth almost certainly added *hors catalogue* (*fig.10*).[79] The rest were portraits and studies of young women and young girls, only one of which can be identified with certainty.

There was a remarkable consistency in Cassatt's presentation; the portraits were generally life-sized, head-and-shoulders or half-length. Formats were modest, and there was no attempt to create a stir by producing a large picture. Except for the portrait of her father, all the works were recently completed, and only one was borrowed—from Henri Rouart. There was a nice balance of media, seven or eight oils, one distemper painting (clearly done under Degas's influence), and three pastels; nothing was untoward in facture, nothing crudely offensive, or abruptly declamatory.

One painting, *Femme dans une loge* (cat. no.71), was constantly picked out by the critics. Draner included it among his caricatures—in the process converting a vertical canvas into a horizontal one. D'Hervilly's description will stand for others by de Lostalot, Silvestre, Leroy, and Houssaye: "A young red-headed woman, in a theater box backed by a mirror that reflects the brilliantly illuminated theater, is the picture by this bold painter that visitors find the most striking. Here there is a modeling of flesh by reflections that reveals a very individual talent."[80] This contrasted with a sour reaction from Edmond Renoir, who thought the mirror reflection served no purpose.

Few of her other pictures received such close critical scrutiny. *Femme lisant* (cat. no.72) was called "a charming work" by Silvestre and "a miracle of simplicity and elegance" by Houssaye. Sébillot thought the portrait of her father "well-observed, very serious."

But Mary Cassatt did cause a stir with her frames. These were variously painted—one (IV-48) in vermilion, another (cat. no.71) in green.[81] For Edmond Renoir (again!) "her frames were smeared with red or green," were "very ugly and in the worst taste." D'Hervilly, on the other hand, found her portraits "ingeniously framed."

fig. 10 Mary Cassatt, *Coin de loge* (*Corner of a Theater Box*, drawing after IV–HC), 1879. *La Vie Moderne* (1 May 1879): 54

Cassatt enjoyed an astonishingly successful debut. As her father wrote from Paris to his son in Philadelphia on 21 May,

In addition to my letters I have also sent you a number of newspapers, art journals etc. containing notices of Mame,–Her success has been more and more emphasized since I wrote and she even begins to tire of it–. . . . Every one of the leading daily French papers mentioned the Exposition & nearly all named Mame–most of them in terms of praise, only one of the American papers noticed it and it named her rather disparagingly!!![82] Her critical success was capped by the purchase of *Femme lisant* by Antonin Proust.

Degas's involvement in the organization of the fourth exhibition was absolute. In many ways, it was his show, with the inclusion of his "pupils" Cassatt, Forain, and Zandomeneghi, the adoption of "Independent" instead of "Impressionist," and the exclusion of those artists who submitted to the Salon. Many facets of his close concern are reflected in his notebook jottings–lists of participants, drafts for the poster, plans of the rooms at 28 avenue de l'Opéra, and lists of Cassatt's intended contribution and of his own.

His notebook list ran to twenty-five numbers–and so did the printed catalogue. But as with Cassatt, notebook and catalogue do not necessarily coincide. However, the variations are slight and do not substantially alter the nature of Degas's choice.[83] Pissarro, much surprised, had said in May 1878 that Degas had nothing available, not even a drawing, for exhibition. If that were really true, then much of what Degas intended to present to the 1879 show must have been completed in the previous twelve months. He could, of course, borrow works, and he could include older works.

Degas's selection was dominated by eight portraits, only one of which was lent, Ernest May's *Portraits, à la Bourse* (cat. no.73). All were recently completed, two very recently. One drawing for the portrait of Duranty was dated 25 March 1879; one for that of Diego Martelli (*fig.11*) was dated 3 April, a week before the show opened. Another documented picture is the portrait of Miss LaLa, the studies for which are dated January 1879.[84] He included seven dance and theater subjects, one of which (lent by Brame) dated from 1874 (IV–72),[85] the rest being arguably 1878–1879. Recent also were his one racetrack picture (IV–63), and his single café-concert subject (IV–70), the latter lent by Camille Groult, a distingushed collector of eighteenth-century French art. His one laundress picture (cat. no.75), lent by the actor Coquelin Cadet, could be earlier in date. But almost certainly executed during the previous year were the five fans (IV–78–81 and cat. no.76).

So the sum of his contribution was a few earlier pictures, in addition to eleven borrowed from collectors; they included a variety of subject matter that, even

fig. 11 Edgar Degas, *Portrait de M. Diego Martelli (Portrait of Diego Martelli*, IV–57), 1879. Oil on canvas, 43½ x 39⅛ in. (110 x 100 cm). National Gallery of Scotland, Edinburgh

without a nude, a café interior, or a modiste, compared in range and quality with his selections for 1876 and 1877, and were offered in a wide combination of media, with the use of *détrempe* prominent for the first time.[86]

Critics said little about individual works. There are only four mentions of dance pictures, for example, but those mentions by Silvestre are crucial for identifying two major rehearsal scenes.[87] Otherwise, the laundresses and the café-concert singer receive most comment, the latter, with her disconcerting black glove, caricatured by Draner. Silvestre's allusion to "the semi-lunar brightness that bathes the *Chevaux de course*, number 63" helps identify another picture (*fig.1*).[88] The fans, new though they were to Degas's public image, caused little critical flutter, occasioning only a string of half sentences.[89]

But the most amazing omission was the critics' failure to discuss the portraits. Duranty's portrait is twice cited, but without description or analysis. The portrait of Ernest May on the steps of the Paris stock exchange *may have* been referred to by Louis Leroy when he wrote, "this man's hat, under which, after the most conscientious researches, I found it impossible to find a head." And that is all. Yet it does seem obvious that Degas was staking a very strong claim as a portrait painter in 1879. In many ways, this was the most significant year of his entire career for portraits.[90]

The critics' near-silence prompts the question: were all

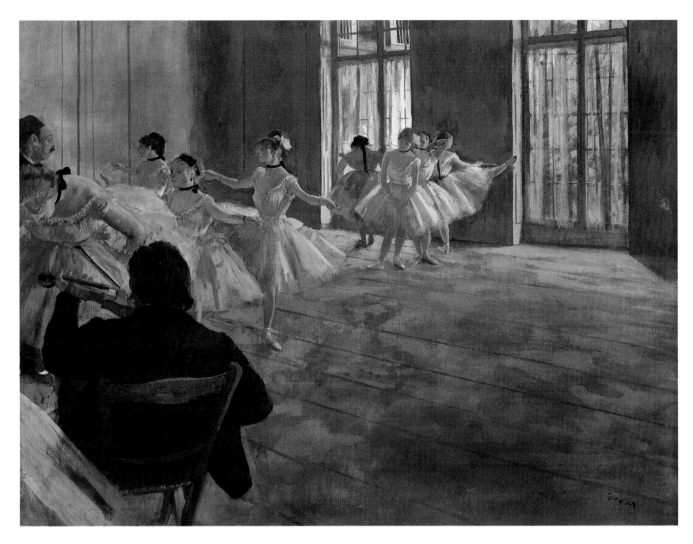

fig. 12 Edgar Degas, *Ecole de danse* (*Dance School*, IV–65), ca. 1874. Oil and tempera on canvas, 17 x 22½ in. (43 x 57 cm). The Shelburne Museum, Shelburne, Vermont. Photo: Ken Burris/Shelburne Museum

the portraits exhibited? And, further, how many of the listed twenty-five works did Degas actually show? Some answers can be pieced together from the critics' remarks. Burty reported only three works hanging when he visited the show—the *Blanchisseuses portant du linge en ville* (cat. no.75) and two *Ecole de danse* (cat. no.45 and *fig.12*). And it seems probable that Caillebotte wrote of *three* works, not eight, in his letter to Monet of 10 April. By 13 April the *Chanteuse de café* (IV-70) was hanging. By 17 April, Leroy added a "pochade de femme," and the top hat in *Portraits, à la Bourse* (cat. no.73). By 18 April when Montjoyeux visited, the *Portrait de M. Duranty* (Duranty, "The New Painting"), the *Chevaux de course* and some fans were to be seen. So just over a week after the opening, thirteen works can be accounted for (if we assume all *five* fans were displayed). Nothing more of substance was added until 1 May, when Silvestre made

the most revealing statement, that "M. Degas . . . has completed his submissions."

Among the late additions described by Silvestre were the portrait of Miss La La (cat. no.74) and *Ecole de danse* (*fig.12*).[91] Discounting the fans, only ten works were cited by the critics. But their silence, especially towards the portraits of Martelli, Mme Dietz-Monnin, Henri-Michel Lévy, Halévy, and Cavé, may have a simple explanation: the vast majority of the reviews had been written by the time Degas decided to hang the paintings.

As for Monet, already in 1878 he was disenchanted with the idea of group exhibitions. Increasingly he felt they no longer served any useful purpose.[92] This belief was not mitigated by his pressing family problems. He left Argenteuil in January 1878; his wife, Camille, gave birth to their second son in March, her health giving rise to considerable anxiety. Monet's private life was made

even more complicated by his involvement with the Hoschedé family, especially his possible liaison with Alice Hoschedé; in August, all members of the Monet-Hoschedé households moved to Vétheuil. Increasingly depressed about Camille's illness and despairing of his own work, he refused to exhibit. At Caillebotte's insistence, however, he sent a list of collectors' names and was cajoled into selecting some of his own recent paintings. He never came to Paris during the preparations nor did he visit the exhibition.[93] His contribution depended in great part on Caillebotte's ability to persuade owners to lend. As it finally materialized, his twenty-nine paintings actually represented—unintentionally, no doubt—his first mini-retrospective.

There were three parts to it: works before 1878, Paris works of 1878, and recent paintings of Vétheuil and Lavacourt. The early section opened with a marine of 1865 (fig.13), wrongly dated 1875 in the catalogue, lent by Duret, and an *Etude de mer* (IV-163), probably of 1867, lent by the artist Antoine Guillemet.[94] The largest picture in the group was the *Jardin à Sainte-Adresse (1867)* (cat. no.81); and with it a view of his aunt's garden nearby (IV–155). A big still life of flowers of 1869 was lent by Henri Rouart (cat. no.78), and a view of Trouville of 1870 (cat. no.80) was lent by the artist Ernest Duez. One of Monet's finest Zaandam pictures of 1871 (IV–138) was followed by his notorious *Effet de brouillard, impression*, lent by de Bellio (IV–146), and four Argenteuil paintings of 1875, three of them snowscapes (IV–159, 160, and 165). From Monet's stay in Paris in 1878 were two views of the Seine (IV–153 and 150), a view of the parc Monceau (IV–152), and the two canvases celebrating the fête of 30 June. His most recent work of Vétheuil and Lavacourt consisted of twelve paintings. Only five of these came from Monet's studio, his sole contribution to the show.[95]

There are several surprises in the critical response to Monet. Qualities are found in his marines of the mid-sixties: Silvestre finds stylistic kinship with Manet in the *Marine* (fig.13). Leroy surprised himself by admiring the *Estacade de Trouville, marée basse* (cat. no.80): "This study is very refined tonally, very accurate, very successful."[96] Yet against all expectations, no one referred to the *Jardin à Sainte-Adresse (1867)* (cat. no.81), the most finished of this early group, and the most prominent, given its large size. The Argenteuil paintings were completely ignored. Perhaps the biggest surprise was that only Edmond Renoir cited *Effet de brouillard, impression*, without recalling its presence in the first exhibition. And how did Leroy miss it?

Leroy, however, joined a considerable band of fellow-critics in singling out Monet's two canvases celebrating the fête of 30 June; *La rue Montorgueil* (fig.2) and *La rue Saint-Denis* (fig.3). "Impressive tours de force," according to Edmond Renoir. "It would have been

fig. 13 Claude Monet, *Marine* (*The Green Wave*, IV–140), 1865. Oil on canvas, 19⅛ x 25½ in. (48.6 x 64.8 cm). The Metropolitan Museum of Art. Bequest of Mrs. H. O. Havemeyer, 1829. The H. O. Havemeyer Collection

difficult to better capture the changing play of colors of the thousands of flags, lanterns, and garlands that filled our dear Paris that day." To Ernest d'Hervilly, they were "works of an absolutely remarkable truth, forcefulness, and reality." Furthermore, "the immense and joyful palpitation of the tricolors repeating themselves endlessly, the surge and agitation of a celebrating populace covering the sidewalks and pavements—all of this has been rendered in a manner that can be called masterful." For Burty, "His *Rue Montorgueil* . . . disappearing beneath the tricolored foliage of the flags is a composition and work of a master." And for Silvestre, Monet "has recovered all his verve and audacity in the two canvases of the *Fête de drapeaux*. What a teeming crowd under the banners, and how the wind makes them ripple in the light! One thinks of a storm and the waves beating a ship with tricolored sails."[97] Silvestre then recalled the comparable painting of the boulevard des Capucines of 1873.

Not one of Pissarro's works enjoyed such critical acclaim. Leroy appeared kind, commenting on "some sincere studies where the gray touches are marvelous," but then classed him as "a traitor" with Tillot and Cals. Burty, severely, Montjoyeux and d'Hervilly, approvingly, alluded briefly to the series of fans. D'Hervilly also picked out "the large landscape, at once so frank and so fine." Edmond Renoir, expansive on Monet, managed one sentence: "Pissarro is an excellent landscape painter; his banks of the Oise River at Pointoise have great character." Houssaye too was brief: "Pissarro . . . splashes the riches of the rainbow over a series of landscapes and artless fans." Silvestre maintained the brevity, but at least

mentioned two paintings: "Of Pissarro, I will point out the *Saules inondés* (*fig.14*) and the truly exquisite little landscape identified as number 186."[98] Sébillot was kindest: "Pissarro seems to be working in a less tortured direction than in his preceding exhibition, and his *Port-Marly* (IV-186) and his *Le pont de Pontoise* (IV–167) remind me of the qualities I liked in his earlier paintings."

Not only is this a disappointingly poor critical harvest, it also provides little help in trying to reconstitute Pissarro's contribution, which, with thirty-eight works listed in the catalogue, was the largest of all. Just four paintings are mentioned, a large canvas (unidentified by d'Hervilly), *Port-Marly* of 1872, *Le pont de Pontoise*, and Silvestre's *Saules inondés*.

It is the greatest irony that Pissarro, whose letters are so revealing on the plans and intentions for the abortive show in 1878, should be so sparsely documented in 1879. Not one of his letters has come down to us from November 1878 to late May 1879. (Conversely, only two letters to him, Cézanne's last and Gauguin's first, exist from the same months.)[99]

Pissarro's decisions have to be deduced from the catalogue list and the minimal critical response. Among his twenty-two paintings, he seems to have chosen one large landscape, most likely the Cleveland painting (cat. no.82), which would then have dominated his 1879 display, just as the *Jardin des Mathurins, à Pontoise* (cat. no.58), dominated that of 1877. He seems not to have concerned himself with the presentation of a series, his seventeen or so pictures of Pontoise having a mixed choice of motifs, though they do follow the seasons.

fig. 14 Camille Pissarro, *Saules inondés en hiver* (*Willows Flooded in Winter*, IV–HC), 1879. Oil on canvas, 21¼ x 25⅝ in. (54 x 65 cm). Photo from Pissarro and Venturi

What was rather new for Pissarro were three paintings of Paris, two of them effects of snow, reflecting his move to a Montmartre apartment in November 1878.

But his major innovation was the inclusion of fans, a dozen no less, as against Degas's five. These fans must have been executed in the previous months, almost certainly under the influence of Degas (*figs.5* and 6). With those of Forain, they introduced a new element into the exhibition; at one stage Degas contemplated having a room of fans, but this did not materialize.[100] Pissarro used the fan as a means of rephrasing and reactivating drawn and painted compositions, stretching back to his London period of 1870–1871. It is possible that he was hoping to attract sales from this minor medium, as he did shortly afterwards with a series of gouaches. Yet in 1879 seven of the twelve fans already were in private hands. Pissarro completed his contribution with four pastels, including a portrait of Murer.

While his fans sounded a nostalgic, retrospective note, his paintings were predominantly recent, that is, from 1877 onward. The only exceptions were *Port-Marly* of 1872 and a Pontoise landscape of 1875.[101] Rather surprisingly, however, he borrowed fourteen oils from collectors as various as Caillebotte, Gauguin, Murer, and Mlle T., and included only eight from his studio. At least one was added after the opening of the show, Silvestre's *Saules inondés*.[102] But, despite all Pissarro's innovative efforts, it seems doubtful that he sold anything.

A few days after the exhibition closed, Caillebotte wrote to Monet, "Our profit amounts to 439.50 francs for each of us. . . . We had more than 15,400 admissions." On 13 May, Degas reported similar news to Bracquemond. The exhibition was "crowned by a success much greater than that obtained in previous years," concluded Martelli.[103] With almost 16,000 visitors, as against 4,000 for the first exhibition, even with an evening opening, it was indeed a success.

Arguably, it was also the biggest group show ever mounted. Two hundred and forty-six works were listed in the catalogue—only exceeded by the two hundred and fifty-two listed in that of 1876. But this excluded the special memorial show of Piette's watercolors (perhaps a dozen or so), as well as Gauguin's contribution, which must have included some paintings along with his one piece of sculpture. It omitted the additions, *hors catalogue*, made by Caillebotte, Cassatt, Degas, Monet, and Pissarro.[104] There could well have been two hundred and sixty-four works rather than two hundred and forty-six.

Yet it began with Paul Mantz declining to review it, because he found it of too little interest.[105] And Caillebotte complained of the "desertion" and some loss of faith among the critics, thinking not only of Mantz, but of Ernest Chesneau and Georges Rivière who did not review it either, and of Burty whose line hardened.[106]

But several critics did make congratulatory noises. Monet had a good press, so did Cassatt, and Degas above all was singled out as the master, whether by Silvestre, de Lostalot, or Duranty. No really great critic suddenly revealed himself in 1879: Henry Havard was certainly not that. On the other hand, Huysmans was not the meteor he has been made out to be. Silvestre's golden opinions of Degas preceded Huysmans's, and Duranty was more sympathetic towards Monet and Pissarro.[107]

The limited but significant critical success also was reflected in the illustrations, especially of the work of Degas and Cassatt, reproduced in *Les Beaux-Arts Illustrés* and *La Vie Moderne*.[108] Together, they more than made up for the demise of Georges Rivière's *L'Impressionniste*. And from these exemplars, Degas may have got the idea of starting a journal of a slightly different nature, more specialized and elitist, reproducing the graphic work of himself, Cassatt, Pissarro, Bracquemond, and others. Without the financial success of the show, it may be doubted tht he would have approached the project of *Le Jour et la Nuit* with such unabated enthusiasm.[109]

For Monet, even though he did not visit the show, it gave him his first retrospective, larger than the *La Vie Moderne* one-man show of the following year, and presaging those held at Durand-Ruel's gallery in 1883 and the Galerie Georges Petit in 1889. And it brought him sales, Mary Cassatt, for instance, buying his painting of *Printemps*.[110] Cassatt herself sold her *Femme lisant* to Antonin Proust; Degas sold a fan to Albert Hecht.[111] Interest in sales continued after the show closed. Gauguin, for example, very much wanted a Degas pastel that was snapped up by Ernest May. May also bought a drawing from Bracquemond, while Bracquemond's employer, Charles Haviland, showed interest in a small oil by Cassatt.[112]

Among the 16,000 visitors to the exhibition were three of Henri Lehmann's students at the Ecole des Beaux-Arts. "They received a profound and salutary shock from the exhibition, to the extent that they decided to leave the Ecole, take a studio together and work on their own."[113] One of these students was Georges Seurat, then nineteen years old.

Appropriately, the last word should be with Caillebotte.[114] In his mid-May letter to Monet, he wrote, on a high note, "I regret you could not follow the show from close at hand. But for the painters and for the public, despite the malevolence of the press, we have achieved much. Manet himself is beginning to see that he has taken the wrong road. Courage then!"

Notes

I should like to dedicate this essay to John Rewald, doyen of Impressionist scholars, ever generous friend and counselor.

For their constant help with the unearthing of reviews and other documentation, I am especially grateful to Ruth Berson and Fronia E. Wissman.

All translations by the author unless otherwise noted, with the exception of certain review citations that have been translated by Felicia Miller.

1. Early historians of Impressionism, such as Geffroy and Duret, say nothing of the critical response. (Gustave Geffroy, *Histoire de l'impressionnisme–La vie artistique*, IIIᵉ série [Paris, 1894], and Théodore Duret, *Histoire des peintres impressionnistes* [Paris, 1906].) In Lionello Venturi, *Les archives de l'impressionnisme* 2 vols. (Paris, 1939), the collection of eighty-five reviews in 2:273–339 contains only five on the Fourth Exhibition, and not one of these is quoted. Rewald, *The History of Impressionism* 4th rev. ed. (New York, 1973), cites only two reviews. Jacques Lethève, *Impressionnistes et symbolistes devant la presse* (Paris, 1959), quotes extensively from the critics of the 1879 Salon, but not from those of the Independent show–although he does reproduce Draner's page of caricatures from *Le Charivari* (23 April 1879):3. The same pattern can be found in *catalogues raisonnés*. Ludovic Rodo Pissarro and Venturi (*Camille Pissarro: Son art, son oeuvre* [Paris, 1939]) list three reviews in their bibliography; Paul-André Lemoisne, *Degas et son oeuvre*, vols. 1–3 (Paris, 1946), prints extracts from two; Daniel Wildenstein, *Claude Monet: Biographie et catalogue raisonné*, vols. 1 and 2 (Lausanne and Paris, 1974 and 1979), cites only six from 1879, whereas he provides comprehensive lists of reviews from other years; Marie Berhaut, *Caillebotte, sa vie et son oeuvre* (Paris, 1978), quotes from six, and also writes that the fourth show "suscite de moins nombreux commentaires dans la presse que les précédentes," 256. Only Oskar Reuterswärd, *Impressionisterna inför publik och kritik* (Stockholm, 1952), 95–110 and 229–230, has produced more than a token selection. His book remains an invaluable source. See also his article, "The Accentuated Brush Stroke of the Impressionists," *The Journal of Aesthetics and Art Criticism* (March 1952):273–278 (which nonetheless gives no quotations from 1879!). For the very limited critical reaction to the fans exhibited in 1879, see Marc Gerstein, "Degas's Fans," *The Art Bulletin* 64, no. 1 (March 1982):105–118.

2. These exhibitions–and that of 1882–have been discussed by Joel Isaacson, *The Crisis of Impressionism 1878–1882* exh. cat. (Ann Arbor: University of Michigan, Museum of Art, 1980), 2–47.

3. Caillebotte to Monet, 1 May 1879, Berhaut, 245, letter 18. Citations for all reviews referred to in this essay are found in the Fourth Exhibition review list in the Appendix.

4. See below, notes 12, 15, and 16 for elucidation of these points.

5. Caillebotte's will is published in Berhaut, 251, and, together with an English translation, in J. K. T. Varnedoe and Thomas P. Lee, *Gustave Caillebotte: A Retrospective Exhibition*, exh. cat. (Houston: The Museum of Fine Arts, 1976), 220.

6. See Cézanne's letter to his parents, 10 September 1876, in John Rewald, *Paul Cézanne Letters*, trans. Seymour Hacker (New York, 1984), 156.

7. On this sale, for which the *procès-verbal* has not come to light, see M. Bodelsen, "Early Impressionist Sales 1874–94 in the light of some unpublished 'procès-verbaux'," *The Burlington Magazine* 110 (June 1968):331–349.

8. Ernest Hoschedé was declared bankrupt on 18 August 1877. See Wildenstein, 1:81, 83, and 91, and H. Adhémar, "Ernest Hoschedé," in *Aspects of Monet*, ed. John Rewald and Frances Weitzenhoffer (New York, 1984), 63. Duranty's letter to Zola has often been dated to June 1878. See Rewald, *Impressionism*, 413, and Adhémar, 65. But it is clear from other elements in the letter that it must date from August 1877 and therefore refers to Hoschedé's *bankruptcy*, not to his sale of June 1878. See also Marcel Crouzet: *Un méconnu du réalisme: Duranty (1833–1880)* (Paris, 1964), 356–357 and 365.

9. See Rewald, *Impressionism*, 414; and Pissarro to Murer, October 1877, *Correspondance de Camille Pissarro, I, 1865–1885*, ed. Janine Bailly-Herzberg (Paris, 1980), 107, letter 50.

10. Quirks of survival probably explain the sudden abundance of letters from Monet and Pissarro in 1878. Compared with the period from January 1872 to December 1877, from which we have approximately fifty-two letters by Monet and thirty-seven by Pissarro, the year 1878 has approximately thirty-five by Monet and twenty-six by Pissarro.

11. See Isaacson, especially 19–27.

12. This letter was dated to 1878 by F. A. Sweet, *Miss Mary Cassatt: Impressionist from Pennsylvania* (Norman, Oklahoma, 1966), 48. Rewald, *Impressionism*, 421 and 436, note 50, placed it in 1879, and was followed by Isaacson, 4. The letter is dated to 1878 in *Cassatt and Her Circle: Selected Letters*, ed. Nancy Mowll Mathews (New York, 1984), 137. The original, now in the collection of Mrs. Page Ely, is in fact dated 10 March 1878.

13. Degas to Caillebotte, Berhaut, 244, letter 10. Legrand was an art dealer, operating from 22bis rue Laffitte. He acted as manager of the third exhibition, as well as one of the experts at the Impressionist sale at the Hôtel Drouot, 28 May 1877. His daughter, Delphine, was painted by Renoir in 1875 (François Daulte, *Auguste Renoir: Catalogue Raisonné*, vol. 1 [Lausanne, 1971], no. 141).

14. Cézanne to Zola, 28 March 1878, in Rewald, *Paul Cézanne Letters*, 162.

15. This page in Degas's notebook has been interpreted by Theodore Reff, *The Notebooks of Edgar Degas* (Oxford, 1976), notebook 27, 36, as relating to the Third Impressionist Exhibition of 1877. However, the absence of Renoir's name surely establishes that it could not refer to 1877. This page must be connected with the negotiations for the projected 1878 show, with a date in late March, just before or just after the meeting at Legrand's on 25 March.

16. Pissarro to Caillebotte, Bailly-Herzberg, 109–110, letter 53, and also Berhaut, 244, letter 11. Both Bailly-Herzberg and Berhaut simply give 1878 as the date of this letter. A dating of late March is suggested here for two reasons: (1) Cézanne's letter, mentioned by Pissarro, must be very close in date (28 March) to Cézanne's letter to Zola (see note 14); (2) the mention of 1 June as a projected opening date clearly connects it with Degas's letter (note 13), and the decision to have a 1 June opening presumably was taken at the general meeting at Legrand's on 25 March.

17. Pissarro to Murer, Bailly-Herzberg, 115–116, letter 60. A date of early May is here proposed because of Pissarro's reference to Caillebotte's visit to the International Exhibition that opened on 1 May.

18. Pissarro to Caillebotte, Bailly-Herzberg, 111, letter 55, and also Berhaut, 244, letter 12.

19. From the same letter as note 18. Not a great deal is known of Degas's movements or his artistic activity in 1878. No painting or pastel is dated to that year, and we have no direct evidence of projects undertaken, e.g., fans, or individual works begun.

20. Théodore Duret's *Les peintres impressionnistes, Claude Monet, Sisley, C. Pissarro, Renoir, Berthe Morisot*, is dated May 1878 on the cover. Bailly-Herzberg has pointed out that the brochure did not appear in the *Bibliographie de la France* until 21 June 1879 and suggested that there may have been a delay in publication, possibly because of Duret's problems with getting illustrations from artists. The brochure, however, must have been published in May 1878. It was reviewed not only by Charles Ephrussi in *La Chronique des Arts et de la Curiosité* of 18 May 1878, but also by Philippe Burty in the English periodical, *The Academy*, of 8 June 1878. Moreover, Zola quoted from it at length in his article of July 1878 in *Le Messager de l'Europe* (see Emile Zola, *Salons*, ed. F. W. J. Hemmings and Robert Niess [Geneva, 1959], 221–222). Mallarmé thanked Duret for "la jolie brochure" on 29 May 1878 (see *Stéphane Mallarmé: Correspondance*, vol. 2, 1871–1885, ed. Henri Mondor and Lloyd James Austin, 179). The quotation cited from Manet's letter to Duret from the summer of 1878 is from Rewald, *Impressionism*, 413, which in turn is taken from the entire letter as given in German in *Kunst und Künstler* (March 1914):325–326.

21. See Bodelsen, 339–340; and H. Adhémar, 64.

22. Pissarro to Murer, Bailly-Herzberg, 126–127, letter 70. Pissarro refers to the exhibition of approximately 380 paintings that opened at Durand-Ruel's gallery on 15 July. It included work by Delacroix, Millet, Théodore Rousseau, Decamps, and Troyon, all of whom were unrepresented at the International Exhibition. Pissarro had referred to their absence in an earlier letter to Murer (see note 17): "il est de ne pas voir un seul maître bien représenté."

23. Martelli's article was published in *Roma Artistica* of 13 February 1879. See Diego Martelli review, 100–102.

24. Monet to de Bellio, 10 March 1879, Wildenstein letter 2:155.

25. Sisley to Duret, Sèvres, 14 March 1879. The translation is taken from Rewald, *Impressionism*, 421.

26. Degas to Caillebotte, Berhaut, 243, letter 6. This letter has been dated to 1878 by Berhaut. However, it must refer to the preparations for the fourth show; compare the list of artists with that in Degas's notebook (see note 27). A date of 16 March 1879 is tentatively suggested. The letter was first published in an appendix ("Four Letters from Degas to Caillebotte") in *Gustave Caillebotte 1848–1894*, exh. cat. (London: Wildenstein, 1966), 30. There, it began as follows: "Dépêche de Rouart ce matin – Gare d'Orléans, Affaire conclue avec Dupont 3,200. Attendez mon retour, Rouart." This sentence is omitted in Berhaut's transcription. It appears to make sense in connection with the following, which is Berhaut's opening (omitted in the quotation used here): "Et bien, maître Caillebotte, ça ne marche pas? Dites-le sérieusement! ???" I have not seen the original to verify the opening sentences of this letter.

27. Reff, notebook 31, 92–93. The list of artists' names supports the dating of Degas's letter to Caillebotte discussed in note 26.

28. Caillebotte to Monet, late March 1879, Berhaut, 244–245, letter 15.

29. Monet to Murer, Vétheuil, 25 March 1879, Wildenstein, 436, letter 156.

30. Cézanne to Pissarro, Paris, 1 April 1879, Rewald, *Cézanne*, 181.

31. Gauguin to Pissarro, Paris, 3 April 1879. The translation is taken from Rewald, *Impressionism*, 423.

32. Diego Martelli to Francesco Gioli, Paris, late March–early April 1879. See Martelli review, 39–40. Martelli also added: "I shall have my portrait twice, one by Zandomeneghi, the other by Degas."

33. Degas to Bracquemond, undated. See Marcel Guérin, *Lettres de Degas* (Paris, 1945), 44–45, letter XVII. This letter has been dated to "early 1879" (Gerstein, 108), but it seems much more likely to be of early April, as work is being deposited in the exhibition rooms.

34. Cals to J. Troubat, Honfleur, 6 October 1879. Partly trans. in Rewald, *Impressionism*, 314.

35. Although Piette's name appears among the list of participants on the title page, "Feu Piette," his work is not listed in the catalogue. It is difficult to establish how many were included: *L'Artiste* of May 1879 refers to three, but this clearly cannot be all of them. Duranty wrote the brief introduction to the sale of Piette's studio, 20–21 February 1879. Perhaps Duranty, as much as Piette's old friend Pissarro, was instrumental in arranging the small commemorative show.

36. Gustave Goetschy, *Le Voltaire*, 5 April 1881.

37. See Martelli review, 29, from Martelli's article in *Roma Artistica* of 27 June 1879.

38. The avenue de l'Opéra was opened by President MacMahon in 1877. See *L'Illustration* (29 September 1877):194–195; and also Norma Evenson, *Paris: A Century of Change, 1878–1978* (New Haven, 1979), 10.

39. The only reference to the possibility of the Compagnie Jablochkoff installing electric light is to be found in Degas's letter to Bracquemond of early April 1879 (see note 33). There, Degas concluded: "La Cⁱᵉ Jablochkoff nous propose de nous éclairer à la lumière électrique." The Compagnie Jablochkoff certainly installed electric lighting at the exhibition of old master drawings that opened at the Ecole des Beaux-Arts on 1 May 1879. However, there, an evening opening was arranged from 8 to 11 p.m. Alfred de Lostalot's review in *L'Illustration* (3 May 1879):289, referred to the "appareils électriques Jablochkoff." Huysmans, in his review of the 1879 Salon, wrote of Bonnat's *Portrait of Victor Hugo*, "L'éclairage est, comme d'habitude, dément. Ce n'est ni le jour, ni le crépuscule, ni le Jablochkoff. . . ." J.-K. Huysmans, *L'art moderne* (Paris, 1883), 67.

40. The order of the drafts as suggested here is from notebook 31 – 56, 59, 58, 39. Clearly, in the final draft on 39, the last line was left for the insertion of the dates, "du. . . ." The dates evidently were not decided when Degas made his draft.

41. Un Domino [Jules Renard] review.

42. For the 1880 poster, see Degas's letter to Bracquemond, Guérin, 51, letter XXIV.

43. Caillebotte to Monet, Paris, 10 April 1879, Berhaut, 245, letter 16. Berhaut follows Gustave Geffroy's transcription (*Claude Monet*

[Paris, 1924], vol. 2, chap. VII). Although Caillebotte is said to have written "8" canvases by Degas, this may in fact be "3": see Burty's review below (note 49). Part of this letter has been quoted by Rewald, *Impressionism*, 424.

44. Albert Wolff review. This review was quoted in full by Lemoisne, *Degas*, 1:245.

45. Emile Cardon review. Cardon promised a further review, but evidently none was published.

46. Bertall, 'Exposition des Indépendants ex-Impressionnistes', *Paris-Journal*, 14 April 1879.

47. Edmond Renoir review.

48. Ernest d'Hervilly review. Parts of d'Hervilly's article reappeared (without his signature) in *Le Voltaire* of 16 April (on Monet), and 1 May (on Caillebotte). Otherwise, *Le Voltaire* did not publish a full review of the show. In May, however, it began running Huysmans's first review of the Salon, later reprinted in *L'art moderne* (1883), 9–95.

49. Philippe Burty review. It seems that Burty – or a plagiarist – provided the article for *Le Journal des Arts*, 9 May 1879.

50. Armand Silvestre review, *L'Estafette*.

51. I have not traced Silvestre's original printed source of this statement.

52. Montjoyeux review. Jules Poignard's novel was *Lucine, roman parisien* (Paris, 1890); his play, in collaboration with Georges Docquois, was *Le Ghoung*, published in Paris, 1908. He also wrote *Les Femmes de Paris* (Paris, 1889).

53. Montjoyeux not only paraphrased parts of Duranty's *La nouvelle peinture*, he also lifted the famous section on light: "La grande lumière *décolore* les tons. . . ." (See this catalogue.). Montjoyeux substituted "clarté" for "lumière." In his review of the Fifth Impressionist Exhibition of 1880, Huysmans too lifted this same phrase (see *L'art moderne* [1883], 101). See also note 59.

54. Caillebotte's letter, Berhaut, 245, letter 17, is in the Bibliothèque de l'Institut d'Art et d'Archéologie, Paris. Hitherto thought to be to an unknown recipient, the letter was clearly written to Montjoyeux in response to his article in *Le Gaulois*. There is one anomaly – the article appeared on 18 April, and Caillebotte's letter is dated 17 April. This must be a slip of the pen by Caillebotte, since there can be no other candidate than Montjoyeux.

55. Henry Havard review. This was Havard's first review of an Impressionist group show. He was destined to review all the remaining shows.

56. Havard (consciously?) assumes the impersonal, no-naming-of-names approach adopted by Duranty in *La nouvelle peinture*. He refers to Duranty thus: "Un écrivain, qui ne saurait être suspect de mauvais sentiments à l'égard des chefs de la nouvelle école, qualifie leurs ouvrages 'd'essais laborieux qui ressemblent aux expériences du chimiste et du physicien'." But the quotation he uses is actually taken from Duranty's review of 1879 (see note 57), which appeared eight days before Havard's. He continues, "Il me semble difficile de trouver une critique plus fine, plus judicieuse et surtout mieux appropriée." Nonetheless, Duranty's "essais de laboratoire" became Havard's touchstone, applied to Degas ("c'est à lui surtout que le reproche de chimie s'adresse"), and to Monet and Pissarro ("Là encore, des essais curieux, instructifs, mais rien de décisif").

57. Although cited in *Les archives de l'impressionnisme*, 2:305, Duranty's relatively short review of the fourth show was not re-published – at least in considerable part – until 1946, when Guérin printed it as a logical appendix to *La nouvelle peinture*. In 1964, Crouzet (381) makes only a brief reference to it. And by and large, scholars of Monet and Pissarro have tended to ignore it. It provides an interesting reversal of Duranty's method from that he used in 1876. Then, he never named Fromentin; he never named a living artist; and – at least in the copy he inscribed to Diego Martelli on 5 September 1878 – he never actually referred to Monet and Pissarro. Now, in 1879, he names Paul Mantz; and he devotes half his review to Monet and Pissarro, who are not only named, but whose work is individually characterized.

58. See Paul Mantz, *Le Temps*, 14 April 1880.

59. His words on the decomposition of light have already been quoted (see note 53). Their critical hold on accounts of Impressionism, whether in contemporary reviews (Zola as well as Huysmans) or later histories, has been considerable. Duranty almost certainly took the concept from Amédée Guillemin, *La lumière* (Paris, 1874), especially 112–113 on "le phénomène de la décomposition." He had a copy of

Guillemin's book in his library (see Vente Duranty, 28–29 January 1881, lot 109). The connection between Duranty and Guillemin has been pointed out by Marianne Marcussen, "Duranty et les impressionnistes, II," *Hafnia. Copenhagen Papers in the History of Art* 6 (1979):27–49, where other elements and sources of Duranty's argument are also discussed.

60. This sentence was quoted (anonymously) by Havard (see note 56).

61. Louis Leroy review.

62. Alfred de Lostalot, "Exposition des artistes indépendants," *Les Beaux-Arts Illustrés*, no. 10 ([26 April] 1879). De Lostalot was a friend of Duranty's. The two of them were closely involved with *Les Beaux-Arts Illustrés* in 1879, Duranty contributing nearly three dozen articles, including six on the Salon of 1879. It was almost certainly for this illustrated periodical that Duranty wanted Monet to send drawings after his *Drapeaux* or his *Pommiers* (see Caillebotte's letter to Monet, 10 April 1879, Berhaut, 245, letter 16).

63. Armand Silvestre, "Le monde des arts," *La Vie Moderne* (24 April 1879):38–39. This is the one review from 1879 that has been most quoted. See Lemoisne, *Degas*, 1:246; Berhaut, *Caillebotte*, 257; Wildenstein, *Monet* 1:96 (paraphrase of opening sentence only); and Rewald, *Impressionism*, 421 (opening sentences only).

64. Lemoisne has quoted Silvestre's words on this *Ecole de danse* under L.537. "Une nouvelle *Leçon de danse* nous fait voir un foyer de théâtre, en plein jour, éclairé du dehors par des croisées donnant sur un jardin et laissant passer, par les rideaux, de belles ondées de lumière qui s'étendent sur le parquet. L'effet est merveilleusement observé et rendu avec une savante délicatesse." But it seems clear that Silvestre is describing not that painting (now in the Frick), but L.399 (now in Shelburne). See also note 87.

65. F.-C. de Syène review. Arsène Houssaye was still editor of *L'Artiste*. He had written in defense of Monet and Renoir in 1870 (see Venturi *Archives*, 283–284). In 1877, he "commissioned Georges Rivière to write an article on the show for *L'Artiste*, but asked that he refrain from discussing Pissarro and Cézanne so as not to upset his readers" (Rewald, *Impressionism*, 394). However that may be, there can be no doubt of Houssaye's support in 1879. Nonetheless, as editor of *L'Artiste*, it does seem extraordinary that he reprinted Bertall's negative and inconsequential article from *Paris-Journal* of 13 April in his June number.

66. Paul Sébillot review. This followed a rather vicious review by Jean de la Leude in the previous number of *La Plume* of 1 May. (It thus reversed the Houssaye-Bertall duet in *L'Artiste*.)

67. Georges Lafenestre review. As with many reviews (e.g. those by Cardon, Silvestre, and Sébillot), Lafenestre combined his notice of the *Indépendants* with one of the inaugural exhibition of the Société des Aquarellistes Français.

68. Huysmans's first article on the Salon appeared in *Le Voltaire* of 17 May. It caused considerable consternation (see Robert Baldick, *The Life of J.-K. Huysmans* [Oxford, 1955], 70–71).

69. Only Paris newspapers and periodicals have been consulted, but by no means all of them. The French provincial press has not been consulted, nor any review in the foreign press quoted. Prominent among the foreign reviews are Diego Martelli's two articles in *Roma Artistica* of 27 June and 5 July (see Martelli review, 28–33).

70. Berhaut has published Caillebotte's contribution to the fourth exhibition, and identified all but four of the paintings (249). Three male portraits appear to be lost (IV–15, 17, and 19: Berhaut 121, 122, and 86 respectively). Leroy and Martelli each described a male portrait, which may account for two of the missing three. Leroy referred to "un jeune homme lie-de-vin assis sur un divan bleu," Martelli to "un portrait d'homme, éclairé par une fenêtre à laquelle il tourne le dos, et dont seul un bout de rideau blanc indique l'existence" (Martelli review, 31–32).

71. Berhaut, 257–258, prints the reviews of Leroy and Bertall, where this painting is ridiculed.

72. Caillebotte's assessment may have affected later views of the critics' reaction to the 1879 show. But hostility and ridicule were by no means the norm.

73. Caillebotte to Montjoyeux, 17 (18?) April (see note 54); Caillebotte to Monet, 1 May 1879, Berhaut, 245, letter 18 and again, mid-May 1879, Berhaut, 245, letter 19.

74. Burty, in his review, wrote, "Il nous livre des toiles hâtivement brossées, d'un dessin inconsistant et d'une couleur sans conviction. Sont-ce des études? . . . Quant à les présenter comme des tableaux, c'est la fatuité."

75. Compare the lists of exhibitions held during Caillebotte's lifetime in Berhaut, 249–250.

76. See Cassatt's letter to Harrison Morris, 15 March 1904, Mathews, 291. "I, however, who belong to the founders of the Independent Exhibition, must stick to my principles, our principles, which were, no jury, no medals, no awards. Our first exhibition was held in 1879 and was a protest against official exhibitions and not a grouping of artists with the same art tendencies."

77. Adelyn Dohme Breeskin, *Mary Cassatt, A Catalogue Raisonné*, Washington, D.C., 1970, identified two works only (Breeskin 64 and 66); Reff (*Notebooks I*, 137–138, notebook 31, 66) identified eight from the eleven in Degas's notebook. *Femme lisant* is definitely Breeskin 51. "Portrait d'enfant" in Degas's notebook would surely have been described as pastel. It is therefore unlikely to be Breeskin 53, and may possibly be Breeskin 85. The second pastel, "Jeune femme au théâtre," is unlikely to be Breeskin 63, which was exhibited in 1880, and is more probably Breeskin 72. It also seems probable that "la Femme désolée" in Degas's list became *Etude de femme avec éventail* and is identifiable as Breeskin 80.

78. See Martelli review, 31: "un groupe de dames en plein air dans un jardin."

79. The catalogue lists three women at the theater—one oil (IV–49) and two pastels (IV–54, 55). Havard, in his review, however, remarked that "quatre de ses portraits ont pour fond des salles de spectacle," without describing any of them. The fourth one must have been a substitute for another work (since Havard says there are eleven works), or was added *hors catalogue* (in which case Havard miscounted). That an oil painting of two young women in a theater box was exhibited seems reasonably certain, as a drawing after it was made by Cassatt for reproduction in *La Vie Moderne* of 1 May 1879 (IV–54), with the caption "Exposition des Indépandants No. 1. *Coin de loge*. (Dessin inédit de Miss Cassatt, d'après son tableau)" (*fig.10*).

80. A drawing by Gillot after this painting was reproduced in *La Vie Moderne* of 9 August 1879, 238, as "*Dans une loge.*–Composition de Miss *CASSATT*."

81. A marked and annotated catalogue of the fourth exhibition, now in the Cabinet des Estampes of the Bibliothèque Nationale, has "cadre vermillon" written against IV–48 and "cadre vert" against IV–49. The former may be Breeskin 80 (see note 77); the latter is certainly *Femme dans une loge*, frequently described by the critics (see note 80), none of whom mentioned the frame.

82. Robert Cassatt to Alexander Cassatt, Paris, 21 May 1879. See Mathews, 144.

83. The differences between notebook list and printed catalogue can be summarized as follows. Degas deleted his portrait of Mary Cassatt and replaced it with a portrait of another artist-friend, Henri Michel-Lévy. He combined the portraits of M. et Mme H. de Clermont under one number. And his *Coulisse* (no. 10 in his notebook list), owned by the same H. de Clermont, was not listed in the catalogue. He replaced these with two fans.

84. For a discussion of these dated drawings, see Ronald Pickvance, *Degas 1879*, exh. cat. (Edinburgh: National Gallery of Scotland, 1979), 45, 50–57.

85. Dated by Lemoisne (no. 447) to 1877–1878, *Danseuse posant chez un photographe* was exhibited in London in May 1875 at the tenth exhibition of the Society of French Artists. See Ronald Pickvance, "Degas's Dancers: 1872–6," *The Burlington Magazine* 105 (June 1963):264, where a date of 1874 was proposed.

86. Degas's use of *détrempe* has been touched upon by Denis Rouart, *Degas à la recherche de sa technique* (Paris, 1945), 10–12, but deserves closer examination, not only technically to determine its use in specific paintings, but also as a means of stylistic expression.

87. See note 64, for Silvestre's description (in *La Vie Moderne* of 1 May) of the Shelburne painting (L.399). The Frick painting (L.537), lent by Henri Rouart in 1879, was surely referred to by Leroy when he wrote of Degas's habit of "faire sortir une jambe du cadre." Silvestre, however, had described another *Ecole de danse* in his review of 24 April: "Comme le jour blafard dont les coulisses d'un théâtre sont éclairées pendant les répétitions est vrai! En quelques touches, la stupide attention des jeunes chorégraphes aux ordres du ballerin qui les

instruit est exprimée avec une intensité à faire bailler." This clearly describes a rehearsal under the artificial light of the theater, not one in which daylight percolates through high muslin-curtained windows, as it does in the Frick and Shelburne pictures. Could this theater rehearsal be *Répétition de ballet sur la scène* (L.498), which, like the Shelburne picture, belonged to Ernest May? Degas only listed two *Ecole de danse* in the catalogue (IV–65, 66); the third one, therefore, was shown *hors catalogue*.

88. The suggestion that the Barber Institute picture should be identified with Silvestre's description, and hence dated to 1878–1879, was first made by Pickvance, *Degas 1879*, 14.

89. Gerstein, *passim*.

90. "1879 was a year in which Degas painted some of his most memorable portraits." (Jean Sutherland Boggs, *Portraits by Degas* [Berkeley, Los Angeles, 1962], 57). See also Pickvance, *Degas 1879*, 50–57.

91. Silvestre's description of *Miss Lola, au Cirque fernando (sic)* is the only one among the reviews in 1879. See review excerpt for cat. no. 74.

92. Monet as reported by Pissarro in his letter to Caillebotte of late March 1878 (see note 16).

93. The foregoing is a summary of Wildenstein, *Monet*, 1:89–96.

94. Some seven of Monet's titles in the catalogue were accompanied by dates. No other artist included dates for their works. Work IV–140, catalogued as *Marine*, was dated 1875. But it is clear from Silvestre's review in *La Vie Moderne* of 24 April that this should have read 1865. Silvestre wrote of "sa *Barque de pêcheurs sur une grosse mer* (IV–140), et là, encore procède-t-il directement de Manet"; and, in *L'Estafette* of 16 April, of "ses *Barques de pêcheurs* (no. 141) [*sic*], une très belle marine exécutée sommairement." The painting in question must be *La vague verte* (Wildenstein 73; Metropolitan Museum of Art, New York), which is dated 1865. (But that date was added later by Monet, and wrongly, since he is not known to have visited the Channel coast in 1865. Wildenstein has therefore placed it in 1866.) Duret's name does not figure in the early provenance; Wildenstein has tentatively identified it as *Marine*, bought by Durand-Ruel in July 1882, and sold to Mary Cassatt in October 1883. The *Etude de mer*, lent by Antoine Guillemet, is unidentified by Wildenstein. It could be Wildenstein 112, whose early provenance is unknown.

95. Of Monet's twenty-nine pictures, nineteen are identified in Wildenstein, 95–96. A further one has been added and another tentatively suggested (see note 94). What is virtually impossible is the identification of the Vétheuil-Lavacourt group that came from Monet's studio (IV–148–151, and 161). Critics help little: Cardon put IV–149 among works he thought had "beaucoup de sincérité et un grand sentiment de la nature," and Silvestre at least identifies three (IV–149, 151, and 161) as "marines de banlieue." For what they are worth, the following suggestions are proffered: IV–149 as Wildenstein 475; IV–150 as Wildenstein 538; IV–161 as Wildenstein 476; IV–164 as Wildenstein 362; IV–165 as Wildenstein 356; and IV–166 as Wildenstein 481.

96. Sébillot also referred to the early work: "Quelques-uns, les plus anciennement peints, sont de curieuses études," preferring them to "ses toiles plus récentes où se trouvent juxtaposés tous les tons de l'arc-enciel." See also F.-C. de Syène review.

97. F.-C. de Syène also described the pair in approving terms in his review. D'Hervilly's description was repeated, anonymously, by Le Griffon Vert in his review.

98. Silvestre wrote this in *La Vie Moderne* of 24 April, varying what he had written in *L'Estafette* of 16 April: ". . . dont les *Saules inondés en hiver* sont une toile d'un aspect très juste et dont j'aime aussi beaucoup le paysage placé sous le No. 186." Work IV–186 was *Port-Marly* of 1872 (Pissarro and Venturi 175), which also was praised by Sébillot; see review.

99. See Bailly-Herzberg, 131–133, letters 76–77, where a letter of 25 November 1878 is followed by one of 27 May 1879. The Cézanne letter is the last *surviving* letter to Pissarro (see note 30); the Gauguin, his first (see note 31).

100. For Degas's comment on a room of fans, see note 33.

101. The Pontoise landscape of 1875 was IV–188, *Côte des brouettes. (Temps gris.)* (Pissarro and Venturi 314).

102. The *Saules inondés en hiver*, as Silvestre called it in *L'Estafette*, must be identical with *Effet de neige, près Pontoise*, dated 1879 (Pissarro and Venturi 477).

103. Caillebotte to Monet, mid-May 1879, Berhaut, 245, letter 19; Degas to Bracquemond, 13 May 1879, Guérin, 45, letter XVIII; Martelli's quotation comes from his review in *Roma Artistica* of 27 June 1879, Martelli review, 28.

104. All but Monet's additions *hors catalogue* have already been discussed. Cardon wrote in a review of 11 April of a painting which "ne porte point de numéro, mais dans le premier plan est garni de dahlias en fleurs." This may be Wildenstein 453. On 1 May 1879, Caillebotte wrote to Monet (Berhaut, letter 18) acknowledging the arrival of two canvases from Vétheuil. "Demain elles seront à l'Exposition. J'ai presque vendu l'une, la plus grande, à Miss Cassatt. . . . Ces deux toiles sont très bien, surtout celle du Temps gris, je crois que vous n'avez rien de mieux à l'avenue de l'Opéra." These two paintings, neither of them identifiable, were added to the show for its last week.

105. Mantz recalled his decision a year later: "Dans une exposition dont on s'est absenté de rendre compte parce qu'elle était peu intéressante . . . ," *Le Temps*, 14 April 1880.

106. See his letter to Montjoyeux, 17 (18?) April 1879, Berhaut, letter 17. Also see note 54.

107. Compare Silvestre in *L'Estafette* of 16 April: "Quel talent original et aristocratique dans ses plus étranges caprices! Le premier, ce curieux artiste a su rendre les lumières blafardes dont les coulisses des théâtres sont éclairées avant la représentation, et les colorations inattendues de la chair et des étoffes sous ce soleil artificiel . . . ," as well as Silvestre's two reviews in *La Vie Moderne* of 24 April and 1 May, with Huysmans's familiar pronouncements in his Salon of 1879 (*L'art moderne*, 12–14, 43).

108. See *La Vie Moderne*, 1 May (Cassatt), 8 May (Degas), 29 May (Degas), and 9 August (Cassatt); and *Les Beaux-Arts Illustrés*, no. 10, 26 April (Cassatt and Degas), no. 12, 10 May (Pissarro and Forain).

109. The projected *Le Jour et la Nuit* has been discussed by Isaacson, 5 and 44, note 22; by Pickvance, *Degas 1879*, 76–82; and by Sue Welsh Reed and Barbara Stern Shapiro, *Edgar Degas: The Painter as Printmaker*, exh. cat. (Boston: Museum of Fine Arts, 1984), xl–li (essay by Douglas Druick and Peter Zegers).

110. According to Monet's *carnet de comptes*, Mlle Cassatt bought a canvas of *Printemps* for 300 francs in May 1879. See Wildenstein, *Monet*, 1:96.

111. Cassatt's sale of *Femme lisant* to Antonin Proust was revealed by Alfred de Lostalot, *Les Beaux-Arts Illustrés*, no. 10 ([26 April] 1879):83; for Degas's sale of a fan to Albert Hecht on 17 April 1879, see Anne Distel, "Albert Hecht, collectionneur (1842–1889)," *Bulletin de la Société de l'Histoire de l'Art français* (1981):267–279; and Gerstein, 110. The fan in question is Lemoisne 562.

112. Gauguin's wish to buy a Degas pastel is mentioned in a letter to Pissarro of 26 July 1879: "J'ai trouvé Degas à son atelier, malheureusement son pastel a été acheté par May je n'ai donc pu le prendre c'est regrettable parce qu'il était épatant." (I owe this reference to the kindness of John Rewald.) On Ernest May's purchase of Bracquemond's *La lecture de la Bible* and Charles Haviland's interest in "un petit tableau" of Cassatt's, see Degas's letter to Bracquemond of June 1879, Guérin, 46–47, letter XIX.

113. Rewald, *Impressionism*, 424.

114. Caillebotte to Monet, mid-May 1879, Berhaut, 245, letter 19. This is a tantalizing reference to Manet. Was he seriously thinking of joining the group? He and Caillebotte presumably met at the *vernissage* of the Salon on Sunday, 12 May, the day after the Independents' show closed. As Caillebotte wrote to Monet in this same letter, "Le tableau de Manet–tableau de Salon–*Les Canotiers*, vous les [*sic*] connaissez, c'est très beau." A dropped remark at a Salon private view: it is the sole evidence we have of the possibility of a significant shift in Manet's attitude towards the Independents.

*References for identifications
and present locations*

1. See figs. 13–17 in
Isaacson, 60–61

3. Beraldi 214
4. Beraldi 219, 4th state
5. Beraldi 215
6. Beraldi 217

7. Berhaut 75, private
collection, Paris
8. Berhaut 93, private
collection, Paris
9. Berhaut 76, Milwaukee
Art Center
10. Berhaut 95, Mr. and Mrs.
Paul Mellon, Upperville,
Virginia
11. Berhaut 105
12. Berhaut 107, Musée
d'Orsay
13. Berhaut 96, Virginia
Museum of Fine Arts,
Richmond
14. Berhaut 116
15. Berhaut 121, per Berhaut
16. Berhaut 82, per Berhaut
17. Berhaut 122, per Berhaut
18. Berhaut 80, Josefowitz
Collection
19. Berhaut 86
20. Berhaut 85, private
collection, France
21. Berhaut 68, Museum of
Fine Arts, Houston
22. Berhaut 55, private
collection, Paris

CATALOGUE

DE LA

4ᴹᴱ EXPOSITION

DE PEINTURE

PAR

*M. Bracquemond — Mᵐᵉ Bracquemond
M. Caillebotte — M. Cals — Mˡˡᵉ Cassatt
MM. Degas — Forain — Lebourg — Monet
Pissarro — Feu Piette
Rouart — H. Somm — Tillot et Zandomenighi.*

Du 10 Avril au 11 Mai 1879

De 10 heures à 6 heures
28, AVENUE DE L'OPÉRA, 28
𝒫𝒜𝑅𝐼𝑆

DÉSIGNATION

BRAQUEMOND (Marie)
13, rue de Brancas, à Sèvres.

1 — Les Muses des Arts. Carton ayant servi
pour une peinture sur faïence.
Appartient à M. Haviland.

2 — Un plat de faïence. (Peinture mate.)

BRAQUEMOND
13, rue de Brancas, à Sèvres.

3 — Au Jardin d'acclimatation. (Eau forte
imprimée en couleurs.)

4 — Une nuée d'orage. (Eau forte.)

5 — Une terrasse de Sèvres. (Eau forte publiée
par le journal l'*Art*.)

23. Berhaut 89, private collection, Paris
24. Berhaut 90, private collection, Paris
25. Berhaut 91, Musée des Beaux-Arts, Rennes
26. Berhaut 78, Musée d'Agen
27. Berhaut 77, private collection, Paris
28. Berhaut 99
29. Berhaut 63
30. Berhaut 100
31. Berhaut 101, private collection, San Francisco
h.c. *Une vache et une chèvre*
h.c. *Un soldat*, perhaps Berhaut 170, Josefowitz Collection
45. Delestre, no. 62
46. Perhaps Breeskin 79, Philadelphia Museum of Art, per Mathews
47. Perhaps Breeskin 85, per Pickvance; perhaps Breeskin 56, National Gallery of Art, Washington, per Mathews
48. Breeskin 80, National Gallery of Art, Washington, per Pickvance
49. Breeskin 64, Philadelphia Museum of Art
52. Breeskin 51, Joslyn Art Museum, Omaha
53. Breeskin 66, Musée du Petit Palais, Paris
54–55. Perhaps Breeskin 61, Philadelphia Museum of Art, or 72; 72, per Pickvance
h.c. Perhaps Breeskin 62
57. Lemoisne 519, National Gallery of Scotland, Edinburgh
58. Lemoisne 517, The Burrell Collection, Glasgow Art Gallery and Museum
59. Lemoisne 534, The Art Institute of Chicago
60. Lemoisne 526, Musée d'Orsay
61. Lemoisne 499, Musée d'Orsay
62. Lemoisne 522, National Gallery, London
63. Lemoisne 262, Musée d'Orsay or 649, Barber Institute of Fine Arts, Birmingham
64. Lemoisne 410, private collection, England
65. Lemoisne 399, Shelburne Museum, Shelburne, Vermont

66. Lemoisne 537, Frick Collection, New York

67. Lemoisne 532, private collection; may not have been exhibited, per Pickvance 1979

69. Perhaps Lemoisne 326, Gulbenkian Museum, Lisbon or 337

70. Lemoisne 478bis, Fogg Art Museum, Cambridge

71. Lemoisne 529, Sammlung Oskar Reinhart, Winterthur

72. Lemoisne 447, Pushkin Museum, Moscow

73. Lemoisne 521

74. Lemoisne 450, Metropolitan Museum of Art

77. Lemoisne 457, Metropolitan Museum of Art

78–81. Perhaps Lemoisne 567, Christie's New York, 6 November 1979, no.10 or 566, Metropolitan Museum of Art

84–85. Perhaps *Portrait de Huysmans*, Château de Versailles, per Mme Chagnaud-Forain

86. Perhaps Cabinet des Dessins, Musée d'Orsay, R.F. 30038, per Faxon, or van Wisselingh, Naarden

88. Perhaps Museum of Fine Arts, Houston, per Faxon

89. Perhaps Cabinet des Dessins, Musée d'Orsay, R.F. 29426, per Faxon

90–92. Perhaps Cabinet des Dessins, Musée d'Orsay, R.F. 29418 or Wadsworth Atheneaum, Hartford, no. 41.170, per Faxon

94–95. Perhaps Cabinet des Dessins, Musée d'Orsay, R.F. 23403 or Boston Public Library, per Faxon

96. Perhaps Cabinet des Dessins, Musée d'Orsay, R.F. 30038, per Faxon

97. Probably Brooklyn Museum of Art, no. 20.667, per Faxon

138. Wildenstein 184, private collection, England

139. Wildenstein 457

140. Wildenstein 73, Metropolitan Museum of Art, per Pickvance

141. Wildenstein 528, Musée d'Orsay

142. Wildenstein 139, J. Paul Getty Museum, Malibu

125 — Paysage, bords de la Risle (Eure).
126 — Marine.
127 — Marine.
128 — Portrait de femme. Dessin.
129 — Portrait d'homme. id.
130 — La lecture (le soir). id.
131 — La Veillée. id.
132 — La Ménagère. id.
133 — Jeune fille. id.
134 — Femme jouant aux échecs. id.
135 — Jeune femme. id.
136 — Jeune femme. id.
137 — Jeune femme. id.

MONET (Claude)
20, rue Vintimille.

138 — Habitation bourgeoise, à Zaandum
 (Hollande).
 Appartient à M. Baudry.
139 — Paysage à Courbevoie.
 Appartient à M. Duret.
140 — Marine (1875).
 Appartient à M. Duret.

141 — Vétheuil, vu de Lavacourt.
 Appartient à M. Duret.
142 — Fleurs.
 Appartient à M. R.
143 — Pommiers.
 Appartient à M. C.
144 — Effet de neige à Vétheuil.
 Appartient à M. C.
145 — La rue Montorgueil, fête du 30 juin.
 Appartient à M. de Bellio.
146 — Effet de brouillard, impression.
 Appartient à M. de Bellio.
147 — Estacade de Trouville, marée basse.
 Appartient à M. Duez.
148 — Paysage à Vétheuil.
149 — Lavacourt.
150 — La Seine à Lavacourt, (soleil couchant).
151 — Vétheuil.
152 — Parc Monceaux.
 Appartient à M. de Bellio.
153 — Bords de la Seine, environs de Paris.
 Appartient à M. Chabrier.
154 — La rue Saint-Denis, fête du 30 juin 1878.
155 — Un jardin (1867).
 Appartient à M. Lecadre.

156 — Église de Vétheuil.
 Appartient à M. Schlessinger.
157 — Jardin à Sainte-Adresse (1867).
 Appartient à M. Frat.
158 — Les Charbonniers (1875).
 Appartient à M. Hayem.
159 — Effet de neige (1875) à Argenteuil,
 Appartient à M. Durand Ruel.
160 — La Mare, effet de neige (1875).
 Appartient à M. Durand Ruel.
161 — Lavacourt, temps gris.
162 — Chemin de halage à Lavacourt.
 Appartient à M. Murer
163 — Étude de mer.
 Appartient à M. Guillemet.
164 — Coucher du soleil.
 Appartient à M. Bellio.
165 — Paysage d'hiver.
 Appartient à M. Bellio.
166 — Le petit bras à Vétheuil.
 Appartient à M. Bellio.

PISSARRO (Camille)
18, rue des Trois-Frères.

167 — Le Pont de Pontoise.
168 — Lisière d'un bois.
169 — Chemin sous bois.
170 — Effet de neige. (Côté du Palais-Royal.)
171 — Effet de neige et glace. (Effet de so-
 leil.)
172 — Effet de soleil. Boulevard Clichy. (Es-
 quisse.)
173 — Sous bois en été.
174 — Le Verger de Maubuisson.
 Appartient à M. M...
175 — Château des Mathurins. (Soleil cou-
 chant.)
 Appartient à M. M...
176 — Automne. (Soleil couchant.)
 Appartient à M. M...
177 — Les Peupliers. (Matinée d'été.)
 Appartient à M. M...
178 — Paysage en février. (Femme revenant
 de la Fontaine.)
 Appartient à M. G...

143. Wildenstein 490
144. Wildenstein 506, Musée
 d'Orsay
145. Wildenstein 469, Alfred
 Lindon, Paris
146. Perhaps Wildenstein 263,
 Musée Marmottan
147. Wildenstein 154,
 Szépmüvészeti Múzeum,
 Budapest
149. Perhaps Wildenstein 475,
 per Pickvance
150. Perhaps Wildenstein 538,
 per Pickvance
152. Perhaps Wildenstein 468
153. Wildenstein 456
154. Wildenstein 470, Musée
 des Beaux-Arts, Rouen
155. Wildenstein 68,
 Hermitage, Leningrad
156. Wildenstein 474
157. Wildenstein 95,
 Metropolitan Museum of
 Art
158. Wildenstein 364, private
 collection, France
160. Wildenstein 350, private
 collection, France
161. Perhaps Wildenstein 476,
 per Pickvance
162. Wildenstein 496
163. Perhaps Wildenstein 112,
 Museum of Art, Carnegie
 Institute, Pittsburgh, per
 Pickvance
164. Perhaps Wildenstein 362,
 Musée Marmottan, per
 Pickvance
165. Perhaps Wildenstein 362,
 Musée Marmottan;
 perhaps Wildenstein 356,
 Musée Marmottan, per
 Pickvance.
166. Perhaps Wildenstein 481,
 per Pickvance
h.c. Foreground with dahlias,
 perhaps Wildenstein 383,
 385, 417, or 418; 453, per
 Pickvance
167. Pissarro and Venturi 443
168. Pissarro and Venturi 489,
 The Cleveland Museum of
 Art or 455, private
 collection, Paris
169. Pissarro and Venturi 416,
 Musée d'Orsay
173. Pissarro and Venturi 489,
 The Cleveland Museum of
 Art or 455, private
 collection, Paris
174. Pissarro and Venturi 345
175. Pissarro and Venturi 397
178. Pissarro and Venturi 480,
 Ny Carlsberg Glyptotek,
 Copenhagen

— 14 —

179 — Les Meules.
 Appartient à M. G...
180 — Le Potager.
 Appartient à Mlle T...
181 — L'Hermitage. Vue de ma fenêtre.
 Appartient à M. G. C...
182 — Vue de l'Hermitage.
 Appartient à M. G. C...
183 — Printemps. Pruniers en fleurs.
 Appartient à M. G. C...
184 — Petit bois de peupliers en plein été.
 Appartient à M. G. C...
185 — Planteurs de choux.
 Appartient à M. G. C...
186 — Port-Marly.
 Appartient à M. G. C...
187 — Petit bois. (Poules et canards.)
 Appartient à M. M...
188 — Côte des Brouettes. (Temps gris.)
189 — L'Hiver. Retour de la foire. (Éventail.)
 Appartient à M. G...
190 — L'Hiver. Environs de Lower Norwood
 (Londres). Éventail.
 Appartient à Mlle L...
191 — Laveuses. (Éventail.)
 Appartient à Mlle L...

— 15 —

192 — Soleil couchant. (Éventail.)
 Appartient à M. G. C...
193 — Meule (Semeur). id.
194 — Clair de lune. id.
195 — Vue de Pontoise. id.
 Appartient à Mlle L...
196 — La Grande route. Printemps. id.
197 — Pommiers en fleurs. id.
198 — La Toilette du matin. id.
199 — L'Étang de Montfoucault. id.
 Appartient à M. Ch...
200 — Cueillette de petits pois. id.
 Appartient à Mlle C...
201 — Portrait de Mlle E. E... (Pastel.)
202 — Portrait de Mlle M... id.
203 — Le Pâtissier. id.
 Appartient à M. M...
204 — Intérieur campagnard. id.
 Appartient à M. C...

ROUART (Henry)
34, rue de Lisbonne.

205 — A Gèdres. (Basses-Pyrénées.)
206 — Royat dans son nid.

— 16 —

207 — Un coin du château de Monaco.
208 — Château de Fleury.
209 — Bords du Loir.
210 — Paysanne.
211 — Au Bas-Bréau.
212 — Au Vieux-Caire. (Égypte.)
213 — A Boulac. (Égypte.)
214 — Château de Tour-Noël. (Dessin.)
215 — Royat. id.
216 — Chateldon. id.
217 — Château de Chateldon. id.
218 — Thiers. id.
219 — Vue prise de Pau. id.
220 — Sous les frênes. id.
221 — Port de Melun. id.
222 — Cour de ferme. id.
223 — Plaine de Brie. id.
224 — Sous les châtaigniers. id.
225 — Crozant. id.
226 — id.
227 — id.

— 17 —

SOMM (Henry)
13, rue Lécluse.

228 — Calendrier de 1878. (Gravure à la pointe
 sèche.)
229 — Calendrier de 1879. (Gravure à la pointe
 sèche.)
230 — 1 cadre, dessins à la plume pour servir
 à l'illustration du *Livre des Baisers,*
 de V. Billaud.

TILLOT (Charles)
42, rue Fontaine.

231 — Plage à marée basse.
232 — Falaises à Villers-sur-Mer.
233 — Fleurs de printemps.
234 — Pivoines et Iris.
235 — Pivoines, Coquelicots, etc.
236 — Pavots et Coquelicots.
237 — Fleurs dans un Vase Persan.
238 — Printemps et Automne. (Deux tableaux
 de fleurs sous le même numéro.)

239 — Jeune Paysanne.

240 — Tête de jeune fille.

241 — Vue de la rue de Barbizon.

ZANDOMENEGHI
25, passage de l'Élysée-des-Beaux-Arts.

242 — Portrait de M. Diego Martelli.

243 — Portrait de M. C...

244 — Un canal de Venise.

245 — Une industrie vénitienne.

246 — Violettes d'hiver.

9 — 1191 Paris, Morris père et fils, imp. brev., rue Amelot, 64.

242. Piceni 35, Galleria d'Arte
Moderna, Florence
246. Perhaps Piceni 37, Paolo
Stramezzi, Crema

h.c. Gauguin
Marble bust of Emil
Gauguin, Gray 2,
Metropolitan Museum of
Art
h.c. Piette
Verger en fleurs
Marché de petite ville
Aquarelles et gouaches

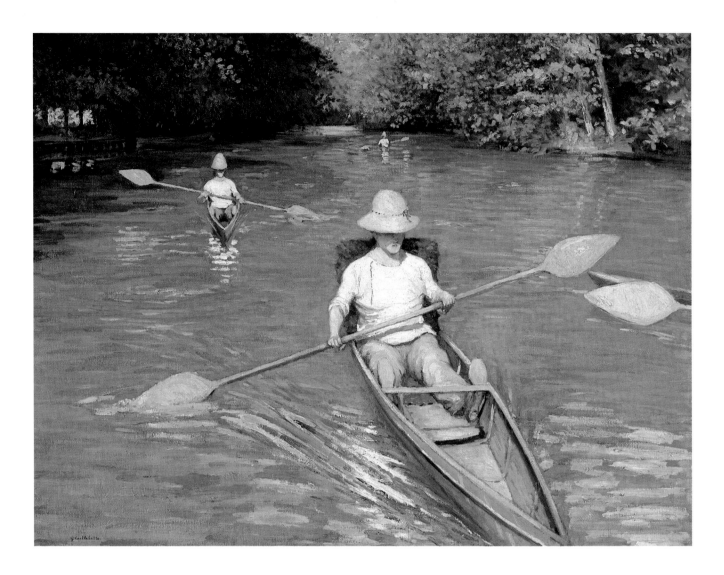

67. Gustave Caillebotte

IV—10

Périssoires, 1877
Sculls

Now known as *Périssoires sur la Yerres* (Sculls on the Yerres) or
Les canotiers (The Canoeists)
Signed and dated upper right: *G. Caillebotte/1877*; also signed
by Renoir, lower left: *G. Caillebotte.*
Oil on canvas, 35 x 45 ½ in. (89 x 115.5 cm)
Collection of Mr. and Mrs. Paul Mellon, Upperville, Virginia
REFERENCES: Berhaut 1978, no. 95; Varnedoe and Lee 1976,
124–125, fig. 1.

Caillebotte seems haunted by the
violet and blue light in which his
paintings are bathed a little too
much. However, there are some
with luminous areas. His *Péris-
soires* and rowing *Canotiers* are
almost interesting works because
of their investigation of light and
plein air. I suppose that certain of
these compositions would
improve if they were placed as
decorations in an apartment. Iso-
lated and subdued by the gilded
wainscotting around them, they
might lose that crude and violent
look that they are given by
daylight.
Paul Sébillot, *La Plume*,
15 May 1879

What is regrettable is that he has
an unfortunate tendency to see
everything in blue. This passion
shows itself crudely in all the
paintings he shows, and particu-
larly in the *Scènes de canotage*.
One must certainly have a fair
amount of good will to appreci-
ate the qualities of the painter
through the blue veil that covers
all his canvases. This singular
aberration of an artist who is
schooled and very talented makes
one think of the analogous case
that is presented in the famous
novel of *Jérôme Paturot*. In
creating the fantastic Oscar, a
painter devoted to blue, did not
Reybaud presage the coming of
Caillebotte?
Alfred de Lostalot, *Les Beaux-
Arts Illustrés*, 1879
Louis Leroy, *Le Charivari*,
17 April 1879

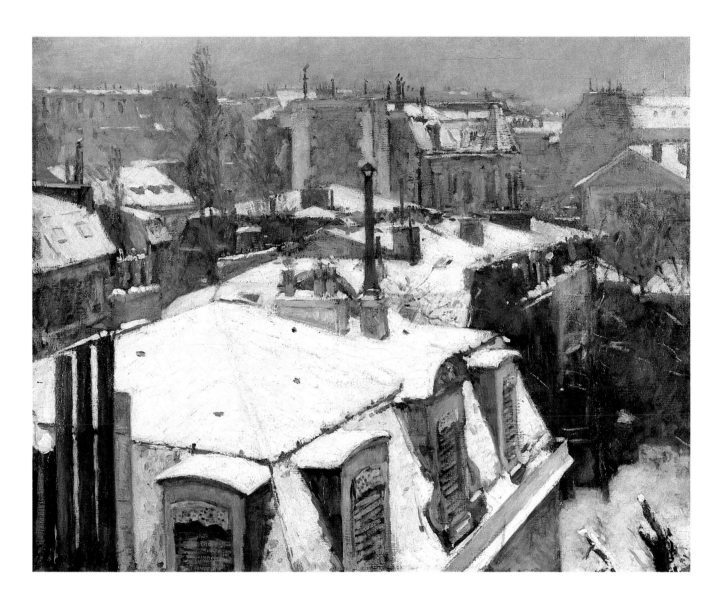

68. Gustave Caillebotte

IV—12

Vue de toits (Effet de neige), 1878
View of Rooftops (Snow Effect)

Now known as *Toits sous la neige, Paris* (Rooftops in the Snow, Paris)
Signed lower left: *G. Caillebotte*
Oil on canvas, 25⅝ x 31⅞ in. (65.1 x 81 cm)
Musée d'Orsay (Galerie du Jeu de Paume), Paris. Martial Caillebotte Bequest, 1894. R.F. 2730
REFERENCES: Berhaut 1978, no. 107; Adhémar and Dayez-Distel 1979, 19, 152; Varnedoe and Lee 1976, no. 42.

After Monet, . . . comes Caillebotte's show, with all genres represented: portraits, landscapes, decorative panels, flat-bottomed canoes, many studies of boaters. A *Vue de toits* and the *Rue Halévy vue d'un sixième étage* are equally deserving of special notice.
Le Voltaire, 1 May 1879

Two *Vues de toits* by the same artist, painted with a simple and powerful note, extend waves of slate, tiles, gables, gutters, mansards, weathervanes, and chimneys into the distance.
F. -C. de Syène [Arsène Houssaye], *L'Artiste*, May 1879

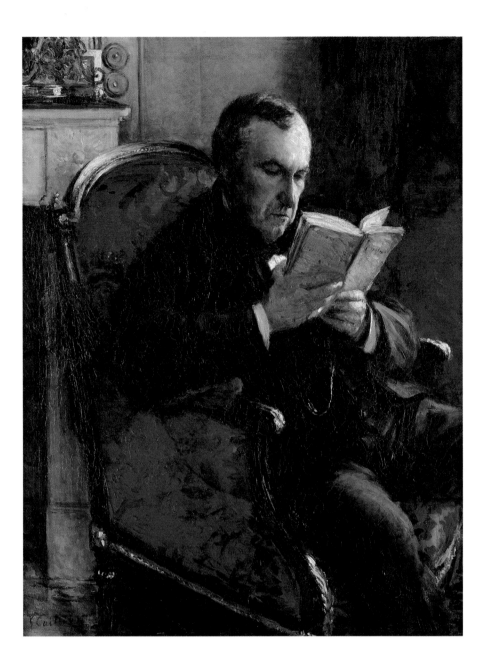

69. Gustave Caillebotte

IV—18

Portrait de M. E. D. . . , 1878

Now known as *Portrait d'Eugène Daufresne*
Signed and dated lower left: *G. Caillebotte/1878*
Oil on canvas, 39⅜ x 31⅞ in. (100 x 81 cm)
Josefowitz Collection
REFERENCES: Berhaut 1978, no. 80.
NOTE: Eugène Daufresne was Caillebotte's mother's cousin.
See Berhaut, above.

You can tell how little there is in these painters by how prolific they are. Caillebotte alone exhibits about twenty canvases that seem to have been dashed off in a single day.
Albert Wolff, *Le Figaro*,
11 April 1879

As for Caillebotte, it may well be that he was a victim of the blue and violet palette. He has not been painting very long, and perhaps his personal inclination would lead him into a different style. Beneath his hard work, and despite his errors, one sees in three or four portraits a kind of cruel intensity that captures you by its ponderous insistence. I would like to see him become more playful with his art, and less obstinate in his savage and dreary attempt to violate nature, which so easily resists him.
[Edmond] Duranty, *La Chronique des Arts et de la Curiosité*,
19 April 1879

Among the thirty-four canvases by the new pontiff of the movement, there are a great number of astonishing straw-hatted boaters, of apocalyptic lady-boaters, and amazing landscapes shaped in solid blue or solid green. He has friends he loves and who love him. He seats them on strange couches, in fantastic poses. The strangest colors, among them green, black, and red, are involved in Homeric struggles. Someone has even shown me one of an uncle of his, sitting glued to an armchair that threatens to collapse. Kinship could not protect this good gentleman from the verve of his nephew. He is sad, but seems to forgive him nevertheless.
Bertall [Charles-Albert d'Arnoux], *L'Artiste*,
1 June 1879

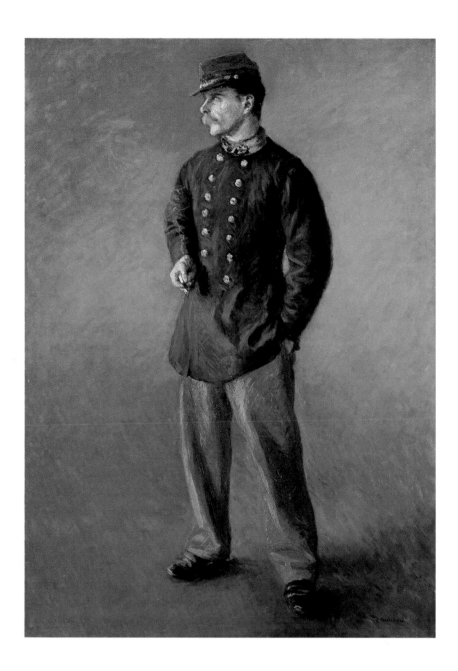

70. Gustave Caillebotte

IV—HC

Un soldat, ca. 1879
A Soldier

Atelier stamp lower right: *G. Caillebotte.*
Oil on canvas, 41¾ x 29½ in. (106 x 75 cm)
Josefowitz Collection
REFERENCES: Berhaut 1978, no. 170.
NOTE: The identification of *Un Soldat* as a work included *hors catalogue* in 1879 depends upon a caricature by Draner (see Pickvance, *fig.*9). Draner has apparently transformed the pensive, mustachioed infantryman into a bored guard at the exhibition itself (see Draner's caption). Otherwise, there is no explanation for Draner's assertion that a military figure in a nearly identical uniform was on duty at a private exhibition.

Murger once sang the *Symphony in Blue*. Caillebotte brings it off better than anyone. Everything he does is blue. It is frightening to think of how much he must spend on cobalt, ultramarine, and indigo. Never has azure been squandered with such profusion on a canvas! If his dreams are in that same color, he must already see himself made a member of the Institute, decorated, overwhelmed with orders for work, and occupying Manet's throne in the very near future.
Louis Leroy, *Le Charivari*,
17 April 1879

P.S. In rereading this article, I see that I have left out Caillebotte. This omission is more blameworthy because Caillebotte has not stinted himself at the Exhibition of the Independents; his abundance borders on prolixity. He is everywhere, covering entire walls, climbing easels. It is he who furnishes the happy note.
Henry Havard, *Le Siècle*,
27 April 1879

Caillebotte is a young man who combines a passion for art and a rare talent with the means to practice it on his own terms. And it is he, more than all the others, who provokes the public's outrage at this exhibition. It is difficult to judge impartially the painting of this artist, for he shows himself to us today in a very different light from the one we met him in three years ago. He has changed so much that you do not know if it is good or bad that he left the path already laid down in his painting of the scrapers, a dry painting, full of will and modesty.
On the other hand, should we prefer him now that he gives us almost forty canvases dominated by a palette of bluish tones ranging through all its shadows, and on which color no longer can contain itself, or reels like a bacchante?
Diego Martelli, *Roma Artistica*,
27 June and 5 July 1879

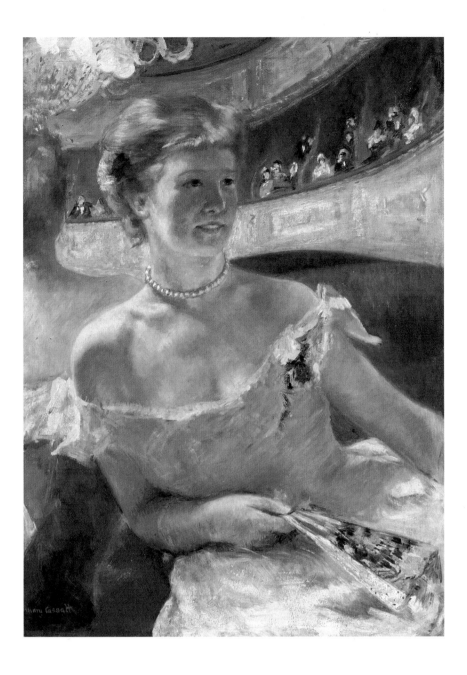

71. Mary Cassatt

IV–49

Femme dans une loge, 1879
Woman in a Loge

Now known as *Lydia in a Loge, Wearing a Pearl Necklace*
Signed lower left: *Mary Cassatt*
Oil on canvas, 31⅝ x 23 in. (80.3 x 58.4 cm)
Philadelphia Museum of Art. Bequest of Charlotte Dorrance
Wright. 1978-1-5
REFERENCES: Breeskin 1970, no. 64; Breeskin 1981, no. 11;
Lindsay 1985, no. 3.
NOTE: Lydia Simpson Cassatt (1837–1882), Mary's older
sister, frequently modeled for the artist. Traditionally this work
has been identified as a portrait of Lydia; however, Lindsay
disputes this identification. See Lindsay, above.

Mary Cassatt, a beginner, evidently has excellent intentions; she sees correctly, but paints a little too hesitantly. Let us add, to be kind, that she promises to have enough talent from now on to abandon both the pursuit of subjects, such as the one in *Femme dans une loge* where the complication of the mirror effect has no point, and frames smeared with red or green, which are truly ugly and in the worst taste.
E. R. [Edmond Renoir],
La Presse, 11 April 1879

. . . but an American lady, Mary Cassatt, is exhibiting some cleverly framed portraits, which are extremely interesting. The work by this bold painter that has most impressed visitors is of a young redheaded woman in a theater box, the back wall of which is a mirror reflecting the brilliantly lit theater. This work suggests the flesh has been modeled by reflection, clearly revealing a very individual talent.
Ernest d'Hervilly, *Le Rappel*,
11 April 1879

There is nothing more gracefully true and aristocratic than her portraits of young girls—unless it is her *Femme dans une loge*, who is placed in front of a mirror that reflects her shoulders and her reddish-blond hair.
F. -C. de Syène [Arsène Houssaye], *L'Artiste*, May 1879

Cassatt is a young American woman who, like Degas (perhaps she is his student), seeks movement, light, and design in the most modern sense. Her half-figure of a woman in a theater box lit by gaslight and reflections from a mirror is a very beautiful work. It is good enough to place its author among the ranks of the best artists.
Diego Martelli, *Roma Artistica*,
27 June and 5 July 1879

One particularly notes the portrait of a young English woman wearing a low-cut dress, facing the viewer from a theater loge: at the back a mirror reflects the hall glowing with light. What difficulties are amassed in such a subject! Cassatt has solved almost all of them. The work is certainly incomplete, and the unusual subject could be surprising at first; but one is soon captivated by all the seductions that the talent and the nature of the artist have put there.
Alfred de Lostalot, *Les Beaux-Arts Illustrés*, 1879

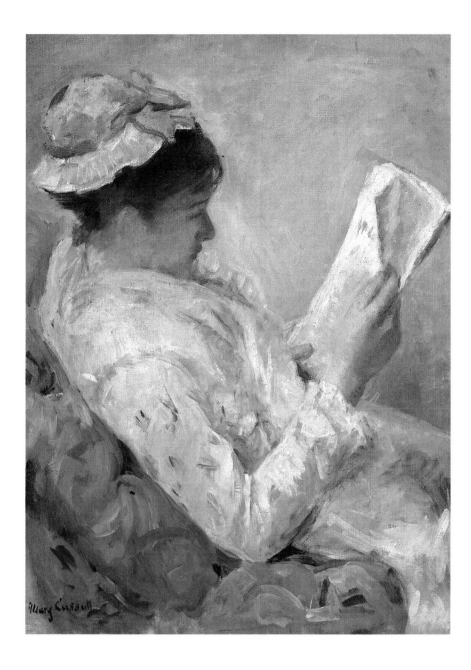

72. Mary Cassatt

IV–52

Femme lisant, 1878
Woman Reading

Signed lower left: *Mary Cassatt*
Oil on canvas, 32¼ x 23½ in. (81.9 x 59.7 cm)
Joslyn Art Museum, Omaha, Nebraska. 1943.38
REFERENCES: Breeskin 1970, no. 51; Day and Sturges,
forthcoming; Washington 1970, no. 8.

Degas has a student, Mary Cassatt, whose portraits or studies of society women are worthy of serious attention.
Ph. B. [Philippe Burty], *La République Française*,
16 April 1879

Mary Cassatt resolutely chose the same path [as Degas]. She is still very far from having the same authority in execution, but her *Femme assise* reading a popular novel is a charming work
(no. 52).
Armand Silvestre, *La Vie Moderne*, 24 April 1879

It is equally impossible to visit the exhibition without being intensely interested in the portraits by Cassatt. A most remarkable sense of elegance and distinction—and very English (she is American)—marks these portraits. Cassatt *merits our very particular attention.*
[Edmond] Duranty, *La Chronique des Arts et de la Curiosité*,
19 April 1879

There is not a canvas nor a pastel by Mary Cassatt that is not an exquisite symphony of color. She is fond of the palette's sharp tones and has the secret of combining them into a whole that is filled with pride, mystery, and freshness. *La femme lisant*, seen in profile, is a miracle of elegance and simplicity.
F. -C. de Syène [Arsène Houssaye], *L'Artiste*, May 1879

A half-figure of a woman reading in an armchair is quite beautiful, above all in the expression of the pose.
Diego Martelli, *Roma Artistica*,
27 June and 5 July 1879

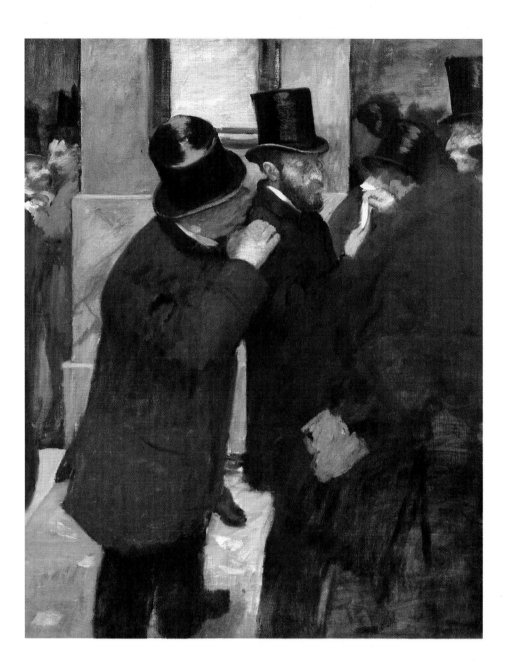

73. Edgar Degas

Portraits, à la Bourse, ca. 1879
Portraits at the Stock Exchange

IV–61
also V–35

Now known as *A la Bourse* (At the Stock Exchange)
Oil on canvas, 39⅜ x 32¼ in. (100 x 82 cm)
Musée d'Orsay (Galerie du Jeu de Paume), Paris. R.F. 2444
REFERENCES: Lemoisne 1946, no. 499; Adhémar and Dayez-
Distel 1979, 36, 155; Boggs 1962, 54, pl. 101; Pickvance 1979,
no. 49.
NOTE: The figure on the right is Ernst May (1845–1925),
banker and art collector. By 1879 his remarkable collection
included works by Manet, Monet, Pissarro, and Sisley, as well
as Degas. The figure on the left, whispering in May's ear, is his
friend M. Bolâtre. This work may also have been shown in the
second group show (no. 38).

. . . and this man's hat, under
which, after the most conscien-
tious researches, I found it impos-
sible to find a head—is an Inde-
pendent hat, as well!
Louis Leroy, *Le Charivari*,
17 April 1879

While most of [these Independent
artists] give the impression that
they hold drawing cheap, Degas
is an exception. He is a distin-
guished artist, even though the
works he sent in 1879 are far
from surpassing those of previous
years. . . .
Paul Sébillot, *La Plume*,
15 May 1879

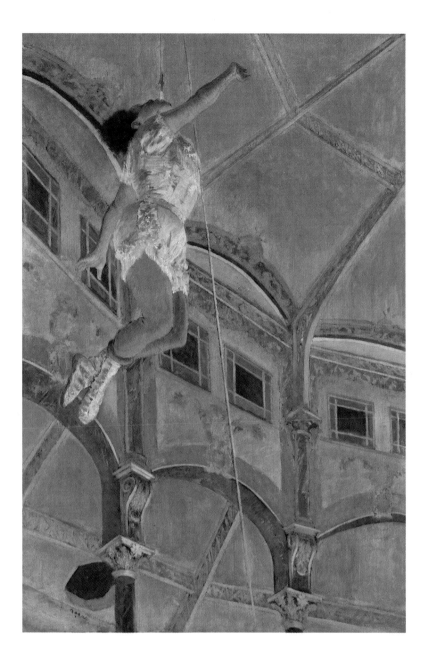

IV—62

74. Edgar Degas

Miss Lola, au Cirque Fernando, 1879

Now known as *La La at the Cirque Fernando, Paris*
Signed lower left: *degas*
Oil on canvas, 46 x 30½ in. (117 x 77.5 cm)
The Trustees of the National Gallery, London. 4121
REFERENCES: Lemoisne 1946, no. 522; Davies 1970, no.
4121; Reff 1976, 171, 178, 180, fig. 120; Pickvance 1979, no.
47; Guillaud et al. 1984, 45, fig. 43.
NOTE: Contemporary sources including Degas himself have
identified this well-known circus performer as "Miss La La."
Her identification as "Miss Lola" in the fourth exhibition
catalogue was in error. See Davies, above.

That surprising artist named
Degas is here at the exhibition
with all his sarcasm and sharp
wit, all his capriciousness, a man
in a class all by himself who peo-
ple are beginning to think a great
deal of, and who will be unusu-
ally esteemed in coming years.
Twenty painters owe their success
to his influence, for you cannot
get near him without catching
some of his excitement.
[Edmond] Duranty, *La Chro-
nique des Arts et de la Curiosité*,
19 April 1879

As it has been enriched by several
new works, it seems necessary to
return to the exhibition of the
Independents, particularly
because it is Degas who has com-
pleted his submissions. . . .
["Miss La La"] is a mulatto
shaped like a young man and has
no equal in hanging by her teeth
from the ridgepole of hippo-
dromes. Degas shows her in this
poetic occupation, her frizzy head
violently thrown back, her spine
arched, her legs hanging and
slightly crossed, slowly twirling
at the end of a cable in the trem-
bling lights of the arched ceiling
and the noisy atmosphere of the
cheers. The drawing is exquisitely
true and accurate, and the violet
shorts that wrinkle above the
tights are the most amusing style
possible.
Armand Silvestre, *La Vie
Moderne*, 1 May 1879

Parisian wit and Impressionist
audacity vigorously set off by a
fanciful Japanese touch: such are
the elements that Degas is able to
combine to create very marked,
very individual originality. Degas
searches out mysterious and wild
effects. None knows better than
he how to use silvery sparkling
lights, pale opalescences, glowing
incandescent reds, coppery radia-
tions, and twilit half-tones.
F. -C. de Syène [Arsène Hous-
saye], *L'Artiste*, May 1879

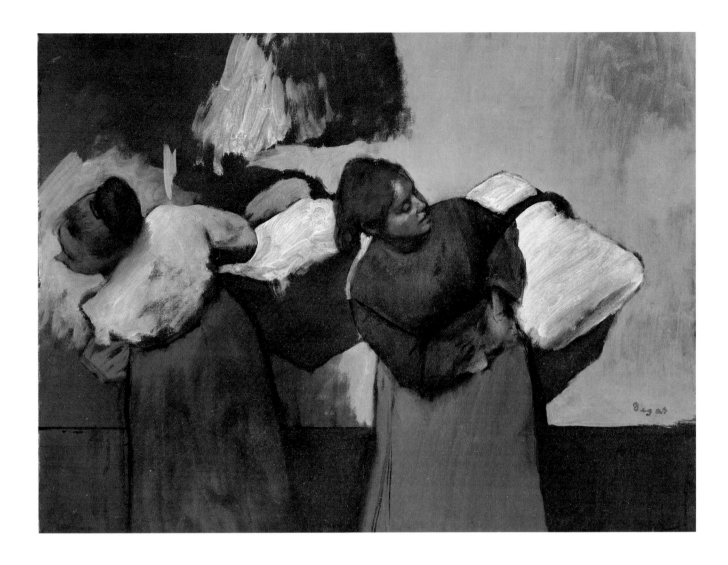

75. Edgar Degas

IV—64

Blanchisseuses portant du linge en ville,
ca. 1876–1878
Laundresses Carrying Linen in Town

Signed lower right: *Degas*
Oil colors freely mixed with turpentine on paper mounted on
canvas, 18 x 24 in. (46 x 61 cm)
Private collection, England
REFERENCES: Lemoisne 1946, no. 410; Isaacson 1980, no. 14.

When we took our notes, Degas
still had only three studies: some
*Blanchisseuses portant du linge
en ville* and two *Ecoles de danse.*
Since then he has probably sent
more entries. These were enough
to establish his refined knowledge
of drawing, his precise knowl-
edge of the colors of clothing, his
astonishing knowledge of light in
interiors. It is truly regrettable
that this distinguished, excep-
tional, witty, and grave artist is
not represented in the Luxem-
bourg [museum established for
contemporary art] by one of his
pastels that the elite of the *ama-
teurs* fight over.
Ph. B. [Philippe Burty], *La
République Française,*
16 April 1879

We are most intensely interested
in those too rare canvases of
Degas. It is always the same pro-
cess of synthesis joined with feel-
ing for accuracy that is really
admirable. Look at these *Blan-
chisseuses* (no. 64) bending under
the weight of their baskets. From
a distance one might say they are
by Daumier, but close up they are
much more than a Daumier.
There is a considered mastery in
this picture, whose power is inde-
finable. It is the most eloquent
protest against the confusion of
colors and complication of effects
that is destroying contemporary
painting. It is a simple, correct,
and clear alphabet thrown into
the studio of the calligraphers
whose arabesques have made
reading unbearable.
Armand Silvestre, *La Vie
Moderne,* 24 April 1879

76. Edgar Degas

IV–77

Eventail, ca. 1877–1879
Fan

Now known as *Fan Mount: The Ballet*
Watercolor, india ink, silver, and gold on silk, 6 ⅛ x 21 ¼ in.
(15.6 x 54 cm)
Lent by The Metropolitan Museum of Art. Bequest of Mrs.
H. O. Havemeyer, 1929. The H. O. Havemeyer Collection.
29.100.554
REFERENCES: Lemoisne 1946, no. 457; Gerstein 1982, 110,
fig. 1.

And the *Portrait of Duranty*, find
[a portrait] at the next Salon with
as much style . . . And his fans?
And his racehorses?
Montjoyeux [pseud.],
Le Gaulois, 18 April 1879

Some of his fans are like very
strange Japanese fantasies.
Paul Sébillot, *La Plume*,
15 May 1879

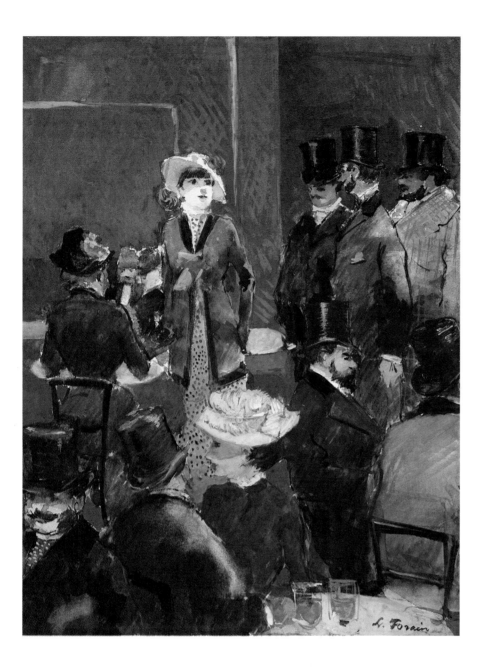

77. Jean-Louis Forain

IV–86

Intérieur de café, ca. 1879
Café Interior

Now known as *Au café* (At the Café)
Signed lower right: *L. Forain*
Gouache on paper, 12⅞ x 10 in. (32.8 x 25.5 cm)
E. J. van Wisselingh and Co., Naarden, Holland. G 9194
REFERENCES: London 1973, no. 6; Amsterdam 1975, no. 13.

Forain, a very young man, follows Degas with one foot and the caricaturist Grévin with the other. Despite that, his watercolors are stamped with originality, fruit of the young spirit and their creator's lack of constraint. Above all, he renders interiors of the Folies-Bergère, the evening refuge of the cocottes, with a completely Parisian sensibility. This artistic instinct, affirmed by study, will one day make him an uncommon and brilliant artist.
Diego Martelli, *Roma Artistica*, 27 June and 5 July 1879

Also in this group is Louis Forain, a very young man showing some sketches that have some very good points. If he decided to study, to commune with nature, to learn his profession, he might emerge from the crowd. But the failing of this school is that they do not want to learn anything. They elevate their ignorance to the level of principle, and their schoolboy smears to an artistic theory.
Albert Wolff, *Le Figaro*, 11 April 1879

Also worth mentioning are Forain's types. He proceeds, like the Japanese, by cutting true-looking silhouettes against violent but harmonious backgrounds.
Ernest d'Hervilly, *Le Rappel*, 11 April 1879

Forain is a caricaturist. He models himself on Daumier, but he has such a long way to go before he approaches this master that we will look for him at a later stage.
Henry Havard, *Le Siècle*, 27 April 1879

Forain, whom the readers of *La Vie Moderne* will come to know well, has a cold humor, like a comic Englishman. Whether he shows us a swarm of elegant cads pouncing, like a bunch of dressed-up sparrows, on a ripe fruit from M. Sari's orchard, or Coquelin the younger in the *Sphinx*, exhaling his melancholy over the silent keyboard of the harpsichord, it is the same excessively foppish feeling, and the same silhouettes cut out under gaslight in a cloud of perfume by a malicious child. In a word, a very particular sensibility.
Armand Silvestre, *La Vie Moderne*, 1 May 1879

In a series of ruthless and candidly captured watercolors, Forain unrolls before us the life of the dandies who parade their dismal stupefaction from the cafés of the boulevards to the lobbies of the little theaters.
F.-C. de Syène [Arsène Houssaye], *L'Artiste*, May 1879

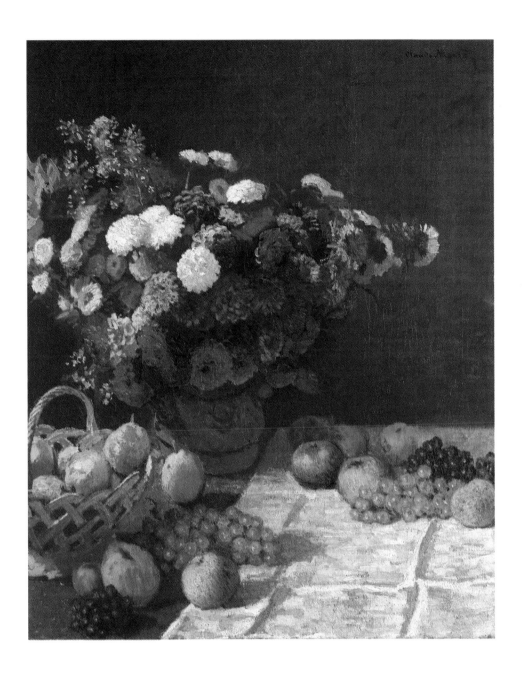

78. Claude Monet

IV—142

Fleurs, 1869
Flowers

Now known as *Still Life with Flowers and Fruit*
Signed upper right: *Claude Monet*
Oil on canvas, 39⅛ x 31¾ in. (100 x 80.7 cm)
The J. Paul Getty Museum, Malibu. 83.PA.215
REFERENCES: Wildenstein 1974, no. 139; Malibu 1984,
no. 16; Daulte et al. 1982, no. 4.

Some of the older paintings of
Monet's are intriguing studies,
but I confess that I have trouble
understanding a number of his
newer canvases where all the
colors of the rainbow have been
juxtaposed.
Paul Sébillot, *La Plume,*
15 May 1879

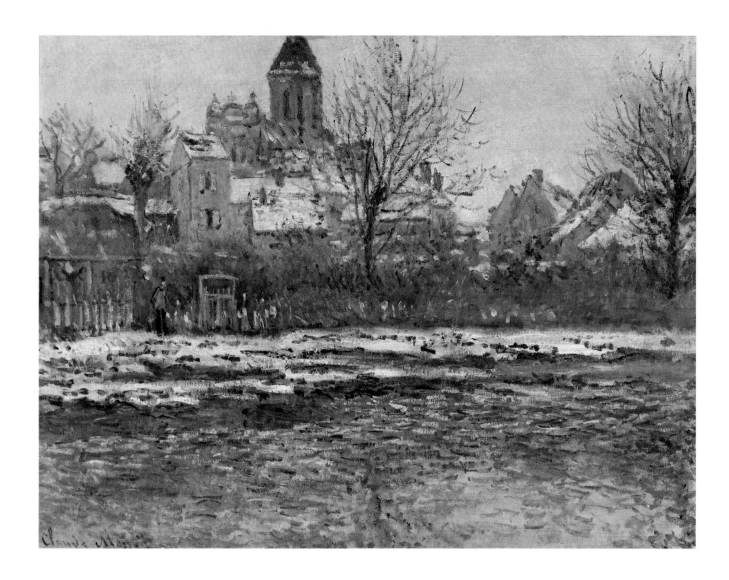

79. Claude Monet

IV—144

Effet de neige à Vétheuil, 1878–1879
Snow Effect at Vétheuil
Now known as *Eglise de Vétheuil, neige* (Church at Vétheuil, Snow)
Signed lower left: *Claude Monet*
Oil on canvas, 20½ x 28 in. (52 x 71 cm)
Musée d'Orsay (Galerie du Jeu de Paume), Paris. Gustave Caillebotte Bequest, 1894. R.F. 3755
REFERENCES: Wildenstein 1974, no. 506; Adhémar and Dayez-Distel 1979, 74, 164; Adhémar et al. 1980, no. 66.

The majority of the public laughs before these oil and watercolor monstrosities, which saddens me because I saw more than one man of talent drown in this small church where pride equals mediocrity. Such is Claude Monet, who was not just anyone. I have seen some very interesting landscapes by him. For a moment I thought that the creator of these impulsive sketches, this glib but sensitive impression of nature, would become someone. And now here he is, stuck forever in a mess he will never get himself out of.
Albert Wolff, *Le Figaro*,
11 April 1879

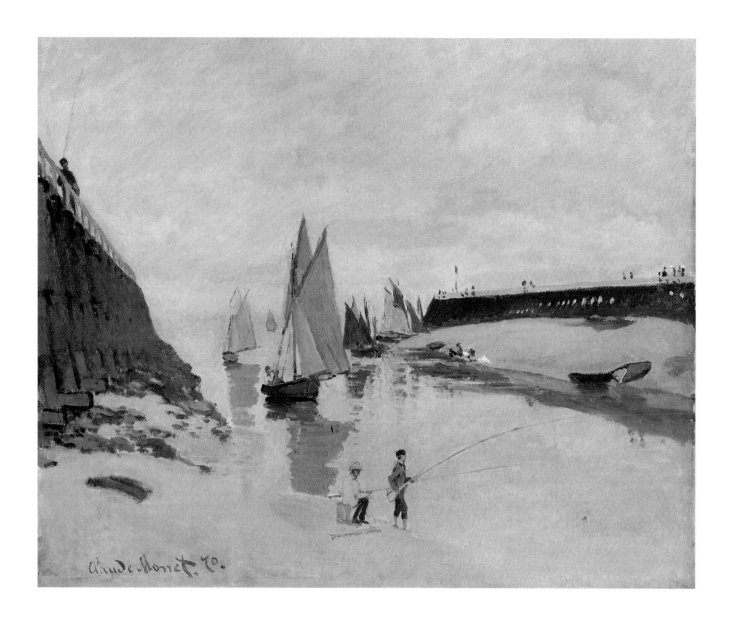

80. Claude Monet

IV—147

Estacade de Trouville, marée basse, 1870
Jetty at Trouville, Low Tide
Signed and dated lower left: *Claude Monet. 70.*
Oil on canvas, 21¼ x 25⅞ in. (54 x 65.7 cm)
Szépmüvészeti Múzeum, Budapest. 4970
REFERENCES: Wildenstein 1974, no. 154; Garas 1973, 276, 286.

[One painting by Monet], *Entrée de port à marée basse*, really bothered me. This study is very refined tonally, very accurate, very successful. What are all these fine qualities doing in an Impressionist work? Because whatever you try to do, you can never succeed in being completely absurd. A distressing blow to doctrine and the unity of artistic principles.
Louis Leroy, *Le Charivari*, 17 April 1879

These really are refreshing breezes . . . from the ocean that blow in Monet's seascapes. . . . *L'estacade de Trouville*, for example, has been painted with an accurate and true range [of color].
F.-C. de Syène [Arsène Houssaye], *L'Artiste*, May 1879

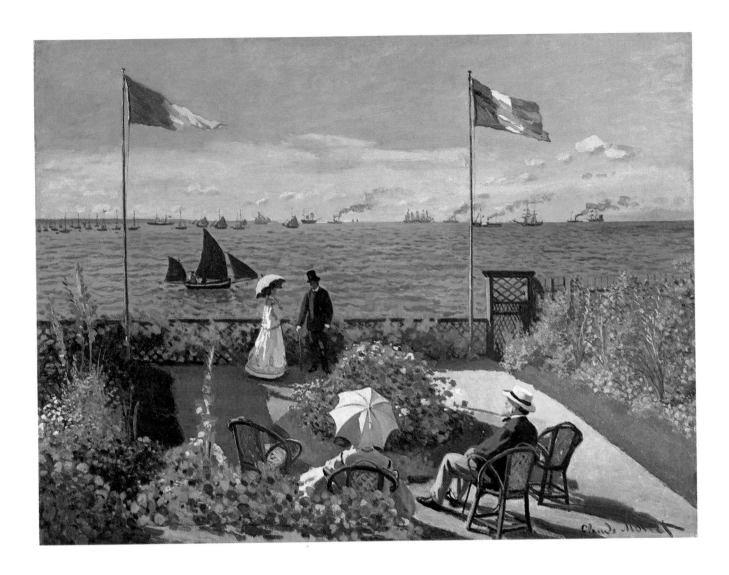

81. Claude Monet

IV–157

Jardin à Sainte-Adresse (1867)
Garden at Sainte-Adresse (1867)

Now known as *Terrace at Sainte-Adresse*
Signed lower right: *Claude Monet*
Oil on canvas, 38⅝ x 51⅛ in. (98.1 x 129.9 cm)
Lent by The Metropolitan Museum of Art. Purchased with special contributions and purchase funds given or bequeathed by friends of the Museum, 1967. 67.241
REFERENCES: Wildenstein 1974, no. 95; Baetjer 1984, 1:128; Isaacson 1978, no. 21.

Claude Monet has submitted some thirty canvases to the Impressionist exhibition. This artist is far from being an unknown. He has exhibited fairly regularly since 1866, and the official Salon has accepted his work many times. It says it all to note that we have a talent that has been matured by the best master: hard work. Monet is in fact a tireless worker, and his body of work is sizeable. . . . He has found his own path, the landscape, and especially the water's edge, whether of the sea or of a river. He renders their picturesque and poetic aspect with a sweetness, charm, and tonal intensity that place him unquestionably in the top rank of painters in the modern landscape school.
E.R. [Edmond Renoir], *La Presse*, 11 April 1879

The last room belongs to the high priests of Impressionism. Monet and Pissaro [*sic*] reign there as masters. I confess humbly I do not see nature as they do, never having seen these skies fluffy with pink cotton, these opaque and moiré waters, this multi-colored foliage. Maybe they do exist. I do not know them.
As for technique, it is trying, it seems difficult and overworked. Using impasto excessively, they work for an ease of appearance that is earned only by effort. Here again some curious works are produced—instructive, but not decisive.
Henry Havard, *Le Siècle*, 27 April 1879

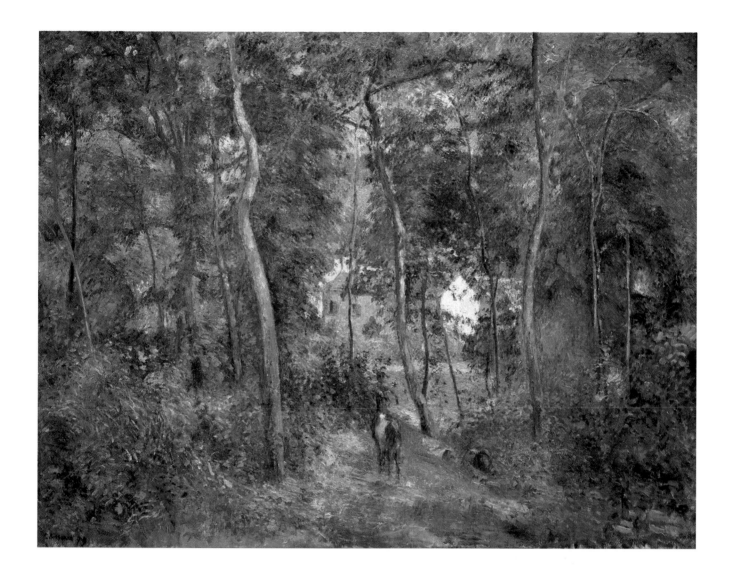

82. Camille Pissarro

IV–168 or 173

Lisière d'un bois *or* **Sous bois en été,** 1879
Edge of the Woods *or* Undergrowth in Summer

Signed and dated lower left: *C. Pissarro 79*
Oil on canvas, 49⅝ x 63¾ in. (126 x 162 cm)
The Cleveland Museum of Art. Gift of the Hanna Fund. 51.356
REFERENCES: Pissarro and Venturi 1939, no. 489; Cleveland
1978, 215; Lloyd et al. 1981, no. 52.
NOTE: The other version of this subject, exhibited in the fourth
exhibition as either no. 168 or 173, is *Lisière de bois* (Pissarro
and Venturi, no. 455), now in a private collection, Paris.

The fecundity of these painters
tells you that they are contented
with just a little. . . . Before lunch
Pissarro does his dozen paintings;
he shows forty.
Albert Wolff, *Le Figaro*, 11 April
1879

Pisarro [*sic*] seems to be working
in a less tortured direction than in
his preceding exhibition.
Paul Sébillot, *La Plume*,
15 May 1879

Several traitors have slipped into
the exhibition in the avenue de
l'Opéra: . . . Pissarro with some
sincere studies where the gray
touches are marvelous.
Louis Leroy, *Le Charivari*,
17 April 1879

IV—169

83. Camille Pissarro

Chemin sous bois, 1877
Path through the Woods

Now known as *Chemin sous bois en été* (Path through the Woods in Summer)
Signed and dated lower right: *C. Pissarro, 1877*
Oil on canvas, 31⅞ x 25⅞ in. (81 x 65.7 cm)
Musée d'Orsay (Galerie du Jeu de Paume), Paris. Gustave Caillebotte Bequest, 1894. R.F. 2731
REFERENCES: Pissarro and Venturi 1939, no. 416; Adhémar and Dayez-Distel 1979, 89, 167; Milkovich 1977, 15, no. 21.

Pizzaro [*sic*] is older, although his energy belies his fifty years. Beautiful apostle's head, whitened in the unceasing fight for tomorrow. Married also, and father of many children, he divides his time between Pontoise and Paris. Integrity makes the man, and courage makes the artist. Contrary to Monet [he is] firm as a rock, not knowing either weariness or loss of belief. Surer of himself than the others, not asking more than to believe in good and dream of the future. Poor as Job and prouder than he.
Montjoyeux [pseud.],
Le Gaulois,
18 April 1879

Pissarro is without a doubt gifted with fine sensibility and great delicacy. Layers of dross, of whitewash, seem to have been removed, and the direct connections between Monet and Théodore Rousseau, between Pissarro and Millet, appear clearly.
[Edmond] Duranty, *La Chronique des Arts et de la Curiosité*,
19 April 1879

Pissarro, a little more of a dreamer perhaps because of his southern origins, is, however, as strong as [Monet], if not always, then at least in a few of his paintings. Always rude and monotonous in his technique, Pissarro seems to pour the excess of his rage and honesty into all of his paintings. An unhappier man than anyone and a more honest one than most, his painting reveals his better nature, affecting you like a person who always wants to tell you the story of his soul.
Diego Martelli, *Roma Artistica*,
27 June and 5 July 1879

Pissarro does not seem to possess as much originality as before.
Ph. B. [Philippe Burty],
La République Française,
16 April 1879

We see there the paintings . . . of Pissarro, whose scrupulous research sometimes produces an impression of hallucinogenic truth.
Emile Zola, *Le Messager de l'Europe* [Saint Petersburg],
July 1879

84. Federico Zandomeneghi

IV–242

Portrait de M. Diego Martelli, 1879

Signed, dated, and inscribed lower right: *A Diego Martelli/
Zandomeneghi 79*
Oil on canvas, 28⅜ x 36¼ in. (72 x 92 cm)
Galleria d'Arte Moderna, Florence. Bequest of Diego Martelli.
C. G. 230
REFERENCES: Piceni 1967, no. 35; Cinotti 1960, 37, pl. 15.
NOTE: Diego Martelli (1839–1896), a Florentine writer and
art critic, was a defender of contemporary art, including
Impressionism. During a visit to Paris in 1878–1879 he
befriended Degas and his disciples, Zandomeneghi among
them.

Monet, Pissarro, and Zandome-
neghi are not eye-catchers
because of inherent strength.
There is at any rate a phenome-
non working here that should be
noted: the crowd of invited guests
prefers to stop at those works
that invoke ordinary notions in
art. These canvases would sur-
prise no one at the official Salon.
They are exactly the ones that
provoke marked approval. The
conclusion? That, because of its
lack of education, the crowd is
still unworthy to penetrate the
sanctuary of Intransigent art.
That is the argument that the
Impressionist ringleaders would
not fail to put before us. Perhaps
it would not be entirely
conclusive.
Le Temps, 11 April 1879

The little Impressionist school,
which has seen itself deserted by
many of its faithful, has made
some new recruits. Among them
is Zandomeneghi, an Italian who
is a most transient Intransigent.
Paul Sébillot, *La Plume*,
15 May 1879

Zandomeneghi has completed a
bold group of paintings that have
fresh, opulent, and even tonal-
ity. . . . He is a modern who will
become a forefather.
F.-C. de Syène [Arsène Hous-
saye], *L'Artiste*, May 1879

The Fifth Exhibition *1880*

fig. 4 Gustave Caillebotte, *Dans un café* (*In a Café*, v–6), 1880. Oil on canvas, 61 x 45¼ in. (155 x 115 cm). Musée des Beaux-Arts, Rouen. Photo: Giraudon/Art Resource, New York

Disarray and Disappointment

Charles S. Moffett

April is the cruellest month, breeding
Lilacs out of the dead land, mixing
Memory and desire, stirring
Dull roots with spring rain.
　　　　T. S. Eliot, The Waste Land

The fifth group show, held 1–30 April 1880, was not well received by most critics. Of course the death of Edmond Duranty on 10 April was a coincidence, but nonetheless, the demise of the author of *The New Painting*[1] during the course of the exhibition seems inescapably significant.

　　The show was the weakest of those yet organized by the loose confederation of artists known alternatively as the Impressionists, the Intransigents, and the Independents. Certain key figures chose not to participate and were replaced by others whose work was less than convincing, if not patently inappropriate, in an exhibition of avant-garde art. Renoir, Sisley, and Cézanne, all of whom had chosen not to send work to the fourth group show in 1879, were absent again and were joined by Monet who had decided instead to submit two paintings to the Salon.[2] While he may have been influenced by the success of Renoir's *Madame Charpentier and Her Children* at the Salon of 1879 (fig.1), Monet must also have been aware that in 1879 the Salon jury had rejected the pictures sent by Sisley and Cézanne. The jury accepted only his relatively conservative *Lavacourt*, 1880 (Isaacson, *fig.7*); the more ambitious *Les glaçons* (cat. no.120) was refused, but in 1882 Monet included it in the seventh group show.

　　In a letter of 8 March 1880 to the critic Théodore Duret, Monet explained why he had decided to send work to the Salon for the first time since 1870:
Since you are among those who have advised me to submit to the judgment of the official jury, it behooves me to let you know that I am going to try this experiment. . . . I believe that it is in my interest to adopt this position because I can be rather sure of doing some business, in particular with [Georges] Petit, once I have forced the door of the Salon. . . . It is not my inclination to do this, but it is unfortunate that the press and the public have

not taken seriously to our exhibitions, preferring instead the official emporium.''[3]
The pressure from such influential individuals as Duret, the prospect of selling pictures to at least one important dealer, and the failure of the group shows to achieve their goals contributed, therefore, to Monet's decision. But he also admitted that his return to the Salon required a stylistic compromise and invited the anger of his colleagues:
I am working hard on three pictures of which only two are for the Salon; one of them is too much to my own liking to send, and it would be refused. In its place I must do something tamer, more bourgeois. I am going to play for high stakes, without even counting in the fact that the [Impressionist] group calls me a turncoat. . . .[4]

　　In view of Monet's comments, then, it is not surprising that the fifth show met with limited success. Of the artists who participated in the first exhibition in 1874, only Caillebotte, Degas, Guillaumin, Morisot, Pissarro, and Rouart remained. They were joined by Félix and Marie Bracquemond, Cassatt, Forain, Gauguin, Lebourg, Levert, Tillot, Vidal, Vignon, and Zandomeneghi, all of whom had exhibited in at least one previous group show. The only true newcomer was Raffaëlli, who had previously shown at the Salon. In view of the vulnerability of the show, certain reviewers approached it sympathetically, but two conservative critics described the situation bluntly. In the 2 April 1880 edition of *Le Siècle*, Henry Havard commented,
Moreover, let us acknowledge that Impressionism is dying. The holy phalanx is no longer up to strength. Degas is still without disciples, and Pissaro[sic] generates no pupils. In addition, the former leaders are deserting. Claude Monet has gone over to the enemy; this year he exhibits at the Salon.[5]
Four days later, Gustave Goetschy announced acerbically in *Le Voltaire*,
Following Desboutin [who participated only in the second exhibition, 1876], Renoir, and Sisley . . . here we have Monet, one of the most authoritative leaders [of the movement], also divorcing himself [from the little phalanx of Independents] for reasons that are also unpardonable.[6]

Only Albert Wolff, the influential critic for *Le Figaro*, the newspaper with the largest circulation in Paris, condemned the enterprise in even stronger terms. With the exception of the work by Degas, Morisot, and Raffaëlli, he judged the exhibition

not worth taking the trouble to see and even less worthy of discussion. It is pretention coupled with incompetence. It is neither art nor preparatory work but outrageously colored landscapes and disproportionate figures: always the same empty daubing. These men never change; they cannot forget anything because they never knew anything. Why does a man like Degas dally with this pack of incompetents?[7]

From the beginning, then, there existed deeply rooted problems made all the more evident by Monet's defection. Nevertheless, the organizers proceeded, and the exhibition took place in a new building still under construction at 10 rue des Pyramides, just off the rue de Rivoli. The exhibition space itself seems to have underscored the disarray of the group. Goetschy found it noisy and poorly lit.

This year they chose to place the show on the mezzanine of an unfinished building on the rue des Pyramides. The incessant noise of work fills the place; masons, metalworkers, carpenters, spacklers, painters, and others that I do not even mention—fill the building from bottom to top. The sounds of hammer blows come simultaneously from every floor, causing the awful portraits by Caillebotte to constantly shake, and disturbing the bizarre sense of contemplation that one experiences before the inexplicable barrages of color by Guillaumin who, let it be said in passing, seems to me one of the biggest jokers that house painting has foisted on Impressionism. . . . Wherever they go next year, they would be wise to choose a larger, better-lit space than the one they occupy at the moment.[8]

Havard concurred: "In other words, they have gained in neither lighting nor comfort, and their new installation is inferior to the last."[9]

Degas, who played an active role in the planning, insisted that the group bill itself as "A Group of Independent Artists,"[10] the wording that was used for the poster (fig. 2), but the phrase was not used on the cover of the checklist which reads "Catalogue de la 5ᵐᵉ Exposition de Peinture" (see catalogue reprint). As was typical of the preparations for earlier shows, there were conflicting ideas within the group about its identity, organizational procedures, and even the poster. In an undated letter that Degas sent to Félix Bracquemond shortly before the opening, he described the unhappy situation.

It is opening April 1st. The posters will be up tomorrow or Monday. They are in bright red letters on a green background. There was a big fight with Caillebotte as to whether or not to put the names. I had to give in and let him put them up. When on earth will they stop the

headlines? Mlle Cassatt and Mme Morisot did not insist on being on the posters. It was done the same way as last year and Mme Bracquemond's name will not appear—it is idiotic. All the good reasons and the good taste in the world can achieve nothing against the inertia of the others and the obstinacy of Caillebotte. . . . Start bringing your things. There will probably be two panel screens, one in the center of the room with the four windows and the other in the entrance room. You will be able to arrange your entire stock of engravings on them. . . . If you insist and Mme Bracquemond insists too, her name can be put on the second thousand posters during the exhibition. Answer.[11]

Degas's casual remarks about the installation suggest that it was more or less unplanned. In any case, as several critics observed, the hanging emphasized the fragmented character of the group. "There are many rooms," wrote Havard,

and the walls are wide; each artist can shape his domain according to his means; some even occupy an individual room, and, for many of these misunderstood artists, that seems to be the primary purpose of the exhibition. The ease with which they please themselves proves, in effect, that in their eyes quantity is as important as quality, and that if they cannot hope to succeed by merit then they will do so by numbers.[12]

As usual, Havard's observations were echoed by his colleague at *Le Voltaire*. "The eighteen artists who form the group of Independents do not seem named in order to remain together much longer. No artistic relationship links one to the other. It is a group composed of disparate and diverse elements."[13] Moreover, the distinguished critic Armand Silvestre, who reviewed the show for the fashionable but serious magazine *La Vie Moderne*, complained that several of the participants were connected with the group for capricious rather than esthetic reasons. He found the group eclectic, lamenting that there was not a "trace of the vision that gave the little school the recognition it deserved in the art of recent years," and indicating that some of the pictures shown were not even worthy of the Salon.[14] In short, the exhibition disappointed an important critic who often had championed the avant-garde.

Other reviewers also pointed out the contrast between the bona fide Independents and those artists whose presence was obviously inappropriate. In an article published in the *Gazette des Beaux-Arts*, Charles Ephrussi differentiated between the "radicals" and those who had "emigrated" from the Salon; furthermore, he noted that "the shift had not been a complete success; the strong character of the work of the Impressionists serves only to make the colorless, dull work of the others more insipid, and their mediocrity more mediocre."[15] For the most part, he could see no "new or individual tendency" that distinguished their work from "the four thousand

fig. 1 Pierre-Auguste Renoir, *Madame Charpentier and Her Children*, 1878. Oil on canvas, 60½ x 74⅞ in. (153.7 x 190.2 cm). The Metropolitan Museum of Art, Wolfe Fund, 1907. Catherine Lorillard Wolfe Collection

canvases" on view each year at the Salon. His colleague at *La Chronique des Arts*, Arthur Baignères, agreed, lamenting the decidedly retrograde character of the exhibition:

I leave at the periphery the rest of the group that is lacking in unity. They are the supernumeraries who are there to swell the ranks. Who would have said that we would be disappointed by the Impressionists and that the fifth show would take them backwards?[16]

Eugène Véron, the critic for *L'Art*, took an even more extreme position, suggesting that the term *Independence* had lost its meaning:

Unfortunately, at the exhibition on the rue des Pyramides there is a large proportion of weed mixed in with the good grain. At least half of the participants seem to think that, to make art, "Independence" alone is not sufficient, and therefore they add something else. For them, independence consists primarily of freeing themselves from consideration of form, color, and even the most elementary rules of perspective.[17]

In the longest review of the 1880 exhibition, the novelist and critic Joris-Karl Huysmans, one of the earliest defenders of the modern movement, also decried the obvious decline. Using such phrases as "deficiency of talent," "brutally incompetent technique," and "loss of composure," he offered an "explanation of the affected acts of folly that followed the earlier exhibitions at Nadar's studio [1874] and the Durand-Ruel Gallery

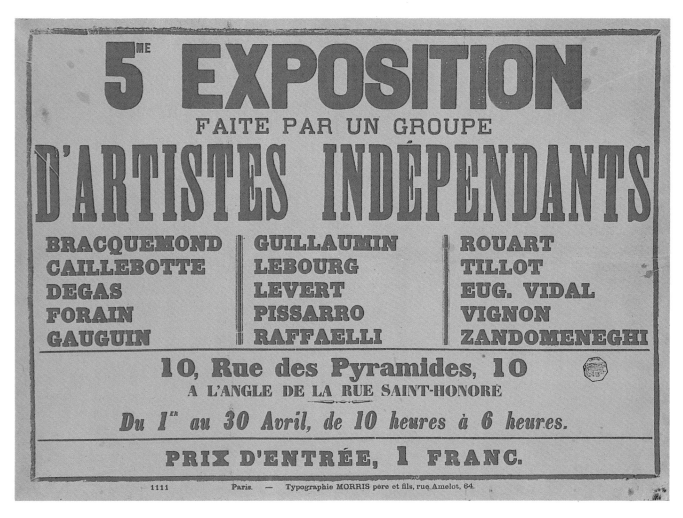

fig. 2 Poster from the fifth exhibition, 1880. Collection
of Mme J. Chagnaud-Forain

[1876]."[18] He felt that the movement had become stylist-
ically mannered, and, like Véron, he criticized the artists
for mindless exaggerations of form and color.
*Notice, for example, that during the summer in a garden
the human figure, in light filtered through green leaves,
turns purplish-blue; and, during the evening, the cheeks
of women who blush become light violet in gaslight
because they use white makeup (known as white of
pearl), but [these artists] broadbrush those faces with
curds of intense violet paint that weigh heavily where
there should be just a little color, a hardly noticeable
nuance.*[19]

More than a century later, even the most revisionist art
historians would still find it difficult to fault the generally
negative attitudes of those who reviewed the 1880 exhi-
bition. Although some of the defectors of 1879 and 1880
would exhibit in at least one of the later group shows, the
seriously flawed fifth show underscores the early 1880s
as a period of transition and change. Henry Havard's

assertion in April 1880 that Impressionism was dying is,
of course, a drastic view based exclusively on the fifth
group show, only part of which represents the ongoing
evolution of the avant-garde. In fact, the disarray that the
peculiar combination of participants reflects offers evi-
dence of the general reaction away from the classic
Impressionist style of the early and mid-1870s.[20] A more
conservative manner had become acceptable, and such
artists as Monet and Renoir openly flirted with stylistic
compromises when they returned to the Salon. At the
same time, however, these painters experimented with a
variety of stylistic possibilities, some of which were bold
and exciting. Evidence of Monet's willingness to experi-
ment daringly is provided by the work that he included in
his exhibition of June 1880 at the gallery operated on the
premises of the magazine *La Vie Moderne*.

While the work shown by many of the artists in the
fifth group exhibition illustrates the conservative aspect
of the reaction against orthodox Impressionism, it is

noteworthy that, at about the same time, the Salon jury was growing more liberal. In 1880 the jury, chaired by Bouguereau, apparently considered awarding a medal to Manet, who was often cited as the leader of the avant-garde. He did not win a medal until the following spring, only a few months before his friend, Antonin Proust, during his brief tenure as Minister of Fine Arts, arranged to have him awarded the Legion of Honor. The fact that the possibility was even discussed in 1880 reflects the confusing esthetic ambience that prevailed at the time of the fifth exhibition. Furthermore, although Manet's imminent official success undoubtedly improved the situation for the avant-garde as a whole, it must also have seemed to render the Independent exhibitions somewhat superfluous, given that the group shows had been created to circumvent the established system of juries and prizes.[21]

However, in the spring of 1880 the Salon jury had not yet acknowledged the merit of Manet's work, few critics had a broad understanding of the most recent advances, and the Independents' group show remained the principal means through which most of the public experienced the new art. Also, much of the critical response to the show reflects an underlying ambivalence in attitudes toward modern art: the two artists who attracted the greatest attention in the press were Raffaëlli and Morisot, the former because of his conservatism and emphasis on finish and detail, and the latter because of her bold execution and patently personal manner. In short, many critics betrayed a marked sympathy for traditional technique, but were also intrigued by the modern movement, albeit reluctantly. Equivocation, disguised by rhetorical posturing and witticisms of an almost uniformly negative variety, was the rule. With few exceptions, the critics lacked vision and conviction; most seem to have sensed the erosion of stylistic boundaries, and as a result the positions of nearly all were hedged. They seem to have been disappointed, disillusioned, or bored. While their malaise is partly understandable, it is telling that most showed a keener interest in Raffaëlli than in Degas. Furthermore, that Raffaëlli was permitted to show forty-one works, compared to perhaps eleven by Degas, suggests that the organizers of the exhibition were as befuddled as everyone else. Huysmans, alone, lamented the lack of recognition accorded Degas's work: "When will the superior position that this artist occupies in contemporary art be recognized? When will it be recognized that this artist is the greatest that we have in France today?"[22]

Moreover, although Huysmans found the public of 1880 unable to distinguish effectively between the art of the avant-garde and that of certain academic artists who had been influenced by the advances of their renegade colleagues, he seems, nevertheless, to have been encouraged by the first signs of growing sophistication. The critic felt that in 1880 the characteristic time lag between

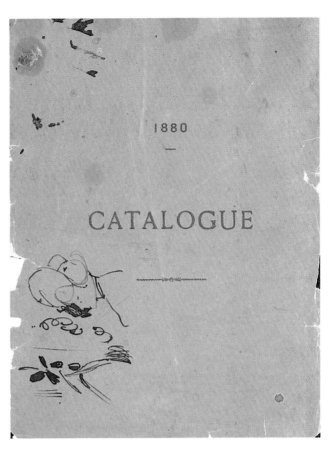

Cover of a Fifth Impressionist Exhibition catalogue that belonged to Jean-Louis Forain. Collection of Mme J. Chagnaud-Forain

the introduction of new, innovative art and the ability of the general public to understand it had begun to narrow: *One can say, however, that a change has taken place in the attitude of the public that meanders through the exhibition of the Intransigents. They do not discern the bungled efforts or color-blindness or the artists' other visual afflictions, nor do they understand that these moribund examples are only interesting cases for study and are not amusing. The public passes peaceably through the rooms, bewildered and irritated again by works whose novelty they find disconcerting, but hardly aware of the unfathomable abyss that separates the modernity of Degas and Caillebotte from that of Messrs. Bastien-Lepage and Henri Gervex. But despite the fundamental stupidity of the public, it stops and looks, astonished and heartened, however slightly, by the sincerity that these works project.*[23]

The reviews of the exhibition provide very limited information about the sequence of the installation, but Huysmans tells us that the first room was devoted to the work of Pissarro and Caillebotte. After mentioning in passing that Pissarro's prints were mounted in purple frames and yellow mats, he described two landscapes that he found especially impressive.

Perched on an easel [is] a summer landscape in which the sun beats furiously on a cornfield. That one is the best landscape by Pissarro that I know. On the field there is a cloud-like manifestation of sunlight, a tremoring of nature heated to an extreme that is most interesting. There is another noteworthy picture, a village whose red roofs are bonded with the foliage of the trees.[24]

However, Huysmans qualified his admiration with remarks indicating that he found most of Pissarro's work unsuccessful, hindered by problems he hoped the artist would eventually overcome:

Pissarro has the temperament of a true artist, that is certain; the day that his painting frees itself from the trappings of its infancy it will be the real modern landscape painting to which the artists of the future will aspire. Unfortunately the outstanding works [in this exhibition] are exceptions; under the pretext of impressions, Pissarro, too, has splashed color onto canvas.[25]

Many critics described a more conservative approach in Pissarro's work that they welcomed. In contrast to Huysmans, they admired his less doggedly Impressionist style. Eugène Véron observed, "Pissarro seems less convinced than previously of the need to take pistol shots. . . . In sum, these are interpretations of nature that are perhaps somewhat literal but which, seen from a certain distance, do not miss their mark."[26] Baignères, too, applauded the change in Pissarro's work but also implied that the artist had retreated stylistically. "Pissaro [sic] is becoming simpler. His *Scieur de bois* [cat. no. 98] is a rather pretty landscape. . . . Pissarro seems to be reforming."[27] Indeed, Baignères is typical of many critics who interpreted the avant-garde style of such artists as Pissarro as a passing phase that both obscured individual talent and impeded the realization of superior work: "When these gentlemen are sufficiently well known as a result of their folly, we will see which of them are capable of something. . . ."[28] Only Silvestre found Pissarro's new pictures consistent with the goals of earlier work: "This artist, at least, adheres to the kind of sensations that seem to me to be the only plausible motive for Impressionist art."[29]

The decidedly conservative inflection of most of the discussion of Pissarro's work also characterizes much of the commentary about Caillebotte's pictures. Huysmans, for example, preferred the latter's interpretation of "la formule moderne" compared to that of Manet because he found Caillebotte's approach less avant-garde and more conventional. His remarks about *Nature morte* (cat. no. 89) suggest a nearly reactionary attitude:

Here, as in his other works, Caillebotte's treatment [facture] is simple, without fussiness; it is the modern program as envisaged by Manet, applied and completed by a more substantial painter whose technique is surer.

In short, Caillebotte has rejected the system of Impressionist strokes [taches] that forces the eye to interpolate

in order to restore balance to people and things; he has limited himself to following the orthodox techniques of the masters and has adapted their execution. He has so adapted it to the needs of Modernism that he has, in a sense, rejuvenated it and made it personal.[30]

Huysmans's comments about *Intérieur* (fig. 3), a painting that virtually all of his colleagues found obviously flawed, suggests an even more extreme point of view. *With regard to the execution of this picture, it is simple, sober, and, I will venture, almost Classical. [There are] neither fluttering strokes, nor fireworks, nor goals merely suggested, nor lapses. The painting is finished, evidence of a man who has his craft in his fingertips; he does not try to flaunt his technique but almost to hide it.*[31]

Charles Ephrussi and many other critics reflect a similarly conservative point of view, but they did not agree with Huysmans about *Intérieur*. From a purely technical point of view, Ephrussi found it entirely unsatisfactory: *Caillebotte . . . willfully ignores the laws of perspective as established by Vitruvius, Piero della Francesca, Leonardo, and Albrecht Dürer. Receding planes do not exist for him; space has been abolished. This is a great shame, because Caillebotte has definite talent as a painter.*[32] Ephrussi's assessment of the painting was shared by Silvestre, Goetschy, Mantz, Véron, de Charry,[33] and others. Indeed, it is clear that *Intérieur* suffers from an obvious discrepancy between the size of the woman in the foreground and that of the man lying on the sofa in the background. Whether the problem is attributable to the artist's treatment of proportions or his realization of space, the composition is awkward and raises questions of competence. Despite the presence in the exhibition of such superb works as *Dans un café* (fig. 4), virtually every leading critic seized on the visual gaffe of *Intérieur*. Furthermore, Mantz seems entirely justified in having written that

the woman is enormous, but her husband in the background shrinks and seems like a forgotten doll on a piece of furniture. Although the scene is in a room of limited dimensions, one could estimate the distance between them at two or three miles. The painter of Raboteurs de parquets *[cat. no. 19] is nothing more than a fantasist. Does not this unexpected turn of events justify our disappointment?*[34]

Although A. E., the critic for *La Justice*, also recognized that the fifth group show was not without problems, he wrote a generally favorable review. Like many of his colleagues, including the difficult Albert Wolff, he was especially impressed by Berthe Morisot's contribution.

For me, praise is easy: among these very original canvases, even those that are faulty, there is a series of small masterpieces of an art that one can call intuitive. I have been utterly seduced and charmed by Mlle Morisot's

talent. *I have seen nothing more delicate in painting. Her works* L'été *[cat. no.95],* Le lac du bois de Boulogne *[fig.5],* L'avenue du bois *[V–118],* Portrait *[V–120] have been painted with extraordinarily subtle tones.*[35] Nevertheless, while most critics shared A. E.'s regard for the works exhibited by Morisot, many were disturbed by a lack of finish. For example, de Charry complained, "Mme Morisot shows . . . pretty sketches of women; there is plenty of talent and life in these vaporous and barely indicated lines that are little more than breaths of air. Why, with her talent, does she not take the trouble to finish?"[36] The critic for *L'Art* was similarly perturbed: "Mlle Morisot has reduced painting to its simplest expression. . . . Everything is hardly indicated and everything is charming; but, honestly, she leaves us much to imagine, and it is time to put an end to this pursuit, unless one wishes to reduce painting to a state of mist and dream."[37] Ephrussi's otherwise laudatory remarks in the *Gazette des Beaux-Arts* ended on a similar note,[38] as did those of Mantz who observed in *Le Temps* that "Mme Morisot's canvases are only projects, promises of paintings that will never be done . . . and in front of these incomplete, almost elegant things, one halts, both saddened and delighted."[39] Silvestre, too, was charmed by her work, but "only in principle and not as an end in itself."[40] Only Huysmans attacked her work directly; he compared it to the fashionable, decorative academicism of the successful Salon painter Charles Chaplin (1825–1891) and concluded, "These lifeless sketches reek of a heady, mundane elegance, and perhaps it is fair to use the epithet hysterical to characterize these surprising improvisations."[41]

The ambivalent attitude of most of the critics toward Morisot's work is understandable. Her work of about 1880 seems uneven, and its weaknesses suggest a failure of will, especially compared to her strongest work of the 1870s. Nevertheless, one cannot ignore her wish to have the looser, more abstract pictures of 1879–1880 seen in the group show. She seems to have wanted to test certain formal limits, but these works are undoubtedly also a manifestation of the reaction against orthodox Impressionism encountered in the work of such other artists as Monet, Renoir, and Pissarro. Significantly, the following comments by Goldwater about Monet's development in the early eighties are equally applicable to Morisot's work of about the same date:

What we usually think of as the continuation of Impressionism, and also what is considered a reaction to it, lead in the same direction. The exacerbation of the Impressionist method and attitude, uncontrolled by that normal observation whose finesses are checked by knowledge and convention, by the other senses and by philosophic habit, leads to a work that stands for rather than represents the object under inspection. Certain qualities only, isolated and intensified, exclude all others usually shown

fig. 3 Gustave Caillebotte, *Intérieur* (*Interior, Woman Seated*, V–10), 1880. Oil on canvas, 25¾ x 32 in. (65.4 x 81.3 cm). Private collection, Paris

in association. In these circumstances, theory—the theory of the Symbolists—is not necessary to get away from that pedestrian banality, that accepted rendering of everyday reality, toward which Impressionism presumably pointed. In fact, quite the contrary, because by a most unexpected route the extremity of Impressionist analysis, so sharp that it retained no traces of usual, pedestrian vision, has arrived at the Mallarméan [Symbolist] principle of suggestion by infinite nuance alone.[42]

Unfortunately, the widely held contemporary view of the 1880 show as a failure seems to have prejudiced the critics even against work of exceptional quality, notably that of Degas. However, Degas may have invited disappointment when he failed to exhibit *Petite danseuse de quatorze ans (statuette en cire)* (Wissman, fig.4) and *Petites filles spartiates provoquant des garçons (1860)* (fig.6), as well as other works listed in the 1880 catalogue.[43] The exceptional *Examen de danse* (cat. no.92), for example, elicited only slight enthusiasm. Mantz's assessment of Degas's offering as a whole is typical: "The exhibition by Degas is perhaps not as interesting as you could have hoped."[44]

Interestingly, although his work was perceived as difficult and uninviting, several reviewers seem to have respected it without liking it. The critic for *Le Pays*, for example, assumed the role of an apologist. "He does not always emphasize the grace and beauty of his models, but the farther one stands back, the more charming they are, and they are accurately and well recorded. At first sight his work is disagreeable to the eye, but one grows accustomed to it."[45] Eugène Véron, who found Degas's work obstinate and unnecessarily realistic, could not understand why the talented artist emphasized

fig. 5 Berthe Morisot, *Le lac du bois de Boulogne* (*Summer's Day*, v–116), 1879. Oil on canvas, 18 x 29⅝ in. (45.7 x 75.2 cm). The National Gallery, London. Lane Bequest, 1917

ungainliness instead of prettiness. Nevertheless, he admired his talent:

Degas continues to be passionately devoted to movement, pursuing it even in violent and awkwardly contorted forms. It is not surprising to see such stubbornness end like this, but it is not the mission of art to say everything, as if giving legal evidence in a court action. Degas has done charming paintings of dancers. Why not stop when the subject is exhausted? Degas, still young, is an artist of undeniable merit.[46]

Baignères, the equally conservative critic for *La Chronique des Arts*, concurred but summed up the attitude of most critics when he commented disparagingly that "one can only sigh and imagine another Degas with the same qualities and none of the shortcomings; but this is a dream, and in art as in nature one cannot demand roses from a thistle."[47]

Nevertheless, two very important critics praised him, despite their own strongly expressed objections to certain aspects of the pictures exhibited. Mornand, in a review published the day after the show closed, expressed himself succinctly: "Degas is coarser [than Morisot], but one senses, despite his intentional

eccentricities, the temperament of an artist endowed with undeniable power. He will realize his potential sooner or later."[48] And, following a long, acerbic diatribe ("thin little dancers of uncertain form and disagreeable, repulsive attributes . . . graceless movement . . . perspective that is often irrational . . . unsightly figures . . . a *Femme à sa toilette* [*sic*] [cat. no.91], standing, seen from behind, a poor sense of movement, hardly sketched in, rendered like a cut-out . . . awkward poses in *Examen de danse* and *Danseuses* [fig.7]"), the critic for the influential *Gazette des Beaux-Arts* concluded with words of support, declaring that

despite these intentional vulgarities, one really must praise the audacity in the foreshortening, an astonishing strength of the drawing in the extended arms and even in the barely indicated hands.[49]

In addition to the many critics who admired Degas begrudgingly or with serious reservations and qualifications, four recognized his contribution to the exhibition as exceptional. As has been noted above, Huysmans devoted much of his essay on the fifth show to a long encomium of Degas's work, but he described the artist as an isolated phenomenon. "A painter of modern life was

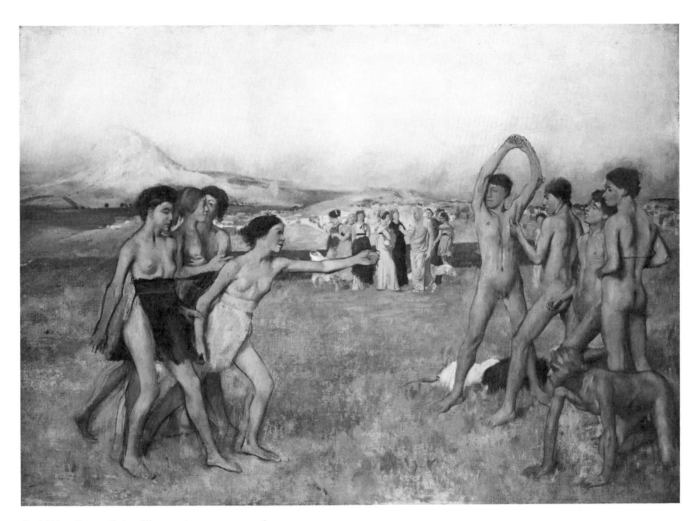

fig. 6 Edgar Degas, *Petites filles spartiates provoquant des garçons*
(*Young Spartans*, V−33, not exhibited), ca. 1860. Oil on canvas, 43 x
60¾ in. (109.2 x 154.3 cm). The National Gallery, London

born, a painter who derives from no one and resembles nobody; his manner of execution is entirely new.''[50] Furthermore, he concluded his discussion with a prediction that Degas's importance, as he had defined it, would not be acknowledged for ''an unlimited period of years.''[51] But the situation was not as extreme as Huysmans led his readers to believe. The influential Armand Silvestre, writing in *La Vie Moderne*, reiterated his strongest support for the artist:

As in previous years, Degas remains the indisputable and undisputed master. [He has] a truly admirable sense of movement in line and harmony in color. . . . It is all so interesting, but I do not know how to restate my praise without repeating myself. [The new work] is equally powerful in intention and character.[52]

The respected critic Philippe Burty's comments in *La République Française*, albeit limited to a single paragraph, also reflect significant support for both Degas and the group shows: ''Degas [is] the very persistent

organizer of these exhibitions that are so instructive for criticism and the public. . . . It is regrettable that the [Musée du] Luxembourg does not acquire one of these brilliant, tightly executed works.''[53] And, last, it will be recalled that Wolff praised him in the widely read but exceedingly acerbic review of the exhibition that appeared in *Le Figaro*.[54]

However, Burty was considerably less positive about the work of Degas's friend and protégé Mary Cassatt: ''Miss Mary Cassatt seeks tonal strength that is not always forthcoming from her pencil. Her beginnings have been much applauded. Regrettably we now see her aspiring to the partially completed image.''[55] Although Burty objected especially to her participation in the current vogue for unfinished compositions, he also took the trouble to describe in less-than-flattering terms a large, finished pastel, *Au théâtre* (fig. 8): ''The best of her studies seems to be . . . a young person with a fish face and orange hair who is dressed in yellow muslin and seated

on a tomato-colored sofa; the reflection of the furniture, costume, and hair in the mirror vaguely suggests the image of a basket of fruit."[56] Armand Silvestre, too, mentioned *Au théâtre*, but he took a generally positive, although qualified, approach to Cassatt's work as a whole:

The woman in a yellow dress [seated] on a red-velvet armchair looks, from a distance, like a Degas; but upon closer examination one sees that [Degas's] student fails to achieve the certainty of execution and the intensity of impression of her master. This reservation notwithstanding, all of the fifteen images sent by Miss Cassatt recommend themselves by virtue of well-rendered movement or harmoniousness.[57]

Despite Silvestre's disclaimer, his qualification is significant; in nearly all instances of approbation in reviews of the fifth show, the critics qualify or modify their admiration. One is left with the impression that the good art was not quite good enough. Ephrussi like Silvestre admired *Au théâtre*, but found Cassatt's work generally lacking a certain strength and seriousness; he referred patronizingly to the artist's touch as "if not firm and skilled, at least light and delicate."[58]

Cassatt also inspired predictably pejorative remarks from the conservative critics Véron and Baignères. Véron dismissed her as a mindless imitator of light effects: "Mary Cassatt is a colorist. She works to reproduce exactly certain effects of light, which are not always pleasing. Her *Femme au théâtre* [sic] includes reflections that are yellow, green, etc., that may be real, but are hardly agreeable to the eye."[59] Evidently the effects that Ephrussi found too pretty ("light and delicate") were too realistic for his conservative colleague. Nevertheless, Véron's comments are at least more objective than those of Baignères, who excused Cassatt's efforts as "l'impressionnisme féminin" and quipped, "Miss Cassatt, devoted to the theater, shows us a patch of yellow in the red. It is a woman in a loge."[60]

Nevertheless, Baignères found Cassatt's *Le thé* (fig.9) very successful. Begrudgingly, he wrote, "I prefer *Le thé*. As always, the facial expressions are completely neglected, but the young woman seen at an angle in the foreground is well modeled in the light, with neither gimmicks nor *repoussoir*."[61] Huysmans, too, in the short paragraph that he devoted to Cassatt, applauded *Le thé* as "her excellent canvas,"[62] but Mantz found it particularly offensive:

Unfortunately, in order to complete the decor and add some realism to the setting, she had to accommodate some accessories and placed a tray filled with the necessary paraphernalia on a table. . . . It is poorly drawn, the tea service is misshapen; she did not know how to realize her idea. The wretched sugar bowl remains floating in the air like a dream. There are tragic moments in the life of the Independents.[63]

Even from a purely academic point of view, Mantz's criticism does not seem justifiable. His attack on *Le thé* seems surprisingly capricious, but perhaps his strong admiration for such earlier artists as Delacroix prejudiced his interpretation of Cassatt's realistic Impressionism. More understandable is the disappointment of Henry Havard, the critic for *Le Siècle*, who observed that her work was more conservative than previously. Like other artists who had begun to consider alternatives to the classic Impressionism of the mid-1870s, Cassatt had begun to experiment with stylistic possibilities that some critics considered less daring.

Finally, Mary Cassatt was not the only one who has made compromises this year. Her talent remains alive, but her originality has abated. Of four portraits that she shows, only one is out of the ordinary; give her one or two more years, and you will see a lamb who will desert the fold and run with the wolves.[64]

The disarray within the ranks of the participants in the fifth group show was emphasized, perhaps even exacerbated, by the presence of forty-one works by Raffaëlli. In the words of Jules Claretie in *Le Temps*,

but what is surprising and really unparalleled in this exhibition are the paintings and studies of J.-F. Raffaëlli, a sort of Meissonier of poverty, the painter of the disenfranchised, the poet of the Parisian suburbs. His temperament is unique, powerful and refined, half-Flemish and half-Parisian, a newcomer whose struggle, artistic development, and history I will write about someday. But Raffaëlli has nothing Impressionist about him.[65]

While Claretie seems to have been delighted by the strong presence of Raffaëlli's work in the exhibition, Mantz found it wholly inappropriate.

Raffaëlli, one of Gérôme's students, is a master that some people try in vain to pass off as a rebel. Originally he exhibited at the Salon as a mere mortal, and it was at the Champs-Elysées [i.e., the Salon] that you initially saw his Deux vieux *[V–144], which you will find again in the show on the rue des Pyramides.*[66]

Difficult as it may be to understand today, Claretie's admiration for Raffaëlli's work was shared by nearly every critic who reviewed the exhibition. Furthermore, except for the extended discussion of Degas's work in Huysmans's review, Raffaëlli elicited more positive critical attention than any other artist in the show. His more conservative manner, attention to detail, and subject matter proved particularly appealing. Although his work was evidently exhibited near that of Degas, it made a strong impression. Baignères, for example, reported in *La Chronique des Arts*,

After Degas, at the exhibition on the rue des Pyramides we find a pupil of Gérôme's who is equally out of place in Impressionism. . . . Raffaëlli has not abandoned the cause of the study and of drawing. What is he going to do aboard this hulk? Probably he yielded to the wish to

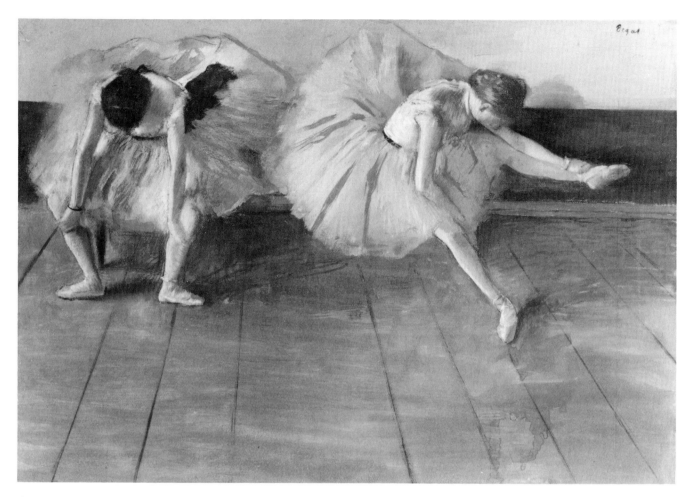

*exhibit many pictures and to be more visible than at the
exhibition on the Champs-Elysées, where, however, he
has always been very conspicuous.*
Furthermore, the Exposition des Indépendants itself
seems to have had no significance for Baignères; despite
the context in which Raffaëlli's work was being shown,
the critic stated, "As long as he resists the contagion and
remains himself, he will have a handsome future."[67] In
the *Gazette des Beaux-Arts*, Ephrussi echoed his col-
league's opinion: "Today Raffaëlli enjoys a notoriety to
be reckoned with."[68] Surprisingly, Huysmans, too,
admired the artist; he cited two landscapes that he
believed were as good as any he had ever seen, and of the
work in general he wrote, "One or two [are] perhaps too
Jean Valjean; all the others [are] surprises of truth and
life."[69] And in the most vitriolic review of the exhibition,
Albert Wolff included Raffaëlli in the group of three art-
ists whose work he excepted from the debacle, devoting a
third of his text to a tribute to the artist, and concluding
by stating, "But Raffaëlli is not of [the Impressionist]

school; his tightly wrought art has nothing to do with the
formless rapid sketches of the ladies and gentlemen of
Impressionism. Why the hell did Raffaëlli join this
enterprise?"[70]

More than a century later, Raffaëlli's subject matter
and style are obviously anomalous in the context of an
avant-garde exhibition. He was an academically oriented
genre painter who had been influenced by new tenden-
cies, but he can hardly be counted among the avant-
garde. Nevertheless, the appeal of his work to both the
critics and the public of 1880 is unquestionable. As the
critic for *Le Pays* observed,
*But surely the most astonishing painter in the company is
Rofaëlli [sic]. He has come here for contrast and to give
the others a rest.*

Among some other great canvases, he gives us Mon-
sieur le maire et son conseiller municipal *[cat. no. 100].
The two figures are startlingly real. . . . The minor sub-
jects always attract the attention of all the visitors.*[71]
Indeed, his popularity was remarkable; Goetschy, almost

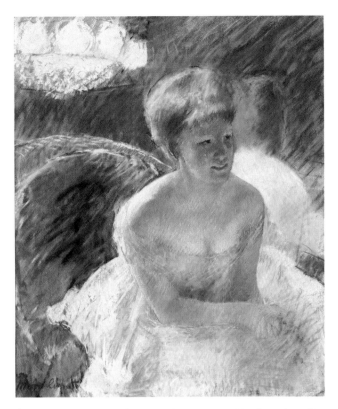

fig. 8 Mary Cassatt, *Au théâtre* (*Lydia Leaning on Her Arms, Seated in a Loge*, v–22), ca. 1879. Pastel on paper, 21 5/8 x 17 3/4 in. (55 x 45.1 cm). The Nelson-Atkins Museum of Art, Kansas City, Missouri. Anonymous Gift

always difficult to please, called him "an artist of real value";[72] Mantz praised him as "an artist of some consequence";[73] and Mornand announced, "Several individuals have already distinguished themselves from this pack of maniacs. . . . Raffaëlli's skill is astonishingly powerful in its effect and gives the impression of relief."[74] Even the generally astute Silvestre, in a review published in *La Vie Moderne*, a magazine devoted to avant-garde interests, lauded Raffaëlli's contribution in the strongest possible terms:

On the other hand, I come to a completely intriguing artist, whose exhibition is as important for the number of works submitted as for their quality. Jean-François Raffaëlli is powerfully gifted, above all as a draftsman. There is not a single one of his thirty-five canvases that does not deserve attention. . . . There is a poet in Raffaëlli, as well as a painter with an extraordinary facility for detail. . . . Raffaëlli plays, I repeat, a very important role in this exhibition.[75]

Raffaëlli's astounding success was made possible by what has been termed "the crisis of Impressionism."[76] As a result of the defections and the internal problems affecting the group, and at the invitation and behest of Degas, he participated in an event that exaggerated his qualities and minimized his weaknesses. In addition, the

insecurity of the critics and the public further obscured the fact that the Impressionist movement was undergoing an especially difficult transition. Risks and experimentation were no longer fashionable. The public and the critics had experienced a surfeit of art made on the proverbial leading edge, and Raffaëlli's art offered the illusion of a viable, saner alternative. The situation created by these conditions provides an analogy to the rise of Realism and Super-Realism in the 1970s, following two decades of abstraction in American painting. In today's vernacular, Raffaëlli was in the right place at the right time, and his burst of success supports the proposition that timing is everything. He offered apparent stability during a period of instability, stylistic floundering, and disloyalty. As the critic for *Le Siècle* observed at the time,

Certainly Raffaëlli is an artist of talent, no one denies it, and this time it is he who has the advantage and achieves the liveliest success at the rue des Pyramides; but is he an Impressionist? Assuredly not. His little studies are curious, very deliberate, and very correct; they have a very personal but skillful character that stands out in this milieu where inexperience appeals regularly to the bizarre for assistance.[77]

For the most part, the other artists who exhibited in 1880 were perceived as also-rans. Baignères, for example, dismissed them as "supernumeraries."[78] Mantz distinguished them from the avant-garde, stating that "the other artists about whom we have yet to speak are by no means Intransigents,"[79] but he included Morisot in the group. In fact, many critics made a similar distinction, but the effort was feckless because "the others" were hardly discussed and in some instances not even mentioned by name. Goetschy, for example, dismissed Gauguin and Levert as artists of no consequence: ". . . the works of Gauguin and Levert that would gain hardly anything by being seen elsewhere, even if it were at Cabanel's atelier itself."[80] Although Levert's work has more or less vanished during the last century, suggesting that the initial critical response may have been well founded, that of Gauguin seems to have been similarly disdained initially. He was not recognized as an emerging talent, nor was he identified as a member of the avant-garde. The handsome marble portrait of his wife, Mette (fig. 10), was ignored, and Silvestre's brief mention of his pictures indicates that his technique was regarded as crude: "There are qualities in the work exhibited by Gauguin, and his *Effet de neige* (v–57) is exceedingly accurate, but his coarse execution is hideously heavy."[81] Although today we can easily see the merit of such works as *Les maraîchers de Vaugirard* (cat. no.94), which appears to have been influenced by the work of both Pissarro and Cézanne, Gauguin's work in 1880 was apparently regarded as uninteresting, heavy-handed, and negligible.

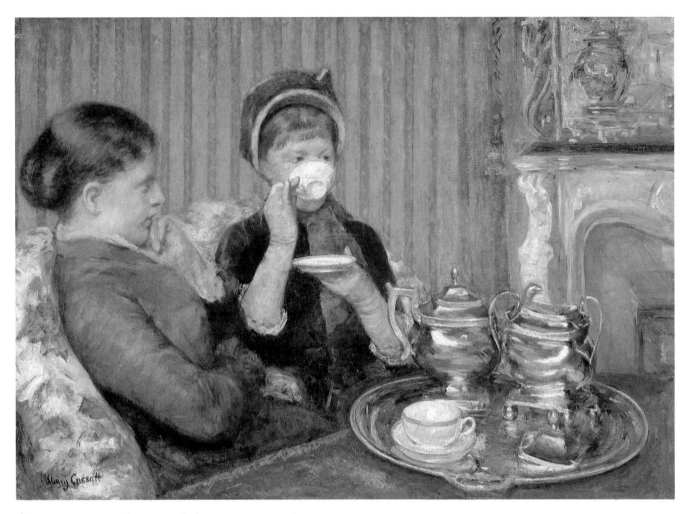

fig. 9 Mary Cassatt, *Le thé* (*Five O'Clock Tea*, V–21), 1880. Oil on canvas, 25½ x 36½ in. (64.7 x 92.7 cm). Museum of Fine Arts, Boston. Maria Hopkins Fund

However, Gauguin fared well in contrast to Guillaumin, whose work was savaged by the few critics who mentioned it. Véron reported that it attracted considerable attention because it was so terrible. "Everyone has noted the strange colors of Guillaumin. In this connection the portraits are especially noteworthy. The faces are patchworks of yellows, red, and greens that look like poorly cleaned artists' palettes. [The result] is bizarre and dreadful."[82] Silvestre, who was willing to tolerate Guillaumin's landscapes, was outraged by the artist's interpretation of individuals: "I do not dislike Guillaumin's landscapes, despite their intentional crudeness. . . . But when Guillaumin attempts the figure, he treats it with a feeling for color that is absolutely unacceptable."[83] He found *Portrait de M. G.* (V–72) so annoying that he mentioned it in each section of his two-part review. Initially he decried it as "totally monstrous because of the coarse modeling [effected by] a range [of color] that goes in two different directions,"[84] and a week later he wrote,

"I do not know anything phonier than his *Portrait de M. G.*"[85]

Other reviewers concurred but took less trouble to express their contempt. Goetschy labeled him "one of the prettiest jokers that house painting has bequeathed to Impressionism" and "a bad imitator of Monet."[86] Baignères found him both recalcitrant and retrograde: "But while Pissarro seems to be reforming, Guillaumin, who has sunk again to the bottom, amuses himself by making a mess with yellow, red, and green."[87]

Although Guillaumin's reputation has improved during the last century, albeit slightly, his work has proven more interesting to the modern viewer than the mannered images of Albert Lebourg. But in 1880 Lebourg was much more highly regarded. The critics who mentioned Lebourg's work were generally positive but often perplexed by his participation in the Exposition des Indépendants. Silvestre queried,
I ask myself why this one figures among the representa-

tives of the school. Lebourg could perfectly well present his paintings to the jury working at the Champs-Elysées, without raising the slightest fuss. Although one would wish for a more finished execution, the tonal finesse of certain of the works exhibited is to be appreciated.[88] Havard and Mornand also admired his work and found his presence in the exhibition inappropriate, the latter noting that "his title as an Independent is superfluous."[89] In short, he was one of several artists in the fifth show whose work, like that of Raffaëlli, contributed to a blurring of the boundaries between the standards of quality advocated by the avant-garde and the Salon. In addition, a failure or inability to recognize such distinctions was painfully evident in the comments of certain critics who seem to have been oblivious to the actual nature of the modern movement. Jules Claretie, for example, described Lebourg's paintings as "totally superior, a special art,"[90] and A. E. referred to him as "an artist of the first order."[91] However, it must also be noted that A. E. pointedly ignored the work of Caillebotte and Pissarro: "Let us pass Messrs. Caillebotte and Pissaro [sic] in silence and speak highly of Lebourg."[92]

Silvestre's term *superfluous* could also apply to other minor artists in the exhibition. Indeed, he referred to Eugène Vidal and Paul-Victor Vignon as "classic in spite of themselves." However, in connection with Vidal, he also pointed out that "it is not enough to leave things in a preparatory state in order to revitalize painting. If this were the case, Bouguereau would have his hour as an Impressionist."[93] In other words, he believed that loose, broadly painted, preliminary work by Vidal had been presented, and perhaps interpreted, as Impressionist painting. That the critic felt the need to make the observation is an indication of the fundamental difficulties experienced by the average viewer in 1880.

But the exhibition itself exacerbated the problem. The rather large complement of work by minor, secondary, and inappropriate artists obfuscated the work of the bona fide members of the avant-garde; the best work in the show was absorbed in a wave of mediocrity. Véron attempted to deal peremptorily with the problem:
We will not discuss Rouart and Tillot, who have no visible relationship to the milieu in which they find themselves. If their works were sent to the official Salon, they would blend in very easily with the respectable mediocrity that constitutes the majority.[94]
Indeed, Tillot's pleasant flower paintings and landscapes, influenced by the tamest aspects of Fantin-Latour's Realism and orthodox Impressionism, proved especially irksome to Silvestre: "Nor does Tillot seem to me an Impressionist at all. He does not lack talent, but his talent does not indicate the slightest aversion to the work of earlier landscapists."[95] And A. E., who also found him talented, complained similarly, "Tillot himself has nothing to do with Impressionism."[96] Moreover, Tillot is not

an isolated example; A. E., Mornand, Havard, and Goetschy offered nearly identical comments about Vidal.[97]

The unfocused character of the show was further complicated by the presence of the work of secondary figures that was sincerely admired by leading critics. Marie Bracquemond's paintings, for example, were obviously out of place, but Silvestre admitted,
This art, in the final analysis, is more inspired by the landscapes of Boucher than the actual look of nature. But it is so likeable that I do not have the nerve to complain about it. I will cite, therefore, the Etude d'après nature *[V–3], which is admirably subtle in tone, and the portrait of a blond woman in a white dress [*Portrait, *cat. no.85], the general appearance of which is delightful because of the eyes.*[98]
A. E. agreed and proclaimed, "It is a masterful debut, and her *Femme en blanc* [sic] (cat. no.85) places her at one stroke at the head of her group."[99] However, Goetschy believed that her anomalous presence contributed nothing: "In joining the Independents, the Bracquemonds are indulging in a fantasy. So be it. Their works neither gain nor lose by it."[100] Havard, taking a stronger stand, characterized her work as "ethereal idylls that are far from this world,"[101] and Huysmans dismissed it as "flaccid and whitish."[102] But regardless of whether or not a particular critic liked her work, most agreed that it was inappropriate to the exhibition.

Marie Bracquemond's husband Félix, too, was obviously out of place. As evidence that the well-known graphic artist was miscast, Havard cited *Portrait de M. Ed. de Goncourt* (cat. no.87), a preparatory drawing for an etching, often mentioned in reviews of the exhibition. "Bracquemond's portrait of de Goncourt, perhaps a little weak but tightly crafted and very finished, is, at the very least, an equally flagrant contradiction of the principles of the school."[103] Nevertheless, the drawing was admired by Goetschy, Mantz, Burty, Véron, and Ephrussi, among others. Although some critics also pointed out that it was clearly inappropriate to an Exposition des Indépendants, Ephrussi suggested that Bracquemond was "in his place everywhere."[104] The enormous popularity of the portrait of Edmond de Goncourt leads one to the inescapable conclusion that because the exhibition was such a confusion of mediocre and conflicting styles, obvious quality of any kind appealed to a wide variety of critics. Not surprisingly, Huysmans alone was unsympathetic to the drawing; he criticized "the excessive hardness of the flesh" and "the pores like marble beads."[105]

In contrast to the attention accorded the Bracquemonds, the critics largely ignored the paintings and watercolors of Henri Rouart, who participated in seven of the eight exhibitions. Those who mentioned him noted that his work was hardly related to the aims of the modern movement. Silvestre's remarks are typical but kinder than most.

fig. 10 Paul Gauguin, *Buste marbre (Mette Gauguin*, v–62), 1877. White marble, 13⅝ in. (34.5 cm). Courtauld Institute Galleries, Samuel Courtauld Collection, London. Photo courtesy Witt Library, London

You might ask what Rouart is doing here. His watercolors are pleasing, but attempt nothing beyond what has already been done.

His Paysage *(no.181) shows a certain gift for color, but you would have to be extremely clever to find in it any revolutionary or reforming instincts. His* Vue de Melun *[cat. no.101] has very fine and distinguished tone.*[106]

Forain is another whose work received little serious attention. Only Huysmans, soon to emerge as a leading Symbolist novelist, showed a strong interest in his work. He admired his treatment of women ("Forain is even more spontaneous, more original, when he focuses on girls"), his Realism ("what is extraordinary in this work is the powerful Realism that emerges"), and his emphasis on subjects from modern life ("On his good days, when he is not too easily satisfied and his drawing does not lean too much toward caricature, Forain is one of the most penetrating painters of modern life that I know").[107] But Huysmans's colleagues did not concur. Véron complained, "These studies are characterized by glowing color that I do not find very real,"[108] and Silvestre conceded a certain individuality, but described him as a predictable caricaturist:

[The work shown] by Forain is in his usual manner and offers nothing new. More and more his talent is limited to caricature, with a measure of humor that saves it from a lack of distinction. I especially like his Actrice allant rentrer en scène *[V–45] which is very accurate and well done. This young draftsman remains essentially Parisian and continues to be individual.*[109]

The only artist who participated in the fifth group show still to be mentioned is Federico Zandomeneghi, who had exhibited with the group for the first time the year before. His work is seldom discussed in reviews of the show, but it attracted the enthusiastic attention of two of the most astute critics, Huysmans and Silvestre. Huysmans was especially impressed with the artist's realism, accuracy of characterization, and attention to gesture. He particularly admired *Mère et fille* (cat. no.102), which he described in detail, and concluded his comments about the picture with a sentence explaining why it was among the most impressive works in the exhibition. "It was done on the spot, executed with none of the grinning faces so dear to ordinary daubers of genre subjects, and it is painted in a soft lilac tone, without too much or too little detail."[110]

Silvestre also praised *Mère et fille* ("a picture that must be judged as expert"); but, unlike Huysmans, he did not like the portrait of Paul Alexis, now lost, showing the sometime critic leaning against a mantel in a room where the walls were decorated with birdcages. However, he did describe Zandomeneghi as "in the true tradition of the Intransigents."[111] To some critics, the distinction was important and worth underscoring repeatedly.

The compromised, scattered, and diluted focus of the Fifth Impressionist Exhibition did little to advance the cause of the modern movement. The show suggested that the avant-garde had lost its thrust, and the viability of the jointly organized shows was in question. In addition, it further complicated the possibility of clearly defining the terms Impressionist, Intransigent, and Independent. Each word seemed to pertain to interconnected splinter groups that lacked solidarity and cohesion. The conservative critics delighted in the disarray, but those who supported the avant-garde were genuinely discouraged. However, the debacle forced the critics in general to begin to come to terms with the existence of a multifaceted, complex modern movement that previously had enjoyed greater integrity and, in retrospect, more obvious value. Paradoxically, the apparent disintegration of the movement, at least as reflected by the 1880 show, resulted in a clearer understanding of what had happened only a few years earlier.

The shows inaugurated in 1874 as "umbrella" exhibitions for a diverse and relatively amorphous avant-garde had been progressively racked by factionalism, internal squabbling, personal ambitions, defections, failure to generate sales, ongoing critical hostility, and a marked

loss of momentum exacerbated by the presence of inappropriate newcomers. In a letter to Pissarro, dated 24 January 1881, Caillebotte blamed Degas for many of the problems:

Degas introduced disunity into our midst. . . . He claims that he wanted to have Raffaëlli and the others because Monet and Renoir had reneged and that there had to be someone. But for three years he has been after Raffaëlli to join us, long before the defection of Monet, Renoir, and even Sisley. He claims that we must stick together and be able to count on each other (for God's sake!); and whom does he bring us? Lepic, Legros, Maureau. . . . (Yet he didn't rage against the defection of Lepic and Legros, and moreover, Lepic, heaven knows, has no talent. He has forgiven him everything. No doubt since Sisley, Monet, and Renoir have talent, he will never forgive them.) In 1878 [he brought us] Zandomeneghi, Bracquemond, Mme Bracquemond; in 1879 Raffaëlli . . . and others. What a fighting squadron in the great cause of Realism!!!!. . . . [Degas] has cried out against all in whom he admits talent, in all periods of his life. One could put together a volume from what he has said against Manet, Monet, you. . . . To cap it all, the very one who has talked so much and wanted to do so much has always been the one who has personally contributed the least. . . . All this depresses me deeply. If there had been only one subject of discussion among us, that of art, we would always have been in agreement.[112]

In the same letter, Caillebotte also drew attention to a purely practical but extremely significant cause of the disintegration of the group, the economic factor: "You know that there is only one reason for all this, the needs of existence. When one needs money, one tries to pull through as one can. Although Degas denies the validity of such fundamental reasons, I consider them essential."[113] As mentioned earlier in this essay, the principal reason for Monet's decision to defect to the Salon was the financial advantage. In March 1881, in a letter to

Durand-Ruel, Renoir defended on similar grounds his decision to return to the Salon in 1878. "There are in Paris scarcely fifteen art-lovers capable of liking a painting without Salon approval. There are 80,000 who will not buy an inch of canvas if it is not in the Salon. . . . My submitting to the Salon is entirely a business matter."[114]

Although Monet later rejoined the group in 1882 for the seventh group show, as did Renoir and Sisley, his defection in 1880 suggests that he was perhaps even more an Independent than those who remained. He chose to assert his own identity and bring his art before the public in the most convincing possible manner, free of the internal and external problems of the group who claimed to be the Independents. Moreover, like Renoir in 1879 and Manet in April 1880, in June 1880 he held a one-man show at the gallery of *La Vie Moderne*. Perhaps influenced by the example of his friend Manet, he seems consciously to have begun to try to avoid identification with a vaguely defined, constantly changing confederation of both genuine and would-be avant-garde artists.

The failure of the fifth group show to function as an effective vehicle for the avant-garde suggests that the exhibitions may have already served their purpose and were no longer necessary. Reputations had been established, and the movement had garnered substantial recognition and attracted the attention of important critics. It is also apparent, at least in retrospect, that the new art had established itself as a force with its own momentum that was exclusive of the exhibitions that had played such a powerful role in the rise of the movement. Evidence that this in fact was the case is provided by Monet's response to an interviewer who asked him in the spring of 1880 if he could still be considered an Impressionist: "I am still and always intend to be an Impressionist . . . but I see only very rarely the men and women who are my colleagues. The little clique has become a great club which opens its doors to the first-come dauber."[115]

Notes

All translations are by the author unless otherwise noted.

1. The complete text of Edmond Duranty's essay, *The New Painting: Concerning the Group of Artists Exhibiting at the Durand-Ruel Galleries*, Paris, 1876, is reprinted in this catalogue in both English and French.

2. Monet apparently decided in January that he would not participate in the fifth group show. In the 24 January edition of *Le Gaulois*, Tout-Paris announced (see the Fifth Exhibition review list in the Appendix for the complete citation for this and all other reviews quoted in this essay): "In a few days, admirers of the 'New School' of pictures will receive, in the mail or otherwise, a letter worded as follows: 'The Impressionist School has the honor of informing you of the sad loss that

it recently suffered in the person of Claude Monet, one of its venerated masters. The burial services for Monet will be celebrated next 1 May – the morning of the opening [of the Salon] – in the church of the Palace of Industry, salon of Cabanel.

"Please do not attend.

"DE PROFUNDIS!

"[Signed] Degas, Head of the School; Raffaëlli, successor of the deceased; Cassatt, Caillebotte, Pissarro, Louis Forain, Bracquemond, Rouard [*sic*], etc . . . , ex-friends, ex-students, and ex-partisans.

"In effect, in a few days, Claude Monet, the Impressionist par excellence, will desert the camp of his friends in order to hurl himself body, soul, and brush *Dans le sein maternel*

"*De M. Cabanel* . . . [Onto the maternal breast of Cabanel]."

3. For the original French text, see Daniel Wildenstein, *Claude Monet, Biographie et catalogue raisonné*, vol. 1 (Lausanne and Paris, 1974), 438, letter 173.

4. Wildenstein 438, letter 173.

5. Henry Havard review.

6. Gustave Goetschy review.

7. Albert Wolff review.

8. Goetschy review.

9. Havard review.

10. See John Rewald, *The History of Impressionism*, 4th rev. ed., 2d printing (New York, 1980), 439.

11. Undated letter from Degas to Bracquemond in Edgar-Germain-Hilaire Degas, *Letters*, ed. Marcel Guérin (Oxford, 1947), 55–56, letter 33; for the original French text see Edgar-Germain-Hilaire Degas, *Lettres de Degas*, ed. Marcel Guérin (Paris, 1945), 51–52, letter XXIV.

12. Havard review.

13. Goetschy review.

14. Armand Silvestre, 24 April 1880 review, 262.

15. Charles Ephrussi review, 488.

16. Arthur Baignères review, 118.

17. Eugène Véron review, 93.

18. J.-K. Huysmans review, 89.

19. Huysmans review, 88–89.

20. Robert Goldwater, "Symbolic Form: Symbolic Content," in *Acts of the Twentieth International Congress of the History of Art, Studies in Western Art*, 4 vols., *Problems of the 19th & 20th Centuries* (Princeton, 1963), 4:111–121, and Joel Isaacson, *The Crisis of Impressionism*, exh. cat. (Ann Arbor: University of Michigan, Museum of Art, 1980), 2–47.

21. Charles S. Moffett, "Manet and Impressionism," *Manet 1832–1883*, exh. cat. (New York: Metropolitan Museum of Art, 1983), 43.

22. Huysmans review, 120.

23. Huysmans review, 121.

24. Huysmans review, 91–92.

25. Huysmans review, 91–92.

26. Véron review, 94.

27. Baignères review, 118.

28. Henry Mornand review, 67.

29. Silvestre, 24 April 1880 review, 262.

30. Huysmans review, 98.

31. Huysmans review, 94–95.

32. Ephrussi review, 487–488.

33. Paul de Charry review.

34. Paul Mantz, 14 April 1880 review.

35. A. E. review.

36. de Charry review.

37. Véron review, 94.

38. Ephrussi review, 487.

39. Mantz review.

40. Silvestre, 24 April 1880 review, 262.

41. Huysmans review, 111.

42. Goldwater review, 116.

43. See Goetschy review: "I delayed the appearance of this article by one day in order to speak to you about a wax statuette that is said to be marvelous; it depicts a fourteen-year-old ballerina modeled from life, dressed in a real tutu, and wearing real dancers' shoes. But Degas is not an Independent for nothing! He is an artist who produces slowly, to his own liking and at his own speed, without regard for exhibitions and catalogues. . . . You will see neither his *Dancer* nor his *Young Spartan Girls*, nor yet other works that he has promised us."

44. Mantz review.

45. de Charry review.

46. Véron review, 94.

47. Baignères review, 118.

48. Mornand review, 68.

49. Ephrussi review, 486.

50. Huysmans review, 112–113.

51. Huysmans review, 121.

52. Silvestre, 24 April 1880 review, 262.

53. Ph[ilippe] Burty review.

54. Wolff review.

55. Burty review.

56. Burty review.

57. Silvestre, 24 April 1880 review, 262.

58. Ephrussi review, 287.

59. Véron review, 94.

60. Baignères review, 118.

61. Baignères review, 118.

62. Huysmans review, 110.

63. Mantz review.

64. Havard review.

65. Jules Claretie review.

66. Mantz review.

67. Baignères review, 118.

68. Ephrussi review, 488.

69. Huysmans review, 68.

70. Wolff review.

71. de Charry review.

72. Goetschy review.

73. Mantz review.

74. Mornand review, 68.

75. Silvestre, 1 May 1880 review, 276.

76. This term refers to the period in the late 1870s and early 1880s when the avant-garde movement seemed to be rapidly disintegrating. See Isaacson 1980, 2–47.

77. Havard review.

78. Baignères review, 118.

79. Mantz review.

80. Goetschy review.

81. Silvestre, 24 April 1880 review, 262.

82. Véron review, 93.

83. Silvestre, 1 May 1880 review, 276.

84. Silvestre, 24 April 1880 review, 262.

85. Silvestre, 1 May 1880 review, 276.

86. Goetschy review.

87. Baignères review, 118.

88. Silvestre, 1 May 1880 review, 275.

89. Mornand review, 68.

90. Claretie review.

91. A. E. review.

92. A. E. review.

93. Silvestre, 1 May 1880 review, 276.

94. Véron review, 94.

95. Silvestre, 1 May 1880 review, 276.

96. A. E. review.

97. Mornand review, 68; Havard review; and Goetschy review.

98. Silvestre, 24 April 1880 review, 262.

99. A. E. review.

100. Goetschy review.

101. Havard review.

102. Huysmans review, 111.

103. Havard review.

104. Goetschy review; Mantz review; Ephrussi review, 488; Burty review; Véron review, 94; Silvestre, 1 May 1880 review, 275–276.

105. Huysmans review, 111.

106. Silvestre, 1 May 1880 review, 276.

107. Huysmans review, 107, 108, and 110.

108. Véron review, 94.

109. Silvestre, 1 May 1880 review, 276.

110. Huysmans review, 109.

111. Silvestre, 1 May 1880 review, 276.

112. Letter from Caillebotte to Pissarro, 24 January 1881, as quoted in Rewald, 448.

113. Rewald, 448.

114. As quoted in Rewald, 416 and 436, note 42.

115. See E. Taboureux, "Claude Monet," *La Vie Moderne*, 12 June 1880, 380, as quoted in Rewald, 447.

80-1115 PARIS. IMPRIMERIE MORRIS PÈRE ET FILS
RUE AMELOT, 64.

CATALOGUE
DE LA
5^{ME} EXPOSITION
DE PEINTURE
PAR

M^{me} M. Bracquemond — M. Bracquemond
M. Caillebotte — M^{lle} Cassatt — M. Degas
MM. Forain — Gauguin — Guillaumin
MM. Lebourg — Levert
M^{me} Berthe Morisot — MM. Pissarro
Raffaëlli — Rouart — Tillot
Eug. Vidal — Vignon — Zandomeneghi.

Du 1^{er} au 30 Avril 1880

De 10 heures à 6 heures
10, RUE DES PYRAMIDES, 10
(A L'ANGLE DE LA RUE SAINT-HONORÉ.)
PARIS

DESIGNATION

BRACQUEMOND (M^{me} Marie)
13, rue de Brancas, à Sèvres.

1 — Portrait.
2 — L'Hirondelle.
3 — Étude d'après nature.

BRACQUEMOND
13, rue de Brancas, à Sèvres.

4 — Portrait de M. Ed. de Goncourt.
5 — Eaux-fortes pour décoration de services de faïence et de porcelaine.

CAILLEBOTTE (Gustave)
31, boulevard Haussmann.

6 — Dans un café.

7 — Portrait de M. J. R.

8 — Portrait de M. G. C.

9 — Intérieur.

10 — Intérieur.

11 — Nature morte.

12 — Vue prise à travers un balcon.

13 — Vue de Paris, soleil.

14 — Portrait de M. C. D. Pastel.

15 — Tête d'enfant. id.

16 — Paysage. id.

CASSATT (Mlle Mary)

17 — Portrait de Mme J.

18 — Portrait de Mlle G.

19 — Portrait de Mlle H.

20 — Sur un balcon.

21 — Le thé.

22 — Au théâtre.

23 — Portrait de Mme C.

24 — Jeune Femme.

25 — Femme au théâtre. (Eau-forte. — Premier état, dernier état.)

26 — Femme lisant. Eau-forte.

27 — Portrait d'enfant. idem. Premier et second état.

28 — Enfant en chapeau. idem.

29 — Au coin du feu. idem.

30 — Homme lisant. idem.

31 — Le Soir. idem.

32 — Portrait de Femme. idem.

DEGAS
19 bis, rue Fontaine Saint-Georges.

33 — Petites filles Spartiates provoquant des garçons (1860).

34 — Petite Danseuse de quatorze ans (statuette en cire).

35 — Portraits à la Bourse.
Appartient à M. E. M.

36 — Portrait.

37 — Portrait.

38 — Étude de loge au théâtre. Pastel.

39 — Toilette. Pastel.

40 — Examen de danse. idem.
Appartient à M. E. M.

41 — Danseuses.
Appartient à M. L.

42 — Dessins.

43 — Idem.

44 — Eaux-fortes. Essais et états de planches.

FORAIN (Jean-Louis)
56, rue Blanche.

45 — Actrice allant rentrer en scène.
Appartient à Mlle V. de M.

46 — Etude d'homme.

47 — Dessin.

48 — Idem.

49 — Idem.

50 — Idem.

51 — Idem.

52 — Idem.

53 — Eau-forte.

54 — Idem.

GAUGUIN (Paul)
74, rue des Fourneaux.

55 — Les Pommiers de l'Hermitage (Seine-et-Oise).

56 — Les Maraîchers de Vaugirard.

57 — Effet de Neige.

58 — Nature morte.

59 — La sente du père Dupin. (Seine-et-Oise.)

60 — Etude.

61 — Ferme Pontoise.

62 — Buste marbre.

GUILLAUMIN (Armand)
73, rue de Buffon.

63 — Bords de la Marne.

64 — Port d'Austerlitz.
Appartient à M. Perrinet.

65 — Port d'Austerlitz, effet de neige.

66 — Port d'Austerlitz, effet de neige.

67 — Quai de la Gare, effet de neige.

68 — Rue des Écoles à Fontenay-aux-Roses.

32. Perhaps Breeskin Prints 5, per Mathews

33. Lemoisne 70, National Gallery, London; not exhibited, per Goetschy

34. Mr. and Mrs. Paul Mellon, Upperville, Virginia; not exhibited

35. Lemoisne 499, Musée d'Orsay

36. Lemoisne 517, The Burrell Collection, Glasgow Art Gallery and Museum

38. Lemoisne 584

39. Perhaps Lemoisne 554, private collection, New York

40. Lemoisne 576, Denver Museum of Art

41. Lemoisne 559, Shelburne Museum, Shelburne, Vermont

44. *Au Louvre, Musée des Antiquités*, Delteil 30

h.c. Perhaps Lemoisne 828, John G. Johnson Collection, Philadelphia or 476, Rhode Island School of Design

h.c. Lemoisne 625, Mr. and Mrs. Paul Mellon, Upperville, Virginia

46. Perhaps Cabinet des Dessins, Musée d'Orsay, R. F. 10806, per Faxon

55. Perhaps Wildenstein 31

56. Wildenstein 36, Smith College Museum of Art, Northampton

57. Perhaps Wildenstein 37, Szépművészeti Muzéum, Budapest

58. Wildenstein 28, Konstmuseum, Göteborg or 47, per Wildenstein

59. Perhaps Wildenstein 35, Señor Alberto Phelps, Caracas

60. Perhaps Wildenstein 38, Ny Carlsberg Glyptotek, Copenhagen

61. Perhaps Wildenstein 34

62. Gray 1, Courtauld Institute Galleries

64. Perhaps Serret and Fabiani 53

66. Perhaps Serret and Fabiani 43, Museé d'Orsay, per Derbanne

67. Perhaps Serret and Fabiani 29, Museé d'Orsay

76. Perhaps Parke-Bernet
New York, 8 April 1964,
no. 100

80. Perhaps Serret and Fabiani
85

82–83. Perhaps J. Erwteman,
Brussels

113. Bataille and Wildenstein
75, Musée Fabre,
Montpellier
114. Bataille and Wildenstein
86, Dallas Museum of Art
115. Bataille and Wildenstein
84, The Art Institute of
Chicago
116. Bataille and Wildenstein
79, National Gallery,
London
118. Bataille and Wildenstein
85
119. Bataille and Wildenstein
80, Nationalmuseum,
Stockholm
120. Bataille and Wildenstein
81, Musée d'Orsay
127. Perhaps Bataille and
Wildenstein 703, per
Gerstein thesis

128. Pissarro and Venturi 499,
The Robert Holmes à
Court Collection, Perth
130. Pissarro and Venturi 519
131. Pissarro and Venturi 505,
private collection, Paris
133. Pissarro and Venturi 473
134. Perhaps Pissarro and
Venturi 448; 451, Galleria
d'Arte Moderna,
Florence; 486; 496,
Musée d'Orsay; or 514
136. Pissarro and Venturi 525,
Tate Gallery, London

— 10 —

69 — Fontenay-aux-Roses.
70 — La Marne à Ivry.
 Appartient à M. Bonnet.
71 — Portrait de M. A.
 Appartient à M. Aguiar.
72 — Portrait de M. G.
73 — Paysage, printemps.
74 — Paysage à Fontenay.
75 — Fosse Basin à Fontenay.
76 — Collégien.
 Appartient à M. Parard.
77 — Plaine de Châtillon.
78 — Plaine de Châtillon, automne.
79 — Carrière abandonnée.
80 — Pont-Marie.
81 — Mlle B. pastel.
 Appartient à Mme G.
82 — M. Martinez, pastel.
83 — Mme M., pastel.
84 — Mme G., pastel.

— 11 —

LEBOURG (Albert)
3, rue Jouffroy.

85 — Marine, Rouen.
86 — Paysage, Normandie.
87 — Paysage, Normandie.
88 — Vue de Paris.
89 — Vue de Paris.
90 — Tente arabe.
91 — Intérieur d'une mosquée.
92 — Une cour de mosquée.
93 — Café maure.
94 — L'Amirauté, Alger.
95 — Dessin (Fusain.)
96 — Id. id.
97 — Id. id.
98 — Id. id.
99 — Id. id.
100 — Id. id.
101 — Id. id.
102 — Id. id.
103 — Id. id.

— 12 —

104 — Dessin (Fusain)

L. LEVERT
A Fontenay-sous-Bois.

105 — Bords de l'Ésonne.
106 — La ferme de Saint-Marc.
107 — Chaumières à Carteret.
108 — Plaine de Barbizon.
109 — Une plâtrière à Fontenay-sous-Bois.
110 — Plaine de la Brie.
111 — Id. id.
112 — Cadre d'eaux fortes.

MORISOT (Mme Berthe)

113 — Été.
114 — Hiver.
115 — Femme à sa toilette.
116 — Le lac du bois de Boulogne.
117 — Paysage.
118 — L'avenue du Bois, effet de neige
119 — Au jardin.
120 — Portrait.

— 13 —

121 — Tête de jeune fille.
122 — Paysage.
123 — Aquarelle.
124 — id.
125 — id.
126 — id.
127 — Éventail.

PISSARRO (Camille)
18, rue des Trois-Frères.

128 — Le scieur de bois.
 Appartient à M. Gauguin.
129 — Jardin.
130 — Récolte des petits pois.
131 — Automne, chemin sous bois.
132 — Paysage, route d'Ennery.
133 — Récureuse de casserole.
134 — Jardin potager.
135 — Printemps.
136 — Gardeuse d'oies (Mayenne.) Peinture sur
 ciment.
137 — Paysage d'été.

138 — Éventail.

Appartient à M. Doucet.

Eaux-fortes :

139 — Un cadre : Quatre états du paysage faisant partie de la première livraison de la publication « le Jour et la Nuit. »

140 — Un cadre : Trois états de la foire de la Saint-Martin.

— Un état, pointe sèche. Marchande de marrons.

141 — Un cadre : Un état, paysage, route et côteaux près Laroche-Guyon.

— Un état, effet de pluie.

— Un état, vache et figure.

— Un état, pointe sèche, côteaux de l'Hermitage, Pontoise.

142 — Un cadre : Trois états, paysage, masure. Deux états, paysage, arbres et coteaux.

143 — Un cadre : Un état, petit bois à l'Hermitage, Pontoise.

RAFFAELLI (Jean-François)

19, rue de la Bibliothèque, Asnières, (Seine).

144 — Deux vieux.

145 — Profil d'enfant.

Appartient à Mme Durand.

146 — Terrains remblayés de démolitions.

147 — Rôdeur de barrières, aquarelle.

148 — Salon d'attente d'un dentiste.

Appartient à M. Levallois.

149 — Jeune femme pensive après la lecture d'une lettre.

150 — Maire et Conseiller municipal.

Appartient à M. Salomon.

151 — Jeune femme hésitant avant d'entrer dans le bain.

152 — Homme tenant un sac à charbon (aquarelle.)

Appartient à M. Doucet.

153 — Le mouvement, dans la route d'Argenteuil (Pastel.)

139. Delteil 16
140. *Foire*, Delteil 21
Marchande, Delteil 15
141. *Laroche-Guyon*, Delteil 27 or 5, per Lloyd *GBA*
Effet, Delteil 24
Vache, Delteil 58
L'Hermitage, perhaps Delteil 28
142. *Masure*, Delteil 20
Paysage, perhaps Delteil 19
143. Perhaps Delteil 17
144. Illustrated in *Gazette des Beaux-Arts* (1 May 1880): 485
One of the *chiffonnier* pictures is illustrated in *L'Art* 21 (1880): 91; a *chiffonnier* and a *balayeur* illustrated in *La Vie Moderne* (24 April 1880): 262

150. Private collection, New York

154 — La route, hors les murs des fortifications, par la neige.

Appartient à M. J. K. Huysmans.

155 — Tête d'Auvergnat (aquarelle et pastel.)

156 — Balayeur, paysage des environs de Nice.

Appartient à M. Taigny.

157 — Marchand d'habits sur la route d'Argenteuil (aquarelle et pastel.)

158 — Chiffonnier éreinté (aquarelle.)

159 — Tête de vieille femme (pastel.)

160 — Bonhomme tirant une brouette.

161 — Chiffonnier hors les murs (aquarelle.)

Appartient à M. E. May.

162 — Type de balayeur.

Appartient à M. Heilbuth.

163 — Type de chiffonnier.

Appartient à M. Heilbuth.

164 — Eaux-fortes et pointe sèche.

165 — Plaine couverte de neige (pastel.)

166 — Quatre eaux-fortes pour le livre (Croquis naturalistes de J. K. Huysmans.

167 — États successifs d'une eau forte de mon (Chiffonnier éreinté.)

168 — Par de la brume et du vent, étude à l'aquarelle.)

169 — L'allumeur de quinquets de Sorrente (Italie.)

Appartient à M. S. T.

170 — Homme portant deux pains.

171 — Chiffonnière (aquarelle.)

172 — Balayeur souffrant du froid.

Appartient à M. Jules Claretie.

173 — La plaine de Gennevilliers.

174 — Type de cantonnier.

175 — Dessin de mon tableau (Maire et Conseiller municipal.)

Appartient à M. Duranty.

176 — Du soleil sur la grande route.

177 — Un commissionnaire de Paris.

Appartient à M. Massé.

178 — Portrait.

Appartient à Mlle C. S.

179 — Anes et poules dans l'herbe (aquarelle.)

166. *Le marchand de marrons*, Delteil 137
Les remparts du nord de Paris, Delteil 138
La bièvre, Delteil 139
Les maigres repas, Delteil 140
167. Delteil 3
179. Christie's London, 6 December 1974, no. 260

180. Delteil Raffaëlli Appendix

182. Perhaps Musée d'Orsay

RAFFAELLI (Jean-Marius)

4, rue de Ravignan.

180 — Six eaux fortes.

ROUART (Henri)

35, rue de Lisbonne.

181 — Paysage.
182 — Melun.
183 — Etude.
184 — Belchenia (Pyrénées.)
185 — Venise (Aquarelle).
186 — Id. id.
187 — Id. id.
188 — Id. id.
189 — Id. id.
190 — Id. id.
191 — Id. id.
192 — Id. id.

TILLOT (Charles)

42, rue Fontaine Saint-Georges.

193 — Falaises de Villers (marée basse).
194 — Vue prise des hauteurs d'Auberville (Villers-sur-mer).
195 — Plage de Villers.
196 — Eglise de Lavardin (Loir-et-Cher).
197 — Allée de forêt au printemps.
198 — Tête de jeune fille.
199 — Pivoines dans une corbeille.
200 — Pivoines et Iris dans un vase de Delft.
201 — Giroflées.
202 — Chrysanthèmes.
203 — Soucis et Chrysanthèmes.
204 — Un cadre d'études et esquisses.
205 — id. id.
206 — Tête d'étude.

225. Piceni 40, Giuliano Matteucci, Viareggio

VIDAL (Eugène)

11, rue de la Tour-d'Auvergne.

207. — Portrait de Georges Grand.
208. — Portrait de M. J. S.
209. — Dessin pour le portrait de M. Taillade.
210. — Portrait de M. Gaston B.
211. — Femme en blanc.
212. — Au café.
213. — Tête de fillette.
214. — Étude de femme.
215. — Portrait de M. S.

VIGNON (Paul-Victor)

29, rue Saint-Georges.

216. — Effet de neige. Montesson.
217. — Rue à Clamart.
218. — Chemin dans les vignes, étude.
219. — Chemin près Carrières-Saint-Denis.
220. — Près les Gressets.

221. — La Seine, près la Grenouillère.
222. — Arbres fruitiers et maisons.
 Appartiennent à M. Martin.
223. — Chemin vert, près Chatou.
224. — Carrières, près Chatou.
 Appartiennent à M. Murat.

ZANDOMENEGHI (Federico)

4, place d'Anvers.

225. — Mère et fille.
226. — Portrait de M. Lanciani.
227. — Portrait de M. Paul Alexis.
228. — Etude.
229. — Eventail.
230. — Eventail.
231. — Eventail.
232. — Eventail.

80 — 1115 Paris. Morris père et fils, imp. brevetés, rue Amelot, 64.

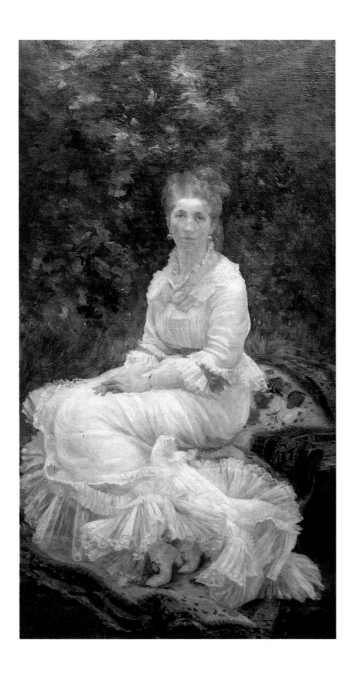

85. Marie Bracquemond

V—1

Portrait, 1880

Now known as *La dame en blanc* (The Woman in White)
Signed lower right: *Marie B.*
Oil on canvas, 70⅞ x 39⅜ in. (180 x 100 cm)
Musée de Cambrai
REFERENCES: Isaacson 1980, 62, fig. 19.

Bracquemont [*sic*] seems to have given up muddling with clay paste for oils. We congratulate her sincerely. It is a masterful debut, and her *Femme en blanc* places her at one stroke at the head of her group.
A. E. [Arthur d'Echerac], *La Justice,* 5 April 1880

Bracquemond, who draws and paints ravishingly, exhibits a good portrait and a charming plein-air study.
Gustave Goetschy, *Le Voltaire,* 6 April 1880

Marie Bracquemond, her work strengthened by serious study, gracefully paints intimate scenes, including a young woman in white posing in an orchard for a painter. . . .
Ph[ilippe] Burty, *La République Française,* 10 April 1880

Using an even lighter palette [than Morisot], Marie Bracquemond achieves very harmonious effects in which there are tapestry backgrounds that seem to shine from the light of an apotheosis. Essentially her art is more inspired by Boucher's landscapes than by the real appearance of nature. But it is so pleasant that I do not have the courage to hold this against her. Therefore, I will mention . . . the portrait of a blond woman in a white dress, the general appearance of which is delightful because of the eyes.
Armand Silvestre, *La Vie Moderne,* 24 April 1880

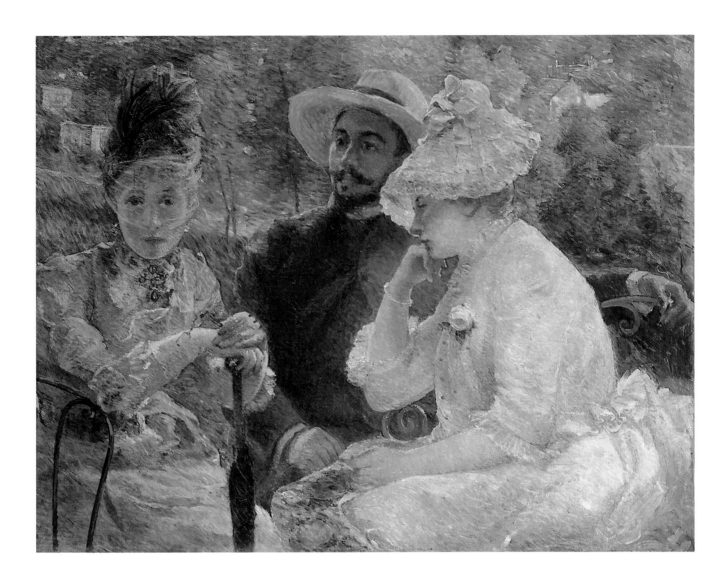

86. Marie Bracquemond

V—HC

Sur la terrasse à Sèvres (La terrasse de la villa Brancas), 1880

On the Terrace at Sèvres (The Terrace of the Villa Brancas)

Oil on canvas, 34⅝ x 45¼ in. (88 x 115 cm)
Petit Palais, Geneva. 11034
REFERENCES: Isaacson 1980, no. 5, frontispiece.
NOTE: Pierre Bracquemond, the artist's son, who witnessed the creation of the painting, said that Marie Bracquemond's sister Louise posed for the two female figures. The inclusion of this work in the fifth group show was first suggested by Gustave Geffroy in 1919. See Isaacson, above.

With her poetic talent, her misty studies of undecided tones, somewhat faded colors, dull paleness, and vague delicacy, Marie Bracquemond is even further from Realism [than Rouart]. Whether set in the fields or in a boat, her ethereal idylls are far from this world.
Henry Havard, *Le Siècle*, 2 April 1880

Bracquemond loses herself in mist. How insipid!
Paul de Charry, *Le Pays*, 10 April 1880

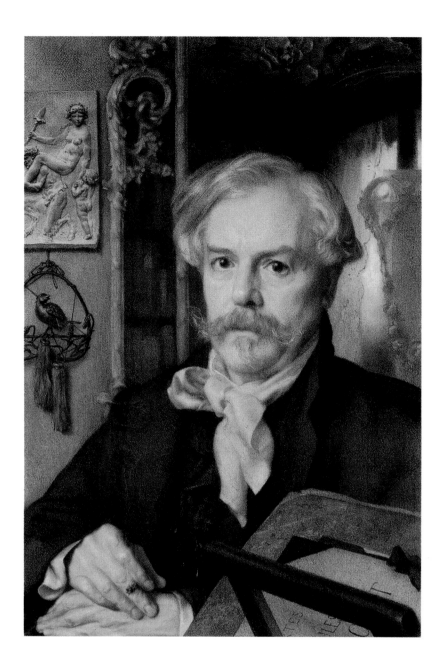

87. Félix Bracquemond

V–4

Portrait de M. Ed. de Goncourt, 1880

Charcoal on canvas, 21⅝ x 14⅞ in. (55 x 37.9 cm)
Signed and dated lower right: *Bracquemond 1880*
Cabinet des Dessins, Musée du Louvre. R.F. 22889
REFERENCES: Paris 1974, nos. 12 and 12b.
Washington only
NOTE: Edmond (1822–1896) and Jules (1830–1870) de
Goncourt were novelists, diarists, and art critics whose detailed
observations of the Impressionists' works and lives are
published in *Journal: Mémoires de la vie littéraire*, 4 vols.
(Paris, 1956).

Bracquemond's *Portrait de M. E. Goncourt* is a striking likeness but the drawing is rather weak for such an energetic etcher. The modeling of the flesh is barely distinguished from that of the fabric. Perhaps this flaw has to do with using pencil on rough-grained paper? Such expedients sometimes cost more than they are worth.
Eugène Véron, *L'Art*, 1880

In joining the Independents, the Bracquemonds are indulging in a fantasy. So be it. Their works neither gain nor lose by it. Bracquemond is a wonderful draftsman and etcher who is a master of his art. He is showing some odd decorative fantasies and a beautiful portrait of Edmond de Goncourt, a drawing destined to be engraved.
Gustave Goetschy, *Le Voltaire*, 6 April 1880

Bracquemond provides the Ingres-like element here. His portrait of Edmond de Goncourt is as closely studied, as polished as possible. The eminent writer has been painted in his study, which is decorated with a hundred rare and costly curios. He is seen half-length, cigarette in hand, his right arm resting on a box containing his brother Jules's etchings.
Ph[ilippe] Burty, *La République Française*, 10 April 1880

Even at the exhibition on the rue des Pyramides you find some artists of subtle talent whose cohabitation with the Independent group throws the public off track, making it think the work is ironic. That skillful engraver, Bracquemond, has underscored this paradox by exhibiting a drawing in black pencil, lovingly finished, side by side with the works already mentioned that are the apotheosis of the "near enough." It is a portrait of Edmond de Goncourt, a life-sized half-figure. Its modeling is done with a caressing, patient zeal that expresses the most tender respect for nature. This portrait, conforming little with house doctrine, has a very sensible air in the surrounding delirium.
Paul Mantz, *Le Temps*, 14 April 1880

I now pass in front of . . . the portrait of Edmond de Goncourt by Bracquemond. This portrait is in the style of Holbein, but the skin is too hard with its pores like marble beads.
Joris-Karl Huysmans, *L'art moderne*, 1883

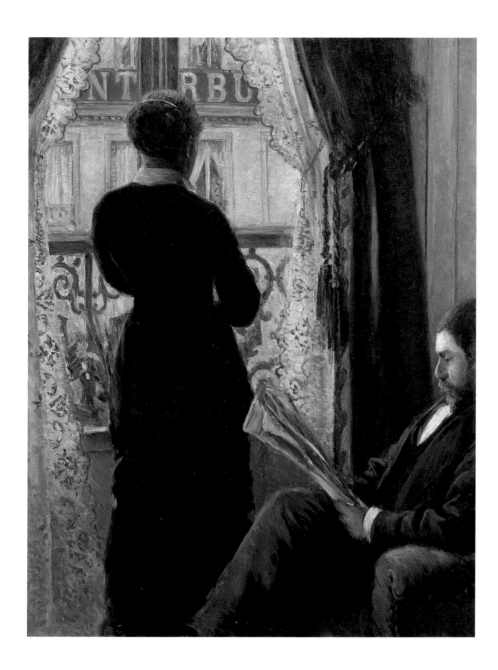

What a soft and warm light illuminates the young woman seen from the back standing before a balcony (no. 12)! The ambient air is rendered with vigor, the figure is well posed.
Charles Ephrussi, *Gazette des Beaux-Arts*, 1 May 1880

One of them is simply a masterpiece. The subject—oh my God—is extremely ordinary. A woman standing at a window turns her back to us and a man, sitting in an armchair, seen in profile, reads the newspaper near her—that's all; but what is truly magnificent is the frankness, the life of this scene.
The woman, who idly looks at the street, palpitates, moves. One sees her lower back move under the marvelous dark blue velvet that covers it; if you touch her with your finger, she will yawn, turn around, exchange an empty phrase with her husband who is hardly interested in reading the news items. . . .
It is a moment of contemporary life, fixed as such. The couple is bored, as often happens in life. The smell of a household in an easy-money situation is exuded by this interior. Caillebotte is the painter of the bourgeoisie of business and finance at ease, able to provide well for their needs without being very rich, living near rue Lafayette or around the boulevard Haussmann.
As for the execution of this canvas, it is simple, sober; I will say, almost classic. Neither fluttering strokes, nor fireworks, nor intentions only indicated, nor weaknesses. The painting is finished, proving that this man knows his craft to his fingertips and does his best not to brag about it, almost to hide it.
Joris-Karl Huysmans,
L'art moderne, 1883

88. Gustave Caillebotte

V–12

Intérieur, 1880
Interior

Now known as *Intérieur, femme à la fenêtre* (Interior, Woman at the Window)
Signed and dated lower right: *G. Caillebotte/1880*; atelier stamp lower left: *G. Caillebotte*
Oil on canvas, 45⅝ x 35 in. (116 x 89 cm)
Private collection, Paris
REFERENCES: Berhaut 1978, no. 130; Varnedoe and Lee 1976, no. 47; Maillet 1984, no. 8.

In an interior where two people are shown dimly in the middle of an appropriate half-light, through the glass of a window whose curtains are drawn you see the blazing sign of a house across the street. Five capital letters in gold, intrusive despite the distance, place themselves in the center of the canvas and catch the attention of the spectator who does not hesitate, moreover, to admit that, among the ways to spoil his painting, Caillebotte chose the most assured.
Paul Mantz, *Le Temps*,
14 April 1880

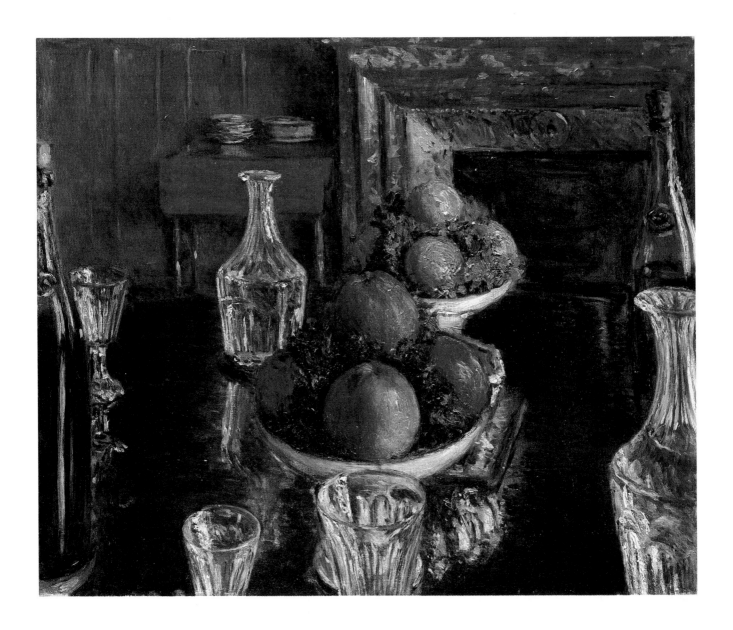

89. Gustave Caillebotte

V—11

Nature morte, 1879
Still Life

Signed and dated lower right: *G. Caillebotte 1879*
Oil on canvas, 19¾ x 23⅝ in. (50 x 60 cm)
Private collection
REFERENCES: Berhaut 1978, no. 123; Varnedoe and Lee
1976, no. 44.

This is how still lifes should be done: some oranges and apples piled into pyramids in fruit bowls, set on artificial moss; some large glasses, carafes of wine, and bottles of Saint-Galmier water to fill a table covered with an oilcloth that reflects the color of the objects placed on it, losing its own color.
The effect has been well-studied. . . . Here there are no false contrasts. . . . and the shine of the fruit is neither over- or underemphasized, not sharpened into little bright points spread around for nothing. Here, as in his other works, Caillebotte's technique is simple, without fuss. This is the modern program as envisaged by Manet, applied and completed by a more substantial painter whose technique is surer.
Joris-Karl Huysmans,
L'art moderne, 1883

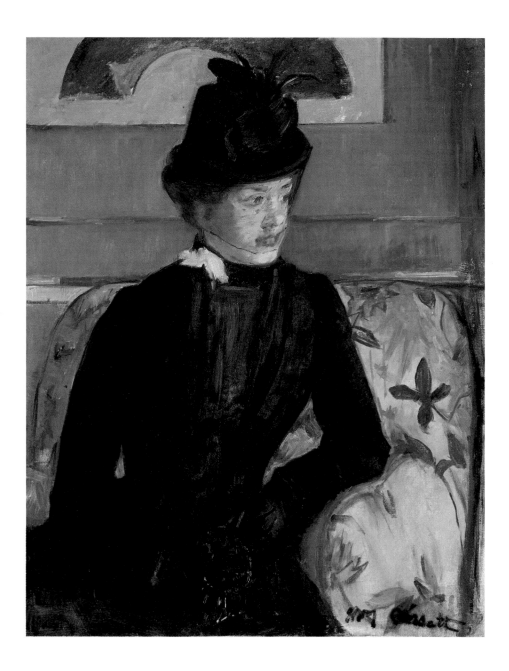

90. Mary Cassatt

V—17

Portrait de Mme J., ca. 1880

Now known as *Young Woman in Black*
Signed lower right: *Mary Cassatt*
Oil on canvas, 31¾ x 25½ in. (80.6 x 64.6 cm)
The Peabody Institute of the City of Baltimore, on indefinite
loan to The Baltimore Museum of Art. PI 10.10
REFERENCES: Breeskin 1970, no. 129; Washington 1970, no.
32; Breeskin 1981, no. 20.

Finally, Mary Cassatt is not the only one who has made compromises this year. Her talent has remained as lively, but her originality has abated. Of the four portraits that she exhibits, only one is strange. Give her another year or two and then you will have a lamb that will desert the fold to go howl with the wolves.
Henry Havard, *Le Siècle*,
2 April 1880

Miss Mary Cassatt seeks tonal strength that is not always forthcoming from her pencil. Her beginnings were much applauded. Regrettably we now see her aspiring to the partially completed image. One of her portraits is an Englishwoman in black leaning in an armchair. The subject's face is lively, but the background is too conspicuous.
Ph[ilippe] Burty, *La République Française*, 10 April 1880

. . . I will name Mary Cassatt, whose work develops directly from [Degas's]. Her *Portrait de Mme J . . .* in a black dress, sitting on flowered cushions, is a piquant little piece.
Armand Silvestre, *La Vie Moderne*, 24 April 1880

Mary Cassatt is a colorist. She works to reproduce exactly certain effects of light, which are not always pleasing.
Eugène Véron, *L'Art*, 1880

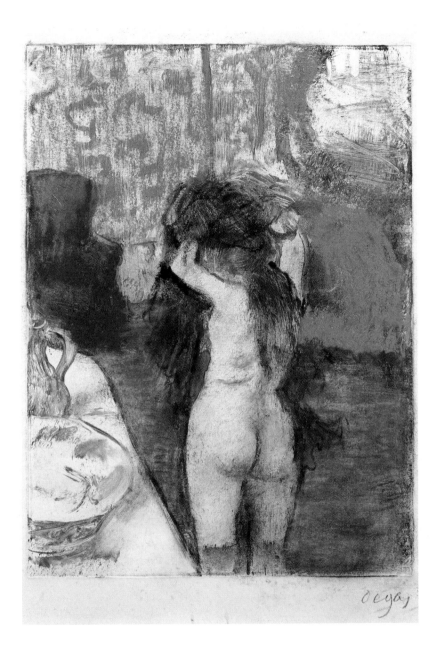

Degas continues to be passionately devoted to movement, pursuing it even in violent and awkwardly contorted forms. It is not surprising to see such stubbornness end like this, but it is not the mission of art to say everything, as if giving legal evidence in a court action. Degas has done some charming paintings of his dancers; why not stop when the subject was exhausted? He is still young and an artist of indisputable value. Degas often has shown that he is not one of these men with no imagination who is forced to repeat a single idea. He has only to wish for it to take the rank that belongs to him, but he is not likely to do this as long as he stays in that little church he has locked himself into. Is he trying to get others to say of him that, like Caesar, he would rather be first in a village than second in Rome?
Eugène Véron, *L'Art*, 1880

Degas is still an incomparable artist, consummately knowledgeable and powerfully original. He has truly found a new formula for painting, with his own character and style. His *Toilette*, showing a woman with a yellow chignon who is seen from the back while doing her hair, depicts movement with surprising accuracy and presents a truthful effect.
Gustave Goetschy, *Le Voltaire*, 6 April 1880

91. Edgar Degas

V–39

Toilette, ca. 1879

Now known as *La sortie du bain* (After the Bath)
Signed lower right in margin: *Degas*
Monotype in black ink on china paper, heightened with pastel; plate, 8¼ x 6¼ in. (21 x 15.9 cm)
Private collection, New York
REFERENCES: Lemoisne 1946, no. 554; Janis 1968, no. 178; Adriani 1984, no. 127.
NOTE: This appears to be a variant of the image described in the reviews by Ephrussi, Goetschy, and Silvestre.

By the same artist, here is a *Femme à sa toilette*, standing, seen from behind, a poor sense of movement, hardly sketched in, rendered like a cut-out, and, one would believe, without any understanding of form.
Charles Ephrussi, *Gazette des Beaux-Arts*, 1 May 1880

As in past years, Degas remains the indisputable and undisputed master. With his truly admirable sense of movement in line and harmony in color, Degas could not draw a line that would not be at least relatively final. What a marvel of grace and life-like delicacy is his figure of a woman getting dressed, tilting her blond head onto her arms lifted behind her! His intelligence seizes poses with perfect accuracy.
Armand Silvestre, *La Vie Moderne*, 24 April 1880

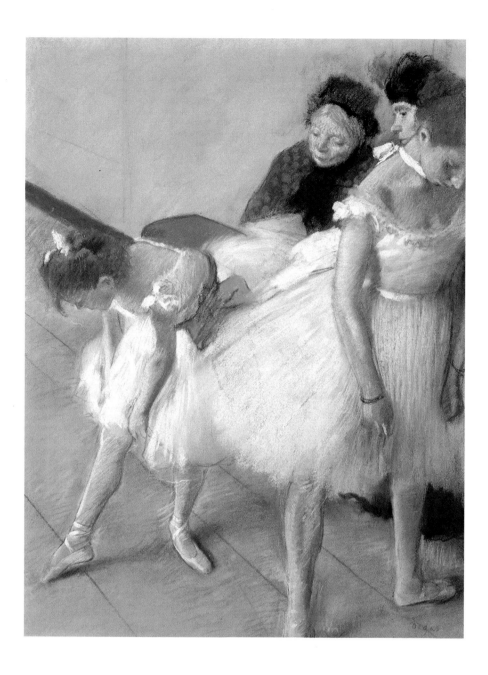

92. Edgar Degas

V-40

Examen de danse, ca. 1880
The Dance Examination

Signed lower right: *Degas*
Pastel and charcoal on paper, 24¹⁵/₁₆ x 18¹⁵/₁₆ in. (63.4
x 48.2 cm)
Denver Art Museum. Anonymous gift. 1941.6
REFERENCES: Lemoisne 1946, no. 576; Denver 1981, 152–
153; Baltimore 1962, no. 45; Werner 1968, no. 8.

Degas, the painter of dancers, makes keen and accurate observations. His little ballet rats are perfectly realistic. He does not always emphasize the grace and beauty of his models, but the farther back one stands, the more charming they are, and they are accurately and well recorded. At first sight it is disagreeable to the eye, but one grows accustomed to it.
Paul de Charry, *Le Pays*,
10 April 1880

Look at this dance examination. A dancer bends over retying a lace, and another has her head on her stomach, her hooked nose arching from beneath her mop of red hair. Near them are a friend in street clothes, vulgar, her cheeks covered with freckles, her shock of hair stuffed under a hat bristling with red feathers, and a woman, someone's mother, with the puffy face of an old concierge, wearing a leaf-patterned shawl, who chat during the interludes. What truth! What life! See how realistic these figures are, how accurately the light bathes the scene. Look at the expressions on these faces, the boredom of painful mechanical effort, the scrutiny of the mother whose desires are whetted whenever the body of her daughter begins its drudgery, the indifference of the friends to the familiar weariness. All these things are noted with analytical insight at once subtle and cruel.
Joris-Karl Huysmans,
L'art moderne, 1883

In his *Examen de danse* and *Deux danseuses* (for Degas has a well-known predilection for choreographic subjects), what graceless poses, what angular and dislocated limbs we see flailing with the movements of a clown who never dreamt that Terpsichore is a muse! . . . Despite these intentional vulgarities, one really must praise the audacity of the foreshortening, the astonishing strength of the drawing in the extended arms and even in the barely indicated hands. We must praise, too, this shrewd observation directed uniformly over the secret miseries of these high priestesses of the harmonious art of the dance.
Charles Ephrussi, *Gazette des Beaux-Arts*, 1 May 1880

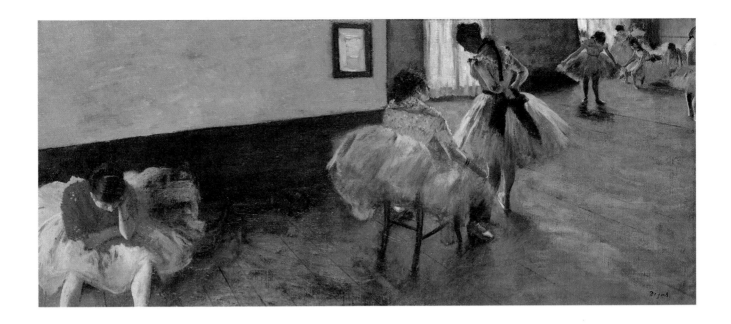

93. Edgar Degas

V—HC

La leçon de danse, ca. 1879
The Dance Lesson

Signed lower right: *Degas*
Oil on canvas, 15 x 34 in. (38 x 86.3 cm)
Collection of Mr. and Mrs. Paul Mellon, Upperville, Virginia
REFERENCES: Lemoisne 1946, no. 625; Washington 1966, no. 55; Shackelford 1984, 84, 86, no. 25.

The exhibition by Degas is perhaps not as interesting as you could have hoped. It is true that, on the opening day, it was still incomplete. The catalogue, an early riser, listed works that we searched for in vain. Degas's compositions repeat the same subjects that already have often inspired him. His art lives on the theater. In pastels or paint, the artist excels in silhouettes of little dancers with sharp elbows. Unfortunately, Degas, who had an early Florentine manner, and who always seeks character, has a tendency to fall into caricature. What is still true with him is pantomime, and also light. The view of a long high-ceilinged gallery where little girls in muslin worry with the difficulties of academic dance is enveloped in a transparently fine atmosphere.
Paul Mantz, *Le Temps,*
14 April 1880

Another of his paintings is dismal. In a huge exercise room, a woman slouches with her cheek on her hand, a statue of boredom and fatigue, while another sits, her skirts puffed over the back of her chair, mindlessly staring at the groups who frolic to the sound of a single violin.
Joris-Karl Huysmans,
L'art moderne, 1883

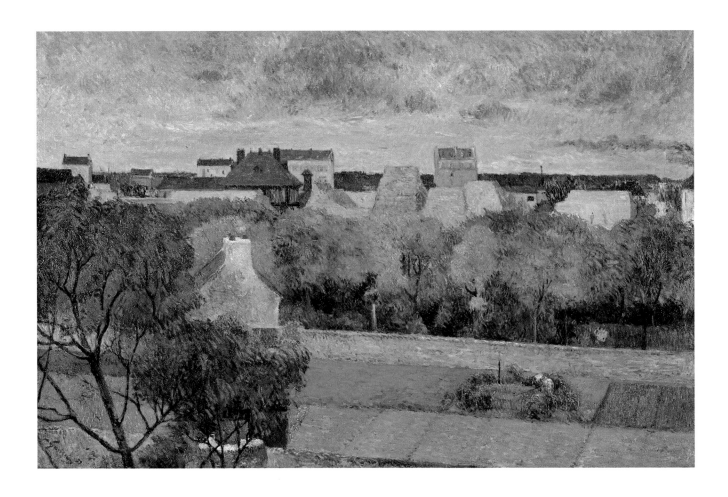

94. Paul Gauguin

V–56

Les maraîchers de Vaugirard, ca. 1879
The Market Gardens of Vaugirard

Signed and dated lower left: *P. Gauguin 79*
Oil on canvas, 25 5/8 x 39 3/8 in. (65 x 100 cm)
Smith College Museum of Art, Northampton, Massachusetts.
Purchased. 1953:55
REFERENCES: Wildenstein 1964, no. 36; Chetham et al. 1970,
no. 23; Isaacson 1980, no. 22; Brettell et al. 1984, no. 74.

In what street of what undeveloped district will the Independents establish themselves next year? I don't know, and they probably don't know either. But whatever new place they hope to choose, they would be wise to take one bigger and better-lit than the one they now occupy. I am not speaking of the works of Gauguin and Levert that would gain hardly anything by being seen elsewhere, even if it were at Cabanel's atelier itself.
Gustave Goetschy, *Le Voltaire*, 6 April 1880

As elsewhere, blue is the obstacle, the great stumbling block against which the Impressionists crash. And so Caillebotte, whose beginnings created a sensation, went into service under Pissarro's flag, like Zandomeneghi and above all Gauguin, or rather, he went over to the blue camp.
Charles Ephrussi, *Gazette des Beaux-Arts*, 1 May 1880

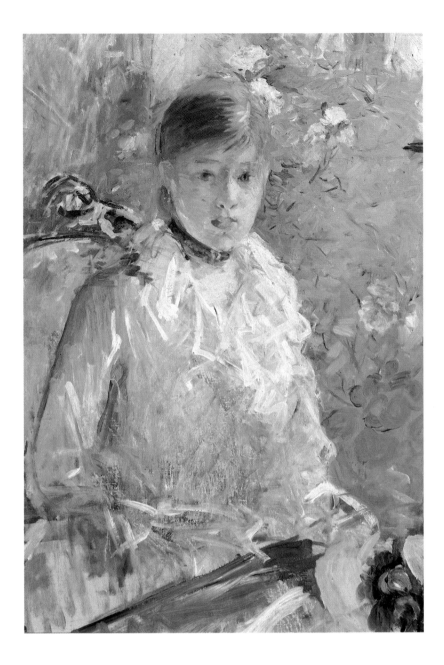

95. Berthe Morisot

V—113

Eté, 1878
Summer

Now known as *Jeune fille près d'une fenêtre* (Young Woman by a Window)
Oil on canvas, 30 x 24 in. (76 x 61 cm)
Musée Fabre, Montpellier. 07–5–1
REFERENCES: Bataille and Wildenstein 1961, no. 75; Dejean 1979, no. 58.
NOTE: Dejean has identified this work as a self-portrait. See Dejean, above.

I have been utterly seduced and charmed by Morisot's talent. I have seen nothing more delicate in painting. Her works, *L'été*, *Le lac du bois de Boulogne*, *L'avenue de bois*, and a *Portrait*, have been painted with extraordinarily subtle tones.
A. E. [Arthur d'Echerac], *La Justice*, 5 April 1880

Morisot is showing some pretty sketches of women. There is a lot of talent and life in these vaporous and barely drawn lines. Her work is almost atmospheric. With this talent, why does she not take the trouble to finish? Morisot is a woman, and therefore capricious. Unfortunately, she is like Eve who bites the apple and then gives up on it too soon. Too bad, since she bites so well!
Paul de Charry, *Le Pays*, 10 April 1880

Berthe Morisot handles the palette and brush with a truly astonishing delicacy. Since the eighteenth century, since Fragonard, no one at all has used clearer tones with such intelligent assurance. Her young women in white, lilac, or bright yellow dresses, sitting on divans covered in soft-looking fabrics, standing in sunny gardens, or reclining in little boats as they slip past green lawns, have the true ingenuousness, the true charm of youth.
Ph[ilippe] Burty, *La République Française*, 10 April 1880

But I also like *L'été* a great deal, with its young woman who nonchalantly holds a straw hat.
Armand Silvestre, *La Vie Moderne*, 24 April 1880

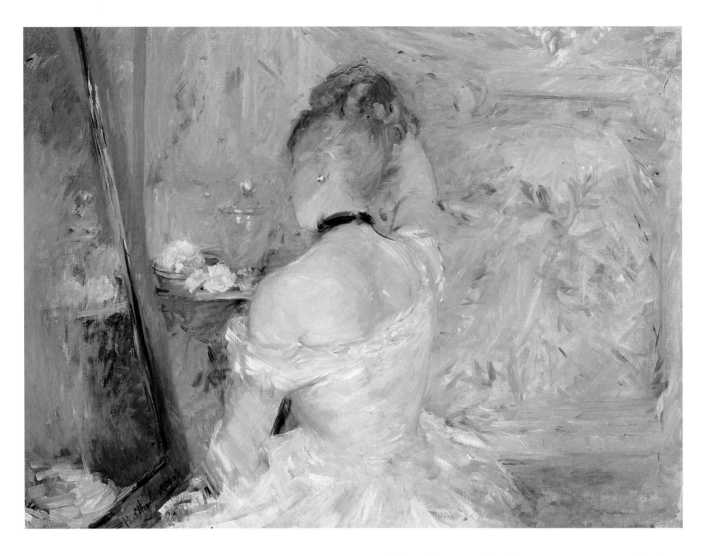

96. Berthe Morisot

V–115

Femme à sa toilette, ca. 1875
Woman at Her Toilette

Signed lower left: *Berthe Morisot*
Oil on canvas, 23¾ x 31⅝ in. (60.3 x 80.4 cm)
The Art Institute of Chicago. The Stickney Fund. 1924.127
REFERENCES: Bataille and Wildenstein 1961, no. 84; Chicago
1961, 288, 340.
San Francisco only

I think one of the best works is the woman at her dressing table, seen from behind, whose ambered white skin is seen against a background almost as light.
Armand Silvestre, *La Vie Moderne*, 24 April 1880

The same impossibilities, the same seduction [exist] in the *Femme à sa toilette*. She is an ash-blonde with a lost profile. The entirety is in gray tones spotted here and there with touches of pale pink.
Paul Mantz, *Le Temps*, 14 April 1880

Berthe Morisot is French in her distinction, elegance, gaiety and nonchalance. She loves painting that is joyous and lively. She grinds flower petals onto her palette, in order to spread them later on her canvas with airy, witty touches, thrown down a little haphazardly. These harmonize, blend, and finish by producing something vital, fine, and charming that you do not see so much as intuit. . . . Here are some young women rocking in a boat on choppy water; there are some picking flowers; this one walks through a winter landscape; that one is at her dressing table. All are seen through fine gray tones, matte white, and light pink, with no shadows, set off with little multi-colored daubs, the whole giving the impression of vague and undecided opaline tints.
Charles Ephrussi, *Gazette des Beaux-Arts*, 1 May 1880

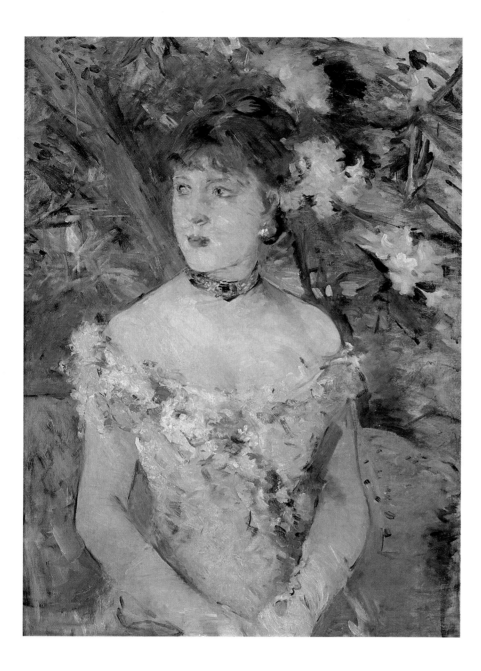

Even Berthe Morizot [*sic*], a thoroughgoing, unrepentant Impressionist, here and there provides some remarkably attractive touches of white.
Jules Claretie, *Le Temps*,
6 April 1880

. . . Morizot [*sic*] excels in the mixture of subtly shaded pallid tones. For example, she paints the portrait of a woman in a low-necked dress sitting in a garden. The flesh is blond, vague flowers touch the grayed greenery with rosy lilac notes. Everything is floating; nothing is formulated. The tone itself hesitates, undecided, and there is in it a Fragonardian refinement, the feeling of a phantom world where colors do not yet have vitality, where the indistinct tones do not yet know that later they will acquire an individual character and a civil status.
Paul Mantz, *Le Temps*,
14 April 1880

Several personalities already have distinguished themselves among this crowd of maniacs. In the first rank we will name Morisot, whose refined and elegant style provides a pleasant reprieve. Along with a serious effort to paint truthfully, her delicately executed portraits and sketches of Parisian landscapes show an absolutely delightful light touch. She generously wraps everything in air, and only a certain loose look to her work subtracts from its overall accuracy.
H[enri] Mornand, *La Revue Littéraire et Artistique*,
1 May 1880

97. Berthe Morisot

V—120

Portrait, 1879

Now known as *Jeune femme en toilette du bal* (Young Woman Dressed for the Ball)
Oil on canvas, 28 x 21¼ in. (71 x 54 cm)
Musée d'Orsay (Galerie du Jeu de Paume), Paris. R. F. 843
REFERENCES: Bataille and Wildenstein 1961, no. 81;
Adhémar and Dayez-Distel 1979, 81, 166.

It is certain that Berthe Morisot's charming and delicate sketches offer such fresh impressions in such delicate and clear tones that they would demand to be seen anywhere else other than at the tip of your nose, in dull and badly distributed light, in a low, narrow mezzanine with no room to draw aside or move back.
Gustave Goetschy, *Le Voltaire*,
6 April 1880

[Cassatt's] success in modeling has been achieved to an even greater degree by Berthe Morisot in some of her paintings. It is even more remarkable, given that she has reduced painting to its simplest expression. Color is almost absent and her figures recall those fleeting and floating shadows that Virgil describes in the *Aeneid* or Dante in the *Divine Comedy*. These attenuations of color, however, do not rob her painting of its delicate and sensitive tone.
Eugène Véron, *L'Art*, 1880

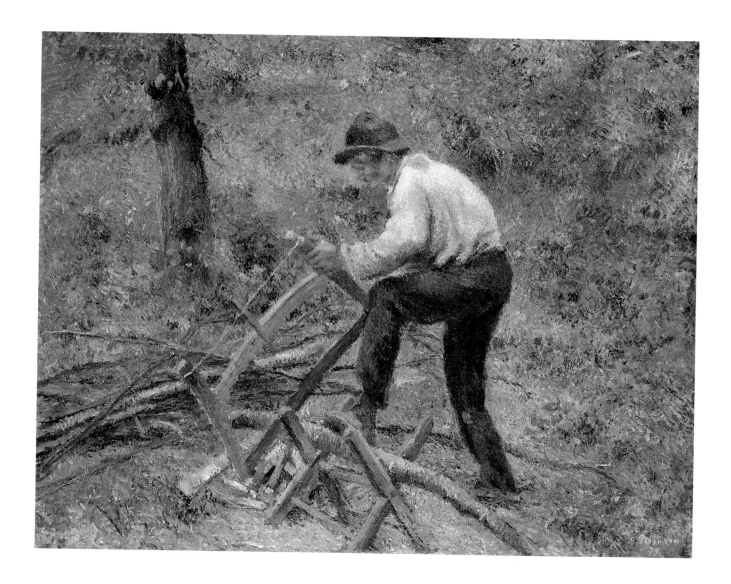

98. Camille Pissarro

V—128

Le scieur de bois, 1879
The Woodcutter

Signed and dated lower right: *C. Pissarro/79*
Oil on canvas, 35 x 45¾ in. (89 x 116.2 cm)
The Robert Holmes à Court Collection, Perth, Western
Australia. 1008
REFERENCES: Pissarro and Venturi 1939, no. 499; Bodelsen
1970, no. 37; Christie's New York, 15 May 1985, no. 16.
NOTE: The woodcutter has been identified as Père Melon. See
Pissarro and Venturi, above.

Pissaro [sic] is becoming simpler.
His *Scieur de bois* is a rather
pretty landscape. But while Pis-
saro seems to be reforming, Guil-
laumin . . . amuses himself by
making a mess with yellow, red,
and green.
Arthur Baignères, *La Chronique
des Arts et de la Curiosité,*
10 April 1880

In his rustic scenes, notably his
paintings *Scieur de bois* and
Récolte de petits pois, Pisaro [sic]
unsuccessfully tries to attain the
rough, male simplicity of the
master Millet. . . .
Gustave Goetschy, *Le Voltaire,*
6 April 1880

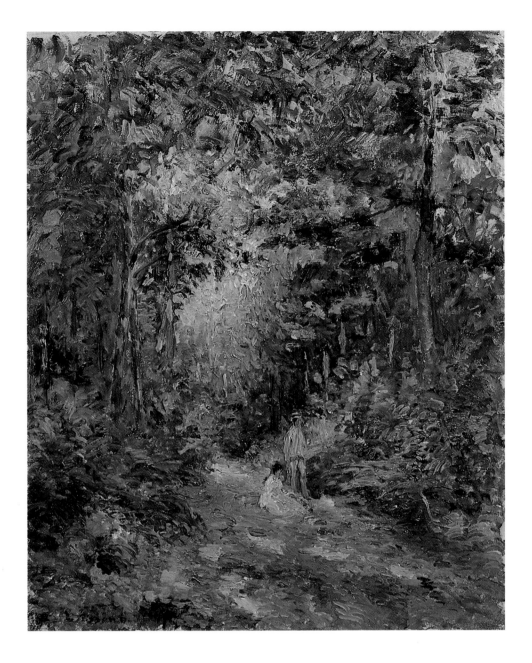

99. Camille Pissarro

V–131

Automne, chemin sous bois, 1876
Autumn, Path through the Woods
Signed and dated lower left: *C. Pissarro 1876*
Oil on canvas, 3 1⅞ x 2 5⅝ in. (81 x 65 cm)
Private collection, Paris
REFERENCES: Pissarro and Venturi 1939, no. 505.

Pissarro has the temperament of a true artist, that is certain; the day that his painting frees itself from the trappings of its infancy it will be the real modern landscape painting to which the artists of the future will aspire. Unfortunately the outstanding works [in this exhibition] are exceptions; under the pretext of impressions, Pissarro, too, has splashed color onto canvas. He is off-and-on, his works bounce from the worst to the best, like Claude Monet, who now exhibits with the Officials.
Joris-Karl Huysmans, *L'art moderne*, 1883

Pissaro [*sic*] appears less convinced than before that he needs to attack tradition with a smoking pistol, . . . and his large paintings of greenery, if they were varnished, would not seem like anything unusual. They are, in short, interpretations of nature that are perhaps somewhat literal but which make a certain statement, if seen from a distance.
Eugène Véron, *L'Art*, 1880

Camille Pissarro really is a remarkable artist. Despite all our esteem for his talent and his evident convictions, we could not list him among the landscape painters we like. He leans toward the architectural side of nature too much. The planes of his hills and of his seeded fields are almost colossal. A tree looks to him like nothing more than a beam leafing out again with a few twigs, the sap's last illusory effort. I cannot tell you how much this nature, so lacking in freedom, reminds me of the Mettray colony [a youth detention camp].
Ph[ilippe] Burty, *La République Française*, 10 April 1880

Of the trio Pissaro [*sic*], Monet, and Sisley, Pissaro remains in the front rank. His exhibition is considerable, and is as interesting as in past years. A singular brotherhood of spirit! Pissaro seems to oscillate between Millet and Jundt. But while he sometimes approaches the sincerity of the former, as in his very beautiful fan, he does not always manage to better the irresolute execution of the latter, as in his *Récolte de petits pois*. However, his engravings are remarkable. I would also like to mention his *Chemin sous bois en automne*, which creates an impression of great truthfulness. This artist, at least, remains well within the order of sensations that seem to me to be the only plausible justification for Impressionist art.
Armand Silvestre, *La Vie Moderne*, 24 April 1880

100. Jean-François Raffaëlli

V—150

Maire et conseiller municipal, ca. 1879
Mayor and Town Counselor
Signed lower right: *J. F. Raffaëlli*
Oil on canvas, 21 x 28¾ in. (53.5 x 73 cm)
Private collection, New York
REFERENCES: Fields 1979, 173–174, fig. 41; Isaacson 1980, no. 42.

On the other hand, I come to a completely intriguing artist, whose exhibition is as important for the number of works submitted as for their quality. Jean-François Raffaëlli is powerfully gifted, above all as a draftsman. There is not a single one of his thirty-five canvases that does not deserve attention. His *Maire et conseiller municipal* is a figure study full of truth.
Armand Silvestre, *La Vie Moderne*, 1 May 1880

Raffaëlli is an artist of real value. His *Chiffonniers*, his *Maire et conseiller* are a couple of rough pieces. Their technique is intriguing and their execution interesting, occasionally reminiscent of Ribot.
Gustave Goetschy, *Le Voltaire*, 6 April 1880

But what is surprising and really unparalleled in this exhibition are the paintings and studies of J.-F. Raffaëlli, a sort of Meissonier of poverty, the painter of the disenfranchised, the poet of the Parisian suburbs. His temperament is unique, powerful and refined. . . . But Raffaëlli has nothing Impressionist about him.
Jules Claretie, *Le Temps*, 6 April 1880

But surely the most astonishing painter in the company is Roffaëlli [*sic*]. He has come here for contrast and to give the others a rest.
Among some other great canvases, he gives us *Monsieur le maire et son conseiller municipal*. The two figures are startlingly real.
Paul de Charry, *Le Pays*, 10 April 1880

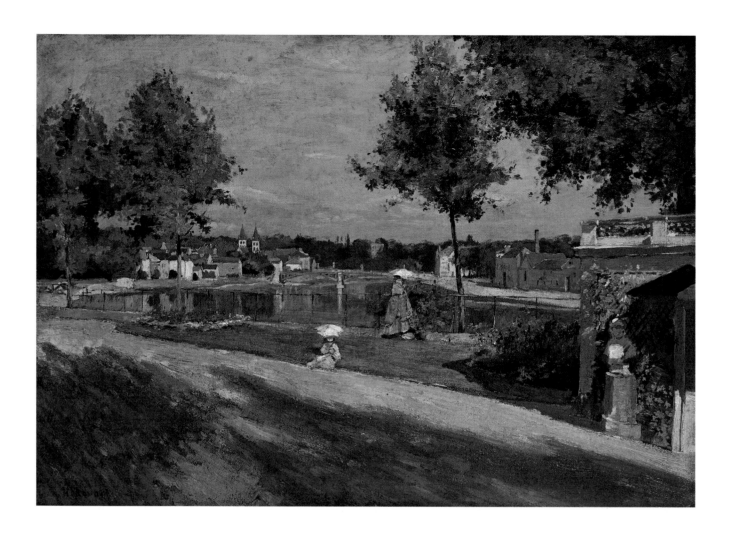

101. Henri Rouart

V–182

Melun, ca. 1880

Now known as *La Terrasse au bord de la Seine à Melun*
(Terrace on the Banks of the Seine at Melun)
Signed lower left: *H. Rouart*
Oil on canvas, 18¼ x 25¾ in. (46.5 x 65.5 cm)
Musée d'Orsay (Galerie du Jeu de Paume), Paris. Gift of
M. Marin, 1934. R.F. 3832
REFERENCES: Adhémar and Dayez-Distel 1979, 170, 184;
Isaacson 1980, no. 50.
NOTE: Melun is situated on the Seine south of Paris, at the
northern edge of the forest of Fontainebleau, where Rouart's
family owned property. His mother and sister Hélène are
depicted in this picture, respectively standing and seated on the
lawn.

We will not discuss Rouart and
Tillot, who have no visible rela-
tionship to the milieu in which
they find themselves. If their
works were sent to the official
Salon, they would blend in very
easily with the respectable medi-
ocrity that constitutes the
majority.
Eugène Véron, *L'Art*, 1880

You might ask what Rouart is
doing here. His watercolors are
pleasing, but attempt nothing
beyond what has already been
done.
His *Paysage* (no. 181) shows a
certain gift for color, but you
would have to be extremely clever
to find in it any revolutionary or
reforming instincts. His *Vue de
Melun* has very fine and distin-
guished tone.
Armand Silvestre, *La Vie
Moderne*, 1 May 1880

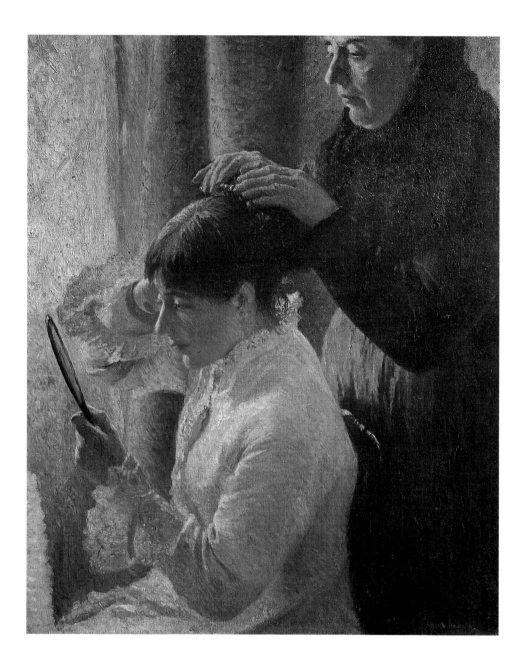

102. Federico Zandomeneghi

V–225

Mère et fille, 1879
Mother and Daughter

Signed and dated lower right: *Zandomeneghi 1879*
Oil on canvas, 24⅜ x 20½ in. (62 x 52 cm)
Collection of Mr. Giuliano Matteucci, Viareggio
REFERENCES: Piceni 1967, no. 40; Cinotti 1960, 32, 37, 39,
62, 67, pl. 17; Piceni 1984, no. 8.
NOTE: The models are probably Zandomeneghi's mother,
Anna, and his sister, Antonietta, who visited the artist in Paris
during this period. See Piceni 1984, above.

Speak to me of Zandomeneghi.
Here is someone in the true tradi-
tion of the Intransigents. This
particular offering, *Mère et fille,*
is a painting that ought to be
highly prized by the initiates.
Armand Silvestre, *La Vie
Moderne,* 1 May 1880

One of [Zandomeneghi's pic-
tures], called *Mère et fille,* shows
an old mamma, looking like a
nice old housewife, doing the hair
of her daughter who sits before a
window in her dressing gown.
The daughter turns to look at her-
self in a mirror with a typically
feminine movement, well-
captured by the artist. You need
to see the attentive care of the
mother who scarcely dares to
hold the golden knobs of the
comb with her thick, rough fin-
gers, their skin like turkey flesh,
deformed by work. Then, imag-
ine the pretty smile of the little
Parisian, lifting her arm adorned
by a coral bracelet, or rather a
serpent of pink celluloid! It was
done on the spot, executed with
none of the grinning faces so dear
to ordinary daubers of genre sub-
jects, and it is painted in a soft
lilac tone, without too much or
too little detail.
Joris-Karl Huysmans,
L'art moderne, 1883

The Sixth Exhibition *1881*

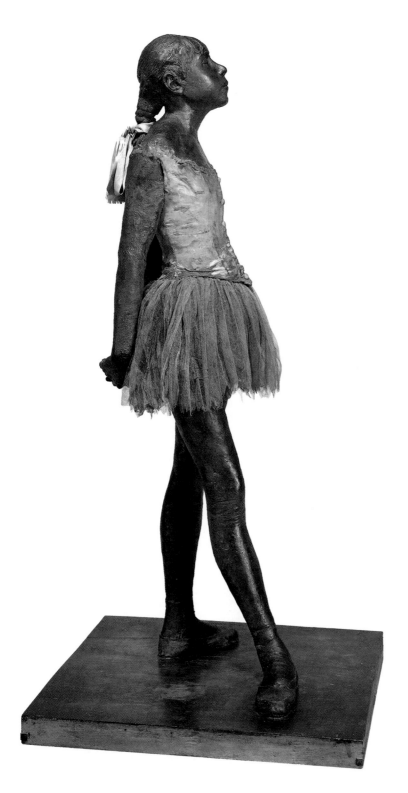

fig. 4 Edgar Degas, *Petite danseuse de quatorze ans, statuette en cire*
(*The Little Fourteen-Year-Old Dancer*, VI–12), ca. 1881. Wax, silk,
satin ribbon, hair; 39 in. (99 cm). From the Collection of Mr. and Mrs.
Paul Mellon, Upperville, Virginia

Realists among the Impressionists

Fronia E. Wissman

The address of the Sixth Impressionist Exhibition was the same as that of the First: 35 boulevard des Capucines. But in this detail, as in matters of much greater substance, apparent similarities between the 1874 and 1881 exhibitions are deceptive. Instead of the generous accommodation of Nadar's airy studio, the exhibition space was composed of five small rooms connected by several corridors in a cramped mezzanine at the back of the building. Furnished with Algerian settees and rocking chairs,[1] the low-ceilinged rooms were so poorly lit and the space so confined that viewing the over one hundred seventy works was difficult—in fact, one critic complained that he had to bend over to see the art.[2]

The spaces occupied by the exhibitions at 35 boulevard des Capucines were not the main point of contrast between the 1874 and 1881 exhibitions. Most crucial were the absences in 1881 of Claude Monet, Auguste Renoir, and Alfred Sisley, each of whom chose instead to submit paintings to the government-sponsored Salon.[3] Moreover, relations were fractious between the artists who did participate in the sixth exhibition. (It is unclear whether the artists of 1881 gave themselves a name; as usual, none appears on the catalogue cover, and no poster has come to light.) As in previous years, Degas, his friends, and what was perceived to be Degas's disruptive attitude and behavior were at the center of the difficulties. In a deservedly often-quoted letter, Caillebotte complained heatedly to Pissarro:

What is to become of our exhibitions?

This is my well-considered opinion: we ought to continue, and continue only in an artistic direction, the sole direction—in the final sense—that is of interest to us all. I ask, therefore, that a show should be composed of all those who have contributed real interest to the subject, that is, you, Monet, Renoir, Sisley, Mme Morisot, Mlle Cassatt, Cézanne, Guillaumin; if you wish, Gauguin, perhaps Cordey, and myself.[4] That's all, since Degas refuses a show on such a basis. . . . Degas introduced disunity into our midst. . . .

He claims that he wanted to have Raffaëlli and the others because Monet and Renoir had reneged and that there had to be someone. But for three years he has been

after Raffaëlli to join us, long before the defection of Monet, Renoir, and even Sisley. He claims that we must stick together and be able to count on each other (for God's sake!); and whom does he bring us? Lepic, Legros, Maureau. . . . (Yet he didn't rage against the defection of Lepic and Legros, and moreover, Lepic, heaven knows, has no talent. He has forgiven him everything. No doubt, since Sisley, Monet, and Renoir have talent, he will never forgive them.) In 1878 [he brought us] Zandomeneghi, Bracquemond, Mme Bracquemond;[5] in 1879 Raffaëlli . . . and others. What a fighting squadron in the great cause of realism!!!! . . .

I shall sum up: do you want an exclusively artistic exhibition? I don't know what we shall do in a year. Let us first see what we'll do in two months. If Degas wants to take part, let him, but without the crowd he drags along. The only ones of his friends who have any right are Rouart and Tillot. . . .[6]

Pissarro countered Caillebotte's sense of outrage with his own sense of loyalty, suggesting that a spirit of community, rather than artistic principles, be the cohesive factor for the group. "The only possible principle, as just as it is fair, is one of not abandoning colleagues, who have been accepted [in the past], rightly or wrongly, and who cannot be thrown out without ceremony."[7] Pissarro took pains to remind the younger artist that among Degas's recruits, whom Caillebotte found objectionable, was Caillebotte himself. "As for what you tell me of Degas, admit that if he has sinned by giving us some artists who do not fit in the program, nonetheless he has been lucky several times; [if you] remember that he brought to us Mlle Cassatt, Forain, and *you*, he will be pardoned!"[8]

Caillebotte and Pissarro could not resolve their differences.[9] "I don't know what I shall do," Caillebotte wrote back to Pissarro. "I don't believe that an exhibition is possible this year. But I certainly shan't repeat the one held last year."[10] And he did not. Unable to come to terms with Degas, Caillebotte did not participate in the 1881 exhibition.

Considering the circumstances, and without more evidence to contradict the speculation, it is probable that

fig. 1 Jean-François Raffaëlli, *Bonhomme venant de peindre sa barrière (Fellow About to Paint His Fence,* VI–122), ca. 1881. Oil on canvas. Location unknown. Photo: *La Vie Moderne* (16 April 1881): 251

Degas organized the 1881 exhibition. "Usually M. Degas leads the caravan. About February, he goes out to look [for an exhibition space], consulting the notice-boards and interrogating the concierges."[11] With the absence of Monet, Renoir, and Sisley, Degas and his followers were the main contributors. Cassatt, Degas, Forain, Raffaëlli, Rouart, Tillot, Vidal, and Zandomeneghi –a full eight of the thirteen artists–were in Degas's camp.[12] These artists were brought into the group through association with Degas for several reasons, among which were affinities based on their representations of aspects of modern, urban life, disregarding conventional beauty. In supporting Tillot, a still-life painter who had been with the group from the beginning, Degas was in all probability underscoring the diversity of the group, perhaps in a futile attempt to escape restrictive labels.

While the where, when, and who of the sixth exhibition are questions easily answered, the what–which specific paintings, drawings, and sculptures were shown–is less easily determined. As for all the shows, the catalogue offers only indefinite titles for most of the works exhibited, such as *Portrait* or *Paysage breton,* making identifications difficult. That, combined with the high incidence of little-known artists, such as Guillaumin, Raffaëlli, Rouart, Tillot, Vignon, and Zandomeneghi, limits the amount of information available or retrievable about this particular exhibition. In addition, the critics who reviewed the show for the Parisian newspapers and magazines were unusually laconic this year. They chose to write in generalities about the idea of group exhibitions or the overall contribution made by a given artist, rather than in detail about specific works. We do, however, gain something significant from these writers. The subject of greatest interest to the majority of them, and, upon inspection, to the artists, was the issue of Realism, a term that encompassed the subsidiary ideas of the modern and the ugly. The remainder of this essay examines the reception accorded the 1881 exhibition and to do so draws its material from these contemporary accounts.

In their reviews the critics underscored the ideological link between the artists in this sixth exhibition and Realist and Naturalist writers.[13] Realists, such as Balzac and Flaubert, and Naturalists, such as Zola, derived their subject matter from the world around them and concentrated on people from the middle and lower classes, exploring contemporary situations and settings objectively and in great detail. They claimed that since environment determines the nature and behavior of human beings, and virtually negates the concept of free will, a person's actions can be understood only by a thorough examination of his milieu.[14] In a comparable manner, Realist artists followed the lead of Courbet and others, drawing on everyday life for their material and cataloguing the physical facts of their subjects' lives.[15] Again, it was the lower classes who fascinated both writers and artists, providing unidealized subject matter that some critics found objectionable.

Forgetting that nature is complex and that in her huge embrace she holds order and disorder, the beautiful and the imperfect, the normal and the monstrous; forgetting as well that if the task of science is to observe everything in order to draw general conclusions, it cannot be the same with the arts and letters which, without scorning the truth, concern themselves above all with rendering the beautiful, the agreeable, the characteristic; [instead] they seem to choose that which is ugly, deformed, repugnant. . . .[16]

The ugly, deformed, and repugnant were generally subjects of modern life, such as, in this sixth exhibition, Raffaëlli's ragpickers, Degas's dancers and criminals, and Gauguin's wood sculptures and painting of a nude.

These works shared not only an interest in Realist subjects, but also their reliance on line and drawing to convey information. In this, Degas and his recruits fulfilled the stipulations for drawing as set forth by Duranty in his 1876 pamphlet, *La nouvelle peinture*.

And what drawing wants in terms of its current goals is just to know nature intensely and to embrace nature with such strength that it can render faultlessly the relations between forms, and reflect the inexhaustible diversity of character. . . . The fundamental idea gains sharpness of focus. This is the joining of torch to pencil, the study of states of mind reflected by physiognomy and clothing. . . .

The artist's pencil will be infused with the essence of life. We will no longer simply see lines measured with a compass, but animated, expressive forms that develop logically from one another. . . .

But drawing is such an individual and indispensable means of expression that one cannot demand from it methods, techniques, or points of view. It fuses with its goal, and remains the inseparable companion of the idea.[17]

Degas, of course, was the supreme draftsman, yet Raffaëlli, too, could draw. "Raffaëlli excites, he lures, he remembers; each figure has exactly the characteristic trait that makes him an individual. On seeing [Raffaëlli's work], you say to yourself: That's it! M. Raffaëlli is at once a painter and an observer."[18]

Raffaëlli's powers of characterization were well-represented in 1881. The worst the critics had to say about his huge contribution (thirty-three works hung in the main room) was that his work was monotonous.[19] It was certainly homogeneous, since the titles refer to pictures that have similar, if not identical, subjects. Raffaëlli found enthusiastic supporters for his work, including Albert Wolff, a critic continually hostile to the group exhibitions. Wolff urged collectors to buy Raffaëlli's works while their prices were still low, as they were bound to increase in value.[20] He was hardly a disinterested observer of art market trends, as he had lent to the exhibition two paintings by Raffaëlli from his own collection, *Terrains vagues* and *Marchand d'ails et d'échalotes* (Boston, Museum of Fine Arts).

As Barbara Schinman Fields makes clear in her dissertation on the artist, Raffaëlli garnered the most praise from writers with Naturalist tendencies themselves, Joris-Karl Huysmans notable among them.[21] Of *Les déclassés* (cat. no.112) he said:

He shows them to us, [seated in front of their glasses of absinthe, in a café under an arbor where the barren vines, deprived of leaves, twist and climb,] with their filthy outfits in tatters and their boots falling apart, with their black hats that have lost their nap and been warped out of shape, with their unkempt beards, their sunken eyes, their dilated, watery pupils, one with his head resting on

fig. 2 Jean-François Raffaëlli, *Cantonnier, Paris 4 K. 1* (*Roadman, Paris 4 Kilometers*, VI–92), ca. 1881. Oil on canvas. Location unknown. Photo: Arsène Alexandre, *Jean-François Raffaëlli*. Paris: H. Floury, 1909

his hand, the other rolling a cigarette. In this picture a movement of an emaciated hand placing a pinch of tobacco on the paper speaks volumes about their daily habits, about the ever renewed miseries of an inflexible life.[22]

It is autumn, the sky is gray and overcast, the grape arbor is bare. Everything in the painting is old, lackluster, tired, and rundown. As progeny of the impoverished Parisian suburbs, these absinthe drinkers are visually locked into their environment by the gridwork of the sapling fence, the ramshackle furniture and arbor, and the whitewashed wall against which their heads are silhouetted. There is, one feels, no escape for them. The square format of the painting centers the figures and bluntly presents them for our inspection, reinforcing the architectonic nature of their "cage."

Raffaëlli's *Bonhomme venant de peindre sa barrière* (*fig.1*) and *Cantonnier, Paris 4 K. 1* (*fig.2*) are two more examples of his descriptive, objective vision. These men, doing nothing in particular, are seen in the interval between activities: the one has just finished painting his

fence green and is looking for something else to paint with the remaining color in the pot,[23] the other, seated uncomfortably on a highway marker, looks away from Paris, perhaps irresolute in his travels. These works were seen to continue a tradition of painting humble subjects. The critics found for Raffaëlli a heritage and precedents that would legitimize his art, calling him the "Ostade of Parisianism,"[24] referring to the seventeenth-century Dutch family of painters.

However, Huysmans found a more convincing precedent in the Le Nain brothers, the seventeenth-century painters of French peasants. Since them, Huysmans declared, "no one had dared to put [the poor devils of the cities] in the places where they live and who are forcibly adapted to their deprivations and their needs. M. Raffaëlli has taken up and completed the work of the Le Nain."[25] Huysmans's comparison is by far the better. The figures in the Ostades' pictures, drinking and carousing in carefully detailed taverns and rooms,[26] are more raucous and coarse than Raffaëlli's. The figures in the Le Nain brothers' works, on the other hand, share with those of Raffaëlli a calm that borders on inactivity, a repose that approaches lethargy. They are figures whose surroundings offer few clues to whatever story they might tell, figures who inhabit a no-man's land.[27]

Zandomeneghi's *La place d'Anvers* (cat. no. 113) also depicts modern life, but contrasts with Raffaëlli's by representing an urban, rather than suburban, milieu. It is a curious amalgam of street scene and genre, of Caillebotte and Cassatt, and shows a city square with plantings of flowers and trees in which the primary population is composed of nurses, nannies, and their small charges. This blend of the urban and domestic looks forward to some of Vuillard's work of the 1890s, in which the lives and actions of children in public spaces form an artistic focus. The combined urban-domestic subject matter finds its counterpart in the varied styles Zandomeneghi used: a divisionist brushstroke for the setting, a replication of the effect of full sunlight in the contemporary manner of Pissarro and Gauguin, and a smoother surface for the figures, especially the faces, more akin to Renoir's style. In giving a view of a specific kind of urban recreation in *La place d'Anvers*, Zandomeneghi focuses on the details that define types. This is in contrast to Monet's earlier views of parc Monceau (see cat. no. 50), in which the light falling through foliage is the focus of interest, and the figures in the park are merely more objects to be defined and patterned by that light. Zandomeneghi, on the other hand, takes pains to describe the hats, bonnets, and cloaks that mark the maids and nannies, and the casual and ungentlemanly stance of the man to the left, whose object of attention is coyly hidden behind the tree.

Degas's entries to the earlier group shows established the urban milieu most commonly studied by the Realists —not the urban park, but café and theater life. These themes were taken up by two of his circle, Forain and Vidal. The similarities between Degas's and Forain's work were noted by more than one critic.[28] Forain's *Loge d'actrice* (cat. no. 108) shows an actress in *déshabillé* staring out at the viewer, as her hairdresser turns to talk to the older man in evening clothes, the protector of the young woman. The contrast between the small, blond actress with her large, doe-like eyes, fingering some flowers on the dressing table, and the huge, black, buxom mass of the hairdresser, likewise fingering the actress' hair, verges on the farcical. In a work with a similar theme by Degas, Lemoisne 497 for example, in which a seamstress mends a dancer's skirt while a male admirer looks on, the tone is serious and even somber. Forain makes explicit and anecdotal that which Degas leaves suggested and ominous.

The vagaries of history have preserved for us Forain's representation of the relationship between an actress and a man, but more works of art have been lost than have been saved. Although such a statement is self-evident, its truth is made the more poignant upon reading numerous reviews of these group exhibitions. A case in point are the comments made on the works of Eugène Vidal, a pupil of Gérôme and a friend of Lebourg, and particularly on his *Au café*. From its description, the watercolor shows two women at a café, one dressed in black adjusting her veil over her blond hair, another sitting in the full sun.[29] Such a tantalizing description of a painting said to be done with "a real sincerity"[30] makes our ignorance of it the more keenly felt.

It is highly ironic that, although Degas as usual was the focal point of the interest, energies, and concerns surrounding the 1881 exhibition, many of his entries remain lost or unidentified. Although the catalogue lists only eight entries for him, as was the case with all the exhibitions, the artist brought in additional items yet again at the last minute, works whose presence on the walls has been determined only through a careful reading of the reviews. With one exception, he showed relatively minor works, unidentified portraits, pastel studies of criminals, and, *hors catalogue*, scenes of the stage (cat. no. 105, *Cabaret*), a nude (cat. no. 107, *Maison close*),[31] and *Projet de portraits en frise* (fig. 3), all hung in a yellow room. Besides these works, the statuette of a dancer, absent from the 1880 show, finally appeared in its glass case, sometime after 8 April 1881. The presence of the empty case in 1880 had been another irritant for Caillebotte: "Degas's case is not enough for me."[32] All of these works exemplified Degas's brand of Realism, yet what baffled the critics was not his decision to treat these modern subjects, but the subjects' unattractiveness. Henry Trianon linked the work of Degas to Naturalism: "M. E. Degas seems to be one of these Naturalists. His entries to the exhibition are but disagreeable things."[33] Even his dancers this year were seen to be ugly and horrible.[34] The

expressive qualities of non-beauty and of unfinished work remained incomprehensible to the critics.

The *Petite danseuse de quatorze ans (statuette en cire)* (cat. no.106) epitomized the ugly, the modern, and the real.[35] Claretie commented sagaciously that she is "of a strangely attractive, disturbing, and unique Naturalism, which recalls with a very Parisian and polished note the Realism of Spanish polychromed sculpture."[36] He further made note of "the vicious muzzle of this young, scarcely adolescent girl, this little flower of the gutter," while Mantz spoke of "the instinctive ugliness of a face on which all the vices imprint their detestable promises."[37] More bluntly, one critic wrote that Degas had chosen "among the most odiously ugly; he makes it the

standard of horror and bestiality."[38] It is true that the girl, Marie van Goeten, was not a pretty child, and Degas's choice of pose for her did not emphasize any graceful carriage she might have had. Her snub nose and heavy-lidded eyes slope downwards, with the planar modeling of her cheekbones running in a diagonal ridge from the outside corner of her eye to her mouth. Theodore Reff has written wonderfully on the genesis of the sculpture, and his information need not be repeated here.[39]

What is necessary to repeat, however, is the description of the work as it appeared in the sixth exhibition, for Degas showed a wax figure (*fig.4*) and not the bronze versions seen in museums today. Degas tinted the wax to

fig. 3 Edgar Degas, *Projet de portraits en frise (Project for Portraits in a Frieze*, VI–HC), ca. 1880. Black chalk and pastel on gray paper, 19¾ x 25⅝ in. (50 x 65 cm). Private collection

fig. 5 Edgar Degas, *Physionomie de criminel* (*Physiognomy of a Criminal*, VI–17), 1881. Pastel on paper, 25¼ x 30 in. (64 x 76 cm). Location unknown. Photo: Lemoisne 638

fig. 6 Edgar Degas, *Physionomie de criminel* (*Physiognomy of a Criminal*, VI–18), 1881. Pastel on paper, 19 x 24¾ in. (48 x 63 cm). Location unknown. Photo: Lemoisne 639

resemble flesh, added a green satin ribbon to tie the braid of real black hair, and dressed the statue in a silk faille bodice, a skirt of tulle and gauze, and fabric slippers.[40] He used a translucent wax that reflects light back from within the sculpture itself.[41] The vitality of the surface and the costume, integrated with the basic sculptural form by a thin layer of wax (despite the clothes, this was not a doll to be dressed and undressed), established the uneasy relationship of illusion and reality that so disconcerted the early viewers. Huysmans best articulated the minority, sympathetic reaction.

[Degas exhibits] a statue of wax entitled The Little Fourteen-Year-Old Dancer, *before which an astonished public [runs away], as if embarrassed. The terrible realism of this statuette makes the public distinctly uneasy, all its ideas about sculpture, about cold, lifeless whiteness, about those memorable formulas copied again and again for centuries, are demolished. The fact is that on the first blow, M. Degas has knocked over the traditions of sculpture, just as he has for a long time been shaking up the conventions of painting. . . .*

At once refined and barbaric with her [ingenious] costume and her colored flesh, palpitating, lined with the work of its muscles, this statuette is the only truly modern attempt I know in sculpture.[42]

As Huysmans says, it is "the terrible realism" that is, still, so unnerving.

The *Petite danseuse* was a radical step from his usual production and was the only sculpture Degas ever exhibited. However, it is a witness to the continuing concerns of the artist, most obviously to his interest in the world of dance and in physiognomic studies. A more personal note is struck by the studies of criminals, which have also been related to Degas's interest in the study of expression

(*figs. 5, 6*).[43] Several of the reviewers identified the men as the assassins Abadie, Kirail, and Knobloch.[44] Emile Abadie, with accomplices, committed three murders early in 1879. The third victim was a Mme Joubert, who was murdered in March of that year in her book and newspaper store at 26 rue Fontaine Saint-Georges. Degas at the time lived down the block from her establishment at 19bis Fontaine Saint-Georges.[45] Perhaps he had bought his newspapers from her and was curious to know what the murderers looked like. True to the tradition of physiognomic studies, their faces bear the physical signs of their brutality. As Mantz had commented on "the instinctive ugliness of a face [of the *Petite danseuse*] on which all the vices imprint their detestable promises," so Geffroy wrote in a similar vein of the studies of the murderers.

He has sent the Portraits de criminels: Kirail, Knobloch, Abadie—*their wan and troubling faces, taken in the dull light of the Criminal Court. Only a keen observer could render with such singular physiological sureness these animal foreheads and jaws, kindle these flickering glimmers in these dead eyes, paint this flesh on which are imprinted all the bruises, all the stains of vice.*[46]

Géricault's portraits of criminals and the insane come to mind as precedents for Degas's works.

Degas's influence was so strong that several of his and Gauguin's works in the 1881 exhibition present a matrix among themselves of shared subject matter and formal concerns. Theodore Reff has delineated the somewhat tangled web that connects Degas's *Petite danseuse*, his *Projet de portraits en frise*, and Gauguin's *Dame en promenade* (*fig. 7*) (plus another sculpture by Degas, *The Schoolgirl*, not shown in any of the group exhibitions).[47] Briefly, a combination of the right- and left-hand figures

fig. 7 Paul Gauguin, *Dame en promenade, figurine en bois* (*Woman out for a Walk*, VI–39), CA. 1881. Wood stained red, 9⅞ in. (25 cm). Location unknown. Photo courtesy of William Beadleston, Incorporated

fig. 8 Paul Gauguin, *La chanteuse, médaillon, sculpture* (*The Singer*, VI–38), 1880. Mahogany, 20⅞ in. (53 cm). Location unknown. Photo courtesy of the Johns Hopkins University Press

in *Portraits en frise* informs Gauguin's *Dame en promenade* (as well as Degas's own *Schoolgirl*). In addition, Gauguin's medallion relief, *La chanteuse* (fig.8), takes its subject, a café-concert singer, from Degas's repertoire.

Gauguin's *Dame en promenade* was seen to be every bit as ugly as Degas's little dancer. Gauguin had shown sculptures in previous group exhibitions, but they were conservative marble busts and had not prepared the critics for the two pieces in wood of 1881. Of *Dame en promenade* Trianon exclaimed, "Ah, honestly, she is so ugly and skinny that one could scream."[48] Elie de Mont was rendered almost, but not quite, speechless. "As for the sculpture, what can it mean and prove? I will not speak of the *Dame en promenade* that he has the nerve to show to the public."[49] The sculpture's homeliness may derive in part from Gauguin's inexperience in wood-carving, but it could also be a result of the artist's effort not to idealize, not to prettify, the subject.

Huysmans called the work "gothically modern," and had no more to say about it.[50] Earlier in his review, however, he had had much to say about wooden sculpture. Recalling medieval sculpture, Huysmans extolled the material properties of wood.

There is in these works so realistic, so human, a play of features, a corporeal life that has never again been found in sculpture. Now, see how malleable and supple wood is, how docile and almost unctuous under the will of these masters; see how the fabric of the light and precise dress is tailored entirely in oak, see how it clings to the person wearing it, how it conforms to the figure's posture, how it helps to express its functions and character.

Well, then, transfer to Paris this process, this material; now put it in the hands of an artist who savors the modern like M. Degas, . . .[51]

There was no possibility, Huysmans continued, of any other artist at the time making viable sculpture. He did not give enough credit to Gauguin, who, with *Dame en promenade*, offered a thoroughly modern sculpture in a medium well-suited to his talents. But perhaps his figure's high-necked, armor-like bodice, stiff stance (which reminded Trianon of Egyptian papyrus figures),[52] and pugnacious stare may have represented for Gauguin the unrelenting, aloof, public, urban demeanor, real yet artificial, that he was so soon to flee.[53]

La chanteuse is another, even more specific reference

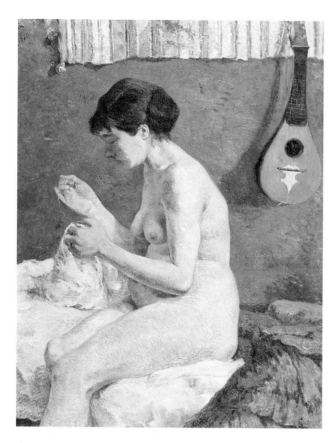

fig. 9 Paul Gauguin, *Etude de nu* (Nude, VI–36), 1880. Oil on canvas, 45¼ x 31½ in. (115 x 80 cm). Ny Carlsberg Glyptotek, Copenhagen

to the modern, urban world. The features of Gauguin's singer are those of Valéry Roumy, a well-known cabaret singer.[54] The medallion is thus a portrait as well as an idiosyncratic representation of urban recreation. For Gauguin, the context of the café-concert, which so interested Manet and Degas, was of no concern.

These two sculptures inaugurate Gaugin's lifelong involvement with wood carving. However, it is unclear what wood he used for *La chanteuse*. Huysmans noted that the singer was painted plaster,[55] while Trianon specified that it was pear wood on a golden base.[56] Since the object known today is mahogany, it is obvious that a certain confusion exists. In any case, the varying contemporary accounts concur that the work was colored in some way. As well, *Dame en promenade* was not presented as simple carved wood, but was tinted a reddish hue. These two works demonstrate Gauguin's experiments with combined media, his seeming impatience with the limitations of working with natural wood, and with one medium at a time.[57]

Gauguin's major contribution to the sixth exhibition was a painting of a woman—an ordinary, slightly overweight, pear-shaped woman—naked, sitting on a rumpled bed, and mending (*fig. 9*). A mandolin and a

striped curtain hang on the wall behind her. The space in which the woman sits is compressed; the bed abuts the wall and we see her from close up, so that one's first and lasting impression is of a large quantity of flaccid flesh. Gauguin made no attempt at idealization, as Renoir did in his nudes done at roughly the same time. Dalligny complained that the nude "is not at all seductive."[58] Havard, after noting that the very fact Gauguin had painted a nude set him apart from the other artists of the group, wrote at greater length.

Not that the young person whose charms he reveals is a very attractive beauty, nor of a tempting freshness: knock-kneed and gamy, with two tired breasts that are trying to join an abdomen whose roundness betrays a well-advanced pregnancy, she is assuredly poorly made to awaken indiscreet desires.[59]

Clearly these male critics were disappointed that Gauguin's nude was not made into a sex object for them. They missed the eroticism offered by the academic nudes at the Salon, nudes whose marginal decency was nominally veiled by titles referring to mythology or Classical themes.

The blatant Realism of this woman sewing bothered the contemporary audience. Rembrandt's equally unvarnished look at the world around him was evoked in this connection,[60] just as Dutch genre painters and the Le Nain were evoked for Raffaëlli. Huysmans went so far as to disclaim the reality and modernity of Courbet's nudes, in comparison to Gauguin's. Not since Rembrandt, the critic went on, has anyone painted a nude so inextricably allied to one's own time, a nude so carefully observed that one can learn about her life from her posture and her skin.[61] This echoes Duranty's plea for capturing the essence of modern life. In his praise, Huysmans appears to have overlooked Degas's nudes that predate by some years Gauguin's woman sewing. They fulfill all his requirements for depictions of modern women and do it better than Gauguin's, as they are studies of habitual and unlearned actions and more "modern" in their presentation.[62]

Gauguin's *Etude de nu* is a curious mixture of seventeenth-century precedent and aspects of the artist's own work. The mandolin on the wall appears in several other pictures as a studio prop and still-life element, most notably in *Sur une chaise*, no. 34 of this same 1881 exhibition (Wildenstein 46). The curtain also figures in the background of other pictures, such as in a portrait of the artist's wife, Mette Gauguin, done several years earlier (Wildenstein 26), in which Mme Gauguin is seated at a table sewing. The two pictures together appear to be different versions of the same picture, akin to Goya's naked and clothed Maja. The artist's wife is dressed and safe behind the table, while the nude is pushed forward to the picture plane so that the viewer has no escape from her nakedness. (One notes with a smile that the condition of

nudity does not extend to the thimble.) The cozy, domestic environment of the representation of Mme Gauguin pushes that painting into the category of genre, in which we see the figure in an information-giving and character-forming milieu. *Etude de nu*, on the other hand, defies categories. Not a portrait, not a genre scene, it is nothing more than a picture of a naked woman sewing.

Gauguin was unhappy with Huysmans's evaluation of his *Etude de nu* and pointed to the critic's understandable literary perspective as the weak portion of his argument. In a letter of 1883 Gauguin wrote that Huysmans's essay

in the first place is a critique and not an artistic discussion with supporting arguments. And with that he is wrong from beginning to end and puts the Impressionists forward without understanding at all how they are modern. He looks at it from the literary viewpoint and sees only Degas, Raffaëlli, Bartholomé and Company [?] because they deal with the figure; basically Naturalism pleases him. He didn't for a minute understand Manet and you whom he says he doesn't understand . . . I am still stunned by the flattery that he throws at me because of the figure and despite the praise I see that he is captivated only by the literary character of my nude and not by its painterly aspect.[63]

Huysmans's insistence on the literary nature of paintings prompts some questions—at least in Gauguin's case—at the expense of their painterly nature, and his estimation of Degas's sculpture that completely eclipses Gauguin's. While it is true that neither of Gauguin's sculptures attains the power and stature of Degas's single work, nonetheless Gauguin's carvings in wood seem to fulfill Huysmans's requirements of the modern more completely than Degas's wax, at least in a literal, material sense. Huysmans was the only critic to mention a ribbon around the neck of Degas's *Petite danseuse*. Was it there or not? In writing of Cassatt's *Le jardin* (cat. no. 103), the critic said that the woman is reading. To many, the

fig. 10 Camille Pissarro, *La récolte des pommes de terre* (*The Potato Harvest*, VI–77), 1880. Gouache on paper, 10⅝ x 19¼ in. (27 x 49 cm). Location unknown. Photo: Pissarro and Venturi 1338

fig. 11 Camille Pissarro, *La ravaudeuse* (*The Mender*, VI–88), 1881. Gouache on paper, 12¼ x 9½ in. (31 x 24 cm). Location unknown. Photo: Pissarro and Venturi 1355

differences between knitting, crocheting, and other forms of needlework are negligible. It is difficult, however, to imagine a woman reading anything so small that her hands would be in the position shown. Was Huysmans writing about what was there or about what he thought was there? If he mistakes details in pictures that have been positively identified, is it wise to rely on his descriptions in other matters? His reviews of the group exhibitions were not published during the run of the shows or even shortly thereafter. They have not been found in contemporary newspapers or periodicals and appeared only in 1883 when published in *L'art moderne*.[64] It is possible, then, that the reviews were not even written at the time, but only later, based on notes, and perhaps not the most complete notes. It is difficult to know how far to trust Huysmans, yet it is tempting to do so, as his powerful and evocative prose, his fine mind, and his acuity of perception continue to dominate the contemporary critical reaction to the 1881 exhibition.

Only with this exhibition did Huysmans come to admire Pissarro; by this time the critic's taste and the painter's development had grown closer. Pissarro's participation in the sixth group show was, as we have seen,

based on his sense of loyalty to the original cause and to the artists who supported the "impressionist" vision. Yet by 1881 he was beginning to rethink his treatment of the French countryside. His activity at the beginning of the 1880s can be seen as a time of questioning and searching, of experimentation with other media. As the figure grew in scale to fill the foreground of his works, the landscape was relegated to a background role. While in the group exhibition of 1882 Pissarro would show large oil paintings of peasants, such as *Jeune paysanne au chapeau* (cat. no.128) and *Jeune paysanne prenant son café* (cat. no.127), in 1881 he confined his entries in this area to lesser-scale gouaches. His introduction of new subject matter in a minor medium that was later codified in oils is analogous to his showing of etchings for the first time in 1880. In some of these prints he experimented boldly both with technique and with a flattening of space so that the pictures read as horizontal bands.

The comment most often made in reference to Pissarro's 1881 contribution was on its great similarity to the work of Jean-François Millet.[65] While the comparison made to Millet is apt, varying degrees of closeness were remarked on by critics. C.E. stated that Pissarro's peasants were not as good as Millet's, that Pissarro painted them as they were, that is, heavy and thick. He objected to Pissarro's Realism, regretting the absence of Millet's generalized idealizations. Silvestre in *La Vie Moderne*, on the other hand, gave Pissarro more credit and claimed that while Pissarro's subjects recalled Millet's, Pissarro was nonetheless an original artist.[66]

Pissarro returned to Millet again and again for inspiration for his gouaches (opaque watercolor) such as *La récolte des pommes de terre* (fig.10, at the time owned by Cassatt), and *La ravaudeuse* (fig11).[67] The latter subject was a favorite one for Millet and would have been accessible to Pissarro in a print (Millet, Delteil 9). *La gardeuse de chèvres* and *Paysanne bêchant*, both still unidentified, may derive from Millet's example as well.[68] Despite C.E., Pissarro's essentially clumsier, unidealized figures seem closer to the "truth" of peasants' lives than Millet's classically inspired, art historically-charged images. In other words, we now find them more real than Millet's.[69]

Pissarro was exploring aspects of modern peasants' lives that Millet had left untouched. In a work such as *La foire de la Saint-Martin à Pontoise* (Pissarro and Venturi 1618) he chronicled the commercial side of agricultural life, the place of interchange between the fields and the consumers. Town markets were to become a theme in Pissarro's work in the 1890s, when his entire iconography assumed an urban character. Prophetic too is his pastel of *Boulevard Rochechouart* (fig.12), a clear prefiguration of his street scenes of the 1890s, as are the etching (Delteil 65) and painting (Pissarro and Venturi 609) of the place de la République in Rouen from 1883. A high perspective, but not as extreme as in Caillebotte's urban views, emphasizes the press of vehicles of the urban setting and contrasts with the open expanse of Pissarro's landscapes.

The location and identification of Pissarro's landscapes in oil of this year remain as elusive to the researcher as do the gouaches, which is regrettable considering the critical acclaim they garnered.

In short, M. Pissarro can now be classed among the remarkable and daring painters we have. If he can preserve this eye—so perceptive, so agile, so fine—we will certainly have in him the most original landscapist of our time.[70]

Huysmans's description of *La sente du Choux en mars* (fig.13) (which in his review he called *Le soleil couchant sur la plaine du chou*) bears repeating for its lyricism.

A landscape in which a snowy sky rushes to infinity, beaten by the tops of the trees, in which a river flows, next to which factories smoke and roads climb through the woods—it is the landscape of a powerful colorist who has finally grasped and resolved the awful difficulties of broad daylight and of open air. It is the new formula that has been sought for so long and now is fully realized; the real countryside has finally emerged from these combinations of chemical colors and there is, in this nature bathed in air, a great calm, a serene plenitude that derives from the sun, an enveloping peace rising from this vigorous place in which the brilliant tones move without a hindrance under a vast firmament to the clouds.[71]

Some critics were not as enthusiastic as Huysmans. Mantz complained of Pissarro's monotonous technique that, in his view, permitted no air, no light, and no breathing room in his pictures. Everything was treated in the same way, with no differentiation made for varying

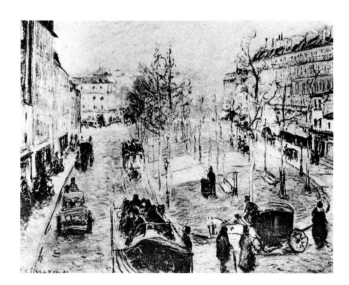

fig. 12 Camille Pissarro, *Boulevard Rochechouart* (VI–90), 1880. Pastel on paper, 23 5/8 x 29 1/2 in. (60 x 75 cm). Location unknown. Photo: Pissarro and Venturi 1545

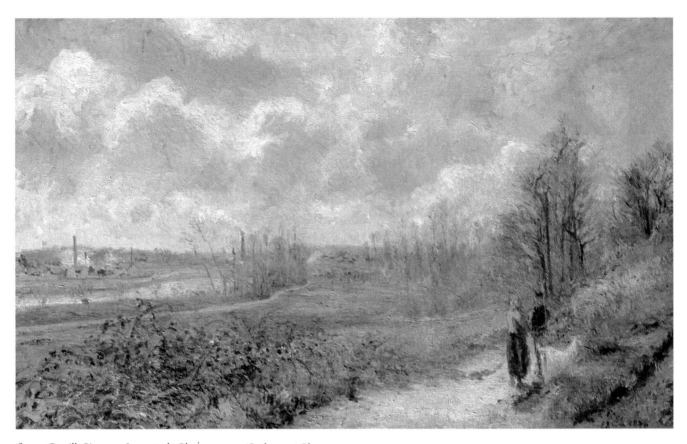

fig. 13 Camille Pissarro, *La sente du Choux en mars* (*Pathway at Chou in March*, VI–63), 1878. Oil on canvas, 19¾ x 36¼ in. (50 x 92 cm). Musée des Beaux-Arts, Douai

locales, times of day, or seasons.[72] Mantz was reacting to Pissarro's solution to the "crisis of Impressionism," part of which included the artist's using tiny, vibrantly colored brushstrokes that formed a dense, even, thick surface, in contrast to the more broadly brushed canvases of the 1870s. The heavily worked surfaces reflected a more intense, more concentrated analysis of the scene than before, and an attempt to render the scene in its component parts, forfeiting visual clarity if necessary. Huysmans understood Pissarro's aims.

And all of this trembles in a powder of sunlight, in a vibration of air, unparalleled in painting until now; . . . From close up [the painting] is like brickwork, a strange, wrinkled [patchwork], a stew of colors of all kinds covering the canvas with lilac, Naples yellow, madder-red, and green; at a distance, it is the air that moves, it is the sky that is boundless, it is nature that palpitates, it is water that evaporates, it is the sun that radiates, it is the ground that rises and smokes![73]

Pissarro's stylistic development was matched by his increasing interest in the problem of framing these new works. He experimented with many different colors of gold for the frames, ranging from yellows and peaches to greens, and painted the edges of the frames in complementary colors.[74] Similarly, other artists used white frames to help their pictures stand out against the dark walls.[75]

Two of the most important and critically well-received artists did not deal with Realist themes of modern urban or suburban life, and their pictures were decidedly not ugly. The two women artists, Berthe Morisot and Mary Cassatt, enjoyed almost universally positive responses to their works of female-dominated, upper-middle-class, domestic life. Elie de Mont, for example, claimed that they were the only interesting artists exhibiting.[76] They often were seen as a pair, two women artists who pursued similar goals. However, when Silvestre claimed that they had taken up the banner [of Impressionism],[77] he overlooked the facts that Morisot had been with the group from the first show in 1874, while Cassatt had joined only in 1879 as one of Degas's recent followers. A similar misconception was expressed by Mantz when he characterized the two women as faithful adherents to Impressionism.[78]

Morisot's contribution, like Pissarro's, has proved difficult to identify and locate. One reviewer claimed that

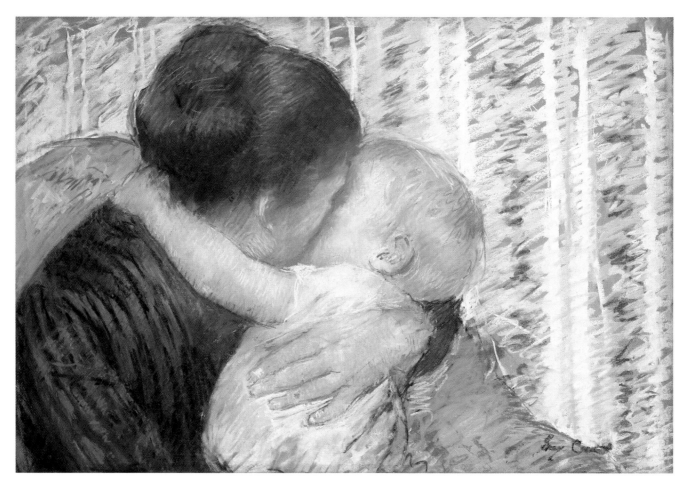

fig. 14 Mary Cassatt, *Mère et enfant (Mother and Baby, VI–8), 1880.
Pastel on paper, 16½ x 24 in. (42 x 61 cm). Photo courtesy Christie's,
New York

her ten entries were hung together in one small room,
although the catalogue lists only seven objects.[79] Again,
generic titles, such as *Esquisse au pastel*, and generalized
reviews offer few clues. Yet C.E. suggests another reason
for the elusiveness of specifics:

*For her the subjects have only a secondary importance,
almost insignificant; they are only a pretext for luminous
effects, for harmonious combinations, accepted or rather
tolerated so that the eye can rest on a perceptible form,
but whose lines and contours are scarcely determined.*[80]

As was the case with Monet, the object of Morisot's
scrutiny simply was the vehicle for the real subject, the
study of light as it defined, or did not define, physical
form (cat. no. 110). The critics more often than not
applauded Morisot's works, despite their "sketchy"
nature; this is testimony to the acceptance that the
impressionistic technique enjoyed by 1881.[81]

Cassatt made a strong showing with eleven entries,
four oils and seven pastels. Her *Le thé* (cat. no. 104) was
judged *pleasing* by the critic for *L'Art*,[82] *pleasing* written

in English to underscore the imported nature both
of the tea-drinking ceremony and of its American
expatriate recorder. Huysmans, with his admittedly liter-
ary bent, saw in Cassatt's pictures evocations of Dick-
ens's paeans to motherhood.[83] Such a picture as *Mère et
enfant* (fig. 14) and its theme would become, in time, syn-
onymous with the artist.

La lecture (fig. 15) is one of these maternal scenes; it
had special resonance for the Cassatt family. It shows
Cassatt's mother reading to her grandchildren, the art-
ist's nieces and nephew.[84] Grandmother Cassatt wrote of
it to one of the children depicted:

*Do you remember the one she painted of you & Rob &
Elsie listening to me reading fairy tales? She finished it
after you left & it is now at the exhibition–A gentleman
wants to buy it but I don't think your Aunt Mary will sell
it–she could hardly sell her mother & nieces & nephew I
think–*[85]

However, Cassatt did sell the painting to Moyse Dreyfus
sometime later, and the family's distress over this action

was not settled for several years. In a letter to her brother Alexander, Cassatt explained the arrangement.

Dreyfus told me finally that I might have the group of Mother & the children for you. I would rather keep it myself but I know he would not be pleased if I made him give it up to anyone but you. He won't take back the money for the picture. . . .[86]

Since this incident, the picture has remained in the Cassatt family.

The 1881 group exhibition, the third in which Cassatt took part, was a successful one for her. Her father described the situation in a letter to Alexander, who was living with his family in Haverford, Pennsylvania, a small town near Philadelphia.

I sent you sometime ago a number of newspaper notices of Mame's [the family's name for Cassatt] exposition and promised to send more—I have a lot of others but there has been so much of it that we all cry "too much pudding;" So I spare you any further infliction, except the article from the Figaro—a paper that has always been bitterly hostile to the Independents & never before deigned to take any notice of Mame—Mame's success is certainly more marked this year than at any time previous. It is noticeable that of the three American papers published in Paris the "Parisian" is the only one that notices the Exposition—Mame keeps the colony [of Americans in Paris] at such a distance that she cannot expect any support from them—The thing that pleases her most in this success is not the newspaper publicity, for that she dispises [sic] as a rule—but the fact that artists of talent & reputation & other persons prominent in art matters ask to be introduced to her & compliment her on her work &&&She has sold all her pictures or can sell them if she chooses—The things she painted last summer in the open air are those that have been most praised—[87]

Clearly Cassatt enjoyed a triumph, if she was truly in a position to dispose of all her entries; in addition, Paul Durand-Ruel began handling her work in 1881.

Robert Cassatt enclosed the article written by Albert Wolff, who was a curmudgeon at best; the following remarks are, by Wolff's standards, complimentary.

. . . Mlle Cassatt is a veritable phenomenon; in more than one of her works she is on the point of becoming a considerable artist, with an extraordinary feeling for nature, penetrating powers of observation, and an ability to subordinate herself to the model which is characteristic of the greatest artists. . . .

If he had ended his comments there, the praise would have been high indeed. However, he went on.

. . . then, after this marvelous intelligence has completed

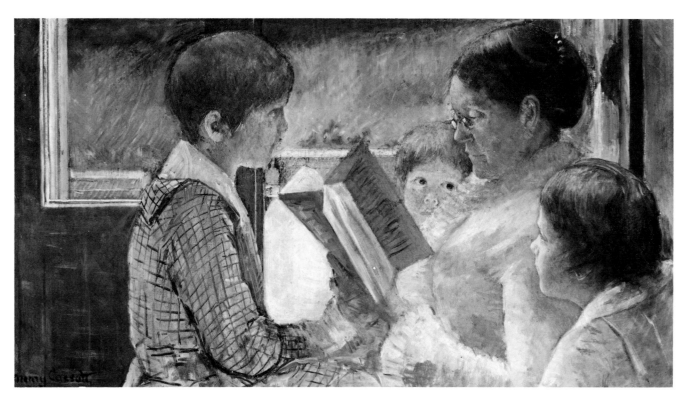

fig. 15 Mary Cassatt, *La lecture* (*Mrs. Cassatt Reading to Her Grandchildren,* VI–1), 1880. Oil on canvas, 22 x 39⅜ in. (55.7 x 100 cm). Private collection

its work and, while it rests, a little spider takes the palette and brushes and leaves its mark on the canvas either in the inferior drawing of the hands, or in touches of color which seem out of place, or even in a corner of the painting which is misshapen and monstrous which makes the viewer shudder and say, "What a shame!"[88]

Cassatt's works were seen to be technical throw-backs to much earlier art by at least two critics and, significantly, by the artist herself. *Le jardin* (cat. no.103) recalled, for Champier, the light-toned portraits by certain "primitives" of the fifteenth century.[89] His referent is specified by Havard, when he called upon Italian fresco painters of the fourteenth and fifteenth centuries as likely precedents for Cassatt's pale tonalities.

For us, these delicate sketches, slightly dulled, with their faded, soft, and harmonious tonalities, recall the fresco or distemper murals of the end of the fourteenth century and the century following.[90]

This archaism, characterized by pale tones and a matte finish, was consciously sought by Cassatt. In the same letter to her brother quoted above, she set forth her intent in painting *La lecture*.

Please tell Lois [Alexander's wife] I think the group will look well in a light room; that is light paper & perhaps over a door; it is painted to look as much like frescoe [sic] as possible so that it would be appropriate over a door as the Italian painters used to do, they are called "dessus de porte" here.[91]

Painting a picture so that it would look like an Italian fresco speaks of aims very different from trying to render sunlight as naturalistically as possible. Cassatt too, then, was seeking a new form of expression, seeking, as Renoir was doing at this time, the assurance of the past.

The fresco-like aspect of Cassatt's *La lecture* testifies to the emerging concern with the decorative and with decorative schemes in general in the 1880s and 1890s. One wonders if Gauguin was attempting a similar effect in the matte surface of his *Etude de nu*. *La lecture* forms a small ensemble within the context of the sixth group show with *Portraits en frise* by Degas and *Panneau pour une salle à manger* by Zandomeneghi.[92] The concept of the decorative in the nineteenth century is an issue not yet sufficiently delineated. By using these pictures as examples of the decorative, however, certain characteristics can be discerned. Large, easily distinguished shapes, a planar organization, shallow space, a generally cool palette, and an even light that abolishes most shadows combine to produce an effect of calm and repose. Indeed, Cassatt's *Mère et enfant* not only uses these devices but adds the abstraction produced by the lost profiles and scribbled lines of pastel. These pictures, like Zandomeneghi's *La place d'Anvers*, in looking back to Monet's panels of 1876 for Hoschedé and ahead to Vuillard's ensembles of the 1890s, form a watershed of important artistic concerns.

Realism, the urban figure, the ugly, the decorative—all were brought together in the sixth group exhibition. It was an uneasy alliance. In 1882 Monet, Renoir, Sisley, and Caillebotte again exhibited with the Independents; Degas, after his strong presence in 1881, stayed away. The sixth exhibition, generally known for the appearance of Degas's sculpture, might better be recognized as the triumph of Degas and Realism among the Impressionists, a Realism argued for by Duranty in 1876, but realized only five years later.

Notes

I owe Charles F. Stuckey an incalculable debt. His unflagging support, encouragement, good will, and generosity were instrumental in the development of this essay.

All translations by author unless otherwise noted.

1. See G.G. in review list for Sixth Exhibition in Appendix for this and all other reviews. Algerian settees are low sofas having one end higher than the other.

2. See Jules Claretie and Henry Havard reviews. Havard complained that there was not enough distance between viewer and picture. The catalogue lists 170 works; others were brought in at the last minute (*hors catalogue*). For an overview of this sixth exhibition, see Oscar Reuterswärd, "La VI⁢e exposition des impressionnistes dite des Artistes Indépendants vue par la presse et l'opinion," *Gazette des Beaux-Arts* 94 (November 1979):183–192.

3. Degas was behind the ruling of 1877 that prohibited artists from showing both at the Salon and with the Independents. John Rewald, *The History of Impressionism*, 4th rev. ed. (New York, 1973), 390.

4. It would be interesting to know what had happened to prompt Caillebotte to list these particular names, as neither Cézanne nor Cordey had shown with the group since 1877.

5. Caillebotte has forgotten that Félix Bracquemond was a member of the original 1874 Société anonyme.

6. Caillebotte to Pissarro, 24 January 1881, trans. in Rewald, 447–449. French in Marie Berhaut, *Caillebotte, sa vie et son oeuvre* (Paris, 1978), 245–246, letter 22.

7. Pissarro to Caillebotte, 27 January 1881, in Janine Bailly-Herzberg, *Correspondance de Camille Pissarro, 1865–1885* (Paris, 1980) 145, letter 86 and Berhaut, *Caillebotte*, 246, letter 23.

8. Pissarro to Caillebotte, Berhaut, 246, letter 23 and Bailly-Herzberg, 146, letter 86.

9. In addition, Cassatt sided with Pissarro. Pissarro to Caillebotte, Berhaut, 246, letter 23. "Je n'ai montré votre lettre qu'à Mlle Cassatt qui est de mon avis. J'en parlerai demain à Gauguin et Guillaumin."

10. Caillebotte to Pissarro, 28 January 1881, trans. in Rewald, 449, French in Berhaut, 246, letter 24.

11. See Gustave Goetschy review.

12. The thirteen (fourteen, including Cals, represented by works shown posthumously, a tribute accorded previously to Ludovic Piette in 1879) were the same who figured in the 1880 show, with the exceptions of Félix and Marie Bracquemond, Caillebotte, Albert Lebourg, Stanislas Lépine, Monet, Jean-Marius Raffaëlli, the younger brother of Jean-François, Renoir, and Sisley.

13. See Henry Trianon review. "Les peintres et les sculpteurs naturalistes, sauf de rares exceptions, se montrent aussi étroitement absolus que leurs frères de lettres." While twentieth-century scholars have attempted a distinction between the terms Realism and Naturalism, the art critics of the 1880s, many of whom were writers themselves, seemed to have used the words interchangeably.

14. This is a crude derivation of the Positivism of Auguste Comte and Hippolyte Taine. For a very brief discussion, see Theodore Zeldin, "Science and Comfort," *France 1848–1945: Taste and Corruption*, 247–260 (Oxford and New York, 1980). For a more subtle and accurate reading, see Shiff in this catalogue.

15. See Gabriel P. Weisberg, *The Realist Tradition: French Painting and Drawing 1830–1900*, exh. cat. (Cleveland: The Cleveland Museum of Art, 1980), for an invaluable overview that brings to light much overlooked and helpful information.

16. Trianon review.

17. Edmond Duranty, in this catalogue.

18. See Auguste Dalligny review.

19. See Armand Silvestre review (16 April 1881):250 and C.E. review (23 April 1881):135.

20. See Albert Wolff review.

21. Barbara Schinman Fields, *Jean-François Raffaëlli (1850–1924): The Naturalist Artist*, Ph.D. diss. (Columbia University, 1979), 42–58. This is the most thorough study of the artist and is the touchstone for any further work.

22. See Joris-Karl Huysmans review, 245–246. Trans. in Joel Isaacson et al., *The Crisis of Impressionism 1878–1882*, exh. cat. (Ann Arbor: The University of Michigan Museum of Art, 1980), 171, cat. no. 45. Bracketed material inserted from the original French and translated by author.

23. Huysmans review, 244.

24. Claretie review, "Cet Ostade de parisianisme" and Cardon review, "C'est un observateur comme les Flamands, avec l'esprit d'un Parisien."

25. Huysmans review, 245.

26. See examples in Peter C. Sutton, *Masters of Seventeenth-Century Dutch Genre Painting*, exh. cat. (Philadelphia: Philadelphia Museum of Art, 1984), 281–291, cat. nos. 89–94.

27. *Les frères Le Nain*, ed. Jacques Thuillier, exh. cat. (Paris: Grand Palais, 1978). See *Peasants before Their House* in The Fine Arts Museums of San Francisco for a particularly beautiful example.

28. C.E. (23 April 1881): 135 and Elie de Mont reviews.

29. See Paul de Charry review.

30. See Gonzague-Privat review.

31. While pictures with these kinds of subjects were shown *hors catalogue*, there is no way to determine definitively that these are the exact works.

32. Caillebotte to Pissarro, 28 January 1881, Berhaut, 246, letter 24.

33. Trianon review.

34. Wolff review.

35. See Charles W. Millard, *The Sculptures of Edgar Degas* (Princeton, 1976), throughout, for fullest discussion of *Petite danseuse* in its various aspects.

36. Claretie review.

37. Trans. in Reff, "To Make Sculpture Modern," in *Degas: The Artist's Mind*, 243 (New York, 1976).

38. Trianon review.

39. Reff, "To Make Sculpture Modern," 239–269. As well, see George T. M. Shackelford, *Degas, the Dancers*, exh. cat. (Washington, D.C.: National Gallery of Art, 1984), 64–83.

40. Huysmans noted a ribbon around the neck as well, but he is the only critic to have done so.

41. Shackelford, 66.

42. Trans. in Shackelford, 66–67; Huysmans review, 226–227. Bracketed words the present author's.

43. Reff, "My Genre Painting," in *Degas: The Artist's Mind*, 217–220.

44. C.E. (16 April 1881): 126, Goetschy, and Geffroy reviews.

45. I want to thank Charles F. Stuckey for giving me the reference to Charles W. Millard's review of Theodore Reff's *The Notebooks of Edgar Degas* in *The Art Bulletin* 60 (September 1978): 565–568, in which this information appears, 567.

46. Geffroy review.

47. Reff, "To Make Sculpture Modern," 255–262.

48. Trianon review.

49. de Mont review.

50. Huysmans review, 242.

51. Huysmans review, 229–230.

52. Trianon review.

53. See the sketch of Gauguin carving this figure, drawn by Pissarro and now in The National Gallery, Stockholm, illus. in Christopher Gray, *Sculpture and Ceramics of Paul Gauguin* (Baltimore, 1963), 2.

54. Again, it is Charles Stuckey who provided the reference that identifies the figure. See Merete Bodelsen, "Gauguin Studies," *The Burlington Magazine* 109 (April 1967): 225. A Forain pastel of Roumy, formerly in Gauguin's collection, is in the print room of the Statens Museum for Kunst, Copenhagen. It is inscribed on the verso, "Valéry Roumy (Montmartoise) ca. 1880 donné par F. au peintre Paul Gauguin."

55. Huysmans review, 242.

56. Trianon review.

57. This practice corresponds to Degas's *Petite danseuse* as well as to academic polychromed sculpture and looks forward to the rest of Gauguin's sculpted oeuvre, in which painting and sculpture formed an inextricable unit. See, for example, Gérôme's *The Hoop Dancer* and *The Ball Player* in Peter Fusco and H. W. Janson, *The Romantics to Rodin*,

exh. cat. (Los Angeles: Los Angeles County Museum of Art, 1980), nos. 153 and 156.

58. Dalligny review.

59. Havard review.

60. Trianon review.

61. Huysmans review, 238–239.

62. Rewald, 452.

63. Gauguin letter, 1883, Archives Charavay. "C'est premièrement une critique et non une discussion artistique avec des arguments à l'appui. Et avec cela il se trompe d'un bout à l'autre et met en avant les impressionnistes sans comprendre du tout en quoi ils sont modernes. Il le prend du côté de la littérature, aussi il ne voit que Degas, Raffaëli [sic], Bartholomé et Cie parce que ceux-ci font la figure; au fond c'est le naturalisme que le flatte. Il n'a pas compris une seule minute Manet et vous qu'il cite il ne vous comprend pas . . . je suis encore tout bleu du coup d'encensoir qu'il me jette à travers la figure et malgré le côté flatteur je vois qu'il n'est séduit que par la littérature de ma femme nue et non par le côté peintre."

See Pissarro-Huysmans correspondence for discussion of literary-artistic criticism. Bibliothèque de l'Arsenal 15097/13 for Huysmans's letter to Pissarro, partially reprinted in Bailly-Herzberg, note. 1, 207–208; for Pissarro's letters to Huysmans, Bailly-Herzberg, 205, 207–208, and 210–211, letters 146, 149, and 152.

64. Indeed, researchers before the present team have been unable to locate Huysmans's reviews before L'art moderne of 1883. See Cahiers J.-K. Huysmans 20 (May 1947).

65. Six reviewers noted a resemblance: Claretie; Silvestre, La Vie Moderne; Dalligny; Goetschy; Champier; and C.E.

66. C.E. (16 April 1881): 127; Silvestre (16 April 1881): 251.

67. This is Pissarro and Venturi 1355; the picture could as easily be Pissarro and Venturi 1356.

68. Other borrowings include Paysan émondant (Pissarro and Venturi 1340?), which bears witness to Corot's many scenes of peasants gathering windfall for firewood and La foire de la Saint-Martin à Pontoise (Pissarro and Venturi 1618), which reexamines in gouache, in a fan shape, a theme explored a year earlier in a print (Pissarro, Delteil 21) one that was exploited many times by Pissarro's friend and earlier exhibitor with the group, Ludovic Piette.

69. Pissarro wrote to Duret on 12 March 1882: "ils me jettent Millet à la tête, mais Millet était biblique! pour un hébreu il me semble l'être peu, c'est curieux!" Bailly-Herzberg, 158, letter 100. See Christopher Lloyd et al., Pissarro, exh. cat. (London: Hayward Gallery, 1981), nos. 153–154 for comment on this matter.

70. Huysmans review, 236.

71. Pissarro, no. 48, straightened out the confusion between this painting and Soleil couchant (La plaine du choux). Huysmans review, 234.

72. Mantz review.

73. Huysmans review, 235.

74. Huysmans review, 251.

75. Claretie review. Also, see letters from Eugène Manet to Berthe Morisot on the subject of white frames for works the following year. The Correspondence of Berthe Morisot, ed. Denis Rouart (New York, 1959), 106–107.

76. de Mont review.

77. Silvestre, (16 April 1881): 251.

78. Mantz review.

79. Geffroy review.

80. C.E. (23 April 1881): 134.

81. See Zola's four articles on "Naturalism" at the Salon of 1880. He preferred the term naturalism to impressionism. See Le Voltaire, 18–22 June 1880.

82. See L'Art review, 42.

83. Huysmans review, 232–233. "C'est la vie de famille peinte avec distinction, avec amour; l'on songe involontairement à ces discrets intérieurs de Dickens, à ces Esther Summerson [Bleak House], à ces Florence Dombey [Dombey & Son], à ces Agnès Copperfield [David Copperfield], à ces petites Dorrit [Little Dorrit], à ces Ruth Pinch [Great Expectations], qui bercent si volontiers des enfants sur leurs genoux. . . ."

84. See Suzanne G. Lindsay, Mary Cassatt and Philadelphia, exh. cat. (Philadelphia: Philadelphia Museum of Art, 1985), no. 7, for a stimulating discussion of this picture.

85. Katherine Cassatt to Katherine Cassatt, 15 April 1881, in Nancy Mowll Mathews, Cassatt and Her Circle: Selected Letters (New York, 1984), 159.

86. Mary Cassatt to Alexander Cassatt, 22 June [1883], Mathews, 169–170.

87. Robert Cassatt to Alexander Cassatt, 18 April 1881, Mathews, 160–161.

88. Trans. in Mathews, 161–162, note 1.

89. Champier review, 168.

90. Havard review. As well, C.E. (23 April 1881): 134. "Quoique peinte à l'huile, la toile a l'aspect clair et mat de la fresque; on voudrait voir un talent si sérieux s'exercer, dans cette manière, à la décoration de quelque salle d'école ou de quelque mairie."

91. Mary Cassatt to Alexander Cassatt, 22 June [1883], Mathews, 170.

92. Ronald Pickvance, Degas 1879, exh. cat. (Edinburgh: National Gallery of Scotland, 1979), no. 67. Degas's Portraits en frise is inscribed "Portraits en frise pour décoration dans un appartement." As Pickvance makes clear, however, this inscription is not helpful, as no decorative schemes by Degas are known. And sadly, the dining room panel is today unidentified.

CATALOGUE

DE LA

6^{ME} EXPOSITION

DE PEINTURE

PAR

M^{lle} Mary Cassatt — MM. Degas — Forain
MM. Gauguin — Guillaumin
M^{me} Berthe Morisot
MM. Pissarro — Raffaelli — Rouart
Tillot—Eug. Vidal—Vignon—Zandomeneghi

Y.d.: 809 tome 6
6146 8°
Du 2 Avril au 1^{er} Mai 1881

DE 10 HEURES A 6 HEURES

35, BOULEVARD DES CAPUCINES, 35
PARIS

DÉSIGNATION

CASSATT (M^{lle} Mary)

1 — La Lecture. Peinture.
2 — Le Jardin. id.
3 — L'Automne. id.
4 — Le Thé. id.
5 — Tête de jeune fille. Pastel.
6 — Tête de jeune fille. id.
7 — Tête d'enfant. id.
8 — Mère et Enfant. id.
9 — Portrait d'enfant. id.
10 — Portrait d'une jeune Violoniste. Pastel.
11 — Tête d'enfant. id.

References for identifications and present locations

1. Breeskin 77, private collection, New York
2. Breeskin 98, Metropolitan Museum of Art
3. Breeskin 96, Musée du Petit Palais, Paris
4. Breeskin 65, Metropolitan Museum of Art
5–7, 9. Perhaps Breeskin 86; 106, Art Institute of Chicago; or 132, per Mathews
8. Breeskin 88, Christie's New York, 1 June 1984, no. 165

h.c. a) *Vue de coulisses*, perhaps Lemoisne 1024, National Gallery of Art, Washington or 500, Corcoran Gallery of Art, Washington, D.C.
b) *Projet de portraits en frise*, Lemoisne 532, private collection
c) *Chanteuses en scène*, perhaps Lemoisne 405, Musée de Lyon; 404, Corcoran Gallery of Art, Washington, D.C.; or 372
d) *Femme nue*, perhaps Janis 180, Museum of Fine Arts, Boston or 87, Stanford University Art Museum

12. Mr. and Mrs. Paul Mellon, Upperville, Virginia

17–18. Lemoisne 638 and 639

20. Perhaps Musée Carnavalet, Paris or National Gallery of Art, Washington, per Faxon

21. Perhaps Browse 9, private collection, Paris

22. Private collection, Paris

23. Perhaps Browse 1, private collection, London, per Browse

30. Perhaps Wildenstein 30, Museum voor Stad en Lande, Groningen

31. Perhaps Wildenstein 44, private collection, New York

32. Wildenstein 45

33. Wildenstein 48, private collection, Paris, per Wildenstein

34. Wildenstein 46, private collection, New York, per Wildenstein

35. Wildenstein 49, private collection, Winterthur

36. Wildenstein 39, Ny Carlsberg Glyptotek, Copenhagen

37. Wildenstein 43

38. Gray 3

39. Gray 4

43. Serret and Fabiani 54

44. Perhaps Serret and Fabiani 53

45. Private collection, Paris

56. Bataille and Wildenstein 104

57. Perhaps Bataille and Wildenstein 94, private collection, New York or 95

58. Previously thought to be Bataille and Wildenstein 31

59. Bataille and Wildenstein 453, Sotheby's London, 2 April 1974, no. 13

63. Pissarro and Venturi 452, Musée de la Chartreuse, Douai

— 4 —

E. DEGAS
19 bis, rue Fontaine.

12 — Petite Danseuse de quatorze ans (statuette en cire).
13 — Portrait.
14 — Portrait.
15 — Portrait.
16 — Portrait.
17 — Physionomie de criminel.
18 — Physionomie de criminel.
19 — Blanchisseuse.

FORAIN (Jean-Louis)
233, rue du Faubourg-Saint-Honoré.

20 — Au théâtre. Peinture.
21 — Coin de Bal masqué à l'Opéra. Peinture.
22 — Loge d'actrice. Aquarelle.
 Appartient à M. E. Blum.
23 — Couloir de théâtre. Aquarelle.
 Appartient à M. A. Meyer.

— 5 —

24 — Marine. Aquarelle.
25 — Portrait de Mlle Madeleine C... Pastel.
26 — Dessin.
27 — Dessin.
28 — Dessin.
29 — Dessin.

GAUGUIN (Paul)
8, rue Carcel (Vaugirard).

30 — Une nuit à Vaugirard.
31 — Le terrain de ma propriétaire.
32 — La tombée des feuilles.
33 — Fleurs et Tapis.
 Appartient à M. de Bellio.
34 — Sur une chaise.
 Appartient à M. Degas.
35 — Pour faire un bouquet.
36 — Etude de nu.
37 — Le petit Mousse.
38 — La Chanteuse. Médaillon. (Sculpture).
39 — Dame en promenade. (Figurine en bois).

— 6 —

GUILLAUMIN (Armand)
73, rue de Buffon.

40 — Paysage à Châtillon.
41 — Jardin. id.
42 — Quai des Célestins.
43 — Quai Sully.
 Appartient à M. Gauguin.
44 — Quai d'Austerlitz.
45 — Quai de la Râpée.
46 — Quai Henri IV.
47 — Route de Vanves-à-Clamart.
48 — Portrait de Mlle B. en costume de page.
49 — Paysage.
50 — Quai Saint-Bernard. Aquarelle.
51 — Portrait de M. J. A. Pastel.
52 — Portrait de M. Martinez. id.
53 — Portrait de M. C. G. id.
54 — Portrait de Mlle M. L. id.
55 — Etude de bateaux. id.

— 7 —

MORISOT (Mme Berthe)

56 — Etude de plein air.
57 — Nourrice et Bébé.
58 — Jeune femme en rose.
59 — Portrait d'enfant.
60 — Esquisse au pastel.
61 — Id. id.
62 — Paysage.

PISSARRO (Camille)
18, rue des Trois-Frères.

63. — La Sente du choux en mars.
 Appartient à M. J. P.
64. — Le Clos du choux, le matin.
 Appartient à M. J. P.
65. — La Côte des Grouettes (Automne).
 Appartient à M. P.
66. — Une Cour à l'Hermitage (étude).
 Appartient à M. P

67. — Paysage d'été avec figures.
Appartient à M. P.

68. — Chaumières au Val Hermé.

69. — Chaumières au id.

70. — La Maison du passeur au choux.

71. — Soleil couchant (la Plaine du choux)

72. — Paysage pris sur le vieux chemin d'Ennery (près Pontoise).

73. — Temps gris. Automne au Val Hermé.

Gouaches

74. — La Moisson.
Appartient à M. Clapisson.

75. — Village de la Mayenne.
Appartient à Mlle Cassatt.

76. — La Récolte des pommes de terre.
Appartient à M. Dreyfus.

77. — La Récolte des pommes de terre.
Appartient à Mlle Cassatt.

78. — Fendeur de bois.
Appartient à M. May.

79. — Paysanne bêchant.
Appartient à M. Bérard.

80. — La Gardeuse de chèvres.
Appartient à M. Ch. Ephrussi.

81. — Une Rue à Lower Norwood (environs de Londres).
Appartient à M. Rouart.

82. — Paysage.
Appartient à M. Gauguin.

83. — Enfants dessinant.

84. — Paysan émondant.

85. — Le Retour à la ferme.

86. — La Foire de la Saint-Martin à Pontoise.

87. — Paysannes du Val Hermé causant dans la rue.

88. — La Ravaudeuse.

89. — Paysage (pastel).

90. — Boulevard Rochechouart (pastel).

RAFFAËLLI (Jean-François)

19, rue de la Bibliothèque, Asnières (Seine)

✗ 91. — Les Déclassés.
Appartient à M. Ernest Blum.

92. — Cantonnier, Paris 4 k. 1.
Appartient à M. Ernest Blum.

68–69. Perhaps Pissarro and Venturi 506, private collection or 511

77. Pissarro and Venturi 1338

78. Pissarro and Venturi 1336

79. Perhaps Pissarro and Venturi 1349

82. Pissarro and Venturi 1331, Ny Carlsberg Glyptotek, Copenhagen

83. Pissarro and Venturi 1334

84. Pissarro and Venturi 1340

85. Pissarro and Venturi 1350

86. Pissarro and Venturi 1618

87. Pissarro and Venturi 1344

88. Pissarro and Venturi 1355 or 1356

90. Pissarro and Venturi 1545

91. Private collection, Philadelphia

93. — Homme regardant dans une tranchée.
Appartient à M. Ernest Blum.

94. — Deux chiens se rencontrant sur la route.
Appartient à M. Raoul Toché.

95. — Terrains vagues.
Appartient à M. Albert Wolff.

96. — Marchand d'ails et d'échalotes.
Appartient à M. Albert Wolff.

97. — Sur la Place des Écoles, à Asnières.
Appartient à M. le Dr Heurteloup.

98. — Cheval.

99. — Portrait de ma Petite-fille.

100. — Cassant une croûte.

101. — Grue à vapeur.

102. — Barrière de Clichy.

103. — Dans l'Orage, pastel.

104. — Deux Vaches et trois Poules.
Appartient à M. Charles Hayem.

105. — Le Quai de Clichy, les ponts.

106. — Vue sur la Cour d'un charron, aquarelle.

107. — Portrait de l'Auteur.

108. — Dans la Neige.
Appartient à M. Oppenheim.

109. — Affûteur de scies.

110. — Affûteur de scies, travaillant.

111. — Chiffonnier au bord des Carrières.
Appartient à M. Ayarra de Garay.

112. — La Neige, au bord de l'eau, aquarelle.

113. — Bourgeois lisant « les faits divers. »

114. — Chemin de fer sous la neige.

115. — Locomotive en manœuvre.
Appartient à M. Jules Claretie.

116. — Homme portant un sac, aquarelle.

117. — La Neige, à Clichy.
Appartient à mademoiselle Gabrielle Gauthier.

118. — Déclassé.
Appartient à M. Célérier.

119. — Route d'Argenteuil, aquarelle.
Appartient à M. Drake del Castillo.

120. — Dessin à la plume.

121. — Le Tas de verres cassés, aquarelle.

122. — Bonhomme venant de peindre sa barrière.

96. Museum of Fine Arts, Boston

122. Illustrated in *La Vie Moderne* (16 April 1881): 251

123. — Chiffonnier tenant un panier.
Appartient à M. H. de Lamonta.

✗ 124. — Un Commissionnaire de Paris.
Fait partie de la collection particulière de M. Georges Petit.

ROUART (Henri)
34, rue de Lisbonne.

125. — Cimetière de Chouans en Bretagne.
126. — Vue d'Antibes.
127. — Entrée du port de Portrieux.
128. — Environs de Pau.
129. — Chaumières bretonnes.
130. — Près d'Antibes.
131. — Port d'Antibes.
132. — Escalier du Château des Grimaldi à Cagnes.
133. — Paysage breton.
134. — Portrieux.
135. — Saint-Jean-de-Luz.
136. — Bateau à sables (Antibes).

137. — Village breton.
138. — Chemin en Bretagne.
139. — Tour Constance à Aigues-Mortes

TILLOT (Charles)
42, rue Fontaine-Saint-Georges.

140. — Fleurs de printemps.
141. — Giroflées.
142. — Giroflées.
143. — Portrait d'enfant.
144. — Tête de jeune fille.
145. — Jeune Italienne.
146. — Plage de Villers.
147. — Rade de Saint-Malo, étude.
148. — id. id.
149. — Etudes et esquisses d'après nature.

VIDAL (Eugène)
26, boulevard de Clichy.

150 — Au café.

VIGNON (Victor)
29, rue Saint-Georges.

151 — Paysage.
152 — Paysage.
153 — Chemin des Bourbiers, neige fondue.
154 — Chemin à la Celle Saint-Cloud.
155 — La Seine à Port-Marly.
156 — Saulaie à Bougival.
157 — Arbres fruitiers à la Ferté-Milon (Aisne).
158 — Chemin de Bouzanleu (Aisne).
159 — Montbuisson (Seine-et-Oise).
160 — Noroy-sur-Ourcq.
161 — Chemin creux à Saint-Waast.

162 — Arbres fruitiers à la Jonchère.
163 — Chemin vert à Bougival.
164 — Troesnes.
165 — La Jonchère.
Appartient à M. Mitrecey.

ZANDOMENEGHI (Federico)
4, place d'Anvers.

166 — La Place d'Anvers.
167 — Etude.
168 — Portrait, dessin.
169 — Panneau pour une salle à manger.
Appartient à M. G.
170 — Portrait de M. L.

1—1436 Paris, Typ. Morris père et fils, rue Amelot. 64.

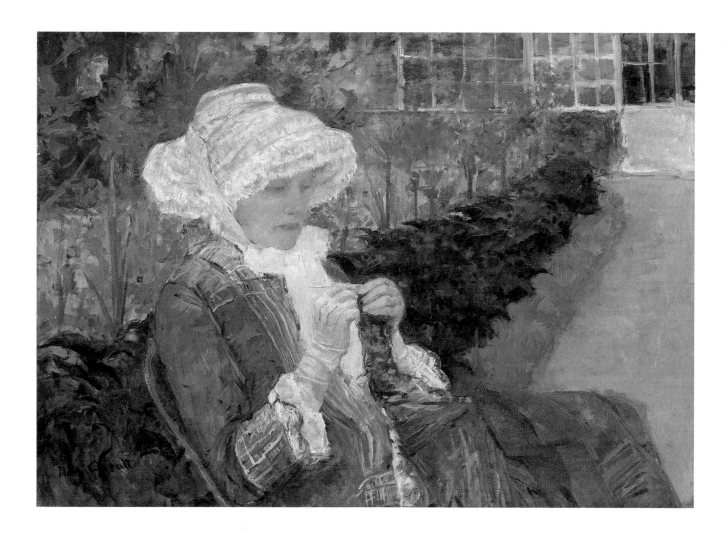

103. Mary Cassatt

VI—2

Le jardin, 1880
The Garden

Now known as *Lydia Crocheting in the Garden at Marly*
Signed lower left: *Mary Cassatt*
Oil on canvas, 26 x 37 in. (66 x 94 cm)
Lent by The Metropolitan Museum of Art. Gift of Mrs.
Gardner Cassatt, 1965. 65.184
REFERENCES: Breeskin 1970, no. 98; Spassky et al. 1985,
635–638; Lindsay 1985, no. 6.

How can one not be interested, for example, by the studies and works of Cassatt, whose pictures have such grace, finesse, delicacy and, dare I use the word, distinct femininity. The eleven paintings she shows at the Independents are all of great interest. Among them

I especially like her woman seated outdoors with knitting in her hands. Shaded by a large white bonnet, her face has a lovely tonality that is simple and peaceful.
Gustave Goetschy, *Le Voltaire*, 5 April 1881

Like her brothers in independence, Manet and Degas, Cassatt works relentlessly to bring her eyes to a state of sensitivity, nervous excitement, even irritation, so she can seize the smallest flicker of light, the smallest atom of color, and the slightest tint of shadow. Her retina has been refined and sharpened to perceive the nuances of a single color in its fleeting gradations to the point that the different ranges are increased by an infinite number of tones, half-tones, and quartertones. The lightest spot affects the eye and conveys with immense delicacy, not the contour, but the tiny luminous movement that makes color. Everything becomes value, external appearance, and

mass. This system, which requires a whole special structure and training of the visual faculties, is applied to *La jeune femme au jardin*. She knits, wearing a hat with a pink tulle border whose brim casts a soft shadow on a face modeled in half-tones of extreme delicacy. The same figure shows us to what degree the artist has mastered the relation and opposition of tones, their logical deductions, and the penetration of one color by another. Beyond the blue dress is a garden path seen in perspective, bordered by red-brown leaves at the foot of green shrubs. These contrasts resolve themselves in clever harmony.
C. E. [Charles Ephrussi?],
La Chronique des Arts et de la Curiosité, 23 April 1881

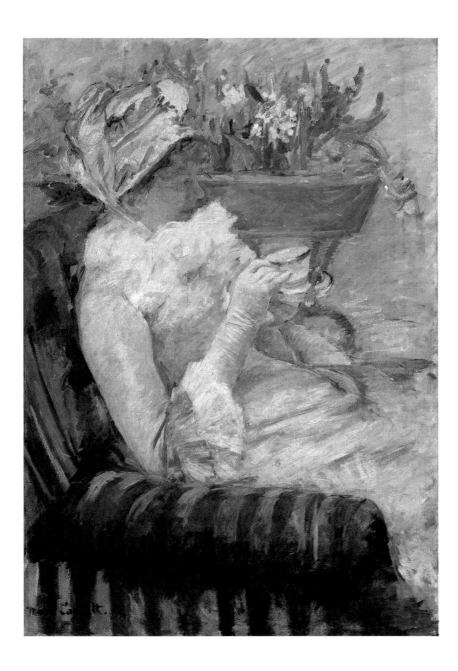

104. Mary Cassatt

VI—4

Le thé, 1879
The Cup of Tea

Signed lower left: *Mary Cassatt.*
Oil on canvas, 36⅜ x 25¾ in. (92.4 x 65.4 cm)
Lent by The Metropolitan Museum of Art. Gift of Dr. Ernest
Stillman, 1922. 22.16.17
REFERENCES: Breeskin 1970, no. 65; Spassky et al. 1985,
632–635.

We prefer above all the woman in the pink dress and bonnet who holds a cup of tea in her gloved hands. She is exquisitely Parisian. The nuances in the pink, the airy lace, and all the lights and reflections that play upon her clothing, hair, and softly pale skin make this *Thé* a delicious work.
Gustave Geffroy, *La Justice,*
19 April 1881

We are not going to try to describe the confusion of women and young ladies in pink, fanning themselves in their chairs and seated on unrealistic sofas that are badly drawn and badly painted. Without color or modeling, they are inconsistent both in tone and form.
Bertall [Charles-Albert d'Arnoux], *Paris-Journal,*
21 April 1881

Mary Cassatt, an English or American woman as her name indicates, also pays tribute to the sketch. Sometimes, however, she achieves an effect, almost a painting. . . .
Le thé is done with a happier brush. Here again is a young woman. She sits on a love seat whose pale blue fabric harmonizes well with her pink satin dress. A planter full of flowers adds its brilliant note to the charm of the overall tonality.
Henry Trianon,
Le Constitutionnel,
24 April 1881

[In] *Le thé,* a smiling woman dressed in pink sits in a chair and holds a little teacup in her gloved hands. [Both *Le thé* and *Le jardin* (cat. no. 103)] add the fine odor of Parisian elegance to the overall tender and peaceful air.
Joris-Karl Huysmans,
L'art moderne, 1883

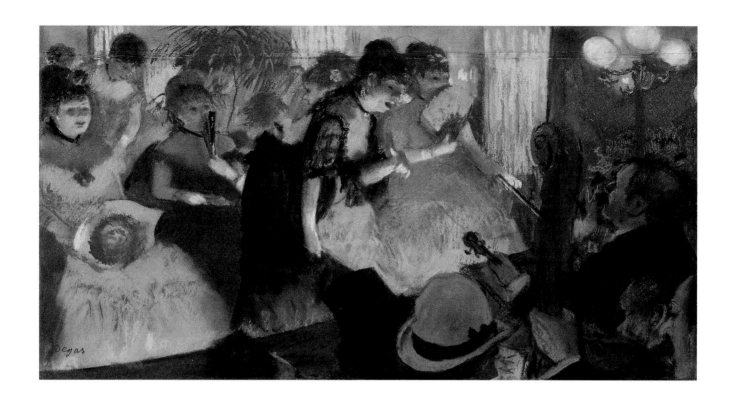

105. Edgar Degas

VI–HC
also III–43

Cabaret, ca. 1877

Titled in the third exhibition: *Café-concert*
Signed lower left: *Degas*
Pastel over monotype on paper, 9 ½ x 17 ½ in. (24.1 x 44.5 cm)
Corcoran Gallery of Art, Washington, D.C. William A. Clark
Bequest, 1926. 26.72
REFERENCES: Lemoisne 1946, no. 404; Janis 1968, no. 26;
Werner 1968, no. 19.
Washington only

Can someone be blind enough to show something that belongs at the bottom of a box? All those little caricatures of café-concert singers . . . not listed in the catalogue, deserve at most the honors of a sketch-pad. The pretension makes them look ridiculous.
Elie de Mont, *La Civilisation*,
21 April 1881

[There also were] some drawings and sketches representing singers onstage holding out paws in the gestures of those dreadful Dresden knick-knacks, blessing the heads of the musicians below, over which the neck of a cello, like a huge "5," emerges in the foreground. Or maybe [they are] swaying their hips and bellowing in the kind of inept convulsions that won quasi-celebrity for that epileptic doll, Bécat.
Joris-Karl Huysmans,
L'art moderne, 1883

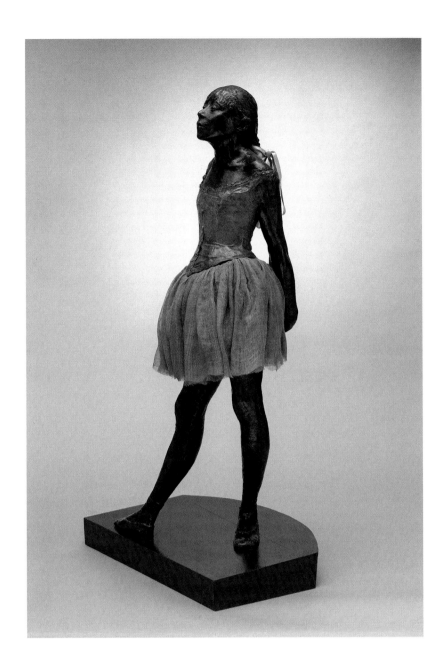

Degas, the painter of dancers, is
this time their sculptor; he gives
us one in wax. A thirteen- or four-
teen-year-old girl is of extraordi-
nary construction and reality.
The model is perfect, and Degas
could redo it in plaster or in
stone. It will be a true
masterpiece.
Paul de Charry, *Le Pays*,
22 April 1881

*For additional quotations
see following page.*

106. Edgar Degas

VI—12

Petite danseuse de quatorze ans, ca. 1881
The Little Fourteen-year-old Dancer

Incised replica of signature: *Degas*; stamped upper left leg: *A A
Hébrard cire perdue/HEB/j*
Bronze cast, with muslin, linen, and satin; height, 37½ in.
(95.25 cm)
Shelburne Museum, Shelburne, Vermont, 26–16
REFERENCES: Rewald 1956, no. 20; Millard 1976, 119–134,
pl. facing 62, pl. 26, 28; Pickvance 1979, no. 78; Isaacson
1980, no. 17; Guillaud et al. 1984, 46; McMullen 1984, 327,
329, 332–336, 338–340, 343–344, 347; Shackelford 1984,
no. 18.

NOTE: The wax original that was exhibited in the sixth
exhibition is now in the collection of Mr. and Mrs. Paul
Mellon, Upperville, Virginia (see Wissman, *fig.4*). The model
was a Belgian girl, Marie Van Goethen (b. 1864), who was then
a ballet pupil at the Opéra. See McMullen, above.

I admit that certain movements are accurate, the movements of the legs, even of the arms, the overall movement, so to speak. So what? This is not enough to make something true and alive. The proof that your fourteen-year-old girl is not real is that there is nothing young about her. Her thinness is hard; this is the thinness and stiffness of age, not of childhood. Were you really able to meet so horrible, so repulsive a model? And assuming that you met her, why did you choose her? I do not always ask that art be graceful, but I do not believe that its role is to represent only ugliness. Your opera rat takes after a monkey, an Aztec, a puny specimen — if she were smaller, one would be tempted to enclose her in a glass jar of alcohol.

Elie de Mont, *La Civilisation*, 21 April 1881

Degas, who has infinite wit and infinite talent as well — a real and a true talent — showed . . . a dancer in wax of a strangely attractive, disturbing, and unique Naturalism, which recalls with a very Parisian and polished note the Realism of Spanish polychromed sculpture. The vicious muzzle of this young, scarcely adolescent girl, this little flower of the gutter, is unforgettable.

Jules Claretie,
La Vie à Paris, 1881

The child is ugly, but exquisite delicacies of her chin, her eyelids, and her ankles hold promise for the future.

I experienced before this statuette one of the most violent artistic impressions of my life — something I have been dreaming of for a very long time.

When I saw in village churches these virgins, these saints of polychromed woods, covered with ornaments, fabrics, and jewelry, I told myself — why does a great artist not have the idea to apply these techniques, so naive and so charming, to a modern and powerful work, and it is a true joy to find my idea realized here.

Around me, people said: it is a doll. How difficult it is to accustom the public to look without anger at a thing that has not seen the light of day before.

But the artist should reassure himself: the work not understood today will perhaps one day be regarded respectfully in a museum as the first work of a new art.

Nina de Villars, *Le Courrier du Soir*, 23 April 1881

If he wants to show us a statuette of a dancer, he chooses her from among the most odiously ugly; he makes it the standard of horror and bestiality. And, yes, certainly among the dregs of the dance schools are poor girls who look like this young monster. However, she is sturdy and carefully studied, but what is the use of these things in the art of sculpture? Put them in a museum of zoology, anthropology, or physiology, fine; but, in a museum of art, forget it!

Henry Trianon,
Le Constitutionnel,
24 April 1881

The only true sculptor of the Intransigent academy is Degas. With a few pastels that will not increase his renown, he shows the *Petite danseuse de quatorze ans*, the wax statuette which has been promised for so long. Last year Degas limited himself to showing us the glass case destined to serve as the shelter for this figurine; but sculpture does not create itself. Degas wished to perfect his work, and we all know that in order to model a form and make it alive, even Michelangelo himself asked some respite.

The piece is finished and let us acknowledge right away that the result is nearly terrifying. . . . The unhappy child is standing, wearing a cheap gauze dress, a blue ribbon at the waist, her feet in supple shoes which make the first exercises of elementary choreography easier. She is working. Back arched and already a little tired, she stretches her arms behind her. Formidable because she is thoughtless, with bestial effrontery she moves her face forward, or rather her little muzzle — and this word is completely correct because this poor little girl is the beginning of a rat. Why is she so ugly? Why is her forehead, half-covered by her hair, marked already, like her lips, with a profoundly vicious character? Degas is no doubt a moralist: he perhaps knows things about the dancers of the future that we do not. He gathered from the espaliers of the theater a precociously depraved flower, and he shows her to us withered before her time. The intellectual result has been reached. The bourgeois admitted to contemplate this wax creature remain stupefied for a moment and one hears fathers cry: God forbid my daughter should become a dancer.

Paul Mantz, *Le Temps*,
23 April 1881

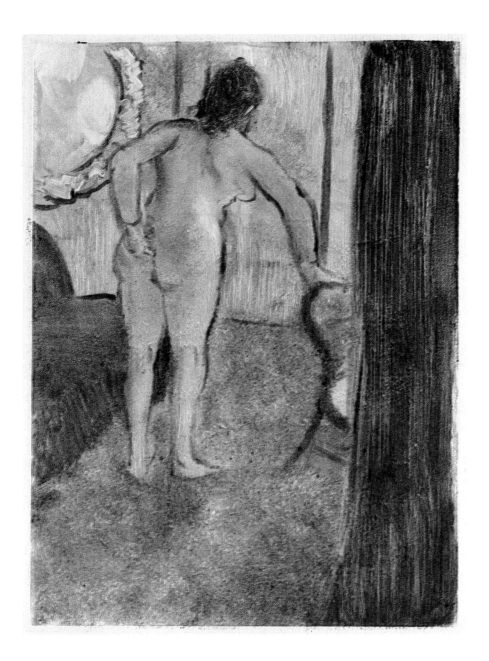

107. Edgar Degas

VI–HC

Dans le salon d'une maison close, ca. 1879
Room in a Brothel
Monotype in black ink on laid paper; plate, 8¼ x 6¼ in.
(21 x 15.9 cm)
Stanford University Museum of Art. The Mortimer C.
Leventritt Fund and The Committee for Art at Stanford. 73.23
REFERENCES: Janis 1968, no. 87; Adhémar and Cachin 1973,
no. 116.

The exhibitors are naturally
divided into two groups: those
who actually merit the name
Independents because they bring
a new note, an original accent, to
their art, and those who only
timidly separate themselves from
established traditions. At the
head of the first group is
Degas. . . .
C.E. [Charles Ephrussi?],
*La Chronique des Arts et de la
Curiosité*, 16 April 1881

Also add two sketches . . . and a
very striking female nude, [seen]
at the back of a room, and you
will have the list of drawn or
painted works brought by this
artist.
In the most casual sketch, as in his
finished pieces, the personality of
Degas wells up; this brief and vig-
orous drawing is thrilling like
that of the Japanese; the flight of
movement, the grasp of a pose,
belong only to him. . . .
Joris-Karl Huysmans,
L'art moderne, 1883

NOTE: This monotype, one of several Degas made of this
subject, may be the one described in Huysmans's review. The
second possibility is Janis, no. 42, now in the Museum of Fine
Arts, Boston.

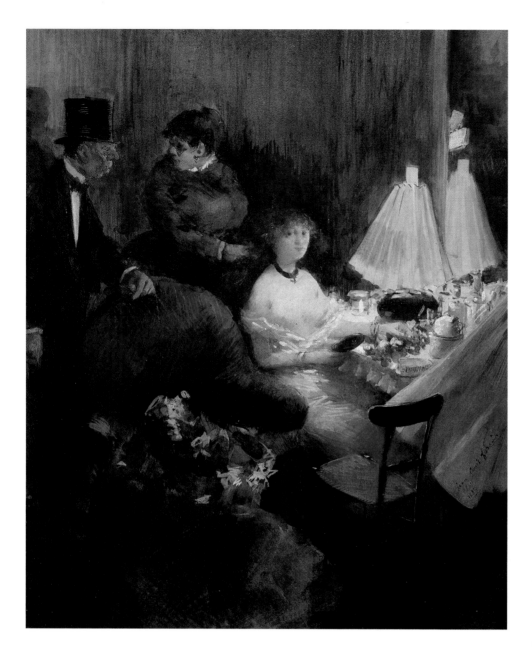

. . . and then Forain, who has closely studied Degas's style and is able to give actors in little pieces a pointed wit that is utterly Parisian.

C. E. [Charles Ephrussi?], *La Chronique des Arts et de la Curiosité*, 23 April 1881

The other [work] shows us an actress seated at a vanity table in her dressing room. Not yet made up and rejuvenated, she appears completely white against the muffled background of the walls, in the filtered glow of one of those huge lampshades now in fashion that look like those tube-shaped gowns our grandmothers used to wear. A gentleman stands nearby, his hand resting on the back of an armchair, scrutinizing her, while she looks at herself in the mirror. Her hair is undone and her head pulled slightly backwards by the hairdresser, whose bosom swells stupendously.

Joris-Karl Huysmans, *L'art moderne*, 1883

108. Jean-Louis Forain

VI—22

Loge d'actrice, 1880
The Actress' Dressing Room

Signed and dated lower right: *jean louis forain/1880*
Watercolor heightened with gouache, 11 x 9 in. (28 x 23 cm)
Private collection, Paris
REFERENCES: Paris, Musée des Arts Décoratifs, 1913, no. 99; Paris, Galerie Brunner, 1913, no. 67; Paris 1978, no. 82.

Forain also knows how to see. His watercolors, *Loge d'actrice* [and] *Couloir de théâtre*, wittily contrast the ugliness of the men with the evil grace of the women. The artificial light and heavy shadows, the pale flesh and black clothing capture very well the fantastic quality of these very real scenes.

Gustave Geffroy, *La Justice*, 19 April 1881

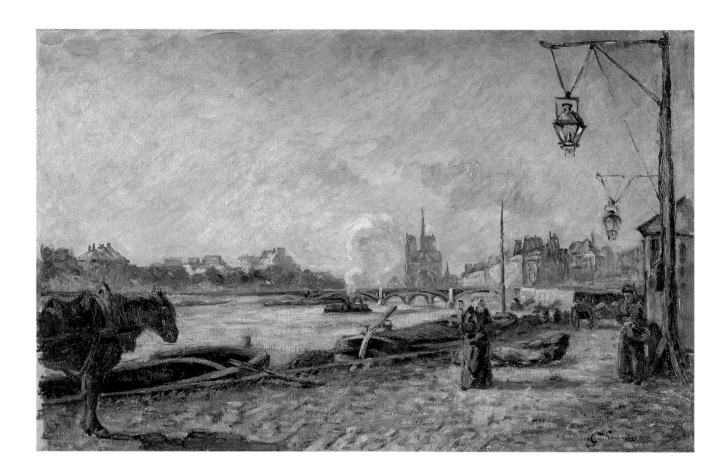

109. Jean-Baptiste Armand Guillaumin

VI-45

Quai de la Rapée

Signed lower right: *Guillaumin*
Oil on canvas, 19¾ x 31 in. (50 x 79 cm)
Private collection, Paris

As for Guillaumin, I hardly dare offer him these reflections. This artist treats Paris as if it were Venice. His quays and his Seine riverbanks make one think of the Grand Canal seen by an overexcited colorist. . . . he accumulates little spots of green, blue, pink, orange, lilac, violet, red, yellow. . . . But these spots come together to confuse and erase everything. In our opinion this constitutes an innovation that merits no further encouragement. In general, in these landscapes it is always noon in July. This is not the way things are in reality; the softness of dawn and the sadness of dusk also seem to us to deserve attention.
Gustave Geffroy, *La Justice*,
19 April 1881

[Guillaumin] sacrifices less to the impression, although he remains just as infatuated with the rough sketch. His touch is biting, and his palette seems tinted with a prismatic sickness. But with him you know where you stand, and he has some respect for surfaces.
Henry Trianon,
Le Constitutionnel,
24 April 1881

Guillaumin, too, is a colorist, and what is more, a ferocious one. At first sight his canvases are a confusion of battling tones and rough contours, a cluster of vermilion and Prussian blue zebrastripes. Step back and blink and everything falls into place; the planes become steady, and the strident tones calm. The hostile colors reconcile themselves, and you are astonished by the unexpected delicacy of certain parts of these paintings. His *Quai de la Rapée* above all is especially surprising from this point of view.
Joris-Karl Huysmans,
L'art moderne, 1883

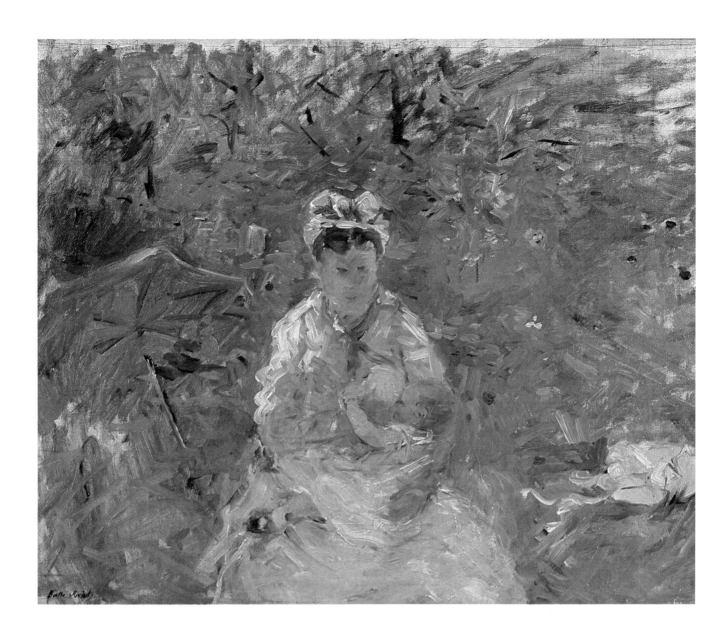

110. Berthe Morisot

VI–57

Nourrice et bébé, 1880
Nurse and Baby

Now known as *La nourrice Angèle allaitant Julie Manet* (The Wet-nurse Angèle Feeding Julie Manet)
Signed lower left: *Berthe Morisot*
Oil on canvas, 19¾ x 24 in. (50.2 x 61 cm)
Private collection, New York
REFERENCES: Bataille and Wildenstein 1961, no. 94.

The *Nourrice et le baby* [sic], the *Jeune femme en rose*, are notes of great finesse, of great tonal delicacy, and of a very true impression.
Elie de Mont, *La Civilisation*, 21 April 1881

The forms are always vague in Berthe Morisot's paintings, but a strange life animates them. The artist has found the means to fix the play of colors, the quivering between things and the air that envelops them. . . . Pink, pale green, faintly gilded light sings with an inexpressible harmony. No one represents Impressionism with more refined talent or with more authority than Morisot.
Gustave Geffroy, *La Justice*, 19 April 1881

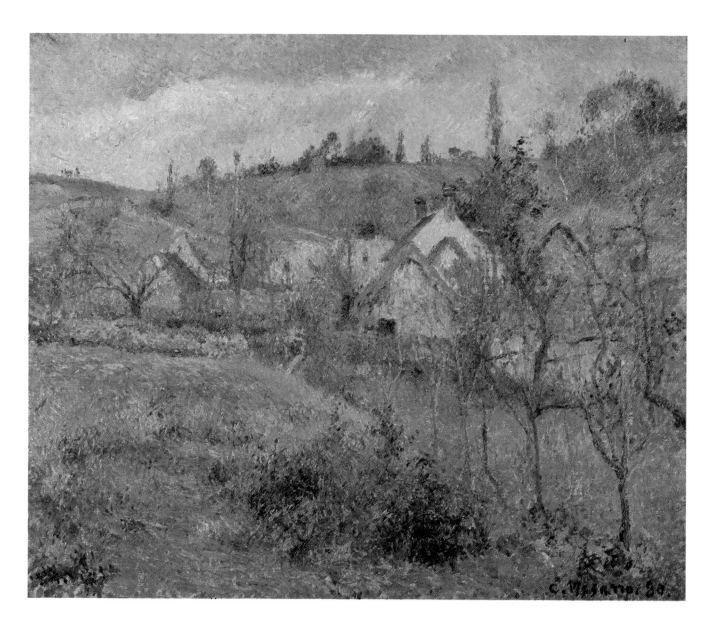

111. Camille Pissarro

VI–68

Chaumières au Val Hermé, 1880
Thatched Cottages at Val Hermé

Now known as *Le Valhermeil, près Pontoise* (Le Valhermeil, near Pontoise)
Signed and dated lower right: *C. Pissarro 80*
Oil on canvas, 21 ¼ x 25 ½ in. (54 x 64.7 cm)
Private collection
REFERENCES: Pissarro and Venturi 1939, no. 506; New York, Acquavella, 1983, no. 6.
San Francisco only

Pissaro [*sic*] . . . showed a very curious series of landscapes, some of which . . . are absolutely remarkable. The majority . . . are framed under glass in the English style. Because of the absence of varnish, the painting is left with a matte finish. This gives it a velvety tone that has a charming effect.
Gonzague-Privat, *L'Evénement*, 5 April 1881

In his brilliant, deep landscapes vibrates a relentless light. But pushing all the tones to the breaking point produces a certain monotony. Moreover, an identical technique renders different effects poorly.
Gustave Geffroy, *La Justice*, 19 April 1881

Pissaro [*sic*] sent no fewer than twenty-seven works in oil and gouache. It is always the same sincere art, recalling Millet only in the similarity of subjects, but it is truly original, with a special vision of things. Yet it remains, despite that, absolutely accurate in tonality.
Armand Silvestre, *La Vie Moderne*, 16 April 1881

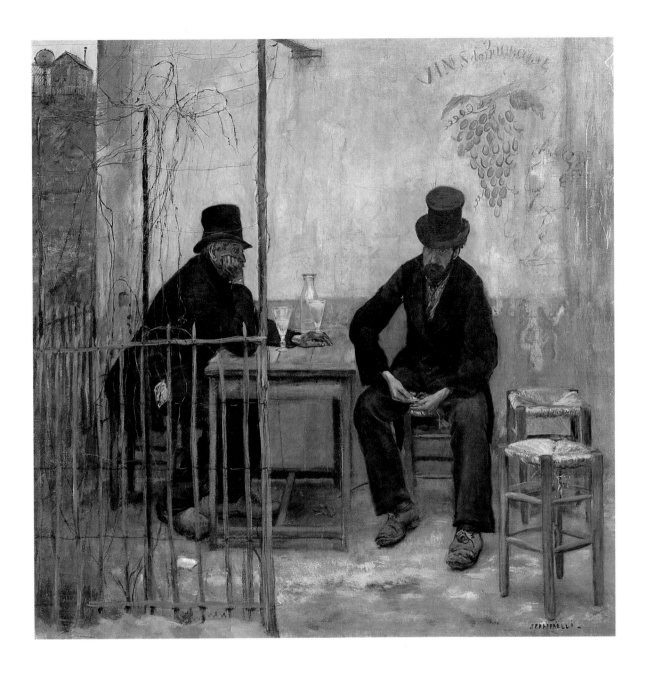

112. Jean-François Raffaëlli

VI–91

Les déclassés, 1881

Now known as *Les buveurs d'absinthe* (The Absinthe
Drinkers)
Signed lower right: *J. F. RAFFAËLLI-*
Oil on canvas, 43⅜ x 43⅜ in. (110.2 x 110.2 cm)
Private collection
REFERENCES: Isaacson 1980, no. 45; Sotheby's New York,
11 May 1977, no. 7; Fields 1979, 180–186, fig. 46.
Washington only

This year Raffaëlli has gone
beyond his little frames. Without
abandoning the easel, he has
taken on larger canvases and
tackled half-life-sized figures.
The *Déclassés* are of this dimen-
sion. They come near being wor-
thy of nothing but praise.
Henry Trianon,
Le Constitutionnel,
24 April 1881

Like Millet he is the poet of the
humble. What the great master
did for the fields, Raffaëlli begins
to do for the modest people of
Paris. He shows them as they are,
more often than not stupefied by
life's hardships.
Albert Wolff, *Le Figaro*,
10 April 1881

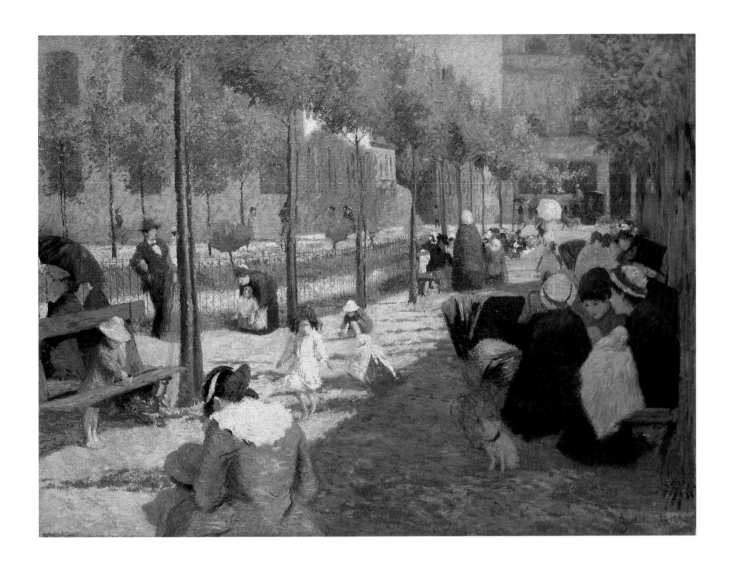

113. Federico Zandomeneghi

VI–166

La place d'Anvers, 1880

Signed lower right: *Zandomeneghi 1880*
Oil on canvas, 39⅜ x 53⅛ in. (100 x 135 cm)
Galleria d'Arte Moderna Ricci Oddi, Piacenza. 256
REFERENCES: Piceni 1967, no. 44; Cinotti 1960, 42, 44–46,
pl. 18, 19.

I return to my subject, and, with the reader's consent, I will then classify the exhibitors of the boulevard des Capucines in two categories: the insane and the rational.
. . . By his drawing, Zandomeneghi belongs to my second category; by his painting, he belongs to the first.
Elie de Mont, *La Civilisation*,
21 April 1881

Caillebotte unfortunately did not show this year, and Zandomeneghi sent two canvases and a drawing in which I find none of the qualities of his painting *Mère et fille* [cat. no. 102] of last year. His *Vue de la place d'Anvers* is only ordinary. . . .
Joris-Karl Huysmans,
L'art moderne, 1883

The Seventh Exhibition *1882*

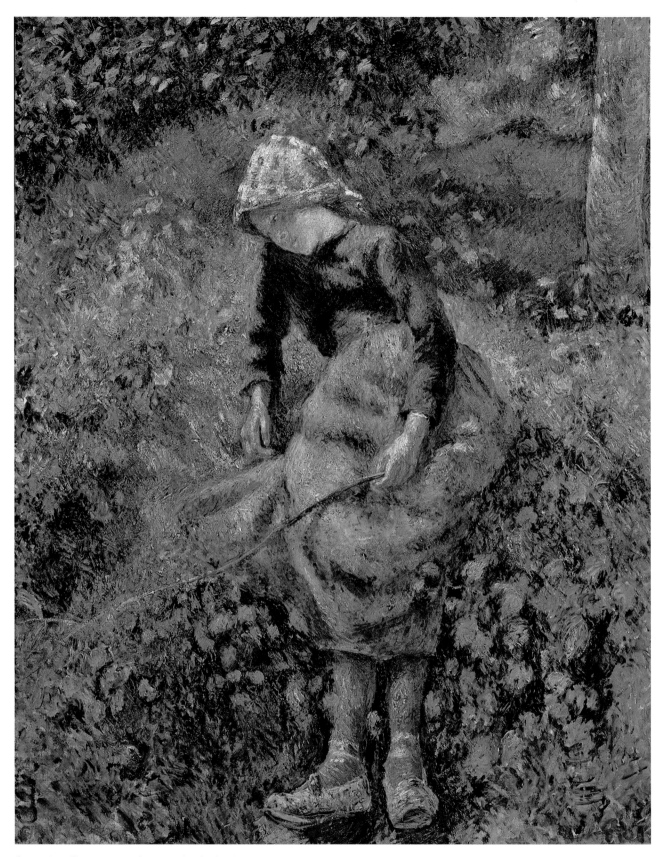

fig. 10 Camille Pissarro, *La bergère* (*The Shepherdess* [*Young Peasant Girl with a Stick*], VII–114), 1881. Oil on canvas, 31⅞ x 25½ in. (81 x 64.7 cm). Musée d'Orsay (Galerie du Jeu de Paume), Paris. Photo: Art Resource

The Painters Called Impressionists

Joel Isaacson

The "Société anonyme". . . .
opens the door to all the incompetents, all the stragglers from the official exhibitions. . . . It is the seed of death.

If the society does not reform its statutes, does not affirm a common principle, it will not live as a society of art.
Ernest Chesneau, review of the First Impressionist Exhibition, 1874[1]

At the point where we are now an exhibition must be extremely well done or not take place at all, and it is totally necessary that we be just among ourselves, that no stain be allowed to compromise our success.
Monet to Durand-Ruel, 10 February 1882[2]

To exhibit with Pissarro, Gauguin, and Guillaumin is like exhibiting with any society whatsoever. A bit more and Pissarro will invite the Russian Lavrof or some other revolutionary. The public does not like what smells of politics, and I do not want, at my age, to be a revolutionary. . . . Get rid of those people and give me artists like Monet, Sisley, Morisot, etc., and I'll be with you, because [then] it is no longer a question of politics, it is pure art.
Renoir, draft of letter to Durand-Ruel, 26 February 1882[3]

Thus we are 8 this year. Caillebotte agrees with me on this list which represents a group defending the same ideas in art, with more or less talent. We cannot insist on equal talent; it is already an important factor not to include anything that mars the whole.
Pissarro to Monet, end February 1882[4]

. . . this is the first time that we do not have any too strong stains to deplore.
Pissarro to de Bellio, 26 March 1882[5]

The holy battalion is reduced to its simplest expression.
Henry Havard, 1882[6]

From the point of view of contemporary life, this exhibition is unfortunately the most summary. . . . One note absorbs all others, that of landscape. The circle of Modernism has really become too restricted and one cannot sufficiently deplore this diminution that vile quarrels have brought about in the collective effort of the little group. . . .
J.-K. Huysmans, 1882[7]

[Théodore] Duret, who knows what he is talking about, thinks that this year's exhibition is the best your group has ever had. This is also my opinion.
Eugène Manet, letter to his wife, Berthe Morisot, March 1882[8]

This year 1882, neither M. Degas, nor Mlle Cassatt, nor MM. Raffaëlli, Forain, Zandomeneghi, have exhibited. On the other hand, two deserters have rejoined their company, MM. Caillebotte and Renoir: and, finally, the painters called Impressionists, MM. Claude Monet and Sisley, have returned to the scene.
J.-K. Huysmans, the most provocative of the more than two dozen critics who wrote on the Seventh Impressionist Exhibition in 1882, began his review with this short but accurate roll call. Renoir and Sisley had not exhibited with the Impressionists since the third exhibition five years earlier in 1877; during that period Monet exhibited, reluctantly, only once in 1879, and Caillebotte, who had been a faithful adherent since joining the group at the second exhibition in 1876, had chosen to withdraw in 1881 rather than accept the friends of Degas (i.e., Raffaëlli, Forain, Zandomeneghi, and others), whom he considered to be mediocre painters. On the other hand, now in 1882, it was Degas's decision to withdraw in the face of a renewed demand that he relinquish his support of his protégés. In his review Huysmans deplored the consequent reduction of contemporary urban subjects in favor, as he saw it, of landscape, and considered the exhibition to be weakened as a result. He castigated the painters for not absorbing their quarrels and keeping their sights aimed at "the common enemy" of cultural officialdom and public ignorance, and he questioned the wisdom of censoring individual expression for the sake of a shortsighted notion of stylistic homogeneity. Such an approach could only backfire, he lamented, and result in monotony, uniformity, and complete sterility.

Huysmans ended up, however, by applauding the landscapes of Monet and Pissarro, saying these artists had come into their own this year. Despite his earlier and continued championship of the work of Degas and his followers he now reversed his earlier criticisms of the landscapists and went so far as to say that it was due to the efforts of Monet and his "Impressionist" colleagues in landscape that was owed the "redemption of painting."[9] That assessment should not be taken as overweighing his allegiance to urban genre painting, but it is surprising nevertheless in the writing of a Realist critic who

fig. 1 Gustave Caillebotte, *Fruits (Fruit Displayed on a Stand*, VII–4), ca. 1881–1882. Oil on canvas, 29⅛ x 39⅜ in. (74 x 100 cm). Museum of Fine Arts, Boston. Fanny P. Mason Fund

had, only gradually, since his debut in 1879 begun to overcome his distaste for what he saw as the roughness and brutality of touch and palette in the work of the landscapists.[10]

Huysmans's momentary bow to the redemptive qualities of French landscape reflects a long-standing controversy within French artistic circles. His view echoes that of the leading Impressionist critic at the time, Théodore Duret, who, as a young writer in 1867, entered the debate as to what direction French painting should take following the decline of history painting, a phenomenon that was increasingly acknowledged with the death of leading masters of the first half of the century, such as Ingres (1867), Delacroix and Horace Vernet (1863), Flandrin (1864), and Ary Scheffer (1858). Assessing the state of French painting in 1867, the year of the

Exposition Universelle, Duret began his discussion of landscape as follows: "I arrive now at the examination of the group of painters in whom resides the truest and most distinct originality of the modern French School. . . ."[11] He ranged himself on the side of the critics who, as Patricia Mainardi has pointed out, came to uphold landscape as a more truly indigenous and sincere product of the French School than genre painting, associated with the northern countries and seen, disparagingly, as the preferred painting of the undiscriminating middle class.[12] Duret maintained this position in the immediately succeeding years; in his review of the Salon of 1870 he weighted the balance with effective economy: "If, in the modern school, the Naturalist painters [i.e., the landscapists] represent, above all, individual creation, the painters of genre personify pastiche and imitation."[13]

During the 1870s Duret enthusiastically transferred his allegiance from the landscapists of the Barbizon generation to the Impressionists, and in 1878, when he published his pamphlet *Les peintres impressionnistes*, he defined the movement in terms of his preferences, consistent with the critical position with which he had begun.[14] *Les peintres impressionistes* discusses five artists: Monet, Sisley, Pissarro, Renoir, and Morisot, whom he calls the "primordial" Impressionists. (Of this group only Renoir was not principally a landscapist, landscape playing in his work "only an accessory role.")[15] In 1878 there was no Impressionist exhibition. Therefore, the restrictive definition of the "peintres impressionnistes" as primarily a school of landscapists and colorists, devoted to depicting the fugitive effects of nature en plein air, was proffered only on paper. Certainly the first three group shows through 1877 did not present such a limited view; nor, subsequently, did the three exhibitions from 1879 to 1881 (in which Renoir, Monet, and Sisley in particular were for the most part conspicuous by their absence) ratify Duret's characterization of the movement. It was only in 1882, as a result of a complicated series of maneuvers, that the exhibition took a form that closely approximated Duret's view. It is no wonder, then, that Duret informed Eugène Manet, during its run, that he thought it the best Impressionist show to date.[16]

The notion of a privileged or genuine group of Impressionists was born with the first exhibition. In 1874 Emile Cardon, Jules Castagnary, Ernest Chesneau, and Marc de Montifaud singled out Monet, Renoir, Sisley, Pissarro, Degas, Morisot, Cézanne, and Guillaumin as the leading artists of the group, an assessment that had to recommend it both an enlightened esthetic judgment and a rough consistency with the composition of the members principally responsible for mounting the exhibition itself.[17] Critics recognized, of course, distinctions between the character of Degas's work and that of the landscapists, but it was only with the second exhibition in 1876 that a breach became evident within the membership itself, and that in response to the first lengthy study of the group, Edmond Duranty's pamphlet *La nouvelle peinture* (reprinted in this catalogue). Although a comprehensive—and highly perceptive—analysis, Duranty's essay revealed a bias toward Degas (and to a lesser extent Caillebotte), which raised hard feelings on the part of Monet and Renoir.[18] Duret's brochure, two years later, then took a quite different tack, putting to one side Duranty's notion of comprehensiveness and isolating instead a primary group of colorists. It was, however, only with the defections and renewed Salon orientations of Renoir, Sisley, Monet, and Cézanne and the accompanying influx into the group shows of 1879–1881 of a number of artists supported by Degas that questions of dominance, exclusion, and esthetic homogeneity came sharply to the fore.

Once Monet and Renoir began to drop away, the charter members Degas and Pissarro, along with Caillebotte, remained as the bellwethers of the group endeavor. It was Caillebotte who began to question seriously in 1881 whether the exhibitions could continue to represent the innovative character of their work with the addition of Degas's friends, who, he felt, diluted the quality of the group's offerings to the public. In January 1881, prior to that year's exhibition, he wrote to Pissarro proposing a show based on talent and a more or less coherent "artistic direction": "Do you want an exclusively artistic exhibition? If Degas wants to take part, let him, but without the crowd he drags along."[19] Pissarro responded that to exclude was to weaken their effectiveness as an exhibiting organization; he felt that it was the esthetic question that had already sown the discord they were now attempting to confront and that there was "little solidity" to be found "on the shaky ground of art."[20] In the end Caillebotte joined Monet, Renoir, Sisley, and Cézanne in abstaining from the show, which ended up with only fourteen participants, the smallest representation of the six exhibitions thus far.

fig. 2 Gustave Caillebotte, *Boulevard vu d'en haut (Boulevard Seen from Above,* VII–10), 1880. Oil on canvas, 25⅝ x 21¼ in. (65 x 54 cm). Private collection, Paris. Photo: Routhier

fig. 3 Pierre-Auguste Renoir, *Femme à l'éventail* (*Woman with a Fan*, VII–160), 1880. Oil on canvas, 25⅝ x 19¼ in. (65 x 50 cm). Hermitage, Leningrad. Photo: Daulte 332

The possibility of mounting a seventh exhibition was addressed only towards the end of 1881. In November Gauguin wrote to Pissarro that someone (unnamed) had proposed to him that the Impressionists hold a new show in an exhibition hall on the grounds of the Salle Valentino, in the neighborhood near the place Vendôme, in a structure built to display a panorama commemorating the battle of Reichshoffen. Gauguin wrote,

I believe that if Degas doesn't put too many sticks in the wheels it is a superb opportunity for an exhibition (lighted day and night). . . . I find the proposition excellent. He offers us a rental of six to eight thousand francs to be paid by him, *and above that figure a share of the gate. . . .*[21]

Gauguin did not name their benefactor, although it was almost certainly Henri Rouart, wealthy engineer, close friend of Degas, and, along with Degas and Pissarro, the only charter member of the group to have participated in each of the first six exhibitions through 1881.[22] Rouart might well have wished to remain quietly in the background so as not to make it appear as if he and Degas were attempting to take over the exhibition. In any case,

it was Rouart who eventually assumed the rent for the hall.[23]

The objections that had been raised in 1881 to the increasing role played by Degas's friends immediately surfaced anew, and it soon became a question of whether Degas would relinquish his support for Raffaëlli and his other recruits, save for Mary Cassatt and, perhaps, Rouart. Within a month Gauguin had received his answer: Degas would resign rather than release Raffaëlli. Whereupon Gauguin declared a similar intention: "Despite all my good will I can no longer continue to serve as buffoon for M. Raffaeli [*sic*] and Co. Please accept my resignation; . . . I believe Guillaumin intends to do the same but I don't want to influence his decision."[24] On 18 January Gauguin wrote once again to Pissarro, complaining that they had by now obligated themselves to a rent of six thousand francs but that nothing had been resolved.[25] One week later, on 25 January, Gauguin reiterated his distrust of Degas and his intentions and begged Pissarro not to abandon the project. He urged him to see Caillebotte and arrange an exhibition. "The essential thing is that the *Impressionists* exhibit . . . ," even if it meant his own exclusion: "Do the exhibition with five if you want, you Guillaumin Renoir Monet and Caillebotte but do it, you know that your future depends on it. . . ."[26]

Gauguin's letter of 25 January, with its quite remarkable combination of self-abnegation and earnest encouragement, seems to have spurred Pissarro to take a more active role. In the next week or so Pissarro engaged Caillebotte's interest, visited Manet to try to secure his sister-in-law Berthe Morisot's participation, wrote to Monet and probably several others, and was in touch with Durand-Ruel, who wrote to Monet, as did Caillebotte.[27] By the first week in February the roles had been assigned in the formation of the exhibition. To begin with, the pattern was very much as it had been the year before. Once galvanized into action, Pissarro sought to mediate between Degas and the "landscapists" Monet, Renoir, Sisley, and Cézanne, who had had so little to do with the recent exhibitions but continued to be recognized as important artists who carried the Impressionist banner despite their absence. Caillebotte at first attempted to compromise by negotiating through Rouart to secure Degas's participation without that of Raffaëlli, but, as had Gauguin in December, by the third week in February he concluded that no exhibition was possible with Degas.[28]

It was thus clear at that date that an exhibition as a concerted manifestation of the old group would not take place. The "group" existed only in memory or in continued aspiration on the part of a few. Degas's serious commitment was compromised by his alienating behavior, and he was forced to withdraw, thus ensuring Rouart's departure as well. Morisot was in Nice and occupied

with her sick child (in the end it was only by virtue of her husband's diligence that she appeared in the show); she and Sisley seem to have been largely dependent on the decisions of Monet and Renoir, although Sisley was also subject to the sway of Durand-Ruel, who became increasingly active during the course of the month. Monet, in response to letters from Pissarro and Durand-Ruel, expressed the view that a new show should be limited to a core group of closely linked artists—we should be "entre nous," he wrote—and, just as Caillebotte and Gauguin did, he revealed little interest in joining an Impressionist exhibition that would contain Degas's followers. Moreover, he was reluctant to leave Pourville, where he had begun work on a new group of views of the Normandy coast, and he was prey to confusion regarding the shifting lineup of forces. It was only in the last week in February that he realized his participation was being decided for him by Durand-Ruel, who possessed a large number of his paintings. Renoir, too, was far from Paris, recuperating from pneumonia in L'Estaque; six days before the show opened he was still arguing for an exhibition that would be based on talent, one that would be "artistically interesting," as he saw it, composed of himself, Monet, Sisley, Pissarro, Morisot, and Degas, the quality of whose work he never questioned. On the other hand, as he wrote to Durand-Ruel on 26 February, he distrusted Pissarro and Gauguin, whom he saw as revolutionaries and anarchists, committed to a radical view of the Impressionist exhibitions, a view he disavowed in accordance with his desire to accommodate himself to the Salon and the wealthy patrons he had been courting since the late seventies. And yet he realized, as did Monet, that he could do nothing to prevent Durand-Ruel from showing the paintings he already owned and so resigned himself to his inclusion.[29]

The powerful role played by Durand-Ruel makes it clear that, despite the ideological jockeying for position and the attempt, on the part of the artists, to affirm artistic criteria, the decisive factor in the determination of the exhibition was economic. In 1880, responding to an improved financial situation, largely owing to the backing of Jules Feder, Director of the Union Générale bank, Durand-Ruel renewed purchases on a regular basis from Sisley, Monet, Pissarro, and, to a lesser extent, Renoir, bringing to them a degree of security they had not experienced since the dealer had been forced to withdraw his earlier short-lived support in 1873.[30] Now, however, on 19 January 1882, the Union Générale failed; Feder was jailed briefly and forced to declare bankruptcy. The stock market was also seriously affected, and the state of affairs was viewed as having repercussions for the painters; in the same letter in which Edouard Manet wrote to Berthe Morisot about Pissarro's visit, he added, "Business is bad. Everyone is penniless as a result of the recent financial events, and painting is feeling the effect."[31]

fig. 4 Pierre-Auguste Renoir, *Une loge à l'Opéra* (*At the Concert*, VII–139), 1880. 39¹/₁₆ x 31¾ in. (99.2 x 80.6 cm). Sterling and Francine Clark Art Institute

Durand-Ruel, who now faced the prospect of repaying Feder's loans much sooner than anticipated, seems to have sprung into action by early February, joining Pissarro and Caillebotte in their overtures to the others in the hope of mounting a profitable exhibition built around a core of paintings already in his collection. While Pissarro and Caillebotte sought to mediate and placate, Durand-Ruel employed a velvet fist, sharing plans and urging work forward, at first merely suggesting to Monet that his refusal to participate was ruining it for others, then, as indicated above, finally making it sufficiently clear to Monet and Renoir that they had no choice, that the exhibition must take place. Monet, Renoir, and Pissarro all agreed at that point, less than a week before the show was to open.[32] On about 24 February, Pissarro wrote to Monet, "Pour Durand et même pour nous, l'exposition est une nécessité."[33]

When, in 1880, Durand-Ruel had resumed his support of the Impressionists, he arranged to take the bulk of their production in exchange for a dependable source of income. He acquired at least thirty works by Monet and approximately twenty by Sisley in 1881 and continued to make purchases right up to the opening of the exhibition in 1882.[34] He was thus able to ensure a plentiful display

of the work of several artists and may well have supplied the majority of paintings by Monet, Pissarro, and Sisley. Their representation at the show was very generous: Monet had thirty-five works listed in the catalogue, Pissarro had thirty-six, Sisley twenty-seven, and Renoir twenty-five plus at least two others not included in the catalogue. The smallest representation was that of Morisot, who did not sell to Durand, but in the end she, too, had a dozen works, not all listed in the catalogue.[35]

About 24 February, Pissarro wrote to Monet to clear up the remaining misunderstandings about participation in the exhibition, informing him, "We hang the paintings Monday morning [27 February]; Sunday night if possible. You can count on us to try to give you complete satisfaction in the placement of your canvases; in any case, Caillebotte and I will be there."[36] The journalist Gaston Vassy visited the exhibition hall the day before the opening and informed the readers of *Le Reveil* on 2 March of what he saw. He was struck above all by the extraordinary energy of Caillebotte, whom he called the "leader" of the association:

Hat on the back of his head, hands in his pockets, M. Caillebote [sic] came and went, giving orders, surveying the hanging of the canvases, and working like a porter, exactly as if he didn't have an income of fifty thousand francs. Alongside him, M. Pissaro [sic], seated on a large trunk, watched him with interest . . . and seemed tired just from being witness to so much activity.[37]

The "7me Exposition des Artistes Indépendants" was opened to the public on Wednesday, 1 March, at 251 rue Saint-Honoré in a building constructed to house the painted panorama of the battle of Reichshoffen, commemorating one of the bitterest defeats of the Franco-Prussian War in 1870. It was perhaps an odd juxtaposition—the "intransigent" Impressionists in the home of this mainstream patriotic display—and two of the critics noted an irony there, but the painters were benefited by a large, airy, well-lighted hall—apparently on the floor above the panorama—a considerable advance over the cramped, make-do quarters of the previous year.[38] Eugène Manet described the location to his wife Berthe Morisot.[39] The room evidently had a very high ceiling, and the upper walls were hung with Gobelins tapestries. Below that the paintings were arranged in three registers, one above the other. Despite the ample setting, the approximately two hundred paintings and pastels filled the walls and a number of pictures had to be placed on large easels, as was the case with several of Berthe Morisot's late entries, one easel holding three pictures, another two. As was usually the case at these exhibitions, not all the pictures were ready the first day and others were added that were not included in the catalogue. On the first day Morisot had only one picture, *A la campagne* (VII–92), set on an easel in the foyer, although

within a day or two her entries were more or less complete. Eugène Manet wrote several times of his efforts to obtain frames for her pictures. Initially he borrowed a white frame from Vignon for one of her landscapes of Nice and ordered another for *A la campagne*, but in the end the works were placed in gray frames with gold ornament, save for one in white with gold. Both white frames (Vignon, Gauguin), familiar by this date, and the traditional gold were there on the walls, the latter prompting some critics to repeat the complaint, heard at earlier shows, that the strong, bright hues of the paintings looked terrible in these gilded borders, ordinarily reserved for the mellowed tones of traditional painting.[40] Three reviewers also noted Pissarro's experimental practice, introduced the previous year and apparently adopted in 1882 only by him, of placing his oils with their matte surfaces under glass, prompting the critics to remark that the paintings looked like pastels.[41]

The hall remained open until eleven at night, continuing a custom inaugurated at the first exhibition. The daily attendance during the first week averaged three hundred forty to three hundred fifty, an unimpressive figure according to Eugène Manet, who reported regularly to Morisot. He informed her that he had set prices for her pictures ranging from five hundred francs for the smaller ones to twelve hundred for the largest, *A la campagne*. Her prices were not as high as Monet's, for whose paintings Durand-Ruel was charging two thousand to twenty-five hundred francs,[42] nor those of Sisley, which Manet indicated were selling for two thousand francs, due in part to the good critical reception that his works at the exhibition had begun to receive. The opening day was very successful, bringing in nine hundred fifty francs, but receipts and attendance apparently fell off shortly thereafter. By mid-March Caillebotte was obliged to inform Monet and Renoir that they would not make their expenses and indicated that they might fall short by as much as two thousand francs.[43]

Those discouraging figures provided one gauge of the situation. On the other hand, this show, which had come together from a bewildering tangle of motives, which had emerged without a will and with no clear principle, without agreement that it even should take place, came to be viewed as the most coherent and unified exhibition to date, as one that in its composition seemed to affirm Caillebotte's and Renoir's faith in talent and artistic direction and Monet's belief in the value of homogeneity. It seemed to ratify Duret's definition of Impressionism as restricted to a few artists devoted to landscape, color, and the open air. Even Pissarro, the champion of unity in diversity, concluded in a letter to Dr. de Bellio, "I am convinced that you would have been pleased with the over-all aspect of our show, for this is the first time that we do not have any too strong stains to deplore."[44] Indeed, to the extent that the work included was current—practically all the

paintings in the show dated from the past two years—the exhibition provided a genuine and generous display of up-to-date practice by the group of artists who had come to be most closely associated with the label and the notion of Impressionism. Pissarro felt that, as such, the exhibition was a clear success; on 20 March, during the run of the show, he wrote to his niece, Esther Isaacson, "We are very pleased with the result, our reputation is affirmed more and more, we are taking our definitive place in the great movement of modern art."[45]

Critical reaction to the exhibition was for the most part favorable. Several reviewers deplored the loss of Degas, Cassatt, and Raffaëlli; others felt that a certain unity had been attained. Charles Bigot, generally negative towards what he saw, nevertheless found the show as a whole to be "truly that of a school"; Henry Havard, more kindly inclined, wrote that "the holy battalion is reduced to its simplest expression." For the most part the notion of simplicity was linked to the lead that Duret had provided in 1878, which stressed landscape painting as the preferred and representative form of pure Impressionism. But the critical response as well as the actual composition of the exhibition was more nuanced and complicated than the conjunction of landscape and purity allows.

Landscape did indeed dominate, about three-quarters of the roughly two hundred and ten exhibited pictures falling into that category (although Sisley was the only one to show landscapes exclusively). Closely assimilable to the coloristic concerns of landscape were the eighteen or so still lifes in the show and the twenty-four paintings by Pissarro of large-scale peasant figures in outdoor settings. An additional twenty figure paintings were contributed by Renoir and Caillebotte, and those received disproportionate critical attention. Caillebotte's seventeen entries included six figure compositions. Foremost among these was the *Partie de bésigue* (cat. no.114), which received more favorable comments from the critics than any other painting in the entire exhibition, including Renoir's *Un déjeuner à Bougival* (cat. no.130); it was also probably the least Impressionist painting in the show, adhering to convention in every category of form to which one might turn. Close behind in critical approval was *Homme au balcon* (VII-2), which was singled out more for the correct drawing of the figure seen from the back than for the qualities of color and light so carefully observed and rendered. The "experimental" Caillebotte fared less well. Only one critic, Huysmans, responded positively to *Fruits* (fig.1), depicting a display of fruits on a market stall, which he favored for its freedom from conventional formulas.[46] And the daring *Boulevard vu d'en haut* (fig.2), mentioned by six critics, ranged in commentary from thorough disparagement to curiosity to, in one instance (A. Sallanches), a recognition of original qualities.[47]

Renoir, too, whose canvases ranged from Impressionist landscapes to conventionally refined indoor figure compositions, was praised most strongly for the academic turn his work had taken since his return to the Salon in 1878. During the past several years he had been pursuing a variety of painting modes while directing himself increasingly towards a wealthy clientele from which he sought portrait and decorative commissions. One of the motivating reasons for his trip to Italy in 1881 (immediately preceding his visit to Cézanne in L'Estaque, where he had taken ill while preparations for the exhibition were going on) was to fill the gaps in his awareness of the old masters and to gain direct contact with the classical tradition. The selection of Renoir's paintings at the exhibition may not have represented the choice he himself would have made, as Philippe Burty suggested in his review.[48] Fearful of the depressive effect the exhibition might have on prices and desirous of ingratiating himself with his clients, Renoir might well have reduced the number of landscapes and eliminated the views of Venice, which were done on the first leg of his Italian journey and proved to be the principal targets of the few negative comments that were made in the press.[49] The fairly generous representation of landscapes, nine of a total of twenty-five entries in the catalogue, may have been due to the intervention of Durand-Ruel. Prior to 1870, Durand-Ruel had invested principally in landscape, handling the painting of the Barbizon School; when he came to support the Impressionists he dealt mainly in the work of Monet, Sisley, Renoir, and Pissarro. Within the nexus of the dealer-critic system we may speak of a linkage between Durand-Ruel and Duret in their shared bias toward landscape. The group of Renoir's pictures thus exhibited may have represented more accurately the range of his work than he himself might have wished, but the critics would have helped to allay his fears, for they concentrated their attention on the figure compositions and praised their conventional qualities. One of the most favorably received paintings was *Femme à l'éventail* (fig.3), the painting that most clearly announced the "dry" style that Renoir had begun to introduce primarily into his portrait commissions.[50] Five critics praised *Une loge à l'Opéra* (fig.4), one of them the rascally and unpleasant Louis Leroy, who specifically endorsed the painting for its non-Impressionist character and recommended it as displaying a style that Renoir ought to follow: "The faces of the two young women, their dress, the color of the ensemble, have bourgeois qualities that Impressionism execrates."[51] The most honored of Renoir's figure paintings, however, was *Un déjeuner à Bougival* (*Luncheon of the Boating Party*), which three critics called the best painting in the exhibition,[52] perhaps because of its rare and successful amalgam of Impressionist richness and delight in the color of the open air with a firm treatment of figural

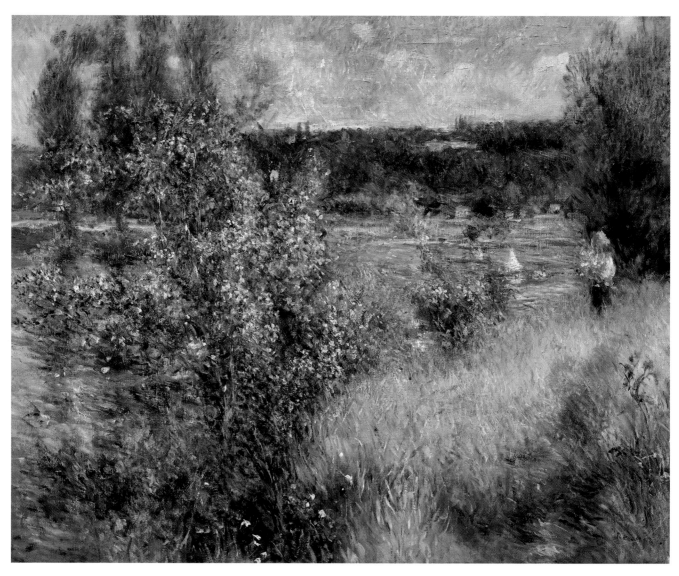

fig. 5 Pierre-Auguste Renoir. *La Seine à Chatou* (*The Seine at Chatou*, VII–154), ca. 1881. Oil on canvas, 29 x 36½ in. (73.6 x 92.7 cm). Museum of Fine Arts, Boston. Gift of Arthur B. Emmons

form. It could be accepted as reaching toward respectability without crossing that threshold that would place it in the domain of the *juste-milieu*. On the other hand, the most daring of his figure paintings, *Jongleuses au Cirque Fernando* (cat. no.134), was mentioned by only one critic, who ridiculed the proportions of the figures, with their hands too long and legs too short.[53] Its provocative, flat-patterned, cut-out arrangement of the two performers against the drop of the circus floor—like a Matisse *avant-la-lettre*—and its seemingly impromptu cropping at the upper edge were not calculated, it seems, to yield an approving word. Nor (if the identification is correct) did his landscape of *La Seine à Chatou* (fig.5),[54] with its almost Morisot-like quickness of stroke and the fresh twist given to the composition by the flowering tree in

left foreground, attract any critical admirers. The focus was elsewhere. Renoir was accepted, despite his absence from the last three shows, as one of the leaders of the Impressionist movement; he had become familiar to the reviewers, however, from his recent Salon appearances, and the praise that he received was for just those qualities of convention and adaptation that the Salon encouraged.

Renoir and Caillebotte were singled out particularly for their figure paintings, and it is to the conventional character of those pictures that they owed their success. Overall, however, it was Pissarro who fared better than any of the other painters in the critical consensus. In his case, too, figure painting played a dominant role. Twenty-seven of his thirty-six entries were figure compositions, mostly of peasant women placed prominently

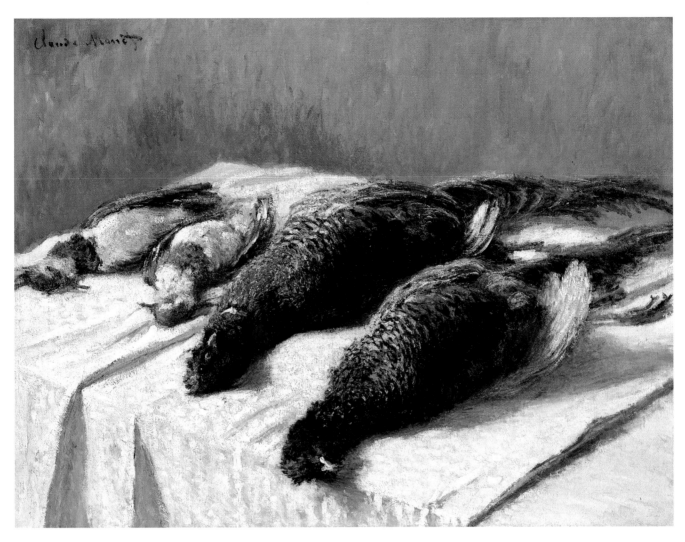

fig. 6 Claude Monet, *Gibiers, nature morte* (*Still Life of Pheasants and Plovers*, VII–82), ca. 1880. Oil on canvas, 26¾ x 35½ in. (67.9 x 90.2 cm). The Minneapolis Institute of Arts. Given by Ann Pierce Rogers in memory of John De Coster Rogers

within an outdoor setting (see cat. nos. 125, 126, 127, 128, and *fig. 10*). Several critics praised them for their robustness, sobriety, and truth and compared them favorably to the paintings of Millet. Huysmans, however, felt that Pissarro had now liberated himself from Millet and the biblical: "He paints his country people without false grandeur, simply, as he sees them," and he went on to call the pictures "true small masterpieces."[55] Pissarro's critical success, broader than that accorded Renoir and Caillebotte, was probably due to the evidence offered by his canvases that he was, indeed, more fully an "Impressionist" than they were, participating in a more integral way in both the world of the figure and of the landscape. One did not have to choose between the two genres nor among differing styles and face the contradiction of

endorsing an Impressionism that was not an Impressionism. Pissarro's peasants were favored primarily for their "human" qualities, but it was at least reassuring to find them cast in the same stylistic mold as his landscapes.

A number of critics, in the end, realized that if they were to deal adequately with this trimmed-down exhibition of the Independents—that is, as an exhibition that saw the return of Monet, Renoir, and Sisley and the absence of Degas and his followers—they had to deal with landscape and the approach to plein air. The critical terms employed, however, were for the most part hackneyed: negative charges of exaggerated color, of crude execution, and of the artists offering little more than sketches, etc.; positive endorsements of the fresh range of colors,

of qualities of truth, delicacy, sincerity, and so on. Sisley and Pissarro fared particularly well; Gauguin, Guillaumin, and Vignon were either ignored or disparaged. Renoir's landscapes were generally overlooked, while those of Caillebotte and Morisot received mixed, although often respectful, notice. Although Monet was not uniformly praised—his recent paintings of Grainval and Fécamp causing the greatest division of opinion—some critics were lavish in their praise: Armand Silvestre called him the "most exquisite of the Impressionists" and "one of the true contemporary poets of the things of nature"; and Huysmans, despite earlier disparagement of Monet's hastiness and coloristic extravagance, now found that a change had taken place, and he called Monet "a great landscapist."[56]

The principal supporters of landscape were Alexandre Hepp, Silvestre, and Ernest Chesneau. Hepp felt that Impressionism had moderated its coloristic excesses (only Gauguin had failed to do so), and he offered this general proposition on its status: "Impressionism today is an intense art. The works it presents have a sincere vitality and a thrust, rich in ideas. In a measured way they carve out for themselves a bold originality, and under the appearance of broad improvisation they hide their care for detail and contour." He added that Durand-Ruel, earlier condemned for supporting them, now "walks in triumph." Silvestre attempted to locate the Impressionists' contribution in the nature of their most characteristic works, associated with landscape and plein air. He endorsed especially the overhaul of conventional techniques, saying there was "more true harmony in certain landscapes by M. Claude Monet than in all the *envois* sent back from Rome in the past ten years," and, in what was by now a commonplace observation, he noted the freedom from chiaroscuro and artificial lighting methods that accompanied the rise of outdoor painting.[57] As we have seen, Huysmans, too, came to view landscape far more positively than he had before and praised Pissarro and particularly Monet without reserve. But he offered no more than familiar criteria having to do with fidelity to appearances and penetration of feeling. Although the exhibition, in its narrowed participation, offered ostensibly the triumph of landscape painting, and some of the critics attempted to recognize it as such, the "impurity" and variety of the show proved more attractive than did the evidences in the work of Monet, Sisley, Guillaumin, and Vignon, and to a lesser degree in Pissarro, Renoir, Morisot, and Caillebotte, of a purer strain of Impressionism embodied in plein air, landscape, and color experimentation. Only two critics sought to define the character of the Impressionists' effort: one a newcomer, Emile Hennequin, the other the veteran Ernest Chesneau.

Hennequin felt that with the first glance one realizes the Impressionists constitute a school that proceeds from common principles. They bring to painting two innovations. One was the perception that in every scene there is a dominant hue that is made to modify and relate the diverse nuances of tone within the painting (in saying this he countered the long-standing negative criticism, to be found in several reviews that year, which saw just such an emphasis as evidence of imbalance and exaggeration).[58] The second Impressionist contribution, which derived from the experience of plein-air painting, was the recognition that, in effect, there are no contours in nature, that contours are actually seen as deformed and diffused, thus requiring a new kind of drawing. Both innovations, he said, derive from the theory that the painter should paint only what he sees. That proposition, which, in one sense, had a considerable history in earlier Realist theory, with its concern for the immediately experienced and the verifiable in nature and society, received a different emphasis in 1882 in the revival of the age-old dichotomy between seeing and knowing. The distinction was now applied, for the first time, I believe, in their short history, to the work of the Impressionists.[59]

Three months later, in a review of an Impressionist exhibition organized by Durand-Ruel in London, the anonymous critic of *The Standard* wrote that Impressionism "aims generally to record what the eye sees, and not what the mind knows the eye ought to see. . . ."[60] That formulation goes an important step beyond Hennequin's observation, but it accords closely with, and might even have derived from Chesneau, whose review of the seventh exhibition appeared in *Paris-Journal*, 7 March 1882. Chesneau compared the Impressionists to the English Pre-Raphaelites, whom he commended for their insistence on recording the minutest details in their desire to paint "nature *as it is*." No less worthy, he wrote, was the effort of the French Impressionists, who devote themselves with an equal passion "to translating not the abstract reality of nature, not nature *as it is*, as the mind of the scientist would conceive it, but nature *as it appears to us*, nature as the phenomena of light and atmosphere create it for our eyes, if we know how to see."[61]

Through reference to the Pre-Raphaelites, Chesneau wished to distinguish the peculiar character of the Impressionists' approach to plein-air painting. He sought at the same time to present his own understanding of the nature and consequences of directly working outdoors, to convey his sense of the kind of seeing and learning that occurs in that situation. This approach is unlike that of the Pre-Raphaelites, whose visual examination of nature was ostensibly so painstaking that one is led to take the detailed result to suggest a cataloguing or full description of what we *know* to be there in the shape, color, and surface of objects in nature. The Impressionists, rather, emergent from the different tradition of the broad Realism of Courbet and Barbizon, chose to translate carefully perceived data into rough, to a degree (in the sense of refusing to know too much) deliberately

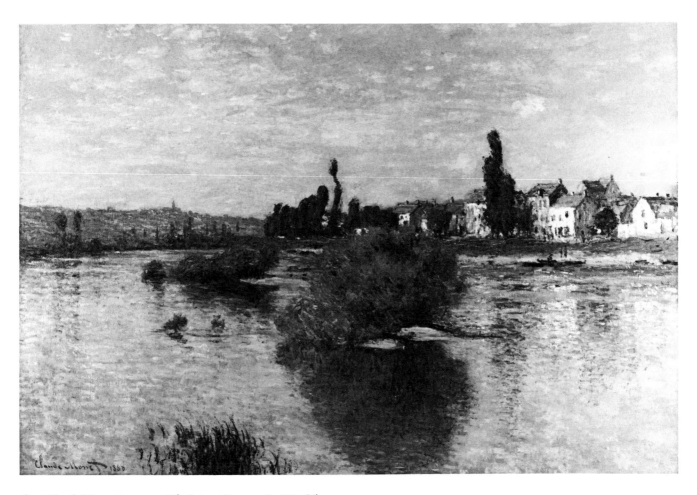

fig. 7 Claude Monet, *Lavacourt (The Seine at Lavacourt)*, 1880. Oil on canvas, 38¾ x 58¾ in. (98.4 x 149.2 cm). Dallas Museum of Art, Munger Fund

naive equivalents. That was one part of the Impressionist effort, a necessary one if the painter was to work outdoors, but also a necessarily partial one. Chesneau recognized, indeed seems to have been acutely aware of, the problems attendant upon painting nature as it appears to us. Thus, for one thing, he characterized the success of the effort as dependent upon what the eye can cope with, what it can, in effect, manage to create—or rather re-create—from what nature offers. For he went on to stress further the problematic aspect of the confrontation between the Impressionist painter and nature by citing the fugitive properties of the natural elements:

Now, these phenomena [of light and atmosphere] are essentially inconstant. Of necessity, the painter is forced to seize them in the fleeting moments of their duration. They do not exist in themselves as abstract reality; they pass, leaving only an impression on our retina and in our memory, a memory of an enchantment of color and movement. That is what the painters aptly named "Impressionists" aspire to and succeed in rendering for us; it is the memory that they wish to and know how to fix.[62]

Chesneau's criticism brackets the history of the Impressionists' exhibitions from 1874 to 1882. In 1874, along with Burty, he extolled the Impressionists' efforts to capture the fugitive in his wonderfully apt remarks on Monet's *Boulevard des Capucines* (Pushkin Museum, Moscow; cf. cat. no.7): "Never has movement's elusive, fugitive, instantaneous quality been captured and fixed in all its tremendous fluidity as it has in this extraordinary, marvelous sketch. . . ."[63] Chesneau's characterization of the phenomena that Monet sought to capture and, he felt, succeeded wonderfully in translating onto canvas in 1874, remains his characterization still in 1882. But in 1882 he added a new element, that of memory. In the intervening years he had come to see the inadequacy of his earlier view of Impressionism as providing an immediate and direct translation of natural phenomena. He realized now that fleeting phenomena cannot be stilled; nor can they be captured. They pass and are retained only in memory, that storehouse of perception that the Impressionist painter recognizes as the ultimate resource for his operation.[64]

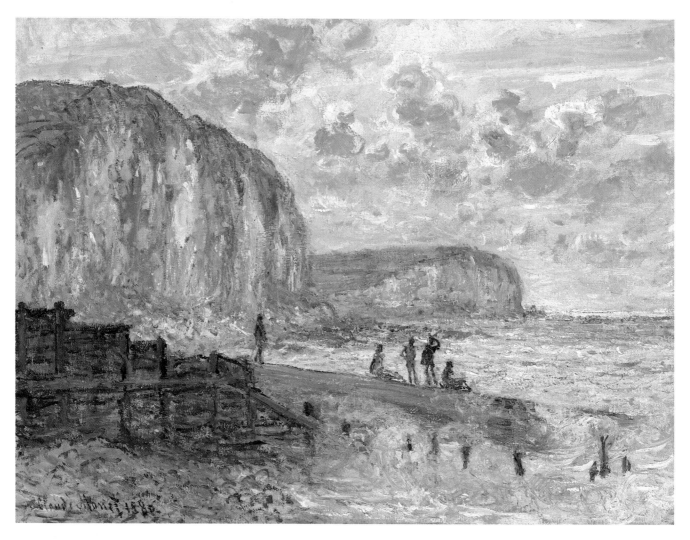

fig. 8 Claude Monet, *Falaises des Petites-Dalles (Cliffs of Petites-Dalles*, VII–73), 1880. Oil on canvas, 23⅞ x 31⅝ in. (60.6 x 80.3 cm). Museum of Fine Arts, Boston. Ross Collection, Gift of Denman Ross, 1906

The implications of Chesneau's view are worth considering.[65] The transient character of phenomena assures that their realization on the canvas—through the medium of memory, if you will—can only be a matter of making signs and equivalents for what has vanished. The painter may attempt at the outset to test his ability against the rapid passage of time, in the initial *ébauche* perhaps, although more likely he knows well enough to generalize according to the dictates of both observation and skilled habit. Technique, knowledge, knowing how to see, and memory must be recognized as complementary to, even as lodging in, the act of observing. In any inquiry into the nature of Impressionism we must take observation into account. It provides the primary generative stimulus for the depiction of the subject;[66] but, to retain Chesneau's terms, it is in the interplay between appearance and

memory that we may recognize the logic of the Impressionists' method. The landscape painters came to realize this more and more as they—Monet in particular—began to insist on repeated observation, increasingly geared to shorter and shorter units of time, and on regular returns to the site to renew the generative experience and enrich the store of memory. If under memory we include other mental processes, as well—such as will, habit, invention, introspection, and fantasy—then we come still closer to an understanding of Impressionist practice, and of the possibilities and limitations of Impressionist theory.

Monet read Chesneau's article in March and informed Durand-Ruel that he thought it well done and liked its favorable tone.[67] We do not know, however, precisely what Monet liked: whether it was Chesneau's positive words on Monet himself or on the exhibition as a whole,

or whether it was his understanding of Impressionism, and, if so, whether Monet approved the critic's statement about the problems of depicting fleeting phenomena or the role of memory. One would hope it was both together.

Monet was a great self-advertiser and spokesman for a particular view of Impressionism. In the first interview he ever gave (and in probably every succeeding one) he stressed the role of plein air, of painting outdoors from beginning to end. When Emile Taboureux sought him out in Vétheuil in 1880, Monet responded with willful exaggeration and, one presumes, a self-congratulatory humor, to Taboureux's request that Monet show him his studio: " 'My studio! But I have never had a studio, and I don't understand why people close themselves up in a room. . . .' And with a gesture broad as the horizon, pointing to the Seine shot through with the golds of the setting sun . . .: 'There is my studio'."[68] That was Monet's public stance. But it was just at this time, in the early 1880s, that he began increasingly to make it clear, in the private medium of his letters, that work in the studio, work based on memory, was an essential part of his task.[69] Hence the hope exists that Monet liked Chesneau's article with its description of the Impressionist's operation because it did indeed recognize the fullness of his art. We are encouraged to think so by a remark of Pissarro's made the following year. It does not speak directly to the question, nor is it without rhetorical flourish, but it points to the broader dimension of Impressionism as the artists themselves seemed to understand it. In a letter to Lucien, 28 February 1883, Pissarro disapproved the "estheticism" associated with Whistler and rejected the label for Impressionism: ". . . Impressionism should be nothing more than a theory purely of observation, without sacrificing fantasy, freedom, grandeur, in short, all that makes for great art, . . ."[70] Impressionism *was* an art of observation, great enough to include the action of fantasy, of memory, and the aspiration to grandeur. It was an art of the *most probing* observation, one that could not be confined, as Chesneau came to realize in 1882, by his earlier view of the "fugitive"; it had to be free to be elaborated in duration. The paintings of Monet and Pissarro that were shown at the exhibition of 1882 underscore this essential aspect of Impressionism, one that became all the clearer as the tendency towards the revision and consolidation of Impressionist practice proceeded during the course of the 1880s.

Monet's contribution to the seventh exhibition ranged from riverscapes of Vétheuil in summer, winter scenes of the break-up of the ice and of floodwaters, gardens, still lifes (including the extraordinary, deliberately painted group of gamebirds he had done at the close of a series of still lifes, begun the fall of 1879 as a species of memorial to his dead wife Camille; *fig.6*), to seascapes of Normandy

fig. 9 Claude Monet, *La mer du haut des falaises* (*The Sea Seen from the Cliffs*, VII–67), 1881. Oil on canvas, 23 ⅝ x 29 ½ in. (60 x 75 cm). Private collection, England. Photo: Courtesy Wildenstein and Co.

painted from the beach at Les Petites-Dalles and from the cliff tops at Fécamp and Grainval. Of especial interest was the juxtaposition of two large winter views of the Seine at Vétheuil. *Les glaçons* (cat. no. 120) had been submitted to the Salon of 1880, when Monet had decided to attempt a return to that institution; it was rejected by the jury, while a second painting, *Lavacourt* (*fig.7*), a summer view looking across the river from Vétheuil, was accepted, evidently because of its greater deliberateness in the definition of form and elaboration of space. At the time that he submitted *Les glaçons* and *Lavacourt* to the Salon he mentioned in a letter a third painting, *Soleil couchant, sur la Seine, effet d'hiver* (cat. no. 121), which he decided not to send because, he wrote, the Salon required "something more discreet and more bourgeois." The *Soleil couchant*, he said, "is too much to my taste to send, and it would be refused."[71] When, in June 1880, he had a solo exhibition at the gallery of *La vie moderne*, he exhibited his rejected *Les glaçons* but still held back *Soleil couchant*. It was only with his return to the Impressionist shows in 1882 that he placed *Soleil couchant* before the public, specifically urging its inclusion, along with *Les glaçons*, while directing Durand-Ruel not to show *Lavacourt* (which Durand owned and presumably would have wished to include).[72] As seen at the exhibition, *Les glaçons*, with its perfectly centered perspective and calibrated recession of ice floes, its rather ingratiating pink and blue palette, represented the more "discreet" version of the wintry setting. *Soleil couchant*, not sufficiently "bourgeois" for the Salon but suitable for the group show, was painted more summarily, in a manner marked by staccato linear accents that establish an energy independent of the picture's descriptive naturalism.

It was as if Monet were still experimenting with the nature of the painted sketch, exaggerating its action as he sought to blow it up to large scale. Other works in the exhibition, smaller in size, seemed to develop the sketch at a high velocity, as if the artist was attempting to paint as quickly as would be required to capture the fleeting phenomena of light and atmosphere that Chesneau referred to as characterizing the world of immediate appearances. It was as if the artist wished to see if he could ply his brush as rapidly as the waves crashed against the cliff walls (*fig.8*), or, by a more delicate manipulation of the wrist, to catch with the brush the curl of grasses or leaves in the river's breeze.[73] Those paintings constitute a rare effort to adopt Impressionist technique to that aspect of Impressionist theory to which Chesneau had contributed in 1874 and that had quickly entered into the critical appraisal of Impressionism thereafter.[74] In these works the notion of Impressionist spontaneity, the interest in capturing the instant, come as close to realization (without, of course, meeting that impossible goal) as in any works from the Impressionist period.[75] They should hold a special place within the Impressionist canon.

Along with *Soleil couchant* and *Les glaçons*, Monet stressed the inclusion in the exhibition of the seascapes he had done the year before at Fécamp. They constituted his newest preoccupation, one which he was at that time (in February 1882) elaborating further in his pictures of Dieppe and Pourville.[76] The paintings of Grainval (cat. no.122) and Fécamp (*fig.9*) represent another facet of Monet's work, his effort to paint more deliberately and develop more challenging compositional structures. Building from his experience of the sites, viewed from a variety of vantage points upon the seaside cliffs (and possibly from his awareness of earlier pictures with similar designs by Millet),[77] he arranged the rocky slopes running up one side of the canvas, creating broad divisions of land and sea, the curve of the cliffs reaching out to clasp the sea in a parenthetical embrace. Within the broad flat shapes he created, especially in the rocky, grassy areas of the cliffs, he would employ his brush inventively in response to the variegated colors he found in the natural setting. In the four Fécamp seascapes at the exhibition he transformed his active observation and comparison of weather, tide, light, and atmosphere into delicate nuances of hue and value, while the topography of the setting was made to conform to changes in shape of canvas. The combinations of precipitous view and decorative harmony, of natural circumstance and esthetic determination, is established with exquisite resolution in these compositions. The Fécamp pictures represented Monet's most advanced work, the kind of painting he was attempting to do again on the cliffs and beaches at Pourville at just the moment Pissarro, Caillebotte, and Durand-Ruel were seeking his support for the show. They point a new direction, to a concern for an estheticizing of nature and experience that came increasingly to the fore, not only in his work, but more generally in the art of the 1880s and 1890s.

Pissarro, too, had begun to evidence a range of new interests in his paintings around 1880. Most striking in the formal sense is the elaboration of a fine-grained, multi-hued color application and distribution, the result in good part of an enlivening interest in color theory.[78] The complex build-up of small, irregular strokes yielded increasingly a heavily-textured granular surface that attested to the long deliberation that went into the execution of each painting, a factor further indicated by the decrease, beginning in 1880, in the number of paintings he produced each year.[79] Although his commitment to outdoor painting continued—and his concern for plein-air effects of color went hand in hand with his interest in color theory—the evidence of a rapid, responsive facture diminished, even though never a major aspect of his work. There is little reason to doubt that Pissarro, as did Monet and Renoir, spent more and more time in the studio, elaborating, refining, and perhaps belaboring, his work.

The content of his paintings also began to evidence change about 1880. In 1879 he had begun to give an enlarged role within the landscape to peasant figures shown at various tasks—washing, carding wool, sawing wood, reaping, plowing, and sowing in the fields. He showed a number of these pictures at the Impressionist exhibitions in 1880 and 1881, but in 1882 three-quarters of his entries had peasant subjects. Moreover, his approach to his subjects had changed. The figures, mostly peasant women, many still adolescent girls, were increased in size and became the focus of the pictures. But the character of their activity was different: rather than working, the figures were shown as oddly abstracted from labor, as idle, resting, gazing, or in subdued conversation. Daydream, reverie, musing, and meditation are words that may reasonably characterize their attitudes; resignation, desire, contentment, and (a sometimes seemingly sexual) longing describe their emotional states.

Form and content join in the slow tempo of these scenes. The ponderated, slow build-up of paint, the detailed application of thick pigment, seems fitting. The figures, not called upon to act within the landscape, are depicted as broad, clearly contoured, and somewhat flattened; they are set in harmony with the similarly treated forms of the closed-in, almost invariably horizonless terrains. The play of light unites the figures with their settings, as does a relatively consistent textural treatment that works along with the broad forms to flatten space and create a decorative image, artificial in form and, iconographically, impregnated with the quality of stasis and the mood of reverie.

UNE VISITE AUX IMPRESSIONNISTES

PAR DRANER

Draner, "Une visite aux impressionnistes," *Le Charivari* (9 March 1882)

The genre is perhaps epitomized by *La bergère* (fig.10). The scene is spatially unclear; the actual slope of the ground in relation to the tree and its overhanging foliage is made deliberately obscure, or seen as not mattering. The adolescent girl is sprawled upon the textured ground, her torso all but unarticulated at the waist, the shape of figure against the shape of ground, like Monet's shapes of cliffs against the sea. Dappled light unites figure and ground, as does the twig in the young girl's hand, stitching the patch of blue skirt to the quilted grass. The twig plays idly, an index to her mood. Here one finds a suggestion of adolescent awakening to body and self, confirmed perhaps by the homespun red of the stockings, which, in this context, contains a hint of coquetry. The meditative mood was conveyed in other pictures in the exhibition: *Etude de figure en plein air, temps gris* (VII–103; Pissarro and Venturi, 541) and its companion piece, *Etude de figure en plein air, effet de soleil* (cat. no.125); *Laveuse, étude* (cat. no.126); *Jeune paysanne prenant son café* (cat. no.127); and *Jeune paysanne au chapeau* (cat. no.128).[80]

Jeune paysanne prenant son café, the most popular of Pissarro's entries in 1882, well illustrates his feeling for mood and structure. The young woman (it is difficult to gauge her age) spoons the liquid at the bottom of her cup as if mesmerized by the act, whose mechanical nature provides an occasion for fanciful musing. Several repeated verticals at the left side of the picture introduce a compositional stability that is then furthered as the vertical spoon links to the horizontal of the right forearm and is paralleled by the upper arm and chair back at the right edge. Within this rectilinear organization the large curve of the woman's body is strongly set against the space of the room, disguising its angled recession; behind the woman the dark wall seems oriented to the broad plane of her body and of the canvas itself. Once again, Monet's paintings of the great curving forms of cliffs against the sea at Fécamp, which were hanging nearby in the exhibition, are called to mind, and one becomes aware of the shared decorative interests that had come to mark the work of both artists at this time.[81]

Together, Monet's artful designs at Fécamp and Pissarro's considered canvases of peasant subjects confirm an orientation of Impressionism that had been overlooked in the emphasis upon plein-air practice and the capturing of the fugitive, the instant, things in movement. Those *were* important elements of Impressionism; the effort that began in the late seventies, to work on canvases only when conditions of light and weather were consistent from one painting session to another, served to underline the commitment to record the observable and the short-lived. The devotion to plein air permits rapid, responsive recording (however generalized it might be). It also allows for prolonged and repeated scrutiny, perceptual

search, and opportunities for correction, both outdoors and in the studio. Pissarro acknowledged his commitment to a long, considered process of work, precisely in relation to the two paintings that we have singled out, *La bergère* and *Jeune paysanne prenant son café*. In 1883, after the pictures appeared in an exhibition mounted by Durand-Ruel in London, he wrote to his son Lucien about the poor reception they received there:
You tell me that if I have a show in London I should send my best works; that sounds simple enough, but when I reflect and ask myself which are my best things, I am in all honesty greatly perplexed. Didn't I send to London the Peasant Woman Taking her Morning Coffee near a Window *and the* Girl with a Stick *[La bergère]? Alas, I shall never do more careful, more finished work. . . . it is only in the long run that I can expect to please, provided those who look at my pictures have a grain of indulgence; but the eye of the passerby is too hasty and sees only the surface. . . .*[82]

Pissarro and Monet were severe critics of their own art. Monet wrote in 1879 to Ernest Hoschedé, at a time when he was being criticized in the press for painting too hastily and settling too easily for mere sketches, "I alone can know the inquietude and the trouble that I give myself in order to finish canvases that do not satisfy me and that please so few people."[83] Neither Monet nor Pissarro are explicit, in these remarks, about working procedure, but we do possess the testimony of Monet's letters about his extended process of work at both site and studio.[84] That is also the message of Pissarro's paintings—thick, clotted records of the durational process that lay behind his "careful," "finished" work.

Both Monet's paintings, in their firm design and complex surface working, and Pissarro's deliberative canvases take us well past an emphasis upon the capture of the fugitive as it had come to be formulated in Duret's understanding of "primordial" Impressionism. They accord more closely with the idea, proffered by Chesneau, of incorporating the record of memory. Or, to generalize from Chesneau's lead, their paintings emerged from cumulative awarenesses that evolved both within and beyond the locus of plein-air activity. If, to that, we add the crucial element involved in the activity of painting itself—the artist's practical working out of his concerns for technique and style, process, and product—then we possess the necessary ingredients for grasping the work, and the nature of the work, adequately.

The exhibition of 1882 would have been much richer with the inclusion of Degas and Cassatt, and the parameters of Impressionism for those who saw it and thought about it would have been consequently enlarged. But the return of the leading colorists was necessary if a sufficient picture of the experimental fervor and accomplishment of the painting associated with the movement was to be made available. The insistence on talent, the search for

"pure art," and the economic pressures that ultimately determined the exhibition's shape were both prejudicial and liberating. In the direction it took, the show promised a glimpse of Impressionism in what had come (in overdetermined fashion) to be considered its pure form; but that form proved to be various, changing, and uncontrollable by any guiding view of esthetic purity.

The Seventh Impressionist Exhibition, although it emerged from an atmosphere of contention and indifference, succeeded in confirming the primary value that the shows had from the first. It provided, despite its serious exclusions, an otherwise unavailable forum for a collective demonstration of the most advanced, thoughtful, and experimental art being produced at the time.

Notes

All translations are author's unless otherwise indicated.

1. Ernest Chesneau, "A côté du Salon. II.—Le plein air, Exposition du boulevard des Capucines," *Paris-Journal*, 7 May 1874. Reprinted in Anne Dayez et al., *Centenaire de l'impressionnisme*, exh. cat. (Paris: Grand Palais, 1974), 270.

2. Monet to Durand-Ruel, 10 February 1882, Daniel Wildenstein, *Claude Monet: Biographie et catalogue raisonné*, 2 vols. (Lausanne and Paris, 1979), 2:214, letter 238.

3. Lionello Venturi, *Les archives de l'impressionnisme*, 2 vols. (Paris, 1939), 1:122.

4. Pissarro to Monet, about 24 February 1882, *Correspondance de Camille Pissarro, 1865–1885*, vol. 1, ed. Janine Bailly-Herzberg (Paris, 1980), 155, letter 98.

5. Pissarro to de Bellio, 26 March 1882, Bailly-Herzberg, 162, letter 104.

6. Henry Havard. See Seventh Exhibition review list in Appendix for complete citation for this and all other reviews.

7. Joris-Karl Huysmans review, 285.

8. *The Correspondence of Berthe Morisot*, ed. Denis Rouart, trans. Betty Hubbard (London, 1957), 112.

9. Huysmans review, 285–286, 290–293.

10. See Huysmans, *L'art moderne*, for the collected reviews from 1879 through 1881.

11. *Les peintres français en 1867* (Paris, 1867), 21.

12. "The Death of History Painting in France, 1867," *Gazette des Beaux-Arts*, 6th ser. 100 (December 1982):221–224.

13. Théodore Duret, "Salon de 1870," in *Critique d'avant-garde* (Paris, 1885), 15–16.

14. Duret, "Les peintres impressionnistes," in *Critique d'avant-garde*, 57–89.

15. "Les peintres impressionnistes," 80. Duret also states that Cals, Rouart, and Degas are not Impressionists, even though they have exhibited with the group, 83–84.

16. Morisot, *Correspondence*, 112.

17. Emile Cardon, "L'exposition des révoltés," *La Presse*, 29 April 1874; Jules Castagnary, "L'exposition du boulevard des Capucines. Les impressionnistes," *Le Siècle*, 29 April 1874; Chesneau, "A côté du Salon"; Marc de Montifaud, "Exposition du boulevard des Capucines," *L'Artiste* (1 May 1874). Reprinted in *Centenaire de l'impressionnisme*, 262–270.

18. Ed. Marcel Guérin, new ed. (Paris, 1946). For more on the role of *La nouvelle peinture*, see Marcel Crouzet, *Un méconnu du réalisme: Duranty* (Paris, 1964), 332–344; Joel Isaacson, *The Crisis of Impressionism 1878–1882*, exh. cat. (Ann Arbor: University of Michigan Museum of Art, 1980), 15–17; John Rewald, *The History of Impressionism*, 4th rev. ed. (New York, 1973), 376–378.

19. Caillebotte to Pissarro, 24 January 1881, Marie Berhaut, *Caillebotte, sa vie et son oeuvre* (Paris, 1978), 245–246, letter 22.

20. Pissarro to Caillebotte, 27 January 1881, Berhaut, 246, letter 23.

21. *Archives de Camille Pissarro*, sale cat., Hôtel Drouot, 21 November 1975 (Paris, 1975), lot no. 33: "A la salle Valentino on a fait un panorama sur cette portion de terrain quelqu'un a installé une grande et belle salle pour des expositions de peinture . . . il est venu un individu me proposer de prendre à sa charge . . . notre exposition. Je crois que si Degas ne met pas trop de bâtons dans les roues c'est une occasion superbe pour faire notre exposition (jour et soir à la lumière). Pour ma part je trouve la proposition excellente. Il nous offre la location pour un prix de 6 à 8000 F *frais faits par lui*, et au dessus de ce chiffre partager les entrées . . . En outre l'exposition dans une salle aménagée pour cela est bien préférable à celle faite dans des petits appartements . . ." The following discussion of preparations for the 1882 exhibition amends in detail the earlier accounts upon which it is largely based: see Rewald, 464–73, and Isaacson, *Crisis*, 24–27.

22. Oscar Reuterswärd, *Impressionisterna inför Publik och Kritik* (Stockholm, 1952), 233, note 1, says that the hall, called the Panorama Room, was leased for the season by Henri Rouart and his brother Ernest, who rented it to several exhibiting organizations. Prior to the *Indépendants* came the French Society of Landscape Painters, and immediately following them was the Society of Animal Painters. (See also reviews by Charles Bigot and Albert Wolff.) Reuterswärd describes the Rouarts' role without providing documentation, but the fact that Henri Rouart paid the rent for the Impressionists' show lends credence to Reuterswärd's information, and thus to the identification of Rouart as Gauguin's angel in November. I would like to thank Valerie Meyer for her translation from Reuterswärd's Swedish.

23. Morisot, *Correspondence*, 109. Reuterswärd, 135, says that Durand-Ruel hired the hall, possibly basing his statement on the claim made by Paul Durand-Ruel in his memoirs; see Venturi, 2:212. I believe, however, that we may view Durand-Ruel's as a faulty recollection after many years had passed and accept the word of Eugène Manet.

24. Gauguin to Pissarro, 14 December 1881, *Archives de Camille Pissarro*, lot 34: "Malgré toute ma bonne volonté je ne puis continuer plus longtemps à servir de bouffon à Mr Raffaeli [sic] Cie veuillez donc accepter ma démission; . . . je crois que Guillaumin est dans les mêmes intentions que moi mais je ne veux nullement peser sur sa décision. . . ."

25. *Archives de Camille Pissarro*, lot 37: ". . . un autre résultat qui m'inquiète c'est l'exposition. . . . tout dort nous avons un engagement de 6000 F sur les bras, la brouille la plus complète dans le ménage et rien de résolu."

26. *Archives de Camille Pissarro*, lot 38: ". . . Si vous abandonnez la partie vous pouvez dire que c'est bien fini. Degas peut en parler à son aise car il ne se retire pas du tout dans son trou sa réputation est faite et n'est pas à faire il a son monde pour le soutenir et même l'académie qu'il blague est toute prête à lui tendre les bras . . . Voyez Caillebotte et organisez-vous pour exposer *cette année* . . . si Caillebotte ne veut pas de moi je vous donne *autorisation* pleine l'essentiel c'est que les *impressionistes* [sic] exposent parce que plus tard on pourra voir qui on veut . . . De toutes façons *Degas voulait* depuis deux ans s'en aller seulement au fond il ne voulait pas s'en aller *seul* il tenait à faire tomber tout avec lui. Faites l'exposition à cinq si vous voulez, vous Guillaumin Renoir Monet et Caillebotte mais faites-la, vous savez il y va de votre avenir. . . ." Gauguin reveals in these letters a more passionate conviction of the importance and potential efficacy of the Impressionist shows than do any of the other painters, including Pissarro and Caillebotte. One wonders whether, in view of his experience as a stockbroker, he felt a particular sense of urgency because he realized more than did the others the implications of the Union Générale's failure. The insurance company for which Gauguin worked went out of business as a result of the sudden downturn, throwing Gauguin out of work and very likely fueling his driving interest in the formation of a new exhibition for the following year; see lots 40, 41.

27. Pissarro visited Monet in early February; see Morisot, *Correspondence*, 104. Although none of Pissarro's letters to the others remains, their responses to him attest to his activity: see Monet to Pissarro, 9 February 1882, Wildenstein, 2:214, letter 237; and Caillebotte to Pissarro [11–12 February 1882], Berhaut, 246, letter 25. As evidence of Durand-Ruel's activity, see Monet to Durand-Ruel, 10 February 1882, Wildenstein, 2:214, letter 238.

28. Caillebotte to Pissarro [12–15 February and 18–19 February 1882], Berhaut, 246–247, letters 26, 27.

29. Renoir to Durand-Ruel, 24 and 26 February 1882, Venturi, 1:119–122, letters 9, 10. In a first draft of letter 10, 26 February, Renoir was much more blunt about his attitude towards Pissarro, whom he linked with Gauguin and Guillaumin as socialists and revolutionaries (see epigraph above and note 3).

30. For a clear sense of the importance of Durand-Ruel's support, see the letter from Pissarro to Esther Isaacson, 4 January 1881, in Bailly-Herzberg, 142, letter 84: "Durand-Ruel un des grands marchands de Paris est venu me voir et m'a pris une grande partie de mes toiles et aquarelles, et me propose de prendre tout ce que je ferai. —C'est la tranquillité pour quelque temps, et le moyen de faire des oeuvres importantes."

31. Morisot, *Correspondence*, 104.

32. In his memoirs, Durand-Ruel recalled the event as directed uniquely by himself to improve the Impressionists' position vis-à-vis the public and claimed that he succeeded in passing off the exhibition as a continuation of the Impressionist group shows with that calculation in mind; Venturi, 2:212.

33. Bailly-Herzberg, 155, letter 98.

34. Durand-Ruel's purchasing activity did not decrease significantly through the remainder of 1882 and 1883 despite his financial setback. In 1882 he acquired more than forty paintings by Monet and half that number from Sisley. In 1883, when he held solo exhibitions for many of the artists, he bought more than thirty Monets and at least ten Sisleys. These are minimum figures based on the provenance records in Wildenstein, vols. 1, 2, and François Daulte, *Alfred Sisley, catalogue raisonné de l'oeuvre peint* (Lausanne, 1959).

35. Morisot, *Correspondence*, 109. No other exhibitions in France could, or attempted to, match the Impressionist exhibitions for the extraordinary opportunity they gave to artists to show the bulk of their current production in a collective setting. Nor have they served as a model for the twentieth century, which for the most part has offered no parallel opportunity. Durand-Ruel's individual exhibitions, four of which were held at his gallery the following year, permitted a very extensive display of a single artist's work, but shorn, of course, of the possibility for comparative assessment and collective demonstration.

36. Bailly-Herzberg, 155, letter 98. Monet, too, came to Paris from Pourville to participate in last-minute arrangements; Monet to Durand-Ruel, 24 February 1882, and to Alice Hoschedé, 5 March 1882, Wildenstein, 2:216, letters 250, 252.

37. Gaston Vassy, writing under the pseudonym of Fichtre (see bibliography). Reuterswärd, 136, reports that there was an opening for invited guests to witness the final preparations on 28 February. Vassy's visit and that of Paul de Katow would seem to confirm it.

38. Wildenstein, 2:4–5. Jules Claretie and Philippe Burty in their reviews both referred to the juxtapositional irony. The spaciousness of the hall was mentioned by Havard and Armand Sallanches. Reuterswärd (135, 140) says that the building had been designed by Charles Garnier in the early seventies for the Panorama and that it was the now disused panorama hall itself that served for the exhibition.

39. Unless otherwise specified the following information on exhibition arrangements, frames, prices, attendance, and receipts is drawn from Eugène Manet's reports in *The Correspondence of Berthe Morisot*, 104–113.

40. Alexandre Hepp in a review mentioned Gauguin's white frames. Pissarro probably used them, as well, along with colored frames, as at the sixth exhibition the previous year. On gold frames, see Bigot and Burty.

41. Burty, Fichtre, and Sallanches reviews. Huysmans had noted in 1881 the practice adopted from the English of attempting to correct for the unwanted shine of varnish by leaving the painted surface matte and covering the painting with glass. He found the result to be "woolly and dull" (*laineux et terne*); "L'exposition des indépendants en 1881," in *L'art moderne*, 275–277.

42. Boudin to Martin, March 1882, in Georges Jean-Aubry, *Eugène Boudin* (Paris, 1922), 88.

43. Monet to Alice Hoschedé, Wildenstein, 2:216, letter 255bis; Barbara White, *Renoir. His Life, Art, and Letters* (New York, 1984), 124.

44. Pissarro to de Bellio, 26 March 1882, Bailly-Herzberg, 162, letter 104. Trans. Rewald, 471.

45. Pissarro to Esther Isaacson, 20 March 1882, Bailly-Herzberg, 160, letter 103.

46. Huysmans review, 287–288.

47. Negative: Burty, Leroy, de Nivelle. As a curiosity: Hustin, Rivière. Original: Sallanches.

48. Burty, informing his readers that Renoir was away from Paris, said Renoir would not have tolerated having on exhibition all that was taken from his deserted studio.

49. Burty, Hepp, de Nivelle, Silvestre, and Wolff reviews. Eugène Manet wrote to Morisot, "The views of Venice are detestable, real failures"; Morisot, *Correspondence*, 106.

50. The painting received high praise from Burty, Hustin, Huysmans, de Katow, Sallanches, and Silvestre in their reviews.

51. Louis Leroy review. The other favorable critics were de Charry, Chesneau, Hennequin, and Sallanches. Two other carefully worked figure paintings were favorably reviewed: *Jeune fille au chat* (cat. no. 129), the only painting in the exhibition to have been shown previously at the Salon, where it had appeared in 1880, was commended by de Charry and Chesneau; and *Les deux soeurs* (*On the Terrace*, Art Institute of Chicago), mediating between academic drawing and Impressionist color, was praised by Hustin and de Katow.

52. De Charry, de Nivelle, and Silvestre reviews. The least favorable comments were by Wolff, who referred to poor drawing, and Huysmans, who, somewhat oddly, felt it had too little of the flavor of Paris, the women too much like a group of English harlots just disembarked at the site (Huysmans, 290).

53. Fichtre review.

54. For the proposed identification of *La Seine à Chatou*, no. 154 in the 1882 show, with the *Seine at Chatou*, now in Boston, see John House et al., *Renoir*, exh. cat. (London: Hayward Gallery, 1985), 227, no. 57.

55. Huysmans review, 291. Hepp praised the robustness of Pissarro's peasants, "true women of Millet, women of the fields." Silvestre compared the paintings to the work of Millet and noted their rustic truth. Burty and Havard also made the comparison to Millet.

56. Huysmans review, 292–293. Of fifteen reviews that cited his work, Pissarro received positive endorsements from ten (Burty, de Charry, Chesneau, Fichtre, Hepp, Hustin, Huysmans, de Katow, Sallanches, Silvestre), a mixed response from three (Hennequin, Leroy, Rivière), and a negative appraisal from only two (Havard and de Nivelle). For Sisley, nine critics were distinctly favorable (*L'art moderne*, Burty, de Charry, Chesneau, Hepp, Huysmans, de Katow, Rivière, Silvestre), four were qualified (Havard, Hustin, de Nivelle, Sallanches), and two negative (Fichtre, Wolff).

57. In 1876 several writers–Duranty, Fromentin (as cited by Duranty), Mallarmé, Silvestre, and Zola (see Duranty and Mallarmé essays in this catalogue)–noted the relationship between plein-air practice and the new tonal range of Impressionist painting, and it was a key point in Duret's *Les peintres impressionnistes* in 1878; see *Critique d'avant-garde*, 64–66. Huysmans in 1879 and 1880 argued that plein-air painting led to a reaction against studio conventions (*L'art moderne*, 44, 99–102), a view offered in 1880 also by Ephrussi and Zola (for these citations see note 74).

58. See the reviews of Havard, Hustin, de Nivelle, and Wolff.

59. A very similar distinction had been made in 1876 by Mallarmé, who wrote that he would leave to sculpture the depiction of mass and solidity; Impressionism properly concentrates on the impermanent–and authentic–in nature, "the Aspect." The key to the Impressionist effort, he felt, was a concentration on "an original and exact perception"; see the final paragraph of Mallarmé's "The Impressionists and Edouard Manet," reprinted in this catalogue. In 1878 Duret would write that the painter "ne reproduit que ce qu'il voit," but when he did so he spoke of it in the sense of painting that which is before the eye, identifiable and verifiable. He continued a doctrine of Realism that is not yet concerned with the phenomenological distinction between seeing and knowing; *Critique d'avant-garde*, 69. For a discussion of the history of the dichotomy between seeing and knowing and some of the salient issues involved in their relationship, see E. H. Gombrich, *Art and Illusion* (New York, 1960).

60. "The Impressionists," *The Standard*, 1 July 1882, in *Impressionists in England. The Critical Reception*, ed. Kate Flint (London, 1984), 45.

61. Chesneau: "L'effort des préraphaélites anglais, qui s'attachent avec une extraordinaire passion à traduire dans ses détails les plus minutieux la nature *comme elle est* nous paraît légitime et répond à certains besoins de notre curiosité esthétique, comme répond à d'autres besoins et est au même titre légitime l'effort des impressionistes [*sic*] français s'attachant avec une égale passion, avec une égale conviction à traduire non plus la réalité abstraite de la nature, non plus la nature *comme elle est*, comme la peut concevoir l'intelligence du savant, mais la nature *comme elle nous apparaît*, la nature telle que la font pour notre oeil, s'il sait voir les phénomènes de l'atmosphère et de la lumière."

62. Chesneau: "Or ces phénomènes sont essentiellement inconstants. De toute nécessité le peintre est forcé de les saisir dans les rapides moments de leur durée. Ils ne subsistent pas en soi comme la réalité abstraite; ils passent, ne laissant qu'une impression sur notre rétine et dans notre mémoire qu'un souvenir, celui d'un enchantement de mouvements et de couleurs. Voilà ce que les peintres bien nommés 'impressionnistes' aspirent et réussissent à nous rendre; c'est ce souvenir qu'ils veulent et savent fixer."

63. Chesneau, 1874, 269: ". . . jamais l'insaisissable, le fugitif, l'instantané du mouvement n'a été saisi et fixé dans sa prodigieuse fluidité, comme il l'est . . . dans cette merveilleuse ébauche. . . ." In the same year Burty wrote of the Impressionists' effort to capture the most

fugitive sensations (*Centenaire de l'impressionnisme*, 261–262), and Armand Silvestre wrote in a similar vein of the "impression instantanée" that Manet sought to convey in *Le chemin de fer*, which appeared at the Salon of 1874; Jacques Lethève, *Impressionnistes et symbolistes devant la presse* (Paris, 1959), 73.

64. Chesneau's introduction of the role of memory into the understanding of Impressionist procedure may be considered in conjunction with an observation made by Huysmans two years earlier in his article on the Fifth Impressionist Exhibition. Although the tone of his review was sharply negative, Huysmans conveyed a fine awareness of the compound process in which the painter was necessarily engaged; he wrote disparagingly of the Impressionist's attempt to recapture on his canvas, once removed from the site, what he had originally seen in nature, "a certain tone perceived, and as if discovered, one beautiful day, a certain tone that the eye succeeds in seeing again, under pressure of the will, even when it no longer exists." (". . . l'entêtement si humain de ramener à un certain ton aperçu et comme découvert, un beau jour, à un certain ton que l'oeil finit par revoir, sous la pression de la volonté, même quand il n'existe plus. . . .") Huysmans found the Impressionists maladroit in part because they labored under such an unfortunate constraint, but he did recognize that such constraints existed. *L'art moderne*, 103; see also Joel Isaacson, *Claude Monet: Observation and Reflection* (Oxford, 1978), 24. Mallarmé seems to have recognized such constraints as well. At the conclusion of his essay on "The Impressionists and Edouard Manet" of 1876 (reprinted in this catalogue), he speaks of the fugitive aspect of nature mirrored by painting through "the will of Idea." In an earlier passage, about the meaning of which we are less certain, because unsure of the reliability of the English translation from the (now lost) French original, Mallarmé writes of Monet, Sisley, and Pissarro as producing "instantaneous and voluntary pictures"; one wonders whether the French original for "voluntary" might have conveyed the sense of willed, planned, or purposeful, a reading suggested by his referring to the paintings as "harmonious" (i.e., brought into harmony) and his mention of the "real or *apparent* promptitude of labour" that went into them (italics added). In his retranslation of the essay into French, Philippe Verdier casts the phrase as "instantanés et spontanés," a reading more to be expected, perhaps, but one that does not jibe with Mallarmé's characterization of these paintings as susceptible to being spoiled by one "touch more or less"; "Stéphane Mallarmé: 'Les Impressionnistes et Edouard Manet' 1875–1876." *Gazette des Beaux-Arts*, 6th ser. 86 (November 1975): 156, 154.

65. Richard Shiff has recently referred to Chesneau's observations in the course of an omnibus review of several books on Pissarro, in which he includes a discussion of the relationship between Impressionist theory and practice, and the issue, in particular, of the possibility of depicting "visual reality"; see his "Review Article," *The Art Bulletin* 66 (December 1984):686–687. Shiff confines himself to Chesneau's dichotomy, nature *as it is*/nature *as it appears to us*, and notes the uncertainties of meaning in that conjunction, particularly in the second of the two terms. What does "*as it appears to us*" mean? Is it a question of nature more or less matter-of-factly shared by all of us in ordinary perception, or is it nature "in the act of appearance" (Shiff), in which case, I take it, the emphasis is placed on the existential relationship, now seen as unique, between the experiencing individual and natural phenomena? Shiff asks whether Chesneau intends one or the other and challenges us to deal with the implications of the alternative meanings. He finds Chesneau's terminology to be ambiguous (I actually prefer Shiff's immediately preceding choice of the different word "ambivalent," for I imagine Chesneau was not entirely certain of his understanding of the matter). I suspect that Chesneau included both the ordinary, empirical sense and the unique, phenomenological one in his formulation. But the emphasis was overridingly on the latter, on nature in the act of appearing to an experiencing individual, is made manifest by the rest of Chesneau's discussion presented here. The process of the witnessing of fugitive effects retainable only in memory (the trace on the retina is, after all, but of the moment), and of the recapturing in representation of (whatever portion of) that memory, requires indeed, as Shiff suggests, "phenomenological research."

66. Observation is primary in that it provides the locus of visual reference, without recourse to which the resultant painting would be a different picture. But observation may nevertheless be preceded by other processes or factors, e.g., emotion, intention, and idea.

67. Monet to Durand-Ruel, 14 March 1882, Wildenstein, 2:216, letter 254. See also letter 255 to Alice Hoschedé.

68. Emile Taboureux, "Claude Monet," *La Vie Moderne* 2 (12 June 1880):380. In his "Review Article," Richard Shiff distinguishes between what might be considered the logic of Impressionist theory and the rhetoric of Impressionist painting. In this dichotomy, we may expect to find in theoretical statements a logical consistency but should accept that painting is a "rhetorical medium," "free to prepare, deliberate, and dissemble" in order to achieve its goal of persuasion, in Impressionism's case, of the "originality or sincerity of its vision" (686). It is not clear from Shiff's account whether Impressionist theory derives from the painters' own indications or from the critics'; presumably he includes both sources. If, to respect the limitations of this note, we confine ourselves to the words of the painters, we must recognize, as in the case of Monet's interview with Taboureux, that we are dealing with a rhetoric and not a logical, or even reliable, theoretical proposition. There is no reason to expect the artists—nor any necessary reason to expect the critics—to offer logical propositions or consistent statements about intent or practice. Monet, for whatever reasons, wished to establish a public persona and create a view of his enterprise that need not be taken as consistent with his practice (see following note). To make use of Shiff's terms, albeit all too briefly, we may suggest that they be reversed, that we recognize the rhetoric of Impressionist theory and the logic of Impressionist painting. We should see Impressionist painting not as a painting calculated to persuade its audience that it is or refers to the spontaneous (Shiff, 687–688 et passim), but as a painting built upon a consistent practice, proceeding from its origins before the motif through stages of responsive, inventive, transformative work, whether at site or studio. At its termination, it should be recognized for what it is: partly a representation and wholly an artificial entity called a painting.

69. In the fall of 1882, Monet began to speak repeatedly of his practice of finishing work in the studio; see Wildenstein, October 1882–August 1883, 2:221, letters 295–296; 223, letters 313, 316; 224, letter 318; 225, letters 324–325; 230, letters 366–368; and 231, letter 371. The practice is implied as well in the first mention in the letters (25 March 1882, at the time of the seventh exhibition) of his incipient series practice, of his wish to see all his Pourville paintings together in the studio at Poissy before delivering them to Durand-Ruel: ". . . je préférerais vous montrer toute la série de mes études à la fois, désireux que je suis de les voir toutes ensemble chez moi" (2:217, letter 260).

70. Pissarro to Lucien Pissarro, 28 February 1883, Bailly-Herzberg, 178, letter 120: ". . . l'impressionnisme ne devait être qu'une théorie purement d'observation, sans perdre ni la fantaisie, ni la liberté, ni la grandeur, enfin tout ce qui fait qu'un art est grand, . . ."

71. Monet to Duret, 8 March 1880, Wildenstein, 1:438, letter 173.

72. Monet to Durand-Ruel, 23 February 1882, Wildenstein, 2:216, letter 249.

73. Other works of this genre at the seventh exhibition were no. 63, *Femme lisant dans un jardin* (Wildenstein 681); no. 71, *Inondation* (W. 642); no. 73, *Falaises des Petites-Dalles* (fig.8; W. 621); and no. 83, *Le matin au bord de la mer* (W. 651). See also W. 611–613, 623–624, 646, 652, 659–663, and 680.

74. See above and note 63. See also Armand Silvestre on Manet, 1874; Ernest d'Hervilly, *Le Rappel*, 1875, in Lethève, 74; Emile Blémont, *Le Rappel*, 1876, in Lethève, 78–79; Mallarmé, "The Impressionists and Edouard Manet," 1876 (reprinted here); Paul Mantz, *Le Temps*, 1877, in Lethève, 84–85; Duret, *Les peintres impressionnistes*, 1878, 101; Emile Zola, "Le naturalisme au Salon," *Le Voltaire*, 19 June 1880, in Zola, *Salons*, ed. F. W. J. Hemmings and Robert Niess (Geneva, 1959), 241; Charles Ephrussi, in the *Gazette des Beaux-Arts*, 2d ser. 21 (1 May 1880): 485–486; in Lethève, 111–112.

75. That the goal is impossible should require no demonstration or defense. In the case of the Monet paintings discussed here, we have an attempt, I believe, to extend the possibility of sketch practice *in the direction of* that goal. The aim would actually be twofold: 1) to create a painting that creates a strong note of the transient and momentary, of things in movement; and 2) to exploit the technique of the sketch in order to make a new formal statement. The second would be the main aim of Morisot, whose brilliant, flashing brushwork was more a matter of stylistic statement and personal autograph than an attempt to capture a sense of the fleeting or of movement.

76. See Wildenstein 2:280-288, letters 708–743.

77. See Millet's *Cliffs at Gruchy*, 1870–1871 (Museum of Fine Arts, Boston); reproduced in color in Alexandra Murphy, *Jean-François Millet*, exh. cat. (Boston: Museum of Fine Arts, 1984), 214, no. 145. Robert Herbert, in lectures, has also referred to and shown similar views appearing in commercial illustration, and these, too, may have been in Monet's mind.

78. On Pissarro's color theory, see Richard Brown, "Impressionist Technique: Pissarro's Optical Mixture," *The Magazine of Art* 43 (January 1950):12–15.

79. From 1877 to 1886 the number of paintings Pissarro produced each year was: 1877–53; 1878–40; 1879–34; 1880–23; 1881–24; 1882–28; 1883–41 (a year that saw a strong return to landscape); 1884–34; 1885–35; 1886–17 (with his conversion to Neo-Impressionism). Figures based on Ludovic Rodo Pissarro and Lionello Venturi, *Camille Pissarro, son art–son oeuvre*, 2 vols. (Paris, 1939).

80. See also Pissarro and Venturi, nos. 101, 110, 112, 120.

81. See Isaacson, *Crisis*, 29, for further discussion.

82. Pissarro to Lucien Pissarro, 20 November 1883, Bailly-Herzberg, 252, letter 190. See also Camille Pissarro, *Letters to his son Lucien*, ed. John Rewald, trans. Lionel Abel (New York, 1943), 46–47.

83. Monet to Hoschedé, 14 May 1879, Wildenstein, 1:437, letter 158.

84. See note 69 for instances of studio practice. For letters recording his procedure of working repeatedly on canvases outdoors, see Wildenstein 2:216, letter 255bis; 217, letter 263bis; and 218, letters 264, 266, all from March–April 1882.

1. Berhaut 165, private collection, Paris
2. Berhaut 139, private collection, Switzerland
3. Previously thought to be Berhaut 176
4. Berhaut 178, Museum of Fine Arts, Boston
5. Berhaut 167, private collection, Paris
6. Berhaut 169
7. Berhaut 153, private collection, Paris
8. Berhaut 152, private collection
9. Berhaut 174, private collection, Paris
10. Berhaut 143, private collection, Paris
11. Berhaut 136, private collection, Paris
12. Perhaps Berhaut 171, private collection, Paris
13. Berhaut 172
14. Berhaut 173
15. Perhaps Berhaut 161, private collection, Paris
16. Berhaut 175, private collection, Paris
17. Perhaps Berhaut 36, private collection, Paris
h.c. *Couple sortant d'une mare*

18. Perhaps Wildenstein 50, Nasjonalgalleriet, Oslo
19. Wildenstein 61
20. Perhaps Wildenstein 58, private collection, Valence, per Wildenstein or Sotheby's London, 30 June 1981, no. 17, no, per Bodelsen 1966
21. Perhaps Wildenstein 56
22. Wildenstein 52, Ordrupgaardsamlingen Charlottenlund, per Wildenstein
23. Perhaps Wildenstein 63, Musée des Beaux-Arts, Rennes
24. Perhaps Wildenstein 64, private collection, Paris
25. Wildenstein 51, private collection, Stockholm
26. Perhaps Wildenstein 65, Musée des Beaux-Arts, Rennes

27. Perhaps Wildenstein 55, private collection, Brussels

28. Wildenstein 62

29. Perhaps Wildenstein 57

30. Gray 6, private collection, Paris

32–33. Perhaps Serret and Fabiani 49, Nasjonalgalleriet, Oslo

43. Perhaps Sotheby's London, 26 June 1985, no. 129

56. Perhaps private collection, Copenhagen

57. Wildenstein 629, National Gallery of Art, Washington

58. Wildenstein 568, Shelburne Museum, Shelburne, Vermont

59. Wildenstein 601

61. Perhaps Wildenstein 655

62. Wildenstein 576, Musée du Petit Palais, Paris

63. Wildenstein 681

64. Wildenstein 645

65. Wildenstein 473, per Isaacson

66. Wildenstein 650, Fondation Rudolf Staechelin, Basel

67. Wildenstein 648, private collection, England

69. Wildenstein 635

70. Wildenstein 683 or 684

71. Wildenstein 642

73. Wildenstein 621, Museum of Fine Arts, Boston or 665

75. Wildenstein 643

76. Wildenstein 649

77. Wildenstein 653, private collection, Norfolk, Virginia

78. Wildenstein 628, Metropolitan Museum of Art

79. Wildenstein 598, per Isaacson

80–81. Wildenstein 694 and 695

82. Perhaps Wildenstein 549 or 550, Minneapolis Institute of Arts

83. Wildenstein 651, private collection, New York

84. Wildenstein 687, Museum of Fine Arts, Boston

85. Wildenstein 569, per Isaacson

86. Perhaps Wildenstein 677, Boymans-van Beuningen Museum, Rotterdam

88. Perhaps Wildenstein 676, The Cleveland Museum of Art

89. Perhaps Wildenstein 678 or 592, Metropolitan Museum of Art

90. Perhaps Wildenstein 679

91. Perhaps Wildenstein 611, Corcoran Gallery of Art or 612

h.c. a) *Bibi et son tonneau*
b) Bataille and Wildenstein 108
c) Perhaps Bataille and Wildenstein 117
d) *Eugène et Bibi*, Bataille and Wildenstein 103, private collection, Paris

92. Bataille and Wildenstein 110

93. Bataille and Wildenstein 105, Ny Carlsberg Glyptotek

94. Perhaps Bataille and Wildenstein 107

96. Perhaps Bataille and Wildenstein 113

97. Bataille and Wildenstein 116, per Clairet

101. Perhaps Pissarro and Venturi 530, private collection, Copenhagen

103. Pissarro and Venturi 541, private collection, Oslo

104. Pissarro and Venturi 542, The Toledo Museum of Art

107. Pissarro and Venturi 513, Metropolitan Museum of Art

108. Pissarro and Venturi 535

110. Pissarro and Venturi 543, private collection, Oslo

111. Pissarro and Venturi 549, The Art Institute of Chicago

112. Perhaps Pissarro and Venturi 563

114. Pissarro and Venturi 540, Musée d'Orsay

117. Pissarro and Venturi 564

118. Pissarro and Venturi 548, National Gallery of Art, Washington

119. Perhaps Pissarro and Venturi 573

120. Pissarro and Venturi 546

122. *Sentier sous bois à l'Hermitage*

123. *La conversation*, Pissarro and Venturi 544, private collection, Kobe

124. *Repos dans les bois*, Pissarro and Venturi 466

125. Pissarro and Venturi 532, private collection, Boston

126. Pissarro and Venturi 1349

128. Pissarro and Venturi 1346, private collection, U.S.A.

134. Pissarro and Venturi 1351

136. Pissarro and Venturi 1358

137. Daulte 330, Sterling and Francine Clark Art Institute, Williamstown

138. Daulte 378, The Art Institute of Chicago

139. Daulte 329, Sterling and Francine Clark Art Institute

140. Daulte 379, The Phillips Collection, Washington

142. Daulte 74, Sterling and Francine Clark Art Institute

143. Musée d'Orsay, per Isaacson

145. Perhaps Daulte 224, private collection

146. Museum of Fine Arts, Boston

147. Mr. and Mrs. David Lloyd Kreeger, Washington, D.C.; Sterling and Francine Clark Art Institute, per Isaacson and House

148. Daulte 328, private collection, Paris

149. Daulte 333, Städelsches Kunstinstitut, Frankfurt

151. Perhaps Daulte 307, National Gallery of Art, Washington

153. Perhaps Daulte 355, private collection, Paris

154. Perhaps Museum of Fine Arts, Boston, per Isaacson and House

156. Perhaps House, no. 59, per Isaacson

160. Daulte 332, Hermitage, Leningrad

h.c. *Jongleuses au Cirque Fernando*, Daulte 297, The Art Institute of Chicago

h.c. *Jeune fille pêcheuse de crevettes*, perhaps Daulte 281, private collection, Geneva or 282, private collection, New York

162. Perhaps Daulte 430, private collection, Winterthur

163. Daulte 436

164. Perhaps Daulte 410, per Isaacson

165. Daulte 435, private collection, Berne

167. Daulte 335, private collection, Paris

169. Daulte 374, Museum of Fine Arts, Boston

170. Perhaps Daulte 429, per Isaacson

172. Perhaps Daulte 405, per Isaacson

173. Perhaps Daulte 428, per Isaacson

175. Daulte 432, private collection

176. Daulte 341, private collection, Paris

180. Perhaps Daulte 434, per Isaacson

181. Perhaps Daulte 437, per Isaacson

183. Daulte 384, private collection

186. Daulte 473, private collection, Switzerland

114. Gustave Caillebotte

VII–1

Partie de bésigue, 1880
The Bezique Game
Signed lower left: *G. Caillebotte*
Oil on canvas, 49⅝ x 63⅜ in. (121 x 161 cm)
Private collection, Paris
REFERENCES: Berhaut 1978, no. 165; Varnedoe and Lee 1976, no. 49.
NOTE: The painting titled *Partie de bézigue* [*sic*] depicts the artist's brother and his friends in an apartment on the boulevard Haussmann, Paris. From left to right: Edouard Dessommes, Paul Hugot, Maurice Brault, Richard Gallo, A. Cassabois and Martial Caillebotte.

Two of his canvases are peremptory: one, the *Partie de bésigue*, more truthful than those of the old Flemish masters where the players almost always are watching us out of the corners of their eyes, where they pose more or less for the gallery, above all in the work of the good Teniers. There is nothing of that here. Imagine that a window is open in the wall of the room and that across from us, without being seen, you glimpse, framed by the window, people smoking, absorbed, frowning, with hesitant hands on the cards while contemplating the triumphal hand of 250.
Joris-Karl Huysmans,
L'art moderne, 1883

. . . *La partie de bésigue*, a very curious and well studied work. One wonders who will win, the two individuals with pipes in their mouths or their partners.
Armand Sallanches, *Le Journal des Arts*, 3 March 1882

Caillebotte has certainly progressed since last year. The *Partie de bésigue* is very remarkable; the poses are well understood, one reads the thought on the players' foreheads, and the absorption is complete. . . . [Renoir's *Un déjeuner à Bougival*, cat. no. 130] and Caillebotte's *Partie de bésigue* share the honors of the exhibition.
Paul de Charry, *Le Pays*,
10 March 1882

115. Gustave Caillebotte

VII–8

Marine, ca. 1880
Seascape
Now known as *Régates à Villiers* (Regatta at Villiers)
Signed lower left, possibly by Renoir: *G. Caillebotte*
Oil on canvas, 29 x 39⅜ in. (73.7 x 100 cm)
Private collection
REFERENCES: Berhaut 1978, no. 152; Varnedoe and Lee
1976, no. 67; Sotheby's New York, 16 November 1984, no. 11.

When Caillebotte is not
demented, he has as much talent
as anyone.
Albert Wolff, *Le Figaro,*
2 March 1882

His seascapes, still soaked, as it
were, with the good smell of the
sea, possess infinite subtleties.
Alexandre Hepp, *Le Voltaire,*
3 March 1882

If Caillebotte were not afflicted
with the peculiar mania of seeing
everything in nature the color of
ink, nothing would distinguish
him from a painter of ordinary
talent.
Fichtre [Gaston Vassy],
Le Réveil, 2 March 1882

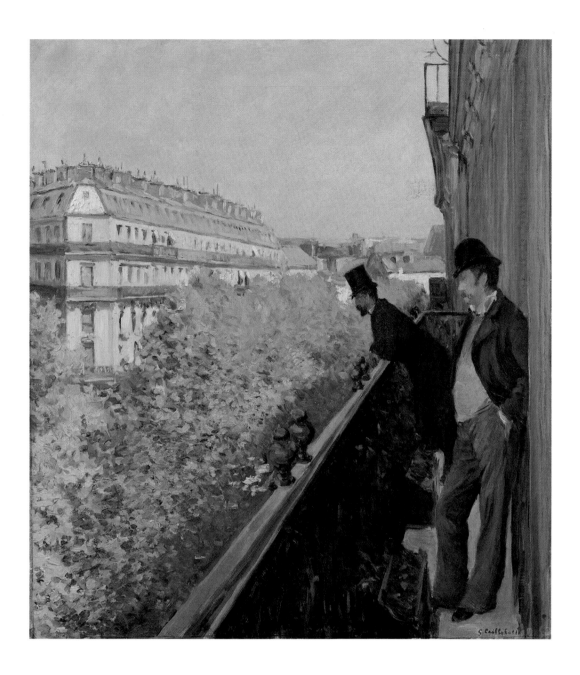

116. Gustave Caillebotte

VII—11

Balcon, 1880
Balcony

Now known as *Un balcon, boulevard Haussmann*
Inscribed lower right: *G. Caillebotte*
Oil on canvas, 26¾ x 24 in. (68 x 61 cm)
Private collection, Paris
REFERENCES: Berhaut 1978, no. 136; Varnedoe and Lee
1976, no. 52.
NOTE: This balcony overlooks the intersection of boulevard
Haussmann and the rue Lafayette, Paris. See Varnedoe and
Lee, above.

Caillebotte abuses violet
shadows. . . .
Emile Hennequin, *La Revue
Littéraire et Artistique*, 1882

One of the most relentless Inde-
pendents, Caillebotte, is showing
around twenty hilarious
paintings.
Jean de Nivelle [Charles Canivet],
Le Soleil, 4 March 1882

Caillebotte, an inoffensive type of
bourgeois, lives very quietly,
detests compliments, asks only to
defend his school, and would
never want to carry off a victory.
Alexandre Hepp, *Le Voltaire*,
3 March 1882

117. Paul Gauguin

VII–23

A la fenêtre, nature morte, 1881
At the Window, Still Life

Signed lower left: *P. Gauguin*
Oil on canvas, 7½ x 10⅝ in. (19 x 27 cm)
Musée des Beaux-Arts de Rennes
REFERENCES: Wildenstein 1964, no. 63; Paris, Grand Palais,
1978, 8.

Paul Gauguin is exhibiting some
hieroglyphs done in oils in white
frames.
Alexandre Hepp, *Le Voltaire*,
3 March 1882

We are a little embarrassed to
mention Gauguin. He is the Inde-
pendent who has the most to do
to earn the name! His exhibition
is the least consequential as well
as the least interesting.
Armand Sallanches, *Le Journal
des Arts*, 3 March 1882

Alas, Gauguin has not made any
progress. Last year this artist
brought us an excellent study of a
nude; this year there is nothing
worthwhile.
Joris-Karl Huysmans,
L'art moderne, 1883

We are not drawn to Paul Gau-
guin either. His painting is drab
and lifeless.
Ph[ilippe] Burty, *La République
Française*, 8 March 1882

Gauguin's languorous note leaves
me rather cold.
Armand Silvestre, *La Vie
Moderne*, 11 March 1882

Well, it is not Gauguin who will
give us "the note that sings."
L[ouis] Leroy, *Le Charivari*,
17 March 1882

Gauguin makes everything dark
and his extraordinary execution
is frightfully heavy. His subjects,
moreover, are treated with a great
deal of prejudice.
Henri Rivière, *Le Chat Noir*,
8 April 1882

118. Jean-Baptiste-Armand Guillaumin

Paysage d'automne or
Paysage (fin octobre), ca. 1876
Autumn Landscape or Landscape (End of October)
Now known as *Grands arbres d'automne* (Tall Trees in
Autumn)
Signed lower left: *A. Guillaumin*
Oil on canvas, 70⅞ x 48⅜ in. (180 x 123 cm)
Nasjonalgalleriet, Oslo. 973
REFERENCES: Serret and Fabiani 1972, no. 49; Bodelsen
1970, no. 16.

[Guillaumin's] drawing is good and his composition is not bad, but his colors are upsetting.
Armand Sallanches, *Le Journal des Arts*, 3 March 1882

Guillaumin is still a "young" man. His scumbles lack body.
Ph[ilippe] Burty, *La République Française*, 8 March 1882

[Guillaumin's] canvases remind one of German chromolithographs. He works with little multicolored dots, all very close to each other. The color is very disagreeable and the effect is absolutely false.
Henri Rivière, *Le Chat Noir*, 8 April 1882

[Guillaumin] little by little finds a path through the chaos where he has been struggling for so long.
Joris-Karl Huysmans, *L'art moderne*, 1883

119. Claude Monet

VII–57

Fleurs de topinambour, 1880
Jerusalem Artichoke Flowers

Now known as *Vase of Chrysanthemums*
Signed and dated lower right: *Claude Monet/1880*
Oil on canvas, 39¼ x 28¾ in. (99.6 x 73 cm)
National Gallery of Art, Washington. Chester Dale Collection.
1963.10.181
REFERENCES: Wildenstein 1974, no. 629; Washington 1965,
no. 1845; Isaacson 1978, no. 67.
Washington only

The landscapes, flowers, and fig-
ures of Monet are summarily exe-
cuted and his colors are strange.
Paul de Katow, *Gil Blas*,
1 March 1882

To my mind, Monet is not only
the most exquisite of the Impres-
sionists, he is also one of the true
contemporary poets of the things
of nature. He does not merely
paint it, he sings it. A lyre seems
hidden in his palette.
Armand Silvestre, *La Vie
Moderne*, 11 March 1882

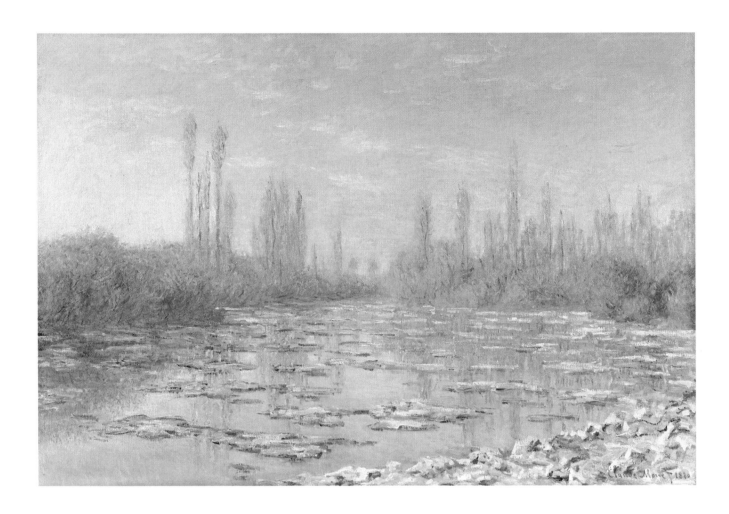

120. Claude Monet

VII–58

Les glaçons, 1880
The Ice Floes

Signed and dated lower right: *Claude Monet 1880*
Oil on canvas, 38¼ x 59¼ in. (97 x 150.5 cm)
Shelburne Museum, Shelburne, Vermont. 27.1.2-108
REFERENCES: Wildenstein 1974, no. 568; Isaacson 1978,
no. 64; Isaacson 1980, no. 31.
San Francisco only

In the first rank let us mention *Les glaçons*, a restrained and robust painting that you admire the more you look at it. The trees are really planted, and the ice is really swept along by the water that really reflects the landscape. One criticism – Monet sees too much red-currant color.
Armand Sallanches, *Le Journal des Arts*, 3 March 1882

Claude Monet has settled at Poissy where his talent comes into its own. The editor Georges Charpentier owns a *Débâcle de glaçons* whose originality is striking.
Ph[ilippe] Burty, *La République Française*, 8 March 1882

I have saved for last *Les glaçons*, a canvas of marvelously accurate impression and immensely decorative effect.
Armand Silvestre, *La Vie Moderne*, 11 March 1882

It is with pleasure that I see once more Claude Monet's *Glaçons*, shown two years ago at the *Vie Moderne*.
Henri Rivière, *Le Chat Noir*, 8 April 1882

[Monet's] ice floes beneath a rusty sky are intensely melancholic.
Joris-Karl Huysmans, *L'art moderne*, 1883

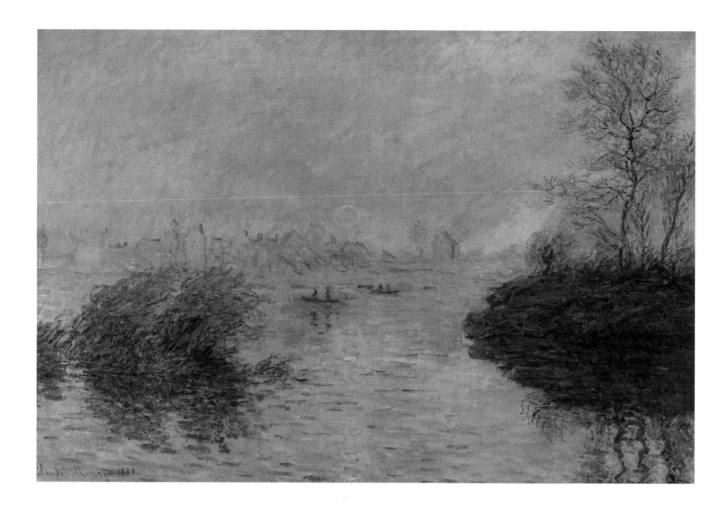

121. Claude Monet

VII-62

Soleil couchant, sur la Seine, effet d'hiver, 1880
Sunset on the Seine, Winter Effect

Now known as *Soleil couchant sur la Seine à Lavacourt, effet d'hiver* (Sunset on the Seine at Lavacourt, Winter Effect)
Signed and dated lower left: *Claude Monet 1880*
Oil on canvas, 39⅜ x 59⅞ in. (100 x 152 cm)
Musée du Petit Palais, Paris. 439
REFERENCES: Wildenstein 1974, no. 576; Isaacson 1978, no. 63; Adhémar et al. 1980, no. 81; Isaacson 1980, no. 32.
NOTE: The inscribed date may have been added to the signature at a later time.

As for the *Soleil couchant sur la Seine*, one thinks simply of a slice of tomato stuck onto the sky and is quite astonished by the violet light it casts on the water and the riverbanks.
Jean de Nivelle [Charles Canivet], *Le Soleil*, 4 March 1882

Le soleil couchant sur la Seine has lovely color and a delicate impression. . . .
Henri Rivière, *Le Chat Noir*, 8 April 1882

Yes, the painter who put brush to these canvases is a great landscapist. His eye, now healed, seizes every phenomenon of light with astonishing fidelity. How true the foam on the waves when struck by a ray of sunlight; how his rivers flow, dappled by the swarming colors of everything they reflect; how, in his paintings, the cold little breath of the water rises in the foliage to the tips of the grass.
Joris-Karl Huysmans, *L'art moderne*, 1883

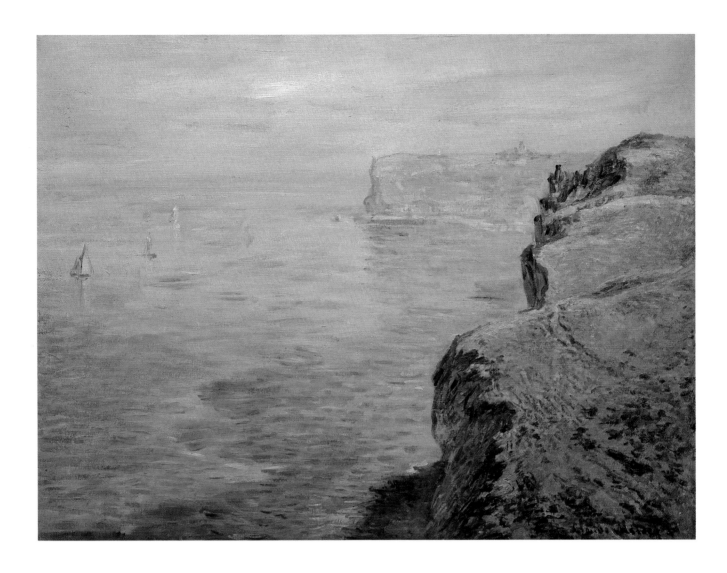

122. Claude Monet

VII–77

A Grainval, près Fécamp, 1881
Grainval near Fécamp

Signed and dated lower right: *Claude Monet 81*
Oil on canvas, 24 x 31 ½ in. (61 x 80 cm)
Collection of Mr. and Mrs. George M. Kaufman, Norfolk,
Virginia
REFERENCES: Wildenstein 1974, no. 653; Isaacson 1980,
no. 33.

Monet, whose talent as a colorist
is indisputable, has painted some
cliffs made out of raspberry and
currant ice cream, whose realistic
melting is thoroughly impressive.
You want to eat them with a
spoon. Underneath, there is
another canvas in green ice cream
that turns out to be a raging
ocean.
Fichtre [Gaston Vassy],
Le Réveil, 2 March 1882

His studies of the sea, the waves
breaking on rocky cliffs, are the
truest seascapes I have ever seen.
Joris-Karl Huysmans,
L'art moderne, 1883

We are not as enthusiastic about
[Monet's] seascapes. The sea has
a rather solid look. If it was on
that sea that Our Lord Jesus
Christ was supported, then the
materialists have nothing to say,
for no miracle took place.
Paul de Charry, *Le Pays*,
10 March 1882

I also like very much this sea at
Grainval (no. 77), with its big
violet shadows that fall from the
cliff and flutter like light fabric.
Armand Silvestre, *La Vie
Moderne*, 11 March 1882

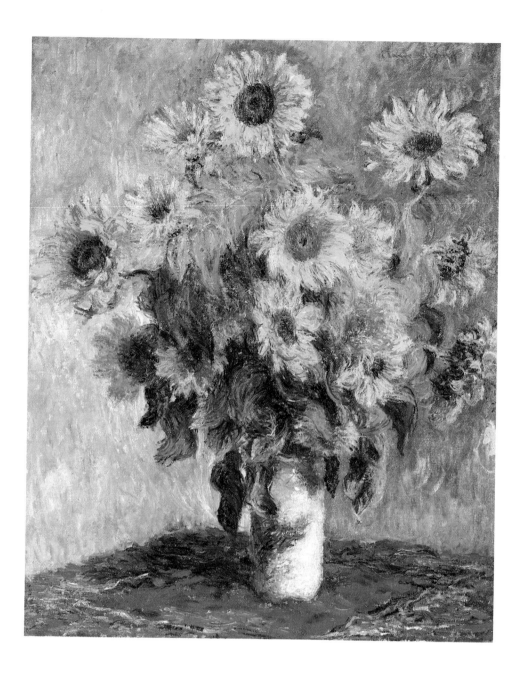

123. Claude Monet

VII—78

Bouquet de soleils, 1880–1881
Bouquet of Sunflowers

Signed and dated upper right: *Claude Monet 81*
Oil on canvas, 39¾ x 32 in. (101 x 81.3 cm)
Lent by The Metropolitan Museum of Art. Bequest of Mrs.
H. O. Havemeyer, 1929. The H. O. Havemeyer Collection.
29.100.107
REFERENCES: Wildenstein 1974, no. 628; Sterling and
Salinger 1967, 3:132–133; Baetjer 1980, 1:128.
NOTE: Wildenstein dates this work 1880. It is stylistically
similar to cat. no. 119, which is signed and dated 1880.
Durand-Ruel purchased it in October 1881. See Wildenstein,
above.

Another Independent remarkable
for his brio and daring is Claude
Monet, unquestionably. We look
forward to seeing him in a few
years when he will have perfected
his style.
Armand Sallanches, *Le Journal
des Arts*, 3 March 1882

Claude Monet paints flowers,
chrysanthemums and gladiolas,
varnished vases, pheasants—in a
word, still lifes—with great talent.
Paul de Charry, *Le Pays*,
10 March 1882

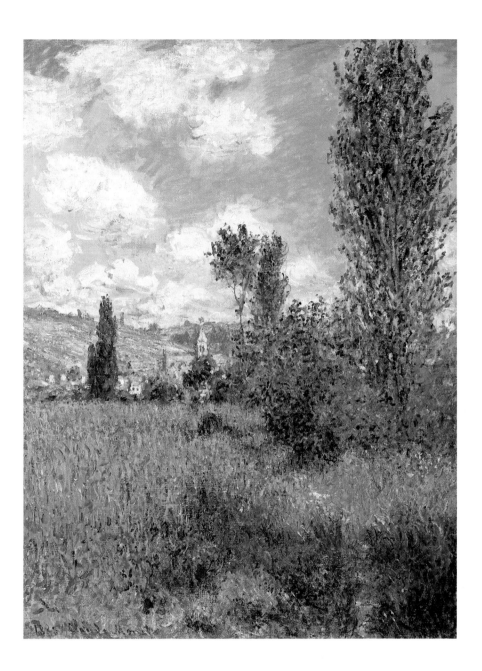

124. Claude Monet

VII–89

Sentier dans l'île Saint-Martin, 1880
Path in the Ile Saint-Martin, Vétheuil

Signed and dated lower left: *1880 Claude Monet*
Oil on canvas, 31½ x 23¾ in. (80 x 60.3 cm)
Lent by The Metropolitan Museum of Art. Bequest of Julia W.
Emmons, 1956. 56.135.1
REFERENCES: Wildenstein 1974, no. 592; Sterling and
Salinger 1967, 3:132; Baetjer 1980, 1:128.

Among Claude Monet's forty
paintings there are two or three
pretty things.
Albert Wolff, *Le Figaro*,
2 March 1882

His *Sentier dans l'île Saint-
Martin* is wonderfully in bloom.
Emile Hennequin, *La Revue
Littéraire et Artistique*, 1882

Decidedly, it is still Monet who is
the chief landscapist of the little
school.
Henri Rivière, *Le Chat Noir*,
8 April 1882

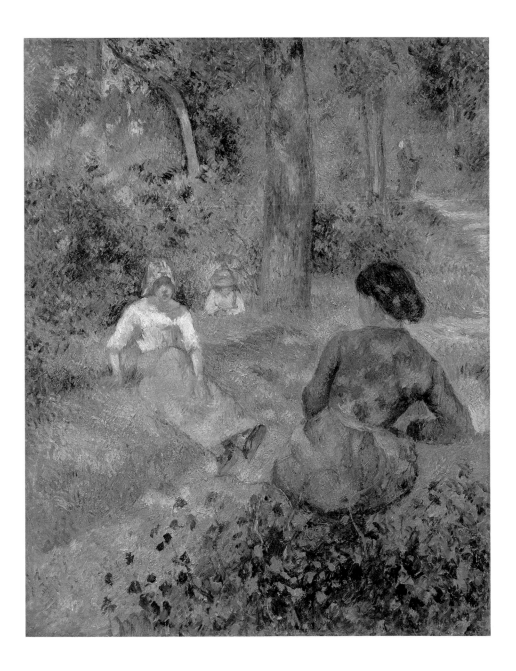

125. Camille Pissarro

VII–104

**Etude de figure en plein air,
effet de soleil,** 1881
Figure Study in the Open Air, Sunlight Effect

Now known as *Peasants Resting*
Signed and dated lower right: *C. Pissarro.81*
Oil on canvas, 31⅞ x 25⅝ in. (81 x 65 cm)
The Toledo Museum of Art. Gift of Edward Drummond
Libbey. 35.6
REFERENCES: Pissarro and Venturi 1939, no. 542; Wittmann
1976, 128; Isaacson 1980, no. 40.

Finally, Pissarro sent some *Pay-
sannes dans les bois* that resemble
pastels, apparently the best the
exhibition has to offer.
Fichtre [Gaston Vassy],
Le Réveil, 2 March 1882

Here, for example, we have *Une
étude de figure en plein air, effet
de soleil*, but the sun is missing;
Pissaro [*sic*] has kept it in his
pocket.
Jean de Nivelle [Charles Canivet],
Le Soleil, 4 March 1882

One artist who certainly has great
talent as a draftsman is Pisarro
[*sic*]. The poses of his figures are
quite natural and lively; move-
ment and life can be felt in all
these women of the marketplace,
dressed in bright colors and
blending together in the broad,
dusty shaft of sunlight.
It is extraordinary how the can-
vas he calls *Etude de soleil en
plein air* is softer and less radiant
than those set in shadow. This
surely depends on the disposition
of the eye. Some people see every-
thing in gray; this one sees things
in pink and violet.
Well, it is not so unpleasant to see
life in rosy tones. It gives more
gaiety to the heart and joy to the
soul.
Paul de Charry, *Le Pays*,
10 March 1882

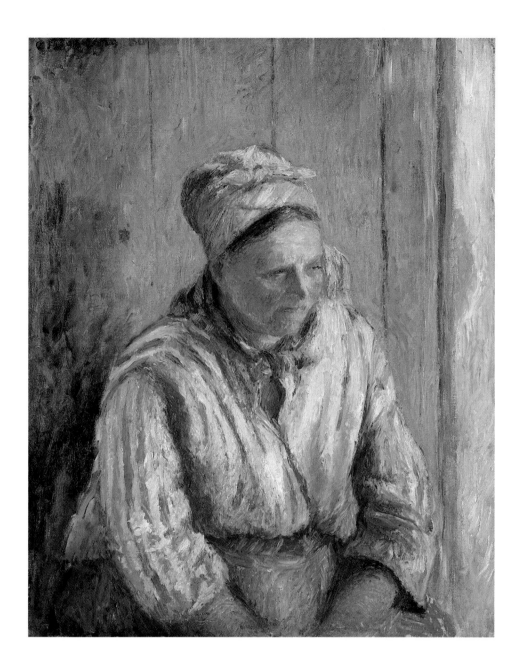

126. Camille Pissarro

VII—107

Laveuse, étude, 1880
Washerwoman, Study
Now known as *La Mère Larchevêque*
Signed and dated upper left: *C. Pissarro 80*
Oil on canvas, 28¾ x 23¼ in. (73 x 59.1 cm)
Lent by The Metropolitan Museum of Art. Gift of Mr. and
Mrs. Nate B. Spingold, 1956. 56.184.1
REFERENCES: Pissarro and Venturi 1939, no. 513; Sterling
and Salinger 1967, 3:18–19; Baetjer 1980, 1:143.

In addition to his landscapes of the Seine-et-Oise, Pissarro exhibits an entire series of peasant men and women, and once again this painter shows himself to us in a new light. As I believe I have already mentioned, the human figure often takes on a biblical air in his work. But not any more. Pissarro has entirely detached himself from Millet's memory. He paints his country people without false grandeur, simply as he sees them. His delicious little girls in their red stockings, his old woman wearing a kerchief, his shepherdesses and laundresses, his peasant girls cutting hay or eating, all are true small masterpieces.
Joris-Karl Huysmans,
L'art moderne, 1883

Our Lady of Pneumonia.
Draner [Jules Renard],
Le Charivari, 9 March 1882

In a word, then, we can say of Pisaro [*sic*] that the poses and bearing of his figures denote a great artist.
Paul de Charry, *Le Pays*,
10 March 1882

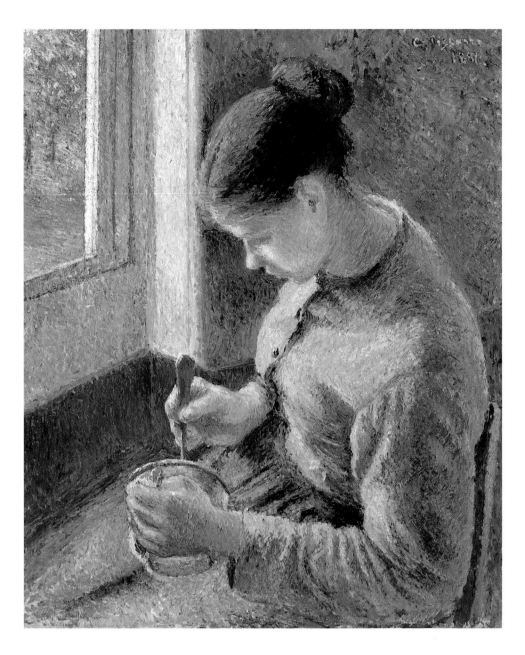

127. Camille Pissarro

VII–111

Jeune paysanne prenant son café, 1881
Young Peasant Woman Drinking Her Coffee

Now known as *Café au lait*
Signed and dated upper right: *C. Pissarro/1881*
Oil on canvas, 25⅛ x 21⅜ in. (63.9 x 54.4 cm)
The Art Institute of Chicago. Potter Palmer Collection.
1922.433
REFERENCES: Pissarro and Venturi 1939, no. 549; Chicago
1961, 358; Isaacson 1980, no. 41.

Pissarro's paintings enormously resemble pastels. This artist prefers to search out subjects like J.-F. Millet's, minus his color. His study *Figure en plein air, effet de soleil* is not without flavor. There is also something to his *Jeune paysanne prenant son café*.
Armand Sallanches, *Le Journal des Arts*, 3 March 1882

[Pissarro's] show is superb. Gray weather, sunsets, tall grasses, vast fields—and in these settings are peasant girls with fresh cheeks and robust grace. True women of Millet, country women who do not draw from the drowsy landscape the melancholies of the Parisians; they are rustic but not clumsy, vigorous but not coarse.
Alexandre Hepp, *Le Voltaire*, 3 March 1882

The realism of *Paysanne bêchant la terre* and the *Jeune paysanne prenant son café* is truly extraordinary.
Pissarro produces a lot of good work.
Paul de Charry, *Le Pays*, 10 March 1882

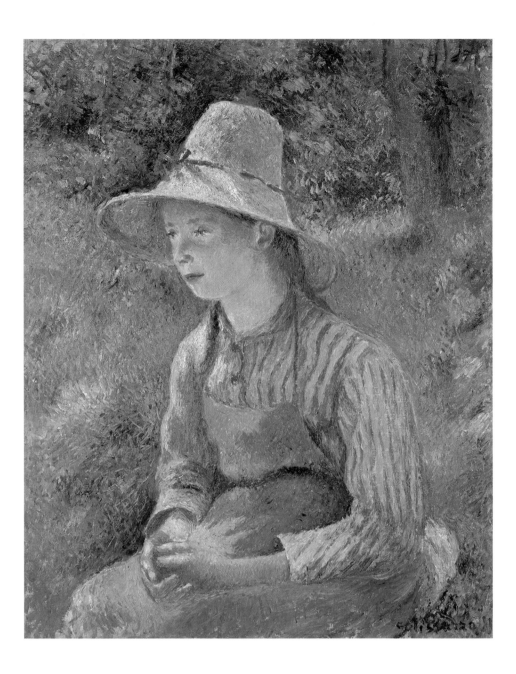

128. Camille Pissarro

VII–118

Jeune paysanne au chapeau, 1881
Young Peasant Girl Wearing a Hat
Now known as *Peasant Girl with a Straw Hat*
Signed and dated lower right: *C. Pissarro 81*
Oil on canvas, 28⅞ x 23½ in. (73.4 x 59.6 cm)
National Gallery of Art, Washington. Ailsa Mellon Bruce
Collection. 1970.17.52
REFERENCES: Pissarro and Venturi 1939, no. 548;
Washington 1975, no. 2424; Lloyd et al. 1981, no. 54.

If the influence of Corot is manifest in the work of Monet, that of Millet is no less so in the work of Pissaro [*sic*]. And this is in no way a criticism. Whatever one may do, one is always someone's son. And besides, here it is not a question of paternity, but merely of the kinship of souls, and a distant one at that. All in all, to recall great models is in itself glorious. I very much like Pissaro's [*sic*] large figures, permeated with rustic charm. They have a very different kind of truth than that found in Bastien Lepage's peasant women. I will mention with absolute admiration the *Laveuse*, the *Jeune paysanne prenant son café*, the *Jeune paysanne au chapeau*, and two large studies numbered 103 and 104.
Armand Silvestre, *La Vie Moderne*, 11 March 1882

The art of Pissarro is different. He prefers to see the robust and fruitful hillsides of our country around Paris. Since Millet, no one has observed and depicted the peasant with this powerful vigor and with this accurate and personal vision.
Ernest Chesneau, *Paris-Journal*, 7 March 1882

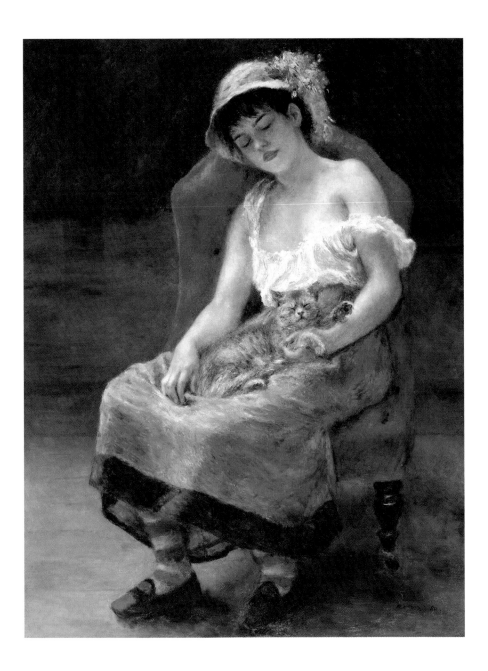

129. Pierre-Auguste Renoir

VII–137

Jeune fille au chat, 1880
Girl with a Cat

Now known as *Sleeping Girl with a Cat*
Signed and dated lower right: *Renoir.80*.
Oil on canvas, 47¼ x 35⁵/₁₆ in. (120.1 x 92.2 cm)
Sterling and Francine Clark Art Institute, Williamstown,
Massachusetts. 598
REFERENCES: Daulte 1971, no. 330; Williamstown 1984, no.
204; White 1984, 96–97, 99, 106; House et al. 1985, no. 50.
Washington only

Among Renoir's works, we are happy to recognize a few we have already seen before—*Loge à l'Opéra*, the *Fille au chat*, and *Déjeuner de canotiers*—but also other figure studies, dazzling flowers, and Algerian landscapes set afire by the sun.
Ernest Chesneau, *Paris-Journal*, 7 March 1882

The *Jeune fille au chat*, *Loge à l'Opéra*, *Jeune fille en pêcheuse de crevettes*, and a ravishing head of a little boy are the cream of the twenty-four paintings he has exhibited.
Paul de Charry, *Le Pays*, 10 March 1882

NOTE: The artist's *Jeune fille endormie* (cat. no.133) is a preliminary treatment of this subject.

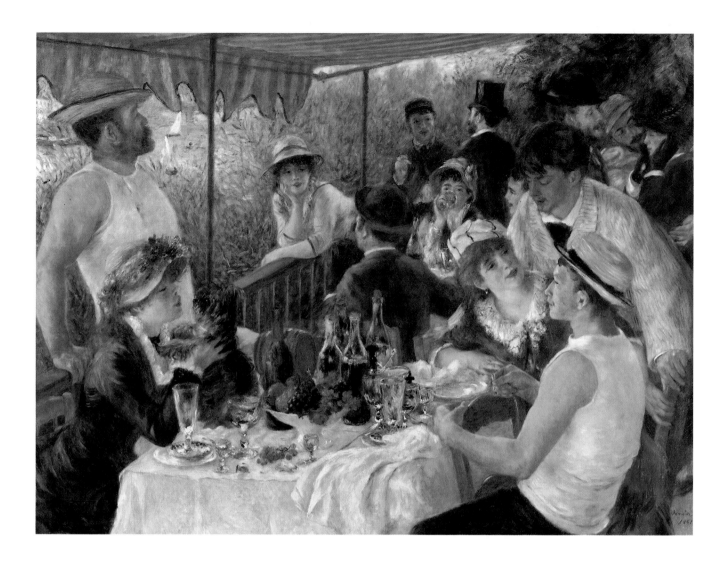

130. Pierre-Auguste Renoir

VII—140

Un déjeuner à Bougival, 1880–1881
A Luncheon at Bougival
Now known as *The Luncheon of the Boating Party*
Signed and dated lower right: *Renoir./1881*.
Oil on canvas, 51 x 68 in. (129.5 x 172.7 cm)
The Phillips Collection, Washington, D.C. 1637
REFERENCES: Daulte 1971, no. 379; Washington 1985, no.
1515; Sutton 1983, no. 35; White 1984, 106, 110–111, 121,
128, 132–133, 154, 163, 165–166, 205, 280, 285; House et al.
1985, no. 52.
Washington only

NOTE: The most plausible identification of models, from
which this one derives, was that made by Meier-Graefe in
1912. On the lower left is Aline Charigot, later Renoir's wife;
directly behind her is Alphonse Fournaise, Jr., son of the
proprietor of the restaurant where the group is posed; in the
center, an unidentified model chats with Baron Barbier, an ex-
cavalry officer and friend of Renoir's; behind them, in a top hat,
Charles Ephrussi, banker and amateur art historian, talks with
an unidentified man; below them the model Angèle is drinking;
on the top right Renoir's friends Eugène Lestringuez and Paul
Lhote, the latter in a straw boater, converse with a girl, possibly
the actress Jeanne Samary; at the bottom right the journalist M.
Maggiolo leans over a woman, possibly the actress Ellen
Andrée; in front of them is Gustave Caillebotte. The setting, on
an island in the Seine at Chatou, is the upstairs terrace of the
Restaurant Fournaise, a celebrated meeting place for oarsmen.
See House et al., above.

If he had learned to draw, Renoir would have a very pretty picture in his *Repas de canotiers*. . . .
Albert Wolff, *Le Figaro*,
2 March 1882

The *Déjeuner à Bougival* is full of movement and is one of the most successful pieces of this Independent Salon. The eye of the painter found new colors for the flora around Paris in the bouquet of wine. And one can scarcely say that it is gray.
Jean de Nivelle [Charles Canivet], *Le Soleil*, 4 March 1882

Un déjeuner à Bougival is a charming work, full of gaiety and spirit, its wild youth caught in the act, radiant and lively, frolicking at high noon in the sun, laughing at everything, seeing only today and mocking tomorrow. For them eternity is in their glass, in their boat, and in their songs. It is fresh and free without being too bawdy. This work and the *Partie de bésigue* by Caillebotte share the honors of the exhibition.
Paul de Charry, *Le Pays*,
10 March 1882

Renoir is unique among this essentially liberal group. His *Déjeuner à Bougival* (no. 140) seems to me one of the best things he has painted; shaded by an arbor, bare-armed boatmen are laughing with some girls. There are bits of drawing that are completely remarkable, drawing—true drawing—that is a result of the juxtaposition of hues and not of line. It is one of the most beautiful pieces that this insurrectionist art by Independent artists has produced. For my part, I found it absolutely superb.
Armand Silvestre, *La Vie Moderne*, 11 March 1882

For example, I like his *Déjeuner à Bougival* less [than his *Femme à l'éventail*]. Some of the boatmen are good, some of the women are charming, but the picture does not have a strong enough smell. The girls are fresh-looking and gay, but they do not exude the odor of a Parisian; they are spring-like trollops fresh off the boat from London.
Joris-Karl Huysmans,
L'art moderne, 1883

Very pretty, the *Dîner de canotiers* by Renoir. In it there are two charming young women, one of whom is playing with a terrier—the most entertaining type of Parisian woman that one can imagine.
Fichtre [Gaston Vassy],
Le Réveil, 2 March 1882

I have saved Caillebotte and Renoir for last because both represent the army's great effort, Caillebotte with his *Partie de bésigue* and Renoir with his *Déjeuner à Bougival*.
Henry Havard, *Le Siècle*,
2 March 1882

. . . a *Déjeuner à Bougival* which is full of high spirits and of propriety: we see the hero of the feast, who looks like M. Ephrussi.
Alexandre Hepp, *Le Voltaire*,
3 March 1882

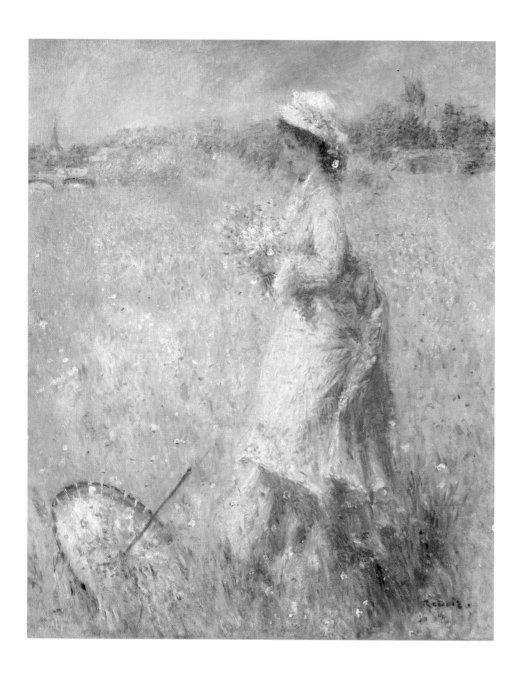

131. Pierre-Auguste Renoir

VII—142

Femme cueillant des fleurs, ca. 1872
Woman Gathering Flowers

Signed lower right: *Renoir.*
Oil on canvas, 25¾ x 21⅞₆ in. (65.5 x 54.4 cm)
Sterling and Francine Clark Art Institute, Williamstown,
Massachusetts. 907
REFERENCES: Daulte 1971, no. 74; Williamstown 1984,
no. 189.
Washington only

Renoir [is] a gallant and adventurous charmer. Like the American, Whistler, who gives us paintings with titles such as *Harmonie en vert et or, en ambre et noir, Nocturnes en argent et bleu,* Renoir could call many of his works harmonies, joining to the title the names of their freshest tints.

This artist has produced quite a bit. I recall in 1876 a large canvas showing a mother and her two daughters, a bizarre painting whose colors looked as if they had been blurred with a cloth, whose oils vaguely imitated the pastels' dying tones. In 1877 I found Renoir had produced more settled works, with more resolution to his coloring and a surer modern feel. Certainly, in spite of visitors who hiss geese-like at these paintings, these reveal a valuable talent. Since then, Renoir seems at last to have found his place. Fascinated like Turner by mirages of light, clouds of gold vapor that sparkle, trembling, in a ray of sunlight, despite the poor quality of our chemical ingredients, he has managed to fix them.
Joris-Karl Huysmans,
L'art moderne, 1883

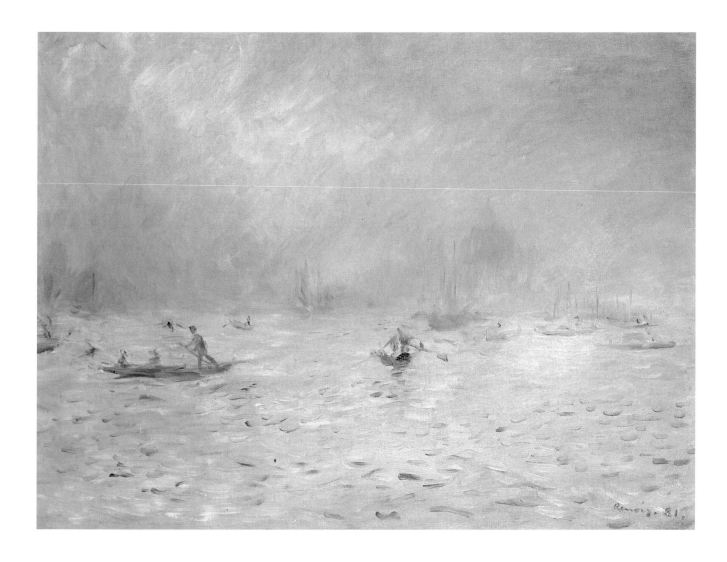

132. Pierre-Auguste Renoir

VII–147

Vue de Venise, 1881
View of Venice

Now known as *Venise, brouillard* (Venice, Fog)
Signed and dated lower right: *Renoir.81.*
Oil on canvas, 17⅞ x 23¾ in. (45.4 x 60.3 cm)
Collection of Mr. and Mrs. David Lloyd Kreeger,
Washington, D.C.
REFERENCES: Daulte 1974, 41; Maxon 1973, no. 37.
NOTE: Two views of Venice were exhibited in the seventh
group show. The first, a view of the Grand Canal (VII–146), is
now in the Museum of Fine Arts, Boston (Murphy 1985, 238).
The second, described here by the critic Jean de Nivelle, is
probably the Kreeger picture. However, Isaacson and House
have identified the second work as the Venetian scene in the
Sterling and Francine Clark Art Institute (Williamstown 1984,
no.211).

Despite being ill for three months in a village on the outskirts of Marseille, Renoir gives us a good many canvases. [Among them is] a *Vue de Venise* that looks like an intensified Ziem. . . .
Alexandre Hepp, *Le Voltaire*, 3 March 1882

It is as if the artists have different pairs of glasses that they anchor on their noses when they want, with lenses made to give the tones they seek. This is the only way to explain categorically the orgy of tones that can at times be found in a single painting. For example, in Renoir's *Vues de Venise*, the artist, through a marvel of imagination, has given the impression of a tempest in the Grand Canal.
Jean de Nivelle [Charles Canivet], *Le Soleil*, 4 March 1882

The Venetian landscapes seem to me an utterly successful compromise between Ziem and Montecelli. Renoir has everything to gain by staying himself.
Armand Silvestre, *La Vie Moderne*, 11 March 1882

Renoir's Venetian views made me stop for a long time. One of them has reflections that overlap like a roof of polished tiles. Transparency is not an issue here. This painter has posed the problem of how to make water . . . solid. On this water gondolas could roll on wheels, yet its surface – choppy, splashed, zebra-striped – could never be taken for land. He has admirably overcome this difficulty, and the result is like nothing ever known.
L[ouis] Leroy, *Le Charivari*, 17 March 1882

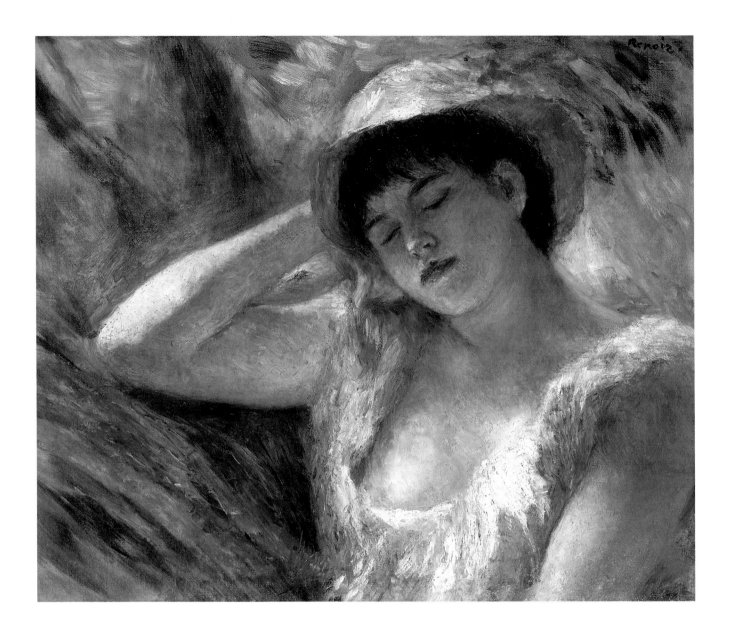

133. Pierre-Auguste Renoir

VII—148

Jeune fille endormie, 1880
Young Girl Sleeping
Now known as *La dormeuse* (The Sleeping Girl)
Signed upper right: *Renoir.*
Oil on canvas, 19¼ x 23⅝ in. (49 x 60 cm)
Private collection, Switzerland. Courtesy of Ellen Melas
Kyriazi
REFERENCES: Daulte 1971, no. 328.
NOTE: This work is a preliminary treatment of *Jeune fille au chat* (cat. no.129).

Renoir is the true painter of young women, rendering in the gaiety of sunlight the blush, the velvet flesh, the pearl of their eyes, and the elegance of costume.
Joris-Karl Huysmans,
L'art moderne, 1883

Renoir is the only Impressionist who shows more figure paintings than landscapes. He also is the only one who appears to me to paint the colors he sees accurately.
Emile Hennequin, *La Revue Littéraire et Artistique*, 1882

The *Portraits de jeunes filles*, the *Déjeuner à Bougival*, a *Loge de théâtre*, are also works of great merit.
Paul de Katow, *Gil Blas*,
1 March 1882

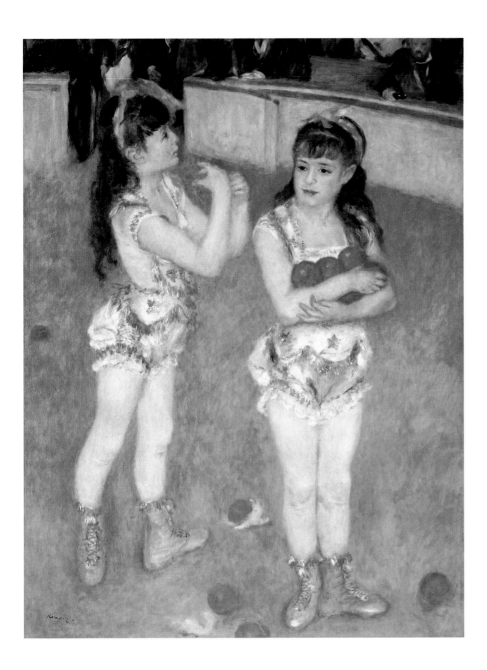

134. Pierre-Auguste Renoir

VII—HC

Jongleuses au Cirque Fernando, 1879
Jugglers at the Cirque Fernando
Also known as *Two Little Circus Girls*
Signed lower left: *Renoir.*
Oil on canvas, 51¾ x 39⅛ in. (131.5 x 99.5 cm)
The Art Institute of Chicago. Potter Palmer Collection.
1922.440
REFERENCES: Daulte 1971, no. 297; Chicago 1961,
394–395; Maxon 1973, no. 24.
San Francisco only
NOTE: Francisca and Angelina Wartenberg were jugglers and
gymnasts in the circus owned by their father, Fernando
Wartenberg, on the boulevard Rochechouart in Montmartre.
See Maxon, above.

Renoir is also showing two poor
little *Saltimbanques* who were
born with legs too short. To con-
sole them the artist has given
them hands that are too long, full
of great oranges.
Fichtre [Gaston Vassy],
Le Réveil, 2 March 1882

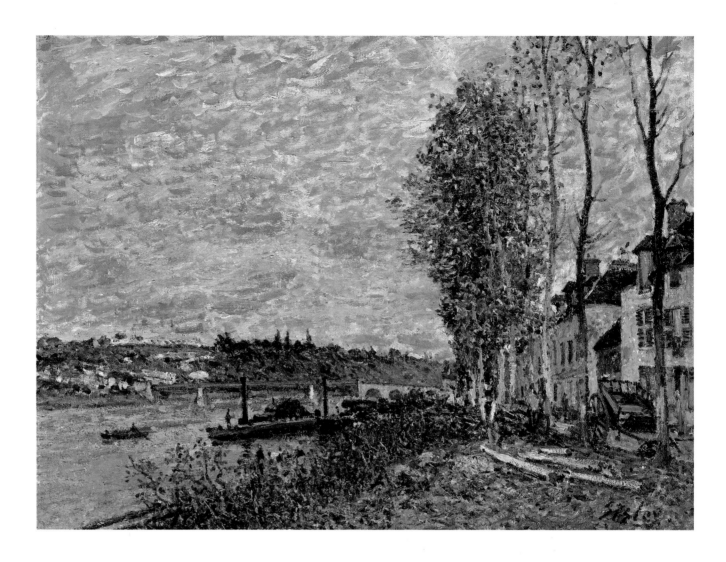

135. Alfred Sisley

VII–169

Saint-Mammès, temps gris, ca. 1880
Saint-Mammès, Cloudy Weather

Now known as *Overcast Day at Saint-Mammès*
Signed lower right: *Sisley*
Oil on canvas, 21 5/8 x 29 1/8 in. (54.8 x 74 cm)
Museum of Fine Arts, Boston. Juliana Cheney Edwards
Collection. 39.679
REFERENCES: Daulte 1959, no. 374; Murphy 1985, 264;
Poulet 1979, no. 40.

Sisley has masterfully taken possession of the banks and waters of the Seine where the breeze, like a moving mirror, splinters into a thousand pieces the gold of autumn leaves and scatters the opal reflections of light, fleecy clouds, their soft gray drenched with melancholy.
Ernest Chesneau, *Paris-Journal*, 7 March 1882

Sisley, along with Pissarro and Monet . . . [was] one of the first to go directly to nature, to dare heed her, and to try to remain faithful to the sensations he feels before her. His artist's temperament is less jerky and nervous, his eye is less delirious, than those of his two fellow artists. Sisley apparently is less determined, less individual than they are today. A painter of real virtue, he still retains some foreign traces here and there. Certain reminders of Daubigny strike me in this year's exhibition. Sometimes his autumn foliage even recalls Piette. Despite all this his work has resolution and inflection. It also has a lovely melancholic smile, and often much serene charm.
Joris-Karl Huysmans, *L'art moderne*, 1883

With Sisley we return to landscapes, and if we had to we could find a few passable ones among them, were it not for his peculiar habit of deliberately sticking nonsense right next to something good.
Jean de Nivelle [Charles Canivet], *Le Soleil*, 4 March 1882

Sisley presents twenty-seven paintings in which one finds all his usual qualities. His landscapes of Saint-Mammès and Veneux-Nadon are well observed.
Henri Rivière, *Le Chat Noir*, 8 April 1882

The Eighth Exhibition *1886*

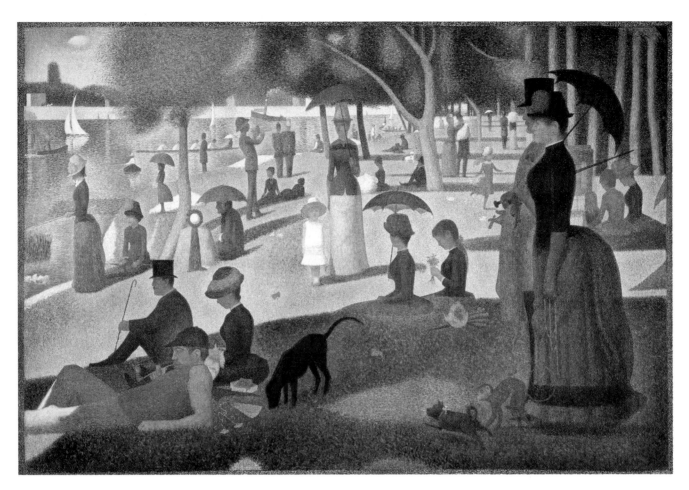

fig. 1 Georges Seurat, *Un dimanche à La Grande-Jatte (Sunday Afternoon on the Island of La Grande-Jatte,* VIII–175), 1884–1886. Oil on canvas, 81 x 120⅜ in. (205.7 x 305.7 cm). The Art Institute of Chicago. Helen Birch Bartlett Memorial Collection

The Rhetoric of Independence and Innovation

Martha Ward

Planning the Exhibition

Plans for the eighth Independent exhibition were underway by October 1885, and from then until the show opened on 15 May 1886, the organizers found themselves in a familiar morass of petty quarrels, shifting allegiances, and jealous rivalries—the personal legacy of their past endeavors.[1] But running through their debates was a new concern, for this was the first of the Impressionist shows that had to compete directly with a dealer-sponsored venture and, as a result, had to question what it meant to be independent in the marketplace. Because of these changing concerns, the avant-garde's rhetorical representation of power in the art world also changed, as critics and artists during the late nineteenth century slowly shifted their attack from the Salon, as the symbol of state regulation, to selected dealers, as the agents of commercial interests.[2] In this respect, the 1886 Impressionist exhibition marks an important turning point.

The independence of the group shows had been valorized in multiple and conflicting terms. By exhibiting their art separately from the established channels of recognition and reward that the Salon was held to epitomize, the painters offered a testament to their sincerity. Standing to gain little tangible reward from their endeavors, and being freed from such concerns, they could develop their own individual styles.[3] In a less elite voice, the shows also suggested a commitment to freedom and democracy. An exhibition without medals and without juries seemed to give the public the power to decide what was worthwhile. Correspondingly, participants took risks in displaying their art without an official stamp of approval.[4] Finally, a stance of independence with radical or revolutionary connotations was suggested by the appearance of a group of like-minded painters who pooled resources and stood in solidarity against the injustices of the established order.[5]

However mutually incompatible these vague defenses of independence were in terms of their assumptions about the market and the public, they reinforced one another: each was principally defined as a form of opposition to the Salon.[6] Representing the official exhibition as rigid and mediocre allowed Independents whose relationships to the market were widely divergent to secure their positions as outsiders and mount shows together under the rubric of *independence*. For example, the positions of Monet, Pissarro, and Degas can be roughly characterized, in turn, as entrepreneurial initiative, union solidarity, and aristocratic disdain. And the Salon-targeted defenses also allowed the dealer Durand-Ruel to sponsor group exhibitions without overtly compromising the ventures' independent status.

The principal organizers of the group show of 1886, Pissarro and Degas, maintained the rhetoric of independence—as the desirable image for identity and action—but not without the disorienting recognition that independence now had to be defined inside a competitive market, not simply outside a single institution. New avenues opened by competing dealers, and taken by Monet and Renoir, forced the issue in 1886. Yet independence had been a vulnerable notion all along, sustained as it was midway between representations of the Salon's omnipotence and the real lack of alternatives among galleries. The artists who planned the show for 1886 had somehow to deal with the contradictions of being Independents enmeshed in a market that dealers seemed to control.

To understand the emergence of this situation in 1886, we need to review how the painters and dealers attempted to survive the long period of economic stagnation that began in 1882. The collapse early in that year of the Catholic bank, the Union Générale, set off a panic on the stock market and a series of bankruptcies, leaving the Impressionists' principal dealer, Durand-Ruel, heavily in debt. The ensuing depression lowered the prices of paintings and forced Durand-Ruel to cut back on purchases as well as stipends for the artists. One might expect the Salon's appeal to have proportionately increased; however, it now actually declined among those Impressionists who had exhibited there during the prosperous period at the turn of the decade. Even Renoir—who had objected to the word *Independent* in the title of the 1882 group exhibition because of its revolutionary associations—would submit to the Salon only twice

more: in 1883, and then, perhaps simply out of nostalgia, in 1890. This suggests, in short, that recognition, status, and the tangible rewards they could bring were perceived to be obtainable elsewhere.

Durand-Ruel's efforts to show the group's works during the depression inadvertently made the artists acutely aware of the extent of their dependence. Not surprisingly, given his large stock of their paintings, the dealer acted promptly to promote the artists and, in the process, to extend his hegemony in the face of new competition. Having already organized and underwritten the group exhibition of 1882, he mounted successive one-man shows of Monet, Renoir, Pissarro, and Sisley in the spring and early summer of 1883. Perhaps Durand-Ruel intended this display to proclaim his dominant position to his chief rival, Georges Petit, whose approval Monet had successfully sought to gain by exhibiting at the Salon of 1880. Durand-Ruel's aggressive marketing strategy in the face of a declining and increasingly competitive Paris market included the exportation of shows with Impressionist paintings to London, Boston, Rotterdam, and Berlin in 1883. These maneuvers distanced the painters from the supervision of their works and the acquaintance of their audiences. Plans faltered for a group exhibition in 1884 – Durand-Ruel was forced by his worsening financial situation to liquidate part of his stock – and the following year he had to contest a slanderous accusation of fraud mounted by a conspiracy of dealers, an incident that heightened the artists' anxiety about the vulnerability of his position. Thus, the support by Durand-Ruel that once offered the painters an opportunity created by the optimism of prosperity became a condition of dependence caused by the dangers of depression.

In 1885, however, Monet reaped the rewards of his earlier efforts when he received an invitation to participate in Georges Petit's annual International Exhibition. He showed there with painters such as Jean Béraud, Albert Besnard, and Henri Gervex, whose company would have been considered a serious threat to the artistic distinction between the Salon and an Independent show. By 1886, the consequences of the premier Impressionist's participation in this show would begin to unfold. Renoir, Raffaëlli, and Monet himself would have to choose between exhibiting with the group or with Petit. All would go after the greater prestige and rewards promised by Durand-Ruel's competitor.

Finally, I should note the significance of one other event that set the stage for 1886. In 1884 artists rejected from the Salon formed the Société des indépendants, part of which was reorganized later the same year to constitute the Société des artistes indépendants. From its ranks would come three important additions to the eighth exhibition – Seurat, Signac, and Redon – all of whom had been introduced to the group through friendship with Guillaumin, the only older Impressionist to become a member of the new organization. The Society's plans for regularly scheduled, jury-free exhibitions shaped a democratic institution around the principle of mutual aid. This principle had been an ideal for some of the organizers of the first Impressionist show and it continued to appeal to the political liberals Guillaumin and Pissarro. But other aspects of independence – the individual risk taken in approaching the public directly, for example, or the prestige gained from participating in an elite endeavor – were undercut by the Society's financial guarantees, artistic heterogeneity, sheer scale, and bureaucracy. Indeed, Society members risked little more than those who pursued the Salon's acceptance: simple obscurity. The point could not have been lost on those who eagerly sought admission to the eighth exhibition.

From the beginning, plans for the eighth exhibition involved recognition that independence had to be established in relation to the vested interests of dealers. In tracing the roundabout pattern of negotiations, however, we shall see how those interests both directly and quite indirectly shaped the show's composition. The new definition of *independence* would be at least as precariously based as its predecessors.

Symptomatic of changes in the veteran Impressionists' affairs since their last show in 1882 was their decision in the fall of 1885 that Durand-Ruel should not host a group exhibition.[7] Writing to the dealer on behalf of Sisley and Pissarro in December, Monet tried tactfully to put the idea to rest. The painters, he said, had no intention of abandoning their loyal supporter, but felt that sponsoring their own show could do no harm and, indeed, might help matters by demonstrating that they were not entirely dependent upon him.[8] Monet had made a similar case to Durand-Ruel in the past to justify his participation in Petit's exhibition, claiming that affiliation with the prestigious dealer would counteract the notion that only Durand-Ruel dared invest in Impressionist paintings. And now Monet had reason to reiterate his position by adapting it to support his friends' purpose. Already he had told Durand-Ruel, Pissarro, and others that he had accepted an invitation to the International Exhibition of 1886 and agreed to Petit's condition that he would not participate in an Impressionist group show, should one be organized.[9] Moreover, Pissarro and Sisley agreed with Monet that they must explore other means to reach the public, particularly after their experiences with the extremely poor market during the summer of 1885.[10] Even when Durand-Ruel announced a major coup early in the fall – an invitation from the American Art Academy to mount a large Impressionist exhibition in New York – the artists' anxieties about dependence surfaced. Pissarro and Monet feared that Durand-Ruel would take their best paintings from his Paris stock to meet the demands posed by the American venture, which was to include three hundred works or more. They

would have trouble borrowing from the remaining stock for exhibitions, and besides, Monet argued, they should be represented best in the only place where judgment counted—Paris. "Here above all, and only here, is there still a little taste."[11]

Thus, the impetus for the last group show, like that of the first in 1874, came partly from the artists' assessments of Durand-Ruel's financial insecurity, but the final gesture of independence was directed at the dealer and, ambivalently, at his emerging markets. Not surprisingly, when Durand-Ruel's strategy to promote their paintings was most in question, the largest number of veteran exhibitors rallied to the Independent cause. To judge from scattered references in their correspondence, Pissarro, Renoir, Sisley, Caillebotte, Cassatt, Morisot, Degas, and Monet were each at one point or another in the fall of 1885 behind the project of a group exhibition.[12]

In early December Pissarro appealed to his colleagues' concern for independence, but discreetly suggested that younger Impressionists be included in the spring show. He wrote to Monet that, to avoid seeming to be under Durand-Ruel's patronage, the exhibition should be organized by the painters themselves and its composition should, above all, "prove the point."[13] Pissarro undoubtedly thought that participation in an Independent show, one clearly divorced from Durand-Ruel, would be in his best financial interests. Yet those interests could scarcely have been well served (in the short run, anyway) by the means he suggested for "proving the point." One notion of independence ran into another when Pissarro, reverting to a model of mutual aid and group identity, sought to add stylistically compatible artists to the exhibition who could benefit from public association with the Impressionists.

Pissarro may well have had Gauguin in mind when making his case for the composition of the 1886 show. Gauguin had recently returned to Paris from Copenhagen to find Durand-Ruel unwilling or unable to support him. Pissarro had also begun to lobby on behalf of Seurat, Signac, and Lucien Pissarro. More will be said later about Seurat's ideas and technique that struck Pissarro so forcefully that he began to experiment with them shortly after Guillaumin introduced him to Seurat at Durand-Ruel's gallery in October 1885. Pissarro's "conversion" to the scientific technique of color juxtaposition soon persuaded Seurat's friend Signac to adopt it as well, and the new method continued to gain young adherents and attract attention until, by the opening of the exhibition, it was the distinguishing feature of a separate group, later named the "Neo-Impressionists." Yet Pissarro had gone to bat for Seurat and Signac surprisingly early, well before he could have anticipated these developments: by the beginning of November, he had apparently already succeeded in convincing Degas and Morisot to accept the two for the coming exhibition.[14]

By the year's end, the matter seems to have been decided. Gauguin announced to his wife: "In March we are going to hold a very comprehensive exhibition including the new Impressionists who have talent."[15]

History often gave an ironic inflection to the rhetoric of independence: the initial plans for the eighth show proved no exception. A month or so after his suggestion to Monet that they establish an independent identity by extending the exhibition's composition beyond the fold of Durand-Ruel, Pissarro persuaded the dealer to look at paintings by Seurat, Signac, and Guillaumin, and to take some of their works to New York. And in May, while Impressionist paintings were on display in America, several sympathetic reviewers of the group show in Paris sought to reinforce the distinction between the Independents and the Salon. The "official" ideal, they unwittingly claimed, was the "Yankee" market.[16]

After the effort in December to separate the show from Durand-Ruel, the independent identity of the exhibition had to be reformulated in March, again in an effort to create a place for the venture apart from the territories of dealers. In an undated letter to Pissarro that was probably written in late March, Guillaumin explained that Degas had agreed to the admission regulations devised by Rouart, Eugène Manet, and himself. "The exhibition will be made completely independent without the intervention of dealers and with the conditions that [participants] cannot send to the Salon or to the exhibition of a dealer like Petit."[17] The actual move to exclude exhibitors in dealer-sponsored shows was most likely a defensive response to a perceived insult; by this time, it seems that Monet and Renoir, and with them, Sisley and Caillebotte, had definitively pulled out of the group venture.

The reinstatement of the traditional rule prohibiting participation in both the group show and the Salon, a rule suspended in 1882 at Renoir's insistence, was relatively inconsequential. But it did symbolically reinforce the appearance of opposition to dealer's ventures. Accordingly, Degas sought to emphasize an appearance of independence by scheduling the exhibition to open on 15 May, to run concurrently with the Salon—just the circumstances that the group had scrupulously avoided when arranging previous ventures, so its independence would not be confused with rejection from the official show. This was not the reasoning, however, that informed Pissarro's vigorous campaign against the proposed dates. "Degas is content, he doesn't have to sell," Pissarro wrote to Lucien in mid-March.
What we lack is money; without this problem, we would have already organized our own exhibition. . . . To pay for an exhibition at the same time as the Salon is to run the risk of selling nothing. Miss Cassatt and Degas say that's not the purpose of the exhibition, but that's easy to say when your bread's assured.[18]

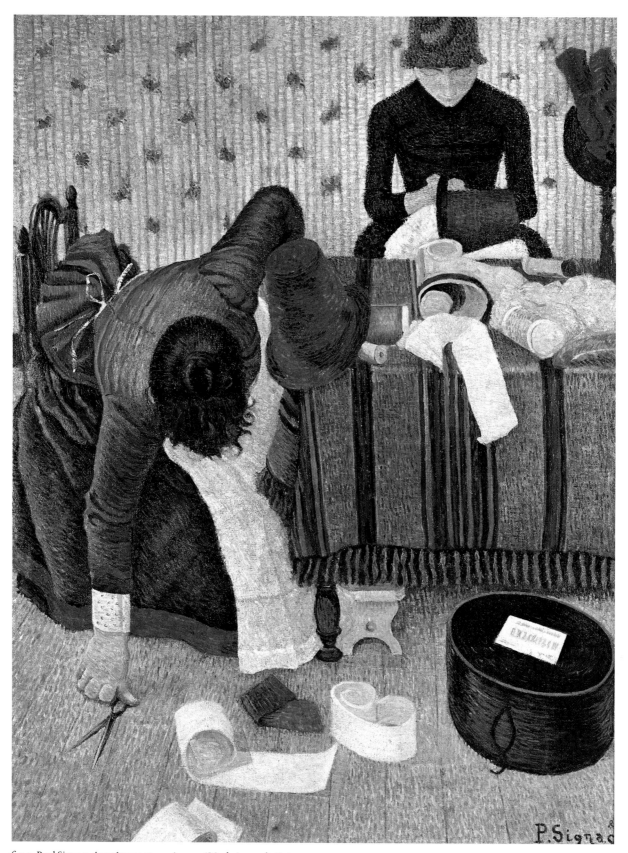

fig. 2 Paul Signac, *Apprêteuse et garnisseuse (Modes), rue du Caire*
(*Two Milliners*, VIII–184), 1885–1886. Oil on canvas, 44 x 35 in.
(111.8 x 89 cm). Sammlung E. G. Bührle, Zurich

Pissarro eventually conceded the date, but made his point in the catalogue. While nearly one-half of the works by Degas were listed with owners, all by Pissarro were for sale.

The problem of distinguishing the position of the Independents from the dealers soon developed a new complication, which involved Pissarro's contingent, the painters who lacked money. The group was probably more or less that which Pissarro had on other occasions called "Guillaumin et C^{ie}"—Seurat, Signac, Guillaumin, and Gauguin; Dubois-Pillet and Hayet, two future members of the Neo-Impressionist group, whom Guillaumin decided not to sponsor for the exhibition because of the verdict he expected from Degas; and possibly Redon, whose participation in the show Guillaumin had successfully pushed through by March.[19] Whatever its exact composition, except for Redon the contingent led by Pissarro and Guillaumin was loosely united by a strong commitment to Impressionism, a generally liberal political orientation, and, aside from Pissarro, a lack of lasting connections with prominent dealers. But by the time the exhibition opened this group would be subdivided, with one branch strictly defined along the lines of Seurat's new technique.

The division actually resulted from a bitter quarrel that broke out in early May between Pissarro and Morisot's husband, Eugène Manet, over the large work that Seurat planned to exhibit, *Un dimanche à La Grande-Jatte* (fig. 1), and Signac's *Apprêteuse et garnisseuse (Modes), rue du Caire* (fig. 2).[20] Pissarro's account of the quarrel makes clear that the latter's objections to Seurat and Signac were fueled by what the Impressionists aligned with Petit had said about the new technique, objections Pissarro countered with a defense of the "progress" that the new art represented. Degas had shown himself in the matter, Pissarro said, to be "a hundred times more loyal" than the others, despite his swipe at *La Grande-Jatte*. After Pissarro had described its merits, Degas had retorted, "I would have noticed that myself, only it's so large." Nevertheless, Degas did not attempt to deprive the new group of its two controversial centerpieces.[21] The immediate problem was resolved by a simple solution. Seurat, Signac, and Camille and Lucien Pissarro, the exponents of the new technique, were given a room to themselves where they could show whatever paintings they wished. The recognition that the interests of the "pure" Impressionists cut across the borders of the two rival exhibitions not only structured the arrangement of the Independent show, but contributed significantly to the formation of the new avant-garde of Neo-Impressionism.

In this connection, I want to pause to interpret the respective positions of Degas and Pissarro. For though they came to the exhibition with quite divergent notions of independence and adapted accordingly to the circumstances, each was well served by Seurat's radicalism.[22]

In comparison to Pissarro, Degas's position was more consistent with his past attitudes. As early as 1880, Degas had expressed disdain for Monet's efforts to win approval from Petit, and since then—if not before—his desire to appear aloof from commercial concerns had increasingly dictated his own transactions. He had diffidently disregarded demands for works from his exclusive dealer, Durand-Ruel, and shunned publicity to the point where reviews now concentrated on his reclusiveness.[23] Degas's concern to stand above commerce did not affect, however, his desire to be associated with artists more acceptable than the Impressionists. He gathered his preferred company for the eighth exhibition: by December, Cassatt and Zandomeneghi were involved; by March, Rouart, Tillot, and Forain; and by early May, Marie Bracquemond. But the Impressionists' arrival *chez* Petit—accompanied by Raffaëlli, the most conservative and the most contested of Degas's introductions to past group shows—must have had such commercial connotations for Degas that he found advantageous the marked contrast established between the two exhibitions by Pissarro's radical group. Otherwise, it is difficult to explain why Degas did not dogmatically oppose Seurat's participation, even after he had seen *La Grande-Jatte*. As Pissarro had already remarked in March in reference to Petit's show, Degas was ready for a fight over the exhibition of 1886: his established stance toward the market combined with new circumstances to make Petit the target and independence the issue.[24]

Pissarro came from a much different perspective to meet Degas on the significance of the Petit exhibition. He had, for instance, agreed with Monet in late 1882 that Petit's sumptuous gallery was a desirable site for a group show.[25] And far from being able to afford an aloof posture, Pissarro had been compelled by the depression in 1885 to grub among the lesser dealers in Paris. Whereas Degas was predisposed to condemn Monet for taking what Petit offered, Pissarro came only gradually to regard the other show as a rival. Even then it was Petit whom he blamed as a conspirator who plotted to divide the Impressionist group, a suspicion that no doubt developed because the dealer had been the first to prohibit participation in both the International Exhibition and the Independent venture.[26] Although Pissarro still strongly associated his art with that of the older Impressionists, there is no evidence that he approached Monet, as he might have, to intervene on his behalf for an invitation to the International Exhibition. A dealer had drawn the line and he would not step across.

Pissarro's resistance to Petit overruled, in effect, his lingering impulses to define independence as opposition to the Salon. He had been the only artist to participate in all the Impressionist exhibitions, and he and Degas had

been the only major group members not to have cast doubt on their commitment to independence by seeking admission to the Salon since the first show in 1874. However, Pissarro now argued against a symbolic confrontation with the Salon, fearing the financial consequences, but he defied his best interests in response to a dealer.

Just as Seurat's radicalism served Degas's elitism, so now it renewed and re-informed Pissarro's identification with Impressionism as an independent movement. "I accept the fight," Pissarro declared after he had defended *La Grande-Jatte* to Eugène Manet in terms of the "progress" that he felt the art of the new Impressionists represented.[27] A variety of associations must already have entered into the notion of "progress" that Pissarro had formed—artistic innovation, scientific and theoretical astuteness, and liberal politics. Now, resistance from the newly established order both corroborated the painters' "progress" and consolidated an avant-garde. "[They] have every interest in combating new tendencies," Pissarro said of the older Impressionists in May.[28] The recognition that those interests now coincided more immediately than ever before with dealers' interests—a recognition that seems not to have struck Pissarro forcefully until he encountered Manet's objections—meant, I think, that he set out to preserve the independent Impressionism, whose most faithful supporter he had been in the past.

Independence from the Salon was not a controversial issue in the criticism of the eighth exhibition. Indeed, some dismissals of the show resorted to parody to acknowledge the unpopularity of the position.[29] No one noticed the symbolic confrontation with the Salon that the opening date of the show was meant to signify; no one compared the venture to the Salon des Refusés that opened about the same time. A few critics noted that Monet preferred to exhibit in June with Petit, and explained that Impressionist painting was receiving, at last, the recognition it deserved. Marcel Fouquier joked that Monet must be waiting for "le premier prix de paysage," while Roger Marx concluded that Renoir and Sisley had been too occupied with commissions to have works ready for the group show.[30] Reviewers did not mention the rule prohibiting participation in dealer-sponsored exhibitions.

In the coming years, however, a few of the critics who sought to defend Pissarro's Neo-Impressionism shifted targets. A sign of what was to come appeared in contemporary reviews of the group show when Jules Christophe wrote of Forain's *Femme respirant des fleurs* (cat. no. 142)—one of two of his pictures lent to the exhibition by dealers—"to mention that this canvas belongs to M. Durand-Ruel is enough to show that savagery . . . accommodates itself to popular taste."[31] On occasion, critics favorable to Neo-Impressionism tentatively replaced the traditional figure of unjustly wielded authority, the Salon jury, with the image of the powerful dealer, whose reasons for promoting or dismissing artists were incompatible with radical styles.[32] On another tack, Félix Fénéon wrote a few months after the eighth exhibition closed that, despite the example provided by Pissarro, Monet dared not recommence the battle against the public, dealers, and collectors.[33] Similarly, Pissarro accused Monet in the late 1880s and early 1890s of painting expressly for the market, a charge that lacked the specificity of the traditional insult to an artist's sincerity: painting for the Salon jury and prize.[34]

Although the matter is difficult to assess, it seems unlikely that the Neo-Impressionist polemics resulted from any frustration generated among the younger painters by expectations that they, like the Impressionists, would find support from dealers once their movement solidified. For the most part, the Neo-Impressionists were financially independent or otherwise employed, and they seem not to have sought actively to establish connections with major dealers during the late 1880s. Although they made some efforts to continue the group shows, the Neo-Impressionists came to rely upon the exhibitions of the Société des artistes indépendants as the major forum for their work.[35] Combined with representations of this Society as an organization based on mutual aid, not entrepreneurial initiative, the painters' distance gave their defenders room to speak.

In any case, the new rhetoric of independence appeared only here and there, and was not widely adopted in the 1880s. Nonetheless, both the tendency and its characteristic tentativeness are significant. As when the widely divergent perspectives of Pissarro and Degas met in 1886, the new definition of independence implicitly condemned both the powerful dealer who offered and the enterprising painter who took. In its translation from the Salon to the galleries, the avant-garde rhetoric had, however, to compromise its absoluteness and break its symmetry. A dealer such as Petit or Durand-Ruel might serve for the moment as a symbol of how the market's financial interests overran artistic merit, but unlike the Salon and the academic values it represented, not all dealers were indicted by the charges. Perhaps no more or no less than any attempt to analyze the cunning of history, the old and new rhetorics of independence never could have done justice to the actual configurations of power.

Maintaining an independent Impressionism proved to be a short-lived illusion for Pissarro. Petit's International Exhibition of 1887 was the most representative display of Impressionist painting in Paris since the seventh group show in 1882. Monet and Renoir served on the organizing committee and exhibitors included Morisot, Sisley, and the resentful but desperate Pissarro. Durand-Ruel accepted few of Pissarro's Neo-Impressionist pictures and some of these were shipped straight to America.

Perhaps caught up in fears generated by the shift in rhetoric he had helped initiate, Pissarro assessed his situation to be more dismal than it actually appears to have been. As a token gesture of his resistance to Petit's gallery—Monet and Renoir invited him, they said, knowing full well his "repugnance for this exhibition"—Pissarro adamantly insisted on exhibiting his pictures in white frames which he suspected would be inappropriate for the luxurious decor.[36] Yet Pissarro soon found dealers willing to promote his Neo-Impressionist pictures and, like his old colleagues, eventually moved between galleries and established a qualified independence in terms of the alternatives they offered. On the other hand, Degas, who had refused to show at Petit's in 1887, would find a different way around the cessation of the Independent group shows: he simply stopped promoting the exhibition of his works.[37]

Criticism of the Exhibition

Located in the same general area where previous group shows had been held, the eighth exhibition occupied a prime site, a suite of five rooms above the fashionable restaurant the Maison Dorée, and across the street from the equally stylish Café Tortoni.[38] By chance, a few doors down on the rue Laffitte, the dealer Bernheim-Jeune had just opened a one-man show of works by de Nittis, a participant in the first group exhibition of 1874 and a founding member of Petit's International Exhibitions in 1882. And, by another coincidence, the eighth exhibition was situated midway between Durand-Ruel's gallery, a five-minute walk to the east, and that of Petit, five minutes to the west.

In evaluating the ambience of the show, however, critics tended to overlook points of comparison in the immediate area and instead directed their attention further south to the Salon at the Palais de l'Industrie. Commensurate with the multiple connotations of independence, the eighth exhibition was variously characterized as pleasantly discreet, undemocratically restrictive, or simply anti-bourgeois.[39]

In any case, critics were right to stress the show's exclusiveness, for the public did not come in droves to the eighth exhibition. Perhaps the Salon offered too much competition, as Pissarro had feared; or perhaps the exhibition announcements lacked too many of the familiar names; or perhaps, as some reviewers remarked, Parisians had simply grown accustomed to Impressionist ventures. Little more than a week after the show opened, Paul Alexis reported an average attendance of 450 visitors per day; a sign, he said, of the exhibition's popularity.[40] Yet when we judge this figure against the 500 visitors that Zola advanced for the group show in 1877, or the daily attendance of 2,000 to 3,000 claimed for the de Nittis show at La Vie Moderne in 1880, the eighth exhibition cannot be deemed a stunning success. And attendance

seems to have decreased. In early June, Pissarro complained that there were scarcely any visitors at all.[41]

Attendance is different, however, from notoriety. And it has been claimed that the eighth exhibition enjoyed notoriety in the extreme because of the reception of *La Grande-Jatte* and the new "scientific" technique. But if our collection of reviews is representative of what was published when and where, then it appears that neither the picture nor the technique created the sort of outrage in the Parisian press that has often been assumed.[42] In reviewing these publications, I want to suggest that some critics faced a situation parallel to that confronted by the painters who organized the show. For just as the artists lost the Salon as the focus of their opposition as a result of changes in the status of Impressionism, so reviewers momentarily found themselves without the traditional rhetorical points of opposition in the press.

The major Parisian newspapers that reviewed the show seem to have done so within two weeks after it opened. Many simply ignored *La Grande-Jatte* or jokingly dismissed it in passing. In a short note published on 23 May, the Neo-Impressionist supporter Alexis satirized in advance the negative account that he predicted would come soon from Albert Wolff, art critic at *Le Figaro* who was traditionally hostile to the Impressionists. But contrary to the expectations of Alexis and others, the legendary Wolff never reviewed the show.[43]

Among the critics publishing at this time, even the two who were most sympathetic to the Impressionists, Octave Mirbeau and Gustave Geffroy, paid scant attention to the innovations of the new group. Mirbeau wrote one highly equivocal sentence about *La Grande-Jatte*, Geffroy did not mention the picture at all, and neither took any notice of the group's technical innovations. They praised Seurat's seascapes as Impressionist paintings and devoted their efforts to discussing Degas's series of nudes, which at this point, roughly two weeks into the exhibition, had generated at least as much critical controversy as *La Grande-Jatte*, and probably more. It must have been during this early period that Pissarro wrote an undated letter to Hughes le Roux, journalist and critic for *La République Française*, urging him to write on the new group. "The exhibition is, I assure you, very interesting this year. Impressionism is entering a completely new phase and you would have the advantage of being the first to glimpse the totally different future that is being prepared. . . ."[44] Le Roux seems not to have responded with an article. Indeed, for whatever reason, and the absence of Monet and Renoir surely did not help matters, many of the noted Impressionist-oriented critics never reviewed the show.

In late May several less well-known newspaper reviewers did publish extensive and basically sympathetic accounts of *La Grande-Jatte*, but the picture only became the focal point for commentators in June. Then a

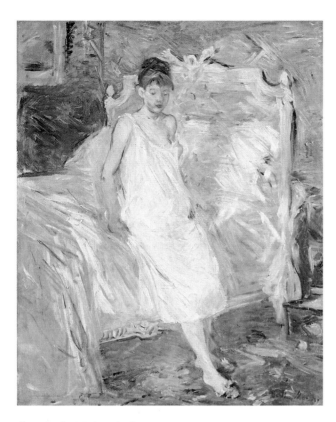

fig. 3 Berthe Morisot, *Le lever* (*Getting Up*, VIII–87), 1886. Oil on canvas, 25⅝ x 21¼ in. (65 x 54 cm). Private collection

new generation of critics, including Adam, Christophe, Ajalbert, and Fénéon, came forth with provocative articles in literary journals or relatively ephemeral publications. They received few immediate responses in the press, for all but Adam's account appeared during the last week of the show or after it had closed on 15 June. Fénéon, in particular, presented an elaborate justification for the new technique, citing scientific sources replete with mathematical equations, and constructing a history of Impressionism that culminated, as Pissarro had told le Roux that it should, with the innovations of the new group.

Thus it seems that, like Wolff, who had symbolized the power of the opposition to the Impressionists, the widely circulating Parisian newspapers did not respond forcefully, one way or the other, to the new style of painting. Indeed, one could argue that consequential opposition to the group came not as an attack but as silence, silence not just from those who had opposed Impressionism but more importantly from Mirbeau, Geffroy, and others who had personal connections with the movement. Among their readers were those who sought (for whatever reason) to have an "informed" opinion, a view from the inside of the group. The situation in 1886 exposed what had always been, despite the rhetoric, to some extent the case: Impressionist painting had supporters

who were entrenched in influential positions in the press. Their silence was arguably the most damaging sort of criticism.

Over the course of the next few years, the defense of Neo-Impressionism continued to come from a host of relatively marginal literary and artistic publications, many of them associated with the Symbolist movement. Christophe, Adam, Fénéon, Kahn, and others promoting the group rarely published in major Parisian papers. Though the critical avant-garde situated itself outside the realm of newspaper journalism, it did not fail to revive within the mainstream the voices that had fallen silent on the occasion of the eighth exhibition. Within a year after the show, Geffroy came out with harsh criticism of Neo-Impressionism from his position with *La Justice*.[45] In *L'Evénement*, Arsène Alexandre attacked Fénéon's style of writing as intentionally obscure and quoted passages from the critic's account of the eighth exhibition.[46] *La Grande-Jatte*, the Neo-Impressionist technique, and the style of the new group's supporters quickly attained a fair measure of notoriety.

Just as independence was essentially a dead issue in reviews of the eighth exhibition, so too were the discussions of Impressionism as a movement generally uninspired. Indeed, enervated is the word that best describes critical writing in May about the principles of the group's practice and the significance of its style. It seems that the controversial aspects of Impressionism, like those of Independence, were so settled by now that they needed no further explication. The voice of opposition, such as it was, briefly rehearsed long-standing objections. Michel said that one-third of the works had been executed with a broom; Havard raised the spectre of color-blindness, referring to Pissarro; Eyriès refused to consider the yellow and purple splotches as landscapes that, he claimed, were simply jokes. It was only the later critics, and especially Fénéon, who reassessed Impressionism, and they did so primarily to redirect the movement to Neo-Impressionism.[47]

Commentary on individual Impressionist artists also rarely exceeded the safe bounds of a well-established discourse on the movement. But in the following survey we shall see that some of the paintings nonetheless proved difficult to accommodate within the existing framework of critical concerns.

Morisot emerged in criticism as the chief representative at the exhibition of Impressionist spontaneity and improvisation. She was, in fact, one of the few painters to be discussed in terms of these once controversial issues. Darzens responded to her display of watercolors, fans, pastels, and oils with a classic formulation of Impressionism: "The artist seizes the fugitive impression of an instant and fixes it without appearing to use any method at all." Significantly, however, praise for Morisot's lack

of finish was rarely connected with the practice of plein-air painting. Instead, it often was conflated with praise for the psychologically elusive qualities of her subjects, such as the troubling stare of the adolescent girl depicted in *Le lever (fig.3)*. "Enigmatic and evocative" were the terms that brought technique and subject together in commentaries by Mirbeau and Geffroy, both of whom valued lack of specificity for its ability to create a strongly suggestive mood.[48]

Though commentators still generally associated Cassatt with Degas, as a woman artist she often was included in accounts with Morisot. Geffroy, who wrote an especially enthusiastic account of her display, claimed that "those who deny that Impressionism has delicacy and charm should see these pictures." Indeed, more serious analysis of Cassatt tended to be eclipsed by praise for delicacy and charm, though on occasion a balance was struck between the presence of feminine attributes and notions of a well-executed technique. Consider, for example, the comment from Octave Maus that Cassatt's work was a "robust painting [that does not betray] a feminine hesitation."[49]

Among the artists considered Impressionists, Guillaumin proved the most controversial. Several critics made the gross error of situating in North Africa the village of Damiette, which Guillaumin had represented in a series of views encompassing different sites, seasons, and times of day (cat. no.146).[50] The small community was in fact located just to the west of Paris, in the department of Seine-et-Oise. The critics' mistake in geography was no doubt prompted by a confusion over similar place names, but it was not an error that a passing glance at Guillaumin's bright colors would have served to correct. Indeed, Geffroy, who recognized the site, argued that Guillaumin's palette was inappropriate for the portrayal of the modest countryside of the tranquil Damiette, complaining that the colored fireworks threatened to turn the rural village into a romantic spectacle. Yet it was Geffroy who was the Romantic in this case. He was schooled in the Impressionism of the 1880s, and what he could praise in Monet's renditions of exotic or dramatic locales he found incongruous in the depiction of rural France—unless, that is, the scene were accompanied by the authority of Pissarro's name.[51]

Despite his participation in previous group shows, Gauguin was still categorized by some reviewers as a student of Impressionism. Critics rarely took stock of the diversity of his display, which ranged from views of Copenhagen and Rouen to forests and fields in Normandy, including as well several still lifes and a scene of seaside bathers. In considering the ensemble, reviewers unwittingly called attention to technical aspects of the works that evinced Gauguin's apprenticeship with Pissarro, such as a tendency to create an overall tonal effect, rather than to juxtapose widely separated hues. Geffroy

fig. 4 Jean-Louis Forain, *Place de la Concorde* (VIII–30), 1884. Oil on canvas, 28 x 20 in. (71 x 50.8 cm). Private collection, England

found the results to be unified; Fénéon implied that they were dull.[52]

Paul Adam departed radically from the emphasis that other commentators placed on Gauguin's competence as an Impressionist. To Adam, Gauguin's landscapes presented visions of a mysterious and unpredictable nature (cat. no.143). His descriptions of the scenes dramatized the presence of objects half-glimpsed through foliage or between tree trunks. The abrupt intersections of planes, which Fèvre criticized for confused perspective, Adam regarded as signs of inexplicable turbulence. Gauguin represented, according to Adam, nature that was "apart and malignant, yet which draws one with the strange allure of dreaded things." Adam's account, although brief, was the only one which demonstrated a familiarity with Gauguin's exploration of a Symbolist primitivism.[53]

Gauguin's critical reception at the eighth exhibition may well have fired his ambition. Though Adam and to a lesser extent Fénéon provided sympathetic accounts of his works, Gauguin nonetheless appeared in their reviews alongside the other painters whom we have considered: he was in the position of a stepping-stone on

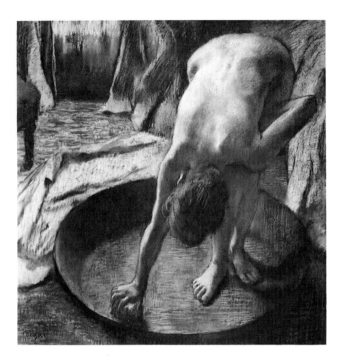

fig. 5 Edgar Degas, *Le tub* (*The Tub*, VIII–19/28), 1886. Pastel on paper, 27½ x 27½ in. (69.8 x 69.8 cm). Hillstead Museum, Farmington, Connecticut

changed dramatically as the exhibition progressed. He emerged in early reviews as the most popular painter at the show with his *Place de la Concorde* (*fig.4*) considered a chef d'oeuvre. Accounts agreed that the picture was very modern, Parisian, and, with some qualifications, well-rendered. In his review of 26 May, Geffroy dismissed the *Place de la Concorde* as anecdotal and accused the artist of making concessions in his large portrait of *Mme W.* (VIII–31) to the taste for muted color. As the more avant-garde reviews began to be published, critics varied in evaluating less finished and less anecdotal works such as *Femme respirant des fleurs* (cat. no.142), but in other entries they detected the influence of academic painters. Some added, not incidentally, that Forain had appeared at the Salon the previous year. Ajalbert, the last in the series to publish, drew the moral: *If he wanted to prove that he is capable of sweet and pretty lickings, he's succeeded. His large portrait [*Mme W*] will no doubt gain him many commissions; but as for us, let's go back to the Forain of earlier times . . . He's not there in the* Place de la Concorde *and the other mawkish paintings listed in the catalogue.*
Just as Forain came to be viewed as a talent corrupted by commercial concerns, which reviewers still assessed in relation to the Salon, so his display was seen to violate the integrity of the Independent exhibition.[56]

the way to Neo-Impressionism. Soon after the exhibition Gauguin disassociated himself from Seurat and Signac by refusing to participate with them in the August show of the Société des artistes indépendants.[54] And within a year, Gauguin had so radically developed the primitivism of his art that no critic could easily have dismissed him as a mere student of Impressionism.

Gauguin shared with the new group a desire to go beyond what they understood Impressionism to represent. In this sense, the show in the spring of 1886 marked the point when the movement of Impressionism entered the ranks of history: a norm that most critics accepted, that dealers sought, and some artists aimed to surpass.

It was equally revealing of the changed climate of opinion in 1886 that several of the artists who were associated with Degas received little serious critical attention. If Degas still sought to include them for a measure of respectability, their presence yielded little in return. Bracquemond, Tillot, and Rouart were virtually ignored, as was the landscapist Vignon, who was sometimes erroneously grouped with the others. In addition to Cassatt, the other generally acceptable artist in Degas's fold was Zandomeneghi, who was indeed praised by a remarkable range of reviewers, extending from the extremely conservative Patrice Eyriès to the most strident Neo-Impressionist supporter, Jules Christophe.[55]

The critical fortunes of Degas's colleague Forain

Degas's works provoked one of the show's major controversies. From the very start, critics alluded to the scandal that might develop over his group of ten pastels, *Suite de nuds [sic] de femmes se baignant, se lavant, se séchant, s'essuyant, se peignant ou se faisant peigner* (*Pastels*) (VIII–19–28; e.g., cat. nos.140 and 141, and *fig.5*).[57]

I want to analyze the response to the series at some length even though this involves a departure from the main themes of this essay. A range of concerns provoked the question of Degas's supposed misogyny, a major issue at the show. The vaguely defined identities of the women, assumptions about the nude as a genre, the obliqueness of Degas's point of view, and evaluations of his irony were considerations that all played a role. What perhaps most immediately prompted the critical unrest, however, was Degas's departure in this series from the description of modern public life that reviewers had come to expect from the artist.

For this reason, I want to look first at how critics evaluated the two other depictions of modern life that Degas exhibited in 1886, *Femme essayant un chapeau chez sa modiste (Pastel)* (*fig.6*) and *Petites modistes (Pastel)* (*fig.7*). Reviewers often considered the two images of milliners as a pair, emphasizing the contrasts between them. For example, Geffroy characterized as "graceful" the pose of the customer in *Femme chez sa modiste*, who adjusts the tilt of her hat and assesses the effect in a nearby full-length mirror. "The astonishing silhouette of

the woman makes one dream of a frescoed profile against a gold ground," he wrote in a tribute that combined his admiration for the figure's demeanor with an allusion to Degas's sources. Geffroy also thought that the harried young shop girls in *Petites modistes* were graceful, but in a significantly different way: "They possess a suburban grace with their monkey-like movements." Not all critics regarded the pair as an apposition of modern life's semi-noble and semi-comic aspects, its artistic and vernacular graces. Ajalbert, for example, assessed the figures as anecdotal personages and characterized the depicted moments as emblematic of their lives. While he decided that the customer was fickle and persnickety, the sort who would choose a hat to rival those of her neighbors, his sympathy rested with the shop girls who appeared anemic and ragged: "These are surely those who earn two francs per day, composing hats at twenty louis, waiting to deliver them."[58]

The responses of Geffroy and Ajalbert were predictable. In reaction to these subjects, they expressed admiration, sympathy, or amusement. More important than the differences in their individual preferences is that Degas's clear definition of public types, which was sharpened by the presence in 1886 of two contrasting images, allowed reviewers to rest content with a more or less evocative description of characters and circumstances. Such analyses generally concluded after critics had specified the types, interpreted the gestures accordingly, and perhaps praised the artist's technique. The routineness of their commentaries indicates their familiarity with Degas's strategies. For, as Christophe remarked somewhat snidely, the images of milliners were "not very new."[59]

In contrast to the depictions of milliners' shops, where the occupations of the figures were specified, the series of nudes offered only fragmentary clues to the public identity of the women. Some reviewers, including Geffroy, did not speculate on the subject. Many settled for the label "slatterns" (*malitournes*) and thus characterized the figures as decidedly ugly and repulsive, probably poor, and indecent. Yet there were a few critics who attempted with more or less zeal to deduce the personal histories and public identities of the women from the shape of their anatomies and their dimly-lit settings. Adam referred to the "fat bourgeoise" in *La boulangère* (cat. no. 141), while Ajalbert imagined the comic sight that this figure would provide with a minuscule husband. Fénéon identified the small obscure spaces in the pictures as shabbily furnished hotel rooms and, commensurate with the seedy connotations of the sites, he claimed the women's bodies bore the scars of "marriages, childbirths, and illnesses." Not content to leave the matter to suggestion, Fèvre made a concrete identification. He noted the cheap metal tubs in which some of the women bathed—"basins as big as troughs"—and, by observing the yellowish tint of the women's flesh, he surmised that the rooms must have

windows facing deep and dirty courtyards (*fig. 6*). The description of the setting metaphorically underscored the specification of the type: "Degas lays bare for us the streetwalker's modern, swollen, pasty flesh," he declared.[60]

The complex commentary that Huysmans published in 1889 had the virtue of acknowledging, through its reversals and contradictions, the images' lack of specificity on this score. For although Huysmans did not suppose the women to be prostitutes, he did conclude that the images had strong sexual connotations. He first observed the corpulence of the women's bodies and the roughness of their flesh and took these clues as indications that their occupations involved manual labor. He supposed that the women must be *charcutières* or *bouchères* "in real life" (presumably he meant in a public space) and he added that their bodies suggested continence, an obvious reference to their lack of seductive appeal. Within the space of a few paragraphs, however, Huysmans reconsidered the figures in light of their solitude and interpreted their gestures as emblematic representations of all women's actions in private. Regardless of their age, beauty, or status, he wrote, women must all at some time stoop, as Degas's figures did, to remove filth from their bodies. And when forced to bend and stretch and distort their shapes, they had to violate the images of women that they themselves found flattering. Here Huysmans's interpretations turned on subtle shifts of emphasis. The significance of the action of bathing, for example, was that it indicated the presence of filth. The oblique foreshortening and radical elongation of anatomical segments—configurations that Huysmans had praised earlier for their artistic mastery and their deviation from the academic norm—now suggested degrading acts of self-mutilation on the part of women. Similarly, although Huysmans had observed the beauty of the red and blue pastels that recorded reflections off the wet and dry surfaces of the figures' skins, these aspects appeared repulsive later in his text. "[The pictures] express a disgust for flesh as no artist has done since the Middle Ages," he claimed. Yet Degas had not imposed his disgust on his subjects, Huysmans argued. On the contrary, the pictures revealed the attitude of some women towards "the pleasures that they have provided." By the end of his essay, then, filth had become the aftermath of sex. And Degas had become the Realist whose art disclosed the attitudes of his subjects, not in accordance with their public identities, but in terms of their most private moments.[61]

Few reviewers of the eighth exhibition assessed the sexuality of Degas's figures so openly as did Huysmans several years later. But Mirbeau, Hermel, Geffroy, and others did discuss the images as representations of women in general, partly in recognition of the solitude of the figures, but also in discussions of the nude as a genre. Indeed, the defense of Degas's pictures as Realist antidotes to Salon

idealization led some critics to elevate their claims to meet the presumed universality of the academic category.

Mirbeau stated on the basis of a comparison with academic art, for example, that Degas's pastels were obviously not intended to "inspire passion for women, nor sensual desire." These images cruelly violated the canons of sentimental and romantic imagery, which characteristically glorified voluptuous breasts, graceful hips, and pearly skins. And no image was more cruel, Mirbeau said, than Degas's depiction in *La boulangère* of a "fat, stout woman with swollen flesh, who rests her hands on her enormous buttocks." Such unpitying representations of women recalled Degas's earlier images of the ballet, Mirbeau observed, where the artist had dissected the illusion of a light and airy dance to reveal the tortured and deformed anatomies of the performers. And although he disassociated himself from the painter's point of view, claiming that Degas must despise women and abhor love, Mirbeau's commentary nonetheless emphasized the comparative morality of the images as a Realist corrective to the contemporary idealization of women.[62]

In a review published a week later, Hermel further explored the issue of integrity and similarly claimed that Degas's pictures had far more moral content than could be recognized by the admirers of "porcelain nymphs." What was truly immoral and despicable in art, Hermel argued, was not the depiction of such women; it was the creation of discreetly sentimental and pornographic images that were designed to seduce the gullible viewer. Degas effectively exposed this sort of deceit and trickery in his series and did so as much through his technique and composition as through his selection of models.[63]

The composition of the images did suggest that the painter had systematically eliminated factors that contributed to the false and deceitful image of woman, whether that image was one staged by the painter in academic painting or designed by a woman herself for the public arena. Indeed, according to several critics, to be convincing, Degas's depictions depended on the illusion that the women whom he represented did not realize that they were being observed. Geffroy most fully developed the implications of Degas's strategy for the definition of his subjects. "Concerned to discover lines that . . . one does not even know to look for, he wanted to paint a woman who did not know she was being watched, as one would see her hidden by a curtain or through a keyhole." Geffroy noted that Degas had assumed points of view that were above, below, or to the side of his subjects. The artist had been able from these oblique positions to catch the women unawares as they bathed, crouched, stooped, and stretched in the assurance that their privacy was undisturbed. Moreover, Geffroy observed, some figures had their backs turned toward the viewer and Degas had not rendered any of the faces with legible expressions. Without these primary indicators of personality and emotion,

the pictures only allowed the women to be assessed as bodies performing habitual actions. "This is woman considered as female," Geffroy decided, "[woman] expressed only in her animality, as if these were superior illustrations to a zoological treatise."[64]

In a similar manner, Maus also shifted emphasis from Degas's concealed point of view, and the detachment and objectivity it implied, to the corresponding image of women as physical beings, devoid of psychological or social identities. Before quoting Geffroy at length, Maus inserted this introduction:

What Degas describes here is a woman undressed, in her portanimal simplicity, not the woman whose triumphant nudity knows how . . . to find the right attitude to accentuate the elegance of her torso. . . . He is solely concerned with the woman who believes that she is alone, absolutely alone, and who, having discarded all coquetry, devotes herself without reflection, naively, naturally, like a young cat, to the cares of her toilette, to cleaning in the freshness of the tub. . . .[65]

Because the women had been observed clandestinely, outside of the public sphere and without the need or desire to perform for others—a fact confirmed by the very deviance of their postures from the norms of academic painting—Maus assumed that they behaved not just unself-consciously but, moreover, unthinkingly. Their actions revealed the innate instincts of the female animal.

It is a striking fact that among the critics who described the figures as animals, only Maus offered an analogy that specifically reinforced the presumed naturalness of the actions and accorded them positive connotations. His comparison with "a young cat" appropriately suggested that bathing was a natural act for the women, an instinctive form of hygiene, a regenerative and refreshing process. In contrast, when other reviewers specified an example from the animal kingdom, they invariably characterized the figures' appearances as "frog-like" or "monkey-like." Like Maus's example of the cat, these were familiar terms for women in stock contemporary slang, a fact that might suggest that they were employed here as convenient social and cultural labels, carrying a minimal residue of the associations suggested by their zoological referents. Geffroy, after all, used the term "monkey-like" in this manner when commenting on the comic suburban grace of the gesticulating shop girls in Degas's *Petites modistes*. But compare that simple notation to the critic's description of the "frog-like" gestures of the nudes:

And he has hidden none of her froglike aspects, none of the maturity of her breasts, the heaviness of her lower body, the twisting bend of her legs, the length of her arms, and the stupefying appearance of belly, knees, and feet. . . .[66]

Geffroy all but turned the women into frogs, letting a bestial context become the common denominator for the

terms of slang and species. For the segmented configuration of the women's bodies did not suggest to Geffroy the remarkable equilibrium of a domestic cat when cleaning itself, but the violent and grotesque disjointedness of a creature out of control. This, then, at its extreme, was the vulgar truth of the images that Huysmans would later call chaste: the Realist antidote to Salon idealization, the vision of a squalid animal that might lurk behind a seductive mask.

Now Geffroy did not imply that Degas was a misogynist for having depicted the female animal. He partly attributed the artist's desire to capture the private moments and unposed actions of the women to an inquisitive search for new lines to record. And in contrast to his vigor when describing the figures' "frog-like appearances," Geffroy later assumed a more distanced tone in characterizing the images as "a distressing and lamentable poem about flesh."

The issues that Geffroy avoided in his account were addressed by Maurice Hermel in a review published several days later. Hermel's attempt to resolve the question of Degas's supposed misogyny was unsuccessful, I think, but it does reveal some of the interpretative problems that the series of nudes presented. Hermel sought to defend Degas against charges that he was "a ferocious misogynist who willfully debases women to animal and nearly monkey-like functions." The slight but possible ambiguities in this sentence (was Degas an "unwillful" or "unferocious" misogynist?) seem only the results of careless phrasing in view of Hermel's continued defense:

He is a feminist . . . and more feminist than the manufacturers of Venuses and Ledas, if one understands by that the gift of seeing and defining woman (a certain type of woman, if you wish) in that which most characterizes her.

Curiously, however, Hermel reintroduced in his concluding statement the animal analogies that he had seemed to dismiss. Now he implicitly acknowledged that Degas's figures brought such analogies to mind, but the gist of his argument was that the images should be understood as harmless, ironic commentaries on social and cultural metaphors. Clearly this claim was meant to answer lingering doubts that Degas's evocation of animal-like functions was intended as an allusion to the actual animals and associations that one might have with them. Here is Hermel's conclusion:

His irony is never pointed and never becomes brutal caricature; it is a homeopathic dose of humor added to the truth. With his dancers, milliners, and café-concert singers, Degas has given the most spiritual commentary on the current metaphors which rank women, according to their natural affinities, in the orders of bovines or frogs, squirrels or cranes [ruminants, batraciens, rongeurs, échassiers].[67]

Revealingly, although his review had been primarily concerned with the suite of nudes, Hermel did not include

these pictures alongside those of milliners as examples of a "spiritual commentary on the current metaphors." The solitary activities in these images, where the artist's strategy had been interpreted as an effort to capture the appearance of instinctive gestures apart from public identities, threatened to confirm degrading "natural affinities" at the expense of "current metaphors." Or, to put the matter more simply, the allusions to animals might be taken on a literal level precisely because the private had been equated with the natural or undeceitful. And if the images were nonetheless seen to be ironic, then the irony was not the harmless play that Hermel perceived in other works by Degas. Perhaps this was what Christophe recognized when, without explanation, he curtly dismissed the series of nudes as "a malicious joke."[68]

The issue of Degas's supposed misogyny was not one that Hermel resolved, despite his endeavors. But his text does reveal why this issue could not be definitively decided through speculations on allusions that Degas may or may not have intended to make. For even if Degas did expressly design the gesticulating arms of the shop girls in Petites modistes to appear "monkey-like," then what was implied by the reference? Was it simply the delight in recognizing a conventional metaphor as such, or the more complicitous recognition that it had been appropriately and justly applied? In view of these questions, it seems that Hermel may have phrased the opening sentence of his defense very carefully so as to suggest that there was such a thing as "unwillful" and "unferocious" misogyny. For one could argue that in images like Petites modistes, Degas exposed or exploited society's own seemingly "unwillful" debasement of women: the sort of bias that permeated culture through its colloquial representations and insidiously appropriated the ranks of "natural affinities" for social orders.

I have tried to show why the series of nudes threatened to violate the culturally acceptable limits of "unwillful" misogyny. A combination of factors led some critics to interpret the images as emblematic representations of the animality of the female sex: the lack of a specific public identity; the presumed universality of the nude as a statement about women's physicality; the equation of privacy with an unposed, and, in that sense, natural state. Yet among those who pursued this line of interpretation, there was one critic at least, Octave Maus, who attributed positive connotations to animality. Significantly, Maus published his review at the end of June, after all other accounts of the series but Huysmans's had appeared. His explanation of the cat-like behavior of the women was accompanied by the claim that, contrary to what others had said, the artist had not intended the works to be satires: they should be understood instead as "a sincere expression of reality."[69] He may well have been right. But if Degas did mean to present a

sympathetic image of the natural and the physical, the self-absorptive and the private—and from today's standpoint it is difficult, I think, to resist the appeal of Maus's interpretation—then we must simply conclude that in 1886 the images failed by and large to convey those intentions. Or, to put this in a different light, we should conclude that critics' own biases in matters concerning the representation of women did not allow this interpretation.

Of all the paintings in the eighth exhibition, Seurat's large and ambitious work *La Grande-Jatte* was historically the most consequential (*fig. 1*). In June the picture provided the focal point for the formation of a new critical avant-garde. As we have seen, the quarrels among the organizers in early May over its display at the rue Laffitte reinforced the rhetoric of independence. In 1890 Jules Christophe readjusted the rhetoric to claim the appearance of *La Grande-Jatte* at the eighth exhibition amounted to a revolution: "The Commune was declared in art by a young twenty-six-year-old man who followed the audacious Camille Pissarro, Blanqui of the brush. . . ."[70]

Some of the contemporary reviews of *La Grande-Jatte* have recently been analyzed by T. J. Clark in conjunction with his larger study of the image's significance as a depiction of contemporary leisure. I want to take his reading of the criticism as a point of departure, for it raises important questions about what critics in 1886 both did and did not discuss in promoting a work that was radically new—indeed, revolutionary.

Let us start with the review that has guided Clark's account of *La Grande-Jatte*, a summary of Seurat's intentions that Jules Christophe published during the last week of the eighth exhibition:
Monsieur Georges Seurat, finally, with the temperament of a Calvinist martyr who has planted, with the faith of a Jan Hus, fifty people, lifesize, on the banks of the Seine at La Grande-Jatte one Sunday in the year 1884, tries to seize the diverse attitudes of age, sex, and social class: elegant men and elegant ladies, soldiers, nannies, bourgeois, workers. It is a brave effort.[71]
Christophe's account differed from previous commentaries on the painting in two significant respects. First, he credited Seurat with a programmatic aim, that of depicting the differing appearances of age, sex, and social class. Second, he noted that Seurat had included workers among the figures in *La Grande-Jatte*. In the past, Sunday had been the time for bourgeois outings, while Monday was the workers' day. In Christophe's account, Seurat's painting documents the erosion of this separation, and the intermingling of classes on the island.

In this connection Clark has pointed especially to the threesome who occupy the bottom left corner of the picture: the primly seated, top-hatted man, identified by one

critic (Paulet) as a clerk; the man sprawling on the grass and smoking a pipe, labeled a canoeist (*canotier*) by Fénéon in a review in September 1886; and in between them, the woman absorbed in her sewing with her books and fan nearby.[72] In looking at the varying demeanors, attires, and attitudes of these figures, there can be little question that their juxtaposition does offer, as Clark argues in his interpretation of the painting, a powerful comment on the mutual agreement among different types to coexist in public by ignoring one another. The question, however, is whether there are different classes on this corner of the island, for it is the one area that Clark finds to correspond with Christophe's comment that there are workers in *La Grande-Jatte*. Clark takes the reclining, pipe-smoking figure to be a worker and it is upon this identification that he implicitly rests part of his argument that the painting is an attempt "to find form for the appearance of class in capitalist society."[73]

I want to review Christophe's commentary carefully, in order both to summarize some of the previous criticism and to show that, in the context of other reviewers' observations, Christophe's list of types in *La Grande-Jatte* seems itself to be somewhat less than candid. We know, for instance, that his reference to "elegant men and elegant women" actually concerned the controversial group at the far right of the picture: the woman, identified by George Moore as a cocotte; her elegantly attired companion who smokes a cigar; and her pet monkey, an undeniably outlandish creature. In the more comprehensive description of the painting that he included in his biography of Seurat in 1890, Christophe referred to the group as the "hieratic and scandalous couple: the elegant young man giving his arm to his pretentious companion with a monkey on a leash."[74] Yet, like other reviewers, Christophe kept quiet in 1886 on the subject of the monkey and the haughty, possibly scandalous appearance of its owner. They seem to have sought to emphasize the manifest seriousness and ambition of the picture rather than jeopardize that status by addressing its burlesque humor.

The next two figures that Christophe mentioned in his 1886 account—soldiers and nursemaids—present no such problems. Several reviews commented on the pair of soldiers in the upper left quadrant of the painting. Maus cracked a good-humored joke about their toy-like appearance that he turned to the painting's advantage. The nursemaid was one of the most popular figures in *La Grande-Jatte*, if the number of reviewers who noted her presence is any indication.[75] She appears discreetly at the left as a faceless configuration: an irregular quadrangle bisected by a triangular wedge and capped with circumscribed circles. No doubt her popularity with critics was partly owing to their delight in having decoded one of the painting's most hieroglyphic characters. Yet this pattern and the frequent citation of the soldiers, the only other

uniformed figures, should not be taken to suggest that critics had difficulty deciphering the identities that Seurat represented. On the contrary, those who addressed the matter either praised the simplicity with which characteristic aspects had been synthesized or complained that the reduction amounted to overly insistent caricature.

Many reviewers mentioned *canotiers*, but none at the eighth exhibition specifically attached this identity to the reclining man at the lower left, who Clark thinks is the worker in *La Grande-Jatte*. The figure was only singled out for special comment by one reviewer, Fouquier, who had some connections with the new group of painters and who published his article two days after the opening of the show. Fouquier joked about the "jockey cap" worn by the man and quipped that he must have lost his legs in the last jumping match. The jockey and the woman with the monkey were farcical, he said, and *La Grande-Jatte* was only good as a joke.[76] Now, it is remotely possible that the comic aspects of the reclining man prompted Christophe not to designate this figure as the worker on the island. After all, the critic did employ a general description in 1886 to gloss over the scandalous woman and the burlesque monkey. But in his more candid and comprehensive description of 1890, Christophe referred to the reclining figure as a canoeist, remarking that he smoked his pipe "without distinction."[77]

This summary brings us to an unsatisfying but necessary conclusion. Christophe said there were workers in *La Grande-Jatte*, either because he thought that was the case or because he wanted to report what Seurat had said. But he never concretely identified the workers and no other reviewer suggested that there were any.

Still, Clark argues, primarily with reference to the "nouvelles couches sociales," that critics in 1886 "seemed aware that Seurat's subject in *La Grande-Jatte* was double-edged: that he wished to show the nature of class distinction in a place given over to pleasure, but also the various things that made distinctions hard to grasp."[78] Clark's own reading of the image in these terms is compelling and convincing, but his claim for the criticism in 1886 is puzzling. For what seems hard to grasp is why critics, with the exception of Christophe, were not attentive to the blatant juxtapositions in Seurat's painting. At best, reviewers scanned the population and took note of various types, disregarding the order of their placement in the image. Ajalbert compiled the longest list —nine types, including the monkey—and he marveled at "all these people who hardly differ, all dressed in the same clothes," but he did not go on to analyze the differences among their attitudes. He praised the image for evoking the intense life in Parisian suburbs on summer Sundays, and then commended the artist for a synthesis that avoided, he said, "the facile subterfuge of an enumerative art."[79] Critics acknowledged diversity but did not attend to its implications. Most were far more

fig. 6 Edgar Degas, *Femme essayant un chapeau chez sa modiste (Pastel)* (*At the Milliner's*, VIII–14), 1882. Pastel on paper, 30 x 34 in. (76.2 x 86.4 cm). The Metropolitan Museum of Art. Bequest of Mrs. H. O. Havemeyer, 1929. The H. O. Havemeyer Collection

concerned to explain why all of the figures appeared to be rigid, stiff, expressionless, and posed. Clark gives ample consideration to the critical preoccupation with similar-ity—it is the basis for his claim that "distinctions are hard to grasp"—but no reviewer seems to have confronted, in fact, any such difficulty.

For the most part, critics' impulses were to make sense of the uniformity of Seurat's design as an expression of the collective attributes of the crowd. Some commentators did discuss the geometrical reduction and compressed definition of the figures as reminiscent of Egyptian art, or they described Seurat's rigid alignment as a modernized Puvis de Chavannes. But they only alluded to the ritualized connotations that such a hieratic investiture might imply and did not address the intermingling of types that replaced the ordering of older art. In contrast, other reviewers interpreted the expressionless faces, isolated stances, and rigid postures to be a more or less subtle parody of the banality and pretensions of contemporary leisure. For example, Fèvre remarked that after looking at the image for a while "one understands then the rigidity of Parisian leisure, tired and stiff, where even recreation is a matter of striking poses."[80] Adam also explained the figures' similarity as a slightly caricatural statement on social customs.

And even the stiffness of these people, their punched-out forms, help to give the sound of the modern, to recall our badly cut clothes, clinging tight to our bodies, the reserve of our gestures, the British cant we all imitate. We strike attitudes like people in a painting by Memling.[81]

These particular critics' responses resemble those we have examined in conjunction with Degas's series of nudes: they implicitly assume an opposition between public appearances and another more spontaneous or natural way of being. A statement on Parisian constraints and customs seems to such reviewers to be the point of *La Grande-Jatte*. In this sense, the criticism of *La Grande-Jatte* relied upon assumptions that also informed the interpretation of Impressionism, even as the familiar equation had to be reversed in reference to a depiction of leisure in the open air—even as what had been the escape into nature was replaced by the ritual of a parade.

It is hardly satisfying to leave matters here, however, with the observation that some critics failed to attend to the juxtapositions in *La Grande-Jatte* because they held onto larger oppositions that obscured social difference. For even as Seurat's methods of constructing paintings became more familiar, critics still failed during his lifetime to come to terms with the social implications of his images. Clark explains in a note that, whereas Christophe and Ajalbert were willing to talk about the social detail in *La Grande-Jatte*, Fénéon was not, because he adopted the by-then well-established critical strategy of deliberately overlooking or downplaying such concerns.[82] This is undoubtedly true. Yet it also is important to emphasize that Seurat himself, from all reports, talked obsessively about his artistic theories, virtually to the exclusion of other issues. The remarkable letters in which he outlined his ideas point by point, between a brief salutation and an abrupt closing, give credence to the stories. Indeed, the detached stance Seurat maintained no doubt contributed in some instances to the downplaying of the social aspects of his images.

When Christophe evoked the language of revolution in 1890 to dramatize the reception of *La Grande-Jatte* at the eighth exhibition, he altered the account of the picture he had provided in 1886. He considerably extended his description of the types in *La Grande-Jatte* but for some reason he dropped the explanation that the picture depicted the different attitudes of "age, sex, and social class." Workers no longer appear in his list of identities. These omissions, in themselves, are relatively insignificant. The addition of an analysis of Seurat's technique is more revealing, for Christophe had been the only supporter of the image in 1886 not to mention at all the new method of painting. There had been outcries at the eighth exhibition about the revolution of *La Grande-Jatte*, Christophe said, but it was Fénéon who had declared its success in his review.[83] When the rhetoric of revolution surplanted that of independence, it did so in the realm of artistic practice.

I think it is fair to say that one text—the review that Fénéon published in mid-June—provoked the controversy and suggested the issues that would subsequently inform debates about the Neo-Impressionist method.[84] Despite the complexity of his presentation, Fénéon's basic claim was relatively simple. Whereas the Impressionists had been led by their observation of nature to achieve luminosity through the use of decomposed color, the new group achieved the same end less arbitrarily with a technique that was based on the science of optical mixture. Fénéon quoted from the text of the American physicist and popularizer, Ogden Rood, which Seurat had consulted. He cited Rood's equations to demonstrate that the results of an optical mixture of hues were brighter than those produced by pigmentary mixture. In accordance with these scientifically derived principles, Fénéon said, the new group juxtaposed small touches of pure color in such a manner as to create maximum luminosity.

Fénéon did not say that scientific research provided an analogy with the painters' own empirical investigations of nature or confirmed their discoveries. This was the status that science had often assumed in earlier commentaries on the Impressionists. Instead, he treated science as a model of abstraction, an autonomous order that had authority for the new group. Through his descriptions of paintings, Fénéon also contributed to subsequent debate over whether the Neo-Impressionist method did not preclude or inhibit more properly "artistic" expression. Here, for example, is part of Fénéon's justly famous passage on one square decimeter (dm²) of *La Grande-Jatte*: *Take this grass plot in the shadow: most of the strokes render the local value of the grass; others, orange-tinted and thinly scattered, express the scarcely felt action of the sun; bits of purple introduce the complement to green; a cyan blue, provoked by the proximity of a plot of grass in the sunlight, accumulates its shiftings toward the line of demarcation, and beyond that point progressively rarefies them. Only two elements come together to produce the grass in the sun: green- and orange-tinted light, any interaction being impossible under the furious beating of the sun's rays. Black being a non-color is therefore deep purple; but it is also attacked by the dark blue arising from neighboring spaces of light.*[85]

What is most striking in this description is that the painting acts autonomously. The presence of one color solicits or provokes another into being; they compete and they blend. The account of the action shifts back and forth between the colored light and the depicted image; the material touches are effaced by the actions of disembodied hues and the illusion they compose. And here, as in other descriptions by Fénéon, there are few references to the painter, and the critic's voice seldom intervenes. Like the colors of the paint, the words of the text work autonomously, without address to the reader.

These decidedly Symbolist and indeed Mallarméan connotations Fénéon brought to the new technique by translating them into a style of writing rather than by

fig. 7 Edgar Degas, *Petites modistes (Pastel)* (*Milliners*, VIII–15),
1882. Pastel on paper, 19 x 27 in. (48.3 x 68.6 cm). The Nelson-Atkins
Museum of Art, Kansas City, Missouri. Anonymous Fund

subjecting them to exposition. And the same is true of the anti-materialist resonances that enter into his account, where the physical nature of the painted canvas dissolves into colored light.[86]

In another part of his review, however, Fénéon evaluated the material surface of *La Grande-Jatte*, again anticipating (and stimulating) the debate that would develop over whether the uniformity of the technique did not preclude the expression of originality:

La Grande-Jatte, *whatever part of it you examine, unrolls, a monotonous and patient tapestry: here in truth the hand is useless, trickery is impossible; there is no place for bravura—let the hand be numb, but let the eye be agile, perspicacious, and knowing. Whether it be on an ostrich plume, a bunch of straw, a wave, or a rock, the handling of the brush remains the same.*[87]

Fénéon first defended the Neo-Impressionist "tapestry" in negative terms: it left no room for *morceaux de bravure*—for displays of fluid paint handling, the primary

purpose of which was to impress the spectator with the ease and proficiency of the artist's touch. Then he transformed this exclusion into a positive esthetic. "Let the hand be numb," he said: let the artist's vision, not manual dexterity, be defined as the essence of painting.

In 1886 Fénéon did not accuse the Impressionists of producing *morceaux de bravure*. But in the coming years, he and the Symbolist critic Gustave Kahn would question the efficacy of Impressionist painting, even though they clearly admired certain works. Indeed, they voiced objections to Impressionism that had hardly been heard at the eighth exhibition. They found Neo-Impressionist works to be complete and unified, surpassing the hazardous and arbitrary results of plein-air painting. They praised the new group for presenting a definitive view of nature, rather than representing an excited and momentary response to it. The Neo-Impressionists worked in the studio to achieve decisive *tableaux*, they said, rather than resting content with mere *études*.

In effect, Fénéon and Kahn revived the controversies about a practice apparently based on spontaneity, originality, and momentary impressions–concepts that had increasingly become norms for defining art as Impressionism itself was more and more accepted. They sometimes phrased their objections to suggest that this acceptance, this normalizing, posed a problem for the artist. In 1887, for example, Fénéon claimed that the Impressionists had a propensity for making "nature grimace in order to prove that the moment was unique and would never come again."[88] Because Impressionism was associated with the presumed uniqueness of the depicted moment and the singularity of a supposedly spontaneous technique, the artist had to make the execution of each painting outdo the performance of the last. The expression of individual experience that should have been the most self-fulfilling aspect of Impressionism might in the end be a self-defeating process. Signatures of originality might be only *morceaux de bravure*.

It is tempting to conclude here that Christophe chose an apt analogy when he referred to the Commune in conjunction with the "revolution" of 1886. It is also tempting to declare that the principal tropes of Impressionist painting, such as spontaneity and the individuality of experience–cultural and social as well as artistic values– were overthrown by an autonomous, collective order. But if that were the appeal, then history gave an ironic inflection to the implicit promise of the new method. Although the scientific technique provided the foundation for a new group and a supposedly universal (unarbitrary) language, it did not in the end foster a community of cooperation or communication. Seurat became increasingly protective of his place in the movement's history, and increasingly secretive about the details of his technical innovations and theories, apparently fearing that they would be vulgarized in the hands of lesser artists and would no longer seem original. After a certain point, critics no longer wrote freely about his ideas, and he no longer shared them with his colleagues. Exasperated, Pissarro and Signac said privately that Seurat was a product of the Ecole des Beaux-Arts.[89] But the pressure to be original was inherent in the late nineteenth-century enterprise of art, whether one situated one's practice outside of the Salon, as the Impressionists had done, or outside of the market, as some of the Neo-Impressionists did for a while. The rhetoric of communal revolution, like the rhetoric of individual independence, had its own necessary oversights.

In the future some critics would claim not to be able to distinguish the landscapes by one Neo-Impressionist from those by another, but no such complaints were recorded at the eighth exhibition.[90] The issue of the mechanical appearance of the method and its consequences for originality had not yet arisen. In this respect, the comments in 1886 are especially important, for they reveal that, until the new technique was informed by "revolutionary" connotations, the landscapes of the group could for the most part be regarded as Impressionist works.

The response to Seurat's landscapes (e.g., cat. no.152) was overwhelmingly favorable from those reviewers who were sympathetic to Impressionist painting and, indeed, in the case of J. M. Michel, from a critic who was not. Mirbeau, Geffroy, and others noted the transparency of the seascapes, and reviewers most often characterized the mood of the unpopulated scenes as melancholic. Commentary did not depart from the standard criteria for Impressionist scenes, however, except for Adam's claim that the works possessed a remarkable calm, depicted an immense space, and provided a "sense of a visual void."[91] In the future, Seurat's paintings would elicit similar praise from Symbolist-oriented critics who commended the works for creating visions of an immaterial realm, composed solely of color and light.

Adam thought that Pissarro's landscapes also provided a sensation of the "visual void," and indeed other reviewers remarked on the spatial qualities of the artist's Neo-Impressionist works, although they did not attribute to them any particular philosophical significance. For example, Fouquier offered these comments on Pissarro's *Plein soleil: Paysanne aux champs* (VIII–102) and *Prairies de Bazincourt, le matin* (VIII–96):

Up close the paintings resemble . . . a collection of diversely colored nail heads. But when one assumes the proper distance, the perspective is established, the planes recede, and since the sky is lightly painted, one has the impression of a vast space and an indefinite horizon.[92]

The remarks must have pleased Pissarro. These were precisely the effects that he would continue to develop in his experiments with the new technique during the next year or so, when he employed small touches to achieve a deep and open space, defined by flat terrains and vast, virtually cloudless skies.

The centerpiece of Pissarro's display was a large figural work, *La cueillette de pommes* (cat. no.149). Pissarro had begun the painting in the early 1880s but, no doubt in preparation for the exhibition, he added tiny daubs of pure color to its already thickly painted surface in order to heighten the complementary contrasts in certain areas. He probably followed the model provided by Seurat who had repainted the surface of *La Grande-Jatte* during the winter of 1885–1886. Yet no critic took note of the admittedly much less pronounced appearance of the new technique in *La cueillette de pommes*, nor did any reviewer comment on the geometrically defined and starkly contrasted zones of light and shade, aspects which related Pissarro's work to *La Grande-Jatte*. Instead, commentary on *La cueillette de pommes* followed past favorable interpretation of Pissarro's peasant

imagery. For instance, Ajalbert praised the robustness and health of the apple gatherers in a general tribute to life in the countryside. Several years later, however, after Neo-Impressionism had acquired a more thoroughly Symbolist cast, George Moore wrote that *La cueillette de pommes* was a dreamlike and timeless vision.

Signac's display, which included seascapes and views of Paris and its industrial suburbs, met with a more varied reception than did landscapes by other Neo-Impressionists (cat. nos. 157, 159, and 160). Geffroy thought that Signac's color oppositions were too harsh, but that the subjects were well chosen. This is a curious remark, considering that the critic objected that Guillaumin's colored fireworks disrupted the tranquil village of Damiette. For Signac's use of bright color to depict industrial suburban sites was, in fact, a far greater departure from the Impressionist norm. Even the critics inclined toward Neo-Impressionism diverged from one another over the significance of these paintings, each providing a somewhat different interpretation. For example, Adam remarked that Raffaëlli would have emphasized the pervasive dark soot and dying vegetation in such sites, but Signac had represented new and gay red roofs and gracious undulations of smoke. Ajalbert implied that Signac had been interested in observing how the sun could alter otherwise depressing suburban appearances, as when "anemic roofs receive solar red transfusions." Fénéon noted the presence of desolate, scorched walls and shriveled trees, observations that suggested the suburbs were roasting, even dying, under the heat of the sun. Yet the differences among these reviewers' descriptions were actually rather slight, for in the midst of celebratory remarks they each subtly introduced in one way or another the notion that the suburbs were indeed dismal, despite the color.[93]

The modernity of Signac's new red roofs and gas tanks in working class suburbs was not the modernity that Monet and Renoir had sought in the 1870s in other suburban locales (cat. no. 158). Nor did the milliners in Signac's large painting at the show, *Apprêteuse et garnisseuse* (fig. 2) possess any of the "suburban grace" of Degas's pair in the *Petites modistes* (fig. 7). Indeed, the figure at work on the right is as rigid and stiff as most of the figures at leisure in *La Grande-Jatte*. Yet only Ajalbert recognized a connection between the two: "In the same manner as M. Seurat, M. Signac has drawn his milliners with the aim, I think, of giving the appearance of people in the simplest way possible."[94] No one speculated on the juxtaposition of the images in the back room at the eighth exhibition, where both work and leisure appeared as hieratic rituals. The fact that, even now, the relationship between *Apprêteuse et garnisseuse* and *La Grande-Jatte* remains unexplored is but one of the many legacies of the criticism of the exhibition.

A postscript is necessary to take note of one artist whose inclusion in this essay has proved as difficult as the evaluation of his works seems to have been for reviewers of the show. Odilon Redon displayed fifteen works in a separate corridor of the rue Laffitte apartment. Critics generally reacted to them with blanket assertions as to whether the dreams of the "Edgar Allan Poe of drawing" were profoundly subjective or simply a mystification. Adam liked Redon's phantoms but declined to describe them, because to do so in a short space would be a "vain enterprise." He put the problem succinctly: "[Redon's] genius is independent of all schools: it has no immediate relationship to Impressionism."[95]

Transformed into the ancestor for a new generation, however, Impressionism itself had been the phantom of the show.

Notes

All translations are the author's unless otherwise noted.

1. John Rewald's several accounts of the events leading up to the exhibition of 1886 have provided much of the material for this essay, far more than I could reasonably acknowledge with individual notes. See especially *The History of Impressionism*, 4th rev. ed. (New York, 1973), 521–524.

2. The gradual eclipse of the Salon by the dealer-critic system is discussed by Harrison C. and Cynthia A. White, *Canvases and Careers: Institutional Change in the French Painting World* (New York, 1965), 94–98. The transfer of responsibility for the Salon from the state to an artists' association, created in 1881, did not substantially alter the representation of the exhibition as an "official" enterprise.

3. Rather than trace these notions through reviews of the group shows or to earlier sources—projects well beyond the scope of this essay—I will give examples here from the criticism of the eighth exhibition. For complete citations of these and other reviews, see the Eighth Exhibition review list in the Appendix. Sincerity linked to lack of financial motivation is represented by the very uninformed statements by Labruyère, 28 May 1886, who accounted for the absence of Monet and Renoir in terms of their disdain for the public and their poverty. Jules Vidal claimed that, because one-half of the pictures in the exhibition had been sold, "mercantilism" now made "intransigence" impossible.

4. In this connection especially, favorable critics tended to cite the mistakes of dismissive reviewers, claiming that they "misled" the public and were thus responsible for audiences' hostility: see Octave Mirbeau review and Paul Adam review, 541.

5. See Firmin Javel's opening remarks where "revolutionary" (used in inverted quotation marks) may be ironic, given the author's attempt to strike a middle-of-the-road position throughout his review.

6. The motivations suggested by these representations do not tally, of course, with the motivations that result from analysis of the painters' actual maneuvers in the marketplace. For an assessment of the latter, see Joel Isaacson, *The Crisis of Impressionism 1878–1882*, exh. cat. (Ann Arbor: University of Michigan, Museum of Art, 1980), 9–11; Albert Boime, "Entrepreneurial Patronage in Nineteenth-Century France," *Enterprise and Entrepreneurs in Nineteenth- and Twentieth-Century France* (Baltimore, 1976), 184–191.

7. In mid-November 1885, Monet reported that Durand-Ruel had written about plans for a large group exhibition that would flatten all the dealer's enemies: Monet to Alice Hoschedé, 17 November 1885, in Daniel Wildenstein, *Claude Monet: Biographie et catalogue raisonné*, 4 vols. (Lausanne, 1979), 2:266, letter 620.

8. Monet to Paul Durand-Ruel, 17 December 1885, Wildenstein, 2:270, letter 642.

9. Monet to Pissarro, 9 November 1885, Wildenstein, 2:266, letter 616; Monet to Durand-Ruel, 17 December 1885, Wildenstein, 2:270, letter 642.

10. Pissarro to Monet, December 1885 in Janine Bailly-Herzberg, ed., *Correspondance de Camille Pissarro* (Paris, 1980), 357–358, letter 298.

11. Monet to Durand-Ruel, 28 July 1885 and 21 January 1886, Wildenstein, 2:260–261, letter 578 and 2:271, letter 650. For Pissarro's reaction, see his letter [21 January 1886] in John Rewald, *Camille Pissarro: Lettres à son fils Lucien* (Paris, 1950), 90.

12. For Renoir, Monet, Sisley, Cassatt, Morisot, Degas, and Zandomeneghi, see Pissarro's letters to Monet, 7 December 1885 and to Mme Pissarro, December 1885, Bailly-Herzberg, 356, letter 297, and 367, letter 303. For Caillebotte, see Monet to Alice Hoschedé, 9 December 1885, Wildenstein, 2:269, letter 637.

13. Pissarro to Monet, 7 December 1885, Bailly-Herzberg, 356–357, letter 297.

14. In a letter of 30 October 1885 Guillaumin urged Pissarro to visit Morisot on behalf of Seurat and Signac. Much later, on 12 March 1886, Guillaumin informed Pissarro that he and Seurat had visited Degas, who had expressed surprise that their participation should be questioned when it had been agreed upon in October. Presumably Signac had also been included in this arrangement. Both letters are in the collection of the Bibliothèque d'Art et d'Archéologie, Paris, and are partially quoted in sale cat., *Archives de Camille Pissarro*, Hotel

Drouot (Paris: 21 November 1975), no. 78, where the date of the first letter is erroneously transcribed "30 déc 1885."

15. Gauguin to Mme Gauguin, 29 December 1885, Maurice Malingue, ed., in *Paul Gauguin: Letters to His Wife and Friends*, Henry J. Stenning, trans. (London, 1949), 58–59, letter 32.

16. Jean Ajalbert review, 385; Labruyère, 28 May 1886 review.

17. Guillaumin to Pissarro, n.d., Bibliothèque d'Art et d'Archéologie, Paris; partially quoted in *Archives Pissarro*, no. 78.

18. Pissarro to Lucien Pissarro [March 1886] (also notes 21, 24, 26, 27, 28 below), Rewald, *Pissarro: Lettres*, 97–98. On 12 March Guillaumin announced to Pissarro that Degas had agreed to an opening on 20 April, observing that they might open even earlier if an apartment were available and Degas could be ready (see above, note 14). Degas's chronic inability to finish works in time for exhibitions may have played a role in his preference for a May opening. But as late as 13 April the date may still have been undecided. Signac wrote to Lucien Pissarro that he would hear by 15 April whether they could rent for the exhibition a locale on the rue de Châteaudun near Clauzet, a dealer who had already displayed works by the emerging Neo-Impressionist group (Pissarro Family Archives, Ashmolean Museum).

19. For "Guillaumin et C^ie" see Pissarro to Lucien Pissarro [16 February 1886], Rewald, *Pissarro: Lettres*, 95. In addition to Hayet and Dubois-Pillet, Guillaumin considered introducing Schuffenecker (see above, note 14).

20. At some earlier point, Morisot had already accepted works by Seurat and Signac after reviewing an ensemble of works presented by each. This arrangement for evaluating new painters had become established policy by May when Pissarro informed Gauguin's friend, Schuffenecker, who sought to join the show, that he would have to go through the procedure of presenting an ensemble to Morisot, as Seurat and Signac had been required to do. (Pissarro's rough draft for the letter is in a private collection.)

21. Rewald, *Pissarro: Lettres*, 100–101; this undated letter must have been written around 7 May 1886 because Pissarro remarked that Monet had returned from Holland the previous day.

22. For an analysis of the proximity of the practices of Pissarro and Degas in the early 1880s in the context of their political orientations, see Michel Melot, "La pratique d'un artiste: Pissarro graveur en 1880," *Histoire et Critique des Arts* 2 (June 1977): 14–38.

23. Octave Mirbeau, "Notes sur l'art," *La France*, 15 November 1884; and Geffroy review.

24. For Pissarro's remark about Degas, see Rewald, *Pissarro: Lettres*, 102. Hard feelings existed nonetheless between Degas and the Neo-Impressionists; see Joan U. Halperin, ed., *Félix Fénéon: Oeuvres plus que complètes*, vol. 1 (Geneva, 1970), 47.

25. Monet to Durand-Ruel, 23 December 1882, Wildenstein, 2:222, letter 305.

26. Rewald, *Pissarro: Lettres*, 102.

27. Rewald, *Pissarro: Lettres*, 101.

28. Rewald, *Pissarro: Lettres*, 101–102.

29. See G. Dargenty review, 244–245. For hyperbolic praise see Ajalbert review, 385.

30. Marcel Fouquier review; Roger Marx review.

31. Jules Christophe review, 193.

32. Halperin, *Fénéon*, 58.

33. Halperin, *Fénéon*, 58.

34. Pissarro to Lucien Pissarro, 9 April 1891, Rewald, *Pissarro: Lettres*, 230–231.

35. *Archives Pissarro*, nos. 170, 173, 176; see also Halperin, *Fénéon*, 47; Rewald, *Pissarro: Lettres*, 113. Pissarro apparently was eager to exhibit with the Société des artistes indépendants but was dissuaded by Degas, Durand-Ruel, and several *amateurs* who argued it was beneath his dignity; see Gustave Kahn, "Les origines de la Société des indépendants," *A.B.C.* (March 1932): 68. See Signac's undated letters from 1887 to Pissarro, *Archives Pissarro*, nos. 170, 173, 176; see also Halperin, *Fénéon*, 47.

36. Monet to Pissarro, 5 March 1887, Wildenstein, 3:221, letter 775.

37. For comments by Monet that make it clear Degas was invited, see Monet to Berthe Morisot, 7 March 1887, Wildenstein, 3:222, letter 777.

38. Robert Herbert has discussed the importance of this general location for understanding the Impressionist exhibitions: "Impressionism,

Originality, and Entrepreneurial Invention," lecture, The Art Institute of Chicago, 8 December 1984.

39. Vidal review; A. Paulet review; [Octave Maus] review, 201.

40. Trublot [Paul Alexis], "A minuit," *Le Cri du Peuple*, 23 May 1886.

41. For Zola and de Nittis, see Rewald, *Impressionism*, 394, 431. For Pissarro, see his letter to Lucien Pissarro [June 1886], Rewald, *Pissarro: Lettres*, 104.

42. Reviews do not necessarily, of course, reflect the reactions of visitors to the show. I find it impossible to believe that *La Grande-Jatte* did not create a stir at the rue Laffitte; in this connection, see George Moore's recollections of opening day: *Confessions of a Young Man* (London, 1888), 32. The anonymous reviewer in the British publication *The Bat* remarked that the long tail of the monkey in *La Grande-Jatte* had created "a clamour in the petite press"; however, our collection of criticism does not include any such references. The reviewer was almost certainly George Moore; see the reprint in Kate Flint, ed., *Impressionists in England: The Critical Reception* (London, 1984), 71. See also Signac's recollection of opening day, which is included along with many other contemporary commentaries in Henri Dorra and John Rewald, *Seurat* (Paris, 1959), 158.

43. Trublot [Paul Alexis], *Le Cri du Peuple*.

44. Quoted from Pissarro's rough draft, addressed to Hughes le Roux, n.d., private collection.

45. See especially Geffroy's comments on Pissarro in "Chronique: Hors du Salon," *La Justice*, 14 May 1887. See also: "Chronique: Le Salon des indépendants," *La Justice*, 15 April 1887.

46. Arsène Alexandre, "Critique décadente: Les impressionnistes en 1886," *L'Evénement*, 10 December 1886.

47. In order of citation: Michel review, 2; Havard review; Eyriès review. See below for Fénéon. Several exceptions to the characterization I have provided should be noted for the record. Henry Havard assertively dismissed Impressionism, claiming that the works could not represent unique sensations as there was a family resemblance among them. Havard introduced the issue by quoting Alfred Stevens's formulation of the same point in Stevens's *Impressions sur la peinture* (Paris, 1886). A. Paulet provided a bizarre account of the history of Impressionism as having fundamentally been shaped by the theories of novelists; he stated that "the most daring of the exhibitors [at the rue Laffitte] appears a reactionary beside Besnard at the Salon." He did, however, perceptively separate Seurat from the others at the show, noting that the artist's interest in line signaled an abandonment of sensation and a return to "l'idée"—a distinction informed by the theoretical debate for centuries about the relative merits of color and line. Finally, Emile Hennequin offered a fairly traditional although extended account of the Impressionists as being uninterested in subjects and concerned above all with technique.

48. In order of citation: Darzens review, 91; Mirbeau review; and Geffroy review.

49. In order of citation: Geffroy review; [Maus] review, 202.

50. *Le Moniteur des Arts*, 174; Henry Fèvre may only have been joking when identifying the site in his review, 155–156. Fénéon noted that the reviewer for *Le Soir* had made the same mistake (Halperin, *Fénéon*, 47, note for line 141). Adam and Ajalbert both corrected the error (Adam review, 541; Ajalbert review, 381).

51. Geffroy review. Cf. laudatory description of Guillaumin's color, Halperin, *Fénéon*, 33.

52. Geffroy review; Halperin, *Fénéon*, 33.

53. Adam review, 545; Fèvre review, 155. Fénéon described Gauguin's paintings in a manner that suggested the critic agreed with Adam.

54. See Signac's letters to Pissarro, n.d., in *Archives Pissarro*, no. 166. An indication of the extent to which a camaraderie existed between the critics who leaned toward Neo-Impressionism and the group around Pissarro is suggested by Ajalbert's apology to Gauguin for having severely criticized his works (review, 390).

55. Eyriès review; Christophe review.

56. In order of citation: Geffroy review; Ajalbert review, 387. For a more detailed account of Forain's reception see Richard Thomson's study, "Jean-Louis Forain's 'Place de la Concorde': A Rediscovered Painting and Its Imagery," *The Burlington Magazine* 125 (March 1983): 157–158.

57. For instance, Javel remarked on 16 May: "As Realism this is com-plete. One will go no farther in the art of frightening the philistines." Mirbeau, Hermel, and Huysmans dramatized the philistine response by imagining the horrified reactions of visitors to the show, but the outrage voiced by such fictional spectators found few echoes elsewhere in press. (The anonymous critic for *La République Française* did ask why Degas had abandoned his dancers to depict the "heavy bodies of these slatterns, surprised in bizarre positions or in occupations that are truly too intimate.") The situation presents an interesting contrast with the reception of *La Grande-Jatte*, a picture that hardly fit the model of a Realist outrage. [Maus] was the only critic to approach Seurat's painting as scandalous. Significantly, his account was published at the end of June, after Fénéon, Christophe, and others had promoted the painting.

58. Geffroy review; Ajalbert review, 336.

59. Christophe review.

60. In order of citation: Adam review, 543; Ajalbert review, 336; Halperin, *Fénéon*, 30; and Fèvre review, 154. Reviewers generally tended to address the pastels as a group and I have followed their model, though there may be important contrasts among works that are overlooked in this approach. Also, it should be noted that all ten of the pastels may not have been initially displayed. The anonymous reviewer for *La République Française* spoke of seven or eight pastels, while Geffroy stated in his review of 26 May that there were six in the suite. In mid-June Fénéon described an outdoor scene, which few earlier reviewers (if any) had commented upon. In this connection, it may be important that on 8 June the newspaper *L'Intransigeant* carried a notice that new works had been added to the eighth exhibition.

61. Huysmans review.

62. Mirbeau review. For a similar interpretation of the significance of Degas's dancers, see Octave Mirbeau, *La France*. As remarks such as Mirbeau's suggest, the reception of Degas's nudes ultimately needs to be discussed in relation to the late nineteenth-century discourse on women and sexuality, a project well beyond the scope of my essay. The unproblematic acceptance in 1886 of Zandomeneghi's depictions of lower-class women bathing underscores that the reception of Degas's paintings was not simply a reaction to his subjects, but to the way in which they were represented.

63. Hermel, 27 May 1886 review.

64. Geffroy review. Cf. George Moore's similar comments in *Impressions and Opinions* (New York, 1891), 318; cited in Halperin, *Fénéon*, 31, note 1. Fénéon, 31, emphasized the implications for Realism of avoiding the illusion of a model who poses.

65. [Maus] review, 202.

66. Geffroy review.

67. Hermel, 27 May 1886 review. For a modern defense of Degas against charges of misogyny, see Norma Broude, "Degas's Misogyny," *The Art Bulletin* 59 (March 1977): 95–107.

68. Christophe review.

69. [Maus] review. Concerning the misinterpretation of Degas's intentions, Fénéon's remarks in his review of Huysmans's *Certains* in 1890 are worth quoting: "He appreciates the descriptive exactitude and misogyny [of Degas's works] more than the abstract beauty of lines. That there is, in the work of M. Degas, as M. Huysmans wants, a philosophy, yes, and it is to the honor of the painter who did not dream of putting it there and to the critic who found it" (Halperin, *Fénéon*, 171).

70. Christophe, "Georges Seurat"; no. 368 in series *Les hommes d'aujourd'hui* (Paris, 1890), 1.

71. Christophe review. Trans. from T. J. Clark, *The Painting of Modern Life: Paris in the Art of Manet and His Followers* (New York, 1985), 263.

72. Halperin, *Fénéon*, 56.

73. Clark, *Modern Life*, 261. Clark is not the first to identify the reclining figure as the worker in *La Grande-Jatte*; see, among other notices, John House's rejection of this identification in "Meaning in Seurat's Figure Paintings," *Art History* 3, no. 3 (September 1980): 47, 57, note 8. I have reiterated House's point that the figure was labeled a *canotier*. Since I suspect that the debate will continue over who is represented in *La Grande-Jatte*, it seemed a good idea to clarify what could be documented on the basis of contemporary criticism, even though the results are disappointing.

74. Christophe, "Georges Seurat"; see above, note 42.

75. Moore review, 71 (nursemaids); Hermel, 28 May 1886 review (*nourrices*); Paulet review (*bonnes*); Ajalbert review (*nourrices*);

Christophe review (*bonne d'enfants*); Christophe, "Georges Seurat," 1 (*nourrice*).

76. Fouquier review.

77. Christophe, "Georges Seurat," 1.

78. Clark, *Modern Life*, 263.

79. Ajalbert review, 392–393. Trans. partly from Clark, *Modern Life*, 264.

80. Fèvre review, 149. Trans. from Clark, *Modern Life*, 263–264.

81. Adam review, 550. Trans. from Clark, *Modern Life*, 264.

82. Clark, *Modern Life*, 315, note 9.

83. Christophe, "Georges Seurat," 1.

84. Halperin, *Fénéon*, 35–37.

85. Halperin, *Fénéon*, 35–36. Trans. from Linda Nochlin, ed., *Impressionism and Post-Impressionism 1874–1904: Sources and Documents* (Englewood Cliffs, 1966), 108–109. For an excellent analysis of Fénéon's style, see Halperin's introduction in Halperin, *Fénéon*, xxxv–xlix.

86. Halperin, *Fénéon*, 35–37.

87. Halperin, *Fénéon*, 36–37. With some modification, trans. from Nochlin, *Impressionism and Post-Impressionism*, 109.

88. Halperin, *Fénéon*, 73.

89. Signac to Pissarro, 7 September 1888, private collection. For Pissarro's letter to Signac of roughly the same period, see Dorra and Rewald, *Seurat*, lxvi.

90. George Moore later recalled that there had been confusion over the identities of the painters, but it should be noted that he was writing long after the polemical issues had developed: *Modern Painting* (London, 1898), 89. Moore's account is cited by Rewald, *Impressionism*, 528, 544, note 12.

91. In order of citation: Michel review; Mirbeau review; Geffroy review; and Adam review, 550.

92. Fouquier review.

93. In order of citation: Geffroy review; Adam review, 549; Ajalbert review, 391–392; Halperin, *Fénéon*, 37.

94. Ajalbert review, 392.

95. Adam review, 547.

PARIS. — TYPOGRAPHIE MORRIS PÈRE ET FILS
64, Rue Amelot, 64.

1886

CATALOGUE

DE LA

8^{ME} EXPOSITION

DE PEINTURE

PAR

M^{me} *Marie Bracquemond* — M^{lle} *Mary Cassatt*
MM. *Degas* — *Forain* — *Gauguin*
M. *Guillaumin* — M^{me} *Berthe Morisot*
MM. *C. Pissarro* -- *Lucien Pissarro*
Odilon Redon — *Rouart* — *Schuffenecker*
Seurat — *Signac* — *Tillot* — *Vignon*
Zandomeneghi

1, RUE LAFFITTE, 1
(Angle du Boulevard des Italiens)

Du 15 Mai au 15 Juin, de 10 heures à 6 heures

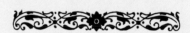

DÉSIGNATION

BRACQUEMOND (M^{me} Marie)

13, rue Brancas (Sèvres).

1 — Jeunes filles (Carton fusain).
2 — Portrait de jeune garçon.
3 — Les joueuses de jaquet.
4 — Portrait de M. F. Bracquemond.
5 — Cueilleuse de pommes (Aquarelle).
6 — Dans le jardin (Aquarelle).

CASSATT (M^{lle} Mary)

7 — Jeune fille à la fenêtre.
Appartient à M. Berend.

4. Bouillon 57, private collection, France

7. Breeskin 125, Corcoran Gallery of Art
8. Breeskin 144, Musée d'Orsay
9. Breeskin 146, National Gallery of Art, Washington
11. Breeskin 131, National Gallery of Art, Washington
12. Perhaps Breeskin 57, per Mathews
14. Lemoisne 682, Metropolitan Museum of Art
15. Lemoisne 681, The Nelson-Atkins Museum of Art, Kansas City, Missouri
16. Lemoisne 831, private collection, Paris
19–28. At least six of these were shown:
Lemoisne 717
Lemoisne 728, Musée d'Orsay
Lemoisne 738, Tate Gallery, London
Lemoisne 765, The Burrell Collection, Glasgow Art Gallery and Museum
Lemoisne 815, Norton Simon Museum, Pasadena
Lemoisne 816, Metropolitan Museum of Art
Lemoisne 847, Metropolitan Museum of Art
Lemoisne 848 or 849
Lemoisne 872, Musée d'Orsay
Lemoisne 874, Musée d'Orsay
Lemoisne 875, Metropolitan Museum of Art
Lemoisne 876, Hillstead Museum, Farmington
Lemoisne 877, Pearlman Foundation, New York
Brame and Reff 82, Hermitage, Leningrad
Brame and Reff 113, National Gallery of Art, Washington

29. Browse 4, private
collection, London
30. Private collection,
England
33. Private collection
34. Perhaps Cabinet des
Dessins, Musée d'Orsay,
R. F. 30042, per Faxon
37. Perhaps Galerie
Reichenbach 1964, no. 8,
per Faxon
39. Perhaps private collection,
Paris, per Faxon
41. Galerie Reichenbach,
Paris, 1964, no. 28, per
Mme Chagnaud-Forain
h.c. *Jacques Blanche*, Musée
des Beaux-Arts, Rouen,
per Faxon

43. Perhaps Wildenstein 160,
Boymans-van Beuningen
Museum, Rotterdam
44. Perhaps Wildenstein 159,
Parke-Bernet New York,
26 October 1967, no. 21
45. Perhaps Wildenstein 158,
Galleria d'Arte Moderne,
Milan
46. Previously thought to be
Wildenstein 156
47. Wildenstein 161, Joan
Whitney Payson Gallery
of Art, Portland, Maine or
124, Sotheby's London,
25 June 1985, no. 13
48. Perhaps Wildenstein 188,
private collection,
Oklahoma, per
Wildenstein or 170,
private collection,
Rotterdam
50. Perhaps Wildenstein 102,
private collection, Basel,
per Wildenstein
51. Perhaps Wildenstein 103,
private collection, Caracas
53. Wildenstein 167, Museum
of Western Art, Tokyo
54. Perhaps Wildenstein 182,
Philadelphia Museum of
Art, per Wildenstein
55. Perhaps Wildenstein 109,
per Wildenstein
56. Perhaps Wildenstein 141,
Ny Carlsberg Glyptotek,
Copenhagen or 142,
Glasgow Art Gallery, per
Bodelsen 1984
57. Perhaps Wildenstein 144,
private collection, New
York
58. Perhaps Wildenstein 152,
Rijksmuseum Kröller-
Müller, Otterlo, per
Wildenstein

— 6 —

8 — Jeune fille au jardin.
Appartient à M. Personnaz.
9 — Étude.
10 — Portrait.
11 — Enfants sur la plage.
12 — Enfants au jardin.
Appartient à M. H.
13 — Mère et Enfant (Pastel).
Appartient à M. Nunès

DEGAS
19, *bis*, rue Fontaine Saint-Georges.

14 — Femme essayant un chapeau chez sa
modiste (Pastel).
Appartient à Mme A.
15 — Petites modistes (Pastel).
Appartient à M. A. R.
16 — Portrait (Pastel).
17 — Ébauche de portraits (Pastel).
18 — Têtes de femme.

Suite de nuds de femmes se baignant, se
lavant, se séchant, s'essuyant, se pei-
gnant ou se faisant peigner (Pastels).

— 7 —

19 — 1
Appartient à M. E. B.
20 — 2
Appartient à M. E. B.
21 — 3
Appartient à M. R. B.
22 — 4
Appartient à M. M.
23 — 5
Appartient à M. H.
24 — 6
25 — 7
26 — 8
27 — 9
28 — 10

FORAIN (J.-L.)
233, rue du Faubourg Saint-Honoré

29 — Femme à sa toilette.
Appartient à M. Durand Ruel.
30 — Place de la Concorde.
Appartient à M. Menier.
31 — Portrait de Mme W.
32 — Portrait de Mme S.

— 8 —

33 — Femme respirant des fleurs.
Appartient à M. Durand Ruel.
34 — Femme fumant une cigarette.
Appartient à Mme T.
35 — Tête d'étude.
36 — Tête d'étude.
37 — Jeune fille au bal.
Appartient à Mme de P.
38 — Femme en noir.
Appartient à M. le comte de F.
39 — Souvenir de Chantilly (Esquisse en gri-
saille).
Appartient à Mme S.
40 — Un coin à l'Opéra (Dessin à l'encre de
Chine).
Appartient à M. Donnadieu.
41 — Pompier dans les coulisses de l'Opéra.

GAUGUIN (Paul)

42 — Nature morte.
43 — Vaches au repos.
44 — Vache dans l'eau.
45 — Un coin de la mare.

— 9 —

46 — Les saules.
47 — Près de la ferme.
48 — Paysage d'hiver.
49 — Le château de l'Anglaise.
50 — L'église.
51 — Vue de Rouen.
52 — Avant les pommes.
53 — Les baigneuses.
54 — Fleurs, fantaisie.
55 — Route de Rouen.
56 — Parc, Danemarck.
57 — Conversation.
58 — Chemin de la ferme.
59 — Falaises.
60 — Portrait.

GUILLAUMIN (Armand)
13, quai d'Anjou.

61 — Paysage d'été à Damiette.
62 — Crépuscule à Damiette.
63 — Paysage, fin de l'hiver.
64 — Chaumières à Damiette.
65 — Portrait.
66 — Intérieur à Damiette.

67 — Jeune fille lisant.
68 — Prairie à Damiette.
Appartient à M. Mendez.
69 — Jardin à Damiette.
70 — Jardin à Damiette.
71 — Les Pêcheuses.
72 — Étude.
73 — Bords de l'Yvette, le matin.
74 — Damiette, paysage du matin.
Appartient à M. Z. Astruc.
75 — Pêcheurs.
Appartient à M. Berend.
76 — Soleil couchant.
77 — Paysage à Damiette.
78 — Portrait (Pastel).
79 — Tête de jeune fille (Pastel).
Appartiennent à M. Nunès.
80 — Enfant endormi (Pastel).
81 — Travesti (Pastel).

MORISOT (Mme Berthe)
40. rue de Villejust.

82 — Jeune fille sur l'herbe.
83 — Jardin à Bougival.

84 — Enfants.
85 — Petite servante.
86 — Portraits d'enfants.
87 — Le lever.
88 — Paysage à Nice.
89 — Roses trémières.
90 — Portrait de Mlle L.
91 — Portrait de Mlle P. G.
92 — Série de dessins.
93 — Série d'aquarelles.
94 — Eventails.
94 bis — Au bain.

PISSARRO (Camille)
A Éragny-sur-Epte (Eure).

95 — Vue de ma fenêtre par temps gris.
96 — Prairies de Bazincourt, le matin.
97 — Coteaux de Bazincourt, l'après-midi.
98 — Poiriers en fleurs, matin.
99 — Automne.
100 — La cueillette de pommes.
101 — Marais de Bazincourt, en automne.
102 — Plein soleil. — Paysanne aux champs.
102 bis — Mère et enfant.

103 — Vaches et paysannes (Gouache)
104 — Paysannes au soleil idem.
105 — Gardeuse d'oies idem.
106 — Eventail (paysannes) idem.
107 — 6 Études de paysannes (Pastel).
108 — 1 id. d'enfant idem.
109 — Récolte de pommes de terre (Eau-forte).
110 — Rue de l'Epicerie, à Rouen, rue Malpalue, à Rouen (Eau-forte).
111 — Vaches et paysage (Eau-forte).
112 — Port de Rouen, effet de pluie et paysage (Eau-forte).
113 — Paysage à Rouen, paysage à Osny (Eau-forte).

PISSARRO (Lucien)
Né à Paris.

114 — Nature morte.
115 — Nature morte.
116 — Projet d'illustration de : « Il était une bergère » (Aquarelle).
117 — Etude à Pontoise (Aquarelle).
118 — Eglise de Bazincourt (Aquarelle).
119 — Environs de Londres.

120 — Villerville.
121 — Burnevillle et Bazincourt.
122 — Illustration de Mait'Liziard (nouvelle de M. Octave Mirbeau), Gravure sur bois.
Appartient à la Revue illustrée.
123 — Tête de paysan — Lapin — Femme à l'herbe — Femme lisant — Pâtissier — Marchande de marrons — Paysan sarclant — Ravaudeuse — Curé à la promenade — (Gravures sur bois).

REDON (Odilon)
76, rue de Rennes.

124 — Tête laurée.
125 — Le secret.
126 — Homme primitif.
127 — L'empreinte.
128 — L'intelligence.
129 — Tentation.
Appartient à M. J. K. Huysmans.
130 — Béatrix.
Appartient à M. Maurice Fabre.
131 — Paysage.
132 — Salomé.
Appartiennent à M. Brethous-Lafargue.

59. Wildenstein 170, Josefowitz Collection, per Wildenstein

60. Wildenstein 186, Musée du Prieuré, St.-Germain-en-Laye or 187, Newark Museum, both per Wildenstein

h.c. *La Toilette*, Gray 7, private collection, Paris

61. Perhaps Serret and Fabiani 125 or 141

62. Perhaps Serret and Fabiani 144, Petit Palais, Geneva

64. Perhaps Serret and Fabiani 105, 117, or Gray 74

67. Perhaps Serret and Fabiani 89

69–70. Perhaps Serret and Fabiani 110, Ny Carlsberg Glyptotek, Copenhagen

75. Perhaps Serret and Fabiani 122, Musée d'Orsay

82. Bataille and Wildenstein 173, Ordrupgaardsamlingen, Charlottenlund

83. Bataille and Wildenstein 148, private collection, per Clairet

85. Bataille and Wildenstein 194, National Gallery of Art, Washington

87. Bataille and Wildenstein 191, private collection

88. Bataille and Wildenstein 118, private collection, Paris

89. Bataille and Wildenstein 157, per Clairet

90. Bataille and Wildenstein 482, per Clairet, or 483

91. Bataille and Wildenstein 159 or 501

94. Bataille and Wildenstein 697; 702, private collection, Montreal, per Gerstein thesis; or 703

94bis. Bataille and Wildenstein 190

95. Pissarro and Venturi 721, Ashmolean Museum, Oxford

96. Pissarro and Venturi 664

97. Pissarro and Venturi 698

98. Pissarro and Venturi 697

100. Pissarro and Venturi 695, Ohara Museum of Art, Kurashiki

101. Pissarro and Venturi 660

102bis. Pissarro and Venturi 691, private collection, Paris

106. Perhaps Pissarro and Venturi 1630, John and Marcia Price, Salt Lake City
109. Delteil 63
110. *Epiceri*, Delteil 64 *Malpalue*, Delteil 53
111. Delteil 59
112. Delteil 44 or 65
113. *Rouen*, perhaps Delteil 50 *Osny*, Delteil 61 or 62

122. Ashmolean Museum
123. *Femme*, Ashmolean *Femme lisant*, Ashmolean *Pâtissier*, Ashmolean *Marchande*, Ashmolean *Curé*, Ashmolean
124. Private collection, Paris, per Wildenstein
125. Perhaps *Le prisonnier (L'accusé)*, Museum of Modern Art, New York or *Le penseur à la fenêtre (Le chevalier)*, private collection

130. Private collection, Le Poët-Laval, per Wildenstein
137. Musée du Petit Palais, Paris

161. Perhaps private collection, Paris, per Rey
163. Private collection, Paris, per Rey

175. Dorra and Rewald 139, The Art Institute of Chicago
176. Dorra and Rewald 153, Tate Gallery, London
177. Dorra and Rewald 157, lost during WW II
178. Dorra and Rewald 154, private collection, New York
179. Dorra and Rewald 161, private collection, Paris
180. Dorra and Rewald 80, Musée d'Art Moderne, Troyes
181. Previously thought to be private collection, Lexington, Kentucky
182. Herbert, no. 54, private collection, Switzerland

184. Sammlung E. G. Bührle, Zürich
185. Private collection, Paris
186. Private collection, Paris
188. National Gallery of Victoria, Melbourne
190. Private collection, Paris

— 14 —

133 — La désespérance.
Appartient à M. Ch. Hayem.
134 — La veuve.
135 — Profil d'enfant.
Appartiennent à M. Ch. Hayem.
136 — Lune noire.
137 — Profil de lumière.
138 — Paysage.
Appartiennent à M. Ch. Hayem.

ROUART (Henri)
34, rue de Lisbonne.

139 — Intérieur.
Appartient à M...
140 — Lisière de bois.
141 — Pyrénées.
142 — Étude.
Appartient à M...
143 — Jardin de l'Évêché à Blois (Aquarelle).
144 — Château du Moulin (Sologne) idem.
Appartient à M...
145 — Porte du château de Blois idem.
146 — Ruines de Bury idem.
Appartient à M....

— 15 —

147 — Village de Moulineux. (Aquarelle).
148 — Belle-Croix. idem.
149 — Intérieur de parc. idem.
150 — Jardins Beaumont, à Pau. idem.
151 — A Jurançon. idem.
152 — Place de Jurançon. idem.
153 — Fondamenta Nuove (Venise) idem.
154 — Barques de Coggia (Venise) idem.
155 — Palli (Venise). idem.
156 — Bateaux de foin (Venise) idem.
157 — Giudecca (Venise) idem.
158 — Derrière le Redemptore (Venise) idem.
159 — Près la Dogana (Venise) idem.
160 — Un soir dans la Giudecca (Venise) idem.
161 — Pont St-Zanni et Paolo (Venise) idem.
162 — Dans la Giudecca (Venise) idem.
163 — A Murano (Venise) idem.
Appartient à M...
164 — Maison des Morets (Mans) idem.
165 — La grabaterie (Mans) idem.

SCHUFFENECKER (Émile)
29, rue Boulard.

166 — A saute-mouton.

— 16 —

167 — Torse de femme (Étude).
168 — Portrait,
169 — Étude de neige.
170 — Quai Montebello.
171 — La Neige dans mon jardin.
172 — Nature morte.
173 — Oranges.
174 — Pastel.

SEURAT (Georges)
128 *bis*, boulevard de Clichy.

175 — Un Dimanche à la Grande-Jatte (1884).
176 — Le bec du Hoc (Grand-Camp).
177 — Le fort Samson (Grand-Camp).
178 — La rade de Grand-Camp.
179 — La Seine, à Courbevoie.
180 — Les pêcheurs.
Appartient à M. Appert.
181 — Une parade (Dessin).
182 — Condoléances, idem.
Appartiennent à M J.-K. Huysmans.
183 — La banquiste, idem.
Appartient à Mme Robert-Caze.

— 17 —

SIGNAC (Paul)
130, boulevard de Clichy.

184 — Apprêteuse et Garnisseuse (Modes), rue du Caire.
185 — La Berge, Asnières.
186 — Le Moulin de Pierre Hâlé, Saint-Briac.
187 — Passage du Puits-Bertin, Clichy.
188 — Les Gazomètres, Clichy.
189 — Du haut de la Garde-Guérin, Saint-Lunaire.
190 — La passe balisée, Saint-Briac.
Appartient à Mme J. S.
191 — La Neige, boulevard Clichy.
192 — Bonne Brise de N ¼ NO, Saint-Briac.
Appartient à M. Heymann.
193 — L'Abreuvoir, Asnières.
194 — Le Jardin du père Lefeuvre, Saint-Briac.
195 — L'Embranchement de Bois-Colombes.
196 — D'une Fenêtre, Lachapelle-Saint-Briac.
197 — Le Port Hue, Saint-Briac.
Appartient à M. Pissarro.
198 — La Grue « l'Union », Ile Saint-Louis.
Appartient à M. Paul Alexis.

— 18 —

199 — Au Café-Concert (Dessin).
 Appartient à M^{me} Robert-Caze.
200 — Aux Tuileries (Dessin).
 Appartient à M. J. K. Huysmans
201 — L'Ile des Ravageurs (Dessin).
 Appartient à M. Seurat.

TILLOT (Charles)
12, rue Fontaine.

202 — Le lac d'Annecy.
203 — L'Approche de l'Orage.
204 — Falaises, à Villers-sur-Mer.
205 — Pivoines et Iris.
206 — Pivoines blanches.
207 — Chrysanthèmes.
208 — Chrysanthèmes blanches et Dahlias.
209 — Roses.
210 — Anémones (2 Études).
211 — Roses dans un vase de Chine.
212 — Pivoines et Pavots.
213 — Baigneuse.
214 — Jeune Fille dans un paysage.
215 — Femme couchée (Étude).

— 19 —

216 — Étude de femme nue.
217 — Recueil de croquis à l'encre de Chine.

VIGNON (Paul-Victor)
29, rue Saint-Georges.

218 — L'Église de Jouy (effet de soleil), mars.
219 — La Côte Saint-Nicolas (hiver), à Auvers-sur-Oise.
220 — La Vieille Sente, à Four.
221 — L'ancien moulin de Jouy (soleil d'avril).
222 — La Sente, à Chaponval.
223 — Champs, près la rue Boucher, à Auvers (printemps).
224 — Église de Jouy (Mai).
225 — Près la rue Remy (hiver), Auvers-sur-Oise.
226 — Le coteau des Grandes-Nises, vu du marais, à Jouy.
227 — Maisons (effet du matin).
228 — Un Chemin vert, à Orrouy.
229 — Une Ferme, vue du Codru, à Jouy,
 Appartient à M. Brulé.
230 — Une Carrière (Champagne), esquisse.
 Appartient à M. Beauvais.

— 20 —

231 — Au Val-Hermay.
232 — Vaux-sur-Oise.
 Appartiennent à M. André.
234 — Auvers (la côte).
 Appartient à M. Aubry.
234 bis — Sente d'Auvers.
234 ter — Sente de Chaponval.

ZANDOMENEGHI (Federico)
Rue Tourlaque, 7.

235 — Peinture.
236 — Peinture.
237 — Peinture.
238 — Peinture.
239 — Pastel.
240 — Pastel.
241 — Pastel.
242 — Pastel.
243 — Pastel.
244 — Pastel.
245 — Pastel.
246 — Pastel.

5 86 1756. — Paris. Morris père et fils. rue Amelot, 64.

191. Minneapolis Institute of Arts
192. Mr. and Mrs. Ray Dolby, San Francisco
195. Leeds City Art Gallery
197. Boymans-van Beuningen Museum, Rotterdam
198. William Doyle, 7 May 1984

235–238. Piceni 92; 270, Mario Borgiotti, Milan; 307, private collection, Turin; perhaps 46, Camillo Giussani, Erba

136. Marie Bracquemond

VIII—4

Portrait de M. F. Bracquemond, 1886
Now known as *Portrait de Félix Bracquemond dans son atelier*
(Portrait of Félix Bracquemond in His Studio)
Signed and dated lower left: *Marie B. 1886.*
Oil on panel, 21⅝ x 16⅜ in. (54.8 x 41.7 cm)
Private collection, Paris
REFERENCES: Bouillon 1972, no. 57.

As for Marie Bracquemont [*sic*],
her accurate charcoal sketches
(portrait of two young girls),
watercolors, and paintings have
nothing Impressionist about
them.
Firmin Javel, *L'Evénement*,
16 May 1886

. . . Marie Bracquemond, a lady
who must excel in embroidering
slippers and who wastes her time
copying magazine illustrations.
Jules Vidal, *Lutèce*, 29 May 1886

A *Portrait de M. F. Bracque-
mond*, a *Portrait de jeune gar-
çon*, and two watercolors distinc-
tively display the talent of Marie
Bracquemond.
Gustave Geffroy, *La Justice*,
26 May 1886

Marie Bracquemond shows . . .
the portrait of *M. F. Bracque-
mond* standing jauntily in his
studio.
Le Moniteur des Arts,
21 May 1886

If one goes by her *Portrait de
M. F. Bracquemond*, she paints
with a rather hard, spare, and dry
touch. But the level of quality of
this painting would not at all pre-
vent her from taking the bacca-
laureate exam—I mean, to com-
pete for the Prix de Rome, if the
rules allowed it.
Marcel Fouquier, *Le XIXᵉ Siècle*,
16 May 1886

137. Mary Cassatt

VIII—7

Jeune fille à la fenêtre, 1883
Young Girl at the Window

Now known as *Susan on a Balcony Holding a Dog*
Signed lower right: *Mary Cassatt*
Oil on canvas, 39½ x 25½ in. (100.3 x 64.7 cm)
Corcoran Gallery of Art, Washington, D.C. Museum Purchase, 1909
REFERENCES: Breeskin 1970, no. 125; Baltimore 1962, no. 104; Washington 1970, no. 29; Breeskin 1981, no. 18.
NOTE: Susan was a cousin of Cassatt's housekeeper, Mathilde Vallet. The dog, one of Cassatt's Belgian griffons, was named "Battie." See Washington, above.

The *Jeune fille à la fenêtre* [is] graceful and flourishing like a young plant in full bloom. [She] stands wearing a white straw hat enveloped in gauze; . . . There is more than just painting here; there is a sort of emanation of life as well, compounded of summer warmth and the sensual perfume of the woman. Those who deny that Impressionism has delicacy and charm should see these pictures. What a time we live in, when such an exhibition, following the one in 1881, does not silence criticism, does not bring in the crowds, and does not definitively recognize Mary Cassatt as the distinguished and expert artist some already know her to be.
Gustave Geffroy, *La Justice*, 26 May 1886

Mary Cassatt is showing a very pretty *Femme au chien*. This woman is at her window, lit by full sunlight. Indifferent to the people swarming below, she is lost in distant reverie. This painting shows carefully observed color.
George Auriol, *Le Chat Noir*, 22 May 1886

Cassatt has no rival in rendering the fluidity of air around her figures.
The well-blended unity of her paintings arises from the softness of modeling caressed by an impalpably light touch and the smoothness of the tones linked by this invisible agent. Look at the young girl at the window: her lips breathe, her eyes have the moist and mobile flash of life, her hat adorned with white gauze and pink silk has the delicacy of a flower in bloom.
Maurice Hermel, *La France Libre*, 27 May 1886

138. Mary Cassatt

VIII—9

Etude, 1886
Study

Now known as *Girl Arranging Her Hair*
Oil on canvas, 29½ x 24½ in. (75 x 62.3 cm)
National Gallery of Art, Washington. Chester Dale Collection.
1963.10.97
REFERENCES: Breeskin 1970, no. 146; Washington 1970, no.
38; Getlein 1980, 58—59.
Washington only

The six paintings and the pastel by Mary Cassatt are portraits of children, young girls, and women studied in the corners of windows bathed in light or in gardens aglow with sunlight. Unity is harmoniously achieved among the figures' rosy complexions, light clothing, and the young green foliage. Her drawing yields to the fabric's softness, the hands' nervousness, the motion of supple bodies. . . . The young girl in a nightdress who twists her hair before her dressing table is still swollen with sleep and damp from her first ablutions.
Gustave Geffroy, *La Justice*, 26 May 1886

Mary Cassatt, whose artistic education is directed by Degas, has serious and real talent as a colorist that makes her highly appreciated by Parisian artists. Fortunately, her art has not yet made its way to the public. One cannot reproach her with any of those little weaknesses that draw the most gifted bit by bit toward easy successes. Cassatt paints what she sees and as she feels it. The six paintings in oils and pastels that she is showing this year are figures studied in the open air or in the corner of a window by the clear and frank light of day. No juggling of effects in this robust painting betrays a feminine hesitation, no difficulties in the draftsmanship, nor of eluded color. There is a definite personality revealed, especially in the very appealing study of a young girl in her slip surrounded by the disorder of her dressing room, twisting her blond hair on her nape with a simple and true gesture.
[Octave Maus], *L'Art Moderne* [Brussels], 27 June 1886

139. Mary Cassatt

VIII–11

Enfants sur la plage, 1884
Children on the Beach

Signed lower right: *Mary Cassatt*
Oil on canvas, 38½ x 29¼ in. (97.6 x 74.2 cm)
National Gallery of Art, Washington. Ailsa Mellon Bruce
Collection. 1970.17.19
REFERENCES: Breeskin 1970, no. 131; Washington 1970, no.
33; Harris and Nochlin 1976, no. 91.

Her color blends the tones of objects and the variation of light and shadow in true proportion. Thus, the *Enfants sur la plage* has the pure sharp outline that people and objects have when seen against sand and the background of water and sky. The short arms and doll-like faces give the sense of flesh under their deep layer of sunburn.
Gustave Geffroy, *La Justice*, 26 May 1886

Her children on the beach are no less precious for their Naturalism and truth. Their cheeks, their chubby arms, and plump thighs have the beautiful sunburned tint, the firm and dense texture of nectarines. These are real babies who play in the sand convincingly.
Maurice Hermel, *La France Libre*, 27 May 1886

Mary Cassatt often calls to mind Berthe Morisot in her choice of subjects, though not in the nervous energy of the rendering. Her *Enfants sur la plage* deserves to be pointed out. Two chubby-cheeked babies dig chasms in the sand that a drop of water or two will fill, two babies with cheeks like jam, intent on their games, not heeding the roaring of the waves.
Jean Ajalbert, *La Revue Moderne* [Marseille], 20 June 1886

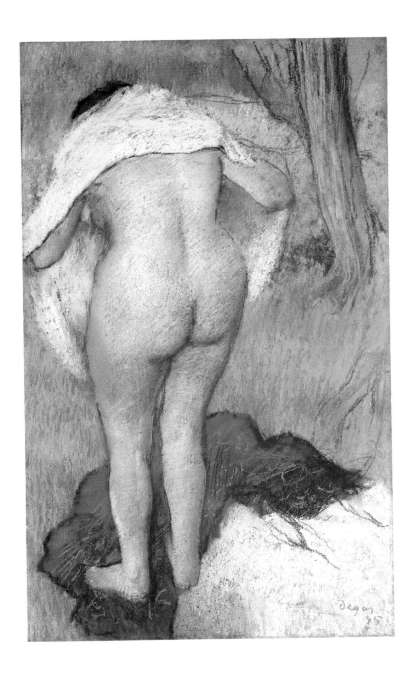

Less original, perhaps, but even more piquant is the woman getting dressed again. In a corner of some broadly sketched greenery is a large bather in the open air who slides over her upraised elbows the white linen that will cover her ample nudity.

How her arms, her back, and hips all move as she puts on her slip again! How easy she is in her movement from her neck to her heels! It would be impossible to analyze more closely a precise action, to lay it out with more logic and sureness.

Consider the delicious harmony of all the elements, the visual joy of the whiteness of the slip shot with tender green and lilac; consider how the flesh, pink in the light, brown in the shadow, infinitely shaded by the ambient atmosphere, has substance and its own quivering life, and that it is all truth embellished by the rarest colors. You will understand that the lovers of porcelain nymphs see in this beautiful piece of painting nothing but a vulgar slattern.
Maurice Hermel, *La France Libre*, 27 May 1886

140. Edgar Degas

VIII–19/28

From **Suite de nus**
Suite of Nudes

Now known as *Girl Drying Herself*
Signed and dated lower right: *Degas/85*
Pastel on paper, 31½ x 20⅛ in. (80.1 x 51.2 cm)
National Gallery of Art, Washington. Gift of the W. Averell Harriman Foundation in memory of Marie N. Harriman. 1972.9.9
REFERENCES: Brame and Reff 1984, no. 113; Washington 1975, no. 2594.
Washington only

NOTE: In the eighth group exhibition Degas exhibited a series of nude studies in pastel titled *Suite de nuds* [sic] *de femmes se baignant, se lavant, se séchant, s'essuyant, se peignant ou se faisant peigner (Pastels)*. The catalogue lists ten works but apparently fewer were shown. Huysmans describes four and a review in *L'Art Moderne* [Brussels] refers to six poses.

The school aims for Realism, having noisily chased away the gods, and one really must not ask it to bring Amphitrite out of the ocean or to dry the hair of Venus Astarte, daughter of the bitter wave.

No! Nana bathing, washing herself with a sponge, taking care of herself, arming herself for battle— this is the Impressionist ideal. Do not forget that the exhibition is only two steps from the street corner.

J. M. Michel, *La Petite Gazette*, 18 May 1886

These are admirable works and their composition is utterly extraordinary. There is wonderful power of synthesis and abstract line in them such as no other artist of our time that I know of can produce. . . .

Clearly, these drawings have not been done to inspire passion for women, nor sensual desire. Degas has not at all sought beauty and grace in these sketches. He has not concerned himself with the sentimental poses that give rise to such *pretty* romances as curving hips, globe-like breasts made taut by outstretched arms, napes bent in a swoon over swan-like throats. On the contrary, there is a ferocity that speaks clearly of a disdain for women and a horror of love. It is the same bitter philosophy, the same arrogant vision, that one finds in his studies of dancers.

Octave Mirbeau, *La France*, 21 May 1886

As Realism, [the series] is complete. No artist will go further in the art of frightening the philistines. But if one admits the somewhat excessive intimacy of the subject (for my part, I see nothing objectionable), one still is forced to bow before the consummate skill of the execution.

Firmin Javel, *L'Evénement*, 16 May 1886

[The artist] wanted to paint a woman *who did not know she was being watched*, as one would see her hidden by a curtain or through a keyhole. Thus he succeeds in seeing her lowering herself into, and standing up out of, her bathtub, feet reddened by the water, sponging the nape of her neck, lifting herself on her short massive legs, reaching out her arms to put her slip back on, on her knees drying herself with a towel, or standing, head lowered, and her rump sticking out, or bending over to one side. He has seen her from floor level, next to marble stands piled with scissors, brushes, combs, switches of false hair. And he has hidden none of her froglike aspects, none of the maturity of her breasts, the heaviness of her lower body, the twisting bend of her legs, the length of her arms, and the stupefying appearance of belly, knees, and feet in unexpected foreshortenings. He has thus written a distressing poem of the flesh, as an artist fascinated by the lines that envelop a figure from the hair down to the toenails, as a scientist who understands the structure of bones, the play of muscles, the contractions of nerves, the mottling and thickness of skin.

Gustave Geffroy, *La Justice*, 26 May 1886

Degas shows some pastels depicting a series of girls bathing, washing, and sponging themselves in a tub, drying themselves off, wiping themselves, combing their hair, or having it combed for them. These vulgar bodies are detailed with an arrogant and repugnant truth.

The artist has brutally underlined the rough grain of the skin, the marks left by clothing, the traces of rouge and powder, the subtle tones of wet skin, the red marks caused by toweling. One could not characterize these violent photographs as *nudes*. It is nakedness, a nakedness not enlivened by any touch of obscenity, a somber and gloomy nakedness, a taciturn indecency, a sad bestiality.

The heart lifts though, for how can one keep from thinking how admirably well seen it all is, with exorbitant intensity, as if with the sharp glance of a surgeon or horse-trader.

Jules Desclozeaux, *L'Opinion*, 27 May 1886

With fine and powerful artistic impudence Degas lays bare for us the streetwalker's modern, swollen, pasty flesh. In the ambiguous bedrooms of registered houses, where certain ladies fill the social and utilitarian role of great collectors of love, fat women wash themselves, brush themselves, soak themselves, and wipe themselves off in basins as big as troughs.

Henry Fèvre, *La Revue de Demain*, May-June 1886

Novelists, painters, and sculptors all sing endlessly of the fleshy splendors of the woman. Wishing to be unique, Degas has chosen to speak of her ugliness. Nevertheless, his observations could have been true had he not forced the act. After all, Degas perhaps spontaneously is a pessimistic child of his century.

Alfred Paulet, *Paris*, 5 June 1886

Degas . . . with his *suite de nud de femmes se baignant, se lavant, se séchant, s'essuyant, se peignant ou se faisant peigner*: too dark, overdone, or comically malevolent.

Jules Christophe, *Le Journal des Artistes*, 13 June 1886

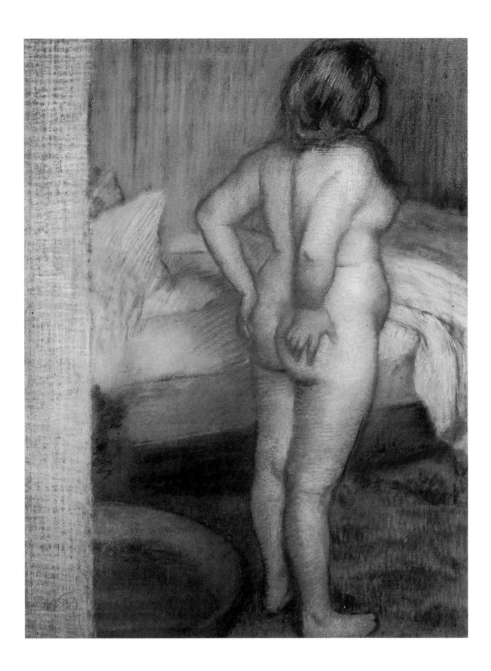

141. Edgar Degas

VIII—19/28

From **Suite de nus**
Suite of Nudes

Now known as *La boulangère* (The Baker's Wife)
Signed lower left: *Degas*
Pastel on paper, 26⅜ x 20½ in. (67 x 52.1 cm)
The Henry and Rose Pearlman Foundation
REFERENCES: Lemoisne 1946, no. 877; Rewald 1974, no. 9.
See note for cat. no. 140.

There follows a series of female nudes who are bathing, washing and drying themselves. The water slides over the skin tensed from the strain of assuming simian positions. The flesh, despite its dull, defective color, is alive, becoming damp under the sponge, dry under the towel.
Jean Ajalbert, *La Revue Moderne* [Marseille], 20 June 1886

Degas, on the other hand, uses bituminous tones monotonously. One senses a prejudice for darkness so that a few felicitous contrasts of shafts of light will impress more easily. But very beautiful drawing predominates. The nude women wash and sponge themselves in froglike poses, their thighs, backs, and contoured hips distended by crouching; these are foreshortenings of consummate skill. The line characteristic of Ingres, whose student Degas once was, is revealed to be pure, confident, and rare under the pencil as it inscribes this fat bourgeoise ready for bed. Her hands flat on her lower back, she contemplates herself, no doubt, in some invisible mirror.
Paul Adam, *La Revue Contemporaine, Littéraire, Politique et Philosophique*, April 1886

And in order to better sum up his rejects, he chooses her fat, potbellied, and short, that is, drowning any grace of contour in tubular rolls of skin and losing all bearing and all line from a plastic point of view. Thus she becomes in life, no matter to what social class she belongs, a butcher, a sausage-maker, in short, a creature whose vulgar form and coarse features invite continence and persuade to horror! . . . This one has finished her maintenance work, and leaning her hands on her rump, she stretches with the rather masculine motion of a man who lifts the tails of his jacket as he warms himself in front of a chimney.
Joris-Karl Huysmans, *Oeuvres complètes*, 1929

For additional quotations see previous page.

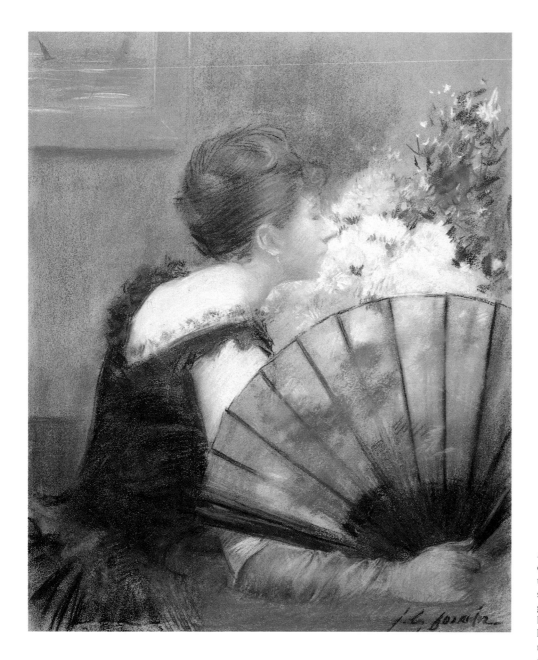

142. Jean-Louis Forain

VIII—33

Femme respirant des fleurs, ca. 1883
Woman Smelling Flowers
Now known as *Femme à l'éventail* (Woman with a Fan)
Signed lower right: *j.l. forain*
Pastel on paper, 35 x 31 in. (88.9 x 78.7 cm)
Private collection

His *Femme respirant des fleurs* is a pretty thing: to say that this canvas [*sic*] belongs to Durand-Ruel is enough to indicate, however, that savagery is adapting itself to highly accepted "conformity."
Jules Christophe, *Le Journal des Artistes*, 13 June 1886

An uneven artist, slipping often on the slope of anecdotal illustration, . . . J.-L. Forain frequently succeeds, when he studies our elegant and vicious customs from life, in giving his works a particular flavor. He is the poet of corruption in evening clothes, of dandyism in the boudoirs, of high life masking empty hearts. . . . To notice at rue Laffitte: the *Femme fumant une cigarette,* the *Femme respirant des fleurs.* . . .
[Octave Maus], *L'Art Moderne* [Brussels], 27 June 1886

. . . but the *Femme respirant des fleurs,* the *Femme fumant une cigarette,* the *Têtes d'études,* the *Jeune fille au bal, Un coin à l'Opéra* testify to a talent capable of expressing worldly elegance, the wedding in evening clothes, the vicious charm.
Gustave Geffroy, *La Justice,* 26 May 1886

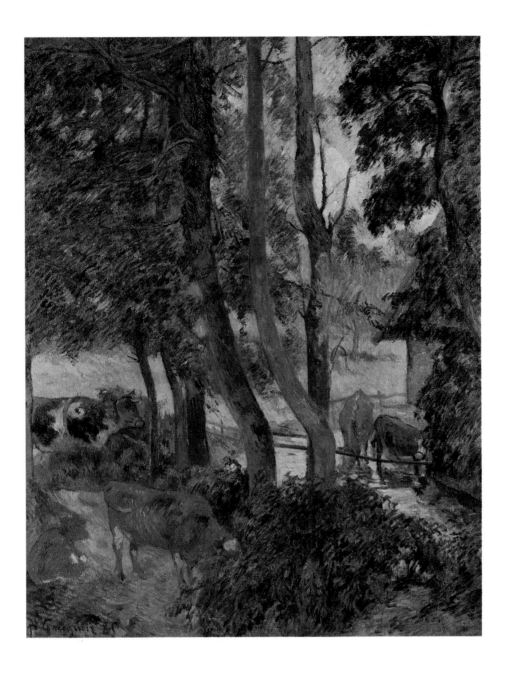

143. Paul Gauguin

VIII—45

Un coin de la mare, 1885
Edge of the Pond

Signed and dated lower left: *P. Gauguin 85*
Oil on canvas, 3 1⁷⁄₈ x 2 5⁵⁄₈ in. (81 x 65 cm)
Civica Galleria d'Arte Moderna, Raccolta Grassi, Milan
REFERENCES: Wildenstein 1964, no. 158; Milan 1979,
no. 181.

Frequent shortcomings weaken
Gauguin's painting. It is tossed
off pell-mell with confused per-
spective and somewhat smoth-
ered colors.
Henry Fèvre, *La Revue de
Demain*, May-June 1886

Gauguin has three superior stud-
ies among the works he has sub-
mitted: *Vaches au repos* and *dans
l'eau* and *Coin de mare*.
Rodolphe Darzens, *La Pléiade*,
May 1886

Paul Gauguin, believe us, a new-
comer among the Impressionists,
is following in [Guillaumin's]
path.
[Octave Maus], *L'Art Moderne*
[Brussels], 27 June 1886

There are some still lifes among
the nineteen canvases Gauguin
exhibits, but mainly they are
landscapes. He has searched out
willows, ponds, farmyards, and
roads. He has painted a view of
Rouen. There is firmness in most
of these studies and an under-
standing of the dominant effect.
Gustave Geffroy, *La Justice*,
26 May 1886

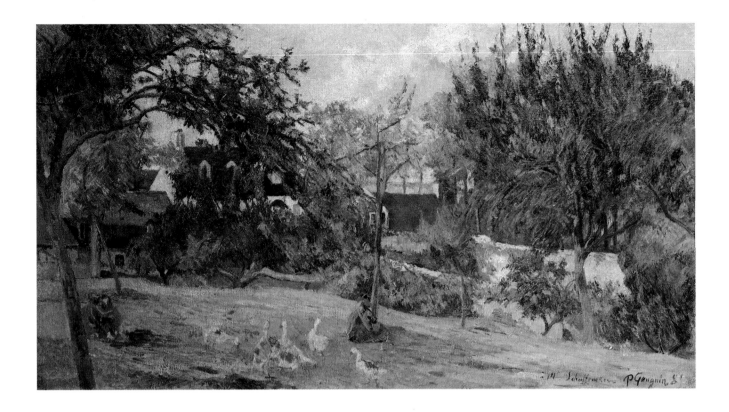

144. Paul Gauguin

VIII—47

Près de la ferme, 1885
Near the Farm

Now known as *Paysage à Saint-Cloud* (Landscape at Saint-Cloud)
Signed, dated, and inscribed lower right: *à M. Schuffenecker-P. Gauguin 85*
Oil on canvas, 22 x 39½ in. (55.9 x 100.3 cm)
The Joan Whitney Payson Gallery of Art, Westbrook College, Portland, Maine. The Joan Whitney Payson Collection
REFERENCES: Wildenstein 1964, no. 161; Portland 1977, no. 5.
NOTE: Emile Schuffenecker (1851–1934) was a colleague and close friend of Gauguin who aided him financially early in his career. Schuffenecker's early paintings were influenced by the Impressionists and he exhibited nine works in the eighth group exhibition. This is one of two possibilities for no. 47 in the 1886 group show. The other was auctioned as lot no. 13 in Sotheby's London sale of 25 June 1985.

Nature, as Gauguin paints it, is a nature apart and malignant, yet which draws one with the strange allure of dreaded things. He evokes the evil influences of countrysides, the egoistic sadness of vegetation, the unguessable life that one senses in it, the way it seems to brood.
Paul Adam, *La Revue Contemporaine, Littéraire, Politique et Philosophique,* April 1886

Gauguin, Guillaumin, Schuffenecker, Vignon, and Signac, newcomers to Impressionism, like all converts are consumed with a fine ardor, a burning desire to go further than anyone and to make Pissarro stop, bemused, in front of their canvases. None of them lacks talent, as Gauguin's landscape *Près de la ferme* proves well enough.
Marcel Fouquier, *Le XIXᵉ Siècle,* 16 May 1886

Next to the exuberant landscapes [of Guillaumin], those of Gauguin seem pale. This conscientious artist makes efforts that elicit sympathy, but he is torn apart by diverse influences from which, however, he manages to free himself here and there. But the monotony of subjects executed hesitantly betrays painful uncertainty. Our desire to avoid concessions for our friends makes us more severe than we would like, for certain canvases reveal good qualities and latent force.
Jean Ajalbert, *La Revue Moderne* [Marseille], 20 June 1886

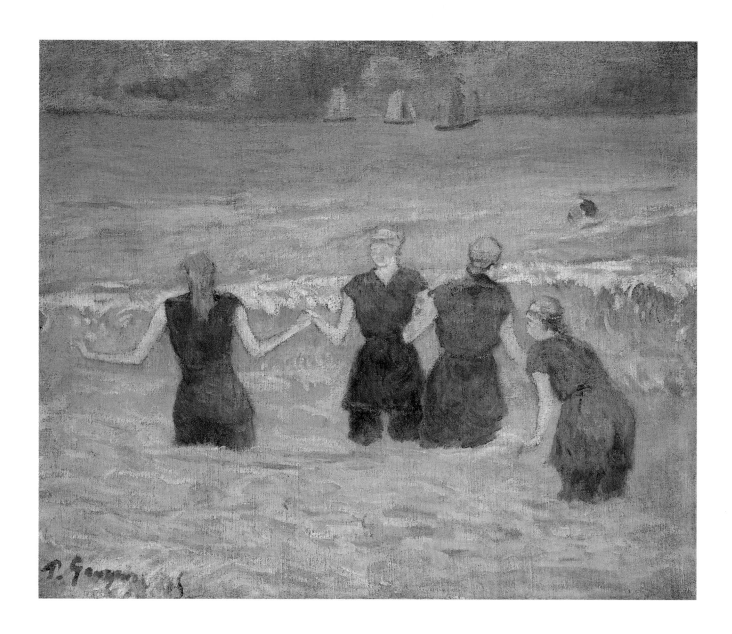

145. Paul Gauguin

VIII–53

Les baigneuses, 1885
Women Bathing
Signed and dated lower left: *P. Gauguin [8]5*
Oil on canvas, 15 x 18³⁄₁₆ in. (38.1 x 46.2 cm)
The National Museum of Western Art, Tokyo. P. 1959-104
REFERENCES: Wildenstein 1964, no. 167; Tokyo 1979, no.
127; Le Paul and Le Paul 1983, 76.

Les baigneuses: An enormous
metallic sea undulates and rolls,
advancing in sheets toward some
women, pitiful and sickly
creatures.
Paul Adam, *La Revue Contem-
poraine, Littéraire, Politique et
Philosophique,* April 1886

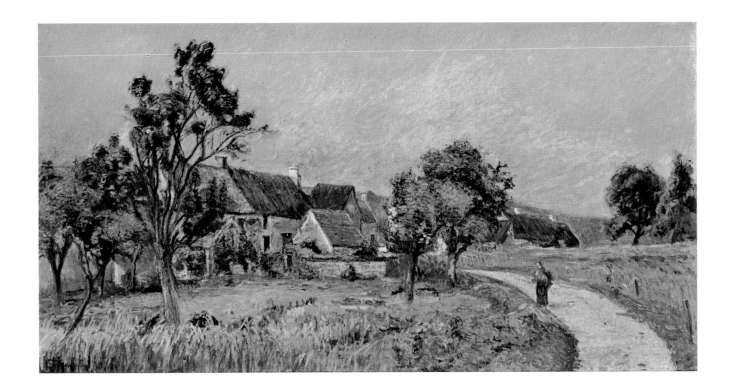

146. Jean-Baptiste-Armand Guillaumin

VIII—62

Crépuscule à Damiette, 1885
Twilight at Damiette

Signed and dated lower left: *Guillaumin 85*
Oil on canvas, 24⅜ x 54¾ in. (72 x 139 cm)
Petit Palais, Geneva. 9401
REFERENCES: Serret and Fabiani 1971, no. 144; Daulte et al.
1968, 50, no. 32; Gray 1972, no. 89.

Gauguin and Guillaumin are *purists*. With the best faith in the world, they make every effort to substitute one formula for another and they do not succeed. They cut, but they have not yet learned to sew.
Firmin Javel, *L'Evénement*,
16 May 1886

Of the colorists of rue Laffitte, Guillaumin is one of the most intense. . . . Up near the frieze a *Crépuscule* hangs, violet clouds in a limpid green sky, one of the most strident color harmonies that we know.
Emile Hennequin, *La Vie Moderne*, 19 June 1886

Finally, in the last room, Guillaumin makes violet colors reappear triumphantly in brilliant landscapes.
La République Française,
17 May 1886

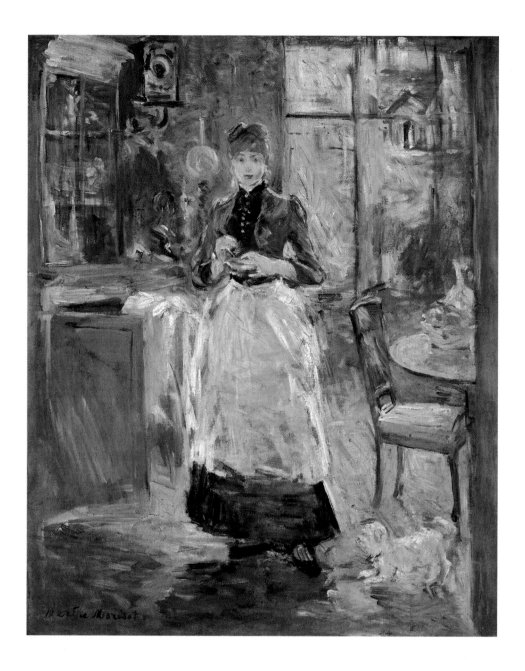

147. Berthe Morisot

VIII—85

Petite servante, 1886
The Little Serving Girl

Now known as: *In the Dining Room*
Signed lower left: *Berthe Morisot*
Oil on canvas, 24⅛ x 19⅝ in. (61.3 x 50 cm)
National Gallery of Art, Washington. Chester Dale Collection.
1963.10.185
REFERENCES: Bataille and Wildenstein 1961, no. 194;
Washington 1975, no. 1849.
Washington only
NOTE: Morisot's maid is depicted in the dining room of her
house on the rue de Villejuste, Paris.

If I may so express myself, she
eliminates cumbersome epithets
and heavy adverbs in her terse
sentence. Everything is subject
and verb. She has a kind of tele-
graphic style gleaming with
words. Two words express her
thought.
Jean Ajalbert, *La Revue Moderne*
[Marseille], 20 June 1886

Berthe Morisot associates herself
a little more closely with the
Intransigents [than does de Nit-
tis]. She also spends time on over-
all impressions, but with a more
penetrating subtlety. She handles
subjects that in banal hands
would turn into genre painting,
but instead she is able to raise the
level of the material by the deli-
cate feeling she puts into it.
Alfred Paulet, *Paris*, 5 June 1886

I do not maintain that Morisot
has produced masterpieces or
even finished works. Her charm-
ing and wittily inspired art lacks
the decision of work that lasts.
Her style remains too purely
Impressionist and contents itself
with exquisite intentions, with
the floating charm of sketches.
Maurice Hermel, *La France
Libre*, 28 May 1886

Berthe Morisot is disturbing. In
her exquisite works there is a
morbid curiosity that astonishes
and charms. Morisot seems to
paint with her nerves on edge,
providing a few scanty traces to
create complete, disquieting
evocations. . . .
Octave Mirbeau, *La France*,
21 May 1886

With more femininity, but per-
haps a less accurate sense of
color, Berthe Morisot has taken
her place beside the American
artist [Cassatt]. . . . *La petite ser-
vante* . . . shows the variety in a
temperament that does not shrink
from the difficulties of the craft
and that bears the stamp of real
aristocracy of feeling and taste.
[Octave Maus], *L'Art Moderne*
[Brussels], 27 June 1886

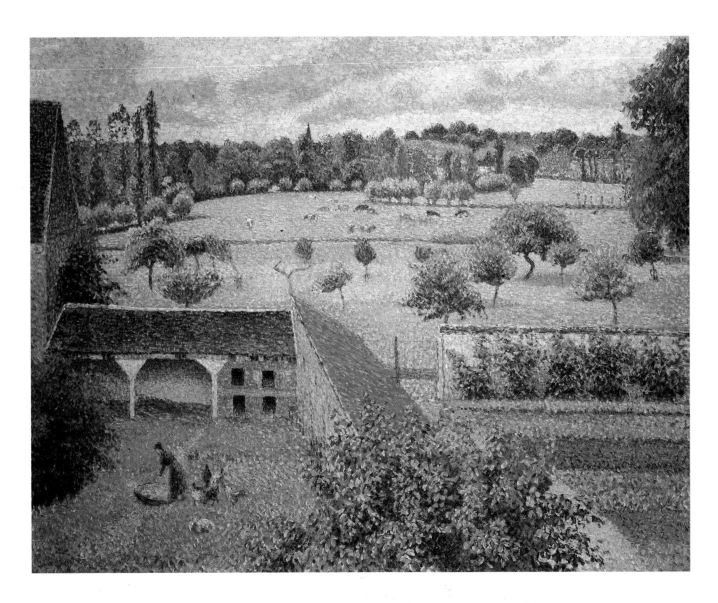

148. Camille Pissarro

VIII–95

Vue de ma fenêtre par temps gris, 1886–1888
View from My Window in Cloudy Weather

Now known as *View from My Window, Eragny*
Signed and dated lower left: *C. Pissarro 1888*
Oil on canvas, 25⅝ x 31½ in. (65 x 80 cm)
The Ashmolean Museum, Oxford. Lent by the Visitors of the
Ashmolean Museum. A794
REFERENCES: Pissarro and Venturi 1939, no. 721; Oxford
1961, 118; Pissarro 1972, 80; Lloyd et al. 1981, no. 65.
NOTE: After exhibiting this work in the 1886 exhibition,
Pissarro reworked and resigned it. (The original inscription was
to the right of the visible signature and appears to have been
dated 1886. See Lloyd et al., above.) In a letter to his son
Lucien, dated 30 July 1886, Pissarro called the work *Temps
gris* and complained that his dealer, Durand-Ruel, disliked it
(see Pissarro, above). It was probably at this point that he began
to rework the painting.

It is a difficult task to speak of
Camille Pissarro.
What we have here is a fighter
from way back, a master who
continually grows and adapts
courageously to new theories.
Pissarro has a supreme sense of
landscape. Infinite flat country-
sides, deep woods, the mysterious
life of things are manifest in the
energy of rising sap, indefinable
sensations of silence, and the
peace of the fields that permeate
his work. . . .
It is cloudy weather with downy
light harmonizing the things seen.
Or else dawn reveals a plain
where mists float over the ground
cut into patterns of
cultivation. . . .

The soul of the artist breathes life
into these orderly countrysides
where trimmed hedges rigidly
frame the plots of ground, where
decent houses sit proudly, fes-
tooned with climbing honeysuc-
kle and wild briony, with no
neglected corner in their little
gardens.
Jean Ajalbert, *La Revue Moderne*
[Marseille], 20 June 1886

Also to be mentioned are *Vue par
un temps gris* and *Les marais de
Bazincourt, en automne*, two
landscapes of soft tonality that
prove the wonderful versatility of
Pissarro's talent.
Rodolphe Darzens, *La Pléiade*,
May 1886

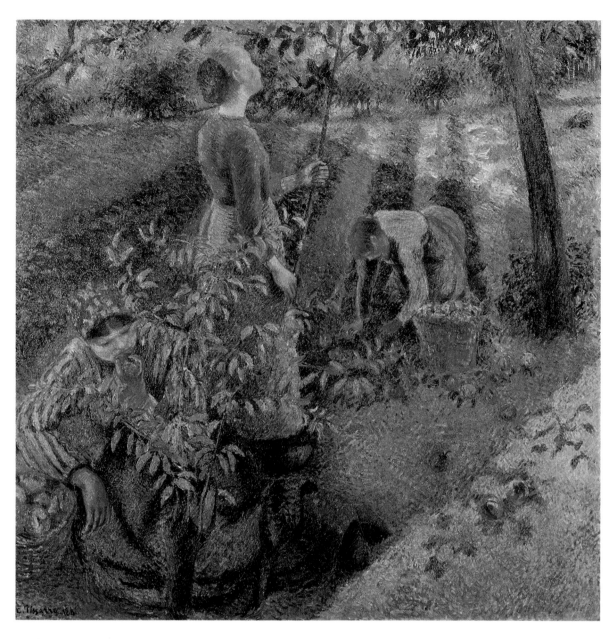

149. Camille Pissarro

VIII—100

La cueillette de pommes, 1886
Apple-picking

Signed and dated lower left: *C. Pissarro 1886*
Oil on canvas, 50⅜ x 50⅜ in. (128 x 128 cm)
Ohara Museum of Art, Kurashiki, Japan
REFERENCES: Pissarro and Venturi 1939, no. 695; Shikes and Harper 1980, 160; Lloyd et al. 1981, no. 64; Lloyd et al. 1984, no. 41.

Camille Pissaro [*sic*] likewise is a very individual painter and the poet of this gathering. His *Paysannes au soleil*, his *Cueillette de pommes*, his *Gardeuse d'oies*, and all his studies of country life are magnificent documents that leave a comforting impression, the opposite of that left by Degas. This poet sees nature as robust. This vision is different from that of the great artists who injected sadness and bitterness into the placidity of country life. The great bucolic painters always have descibed aspects of the same character. They tell us unceasingly of man crushed by the earth that forces him to work but also nourishes him. They always take scenes from the end of day, the hour of the siesta, of repose, of the angelus, showing man crushed, exhausted, and hoping for rest. Pissaro [*sic*] notes a healthier side that is more refreshing to the sight. It is neither more nor less true than the other, only less sad. He makes us see the robust peasant, strong in his work, in the middle of the day in full sunlight.
And he does this as a poet, by instinct, without rhetorical effort. He writes his poems in a magnificent language with superb draftsmanship and color. Then why does this artist scorn to go and triumph at the Salon?
Alfred Paulet, *Paris*, 5 June 1886

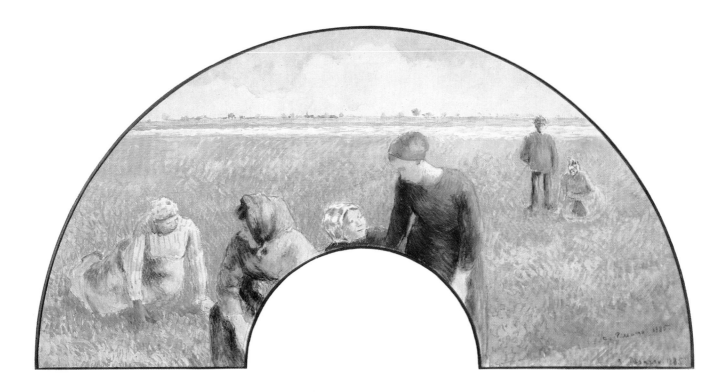

150. Camille Pissarro

VIII—106

Eventail (paysannes), 1885
Fan (Peasant Women)

Now known as *Paysannes ramassant des herbes* (Peasants Gathering Grasses)
Signed and dated twice lower right: *C. Pissarro 1885*
Gouache, red chalk, and pencil on paper, 12 x 24¼ in. (30.5 x 61.5 cm)
Collection of John and Marcia Price, Salt Lake City, Utah
REFERENCES: Pissarro and Venturi 1939, no. 1630; Christie's New York, 5 November 1981, no. 316; Lloyd et al. 1984, no. 85.

There was a time when, just as Lambert [Louis-Eugène, 1825–1900] used to paint cats, Pissarro painted squares of cabbages in a beam of light, employing the most violent violets of the whole school. Lambert is still painting cats, but Pissarro, who has had enough curiosity to vary his work, has made extraordinary progress in his practice pieces. His studies of peasant women make one think of Millet's charcoal sketches. That is to say, they are valuable for their truthful movement, as well as for the moral truth of observation. These are sketches of rare value.
Marcel Fouquier, *Le XIX^e Siècle*, 16 May 1886

I have saved a kind of last tasty morsel for the end, the show by Camille Pissarro, which is admirable in every respect. In him you have a great painter of rare courage who deserves to be placed, along with Claude Monet and Cazin, at the head of modern landscape painters. Some have reproached Pissarro with imitating Millet, but nothing could be more absurd. Pissarro imitates nothing but nature itself, and he sees it with a very individual eye: gay and beautiful light, limpidly serene transparencies, and along with this a very tight, very expert draftsmanship in a style that belongs absolutely to him alone.
Octave Mirbeau, *La France*, 21 May 1886

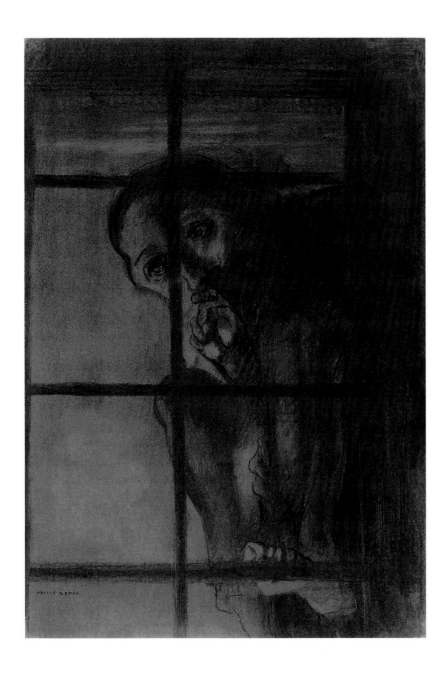

His genius, independent of all schools, bears no immediate relation to Impressionism.
Paul Adam, *La Revue Contemporaine, Littéraire, Politique et Philosophique*, April 1886

Odilon Redon, with his visions of profoundly subjective originality, has an entire panel to himself. ∴ .
Firmin Javel, *L'Evénement*, 16 May 1886

In the middle of this frenzied Naturalism of color, the drawings of Odilon Redon strike a Baudelairean note a la Edgar Poe of nightmare grimaces where laughter is rictus, at once caricature and horrible.
Henry Fèvre, *La Revue de Demain*, May-June 1886

For my part, I would trade all of Redon and his future work for one simple watercolor by Berthe Morisot—three strokes of the brush and a bit of blue and green. —And I will have real dreams. For there are dreams and there are dreams, you know, and just between you and me, I mistrust Odillon's [*sic*] dream.
George Auriol, *Le Chat Noir*, 22 May 1886

151. Odilon Redon

VIII—125

Le secret, 1886
The Secret

Now known as *Le prisonnier* (*L'accusé*) (The Prisoner [The Accused])
Signed lower left: *Odilon Redon*
Charcoal on paper, 21 x 14⅝ in. (53.3 x 37.1 cm)
The Museum of Modern Art, New York. Acquired through the Lillie P. Bliss Bequest. 199.52
REFERENCES: Bacou 1956, 2: no. 33; Berger 1964, no. 589.
NOTE: This is the more likely of two possibilities for no. 125 in the 1886 group show. The other, *Le chevalier*, is now in a private collection in The Netherlands.

As for Odilon Redon, I am unable to recognize the profoundly philosophical talent attributed to him, despite the fashionable enthusiasm for his drawing. All of his compositions seem to me generally grotesque and childish, and voluntarily so, I believe.
Rodolphe Darzens, *La Pléiade*, May 1886

Odilon Redon is exhibiting some of his fantastic visions. As far as craft goes, he is a consummate artist. This is obvious from even a single examination of his works. Too bad, then, for those who are frightened by the vertiginous ideas of this rare poet. We can only quickly mention *Le secret*— behind the bars of a jail, a thoughtful face, lips sealed by one finger, illuminated by intense light.
Jean Ajalbert, *La Revue Moderne* [Marseille], 20 June 1886

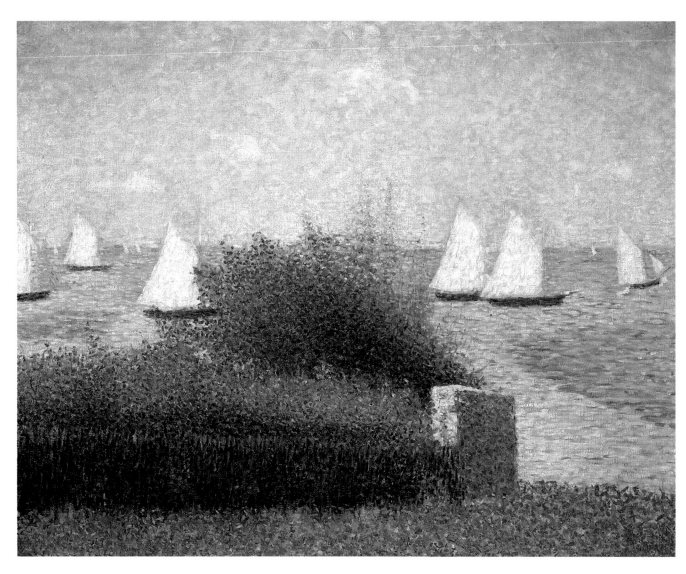

152. Georges-Pierre Seurat

VIII—178

La rade de Grandcamp, 1885
The Harbor at Grandcamp
Signed lower right: *Seurat*
Oil on canvas, 25⅝ x 32 in. (65 x 81.2 cm)
Private collection
REFERENCES: Dorra and Rewald 1959, no. 154; de Hauke 1961, no. 160.
Washington only

Seurat is a radical reformer, not one of these semi-innovators who timidly attempt to use complementary colors. He breaks up the prism with implacable logic, and introduces *petit point* needlework to painting. . . .
Thus, in his landscapes *Le bec du Hoc, Le fort Samson, La rade de Grandcamp, La Seine à Courbevoie,* even though the use of pointillist technique still seems to me too prominent, there is a vibration of light, a richness of color in the shadows permeated with light, a sweet and poetic harmony, an inexpressibly milky, flowered quality that voluptuously caresses the retina. Seurat has the stuff of a superb artist. One only wishes he spread out the tricks of his art with a little less ostentation.
Maurice Hermel, *La France Libre,* 28 May 1886

Some of his landscapes are done with the same method—. . . *La rade de Grandcamp* where a white flight of yachts passes over a blue sea . . . [reveals] an artistic nature unusually fit to analyze the phenomena of light, to penetrate the prism, and to express the most complicated and intense effects with simple means, intelligently employed. We consider Georges Seurat to be a sincere, thoughtful, and observant painter whom the future will judge as he deserves.
[Octave Maus], *L'Art Moderne* [Brussels], 27 June 1886

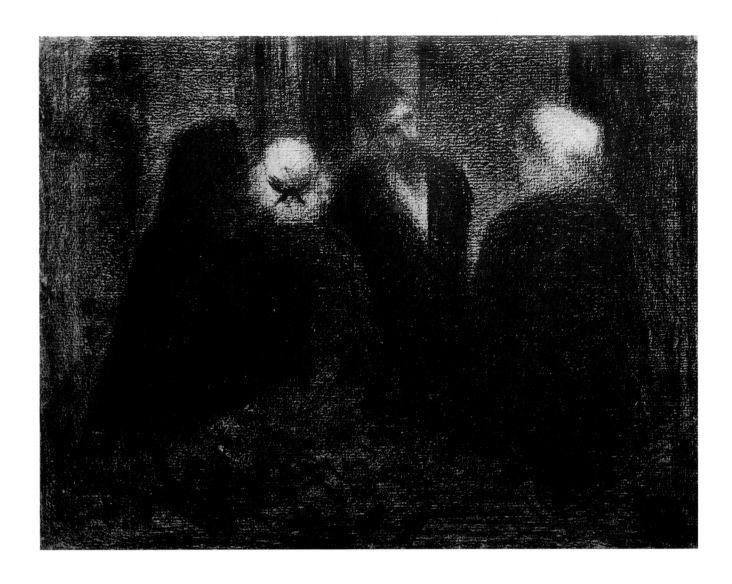

153. Georges-Pierre Seurat

VIII–182

Condoléances, 1886
Condolences

Now known as *Réunion de famille* (The Family Reunion)
Conté crayon on paper, 9½ x 12½ in. (24 x 31.8 cm)
Private collection, Switzerland
REFERENCES: de Hauke 1961, no. 655; Rich 1958, no. 112;
Herbert 1962, 60–61, no. 54.

Seurat is unquestionably the bad little choirboy of the church of the rue Laffitte.
Marcel Fouquier, *Le XIXᵉ Siècle*, 16 May 1886

Georges Seurat has created a strangely expressive drawing that is buried in black, *Condoléances*.
Gustave Geffroy, *La Justice*, 26 May 1886

Seurat paints with little measured touches; the end result is a uniformity that corresponds to his style of drawing.
Jean Ajalbert, *La Revue Moderne* [Marseille], 20 June 1886

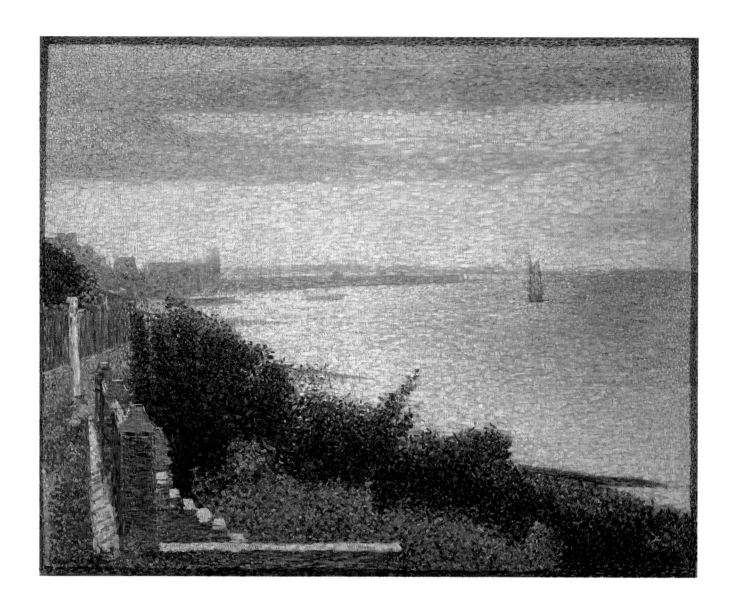

154. Georges-Pierre Seurat

Grandcamp, un soir, 1885
Grandcamp, Evening
Now known as *La Manche à Grandcamp* (The English
Channel at Grandcamp)
Signed and dated lower left: *Seurat 85*; signed lower right:
Seurat
Oil on canvas, 26 x 32½ in. (66 x 82.5 cm)
The Museum of Modern Art, New York. Estate of John Hay
Whitney, 1983. 285.83
REFERENCES: Dorra and Rewald 1959, no. 155; de Hauke
1961, no. 161; Rewald (Whitney) 1983, no. 38.
NOTE: Seurat exhibited this work in the second Exposition de
la Société des Indépendants in 1886 (no. 358).

Seurat has surprised the unpleas-
ant views with a new approach
on which we are not competent to
comment. But judging the general
effect of the canvases, we find
extremely delicate tints in his
series, notably in the seascapes at
Giraud Camp [*sic*]. In them the
sea has the right color, that blue-
gray spangled with green that
makes the northern archipelagoes
so charming.
Emile Hennequin, *La Vie
Moderne*, 19 June 1886

Certain [of the Impressionists]
offer tranquil painting in solid
tones, like Seurat, whose sea-
scapes are done with an expert
technique, resonant with the
open air, and with an enchanting
impression of sadness.
Jules Vidal, *Lutèce*, 29 May 1886

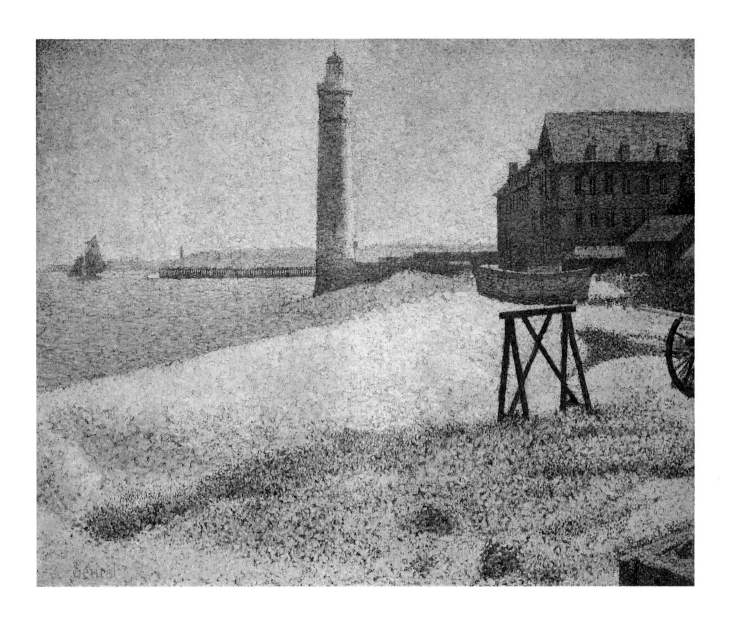

155. Georges-Pierre Seurat

L'hospice et la phare, Honfleur, 1886
The Hospice and Lighthouse at Honfleur

Also known as *The Lighthouse at Honfleur*
Signed lower left: *Seurat*
Oil on canvas, 26¼ x 32¼ in. (66.7 x 81.9 cm)
National Gallery of Art, Washington. Collection of Mr. and
Mrs. Paul Mellon. 1983.1.33
REFERENCES: Dorra and Rewald 1959, no. 168; de Hauke
1961, no. 173; Rewald 1978, 93–94, fig. 93; Bowness 1980,
no. 89.
NOTE: In 1887 Seurat exhibited this work in both the fourth
Exhibition des XX in Brussels (no. 5) and the Paris Salon des
Artistes Indépendants (no. 439).

Seurat's seascapes were not even
challenged by the journalists.
Their calm immensity imposes
itself at first sight, the eroded and
jagged cliffs extending in a line,
the waves renewing themselves in
the distance, and the enormous
sweep of air circulating between
sky and water. Seurat succeeds as
well as Pissaro [*sic*] in giving the
sense of a visual void in the
expanses of atmosphere.
Paul Adam, *La Revue Contem-
poraine, Littéraire, Politique et
Philosophique*, April 1886

156. Georges-Pierre Seurat

La Maria, Honfleur, 1886

Signed lower left: *Seurat*
Oil on canvas, 20⅞ x 25 in. (53 x 63.5 cm)
Národni Galeri v Praze, Prague
REFERENCES: Dorra and Rewald 1959, no. 169; de Hauke
1961, no. 164; Novotný 1959, no. 81.
NOTE: Seurat exhibited this work in the third Salon des
Indépendants in 1887 (no. 444).

Finally, to finish the parade, an
original, over whom the Intransi-
gents themselves are battling in
this Intransigent exhibition.
Some exalt him to excess; others
criticize him out of hand. The
messiah of a new art – or a cold-
blooded mystifier – is Georges
Seurat.
[Octave Maus], *L'Art Moderne*
[Brussels], 27 June 1886

157. Paul Signac

VIII—186

Le Moulin de Pierre Hâlé, Saint-Briac, 1884
Pierre Hâlé's Windmill, Saint-Briac

Signed and dated lower left: *Signac 84*
Oil on canvas, 23 5/8 x 36 1/4 in. (60 x 92 cm)
Private collection, Paris
REFERENCES: Saint-Germain-en-Laye 1982, no. 12.

In this room Paul Signac's painting bursts forth boldly, like a fanfare. . . .
Signac is exhibiting some seascapes, views of Saint-Briac. Green waves darken into blue, . . . foam around the rocks . . . and the light spreads fiercely. . . .
Signac proceeds from an ineffable sureness of eye and hand, with rousing good humor. You sense this artist is enamored of his art, loving nature where he looks to surprise its most fleeting aspects.
Jean Ajalbert, *La Revue Moderne* [Marseille], 20 June 1886

158. Paul Signac

VIII–188

Les gazomètres, Clichy, 1886
The Gas Tanks at Clichy
Signed and dated lower left: *P. Signac 86*
Oil on canvas, 25⅝ x 31⅞ in. (65 x 81 cm)
National Gallery of Victoria, Melbourne. Felton Bequest 1948
REFERENCES: Cachin 1971, nos. 16–17; Homer 1964, 287;
Herbert 1968, no. 90.

Some corners of suburban streets with silhouettes of gas tanks. . . . The colors palpitate and the burning sun shimmers, making the atmosphere vibrate. And all of this strikes the eye without hurting it, in precise evocation, in a hallucination of memory that does not try to reinforce or multiply the sensation by an artist's trick, as Seurat does.
Henry Fèvre, *La Revue de Demain*, May-June 1886

Signac: another debut. For the time being, it is difficult to discuss the future of this young painter who asserts a rare gift for observation in certain canvases, such as *Les gazomètres de Clichy*. . . .
[Octave Maus], *L'Art Moderne* [Brussels], 27 June 1886

159. Paul Signac

VIII—192

Bonne brise de N¼ N-O, Saint-Briac, 1885
Brisk Breeze from the North ¼ Northwest, Saint-Briac

Signed lower right: *P. Signac*
Oil on canvas, 17¾ x 25¼ in. (45.1 x 64.1 cm)
Collection of Mr. and Mrs. Ray Dolby, San Francisco
San Francisco only

Signac has a gay crudeness. His painting is all shimmering light, . . . his water glitters and undulates with refracted sunlight.
Jules Vidal, *Lutèce*, 29 May 1886

Paul Signac deserves to be mentioned among the Impressionist landscape painters. His studies of the Brittany coast are better than his scenes of the Parisian suburbs.
J. M. Michel, *La Petite Gazette*, 18 May 1886

Signac works with broader strokes than Seurat and obtains wonderful effects of light playing off rippling water. His style certifies him as an original artist who, applying the new formula, tries to modify it according to his own temperament.
Rodolphe Darzens, *La Pléiade*, May 1886

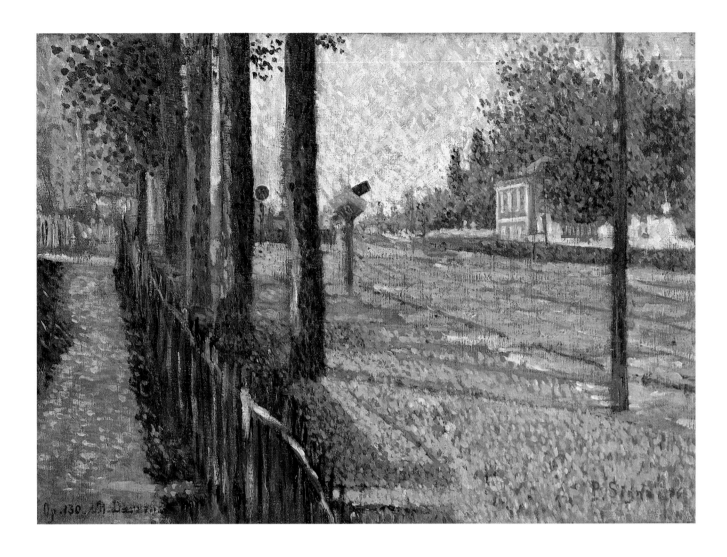

160. Paul Signac

VIII–195

L'embranchement de Bois-Colombes, 1886
The Railway Junction at Bois-Colombes

Signed and dated lower right: *P. Signac 86*; inscribed lower left:
Op 130 R. Darzens
Oil on canvas, 13 x 18½ in. (33 x 47 cm)
Leeds City Art Gallery
REFERENCES: de Forges 1964, no. 14; Bowness et al. 1979, no.
206.

Some well-chosen subjects. . . .
A good sense of the harshness of
light, but his contrasts are some-
times too hard, and not enough
care is taken with the attenuation
of the contours of objects and the
sharpening of color brought by
shadows.
Gustave Geffroy, *La Justice*,
26 May 1886

The outskirts of Paris with their
skies streaked by factory chim-
neys, trees planted in lines, the
flickering of river waters, leprous
banks, sometimes visions of the
blue sea: these are the things
Signac loves to paint. Among all
the others, his paintings clamor
for attention with their intense
color, with a richness that is all
his own. Still very young, Signac
possesses admirable tone, a sense
of what is Parisian that avoids
caricature and ugliness. Had they
been done by Raffaëlli, certain of
his landscapes would have
offered desolate tones, sickly veg-
etation, and soot spread
everywhere.
Paul Adam, *La Revue Contem-
poraine, Littéraire, Politique et
Philosophique*, April 1886

Appendix

La nouvelle peinture

Louis Emile Edmond Duranty

Un peintre [Eugène Fromentin], éminent parmi ceux dont nous n'aimons pas le talent, et qui a de plus le don et la fortune d'être écrivain, disait récemment ceci dans la *Revue des Deux Mondes*:

«La doctrine qui s'est appelée *réaliste* n'a pas d'autre fondement sérieux qu'une observation meilleure et plus saine des lois du coloris. Il faut bien se rendre à l'évidence et reconnaître qu'il y a du bon dans ces visées, et que si les réalistes savaient plus et peignaient mieux, il en est dans le nombre qui peindraient fort bien. Leur œil en général a des aperçus très justes et des sensations particulièrement délicates, et, chose singulière, les autres parties de leur métier ne le sont plus du tout. Ils ont, paraît-il, une des facultés les plus rares, ils manquent de ce qui devrait être le plus commun, si bien que leurs qualités, qui sont grandes, perdent leur prix pour n'être pas employées comme il faudrait; qu'ils ont l'air de révolutionnaires parce qu'ils affectent de n'admettre que la moitié des vérités nécessaires, et qu'il s'en faut à la fois de très peu et de beaucoup qu'ils n'aient strictement raison. . . .

«Le *plein air*, la lumière diffuse, le *vrai soleil* prennent aujourd'hui dans la peinture une importance qu'on ne leur avait jamais reconnue, et que, disons-le franchement, ils ne méritent point d'avoir. . . .

«A l'heure qu'il est, la peinture n'est jamais assez claire, assez nette, assez formelle, assez crue. . . .

«Ce que l'esprit imaginait est tenu pour artifice, et tout artifice, je veux dire toute convention, est proscrit d'un art qui ne devrait être qu'une convention. De là, comme vous vous en doutez, des controverses dans lesquelles les élèves de la nature ont le nombre pour eux. Même il existe des appellations méprisantes pour désigner les pratiques contraires. On les appelle le *vieux jeu*, ce qui veut dire une façon vieillotte, radoteuse et surannée de comprendre la nature en y mettant du sien. Choix des sujets, dessin, palette, tout participe à cette manière impersonnelle de voir les choses et de les traiter. Nous voilà loin des anciennes habitudes, je veux dire des habitudes d'il y a quarante ans, où le bitume ruisselait à flots sur les palettes des peintres romantiques et passait pour être la couleur auxiliaire de l'idéal. Il y a une époque et un lieu dans l'année où ces modes nouvelles s'affichent avec éclat, c'est à nos expositions du printemps. Pour peu que vous vous teniez au courant des nouveautés qui s'y produisent, vous remarquerez que la peinture la plus récente a pour but de frapper les yeux des foules par des images saillantes, textuelles, aisément reconnaissables en leur vérité, dénuées d'artifices, et de nous donner exactement les sensations de ce que nous voyons dans la rue. Et le public est tout disposé à fêter un art qui représente avec tant de fidélité ses habits, son visage, ses habitudes, son goût, ses inclinations et son esprit. Mais la peinture d'histoire, me direz-vous? D'abord, au train dont vont les choses, est-il bien certain qu'il existe encore une école d'histoire. Ensuite, si ce vieux nom de l'ancien régime s'appliquait encore à des traditions brillamment défendues, fort peu suivies, n'imaginez pas que la peinture d'histoire échappe à la fusion des genres et résiste à la tentation d'entrer elle-même dans le courant. . . . Regardez bien, d'année en année, les conversions qui s'opèrent, et sans examiner jusqu'au fond, ne considérez que la couleur des tableaux. Si de sombre elle devient claire, si de noire elle devient blanche, si de profonde elle remonte aux surfaces, si de souple elle devient raide, si de la matière luisante elle tourne au mat, et du clair obscur au papier japonais, vous en avez assez vu pour apprendre qu'il y a là un esprit qui a changé de milieu et un atelier qui s'est ouvert au jour de la rue.»

Ces observations sont faites avec prudence, avec courtoisie, avec ironie et même avec mélancolie.

Elles sont bien curieuses, si l'on songe à l'influence qu'exerce ce peintre sur la nouvelle génération sortie de l'Ecole des Beaux-Arts.

Encore plus curieuses, si l'on songe que cet écrivain, qui considère comme une marque de médiocrité la fidélité à reproduire les habits, le visage, les habitudes de nos contemporains, s'est voué et s'évertue à représenter les habits, les visages, les habitudes de qui? des *Arabes contemporains*. Pourquoi s'obstine-t-il ainsi à entraver la colonisation de l'Algérie? Nul ne le sait. Pourquoi les Arabes contemporains lui paraissent-ils seuls dignes des préoccupations de la peinture? On ne le sait pas davantage.

Parti du Sahel, il s'est rencontré à Paris avec un autre artiste [Gustave Moreau], esprit tourmenté, souvent délicat, nourri de poésie et de symbologie anciennes, le plus grand ami des mythes qu'il y ait peut-être ici-bas, passant sa vie à interroger le Sphynx, et tous deux sont parvenus à inspirer aux nouveaux groupes de ces jeunes gens qu'on élève au biberon de l'art officiel et traditionnel, un étrange système de peinture, borné au sud par l'Algérie, à l'est par la mythologie, à l'ouest par l'histoire ancienne, au nord par l'archéologie: la vraie peinture trouble d'une époque de critique, de bibelotage, et de pasticheries.

Ils s'efforcent d'y amalgamer toutes les *manières*; le ranci et le blafard des figures s'y étalent sur des colorations d'étoffes qu'on soutire maladroitement aux Vénitiens en les surchauffant jusqu'au criard, et en les amollissant jusqu'à les éteindre [Jacques-Fernand Humbert]; on prend, il faudrait dire on chippe, à Delacroix ses fonds en les refroidissant et en les aigrissant [either Emile Lévy or Henri Leopold Lévy]; on bat ensemble du Carpaccio, du Rubens, et du Signol, peut-être casse-t-on dans le mélange un peu de Prudhon et du Lesueur [Fernand Cormon], et l'on sert un étrange ragoût maigre et sûri, une salade de lignes pauvres, anguleuses et cahotées, de colorations détonnantes trop fades ou trop acides, une confusion de formes grêles, gênées, emphatiques et maladives. Les recherches d'une archéologie en pleine mue, mais parvenue à un certain degré d'étrangeté, donnent seules un peu d'accent à cet art négatif et embrouillé. Mais l'archéologie n'est point à eux et ils la doivent aux archéologues. Si donc un art est bien impersonnel, ce n'est pas celui que désignait le peintre-écrivain, mais c'est celui-ci. Toutes les conventions s'y donnent rendez-vous, il est vrai, mais tout y manque de ce qui est de l'homme, de son individualité, de son esprit.

Croient-ils que parce qu'ils auront exécuté les casques, les tabourets, les colonnes polychrômes, les barques, les bordures de robes, d'après les derniers décrets rendus par l'archéologie;

croient-ils que parce qu'ils auront scrupuleusement essayé de respecter, dans leurs personnages, le type le plus récemment admis de la race ionienne, dorienne ou phrygienne; croient-ils enfin que parce qu'ils auront terrassé, pourchassé, envoyé au diable le monstre *Anachronisme*, ils auront fait grande œuvre d'art. Ils ignorent que tous les trente ans, la susdite archéologie fait peau neuve, et que la calotte béotienne à nasal et à couvre-joues, par exemple, qui est le dernier mot de la mode érudite, ira rejoindre à la ferraille le grand casque du Léonidas de David, qui fut dans son temps l'extrême expression du savoir ès-choses antiques.

Ils ignorent que c'est au feu de la vie contemporaine que les grands artistes, les esprits sagaces éclairent ces choses antiques. Les *Noces de Cana* de Véronèse eussent été piteuses sans ses gentilshommes de Venise; M. Renan n'a pas manqué de comparer Ponce Pilate à un préfet en Basse-Bretagne, M. de Rémusat à Saint-Philotée; et, comme me le disait l'autre jour un artiste très observateur, la force des Anglais dans l'art vient de ce qu'Ophélie est toujours *une lady* dans leur esprit. Alors, qu'est-ce donc que ce monde de l'Ecole des Beaux-Arts, même pris dans le dessus du panier? On y montre de la mélancolie, comme des gens sans appétit, privés de la jouissance de leurs sens et qui demeurent assis sans manger devant une table couverte de fort bonnes choses, blâmant ceux qui s'y régalent.

Ils sont mélancoliques, car ils sentent que leurs efforts ne sont pas immenses. En effet, ils se bornent: d'une part, à avoir épuré la literie antique, et restauré le bric-à-brac homérique, de l'autre, à tutoyer les *chaouchs* et les *biskris*. Ils ont fait descendre de son estrade leur modèle d'atelier à barbe noire, et l'ont campé sur un chameau, par devant le portail de Gaillon, en l'enveloppant d'une couverture de laine prêtée par le boucher d'à côté, car cette fréquentation de l'Arabe les a rendus sanguinaires et sanglants, et, au vocabulaire italien qu'on rapporte de Rome, ils ont ajouté le *secar la cabeza* du baragouin *sabir* des moricauds de la province d'Oran.

Et c'est tout; ils s'en iront tranquillement à la postérité après ce petit voyage.

Mais auraient-ils pu être menés beaucoup plus loin par l'étrange éducation de leur jeunesse, qu'a si bien décrite un maître de dessin, M. Lecoq de Boisbaudran, dont le récit simple et exact est plus cruel que toutes les plaisanteries; par l'éducation que voici:

«Les jeunes gens qui suivent les concours font tous leurs efforts, et cela est bien naturel, pour obtenir les récompenses qui y sont attachées. Malheureusement le moyen qui leur semble généralement le plus sûr et le plus facile, c'est d'imiter les ouvrages précédemment couronnés, que l'on ne manque pas d'exposer avec honneur et apparat, comme pour les proposer en exemple et bien montrer la route qui conduit au succès. A-t-on compris toute la portée de ces incitations, en voyant le plus grand nombre des concurrents abandonner leurs propres inspirations pour suivre servilement ces données recommandées par l'Ecole et consacrées par la réussite.

«Sauf de très rares exceptions, on n'arrive à la simple admission au grand concours, c'est-à-dire à l'entrée en loge, qu'après de longues études dirigées exclusivement vers ce but; c'est la durée de cette préparation anti-naturelle qui la rend si dangereuse pour la conservation des qualités originales.

«Les élèves qui s'y attardent finissent par ressembler à certains aspirants bacheliers, plus soucieux du diplôme que du vrai savoir.

«Deux épreuves sont exigées pour l'admission en loge: une esquisse ou composition sur un sujet donné, et une figure peinte d'après le modèle. La préparation à ces deux épreuves devient l'unique préoccupation des jeunes gens. Ils ne veulent point d'autres études que la répétition journalière de ces esquisses et de ces figures banales, toujours exécutées dans les dimensions, dans les limites de temps et dans le style habituel des concours.

«Après des années entières consacrées à de tels exercices, que peut-il rester des qualités les plus précieuses? Que deviennent la naïveté, la sincérité, le naturel? Les expositions de l'Ecole des Beaux-Arts ne le disent que trop.

«Parfois, certains concurrents imitent le style de leur maître ou celui de tel artiste célèbre, d'autres cherchent à s'inspirer d'anciens lauréats de l'Ecole, ceux-ci se préoccupent des derniers succès du Salon, ceux-là de quelque œuvre qui les aura vivement impressionnés. Ces différentes influences peuvent donner à quelques Expositions une variété apparente, mais rien ne ressemble moins à la diversité réelle et au caractère original des inspirations personnelles.»

Bah! messieurs, il n'y a pas de quoi être très fiers de ces points de départ, de cet élevage à la façon d'une race ovine, de cette éducation après laquelle on peut vous appeler les Dishley-mérinos de l'art. Cependant il parait que vous êtes très dédaigneux des tentatives d'un art qui veut s'en prendre à la vie, à la flamme moderne, dont les entrailles s'émeuvent au spectacle de la réalité et de l'existence contemporaine. Vous vous cramponnez aux genoux de Prométhée, aux ailes du Sphynx.

Eh! savez-vous pourquoi vous le faites? c'est pour demander au Sphynx, sans vous en douter, le secret de notre temps, et à Prométhée le feu sacré de l'âge actuel. Non, vous n'êtes pas si dédaigneux. Vous vous inquiétez de ce mouvement artistique qui dure déjà depuis longtemps, qui persévère malgré les obstacles, malgré le peu de sympathie qu'on lui montre.

Avec tout ce que vous savez, vous voudriez enfin être un peu vous-mêmes, vous commencez à en avoir jusqu'à la gorge, de cette momification, de cet écœurant embaumement de l'esprit. Vous commencez à regarder par-dessus le mur, dans le petit jardin de ceux-ci, soit pour y jeter des pierres, soit pour voir ce qu'on y fait.

Allons, la tradition est en désarroi, vos efforts pour la compliquer en témoignent bien assez, et vous sentez le besoin d'ouvrir ce jour sur la rue dont n'est point satisfait votre guide, l'honorable et habile peintre-écrivain si courtois, si ironique et si désenchanté dans ses dires. Vous auriez bien envie, vous aussi, d'entrer dans la vie.

La tradition est en désarroi, mais elle est la tradition, et elle représente les anciennes et magnifiques formules des âges précédents. Vous êtes attachés à la glèbe par les légitimistes de l'art, ceux d'ici passent pour des révolutionnaires artistiques. Le combat n'est vraiment qu'entre eux et vous, et ils n'ont d'estime que pour vous parmi leurs adversaires. Vous méritez l'affranchissement. Ils vous l'apporteront. Mais auparavant, peut-être, vous viendra-t-il par les femmes. Par les femmes? Pourquoi non.

N'est-ce pas bien étrange, lisé-je dans une lettre de ce peintre observateur qui m'a fourni déjà une note intéressante, n'est-ce pas bien étrange? «Un sculpteur, un peintre ont pour femme, pour maîtresse, une femme qui a un nez retroussé, de petits yeux, qui est mince, légère, vive. Ils aiment dans cette femme jusqu'à ses défauts. Ils se sont peut être jetés en plein drame pour qu'elle fût eux! Or, cette femme qui est l'idéal de leur

cœur et de leur esprit, qui a éveillé et fait jouer la vérité de leur goût, de leur sensibilité et de leur *invention*, puisqu'ils l'ont trouvée et élue, est absolument le contraire du *féminin* qu'ils s'obstinent à mettre dans leurs tableaux et leurs statues. Ils s'en retournent en Grèce, aux femmes sombres, sévères, fortes comme des chevaux. Le nez retroussé qui les délecte le soir, ils le trahissent le matin et le font droit; ils s'en meurent d'ennui ou bien ils apportent à leur ouvrage la gaîté et l'effort de *pensée* d'un cartonnier qui sait bien coller, et qui se demande où il ira *rigoler*, après sa journée faite.»

Peut-être, quelque jour, la femme française vivante, au nez retroussé, délogera-t-elle la femme grecque en marbre, au nez droit, au menton épais, qui s'est encastrée dans vos cervelles, comme un débris de vieille frise dans le mur que s'est fait un maçon après des fouilles. Ce jour-là, l'artiste tressaillera sous l'adroit colleur de cartonnages.

Au surplus, elle est bien malade chez vous, la femme grecque, à voir comme vous la reproduisez toujours hâve, livide ou jaune, trébuchante, avec des yeux creux et hagards. Elle a été tant de fois emmenée à l'Ecole de Rome qu'elle a attrapé la *mal'aria*.

En attendant, venez regarder dans le jardinet de ceux d'ici, vous verrez qu'on tente d'y créer de pied en cap un art tout moderne, tout imprégné de nos alentours, de nos sentiments, des choses de notre époque.

Autant, il est vrai, le lieu commun est facile à exprimer, à varier, à moduler dans tous les tons, autant l'idée neuve est exposée à balbutier dans ses premières expressions.

L'avantage matériel, rhétorique, est donc jusqu'ici du côté du quai Malaquais, il serait puéril de le nier. Mais il s'en faut de beaucoup que le monde du quai Malaquais ait raison.

Ce qui a fait la force des hommes de la Renaissance et des primitifs, c'est que, sous le voile antique, et il ne faut même pas dire le voile, mais simplement l'étiquette antique, ils ont exprimé les mœurs, les costumes et les décors de leur temps, rendu leur vie personnelle, enregistré une époque. Ils l'ont fait naïvement, sans critique, sans discussion, sans avoir besoin, comme nous, de démêler la voie juste parmi les fausses pistes.

Nous en sommes arrivés, laborieusement et grâce à des exemples éclatants, nous en sommes arrivés en littérature à mettre la chose hors de contestation. La haute littérature d'art contemporaine est réaliste, en affectant les formes et les procédés les plus variés. Celui qui écrit ces lignes a contribué à déterminer ce mouvement dont il a été l'un des premiers à donner la nette formule esthétique il y a près de vingt ans.

La peinture est tenue d'entrer dans ce mouvement que des artistes de grand talent s'efforcent de lui imprimer depuis que Courbet a, comme Balzac, tracé le sillon d'une façon si vigoureuse. Elle y est tenue d'autant plus, qu'elle est, quelque conventionnelle qu'on voudra, le moins conventionnel de tous les arts, le seul qui *réalise* effectivement les personnages et les objets, celui qui *fixe*, sans laisser de doute ni de vague, les figures, les costumes et les fonds, celui qui *imite*, qui *montre*, qui *résume* le mieux, n'en déplaise à tous les artifices et les procédés.

Quant aux groupes artistiques qui agissent en dehors de l'Ecole des Beaux-Arts, s'y rattachant par quelque fil qu'ils traînent à la patte, ce sont des hybrides.

Les uns viennent de cet atelier d'archéologie anecdotique [Jean-Léon Gérôme] universel où l'on opère le costumage depuis le casque du mirmillon romain jusqu'au petit chapeau du premier consul, où l'on possède des méthodes d'exécution très sûres, une façon de modeler établie une fois pour toutes, où l'on se livre à froid à une espèce de carnaval sentencieux. Ils ont renchéri sur le maître, demandé aux comédiens de leur enseigner quelques grimaces de théâtre à mettre sur la face, invariablement la même, de leurs petits marquis, de leurs incroyables, de leurs pages, moines et archers copiés avec conscience d'après des commissionnaires qu'ils ont affublés d'oripeaux trop frais ou trop fanés. Ceux-là semblent se promener toujours avec conviction à la suite d'un *lavoir* fêtant la mi-carême.

D'autres, qui sont leurs rivaux, ont trouvé des chatoiements, des éclats, des oppositions étincelantes, en marchant derrière Fortuny, tout un virtuosisme d'arpèges, de trilles, de chiffons, de crêpons, qui ne procèdent d'aucune loi d'observation, d'aucune pensée, d'aucun vouloir d'examen. Ils ont chiffonné, maquillé, troussé la nature, l'ont couverte de papillotes. Ils la traitent en coiffeurs, et la préparent pour une opérette. L'industrie, le commerce tiennent une part trop considérable dans leur affaire.

Quand j'aurai compté encore les peintres qui se sont attachés à l'état-major, qui passent leur temps entre le tambour et la trompette, et auxquels on ne peut reprocher que d'être trop faciles, point assez pénétrants, point assez peintres ni assez dessinateurs, et, disons-le, point assez convaincus, bien que quelques uns d'entre eux aient grande bonne volonté et beaucoup d'esprit, le dénombrement sera achevé.

Le débat n'est donc vraiment qu'entre l'art ancien et le nouvel art, entre le vieux tableau et le jeune tableau. L'*idée* qui expose dans les galeries Durand-Ruel n'a d'adversaires qu'à l'Ecole et à l'Institut. C'est là seulement qu'elle peut, doit et désire faire des convertis. Ce n'est aussi qu'à l'Ecole et à l'Institut qu'elle a trouvé justice.

Ingres et ses principaux élèves admiraient Courbet; Flandrin encourageait beaucoup cet autre peintre réaliste, maintenant fixé en Angleterre, épris de scènes contemporaines religieuses, d'où il a su dégager tant de naïveté et de grandeur, soit dans ses tableaux, soit dans ses puissantes eaux-fortes.

Le mouvement, en effet, a déjà ses racines. Il est au moins d'avant-hier, et non pas d'hier seulement. C'est peu à peu qu'il s'est dégagé, qu'il a abandonné le *vieux jeu*, qu'il est venu au *plein air*, au *vrai soleil*, qu'il a retrouvé l'originalité et l'imprévu, c'est-à-dire la saveur dans les sujets et dans la composition de ses toiles, qu'il a apporté un dessin pénétrant, épousant le caractère des êtres et des choses modernes, les suivant au besoin avec une sagacité infinie dans leurs allures, dans leur intimité professionnelle, dans le geste et le sentiment intérieur de leur classe et de leur rang.

Je mêle ici des efforts et des tempéraments distincts, mais qui sont ensemble dans la recherche et dans la tentative.

Les origines de ces efforts, les premières manifestations de ces tempéraments, on les retrouve à partir de l'atelier de Courbet, entre l'*Enterrement d'Ornans* et les *Demoiselles de village*; elles sont chez le grand Ingres, et le grand Millet, ces esprits pieux et naïfs, ces hommes de puissant instinct; chez Ingres, qui s'est assis sur le tabouret d'ivoire avec Homère et qui s'est mêlé à la foule qui regardait Phidias travailler au Parthénon, mais qui ne rapportait de la Grèce que le respect de la nature et revint vivre avec la famille Robillard comme avec le comte Molé et le duc d'Orléans, n'hésitant et ne trichant jamais devant les formes modernes, exécutant ces portraits rigoureux, violents, étranges, tant ils sont simples et vrais, et qui n'eussent pas

déparé une salle de refusés; chez Millet, cet Homère de la campagne moderne, qui regarda le soleil jusqu'à en devenir aveugle; qui a montré le paysan dans les labours comme un animal parmi les bœufs, les porcs et les moutons, qui a adoré la *terre* et l'a faite si ingénue, si noble, si rude et déjà couverte d'irradiations lumineuses.

Elles sont aussi chez le grand Corot et chez son disciple Chintreuil, cet homme qui *cherchait* toujours, et que la nature semble avoir aimé tant elle lui a fait de révélations. Puis elles se montrent parmi quelques élèves d'un professeur de dessin, dont le nom est attaché spécialement à une méthode dite d'*éducation de la mémoire pittoresque*, mais dont le principal mérite aura été de laisser se développer l'originalité, le caractère personnel de ceux qui étudiaient auprès de lui, au lieu de vouloir les ramener à une manière commune, à un joug de procédés inviolables.

En même temps ce peintre de Hollande aux tonalités si justes, et qui a fini par envelopper ses moulins, ses clochers, ses vergues de navires, sous des vibrations grises et violettes si délicates [Johan Barthold Jongkind]; cet autre peintre de Honfleur qui notait et analysait si profondément les ciels de la mer et qui nous a donné la vérité des marines [Eugène Boudin], ont apporté tous deux leur contingent à cette expédition pleine d'élans, où l'on se flatte de doubler le cap de Bonne-Espérance de l'art, et de découvrir des passages nouveaux.

Au Salon des refusés de 1863, apparurent, hardis et convaincus, les chercheurs. Plusieurs d'entre eux ont, depuis, obtenu des médailles, ou se trouvent en assez belle situation de renom, soit à Londres, soit à Paris.

J'ai déjà signalé le peintre de l'*Ex-voto* [Alphonse Legros], ce tableau qui parut en 1861. Il était bien moderne, ce tableau-là, et il avait l'ingénuité et la grandeur des œuvres du quinzième siècle. Que représentait-il? De vieilles femmes *communes*, habillées de vêtements *communs*; mais la stupidité rigide et machinale que l'existence pénible et étroite des humbles donnait à ces faces crevassées et flétries, jaillissait avec une profonde intensité. Tout ce qui peut frapper chez des êtres, retenir devant eux, tout le significatif, le concentré, l'imprévu de la vie rayonnait autour de ces vieilles créatures.

Un autre, un Américain, exposait, il y a trois ans, dans ces mêmes galeries Durand-Ruel [James Abbott McNeill Whistler], de surprenants portraits et des variations d'une infinie délicatesse sur des teintes crépusculaires, diffuses, vaporeuses, qui ne sont ni le jour ni la nuit. Un troisième [Henri Fantin-Latour] s'est créé un pinceau harmonieux, discrètement riche, absolument personnel, est devenu le plus merveilleux peintre de fleurs de l'époque et a réuni, dans de bien curieuses séries, les figures d'artistes et de littérateurs nos contemporains, s'annonçant comme un étonnant peintre de personnages, comme on le verra encore mieux dans l'avenir. Un autre [Edouard Manet], enfin, a multiplié les affirmations les plus audacieuses, a soutenu la lutte la plus acharnée, a ouvert non plus seulement un jour, mais des fenêtres toutes grandes, mais des brèches, sur le *plein air* et le *vrai soleil*, a pris la tête du mouvement et a maintes fois livré au public, avec une candeur et un courage qui le rapprochent des hommes de génie, les œuvres les plus neuves, les plus entachées de défauts, les mieux *ceinturées* de qualités, œuvres pleines d'ampleur et d'accent, criant à part de toutes les autres, et où l'expression la plus forte heurte nécessairement les hésitations d'un sentiment qui, presque entièrement neuf, n'a pas encore tous ses moyens de prendre corps et réalisation.

Je ne nomme point ces artistes, puisqu'ils n'exposent pas ici cette année. Mais il se pourra que les années suivantes ils ne craignent pas de venir dans un lieu où leurs bannières sont arborées et leurs cris de guerre inscrits sur les murs.

Au mouvement se rattachaient aussi jadis le peintre des *cuisiniers* [Théodule Augustin Ribot], ainsi que le peintre des chaudrons et des poissons [Antoine Vallon]; mais celui-ci est retourné au *vieux jeu*, et celui-là a cherché un refuge, une casemate dans le noir de fumée. Ils semblaient autrefois plus disposés à laisser venir à eux la nature claire et riante, ceinte de son arc-en-ciel, *attendrie* des reflets de la lumière et enrichie des irisations qui se jouent dans l'air comme dans un prisme.

Le peintre belge [Alfred Stevens], d'un grand talent, qui n'expose plus depuis longtemps, et que les siens appelaient l'homme de la *modernité*, était, lui aussi, du mouvement, et il en est toujours. Il faut noter encore ce jeune peintre de portraits [Charles Emile Auguste Carolus-Duran], au faire sain et solide, mais sans recherches, que le succès n'abandonne plus; il était parti avec le mouvement, il était frère d'art, il était *matelot* avec quelques-uns de ceux dont j'ai parlé tout à l'heure. Il a préféré rentrer dans les conditions communes et déterminées de l'exécution, se contentant d'occuper le haut de l'échelle dans la moyenne bourgeoise des artistes, ne trempant plus que le bout du doigt dans l'art original où il avait été bercé et élevé, où il avait plongé jusqu'au cou.

Enfin, Méryon le graveur en était, et aussi cet autre graveur, peintre et dessinateur [Félix Bracquemond], si remarquable portraitiste, à la façon d'Holbein, aujourd'hui absorbé par la décoration des faïences; et puis en est encore ce jeune peintre napolitain [Giuseppe de Nittis] qui aime à représenter le mouvement des rues de Londres ou de Paris.

Les voilà donc, ces artistes qui exposent dans les galeries Durand-Ruel, rattachés à ceux qui les ont précédés ou qui les accompagnent. Ils ne sont plus isolés. Il ne faut pas les considérer comme livrés à leurs propres forces.

J'ai donc moins en vue l'exposition actuelle que la *cause* et l'*idée*.

Qu'apportent donc celles-ci, qu'apporte donc le mouvement, et par conséquent qu'apportent-ils donc ces artistes qui prennent la tradition corps à corps, qui l'admirent et veulent la détruire, qui la reconnaissent grande et forte et par cela même s'y attaquent?

Pourquoi donc s'intéresse-t-on à eux; pourquoi donc leur pardonne-t-on de n'apporter trop souvent, et tant soit peu paresseusement, que des esquisses, des sommaires abrégés?

C'est que, vraiment, c'est une grande surprise, à une époque comme celle-ci, où il paraissait qu'il n'y avait plus rien à trouver; à une époque où l'on a tellement analysé les périodes antérieures, où l'on est comme étouffé sous la masse et le poids des créations des siècles passés, c'est vraiment une surprise que de voir jaillir soudainement des données nouvelles, une création spéciale. Un jeune rameau s'est développé sur le vieux tronc de l'art. Se couvrira-t-il de feuilles, de fleurs et de fruits? Étendra-t-il son ombre sur de futures générations? Je l'espère.

Qu'ont-ils donc apporté?

Une coloration, un dessin et une série de vues originales.

Dans le nombre, les uns se bornent à transformer la tradition et s'efforcent de traduire le monde moderne sans beaucoup s'écarter des anciennes et magnifiques formules qui ont servi à exprimer les mondes précédents, les autres écartent d'un coup les procédés d'autrefois.

Dans la coloration, ils ont fait une véritable découverte, dont

l'origine ne peut se retrouver ailleurs, ni chez les Hollandais, ni dans les tons clairs de la fresque, ni dans les tonalités légères du dix-huitième siècle. Ils ne se sont pas seulement préoccupés de ce jeu fin et souple des colorations qui résulte de l'observation des valeurs les plus délicates dans les tons ou qui s'opposent ou qui se pénètrent l'un l'autre. La découverte de ceux d'ici consiste proprement à avoir reconnu que la grande lumière *décolore* les tons, que le soleil reflété par les objets tend, à force de clarté, à les ramener à cette unité lumineuse qui fond ses sept rayons prismatiques en un seul éclat incolore, qui est la lumière.

D'intuition en intuition, ils en sont arrivés peu à peu à décomposer la lueur solaire en ses rayons, en ses éléments, et à recomposer son unité par l'harmonie générale des irisations qu'ils répandent sur leurs toiles. Au point de vue de la délicatesse de l'œil, de la subtile pénétration du coloris, c'est un résultat tout à fait extraordinaire. Le plus savant physicien ne pourrait rien reprocher à leurs analyses de la lumière.

A ce propos, on a parlé des Japonais, et on a prétendu que ces peintres n'allaient pas plus loin que d'imiter les impressions en couleurs sur papier qu'on fait au Japon.

Je disais plus haut qu'on était parti pour doubler le cap de Bonne-Espérance de l'art. N'était-ce donc pas pour aller dans l'Extrême-Orient? Et si l'instinct des peuples de l'Asie qui vivent dans le perpétuel éblouissement du soleil, les a poussés à reproduire la sensation constante dont ils étaient frappés, c'est-à-dire celle de tons clairs et mats, prodigieusement vifs et légers, et d'une valeur lumineuse presque également répandue partout, pourquoi ne pas interroger cet instinct placé, pour observer, aux sources mêmes de l'éclat solaire?

L'œil mélancolique et fier des Hindous, les grands yeux langoureux et absorbés des Persans, l'œil bridé, vif, mobile des Chinois et des Japonais n'ont-ils pas su mêler à leurs grands cris de couleur, de fines, douces, neutres, exquises harmonies de tons?

Les romantiques ignoraient absolument tous ces faits de la lumière, que les Vénitiens avaient cependant entrevus. Quant à l'Ecole des Beaux-Arts, elle n'a jamais eu à s'en préoccuper, puisqu'on n'y peint que d'après le vieux tableau et qu'on s'y est débarrassé de la nature.

Le romantique, dans ses études de lumière, ne connaissait que la bande orangée du soleil couchant au-dessus de collines sombres, ou des empâtements de blanc teinté soit de jaune de chrome, soit de laque rose, qu'il jetait à travers les opacités bitumineuses de ses dessous de bois. Pas de lumière sans bitume, sans noir d'ivoire, sans bleu de Prusse, sans repoussoirs qui, disait-on, font paraître le ton plus chaud, plus monté. Il croyait que la lumière colorait, excitait le ton, et il était persuadé qu'elle n'existait qu'à condition d'être entourée de ténèbres. La cave avec un jet de clarté arrivant par un étroit soupirail, tel a été l'idéal qui gouvernait le romantique. Encore aujourd'hui, en tous pays, le paysage est traité comme un fond de cheminée ou un intérieur d'arrière-boutique.

Cependant tout le monde, au milieu de l'été, a traversé quelques trentaines de lieues de paysage, et a pu voir comme le coteau, le pré, le champ, s'évanouissaient pour ainsi dire en un seul reflet lumineux qu'ils reçoivent du ciel et lui renvoient; car telle est la loi qui engendre la clarté dans la nature: à côté du rayon spécial bleu, vert, ou composé qu'absorbe chaque substance, et, par dessus ce rayon, elle reflète et l'ensemble de tous les rayons et la teinte de la voûte qui recouvre la terre. Eh bien, pour la première fois des peintres ont compris et reproduit ou

tenté de reproduire ces phénomènes; dans telle de leurs toiles on sent vibrer et palpiter la lumière et la chaleur; on sent un enivrement de clarté qui, pour les peintres élevés hors et contre nature, est chose sans mérite, sans importance, beaucoup trop claire, trop nette, trop crue, trop formelle.

Je passe au dessin.

On conçoit bien que parmi ceux-ci comme ailleurs, subsiste la perpétuelle dualité des coloristes et des dessinateurs. Donc, quand je parle de la coloration, on doit ne penser qu'à ceux qu'elle entraîne; et quand je parle du dessin, il ne faut voir que ceux dont il est le tempérament particulier.

Dans son *Essai sur la peinture*, à la suite du *Salon de 1765*, le grand Diderot fixait l'*idéal* du dessin moderne, du dessin d'observation, du dessin selon la nature:

«Nous disons d'un homme qui passe dans la rue, qu'il est mal fait. Oui, selon nos pauvres règles; mais selon la nature c'est autre chose. Nous disons d'une statue qu'elle est dans les proportions les plus belles. Oui, d'après nos pauvres règles; mais selon la nature! ...

«Si j'étais initié aux mystères de l'art, je saurais peut-être jusqu'où l'artiste doit s'assujettir aux proportions reçues, et je vous le dirais. Mais ce que je sais, c'est qu'elles ne tiennent point contre le despotisme de la nature, et que l'âge et la condition en entraînent le sacrifice en cent manières diverses; je n'ai jamais entendu accuser une figure d'être mal dessinée, lorsqu'elle montrait bien, dans son organisation extérieure, l'âge et l'habitude ou la facilité de remplir ses fonctions journalières. Ce sont ces fonctions qui déterminent et la grandeur entière de la figure, et la vraie proportion de chaque membre, et leur ensemble: c'est de là que je vois sortir, et l'enfant, et l'homme adulte, et le vieillard, et l'homme sauvage, et l'homme policé, et le magistrat, et le militaire, et le portefaix. S'il y a une figure difficile à trouver, ce serait celle d'un homme de vingt cinq ans, qui serait né subitement du limon de la terre, et qui n'aurait encore rien fait; mais cet homme est une chimère.»

Ce n'est pas la calligraphie du trait ou du contour, ce n'est pas une élégance décorative dans les lignes, une imitation des figures grecques de la Renaissance qu'on poursuit à présent. Le même Diderot, après avoir décrit la construction d'un bossu, disait: «Couvrez cette figure, n'en montrez que les pieds à la nature, et la nature dira sans hésiter: ces pieds sont ceux d'un bossu.»

Cet homme extraordinaire est au seuil de tout ce que l'art du dix-neuvième siècle aura voulu réaliser.

Et ce que veut le dessin, dans ses modernes ambitions, c'est justement de reconnaître si étroitement la nature, de l'accoler si fortement qu'il soit irréprochable dans tous les rapports des formes, qu'il sache l'inépuisable diversité des caractères. Adieu le corps humain, traité comme un vase, au point de vue du galbe décoratif; adieu l'uniforme monotonie de la charpente, de l'écorché saillant sous le nu; ce qu'il nous faut, c'est la note spéciale de l'individu moderne, dans son vêtement, au milieu de ses habitudes sociales, chez lui ou dans la rue. La donnée devient singulièrement aiguë, c'est l'emmanchement d'un flambeau avec le crayon, c'est l'étude des reflets moraux sur les physionomies et sur l'habit, l'observation de l'intimité de l'homme avec son appartement, du trait spécial que lui imprime sa profession, des gestes qu'elle l'entraîne à faire, des coupes d'aspect sous lesquelles il se développe et s'accentue le mieux.

Avec un dos, nous voulons que se révèle un tempérament, un âge, un état social; par une paire de mains, nous devons

exprimer un magistrat ou un commerçant; par un geste, toute une suite de sentiments. La physionomie nous dira qu'à coup sûr celui-ci est un homme rangé, sec et méticuleux, et que celui-là est l'insouciance et le désordre même. L'attitude nous apprendra que ce personnage va à un rendez-vous d'affaires, et que cet autre revient d'un rendez-vous d'amour. «Un homme ouvre une porte, il entre, cela suffit: on voit qu'il a perdu sa fille!» Des mains qu'on tient dans les poches pourront être éloquentes. Le crayon sera trempé dans le suc de la vie. On ne verra plus simplement des lignes mesurées au compas, mais des formes animées, expressives, logiquement déduites les unes des autres . . .

Mais le dessin, c'est le moyen tellement individuel et tellement indispensable qu'on ne peut pas lui demander de méthodes, de procédés ou de vues, il se confond absolument avec le but, et demeure l'inséparable compagnon de l'idée.

Aussi la série des idées nouvelles s'est-elle formée surtout dans le cerveau d'un dessinateur [Edgar Degas], un des nôtres, un de ceux qui exposent dans ces salles, un homme du plus rare talent et du plus rare esprit. Assez de gens ont profité de ses conceptions, de ses désintéressements artistiques, pour que justice lui soit rendue, et que connue soit la source où bien des peintres auront puisé, qui se garderaient fort de la révéler, s'il plaisait encore à cet artiste d'exercer ses facultés en prodigue, en *philanthrope* de l'art, non en homme d'affaires comme tant d'autres.

L'idée, la première idée a été d'enlever la cloison qui sépare l'atelier de la vie commune, ou d'y ouvrir ce jour sur la rue qui choque l'écrivain de la *Revue des Deux Mondes*. Il fallait faire sortir le peintre de sa tabatière, de son cloître où il n'est en relations qu'avec le ciel, et le ramener parmi les hommes, dans le monde.

On lui a montré ensuite, ce qu'il ignorait complètement, que notre existence se passe dans des chambres ou dans la rue, et que les chambres, la rue, ont leurs lois spéciales de lumière et d'expression.

Il y a pour l'observateur toute une logique de coloration et de dessin qui découle d'un aspect, selon qu'il est pris à telle heure, en telle saison, en tel endroit. Cet aspect ne s'exprime pas, cette logique ne se détermine pas en accolant des étoffes vénitiennes sur des fonds flamands, en faisant luire des jours d'atelier sur de vieux bahuts et des potiches. Il faut éviter, si l'on veut être vrai, de mélanger les temps et les milieux, les heures et les sources lumineuses. Les ombres veloutés, les clartés dorées des intérieurs hollandais viennent de la structure des maisons, des fenêtres à petits carreaux séparés par des meneaux de plomb, des rues sur canaux pleines de buée. Chez nous, les valeurs des tons dans les intérieurs jouent avec d'infinies variétés, selon qu'on est au premier étage ou au quatrième, que le logis est très meublé et très tapissé, ou qu'il est maigrement garni; une atmosphère se crée ainsi dans chaque intérieur, de même qu'un air de famille entre tous les meubles et les objets qui le remplissent. La fréquence, la multiplicité et la disposition des glaces dont on orne les appartements, le nombre des objets qu'on accroche aux murs, toutes ces choses ont amené dans nos demeures, soit un genre de mystère soit une espèce de clarté qui ne peuvent plus se rendre par les moyens et les accords flamands, même en y ajoutant les formules vénitiennes, ni par les combinaisons de jour et d'arrangement qu'on peut imaginer dans l'atelier le mieux machiné.

Si l'on suppose, par exemple, qu'à un moment donné on puisse prendre la photographie colorée d'un intérieur, on aura un accord parfait, une expression typique et vraie, les choses participant toutes d'un même sentiment; qu'on attende, et qu'un nuage venant à voiler le jour, on tire aussitôt une nouvelle épreuve, on obtiendra un résultat analogue au premier. C'est à l'observation de suppléer à ces moyens d'exécution instantanés qu'on ne possède pas, et de conserver intacts le souvenir des aspects qu'ils auraient rendus. Mais que maintenant on prenne une partie des détails de la première épreuve et qu'on les joigne à une partie des détails de la seconde pour en former un tableau! Alors, homogénéité, accord, vérité de l'impression, tout aura disparu, remplacé par une note fausse, inexpressive. C'est pourtant ce que font tous les jours les peintres qui ne daignent pas observer et se servent d'extraits de la peinture déjà faite.

Et puisque nous accolons étroitement la nature, nous ne séparerons plus le personnage du fond d'appartement ni du fond de rue. Il ne nous apparaît jamais, dans l'existence, sur des fonds neutres, vides et vagues. Mais autour de lui et derrière lui sont des meubles, des cheminées, des tentures de murailles, une paroi qui exprime sa fortune, sa classe, son métier: il sera à son piano, ou il examinera son échantillon de coton dans son bureau commercial, ou il attendra derrière le décor le moment d'entrer en scène, ou il appliquera le fer à repasser sur la table à tréteaux, ou bien il sera en train de déjeuner dans sa famille, ou il s'assoiera dans son fauteuil pour ruminer auprès de sa table de travail, ou il évitera des voitures en traversant la rue, ou regardera l'heure à sa montre en pressant le pas sur la place publique. Son repos ne sera pas une pause, ni une pose sans but, sans signification devant l'objectif du photographe, son repos sera dans la vie comme son action.

Le langage de l'appartement vide devra être assez net pour qu'on en puisse déduire le caractère et les habitudes de celui qui l'habite; et la rue dira par ses passants quelle heure de la journée il est, quel moment de la vie publique est figuré.

Les aspects des choses et des gens ont mille manières d'être imprévues, dans la réalité. Notre point de vue n'est pas toujours au centre d'une pièce avec ses deux parois latérales qui fuient vers celle du fond; il ne ramène pas toujours les lignes et les angles des corniches avec une régularité et une symétrie mathématiques; il n'est pas toujours libre non plus de supprimer les grands déroulements de terrain et de plancher au premier plan; il est quelquefois très haut, quelquefois très bas, perdant le plafond, ramassant les objets dans les dessous, coupant les meubles inopinément. Notre œil arrêté de côté à une certaine distance de nous, semble borné par un cadre, et il ne voit les objets latéraux qu'engagés dans le bord de ce cadre.

Du dedans, c'est par la fenêtre que nous communiquons avec le dehors; la fenêtre est encore un cadre qui nous accompagne sans cesse, durant le temps que nous passons au logis, et ce temps est considérable. Le cadre de la fenêtre, selon que nous en sommes loin ou près, que nous nous tenons assis ou debout, découpe le spectacle extérieur de la manière la plus inattendue, la plus changeante, nous procurant l'éternelle variété, l'impromptu qui est une des grandes saveurs de la réalité.

Si l'on prend à son tour le personnage soit dans la chambre, soit dans la rue, il n'est pas toujours à égale distance de deux objets parallèles, en ligne droite; il est plus resserré d'un côté que de l'autre par l'espace; en un mot, il n'est jamais au centre de la toile, au centre du décor. Il ne se montre pas constamment entier, tantôt il apparaît coupé à mi-jambe, à mi-corps, tranché longitudinalement. Une autre fois, l'œil l'embrasse de tout près, dans toute sa grandeur, et rejette très loin dans les petitesses de

la perspective, tout le reste d'une foule de la rue ou des groupes rassemblés dans un endroit public. Le détail de toutes ces coupes serait infini, comme serait infinie l'indication de tous les décors: le chemin de fer, le magasin de nouveautés, les échafaudages de construction, les lignes de becs de gaz, les bancs de boulevard avec les kiosques de journaux, l'omnibus et l'équipage, le café avec ses billards, le restaurant avec ses nappes et ses couverts dressés.

On a essayé de rendre la marche, le mouvement, la trépidation et l'entrecroisement des passants, comme on a essayé de rendre le tremblement des feuilles, le frissonnement de l'eau et la vibration de l'air inondé de lumière, comme à côté des irisations des rayons solaires, on a su saisir les douces enveloppes du jour gris.

Mais que de choses le paysage n'a pas encore songé à exprimer! Le sens de la *construction* du sol manque à presque tous les paysagistes. Si les collines ont telle forme, les arbres se grouperont de telle façon, les maisons se blottiront de telle manière parmi les terrains, la rivière aura des bords particuliers; le type d'un pays se développera. On n'a pas encore su bien rendre la nature française. Et puisqu'on en a fini avec les colorations rustiques, qu'on en a fait une petite partie fine qui s'est terminée un peu en griserie, il serait temps d'appeler maintenant les *formes* au banquet.

Au moins, a-t-il semblé préférable de peindre entièrement le paysage sur le terrain même, non d'après une étude qu'on rapporte à l'atelier et dont on perd peu à peu le sentiment premier. Reconnaissez-le, à peu de chose près, tout est neuf ou veut être libre dans ce mouvement. La gravure se tourmente de procédés, elle aussi.

La voilà qui reprend la pointe sèche et s'en sert comme d'un crayon, abordant directement la plaque et traçant l'œuvre d'un seul coup [Marcellin Desboutin]; la voilà qui jette des accents inattendus dans l'eau-forte en employant le burin; la voilà qui varie chaque planche à l'eau-forte, l'éclaircit, l'*emmystérise*, la peint littéralement par un ingénieux maniement de l'encre au moment de l'impression [Viscount Ludovic Napoléon Lepic].

Les sujets de l'art, enfin, ont convié à leurs rendez-vous les simplicités intimes de l'existence générale, aussi bien que les singularités les plus particulières de la profession.

Il y a vingt ans, j'écrivais, m'occupant justement des sujets en peinture:

«J'ai vu une société, des actions et des faits, des professions, des figures et des milieux divers. J'ai vu des comédies de gestes et de visages qui étaient vraiment *à peindre*. J'ai vu un grand mouvement de groupes formé par les relations des gens, lorsqu'ils se rencontrent sur différents terrains de la vie: à l'église, dans la salle à manger, au salon, au cimetière, sur le champ de manœuvre, à l'atelier, à la Chambre, partout. Les différences d'habit jouaient un grand rôle et concouraient avec des différences de physionomies, d'allures, de sentiments et d'actes. Tout me semblait arrangé comme si le monde eût été fait uniquement pour la joie des peintres, la joie des yeux.»

J'entrevoyais la peinture abordant de vastes séries sur les gens du monde, les prêtres, les soldats, les paysans, les ouvriers, les marchands, séries où les personnages se varieraient dans leurs fonctions propres, et se rapprocheraient dans les scènes communes à tous: les mariages, les baptêmes, les naissances, les successions, les fêtes, les intérieurs de famille; surtout des scènes se *passant souvent* et exprimant bien, par conséquent, la vie générale d'un pays.

J'aurais cru qu'un peintre qu'eût séduit ce spectacle immense, aurait fini par marcher avec une fermeté, un calme, une sûreté et une largeur de vues qui n'appartiennent peut-être à aucun des hommes d'à présent, et par acquérir une grande supériorité d'exécution et de sentiment.

Mais, me demandera-t-on, où est donc tout cela?

Tout cela est en partie réalisé ici, en partie au dehors, et est en partie à l'horizon. Tout cela est en tableaux déjà faits, et aussi en esquisses, en projets, en désirs et en discussion. Ce n'est point sans quelque confusion que l'art se débat de la sorte.

Ce sont moins gens voulant tous nettement et fermement la même chose qui viennent successivement à ce carrefour d'où rayonnent plusieurs sentiers, que des tempéraments avant tout indépendants. Ils n'y viennent pas non plus chercher des dogmes, mais des exemples de liberté.

Des originalités avec des excentricités et des ingénuités, des visionnaires à côté d'observateurs profonds, des ignorants naïfs à côté de savants qui veulent retrouver la naïveté des ignorants; de vraies voluptés de peinture, pour ceux qui la connaissent et qui l'aiment, à côté d'essais malheureux qui froissent les nerfs; l'idée fermentant dans tel cerveau, l'audace presque inconsciente jaillissant sous tel pinceau. Voilà la réunion.

Le public est exposé à un malentendu avec plusieurs des artistes qui mènent le mouvement. Il n'admet guère et ne comprend que la correction, il veut le fini avant tout. L'artiste, charmé des délicatesses ou des éclats de la coloration, du caractère d'un geste, d'un groupement, s'inquiète beaucoup moins de ce fini, de cette correction, les seules qualités de ceux qui ne sont point artistes. Parmi les nouveaux, parmi les nôtres, s'il en était pour qui l'affranchissement devînt une question un peu trop simple, et qui trouvassent doux que la beauté de l'art consistât à peindre sans gêne, sans peine et sans douleur, il serait fait justice de telles prétentions.

Mais, en général, c'est qu'ils veulent faire sans solennité, gaiement et avec abandon.

D'ailleurs, il importe peu que le public ne comprenne pas; il importe davantage que les artistes comprennent, et devant eux on peut exposer des esquisses, des préparations, des dessous, où la pensée, le dessein et le dessin du peintre s'expriment souvent avec plus de rapidité, plus de concentration, où l'on voit mieux la grâce, la vigueur, l'observation aiguë et décisive, que dans l'œuvre élaborée, car on étonnera bien des gens et même bien des écoliers en peinture, en leur apprenant que telles ou telles de ces choses, qu'ils croient n'être que des barbouillages, recèlent et décèlent au plus haut degré la grâce, la vigueur, l'observation aiguë et décisive, la sensation délicate et intense.

Laissez faire, laissez passer. Ne voyez-vous pas dans ces tentatives le besoin nerveux et irrésistible d'échapper au convenu, au banal, au traditionnel, de se retrouver soi-même, de courir loin de cette bureaucratie de l'esprit, tout en règlements, qui pèse sur nous en ce pays, de dégager son front de la calotte de plomb des routines et des rengaines, d'abandonner enfin cette pâture commune où l'on tond en troupeaux.

On les a traités de fous; eh bien! j'admets qu'ils le soient, mais le petit doigt d'un extravagant vaut mieux certes que toute la tête d'un homme banal!

Ils ne sont pas si fous.

On peut appliquer à ce monde quelques-unes des curieuses et belles pensées de Constable, que certains des nôtres peuvent répéter avec lui:

«Je sais que l'exécution de mes peintures est *singulière*, mais

j'aime cette règle de Sterne: Ne prenez aucun souci des dogmes des écoles, et allez droit au cœur comme vous pourrez.

«On pensera ce que l'on voudra de mon art, ce que je sais, c'est que c'est vraiment le mien.

«Deux routes peuvent conduire à la renommée; la première est l'art d'imitation, la seconde est l'art qui ne relève que de lui-même, l'art original. Les avantages de l'art d'imitation sont que, comme il répète les œuvres des maîtres, que l'œil est depuis longtemps accoutumé à admirer, il est rapidement remarqué et estimé, tandis que l'art qui veut n'être le copiste de personne, qui a l'ambition de ne faire que ce qu'il voit et ce qu'il sent dans la nature, ne parvient que lentement à l'estime, la plupart de ceux qui regardent les œuvres d'art n'étant point capables d'apprécier ce qui sort de la routine.

«C'est ainsi que l'ignorance publique favorise la *paresse* des artistes et les pousse à l'imitation. Elle loue volontiers des pastiches faits d'après les grands maîtres, elle s'éloigne de tout ce qui est interprétation nouvelle et hardie de la nature; c'est lettre close pour elle.

«Rien de plus triste, dit Bacon, que d'entendre donner le nom de sage aux gens rusés; or, les maniéristes sont des peintres rusés, et le malheur est qu'on confond souvent les œuvres maniérées avec les œuvres sincères. . . .

«Lorsque je m'asseois, le crayon ou le pinceau à la main, devant une scène de la nature, mon premier soin est d'oublier que j'aie jamais vu aucune peinture.

«Jamais je n'ai rien vu de laid dans la nature.

(Diderot s'écriera, lui, que la nature ne fait rien d'incorrect.)

«Certains critiques exaltent la peinture d'une manière ridicule. On arrive à la placer si haut, qu'il semble que la nature n'ait rien de mieux à faire que de s'avouer vaincue et demander des leçons aux artistes.

«L'artiste doit contempler la nature avec des pensées modestes; un esprit arrogant ne la verra jamais dans toute sa beauté.»

Ils peuvent aussi revendiquer pour eux ces paroles écrites par M. Zola à propos d'un de leurs chefs, du plus hardi de leurs guerriers:

«Pour la masse, il y a un beau absolu placé en dehors de l'artiste, ou, pour mieux dire, une perfection idéale vers laquelle chacun tend et que chacun atteint plus ou moins. Dès lors, il y a une commune mesure qui est ce beau lui-même; on applique cette commune mesure sur chaque œuvre produite, et selon que l'œuvre se rapproche ou s'éloigne de la commune mesure, on déclare que cette œuvre a plus ou moins de mérite. Les circonstances ont voulu qu'on choisît pour étalon le beau grec, de sorte que les jugements portés sur toutes les œuvres d'art créées par l'humanité, résultent du plus ou du moins de ressemblance de ces œuvres avec les œuvres grecques. . . .

«. . .Ce qui m'intéresse, moi homme, c'est l'humanité ma grand'mère; ce qui me touche, ce qui me ravit dans les créations humaines, dans les œuvres d'art, c'est de retrouver au fond de chacune d'elles un artiste, un frère, qui me présente la nature sous une face nouvelle, avec toute la puissance ou toute la douceur de sa personnalité. Cette œuvre, ainsi envisagée, me conte l'histoire d'un cœur et d'une chair; elle me parle d'une civilisation et d'une contrée. . . .

«Tous les problèmes on été remis en question, la science a voulu avoir des bases solides, et elle en est revenue à l'observation exacte des faits. Et ce mouvement ne s'est pas seulement produit dans l'ordre scientifique, toutes les connaissances, toutes les œuvres humaines tendent à chercher la réalité des principes fermes et définitifs . . . l'art lui-même tend vers une certitude.»

Cependant, quand je vois ces expositions, ces tentatives, je suis pris d'un peu de mélancolie à mon tour, et je me dis: ces artistes, qui sont presque tous mes amis, que j'ai vus avec plaisir s'embarquer pour la route inconnue, qui ont répondu en partie à ces programmes d'art que nous lancions dans notre première jeunesse, où vont-ils? Accroîtront-ils leur bien et le garderont-ils?

Est-ce que ces artistes seront les primitifs d'un grand mouvement de rénovation artistique, et si leurs successeurs, débarrassés des difficultés premières de l'ensemencement, venaient à moissonner largement, auraient-ils pour leurs précurseurs la piété que les Italiens du seizième siècle gardèrent aux *quatorze centistes*?

Seront-ils simplement des fascines; seront-ils les sacrifiés du premier rang tombés en marchant au feu devant tous et dont les corps comblant le fossé feront le pont sur lequel doivent passer les combattants qui viendront derrière? les combattants, ou peut-être les escamoteurs, car il est bon nombre de gens habiles, d'esprit paresseux et malin, mais aux doigts laborieux, qui, à Paris, dans tous les arts, guettent les autres et renouvellent avec le monde naïf des inventeurs, des découvreurs de filons, la fable des marrons tirés du feu et les scènes que l'histoire naturelle nous décrit, qui se passent entre les fourmis et les pucerons. Ils s'emparent lestement, au vol, de l'idée, de la recherche, du procédé, du sujet que le voisin a péniblement élaborés à la sueur de son front, à l'épuisement de son cerveau surexcité. Ils arrivent tout frais, tout dispos, et en un tour de main, propre, soigneux, adroit, ils escamotent à leur profit tout ou partie du bien du pauvre autrui, dont on se moque par-dessus le marché, la comédie étant vraiment assez drôle. Encore est-il bon que le pauvre autrui puisse conserver par devers lui la consolation de dire à l'autre: «Eh! mon ami, tu prends ce qui est à moi!»

En France surtout, l'inventeur disparaît devant celui qui prend un brevet de perfectionnement, le virtuosisme l'emporte sur la gaucherie ingénue, et le vulgarisateur absorbe la valeur de l'homme qui a cherché.

Et puis nul n'est prophète en son pays, c'est pourquoi les nôtres ont trouvé bien plus de bienveillance en Angleterre et en Belgique, terres d'esprit indépendant, où l'on ne se blesse pas de voir les gens échapper aux règles, où l'on n'a point de *classique* et où l'on n'en crée point. Les efforts tantôt savants, brillants, heureux, tantôt désordonnés et désespérés de nos amis pour briser la barrière qui parque l'art, y paraissent tout simples et fort méritoires.

Mais pourquoi ne pas envoyer au Salon? demandera-t-on encore. Parce que ce n'est pas de la peinture de concours, et parce qu'il faut arriver à abolir la cérémonie officielle, la distribution de prix de collégiens, le système universitaire en art, et que si l'on ne commence pas à se soustraire à ce système, on ne décidera jamais les autres artistes à s'en débarrasser également.

Et, maintenant, je souhaite bon vent à la flotte, pour qu'il la porte aux Iles-Fortunées; j'invite les pilotes à être attentifs, résolus et patients. La navigation est périlleuse, et l'on aurait dû s'embarquer sur de plus grands, de plus solides navires; quelques barques sont bien petites, bien étroites, et bonnes seulement pour de la peinture de cabotage. Songeons qu'il s'agit, au contraire, de peinture au long cours!

Abbreviated References

The following bibliographical references are listed by the short titles that appear in the entries for the works in the exhibition.

Adhémar and Cachin 1973
Jean Adhémar and Françoise Cachin. *Edgar Degas gravures et monotypes*. Paris: Arts et Métiers Graphiques, 1973

Adhémar and Dayez-Distel 1979
Hélène Adhémar and Anne Dayez-Distel. *Musée du Jeu de Paume*. 4th ed. Paris: Editions de la Réunion des Musées Nationaux, 1979

Adhémar et al. 1980
Hélène Adhémar et al. *Hommage à Claude Monet*, exh. cat. Paris: Editions de la Réunion des Musées Nationaux, 1980

Adriani 1984
Götz Adriani. *Edgar Degas. Pastelle, Olskizzen, Zeichnungen*, exh. cat. Tübingen, Kunsthalle. Cologne: DuMont Buchverlag, 1984

Amsterdam 1975
Maîtres français du XIXᵉ et XXᵉ Siècles, exh. cat. Amsterdam: E. J. van Wisselingh & Co., 1975

Astruc n.d.
Zacharie Astruc. *Mes oeuvres* (unpublished notebook, collection Christian Reiss, Cergy Village, France, n.d.)

Bacou 1956
Roseline Bacou. *Odilon Redon*. 2 vols. Geneva: Pierre Cailler, 1956

Baetjer 1980
Katharine Baetjer. *European Paintings in the Metropolitan Museum of Art by Artists Born in or before 1865: A Summary Catalogue*. 3 vols. New York: The Metropolitan Museum of Art, 1980

Baltimore 1962
Paintings, Drawings and Graphic Works by Manet, Degas, Berthe Morisot and Mary Cassatt, exh. cat. Baltimore: The Baltimore Museum of Art, 1962

Bataille and Wildenstein 1961
M. L. Bataille and Georges Wildenstein. *Berthe Morisot, catalogue des peintures, pastels et aquarelles*. Paris: Editions d'Etudes et des Documents, 1961

Beraldi 1885
Henri Beraldi. *Les graveurs du XIXᵉ siècle*. Vol. 3. Paris, 1885

Berger 1964
Klaus Berger. *Odilon Redon: Phantasie und Farbe*. Cologne: M. duMont Schauberg, 1964

Berhaut 1978
Marie Berhaut. *Caillebotte, sa vie et son oeuvre. Catalogue raisonné des peintures et pastels*. Paris: La Bibliothèque des Arts, 1978

Bodelsen 1966
Merete Bodelsen. "The Wildenstein-Cogniat Gauguin Catalogue," *The Burlington Magazine* 108 (January 1966): 27–39

Bodelsen 1970
Merete Bodelsen. "Gauguin the Collector." *The Burlington Magazine* 112 (September 1970): 590–613

Bodelsen 1984
Merete Bodelsen. *Gauguin and van Gogh in Copenhagen in 1893*, exh. cat. Copenhagen: Ordrupgaardsammlingen, 1984

Boggs 1962
Jean Sutherland Boggs. *Portraits by Degas*. Berkeley and Los Angeles: University of California Press, 1962

Bouillon 1972
Jean-Paul Bouillon. *Félix et Marie Bracquemond*, exh. cat. Mortagne–Chartres, 1972

Bowness et al. 1979
Alan Bowness et al. *Post-Impressionism: Cross-Currents in European Painting*, exh. cat. London: Royal Academy of Arts with Weidenfeld and Nicolson, 1979

Bowness et al. 1980
Alan Bowness et al. *Post-Impressionism: Cross-Currents in European and American Painting 1880–1906*, exh. cat. Washington: National Gallery of Art, 1980

Brame and Reff 1984
Philippe Brame and Theodore Reff. *Degas et son oeuvre. A Supplement*. New York and London: Garland Publishing, 1984

Breeskin 1948
Adelyn Dohme Breeskin. *The Graphic Work of Mary Cassatt*. New York: H. Bittner and Company, 1948

Breeskin 1970
Adelyn Dohme Breeskin. *Mary Cassatt. A Catalogue Raisonné of the Oils, Pastels, Watercolors, and Drawings*. Washington: Smithsonian Institution Press, 1970

Breeskin 1981
Adelyn Dohme Breeskin. *The Art of Mary Cassatt (1844–1926)*, exh. cat. Tokyo: Isetan Museum of Art; Nara: Nara Prefectural Museum of Art, 1981

Brettell et al. 1984
Richard Brettell et al. *A Day in the Country: Impressionism and the French Landscape*, exh. cat. Los Angeles: Los Angeles County Museum of Art, 1984

Browse 1978
Lillian Browse. *Forain: The Painter (1852–1931)*. London: Paul Elek, 1978

Cab. des Est.
Cabinet des Estampes. Bibliothèque Nationale, Paris

Cachin 1971
Françoise Cachin. *Paul Signac*. Greenwich, Conn.: New York Graphic Society, 1971

Chetham et al. 1970
Charles Chetham et al. *19th and 20th Century Paintings from the Collection of the Smith College Museum of Art*. Northampton, Mass.: Smith College Museum of Art, 1970

Chicago 1961
Paintings in the Art Institute of Chicago. Chicago: The Art Institute of Chicago, 1961

Christie's New York, 19 May 1981
Eight Important Paintings from a Private Collection. New York: Christie, Manson & Woods International Inc., 19 May 1981

Christie's New York, 5 November 1981
Impressionist and Modern Drawings and Watercolors. New York: Christie, Manson & Woods International Inc., 5 November 1981

Christie's New York, 15 May 1985
Impressionist and Modern Paintings and Sculpture. New York: Christie, Manson & Woods International Inc., 15 May 1985

Cinotti 1960
Mia Cinotti. *Zandomeneghi*. Busto Arsizio: Bramante Editrice, 1960

Cleveland 1978
Handbook. The Cleveland Museum of Art. Cleveland: The Cleveland Museum of Art, 1978

Comte 1978
Philippe Comte. *Ville de Pau, Musée des beaux-arts, catalogue raisonné des peintures*. Pau: Musée des beaux-arts de la ville de Pau, 1978

Daulte 1959
François Daulte. *Alfred Sisley, catalogue raisonné de l'oeuvre peint*. Lausanne: Editions Durand-Ruel, 1959

Daulte 1971
François Daulte. *Auguste Renoir, catalogue raisonné de l'oeuvre peint. Vol. 1. Figures 1860–1890*. Lausanne: Editions Durand-Ruel, 1971

Daulte 1974
François Daulte. *Auguste Renoir*. Paris: Diffusion Princesse, 1974

Daulte et al. 1968
François Daulte et al. *L'aube du XXᵉ siècle*. Geneva: Petit Palais, 1968

Daulte et al. 1982
François Daulte et al. *Monet*, exh. cat. Tokyo: National Museum of Western Art; Kyoto: National Museum of Modern Art, 1982

Davies 1970
Martin Davies. *French School. Early 19th Century, Impressionists, Post-Impressionists, etc.* London: The National Gallery, 1970

Day and Sturges, forthcoming
Holliday Day and Hollister Sturges, ed. *Joslyn Art Museum: Painting and Sculpture from the European and American Collections*. Omaha: Joslyn Art Museum, forthcoming

Dayez et al. 1974
Anne Dayez et al. *Centenaire de l'impressionnisme*, exh. cat. Paris: Grand Palais, 1974

Dejean 1979
Xavier Dejean. *Le portrait à travers les collections du Musée Fabre, XVIIᵉ, XVIIIᵉ, XIXᵉ siècles*, exh. cat. Montpellier: Musée Fabre, 1979

Delestre 1975
François Delestre. *Cals*, exh. cat. Paris, 1975

Delteil (Degas) 1919
Loys Delteil. *Le peintre-graveur illustré (XIXᵉ siècle)*. Vol. 9. Paris: privately printed, 1919

Delteil (Pissarro) 1923
Loys Delteil. *Le peintre-graveur illustré (XIXᵉ siècle)*. Vol. 17. Paris: privately printed, 1923

Delteil (Raffaëlli) 1923
Loys Delteil. *Le peintre-graveur illustré (XIXᵉ siècle)*. Vol. 16. Paris: privately printed, 1923

Denver 1981
Denver Art Museum. Major Works in The Collection. Denver: Denver Art Museum, 1981

Dorra and Rewald 1959
Henri Dorra and John Rewald. *Seurat. L'oeuvre peint, biographie et catalogue critique*. Paris: Edition d'Etudes et de Documents, 1959

duPont et al. 1985
Diana duPont et al. *San Francisco Museum of Modern Art: The Painting and Sculpture Collection*. New York: Hudson Hills Press with the San Francisco Museum of Modern Art, 1985

Feldstein 1978
Janice J. Feldstein. *The Art Institute of Chicago: 100 Masterpieces*. Chicago: Rand McNally & Co., 1978

Fields 1979
Barbara S. Fields. *Jean-François Raffaëlli (1850–1924): The Naturalist Artist*. Ann Arbor: University Microfilms International, 1979

Flescher 1978
Sharon Flescher. *Zacharie Astruc: Critic, Artist, and Japoniste*. London and New York: Garland Publishing, 1978

de Forges 1964
Marie Thérèse Lemoyne de Forges. *Signac*, exh. cat. Paris: Musée du Louvre, 1964

Garas 1973
Klara Garas. *The Budapest Gallery, Paintings in the Museum of Fine Arts*. Corvina: Corvina Press, 1973

Gerstein 1982
Marc Gerstein. "Degas's Fans," *The Art Bulletin* 64 (March 1982): 105–118

Getlein 1980
Frank Getlein. *Mary Cassatt: Paintings and Pastels*. New York: Abbeville Press, 1980

Gray 1972
Christopher Gray. *Armand Guillaumin*. Chester, Connecticut: The Pequot Press, Inc., 1972

Gray 1980
Christopher Gray. *Sculpture and Ceramics of Paul Gauguin*. Baltimore: Johns Hopkins University Press, 1963; reprinted 1980

Guillaud et al. 1984
Maurice Guillaud et al. *Degas: Form and Space*, exh. cat. Paris: Centre Culturel du Marais, 1984

Harris and Nochlin 1976
Ann Sutherland Harris and Linda Nochlin. *Women Artists: 1550–1950*, exh. cat. Los Angeles: Los Angeles County Museum of Art; New York: Alfred A. Knopf, 1976

de Hauke 1961
César M. de Hauke. *Seurat et son oeuvre*. Paris: Grund, 1961

Herbert 1962
Robert L. Herbert. *Seurat's Drawings*. New York: Shorewood, 1962

Herbert 1968
Robert L. Herbert. *Neo-Impressionism*, exh. cat. New York: The Solomon R. Guggenheim Foundation, 1968

Homer 1964
William Innes Homer. *Seurat and the Science of Painting*. Cambridge: The Massachusetts Institute of Technology, 1964

House et al. 1985
John House et al. *Renoir*, exh. cat. London: Arts Council of Great Britain, 1985

Isaacson 1978
Joel Isaacson. *Claude Monet: Observation and Reflection*. Oxford: Phaidon; New York: Dutton, 1978

Isaacson 1980
Joel Isaacson. *The Crisis of Impressionism, 1878–1882*, exh. cat. Ann Arbor: University of Michigan, Museum of Art, 1980

Janis 1968
Eugenia Parry Janis. *Degas Monotypes*, exh. cat. Cambridge: Fogg Art Museum, 1968

Kyoto 1980
The Joan Whitney Payson Collection, exh. cat. Kyoto: Kyoto Municipal Museum; Tokyo: Isetan Museum of Art, 1980

Lee 1974
Thomas P. Lee. *The Collection of John A. and Audrey Jones Beck*, exh. cat. Houston: The Museum of Fine Arts, 1974

Lemoisne 1946
P. A. Lemoisne. *Degas et son oeuvre*. 4 vols. Paris: Arts et métiers graphiques, 1946–1949. Vols. 2 and 3, 1946

Le Paul and Le Paul 1983
Charles-Guy Le Paul and Judy Le Paul. *L'impressionisme dans l'école de Pont-Aven*. Lausanne and Paris: La Bibliothèque des Arts, 1983

Lindsay 1985
Suzanne G. Lindsay. *Mary Cassatt and Philadelphia*, exh. cat. Philadelphia: Philadelphia Museum of Art, 1985

Lloyd 1985
Christopher Lloyd. *Alfred Sisley*, exh. cat. Tokyo: Isetan Museum of Art; Fukuoka: Fukuoka Art Museum; and Nara: Nara Prefectural Museum, 1985

Lloyd GBA 1985
Christopher Lloyd. "Reflections on La Roche-Guyon and the Impressionists." *Gazette des Beaux-Arts* 104 (January 1985): 37–44

Lloyd et al. 1981
Christopher Lloyd et al. *Camille Pissarro 1830–1903*, exh. cat. London: The Arts Council of Great Britain; Paris: Editions de la Réunion des Musées Nationaux, 1981

Lloyd et al. 1984
Christopher Lloyd et al. *Retrospective Camille Pissarro*, exh. cat. Tokyo: Isetan Museum of Art; Fukuoka: Fukuoka Art Museum; and Kyoto: Kyoto Municipal Museum of Art, 1984

London 1973
Important XIX & XX Century Paintings, exh. cat. London: The Lefevre Gallery, 1973

Malibu 1984
"Acquisitions/1983." *The J. Paul Getty Museum Journal* 12 (1984): 229–316

Maillet 1984
Edda Maillet. *Gustave Caillebotte, 1848–1894*, exh. cat. Pontoise: Musée Pissarro, 1984

Maxon 1973
John Maxon, *Paintings by Renoir*, exh. cat. Chicago: The Art Institute of Chicago, 1973

McMullen 1984
Roy McMullen. *Degas: His Life, Times, and Work*. Boston: Houghton Mifflin Company, 1984

Milan 1979
Origini dell' Astrattismo, exh. cat. Milan: Palazzo Reale, 1979

Milkovich 1977
Michael Milkovich. *Impressionists in 1877: A Loan Exhibition*, exh. cat. Memphis: Dixon Gallery and Gardens, 1977

Millard 1976
Charles W. Millard. *The Sculpture of Edgar Degas*. Princeton: Princeton University Press, 1976

Montreal 1977
Guide. Montreal: The Montreal Museum of Fine Arts, 1977

Morisot 1959
Berthe Morisot. *The Correspondence of Berthe Morisot*. 2d ed. Denis Rouart, ed. New York: E. Wyeth, 1959

Murphy 1985
Alexandra Murphy. *European Paintings in the Museum of Fine Arts, Boston. An Illustrated Summary Catalogue*. Boston: Museum of Fine Arts, 1985

New York, Acquavella, 1983
XIX and XX Century Master Paintings, exh. cat. New York: Acquavella Galleries, 1983

New York, Wheelock Whitney, 1983
Nineteenth Century French Paintings, exh. cat. New York: Wheelock Whitney & Company, 1983

Novotný 1959
Vladimir Novotný. *Treasures of the Prague National Gallery*. London: Batchworth Press, 1959

Orienti 1972
Sandra Orienti. *The Complete Paintings of Cézanne*. New York: Harry N. Abrams, 1972

Otterlo 1956
Catalogus van Schilderijen uit de XIXde en XXste Eeuw. Otterlo: Rijksmuseum Kröller-Müller, 1956

Oxford 1961
The Ashmolean Museum. Catalogue of Paintings. Oxford: The Ashmolean Museum of Art and Archaeology, 1961

Paris, Galerie Brunner, 1913
Cinquième exposition de la Société des peintres et graveurs de Paris, exh. cat. Paris: Galerie Brunner, 1913

Paris, Musée des Arts Décoratifs, 1913
Forain, exh. cat. Paris: Musée des Arts Décoratifs, 1913

Paris 1974
Peintures, graveurs français, exh. cat. Paris: Bibliothèque Nationale–Galerie Mansart, 1974

Paris, Grand Palais, 1978
Salon d'Automne, Gauguin. Paris: Grand Palais, 1978

Paris, Musée Marmottan, 1978
Forain, exh. cat. Paris: Musée Marmottan, 1978

Phillips London, 27 March 1984
Continental Pictures. London: Phillips, Son & Neale, 27 March 1984

Piceni 1967
 Enrico Piceni. *Zandomeneghi*. Milan: Bramante Editrice, 1967

Piceni 1979
 Enrico Piceni. *De Nittis. L'uomo e l'opera*. Milan: Bramante Editrice, 1979

Piceni 1984
 Enrico Piceni. *Three Italian Friends of the Impressionists*, exh. cat. New York: Stair Sainty Matthiesen, 1984

Pickvance 1963
 Ronald Pickvance. "Degas Dancers." *The Burlington Magazine* 105 (June 1963): 256–266

Pickvance 1979
 Ronald Pickvance. *Degas 1879: Paintings, Pastels, Drawings, Prints, and Sculpture from Around 100 Years Ago in the Context of His Earlier and Later Years*, exh. cat. Edinburgh: National Gallery of Scotland, 1979

Pissarro 1972
 Camille Pissarro. *Letters to His Son, Lucien*. 3d ed., John Rewald, ed. Mamaroneck, N.Y.: Paul P. Appel, 1972

Pissarro and Venturi 1939
 Ludovic Pissarro and Lionello Venturi. *Camille Pissarro, son art, son oeuvre*. 2 vols. Paris: Paul Rosenberg, 1939

Pontoise 1983
 Pontoise et ses alentours du XIXᵉ au début du XXᵉ siècles, exh. cat. Pontoise: Musée Pissarro, 1983

Portland 1977
 The Joan Whitney Payson Gallery of Art. Portland, Maine: The Joan Whitney Payson Gallery of Art at Westbrook College, 1977

Poulet 1979
 Anne L. Poulet. *Corot to Braque: French Paintings from the Museum of Fine Arts, Boston*, exh. cat. Boston: The Museum of Fine Arts, 1979

Raimondi 1958
 Riccardo Raimondi. *Degas e la sua Famiglia in Napoli, 1793–1917*. Naples: privately printed, 1958

Reff 1976
 Theodore Reff. *Degas: The Artist's Mind*. New York: The Metropolitan Museum of Art and Harper & Row, 1976

Rewald 1969
 John Rewald. "Chocquet and Cézanne." *Gazette des Beaux-Arts* 74 (July–August 1969): 33–96

Rewald 1973
 John Rewald. *The History of Impressionism*. 4th rev. ed. New York: The Museum of Modern Art, 1973

Rewald 1974
 John Rewald. *An Exhibition of Paintings, Watercolors, Sculpture, and Drawings from the Collection of Mr. and Mrs. Henry Pearlman and Henry and Rose Pearlman Foundation*, exh. cat. New York: The Brooklyn Museum, 1974

Rewald 1978
 John Rewald. *Post-Impressionism from van Gogh to Gauguin*. 3d ed. New York: The Museum of Modern Art, 1978

Rewald (Cézanne) 1983
 John Rewald. *Paul Cézanne. The Watercolors: A Catalogue Raisonné*. Boston: New York Graphic Society, 1983

Rewald (Whitney) 1983
 John Rewald. *The John Hay Whitney Collection*, exh. cat. Washington: National Gallery of Art, 1983

Rich 1958
 Daniel Catton Rich, ed. *Seurat, Paintings and Drawings*, exh. cat. Chicago: The Art Institute of Chicago, 1958

Rishel 1983
 Joseph J. Rishel. *Cézanne in Philadelphia Collections*, exh. cat. Philadelphia: Philadelphia Museum of Art, 1983

Robinson 1983
 Lilien F. Robinson. *La Vie Moderne. Nineteenth-Century French Art from the Corcoran Gallery*, exh. cat. Washington, D.C.: Corcoran Gallery of Art, 1983

Rosenberg 1977
 Pierre Rosenberg. *Pittura francese nelle collezioni pubbliche fiorentine*, exh. cat. Florence: Palazzo Pitti, 1977

Rust 1978
 David E. Rust. *Small French Paintings from the Bequest of Ailsa Mellon Bruce*. Washington: National Gallery of Art, 1978

Saint-Germain-en-Laye 1982
 L'éclatement de l'impressionnisme, exh. cat. Saint-Germain-en-Laye: Musée Départemental du Prieuré, 1982

Schmit 1973
 Robert Schmit. *Eugène Boudin 1824–1898*. 2 vols. Paris: Robert Schmit, 1973

Serret and Fabiani 1971
 G. Serret and D. Fabiani. *Armand Guillaumin, catalogue raisonné de l'oeuvre peint*. Paris: Editions Mayer, 1971

Shackelford 1984
 George T. M. Shackelford. *Degas, The Dancers*, exh. cat. Washington: National Gallery of Art, 1984

Shapiro 1978
 Barbara Stern Shapiro. *Mary Cassatt at Home*, exh. cat. Boston: Museum of Fine Arts, 1978

Shikes and Harper 1980
 Ralph E. Shikes and Paula Harper. *Pissarro, His Life and Work*. New York: Horizon Press, 1980

Sotheby's London, 4 December 1974
 Impressionist and Modern Paintings and Sculpture, the Property of the Hon. Lady Baillie, Deceased, and Others. London: Sotheby Parke Bernet & Co., 4 December 1974

Sotheby's London, 29 November 1976
 Important Impressionist and Modern Paintings from the Collection of the Late Nate B. and Frances Spingold, of New York. London: Sotheby Parke Bernet & Co., 29 November 1976

Sotheby's London, 28 June 1978
 Important Impressionist and Modern Paintings and Sculpture. London: Sotheby Parke Bernet & Co., 28 June 1978

Sotheby's London, 30 June 1981
 Important Impressionist and Modern Paintings and Sculpture. London: Sotheby Parke Bernet & Co., 30 June 1981

Sotheby's London, 4 December 1984
 Impressionist and Modern Paintings and Sculpture, Part I. London: Sotheby Parke Bernet & Co., 4 December 1984

Sotheby's New York, 11 May 1977
 Important Impressionist and Modern Paintings and Sculpture. New York: Sotheby's, 11 May 1977

Sotheby's New York, 16 November 1984
 Impressionist Paintings, Chinese and European Ceramics, French and English Furniture, and Decorations from the Estate of Pauline K. Cave. New York: Sotheby's, 16 November 1984

Spassky et al. 1985

Natalie Spassky et al. *American Paintings in the Metropolitan Museum of Art.* Vol. 2. New York: The Metropolitan Museum of Art with Princeton University Press, 1985

Sterling and Salinger 1967

Charles Sterling and Margaretta M. Salinger. *French Paintings. A Catalogue of the Collection of the Metropolitan Museum of Art.* 3 vols. New York: The Metropolitan Museum of Art, 1967

Sutton 1983

Denys Sutton. *Impressionism and the Modern Vision: Master Paintings from The Phillips Collection,* exh. cat. Tokyo: The Nihonbashi Takashimaya Art Galleries; Nara: Nara Prefectural Museum of Art, 1983

Taggart and McKenna 1973

Ross E. Taggart and George L. McKenna, ed. *Handbook of the Collections in the William Rockhill Nelson Gallery of Art and the Mary Atkins Museum of Fine Art.* Vol. 1. *Art of the Occident.* 5th ed. Kansas City: The William Rockhill Nelson Gallery of Art; Mary Atkins Museum of Fine Art, 1973

Thomason 1984

Sally Palmer Thomason. *Painting and Sculpture Collection, Memphis Brooks Museum of Art.* Memphis: Memphis Brooks Museum of Art, 1984

Tokyo 1879

National Museum of Western Art. Catalogue of Paintings. Tokyo: National Museum of Western Art, 1979

Varnedoe and Lee 1976

J. Kirk T. Varnedoe and Thomas P. Lee. *Gustave Caillebotte: A Retrospective Exhibition,* exh. cat. Houston: The Museum of Fine Arts, 1976

Venturi 1936

Lionello Venturi. *Cézanne, son art, son oeuvre.* Paris: Paul Rosenberg, 1936

Walker 1975

John Walker. *National Gallery of Art, Washington.* New York: Harry N. Abrams, 1975

Washington 1965

Eighteenth and Nineteenth Century Paintings and Sculpture of the French School in the Chester Dale Collection. Washington: National Gallery of Art, 1965

Washington 1966

French Paintings from the Collections of Mr. and Mrs. Paul Mellon and Mrs. Mellon Bruce, exh. cat. Washington: National Gallery of Art, 1966

Washington 1970

Mary Cassatt 1844–1926, exh. cat. Washington: National Gallery of Art, 1970

Washington 1975

European Paintings: An Illustrated Summary Catalogue. Washington: National Gallery of Art, 1975

Washington 1985

The Phillips Collection. A Summary Catalogue. Washington, D.C.: The Phillips Collection, 1985

Werner 1968

Alfred Werner. *Degas Pastels.* New York: Watson-Guptill Publications, 1968

White 1984

Barbara Ehrlich White. *Renoir: His Life, Art, and Letters.* New York: Abrams, 1984

Wildenstein 1964

Georges Wildenstein. *Gauguin.* Paris: Editions d'Etudes et de Documents, 1964

Wildenstein 1974

Daniel Wildenstein. *Claude Monet. Biographie et catalogue raisonné.* Vol 1. Lausanne and Paris: La Bibliothèque des Arts, 1974

Wildenstein 1979

Daniel Wildenstein. *Claude Monet. Biographie et catalogue raisonné.* Vol 2. Lausanne and Paris: La Bibliothèque des Arts, 1979

Williamstown 1984

List of Paintings in the Sterling and Francine Clark Art Institute. Williamstown: The Sterling and Francine Clark Art Institute, 1984

Wisdom 1981

John Minor Wisdom. *The Museum of Fine Arts, Houston. A Guide to the Collection.* Houston: The Museum of Fine Arts, 1981

Wittman 1976

Otto Wittmann, ed. *The Toledo Museum of Art. European Paintings.* Toledo: The Toledo Museum of Art, 1976

Contemporary Reviews

The contemporary reviews of the Impressionist group exhibitions as listed here are the basis for the research of the present catalogue. We have included only those articles that relate directly to the exhibitions and have left out more general, though timely, discussions. New identifications of works in the original exhibitions and confirmations of earlier identifications stem from these reviews, as does the bulk of the material discussed in the essays. The list is a compilation of already published sources, primary among which is Oscar Reuterswärd's *Impressionisterna: Inför Publik och Kritik* (Stockholm: Albert Bonniers Förlag, 1952). Idiosyncrasies of spelling in the titles have been retained.

The First Exhibition 1874

Ariste [pseud.]
"Salon de 1874 à Paris," *L'Indépendance Belge*, 13 June 1874

[Burty, Philippe]
"Chronique du jour," *La République Française*, 16 April 1874
"Exposition de la Société anonyme des artistes," *La République Française*, 25 April 1874

Cardon, Emile
"Avant le Salon," *La Presse*, 28 April 1874
"Avant le Salon: L'exposition des révoltés," *La Presse*, 29 April 1874

Castagnary, [Jules-Antoine]
"Exposition du boulevard des Capucines: Les impressionistes," *Le Siècle*, 29 April 1874

Chesneau, Ernest
"Avant le Salon," *Paris-Journal*, 2 April 1874
"A côté du Salon: II.–Le plein air: Exposition du boulevard des Capucines," *Paris-Journal*, 7 May 1874; same review in following entry
"Le plein air: Exposition du boulevard des Capucines," *Le Soir*, 7 May 1874

La Chronique des Arts et de la Curiosité
"Société anonyme coopérative d'artistes–peintres, sculpteurs, etc., à Paris" (17 January 1874): 19

E. d'H. [Ernest d'Hervilly]
"L'exposition du boulevard des Capucines," *Le Rappel*, 17 April 1874

Leroy, Louis
"L'exposition des impressionnistes," *Le Charivari* (25 April 1874): 2–3

La Liberté
"Nos informations: Le Salon du boulevard des Capucines," 20 April 1874

de l'Isle-Adam, Villiers [C. de Malte, pseud.]

de Lora, Léon [Félix Pothey]
"Petites nouvelles artistiques: Exposition libre des peintres," *Le Gaulois*, 18 April 1874

de Malte, C. [Villiers de l'Isle-Adam]
"Exposition de la Société anonyme des artistes peintres, sculpteurs, graveurs, et lithographes," *Paris à l'Eau-Forte* (19 April 1874): 12–13

de Montifaud, Marc [Marie-Amélie Chartroule de Montifaud]
"Exposition du boulevard des Capucines," *L'Artiste* (1 May 1874): 307–313

de Nittis, Giuseppe
"Corrispondenze: Londra," *Il Giornale Artistico* (1 July 1874): 25–26

Pothey, Félix [Léon de Lora, pseud.]

Prouvaire, Jean [Pierre Toloza]
"L'exposition du boulevard des Capucines," *Le Rappel*, 20 April 1874

Le Sphinx [pseud.]
"Echos de Paris," *L'Evénement*, 20 April 1874

Silvestre, Armand
"Chronique des beaux-arts: Une nouvelle Société coopérative," *L'Opinion Nationale*, 25 January 1874
"Chronique des beaux-arts: L'exposition des révoltés," *L'Opinion Nationale*, 22 April 1874

Toloza, Pierre [Jean Prouvaire, pseud.]

Vert-Vert
"Nouvelles," 25–30 April and 1 May 1874

[Zola, Emile]
"Lettre de Paris," *Le Sémaphore de Marseille*, 18 April 1874

The Second Exhibition 1876

d'Arnoux, Charles-Albert [Bertall, pseud.]

L'Audience
"L'exposition des intransigeants," 9 April 1876

Baignères, Arthur
"Exposition de peinture par un groupe d'artistes, rue le Peletier, 11," *L'Echo Universel*, 13 April 1876

de Banville, Théodore [Baron Schop, pseud.]

Bertall [Charles-Albert d'Arnoux]
"Exposition des impressionnalistes, rue Lepeletier," *Paris-Journal*, 15 April 1876; same review in following entry
"Exposition des impressionnalistes, rue Lepeletier," *Le Soir*, 15 April 1876; same review in following entry
"Les impressionnalistes," *Les Beaux-Arts* (1876): 44–45

Bigot, Charles
"Causerie artistique: L'exposition des 'intransigeants'," *La Revue Politique et Littéraire* (8 April 1876): 349–352

Blavet, Emile
"Avant le Salon: L'exposition des réalistes," *Le Gaulois*, 31 March 1876

Blémont, Emile [Emile Petitdidier]
"Les impressionnistes," *Le Rappel*, 9 April 1876; partially reprinted in *Le Moniteur Universel*

Boubée, Simon
"Beaux-arts: Exposition des impressionnistes, chez Durand Ruel," *La Gazette de France*, 5 April 1876

[Burty, Philippe]
"Chronique du jour," *La République Française*, 1 April 1876

Burty, Ph[ilippe]
"Fine Art: The Exhibition of the 'Intransigeants'," *The Academy* [London] (15 April 1876): 363–364

Chaumelin, Marius
 "Actualités: L'exposition des intransigeants," *La Gazette [des Etrangers]*, 8 April 1876

Claretie, Jules
 "Le mouvement parisien: L'exposition des *intransigeants*. M. Degas et ses amis," *L'Indépendance Belge*, 2 April 1876

Dax, Pierre
 "Chronique," *L'Artiste* (1 May 1876): 347–349; reprint of Rivière in *L'Esprit Moderne*

Duranty, Edmond
 La nouvelle peinture à propos du groupe d'artistes qui expose dans les galeries Durand-Ruel. Paris: E. Dentu, 1876

Enault, Louis
 "Mouvement artistique: L'exposition des intransigeants dans la galerie de Durand-Ruelle," *Le Constitutionnel*, 10 April 1876

d'Hervilly, Ernest [Un passant, pseud.]

Huysmans, Joris-Karl
 "De Degas, etc.," *Gazette des Amateurs*, 1876; partial reprint in Huysmans, "L'exposition des indépendants en 1880," 112. *L'art moderne.* Paris: G. Charpentier, 1883

James, Henry, Jr.
 "Parisian Festivity: Cynical Artists," *The New-York Tribune*, 13 May 1876

Leroy, Louis
 "Choses et autres," *Le Journal Amusant* (15 April 1876): 3, 6–7
 "La réception d'un impressionniste," *Le Charivari* (15 April 1876): 2–3

A. de L. [Alfred de Lostalot]
 "L'exposition de la rue le Peletier," *La Chronique des Arts et de la Curiosité* (1 April 1876): 119–120
 "L'exposition des 'impressionistes'," *Le Bien Public*, 4 April 1876

Maillard, Georges
 "Chronique: Les impressionnalistes," *Le Pays*, 4 April 1876

Mallarmé, Stéphane
 "The Impressionists and Edouard Manet," *The Art Monthly Review and Photographic Portfolio* [London, trans. George T. Robinson] 1, no. 9 (30 September 1876): 117–122; French version in Philippe Verdier, "Stéphane Mallarmé: 'Les impressionnistes et Edouard Manet'," *Gazette des Beaux-Arts* 86 (November 1975): 147–156

Mancino, Léon
 "Deuxième exposition de peintures, dessins, gravures faite par un groupe d'artistes," *L'Art* 5 (1876): 36–37

Le Masque de Fer [pseud.]
 "Echos de Paris: A travers Paris," *Le Figaro*, 1 April 1876

Le Moniteur Universel
 "Revue des journaux: Revue littéraire et anecdotique," 11 April 1876; partial reprint of Blémont in *Le Rappel*

d'Olby, G.
 "Salon de 1876: Avant l'ouverture. Exposition des intransigeants chez M. Durand-Ruel, rue le Peletier, 11," *Le Pays*, 10 April 1876

Un passant [Ernest d'Hervilly]
 "Les on-dit," *Le Rappel*, 2 April 1876

Le Petit Journal
 "Le Salon de 1876," 1 April 1876

Le Petit Moniteur Universel
 "Courrier de Paris: L'école des Batignolles," 1 April 1876

Petitdidier, Emile [Emile Blémont, pseud.]

Porcheron, Emile
 "Promenades d'un flâneur: Les impressionnistes," *Le Soleil*, 4 April 1876

Pothey, Alex[andre]
 "Chronique," *La Presse*, 31 March 1876

Punch [Gaston Vassy]
 "La journée à Paris: L'exposition des impressionnistes," *L'Evénement*, 2 April 1876

Rivière, Georges
 "Les intransigeants de la peinture," *L'Esprit Moderne* (13 April 1876): 7–8; reprinted by Dax in *L'Artiste*

Schop, Baron [Théodore de Banville]
 "La semaine parisienne: L'exposition des intransigeants. L'école des Batignolles. Impressionnistes et plein air," *Le National*, 7 April 1876

Le Siècle
 "Nouvelles du jour," 29 March 1876

Silvestre, Armand
 "Exposition de la rue le Peletier," *L'Opinion Nationale*, 2 April 1876

Vassy, Gaston [Punch, pseud.]

[Vachon, Marius]
 "Carnet de la journée," *La France*, 4 April 1876

Wolff, Albert
 "Le calendrier parisien," *Le Figaro*, 3 April 1876

Zola, Emile
 "Deux expositions d'art en mois de mai," *Le Messager de l'Europe* [Saint Petersburg, in Russian], June 1876; reprinted in Emile Zola, *Le bon combat de Courbet aux impressionnistes. Anthologie d'écrits sur l'art*, 172–186, ed. Gaëton Picon. Paris: Collection Savoir/Hermann, 1974

The Third Exhibition 1877

d'Arnoux, Charles-Albert [Bertall, pseud.]

Ballu, Roger
 "L'exposition des peintres impressionistes," *La Chronique des Arts et de la Curiosité* (14 April 1877): 147–148
 "L'exposition des peintres impressionnistes," *Les Beaux-Arts Illustrés* (23 April 1877): 392

de Banville, Théodore [Baron Schop, pseud.]

Bergerat, Emile
 "Revue artistique: Les impressionnistes et leur exposition," *Le Journal Officiel de la République Française* (17 April 1877): 2917–2918

Bertall [Charles-Albert d'Arnoux]
 "Exposition des impressionnistes," *Paris-Journal*, 9 April 1877

Bigot, Charles
 "Causerie artistique: L'exposition des 'impressionnistes'," *La Revue Politique et Littéraire* (28 April 1877): 1045–1048

Ph. B. [Philippe Burty]
 "Exposition des impressionistes," *La République Française*, 25 April 1877

Caillebotte, Gustave
 "Le pont de l'Europe [drawing]," *L'Impressionniste* (21 April 1877): 5

Cardon, Emile
"Notes & croquis: Les impressionnistes," *Le Soleil*, 12 April 1877

Cham [Amédée Noé]
Cartoons related to exhibition, *Le Charivari* (15, 16, 22, 26, 28, 29 April 1877): 3
"Revue comique, par Cham," *Le Monde Illustré* (5 May 1877): 285

Le Charivari
"Chronique du jour" (10 April 1877): 2

Chevalier, Frédéric
"Les impressionnistes," *L'Artiste* (1 May 1877): 329–333

Claretie, Jules
"Le mouvement parisien: L'exposition des impressionnistes," *L'Indépendance Belge*, 15 April 1877

Le Courrier de France
"Echos et nouvelles," 4 April 1877

Degas, Edgar
"Danseuse à la barre [drawing]," *L'Impressionniste* (14 April 1877): 5

L'Evénement
"La journée à Paris: L'exposition des impressionnalistes," 6 April 1877

Flor, Oscar-Charles [Ch. Flor O'Squarr, pseud.]

de Fourcaud, Louis [Léon de Lora, pseud.]

L. G.
"Le Salon des 'impressionnistes'," *La Presse*, 6 April 1877

Girard, Paul
"Chronique du jour," *Le Charivari* (27 April 1877): 2

Grimm, Baron [Albert Millaud]
"Lettres anecdotiques du Baron Grimm: Les impression-nistes," *Le Figaro*, 5 April 1877

Grimm, Thomas [Pierre Véron]
"Les impressionnistes," *Le Petit Journal*, 7 April 1877

Jacques [pseud.]
"Menu propos," *L'Homme Libre*, 6 April 1877
"Menu propos: Salon impressionniste," *L'Homme Libre*, 11 April 1877
"Menu propos: Exposition impressionniste," *L'Homme Libre*, 12 April 1877

[Lafenestre, Georges]
"Le jour et la nuit," *Le Moniteur Universel*, 8 April 1877

Lepelletier, E.
"Les impressionnistes," *Le Radical*, 8 April 1877

Leroy, Louis
"Exposition des impressionnistes," *Le Charivari* (11 April 1877): 2
"Le public à l'exposition des impressionnistes," *Le Charivari* (14 April 1877): 2–3

de Lora, Léon [Louis de Fourcaud]
"L'exposition des impressionnistes," *Le Gaulois*, 10 April 1877

Maillard, Georges
"Chronique: Les impressionnistes," *Le Pays*, 9 April 1877

Mancino, Léon
"La descente de la courtille," *L'Art* 9 (1877): 68–71

Mantz, Paul
"L'exposition des peintres impressionnistes," *Le Temps*, 22 April 1877

Millaud, Albert [Baron Grimm, pseud.]

Noé, Amédée [Cham, pseud.]

O'Squarr, Ch. Flor [Oscar-Charles Flor]
"Les impressionnistes," *Le Courrier de France*, 6 April 1877

A. P.
"Beaux-arts," *Le Petit Parisien*, 7 April 1877

La Petite Presse
"Les impressionnistes," 9 April 1877

La Petite République Française
"Exposition des impressionnistes: 6, rue le Peletier, 6," 10 April 1877

Le Rappel
"Les impressionnistes," 6 April 1877

Renoir, Pierre-Auguste
"La balançoire [drawing]," *L'Impressionniste* (21 April 1877): 1

Rivière, Georges
L'Impressionniste (6, 14, 21, 28 April 1877)
"A M. le rédacteur du Figaro" (6 April 1877): 1–2
"L'exposition des impressionnistes" (6 April 1877): 2–6
"La presse" (14 April 1877): 1
"L'exposition des impressionnistes" (14 April 1877): 1–4, 6
"Aux femmes" (21 April 1877): 2
"Explications" (21 April 1877): 3–4

Robert, Jules
"La journée: Echos et nouvelles," *Paris-Journal*, 7 April 1877

Schop, Baron [Théodore de Banville]
"Choses & autres," *Le National*, 8 April 1877
"La semaine parisienne: Les bons jeunes gens de la rue Le Peletier. Taches et couleurs. Le brouillard lumineux. Manet condamné par Manet," *Le National*, 13 April 1877

Sébillot, Paul
"Exposition des impressionnistes," *Le Bien Public*, 7 April 1877

Le Siècle
"Nouvelles du jour," 5 April 1877

Le Sifflet
"Les impressionnistes," 15 April 1877

Sisley, Alfred
"Scieurs de long [drawing]," *L'Impressionniste* (28 April 1877): 1

Véron, Pierre [Thomas Grimm, pseud.]

Un vieux Parisien [pseud.]
"L'indiscret: Le dîner des impressionnistes," *L'Evénement*, 8 April 1877

[Zola, Emile]
"Notes parisiens: Une exposition: Les peintres impression-nistes," *Le Sémaphore de Marseille*, 19 April 1877

The Fourth Exhibition 1879

d'Arnoux, Charles-Albert [Bertall, pseud.]

Bertall [Charles-Albert d'Arnoux]
"Exposition des indépendants: Ex-impressionnistes, demain intentionistes," *L'Artiste* (1 June 1879): 396–398; reprint of following entry
"Exposition des indépendants," *Paris-Journal*, 14 May 1879; reprinted in previous entry

Ph. B. [Philippe Burty]
 "L'exposition des artistes indépendants," *La République Française*, 16 April 1879
E. C. [Emile Cardon]
 "Deux expositions," *Le Soleil*, 11 April 1879
Cassatt, Mary
 "Coin de loge [drawing]," *La Vie Moderne* (1 May 1879): 54
 "Jeune femme lisant [drawing]," *Les Beaux-Arts Illustrés* (1879): 84
Cham [Amédée Noé]
 "Croquis par Cham," *Le Charivari* (20, 27 April 1879): 3
Champier, Victor
 L'année artistique: 1879, 176–177. Paris: A. Quantin, 1880
Le Charivari
 "Chronique du jour" (8 April 1879): 2
 "Chronique du jour" (11 April 1879): 2
Claretie, Jules
 "Le mouvement parisien: Les *impressionnistes* et les *aquarellistes*," *L'Indépendance Belge*, 20 April 1879
Degas, Edgar
 "Danseuse [drawing]," *La Vie Moderne* (8 May 1879): 71
Un Domino [Jehan Valter]
 "Echos de Paris," *Le Gaulois*, 10 April 1879
Draner [Jules Renard]
 "Chez MM. les peintres indépendants," *Le Charivari* (23 April 1879): 3
Duranty, [Edmond]
 "La quatrième exposition faite par un groupe d'artistes indépendants," *La Chronique des Arts et de la Curiosité* (19 April 1879): 126–128
La France
 "Lettres, sciences et beaux-arts," 10 April 1879
Le Griffon Vert [pseud.]
 "Echos de Paris: La ville," *Le Voltaire*, 16 April 1879
Havard, Henry
 "L'exposition des artistes indépendants," *Le Siècle*, 27 April 1879
d'Hervilly, Ernest
 "Exposition des impressionnistes," *Le Rappel*, 11 April 1879
Houssaye, Arsène [F.-C. de Syène, pseud.]
Lafenestre, George
 "Les expositions d'art: Les indépendans et les aquarellistes," *Revue des Deux Mondes* 33 (15 May 1879): 478–485
Leroy, Louis
 "Beaux-arts," *Le Charivari* (17 April 1879): 2
Leude, Jean de la
 "Les ratés de la peinture (les indépendants)," *La Plume* (1 May 1879): 65–66
de Lostalot, Alfred
 "Exposition des artistes indépendants," *Les Beaux-Arts Illustrés* (1879): 82–83
Martelli, Diego
 "Gli impressionisti, mostra del 1879," *Roma Artistica*, 27 June and 5 July 1879; French trans. in *Diego Martelli: Les impressionnistes et l'art moderne*, 28–33, ed. Francesca Errico. Paris: Editions Vilo, 1979
Montjoyeux [Jules Poignard]
 "Chroniques parisiennes: Les indépendants," *Le Gaulois*, 18 April 1879

N. [pseud.]
 "Exposition des artistes indépendants, avenue de l'Opéra," *Le Journal des Arts*, 9 May 1879
Noé, Amédée [Cham, pseud.]
Parfait, Paul
 "Chronique du jour," *Le Charivari* (17 April 1879): 2
Poignard, Jules [Montjoyeux, pseud.]
Renard, Jules [Draner, pseud.]
E. R. [Edmond Renoir]
 "Les impressionnistes," *La Presse*, 11 April 1879
La République Française
 "Lettres, sciences, beaux-arts," 11 April 1879
Sébillot, Paul
 "Revue artistique," *La Plume* (15 May 1879): 73
Silvestre, Armand
 "Les expositions des aquarellistes, des indépendants," *L'Estafette*, 16 April 1879
 "Le monde des arts: Les indépendants. Les aquarellistes," *La Vie Moderne* (24 April 1879): 38–39
 "Le monde des arts," *La Vie Moderne* (1 May 1879): 52–53
de Syène, F.-C. [Arsène Houssaye]
 "Salon de 1879," *L'Artiste* (May 1879): 289–293
Le Temps
 "Chronique," 11 April 1879
Vachon, Marius
 "L'exposition des 'indépendants'," *La France*, 14 April 1879
Valter, Jehan [Un Domino, pseud.]
Le Voltaire
 "Echos de Paris," 1 May 1879
Wolff, Albert
 "Les indépendants," *Le Figaro*, 11 April 1879
Zola, Emile
 "Nouvelles artistiques et littéraires," *Le Messager de l'Europe* [Saint Petersburg, in Russian], July 1879, reprinted in Emile Zola, *Le bon combat de Courbet aux impressionnistes. Anthologie d'écrits sur l'art*, 204–208, ed. Gaëton Picon. Paris: Collection Savoir/Hermann, 1974

The Fifth Exhibition 1880

L'Artiste
 "Les impressionnistes" (February 1880): 140–142; partial reprint of Tout-Paris in *Le Gaulois*
Baignères, Arthur
 "5ᵉ exposition de peinture, par MM. Bracquemond, Caillebotte, Degas, etc.," *La Chronique des Arts et de la Curiosité* (10 April 1880): 117–118
Bracquemond, Marie
 "Etude de femme [drawing]," *La Vie Moderne* (24 April 1880): 264
 "Etude [drawing]," *La Vie Moderne* (1 May 1880): 276
Burty, Ph[ilippe]
 "Exposition des oeuvres des artistes indépendant," *La République Française*, 10 April 1880
Champier, Victor
 "La société des artistes indépendants," *L'année artistique: 1880–1881*, 140–141. Paris: A. Quantin, 1881
de Charry, Paul
 "Le Salon de 1880: Préface, les impressionnistes," *Le Pays*, 10 April 1880

Claretie, Jules
 "La vie à Paris: M. de Nittis et les impressionnistes," *Le Temps*, 6 April 1880; reprinted in following entry
 La vie à Paris: 1880, 60–61. Paris: Victor Havard, 1880; reprint of previous entry
A. E. [Arthur d'Echerac]
 "L'exposition des impressionnistes," *La Justice*, 5 April 1880
Ephrussi, Charles
 "Exposition des artistes indépendants," *Gazette des Beaux-Arts* (1 May 1880): 485–488
Goetschy, Gustave
 "Indépendants et impressionistes," *Le Voltaire*, 6 April 1880
Havard, Henry
 "L'exposition des artistes indépendants," *Le Siècle*, 2 April 1880
Huysmans, Joris-Karl
 "L'exposition des indépendants en 1880," *L'art moderne*, 85–123. Paris: G. Charpentier, 1883
Maigrot, Henri [PIF, pseud.]
Mantz, Paul
 "Exposition des oeuvres des artistes indépendants," *Le Temps*, 14 April 1880
Mornand, H[enri]
 "Les impressionnistes," *La Revue Littéraire et Artistique* (1 May 1880): 67–68
PIF [Henri Maigrot]
 "Croquis par PIF," *Le Charivari* (11 April 1880): 3
Raffaëlli, Jean-François
 "Deux vieux [drawing]," *Gazette des Beaux-Arts* (1 May 1880): 485
 "Chiffonnier [drawing]," *L'Art* 21 (1880): 91
 "Chiffonnier and Balayeur [drawings]," *La Vie Moderne* (24 April 1880): 262
Silvestre, Armand
 "Le monde des arts: Exposition de la rue des Pyramides," *La Vie Moderne* (24 April 1880): 262
 "Le monde des arts: Exposition de la rue des Pyramides," *La Vie Moderne* (1 May 1880): 275–276
Tout-Paris [pseud.]
 "La journée parisienne: Impressions d'un impressionniste," *Le Gaulois*, 24 January 1880; partial reprint in *L'Artiste*
Véron, Eugène
 "Cinquième exposition des indépendants," *L'Art* 21 (1880): 92–94
Véron, Pierre
 "Courrier de Paris," *Le Monde Illustré* (10 April 1880): 219
Wolff, Albert
 "Beaux-arts: Les impressionnistes," *Le Figaro*, 9 April 1880
Zadig [pseud.]
 "Echos de Paris," *Le Voltaire*, 3 April 1880

The Sixth Exhibition 1881

d'Arnoux, Charles-Albert [Bertall, pseud.]
L'Art
 "Expositions," 25 (1881): 40–42
Bertall [Charles-Albert d'Arnoux]
 "Exposition des peintres intransigeants et nihilistes, 36, boulevard des Capucines," *Paris-Journal*, 21 April 1881

Cardon, Emile
 "Choses d'art: L'exposition des artistes indépendants," *Le Soleil*, 7 April 1881
Champier, Victor
 "La société des artistes indépendants," *L'année artistique: 1881*, 167–169. Paris: A. Quantin, 1882
de Charry, Paul
 "Les indépendants," *Le Pays*, 22 April 1881
Claretie, Jules
 "La vie à Paris: Les artistes indépendants," *Le Temps*, 5 April 1881
 La vie à Paris: 1881, 148–151. Paris: Victor Havard, 1881
Dalligny, Aug[uste]
 "Les indépendants: Sixième exposition," *Le Journal des Arts*, 8 April 1881
C. E. [Charles Ephrussi ?]
 "Exposition des artistes indépendants," *La Chronique des Arts et de la Curiosité* (16 April 1881): 126–127
 "Exposition des peintres indépendants," *La Chronique des Arts et de la Curiosité* (23 April 1881): 134–135
"G. G. [Gustave Geffroy]
 "L'exposition des artistes indépendants," *La Justice*, 4 April 1881
Geffroy, Gustave
 "L'exposition des artistes indépendants," *La Justice*, 19 April 1881
Goetschy, Gustave
 "Exposition des artistes indépendants," *Le Voltaire*, 5 April 1881
Gonzague-Privat
 "L'exposition des artistes indépendants," *L'Evénement*, 5 April 1881
Havard, Henry
 "L'exposition des artistes indépendants," *Le Siècle*, 3 April 1881
Huysmans, Joris-Karl
 "L'exposition des indépendants en 1881," *L'art moderne*, 225–257. Paris: G. Charpentier, 1883
Louise, Comtesse
 "Lettres familières sur l'art: Salon de 1881," *La France Nouvelle*, 1–2 May 1881
Maigrot, Henri [PIF, pseud.]
Mantz, Paul
 "Exposition des oeuvres des artistes indépendants," *Le Temps*, 23 April 1881
Mars [pseud.]
 "Au long cours, de Paris à Saint-Germain," *Le Journal Amusant* (30 April 1881): 5
de Mont, Elie
 "L'exposition du boulevard des Capucines," *La Civilisation*, 21 April 1881
PIF [Henri Maigrot]
 "Croquis par PIF," *Le Charivari* (10, 24 April 1881): 3
Raffaëlli, Jean-François
 "Anch'io sono pittore, [drawing of 'Bonhomme vient de peindre son barrière']," *La Vie Moderne* (16 April 1881): 251
Le Sphinx [pseud.]
 "Echos de Paris," *L'Evénement*, 3 April 1881

Silvestre, Armand

"Sixième exposition des artistes indépendants," *L'Estafette*, 11 April 1881

"Le monde des arts: Sixième exposition des artistes indépendants," *La Vie Moderne* (16 April 1881): 250–251

Trianon, Henry

"Sixième exposition de peinture par un groupe d'artistes, 35, boulevard des Capucines," *Le Constitutionnel*, 24 April 1881

Trock [pseud.]

"Le mois comique, par Trock," *La Caricature* (23 April 1881): 130

de Villars, Nina

"Variétés: Exposition des artistes indépandants," *Le Courrier du Soir*, 23 April 1881

Wolff, Albert

"Courrier de Paris," *Le Figaro*, 10 April 1881

X. [pseud.]

"Exposition des artistes indépendants," *La Chronique des Arts et de la Curiosité* (2 April 1881): 109–110

The Seventh Exhibition 1882

L'Art Moderne

"Nouvelles parisiennes" (19 March 1882): 93

Bigot, Charles

"Beaux-arts: Les petits Salons. L'exposition des artistes indépendants," *La Revue Politique et Littéraire* (4 March 1882): 281–282

Burty, Ph[ilippe]

"Les aquarellistes, les indépendants et le Cercle des arts libéraux," *La République Française*, 8 March 1882

Canivet, Charles [Jean de Nivelle, pseud.]

de Charry, Paul

"Beaux-arts," *Le Pays*, 10 March 1882

Chesneau, Ernest

"Groupes sympathiques: Les peintres impressionnistes," *Paris-Journal*, 7 March 1882

Draner [Jules Renard]

"Une visite aux impressionnistes par Draner," *Le Charivari* (9 March 1882): 3

Fichtre [Gaston Vassy]

"L'actualité: L'exposition des peintres indépendants," *Le Réveil*, 2 March 1882

Havard, Henry

"Exposition des artistes indépendants," *Le Siècle*, 2 March 1882

Hennequin, Emile

"Beaux-arts: Les expositions des arts libéraux et des artistes indépendants," *La Revue Littéraire et Artistique* (1882): 154–155

Hepp, Alexandre

"Impressionisme," *Le Voltaire*, 3 March 1882

Hustin, A[rthur]

"L'exposition des peintres indépendants," *L'Estafette*, 3 March 1882

Huysmans, Joris-Karl

"Appendice," *L'art moderne*, 261–277. Paris: G. Charpentier, 1883

Katow, Paul de

"L'exposition des peintres indépendants," *Gil Blas*, 1 March 1882

Laroche, André

"Chronique du jour," *Le Charivari* (5 March 1882): 2

Leroy, L[ouis]

"Exposition des impressionnistes," *Le Charivari* (17 March 1882): 2

Maigrot, Henri [PIF, pseud.]

de Nivelle, Jean [Charles Canivet]

"Les peintres indépendants," *Le Soleil*, 4 March 1882

PAF [Jules Renard]

"Croquis par PAF," *Le Charivari* (19 March 1882): 3

PIF [Henri Maigrot]

"Croquis par PIF," *Le Charivari* (12 March 1882): 3

Renard, Jules [Draner and PAF, pseuds.]

Rivière, Henri

"Aux indépendants," *Le Chat Noir*, 8 April 1882

Sallanches, Armand

"L'exposition des artistes indépendants," *Le Journal des Arts*, 3 March 1882

Silvestre, Armand

"Le monde des arts: Expositions particulières: Septième exposition des artistes indépendants," *La Vie Moderne* (11 March 1882): 150–151

Vassy, Gaston [Fichtre, pseud.]

"L'actualité: Les peintres impressionnistes," *Gil Blas*, 2 March 1882

Wolff, Albert

"Quelques expositions," *Le Figaro*, 2 March 1882

The Eighth Exhibition 1886

Adam, Paul

"Peintres impressionnistes," *La Revue Contemporaine, Littéraire, Politique et Philosophique* 4 (April 1886): 541–551

Ajalbert, Jean

"Le Salon des impressionnistes," *La Revue Moderne* [Marseille] (20 June 1886): 385–393

Auriol, George

"Huitième exposition," *Le Chat Noir*, 22 May 1886

The Bat

[London] (25 May 1886): 185–186

Christophe, Jules

"Chronique: Rue Laffitte, No. 1," *Le Journal des Artistes* (13 June 1886): 193–194

Dargenty, G.

"Les impressionnistes," *Le Courrier de l'Art* (21 May 1886): 244–245

Darzens, Rodolphe

"Chronique artistique: Exposition des impressionnistes," *La Pléiade* (May 1886): 88–91

Desclozeaux, Jules

"Chronique: Les impressionnistes," *L'Opinion*, 27 May 1886

Eyriès, Patrice

"L'exposition des impressionnistes," *La Nation*, 21 May 1886

Fénéon, Félix

"Les impressionnistes," *La Vogue* (13–20 June 1886): 261–275

Fèvre, Henry
 "L'exposition des impressionnistes," *La Revue de Demain*
 (May-June 1886): 148–156
Fouquier, Marcel
 "Les impressionnistes," *Le XIXᵉ Siècle*, 16 May 1886
Geffroy, Gustave
 "Salon de 1886: VIII. Hors du Salon. Les impressionnistes,"
 La Justice, 26 May 1886
H. [pseud.]
 "Les impressionnistes," *Journal des Arts*, 11 June 1886
Havard, Henry
 "La peinture indépendante: Huitième exposition des impres-
 sionnistes," *Le Siècle*, 17 May 1886
Hennequin, Emile
 "Notes d'art: Les impressionnistes," *La Vie Moderne*
 (19 June 1886): 389–390
Hermel, Maurice
 "L'exposition de peinture de la rue Laffitte," *La France Libre*,
 27 May 1886
 "L'exposition de peinture de la rue Laffitte," *La France Libre*,
 28 May 1886
Huysmans, Joris-Karl
 "Certains," *Oeuvres Complètes*, 10: 20–25. Paris: Les Edi-
 tions G. Crès et Cⁱᵉ, 1929
Javel, Firmin
 "Les impressionnistes," *L'Evénement*, 16 May 1886

Labruyère
 "Les impressionnistes," *Le Cri du Peuple*, 17 May 1886
 "Les impressionnistes," *Le Cri du Peuple*, 28 May 1886
Marx, Roger
 "Les impressionnistes," *Le Voltaire*, 17 May 1886
[Maus, Octave]
 "Les vingtistes parisiens," *L'Art Moderne* [Brussels] (27 June
 1886): 201–204
Michel, J. M.
 "Exposition des impressionnistes," *La Petite Gazette*,
 18 May 1886
Mirbeau, Octave
 "Exposition de peinture (1, rue Laffitte)," *La France*,
 21 May 1886
Le Moniteur des Arts
 "L'exposition des indépendants" (21 May 1886): 174
PAF [Jules Renard]
 "Croquis par PAF," *Le Charivari* (23 May 1886): 3
Paulet, Alfred
 "Les impressionnistes," *Paris*, 5 June 1886
Renard, Jules [PAF, pseud.]
La République Française
 "L'exposition des impressionnistes" 17 May 1886
Vidal, Jules
 "Les impressionnistes," *Lutèce*, 29 May 1886

Bibliography

The following list supplements John Rewald's authoritative bibliography last updated in 1973 for the fourth edition of *The History of Impressionism* (New York: The Museum of Modern Art). Articles, books, catalogues raisonnés, dissertations, and exhibition catalogues published since 1973 have been alphabetized by author. The bibliography is not restricted to those artists whose work is represented in the present exhibition, but includes citations for as many of the original exhibitors as possible.

General Bibliography

Adhémar, Hélène et al. *Chronologie impressionniste: 1863–1905*. Paris: Editions de la Réunion des Musées Nationaux, 1981.

d'Albis, J. and L. d'Albis. "La céramique impressionniste. L'atelier Haviland d'Auteuil et son influence." *L'Oeil* 223 (February 1974): 46–51.

Austin, Lloyd. "Mallarmé, critique d'art." *The Artist and the Writer in France: Essays in Honour of Jean Seznec*, ed. Francis Haskell et al., 153–162. Oxford: Clarendon Press, 1974.

Bellony-Rewald, Alice. *The Lost World of the Impressionists*. London: Weidenfeld and Nicholson, 1976.

Bizardel, Yvon. "Théodore Duret: An Early Friend of the Impressionists." *Apollo* 100 (August 1974): 146–155.

Blunden, Maria and Godfrey Blunden. *Impressionists and Impressionism*. Geneva: Skira; London: Macmillan, 1981.

Bouillon, Jean-Paul. "L'impressionnisme." *Revue de l'Art* 51 (1981): 75–85.

Brettell, Richard R. et al. *A Day in the Country: Impressionism and the French Landscape*, exh. cat. Los Angeles: Los Angeles County Museum of Art, 1984.

Burt, Marianna Reiley. "Le pâtissier Murer, un ami des impressionnistes." *L'Oeil* 245 (December 1975): 54–61ff.

Callen, Anthea. *Techniques of the Impressionists*. London: Orbis, 1982.

Champa, Kermit S. *Studies in Early Impressionism*. New Haven and London: Yale University Press, 1973.

de Cossart, Michael. "Princesse Edmond de Polignac: Patron and Artist." *Apollo* 102 (August 1975): 133–135.

Crespelle, Jean-Paul. *La vie quotidienne des impressionnistes: Du Salon des Refusés (1863) à la mort de Manet (1883)*. Paris: Hachette, 1981.

Dayez, Anne et al. *Centenaire de l'impressionnisme*, exh. cat. Paris: Grand Palais, 1974.

Dini, Pietro. *Diego Martelli e gli impressionisti*. Florence: Il Torchio, 1979.

Dorra, Henri. "Excerpts from the Correspondence of Emile Bernard from the Beginning to the Rose + Croix Exhibition (1876–1892)." *Gazette des Beaux-Arts* 96 (December 1980): 235–242.

Dufwa, Jacques. *Winds from the East: A Study in the Art of Manet, Degas, Monet and Whistler, 1856–86*. Stockholm: Almqvist & Wiksell, 1981.

Dunstan, Bernard. *Painting Methods of the Impressionists*, rev. ed. New York: Watson-Guptill, 1983.

Fidell-Beaufort, Madeleine. "L'imagerie populaire et l'iconographie impressionniste." *Nouvelles de l'Estampe* 18 (1974): 17–20.

Fischel, Lilli. "Von der Bildform der französischen Impressionisten." *Jahrbuch der berliner Museen* 15 (1973): 58–154.

Flint, Kate, ed. *Impressionists in England: The Critical Reception*. London, Boston, Melbourne, and Henley: Routledge & Kegan Paul, 1984.

Hamilton, George Heard. "The Philosophical Implications of Impressionist Landscape Painting." *The Museum of Fine Arts, Houston Bulletin* 6 (Spring 1975): 2–17.

Hemmings, Frederic William John. *The Life and Times of Emile Zola*. London: Paul Elek; New York: Scribner's, 1977.

House, John. *Impressionism, Its Masters, Its Precursors, and Its Influence in Britain*, exh. cat. London: Royal Academy of Arts, 1974.

The Impressionists and the Salon (1874–1886), exh. cat. Riverside: University of California, Riverside, 1974.

Isaacson, Joel. *The Crisis of Impressionism, 1878–1882*, exh. cat. Ann Arbor: University of Michigan, Museum of Art, 1980.

———. "Impressionism and Journalistic Illustration." *Arts* 56 (June 1982): 95–115.

Keller, Horst. *Aquarelles et dessins des impressionnistes français*. Paris: A. Michel, 1982.

Kolb, Philippe and Jean Adhémar. "Charles Ephrussi, 1849–1905, ses secrétaires: Laforgue, A. Renan, Proust, sa Gazette des Beaux-Arts." *Gazette des Beaux-Arts* 103 (January 1984): 29–41.

Lassaigne, Jacques. *L'impressionnisme, sources et dépassement, 1850–1900*. Geneva: Skira, 1974.

Le Paul, Charles-Guy and Judy Le Paul. *L'impressionnisme dans l'Ecole de Pont-Aven: Monet, Renoir, Gauguin et leurs disciples*. Lausanne and Paris: La Bibliothèque des Arts, 1983.

Marcussen, Marianne. "Duranty et les impressionnistes, I." *Hafnia: Copenhagen Papers in the History of Art* 5 (1978): 24–42.

———. "Duranty et les impressionnistes, II." *Hafnia: Copenhagen Papers in the History of Art* 6 (1979): 27–49.

Martelli, Diego. *Les impressionnistes et l'art moderne*, ed. Francesca Errico. Paris: Editions Vilo, 1979.

Martin-Mery, Gilberte et al. *Naissance de l'impressionnisme*, exh. cat. Bordeaux: Galerie des Beaux-Arts, 1974.

Mathieu, Pierre-Louis. "Huysmans, inventeur de l'impressionnisme." *L'Oeil* 341 (December 1983): 38–45.

Melot, Michel. *L'estampe impressionniste*, exh. cat. Paris: Bibliothèque Nationale, 1974.

———. "L'estampe impressionniste et la réduction au dessin." *Nouvelles de l'Estampe* 19 (1975): 11–15.

Milkovich, Michael. *Impressionists in 1877: A Loan Exhibition*, exh. cat. Memphis: Dixon Gallery and Gardens, 1977.

Monneret, Sophie. *L'impressionnisme et son époque*, 4 vols. Paris: Denoël, 1978–1981.

Ohmori, Tatsuji et al. *Ukiyo-e Prints and the Impressionist Painters: Meeting of the East and the West*, exh. cat. Tokyo: Sunshine Museum, 1979.

Osborne, Carol. "Impressionists and the Salon." *Arts* 48 (June 1974): 36–39.

Passeron, Roger. *Impressionist Prints: Lithographs, Etchings, Drypoints, Aquatints, Woodcuts*. London: Phaidon Press, 1974.

Reuterswärd, Oscar. *Impressionister och purister*. Stockholm: Bonnier, 1976.

———. "1881: La sixième exposition des impressionnistes, dite des Artistes Indépendants, vue par la presse et l'opinion." *Gazette des Beaux-Arts* 94 (November 1979): 183–192.

Rewald, John. "Theo van Gogh, Goupil and the Impressionists." *Gazette des Beaux-Arts* 81 (January 1973): 1–64; (February 1973): 65–108.

Rewald, John and Germain Bazin. *Cent ans d'impressionnisme: 1874–1974, hommage à Paul Durand-Ruel*, exh. cat. Paris: Galerie Durand-Ruel, 1974.

Ruhmer, Eberhard. "Wilhelm Leibl et ses amis pour et contre l'impressionnisme." *Gazette des Beaux-Arts* 95 (May–June 1980): 187–197.

Shiff, Richard. "The End of Impressionism: A Study in Theories of Artistic Expression." *Art Quarterly* 1 (Autumn 1978): 338–378.

Thomson, Richard. "A Neglected Review of the First Impressionist Exhibition: Was the Author Villiers de L'Isle-Adam?" *Gazette des Beaux-Arts* 100 (September 1982): 90–92.

Usselmann, Henri. "Strindberg et l'impressionnisme." *Gazette des Beaux-Arts* 99 (April 1982): 153–162.

Varnedoe, J. Kirk T. "The Artifice of Candor: Impressionism and Photography Reconsidered." *Art in America* 68 (January 1980): 66–78.

Weisberg, Gabriel P. et al. *Japonisme: Japanese Influence on French Art, 1854–1910*, exh. cat. Cleveland: The Cleveland Museum of Art, 1975.

White, Barbara Ehrlich, ed. *Impressionism in Perspective*. Englewood Cliffs: Prentice-Hall, 1978.

Zola, Emile, *Le bon combat de Courbet aux impressionnistes: anthologie d'écrits sur l'art*, ed. Gaëton Picon and Jean-Paul Bouillon. Paris: Savoir/Hermann, 1974.

Zacharie Astruc

Flescher, Sharon. *Zacharie Astruc: Critic, Artist and Japoniste*. London and New York: Garland Publishing, 1978.

Eugène Boudin

Jean-Audry, Georges and Robert Schmit. *Eugène Boudin: La vie et l'oeuvre d'après les lettres et documents inédits*, 2d ed. Neuchâtel: Ides et Calendes, 1977.

de Knyff, Gilbert. *Eugène Boudin raconté par lui-même: Sa vie, son atelier, son oeuvre*. Paris: Mayer, 1976.

Legoy, Gaston. *Sur les pas d'Eugène Boudin: Le Havre, Honfleur, Trouville et autres lieux*, exh. cat. Le Havre: Musée des Beaux-Arts, 1978.

Lemaire, S. "Don au Musée Eugène Boudin de la lettre autographie d'Eugène Boudin contant *la légende de Saint-Siméon.*" *Bulletin de l'Association des Amis du Musée Honfleur* (1972–1975): 8–11.

Melot, Michel. *Graphic Art of the Pre-Impressionists*, trans. Robert Erich Wolf. New York: Abrams, 1980.

Schmit, Robert. *Eugène Boudin, 1824–1898*, exh. cat. Paris: Galerie Schmit, 1973.

———. *Eugène Boudin, 1824–1898*, exh. cat. Bremen: Kunsthalle, 1979.

Selz, Jean. *Boudin*. Paris: Flammarion; New York: Crown Publishers, 1982.

Testanière, Geneviève. *Eugène Boudin, 1824–1898, dans les collections du Musée des Beaux-Arts du Havre*, exh. cat. Le Havre: Musée des Beaux-Arts, 1978.

Young, Mahonri Sharp and Katherine Wallace Paris. *Louis Eugène Boudin: Precursor of Impressionism*, exh. cat. Santa Barbara: Museum of Art, 1976.

Félix Bracquemond

d'Albis, J. and L. d'Albis. *Céramique impressionniste: L'atelier Haviland de Paris-Auteuil, 1873–1882*, exh. cat. Paris: Bibliothèque Forney, 1974.

Bailly-Herzberg, Janine. "French Etching in the 1860s." *Art Journal* 31 (Summer 1972): 383.

Bouillon, Jean-Paul. "La correspondance de Félix Bracquemond: Une source inédite pour l'histoire de l'art français dans la seconde moitié du XIXe siècle." *Gazette des Beaux-Arts* 82 (December 1973): 351–386.

———. "Bracquemond, Rops, Manet et le procédé à la plume." *Nouvelles de l'Estampe* 14 (1974): 3–11.

———. "Note sur le procédé à la plume." *Nouvelles de l'Estampe* 16 (1975): 26, 56.

———. "*A gauche*: Note sur la Société du Jing-Lar et sa signification." *Gazette des Beaux-Arts* 91 (March 1978): 107–118.

———. "Les portraits à l'eau-forte de Bracquemond et leurs sources photographiques." *Nouvelles de l'Estampe* 38 (1978): 4–10.

———. "Artistic Collaboration: Bracquemond and Baron Vitta." *The Bulletin of the Cleveland Museum of Art* 66 (November 1979): 311–319.

———. "Félix Bracquemond. Les années d'apprentissage (1849–1859): La genèse d'un réalisme positiviste." *Nouvelles de l'Estampe* 48 (1979): 12–17.

———. "Les lettres de Manet à Bracquemond." *Gazette des Beaux-Arts* 101 (April 1983): 147–158.

Eidelberg, Martin. "Bracquemond, Delâtre and the Discovery of Japanese Prints." *The Burlington Magazine* 123 (April 1981): 221–227.

Getscher, Robert. *Félix Bracquemond and the Etching Process*, exh. cat. Wooster, Ohio: College of Wooster, 1974.

Holtzman, Ellen. "Felicien Rops and Baudelaire: Evolution of a Frontispiece." *Art Journal* 38 (Winter 1978–1979): 102–106.

Weisberg, Gabriel P. "Les albums ukiyo-e de la collection de Camille Moreau: Source nouvelle pour le japonisme." *Nouvelles de l'Estampe* 23 (1975): 18–21.

———. "Félix Bracquemond and the Molding of French Popular Taste." *Art News* 75 (September 1976): 64–66.

———. "Baron Vitta and the Bracquemond/Rodin Hand Mirror." *The Bulletin of the Cleveland Museum of Art* 66 (November 1979): 298–310.

Marie Bracquemond

Bouillon, Jean-Paul. "Marie Bracquemond." *Women's Art Journal* 5 (Fall 1984–Winter 1985): 21–27.

Kane, Elizabeth. "Marie Bracquemond: The Artist Time Forgot." *Apollo* 117 (February 1983): 118–121.

Gustave Caillebotte

Berhaut, Marie. *Caillebotte, sa vie et son oeuvre: Catalogue raisonné des peintures et pastels*. Paris: La Bibliothèque des Arts, 1978.

Maillet, Edda. *Gustave Caillebotte 1848–1894*, exh. cat. Pontoise: Musée Pissarro, 1984.

Varnedoe, J. Kirk T. "Caillebotte's *Pont de l'Europe*: A New Slant." *Art International* 18 (April 1974): 28–29, 41, and 58.

———. "Gustave Caillebotte in Context." *Arts Magazine* 50 (May 1976): 94–99.

Varnedoe, J. Kirk T. and Thomas P. Lee. *Gustave Caillebotte: A Retrospective Exhibition*, exh. cat. Houston: Museum of Fine Arts, 1976.

Adolphe-Félix Cals

Pillement, G. "Egal de Jongkind et Boudin, Cals peignit sur le motif 30 ans avant Monet." *Galerie-Jardin des Arts* 137 (May 1974): 75–77.

Mary Cassatt

Breeskin, Adelyn Dohme. *Mary Cassatt: Pastels and Color Prints*, exh. cat. Washington, D.C.: Smithsonian Institution, National Collection of Fine Arts, 1978.

———. *Mary Cassatt: A Catalogue Raisonné of the Graphic Work*, 2d ed. Washington, D.C.: Smithsonian Institution Press, 1979.

Getlein, Frank. *Mary Cassatt: Paintings and Prints*. New York: Abbeville Press, 1980.

Hale, Nancy. *Mary Cassatt*. Garden City: Doubleday, 1975.

Lindsay, Suzanne G. *Mary Cassatt and Philadelphia*, exh. cat. Philadelphia: Philadelphia Museum of Art, 1985.

Mathews, Nancy Mowll. *Mary Cassatt and the 'Modern Madonna' of the Nineteenth Century*, Ph.D. diss. New York University, 1980.

———. *Mary Cassatt and Edgar Degas*, exh. cat. San Jose: Museum of Art, 1981.

———. *Cassatt and Her Circle: Selected Letters*. New York: Abbeville Press, 1984.

Milkovich, Michael. *Mary Cassatt and the American Impressionists: A Loan Exhibition Commemorating the Fiftieth Anniversary of Mary Cassatt's Death and the American Bicentennial Celebration*, exh. cat. Memphis: Dixon Gallery and Gardens, 1976.

Richards, Louise S. "Mary Cassatt's Drawings of *The Visitor*." *The Bulletin of the Cleveland Museum of Art* 65 (October 1978): 268–277.

Shapiro, Barbara Stern. *Mary Cassatt at Home*, exh. cat. Boston: Museum of Fine Arts, 1978.

Yeh, Susan Fillin. "Mary Cassatt's Images of Women." *Art Journal* 35 (Summer 1976): 359–363.

Paul Cézanne

Adler, Kathleen. "Camille Pissarro and Paul Cézanne: A Study of Their Artistic Relationship between 1872 and 1885." *De Arte* 13 (April 1973): 19–25.

Adriani, Götz. *Paul Cézanne: Zeichnungen*, exh. cat. Tübingen, Kunsthalle. Cologne: DuMont, 1978.

———. *Paul Cézanne: Aquarelle 1866–1906*, exh. cat. Tübingen, Kunsthalle. Cologne: DuMont, 1982.

Ballas, Guila. "Cézanne et la Galerie d'Apollon au Louvre." *Bulletin de la Société de l'Histoire de l'Art Français* (1980): 259–267.

———. "Paul Cézanne et la revue *L'Artiste*." *Gazette des Beaux-Arts* 98 (December 1981): 223–232.

Cézanne, Paul. *Letters*, ed. John Rewald, trans. Seymour Hacker, rev. and aug. ed. New York: Hacker Art Books, 1984.

Chappuis, Adrien. *The Drawings of Paul Cézanne: A Catalogue Raisonné*, 2 vols. Greenwich: New York Graphic Society; London: Thames and Hudson, 1973.

Doran, P. Michael, ed. *Conversations avec Cézanne*, trans. Ann Hindry. Paris: Macula, 1978.

Faxon, Alicia Craig. "Cézanne's Sources for *Les grandes baigneuses*." *The Art Bulletin* 65 (June 1983): 320–323.

Fulep, Lajos. "Ecrits sur Cézanne." *Acta Historiae Artium* 20 (1974): 107–124.

Hayman, Ronald. "The Subject Matter of Cézanne's Bathers." *Artscribe* 12 (1978): 35–40.

———. "Landscape of Relationships: The Vision of Cézanne." *The Yale Review* 69 (March 1980): 357–373.

Hoog, Michel et al. *Cézanne dans les musées nationaux*, exh. cat. Paris, Orangerie des Tuileries. Paris: Editions des Musées Nationaux, 1974.

Kiefer, Carol Solomon. "Cézanne's Magdalen: A New Source in the Musée Granet." *Gazette des Beaux-Arts* 103 (February 1984): 91–94.

Krumrine, Mary Louise. "Cézanne's Bathers: Form and Content." *Arts Magazine* 54 (May 1980): 115–123.

Lavin, Maud. "Roger Fry, Cézanne, and Mysticism." *Arts Magazine* 58 (September 1983): 98–101.

Lesko, Diane. "Cézanne's *Bather* and a Found Self-Portrait." *Artforum* 15 (December 1976): 52–57.

Lewis, Mary Tompkins. *Cézanne's Religious Imagery*, Ph.D. diss. University of Pennsylvania, 1981.

———. "Cézanne's *Harrowing of Hell and the Magdalen*." *Gazette des Beaux-Arts* 97 (April 1981): 175–178.

Lichtenstein, Sara. "Cézanne's Copies and Variants after Delacroix." *Apollo* 101 (February 1975): 116–127.

Machotka, Pavel. "Cézanne's Landscapes and the Functions of Vision." *Leonardo* 16 (Summer 1983): 177–179.

Novotny, Fritz. "Vor einem Landschaftsbild von Cézanne." *Niederdeutsche Beiträge zur Kunstgeschichte* 16 (1977): 171–180.

Orienti, Sandra. *Tout l'oeuvre peint de Cézanne*. Paris: Flammarion, 1975.

Perucchi-Petri, Ursula. "War Cézanne Impressionist? Die Begegnung zwischen Cézanne und Pissarro." *Du* 35 (September 1975): 50–65.

Reff, Theodore. "Cézanne on Solids and Spaces." *Artforum* 16 (October 1977): 34–37.

———. "Cézanne's Late Bather Paintings." *Arts Magazine* 52 (October 1977): 116–119.

———. "The Pictures within Cézanne's Pictures." *Arts Magazine* 53 (June 1979): 90–104.

———. "Cézanne: The Severed Head and the Skull." *Arts Magazine* 58 (October 1983): 84–100.

Rewald, John. "Cézanne and Guillaumin." *Etudes d'art français offertes à Charles Sterling*, ed. Albert Châtelet and Nicole Reynaud, 343–353. Paris: Presses Universitaires de France, 1975.

———. *Paul Cézanne: The Watercolors, A Catalogue Raisonné*. Boston: New York Graphic Society, 1983.

Rewald, John and Jean Adhémar. "Some Entries for a New Catalogue Raisonné of Cézanne's Paintings." *Gazette des Beaux-Arts* 86 (November 1975): 157–168.

Rilke, Rainer Maria. *Briefe über Cézanne*, ed. H. W. Petzet. Frankfurt-am-Main: Insel-Verlag, 1983.

Rishel, Joseph J. *Cézanne in Philadelphia Collections*, exh. cat. Philadelphia: Philadelphia Museum of Art, 1983.

Rubin, William, ed. *Cézanne, the Late Work*, exh. cat. New York, Museum of Modern Art. Boston: New York Graphic Society, 1977.

Shiff, Richard. *Impressionist Criticism, Impressionist Color and Cézanne*, Ph.D. diss. Yale University, 1973.

———. "Seeing Cézanne." *Critical Inquiry* 4 (Summer 1978): 769–808.

———. *Cézanne and the End of Impressionism*. Chicago: The University of Chicago Press, 1984.

Tsiakma, Katia. "Cézanne's and Poussin's Nudes." *Art Journal* 37 (Winter 1977–1978): 120–132.

Wechsler, Judith, ed. *Cézanne in Perspective*. Englewood Cliffs and London: Prentice-Hall, 1975.

———. *The Interpretation of Cézanne*. Ann Arbor: UMI Research Press, 1981.

Wetenhall, John. "Cézanne's Mont Saint-Victoire seen from les Louves." *Pantheon* 40 (January–March 1982): 45–51.

Edgar Degas

Adhémar, Jean and Françoise Cachin. *Edgar Degas: Gravures et monotypes*. Paris: Arts et Métiers Graphiques, 1973.

Adriani, Götz. *Degas. Pastels, Oil Sketches, Drawings*, exh. cat. Kunsthalle, Tübingen. New York: Abbeville Press, 1985.

Boggs, Jean Sutherland. "Edgar Degas in Old Age." *Allen Memorial Art Museum Bulletin* 35 (1977–1978): 57–67.

———. *Degas at the Museum: Works in the Philadelphia Museum of Art and John G. Johnson Collection*, exh. cat. *Bulletin of the Philadelphia Museum of Art* 81 (Spring 1985).

Brame, Philippe and Theodore Reff. *Degas et son oeuvre: A Supplement*. New York and London: Garland Publishing, 1984.

Brayer, Yves. *Degas: "La famille Bellelli," variations autour d'un chef-d'oeuvre*, exh. cat. Paris: Musée Marmottan, 1980.

Brettell, Richard R. and Suzanne Folds McCullagh. *Degas in The Art Institute of Chicago*, exh. cat. Art Institute of Chicago. New York: Abrams, 1984.

Broude, Norma. "Degas' 'Misogyny'." *The Art Bulletin* 59 (March 1977): 95–107.

Buerger, Janet E. "Degas' Solarized and Negative Photographs: A Look at Unorthodox Classicism." *Image* 21 (June 1978): 17–23.

Buerger, Janet E. and Barbara Stern Shapiro. "A Note on Degas' Use of Daguerreotype Plates." *Print Collector's Newsletter* 12 (September–October 1981): 103–106.

Cooper, Helen A. "An Early Drawing by Degas." *Yale University Art Gallery Bulletin* 37 (Fall 1978): 10–13.

Dunlop, Ian. *Degas*. London: Thames and Hudson, 1979.

Fletcher, S. "Two Monotype-Pastels by Degas at the National Gallery of Art." *Print Quarterly* 1 (1984): 53–55.

Gardey, F. "Le 29ᵉ carnet de Degas au Cabinet des Estampes." *Nouvelles de l'Estampe* 12 (1973): 23.

Gerstein, Marc. "Degas's Fans." *The Art Bulletin* 64 (March 1982): 105–118.

Giese, Lucretia H. "A *Visit to the Museum*." *Museum of Fine Arts Bulletin* [Boston] 76 (1978): 42–53.

Guillaud, Maurice et al. *Degas: Form and Space*, exh. cat. Paris: Centre Culturel du Marais, 1984.

Lipton, Eunice. "Degas' Bathers: The Case for Realism." *Arts Magazine* 54 (May 1980): 94–97.

———. "The Laundress in Late 19th-Century French Culture: Imagery, Ideology, and Edgar Degas." *Art History* 3 (September 1980): 295–313.

———. "Deciphering a Friendship: Edgar Degas and Evariste de Valernes." *Arts Magazine* 55 (June 1981): 128–132.

Lockhart, Anne I. "Three Monotypes by Edgar Degas." *The Bulletin of the Cleveland Museum of Art* 64 (November 1977): 299–306.

McMullen, Roy. *Degas: His Life, Times, and Work*. Boston: Houghton Mifflin Company, 1984.

Mathews, Nancy Mowll. *Mary Cassatt and Edgar Degas*, exh. cat. San Jose: Museum of Art, 1981.

Millard, Charles W. *The Sculpture of Edgar Degas*. Princeton: Princeton University Press, 1976.

Muehlig, Linda D. *Degas and the Dance*, exh. cat. Northampton: Smith College Museum of Art, 1979.

Monnier, Geneviève. "La genèse d'une oeuvre de Degas: *Semiramis construisant une ville*." *La Revue du Louvre et des Musées de France* 28 (1978): 407–426.

Nathanson, Carol A. and Edward J. Olszewski. "Degas's Angel of the Apocalypse." *The Bulletin of the Cleveland Museum of Art* 67 (October 1980): 243–255.

Pickvance, Ronald. *Degas 1879: Paintings, Pastels, Drawings, Prints and Sculpture from Around 100 Years Ago in the Context of His Earlier and Later Years*, exh. cat. Edinburgh: National Gallery of Scotland, 1979.

———. "Degas and the Painting of Modern Life." *Royal Society of Arts Journal* 128 (April 1980): 250–263.

Reed, Sue Welsh and Barbara Stern Shapiro. *Edgar Degas: The Painter as Printmaker*, exh. cat. Boston, Museum of Fine Arts. Boston: Little, Brown and Company; New York Graphic Society, 1984.

Reff, Theodore. "The Landscape Painter Degas Might Have Been." *Art News* 75 (January 1976): 41–43.

———. *The Notebooks of Edgar Degas: A Catalogue Raisonné of the Thirty-Eight Notebooks in the Bibliothèque Nationale and Other Collections*. Oxford: Clarendon Press, 1976.

———. *Degas: The Artist's Mind*. New York: The Metropolitan Museum of Art, Harper & Row, 1976.

———. *Degas in the Metropolitan*, exh. cat. *Metropolitan Museum of Art Bulletin* 34 (1977).

———. "Edgar Degas and the Dance." *Arts Magazine* 53 (November 1978): 45–49.

Rossa, W. I. "Degas' Photographic Portrait of Renoir and Mallarmé: An Interpretation." *Rutgers Art Review* 3 (1982): 80–96.

Sevin, Françoise. "Degas à travers ses mots." *Gazette des Beaux-Arts* 86 (July–August 1975): 18–46.

Shackelford, George T. M. *Degas, The Dancers*, exh. cat. Washington: National Gallery of Art, 1984.

Shapiro, Michael. "Degas and the Siamese Twins of the Café-Concert: The Ambassadeurs and the Alcazar d'Eté." *Gazette des Beaux-Arts* 95 (April 1980): 153–164.

———. "Three Late Works by Edgar Degas." *The Museum of Fine Arts, Houston Bulletin* 8 (1982): 9–22.

Varnedoe, J. Kirk T. "The Ideology of Time: Degas and Photography." *Art in America* 68 (Summer 1980): 96–110.

———. "Of Surface Similarities, Deeper Disparities, First Photographs, and the Function of Form: Photography and Painting after 1839." *Arts Magazine* 56 (September 1981): 114–115.

Marcellin Desboutin

Bailly-Herzberg, Janine. "Marcellin Desboutin and His World." *Apollo* 95 (June 1972): 496–500.

"Desboutin nous montre ses amis impressionnistes et leurs amateurs vers 1874." *Gazette des Beaux-Arts* 85 (October 1974): supp. 2–5.

Jean-Louis Forain

Bory, Jean-François. *Forain*. Paris: Henri Veyrier, 1979.

Brayer, Yves. "Forain, le peintre que j'ai connu." *Gazette des Beaux-Arts* 91 (May–June 1978): 194–201.

Browse, Lillian. *Forain the Painter (1852–1931)*. London: P. Elek, 1978.

Chagnaud-Forain, Jean et al. *Jean-Louis Forain, 1852–1931*, exh. cat. Paris: Musée Marmottan, 1978.

Faxon, Alicia Craig. *Jean-Louis Forain, 1852–1931: Works from New England Collections*, exh. cat. Framingham: Danforth Museum, 1979.

———. *Jean-Louis Forain: A Catalogue Raisonné of the Prints*. New York: Garland Publishing, 1982.

———. "Two Rediscovered Portraits of Degas." *Master Drawings* 20 (Winter 1982): 376–380.

Faxon, Alicia Craig and Yves Brayer. *Jean-Louis Forain: Artist, Realist, Humanist*, exh. cat. Washington, D.C.: International Exhibitions Foundation, 1982.

Guérin, Marcel. *J.-L. Forain Lithographe*, rev. ed. San Francisco: Alan Wofsy Fine Arts, 1980.

Jean-Louis Forain, 1852–1931, exh. cat. Albi: Musée Toulouse-Lautrec, 1982.

Magne, Jacqueline. "Forain témoin de son temps: La satire sociale et morale." *Gazette des Beaux-Arts* 81 (April 1973): 241–252.

Thomson, Richard. "Jean-Louis Forain's *Place de la Concorde*: A Rediscovered Painting and Its Imagery." *The Burlington Magazine* 125 (March 1983): 157–158.

Paul Gauguin

Amishai-Maisels, Ziva. "Gauguin's Early Tahitian Idols." *The Art Bulletin* 60 (June 1978): 331–341.

Birnholz, Alan C. "Double Images Reconsidered: Gauguin's *Yellow Christ*." *Art International* 21 (October–November 1977): 26–34.

Bodelsen, Merete. "En norsk malerinde set med Gauguins øjne." *Konst og Kultur* 62 (1979): 143–148.

Brayer, Yves. *Gauguin et les chefs-d'oeuvre de l'Ordupgaard de Copenhague*, exh. cat. Paris: Musée Marmottan, 1981.

Cachin, Françoise. "Un bois de Gauguin: *Soyez mystérieuses*." *La Revue du Louvre et des Musées de France* 29 (1979): 215–218.

Collins, R. D. J. "Paul Gauguin et la Nouvelle-Zélande." *Gazette des Beaux-Arts* 90 (November 1977): 173–176.

Cooper, Douglas. "An Important Gauguin Discovery." *The Burlington Magazine* 123 (April 1981): 195–197.

Cucchi, Roger. *Gauguin à la Martinique: Le musée imaginaire complet de ses peintures, dessins, sculptures, céramiques, les faux, les lettres, les catalogues d'expositions*, exh. cat. Vaduz: Calivran Anstalt, 1979.

Danielsson, B. "Gauguins Sydhavsar [Gauguin's Years in the South Seas]." *Louisiana Revy* 23 (October 1982): 4–19.

Donnell, Carol. "Representation versus Expressionism in the Art of Gauguin." *Art International* 19 (March 1975): 56–60.

Dorra, Henri. "Gauguin's Dramatic Arles Themes." *Art Journal* 38 (Fall 1978): 12–17.

Field, Richard S. *Paul Gauguin: The Paintings of the First Voyage to Tahiti*. New York: Garland Publishing, 1977.

———. "Gauguins Traesnit." *Louisiana Revy* 23 (October 1982): 28–33.

Gauguin, Paul. *The Writings of a Savage*, ed. Daniel Guérin. New York: Viking Press, 1977.

———. *45 lettres à Vincent, Théo et Jo van Gogh: Collection Rijksmuseum Vincent van Gogh, Amsterdam*, ed. Douglas Cooper. The Hague: Staatsuitgeverij; Lausanne: La Bibliothèque des Arts, 1983.

Gerstein, Marc S. "Paul Gauguin's *Arearea*." *The Museum of Fine Arts, Houston Bulletin* 7 (1981): 2–20.

van Gogh, V. W., ed. *Oeuvres écrites de Gauguin et de van Gogh*, exh. cat. Paris: Institut Néerlandais, 1975.

Gray, Christopher. *Sculpture and Ceramics of Paul Gauguin*. Baltimore: Johns Hopkins University Press, 1963; reprinted New York: Hacker Art Books, 1980.

Guérin, Marcel. *L'oeuvre gravé de Gauguin*, rev. ed. San Francisco: Alan Wofsy Fine Arts, 1980.

Haase, Amine et al. *Paul Gauguin: Das druckgraphische Werk*, exh. cat. Munich: Museum Stuck-Villa, 1978.

Herban, Mathew. "The Origin of Paul Gauguin's *Vision After the Sermon: Jacob Wrestling with the Angel* (1888)." *The Art Bulletin* 59 (September 1977): 415–420.

Jirat-Wasiutynski, Vojtech. "Paul Gauguin and Edgar Allan Poe's *Philosophy of Composition*." *Racar* 1 (1974): 61–62.

———. *Gauguin in the Context of Symbolism*, Ph.D. diss. Princeton University, 1975.

———. "Gauguin's Self-Portraits and the Oviri: The Image of the Artist, Eve and the Fatal Woman." *Art Quarterly* 2 (Spring 1979): 172–190.

———. "Paul Gauguin's Paintings, 1886–91. Cloisonism, Synthetism and Symbolism." *Racar* 9 (1982): 1–2, 35–46.

Kane, William MacGibbon. *Mes Secrets: The Earlier Drawings of Paul Gauguin (1873–1891)*, Ph.D. diss. Boston University Graduate School, 1975.

Le Paul, Charles-Guy and G. Dudensig. "Gauguin et Schuffenecker." *Bulletin des Amis du Musée de Rennes* 2 (1978): 48–60.

Mayer, Dolores A. "Gauguin's *L'univers est créé*: A Creative Vision." *Porticus: The Journal of the Memorial Art Gallery of the University of Rochester* 1 (1978): 40–45.

Pool, Phoebe. *Paul Gauguin*. New York: Funk and Wagnalls, 1978.

Pope, K. K. Rechnitzer. *Gauguin and Martinique*, Ph.D. diss. The University of Texas at Austin, 1981.

Sloan, Thomas L. "Paul Gauguin's *D'où venons-nous? Que sommes-nous? Où allons-nous?* A Symbolist Philosophical Leitmotif." *Arts Magazine* 53 (January 1979): 104–109.

Soederstroem, G. "Strindberg et les cercles d'art parisiens." *Revue d'Histoire de Théâtre* 30 (1978): 321–333.

Sugana, Gabriele Mandel. *Tout l'oeuvre peint de Gauguin*. Paris: Flammarion, 1981.

Teilhet, Jehanne L. "*Te Tamari No Atua*: An Interpretation of Paul Gauguin's Tahitian Symbolism." *Arts Magazine* 53 (January 1979): 110–111.

"To breve [Two Letters]." *Louisiana Revy* 23 (October 1982): 34–36.

Viirlaid, H. K. *The Concept of Vision in Paul Gauguin's 'Vision après le sermon,'* Ph.D. diss. Ottawa: National Library of Canada, 1980.

Weisberg, Gabriel P. "Vestiges of the Past: The Brittany 'Pardons' of Late Nineteenth-Century French Painters." *Arts Magazine* 55 (November 1980): 134–138.

Wildenstein, Daniel and Raymond Cogniat. *Gauguin*. Garden City: Doubleday, 1974.

Wise, Susan. *Paul Gauguin, His Life and His Paintings*. Chicago: The Art Institute of Chicago, 1980.

Zink, Mary Lynn. "Gauguin's *Poèmes Barbares* and the Tahitian Chant of Creation." *Art Journal* 38 (Fall 1978): 18–21.

Jean-Baptiste Armand Guillaumin

Centenaire de l'impressionnisme et hommage à Guillaumin, exh. cat. Geneva: Petit Palais, 1974.

Gray, Christopher. *Armand Guillaumin*. Chester, Conn.: The Pequot Press, 1974.

Gros, R. *Guillaumin à Crozant*. Gueret Creuse Expansion Tourisme, 1982.

Rewald, John. "Cézanne and Guillaumin." *Etudes d'art français offertes à Charles Sterling*, ed. Albert Châtelet and Nicole Reynaud, 343–353. Paris: Presses Universitaires de France, 1975.

Albert Lebourg

Lespinasse, François. *Albert Lebourg*. Lausanne, 1984.

Melki, Arthur. *Exposition Albert Lebourg*, exh. cat. Paris: Galerie Art Melki, 1976.

Alphonse Legros

Geiger, Monique. "Dijon, Musée des Beaux-Arts: Le faiseur de fagots d'Alphonse Legros." *La Revue du Louvre et des Musées de France* 31 (1981): 203–205.

Seltzer, Alexander. *Alphonse Legros: The Development of an Archaic Visual Vocabulary in 19th-Century Art*, Ph.D. diss. State University of New York at Binghamton, 1980.

Weisberg, Gabriel P. "Alphonse Legros and the Theme of *Death and the Woodcutter*." *The Bulletin of the Cleveland Museum of Art* 61 (April 1974): 128–135.

Stanislas Lépine

Rostrup, H. "Lépine, *La Seine vers Rouen*." *Meddelelser fra Ny Carlsberg Glyptotek* 30 (1973): 7–14.

Auguste de Molins

Daulte, François. "L'impressionnisme dans les collections romandes. Ses précurseurs, ses maîtres, son héritage." *L'Oeil* 347 (June 1984): 32–41; includes works by de Molins.

Claude Monet

Adhémar, Hélène et al. *Hommage à Claude Monet*, exh. cat. Paris: Editions de la Réunion des Musées Nationaux, 1980.

Aitken, Geneviève and Marianne Delafond. *La collection d'estampes japonaises de Claude Monet à Giverny*. Paris: La Bibliothèque des Arts, 1983.

Coe, Ralph T. "Claude Monet's *Boulevard des Capucines*: After a Century." *Nelson Gallery and Atkins Museum Bulletin* 5 (February 1976): 5–16.

Delouche, D. "Monet et Belle-Ile en 1886." *Bulletin des Amis du Musée de Rennes* 4 (1980): 27–55.

Gordon, Robert and Andrew Forge. *Monet*. New York: Abrams, 1983.

Herbert, Robert L. "Method and Meaning in Monet." *Art in America* 67 (September 1979): 90–108.

House, John. "New Material on Monet and Pissarro in London in 1870–71." *The Burlington Magazine* 120 (October 1978): 636–642.

Isaacson, Joel. *Monet: Le déjeuner sur l'herbe*. London: Allen Lane, Penguin Press; New York: Viking Press, 1972.

———. *Claude Monet: Observation and Reflection*. Oxford: Phaidon; New York: Dutton, 1978.

———. "*La Débâcle* by Claude Monet." *Bulletin, Museums of Art and Archaeology, University of Michigan* 1 (1978): 1–15.

Jones, Elizabeth H. et al. *Monet Unveiled: A New Look at Boston's Paintings*, exh. cat. Boston: Museum of Fine Arts, 1977.

Joyce, Claire et al. *Monet at Giverny*. London: Mathews, Miller and Dunbar, 1975.

Levine, Steven Z. *Monet and His Critics*, Ph.D. diss. Harvard University, 1974.

———. "Monet's Pairs." *Arts Magazine* 49 (June 1975): 72–75.

———. "Monet, Lumière, and Cinematic Time." *The Journal of Aesthetics and Art Criticism* 36 (Summer 1978): 441–447.

———. "The Window Metaphor and Monet's Windows." *Arts Magazine* 54 (November 1979): 98–103.

———. "Décor/Decorative/Decoration in Claude Monet's Art." *Arts Magazine* 51 (February 1977): 136–139.

———. "Instant of Criticism and Monet's Critical Instant." *Arts Magazine* 55 (March 1981): 114–121.

Rewald, John and Frances Weitzenhoffer, ed. *Aspects of Monet.* New York: Abrams, 1984.

Rossi Bortolatto, Luigina. *Tout l'oeuvre peint de Monet: 1870–1889.* Paris: Flammarion, 1981.

Seiberling, Grace. "Monet's *Les roches à Pourville, marée basse.*" *Porticus: The Journal of the Memorial Art Gallery of the University of Rochester* 3 (1980): 40–48.

———. *Monet's Series.* New York: Garland Publishing, 1981.

Sloane, Joseph C. "The Paradoxes of Monet." *Apollo* 103 (June 1976): 494–501.

Stuckey, Charles F. and Robert Gordon. "Blossoms and Blunders: Monet and the State, I." *Art in America* 67 (January–February): 102–117.

Stuckey, Charles F. "Blossoms and Blunders: Monet and the State, II." *Art in America* 67 (September 1979): 109–125.

Tucker, Paul Hayes. *Monet at Argenteuil.* New Haven and London: Yale University Press, 1982.

———. "The First Impressionist Exhibition and Monet's *Impression, Sunrise*: A Tale of Timing, Commerce, and Patriotism." *Art History* 7 (December 1984): 465–476.

Walter, Rodolphe. "Claude Monet as a Caricaturist: A Clandestine Apprenticeship." *Apollo* 103 (June 1976): 488–493.

Wildenstein, Daniel. *Claude Monet: Biographie et catalogue raisonné. T. 1: 1840–1881.* Lausanne: La Bibliothèque des Arts, 1974. *T. 2: 1882–1886,* 1979. *T. 3: 1887–1898,* 1979. *T. 4: 1899–1926,* 1985.

Wise, Susan, ed. *Paintings by Monet,* exh. cat. Chicago: The Art Institute of Chicago, 1975.

Berthe Morisot

Bailly-Herzberg, Janine. "Les estampes de Berthe Morisot." *Gazette des Beaux-Arts* 93 (May–June 1979): 215–227.

Rey, Jean Dominique. *Berthe Morisot.* New York: Crown Publishers; Paris: Flammarion, 1982.

Giuseppe de Nittis

Cassandro, Michele. *De Nittis.* Bari: Adriatica, 1971.

Piceni, Enrico. *De Nittis: L'uomo e l'opera.* Busto Arsizio: Bramante, 1979.

Auguste-Louis Ottin

Amprimoz, François Xavier. "Un décor 'fourieriste' à Florence." *Revue de l'Art* 48 (1980): 57–67.

Ludovic Piette

Maillet, Edda et al. *Camille Pissarro, Charles-François Daubigny, Ludovic Piette,* exh. cat. Pontoise: Musées de Pontoise, 1978.

Camille Pissarro

Adler, Kathleen. "Camille Pissarro and Paul Cézanne: A Study of Their Artistic Relationship between 1872 and 1885." *De Arte* 13 (April 1973): 19–25.

———. *Camille Pissarro: A Biography.* New York: St. Martin's Press; London: Batsford, 1978.

Bailly-Herzberg, Janine. *Correspondance de Camille Pissarro. Vol. 1: 1865–1885.* Paris: Presses Universitaires de France, 1980.

———. "Camille Pissarro et Rouen." *L'Oeil* 312 (July–August 1981): 54–59.

Boulton, Alfredo. "Camille Pissarro in Venezuela." *Connoisseur* 189 (May 1975): 36–42.

Brettell, Richard R. *Pissarro and Pontoise: The Painter in a Landscape,* Ph.D. diss. Yale University, 1977.

Brettell, Richard R. and Christopher Lloyd. *A Catalogue of the Drawings by Camille Pissarro in the Ashmolean Museum.* Oxford: Clarendon Press, 1980.

House, John. "New Material on Monet and Pissarro in London in 1870–71." *The Burlington Magazine* 120 (October 1978): 636–642.

Huda, Lulli. *Camille Pissarro: Drawings from the Ashmolean Museum, Oxford,* exh. cat. London: Arts Council of Great Britain, 1977.

Lachenaud, Jean-Philippe et al. *Pissarro et Pontoise,* exh. cat. Pontoise: Musée Pissarro, 1980.

Lloyd, Christopher. "Camille Pissarro and Hans Holbein the Younger." *The Burlington Magazine* 117 (November 1975): 722–726.

———. "Camille Pissarro: Drawings or Prints?" *Master Drawings* 18 (Autumn 1980): 264–268.

———. "Reflections on La Roche-Guyon and the Impressionists." *Gazette des Beaux-Arts* 104 (January 1985): 37–44.

Lloyd, Christopher et al. *Pissarro,* exh. cat. London: Arts Council of Great Britain, 1981.

Maillet, Edda et al. *Camille Pissarro, Charles-François Daubigny, Ludovic Piette,* exh. cat. Pontoise: Musées de Pontoise, 1978.

Melot, Michel. "La pratique d'un artiste: Pissarro graveur en 1880." *Histoire et Critique des Arts* 2 (1977): 14–38.

———. "Camille Pissarro in 1880: An Anarchistic Artist in Bourgeois Society." *Marxist Perspectives* 2 (Winter 1979–1980): 22–54.

Milkovich, Michael. *Homage to Camille Pissarro: The Last Years, 1890–1903,* exh. cat. Memphis: Dixon Gallery and Gardens, 1980.

Pissarro, Camille. *Letters to His Son Lucien,* ed. John Rewald with the assistance of Lucien Pissarro. Santa Barbara and Salt Lake City: Peregrine Smith, 1981.

Camille Pissarro: Sa famille, ses amis, exh. cat. Pontoise: Musées de Pontoise, 1976.

Reid, Martin. "Camille Pissarro: Three Paintings of London of 1871. What Do They Represent?" *The Burlington Magazine* 119 (April 1977): 253–261.

Shapiro, Barbara Stern. *Camille Pissarro: The Impressionist Printmaker,* exh. cat. Boston: Museum of Fine Arts, 1973.

Shapiro, Barbara Stern and Michel Melot. "Les monotypes de Camille Pissarro." *Nouvelles de l'Estampe* 19 (1975): 16–23.

Shikes, Ralph E. and Paula Harper. *Pissarro, His Life and Work.* New York: Horizon Press, 1980.

Soler, Richard. *Camille Pissarro au Venezuela,* exh. cat. Paris: Ambassade du Venezuela, 1978.

Thomson, Richard. "Drawings by Camille Pissarro in Manchester Public Collections." *Master Drawings* 18 (Autumn 1980): 257–263.

———. "Camille Pissarro, *Turpitudes sociales,* and the Universal Exhibition of 1889." *Arts* 56 (April 1982): 82–88.

———. "Camille Pissarro and Symbolism: Some Thoughts Prompted by the Recent Discovery of an Annotated Article." *The Burlington Magazine* 124 (January 1982): 14–23.

Thorold, Anne. *Artists, Writers, Politics: Camille Pissarro and His Friends*, exh. cat. Oxford: Ashmolean Museum, 1980.

Lucien Pissarro

Bailly-Herzberg, Janine and A. Dardel. "Les illustrations françaises de Lucien Pissarro." *Nouvelles de l'Estampe* 54 (1980): 8–16.

Chambers, D. *Lucien Pissarro: Notes on a Selection of Wood-Blocks Held at the Ashmolean Museum*, exh. cat. Oxford: Ashmolean Museum, 1980.

d'Offay, Anthony. *Lucien Pissarro, 1863–1954*. London: Anthony d'Offay, 1977.

Thorold, Anne et al. *A Catalogue of the Oil Paintings of Lucien Pissarro*. London: Atheneley Books, 1983.

Jean-François Raffaëlli

Fields, Barbara Schinman. *Jean-François Raffaëlli (1850–1924): The Naturalist Artist*, Ph.D. diss. Columbia University, 1979.

Thomson, Richard. "The Drinkers of Daumier, Raffaëlli and Toulouse-Lautrec: Preliminary Observations on a Motif." *Oxford Art Journal* 2 (April 1979): 29–32.

Odilon Redon

Bacou, Roseline. "Rodolphe Bresdin et Odilon Redon." *La Revue du Louvre et des Musées de France* 29 (1979): 50–59.

Binney, Edwin, III. *One Man's Vision: The Graphic Works of Odilon Redon*, exh. cat. Washington, D.C.: Smithsonian Institution Traveling Exhibition Service, 1978.

Gamboni, Dario. "Remarques sur la critique d'art, l'histoire de l'art et le champ artistique à propos d'Odilon Redon." *Zeitschrift für schweizerische Archäologie und Kunstgeschichte* 39 (1982): 104–108.

Hardouin-Fugier, Elisabeth. "Odilon Redon et Janmot: *Dans le rêve* et *Le poème de l'âme*." *Gazette des Beaux-Arts* 94 (December 1979): 227–230.

Harrison, Sharon Ruth Rich. *A Catalogue of the Etchings of Odilon Redon*, Ph.D. diss. University of Michigan, 1975.

Hobbs, Richard James. *Odilon Redon*. London: Studio Vista, 1977.

Jacob, Mira. *Odilon Redon: Dessins, lithographies*, exh. cat. Paris: Le Bateau-Lavoir, 1979.

Keay, Carolyn. *Odilon Redon*. London: Academy; New York: Rizzoli, 1977.

Koella, Rudolf. *Odilon Redon*, exh. cat. Winterthur: Kunstmuseum, 1983.

Redon, Odilon. *A soi-même: Journal, 1867–1915, notes sur la vie, l'art et les artistes*. Paris: J. Corti, 1979.

Sandström, Sven. "Odilon Redon: A Question of Symbols." *Prints Collector's Newsletter* 6 (May–June 1975): 29–34.

Seznec, Jean. "Odilon Redon and Literature." *French 19th-Century Painting and Literature: With Special Reference to the Relevance of Literary Subject-Matter to French Painting*, ed. Ulrich Finke, 280–298. Manchester: University of Manchester Press, 1972.

Strieter, Terry W. "Odilon Redon and Charles Baudelaire." *Art Journal* 35 (Fall 1975): 17–19.

Pierre-Auguste Renoir

Adhémar, Hélène. "*La danse à la campagne* par Auguste Renoir." *La Revue du Louvre et des Musées de France* 28 (1978): 201–204.

Carey, Martha. *The Luncheon of the Boating Party*. Washington, D.C.: Phillips Collection, 1981.

Daulte, François. *Auguste Renoir. Catalogue raisonné de l'oeuvre peint*. Vol. 1: *Figures 1860–1890*. Lausanne: Durand-Ruel, 1971.

———. "Renoir et la famille Bérard." *L'Oeil* 223 (February 1974): 4–13.

Fezzi, Elda. *L'opera completa di Renoir nel periodo impressionista, 1869–83*. Milan: Rizzoli, 1972.

House, John et al. *Renoir*, exh. cat. London: Arts Council of Great Britain, 1985.

Renoir, Jean. *Pierre-Auguste Renoir, mon père*. Paris: Gallimard, 1981.

White, Barbara Ehrlich. "Renoir's Sensuous Women." *Art News Annual* 38 (1972): 167–181.

———. "Bathers of 1887 and Renoir's Anti-Impressionism." *The Art Bulletin* 55 (March 1973): 106–126.

———. *Renoir, His Life, Art, and Letters*. New York: Abrams, 1984.

Emile Schuffenecker

Grossvogel, Jill Elyse. *Claude-Emile Schuffenecker, 1851–1934*, exh. cat. Binghamton: State University of New York, University Art Gallery, 1980.

Le Paul, Charles-Guy and G. Dudensig. "Gauguin et Schuffenecker." *Bulletin des Amis du Musée de Rennes* 2 (1978): 48–60.

Claude-Emile Schuffenecker and the School of Pont-Aven, exh. cat. Regina, Saskatchewan: Norman Mackenzie Art Gallery, 1977.

Georges-Pierre Seurat

Bean, Jacob. *Seurat: Drawings and Oil Sketches from New York Collections*, exh. cat. New York: Metropolitan Museum of Art, 1977.

Broude, Norma. "New Light on Seurat's 'Dot': Its Relation to Photo-Mechanical Color Printing in France in the 1880s." *The Art Bulletin* 56 (December 1974): 581–589.

———. "The Influence of Rembrandt Reproductions on Seurat's Drawing Style: A Methodological Note." *Gazette des Beaux-Arts* 88 (October 1976): 155–160.

Broude, Norma, ed. *Seurat in Perspective*. Englewood Cliffs: Prentice-Hall, 1978.

Franz, Erich and Bernd Growe. *Georges Seurat: Zeichnungen*, exh. cat. Bielefeld, Kunsthalle. Munich: Prestel Verlag, 1983.

Hefting, P. H. "Figuurstudie, Georges Seurat, 1859–1891." *Vereniging Rembrandt. Verslag* (1975): 50–51.

Herbert, Robert L. "*Parade de cirque* de Seurat et l'esthétique scientifique de Charles Henry." *Revue de l'Art* 50 (1980): 9–23.

Herz-Fischler, Roger. "Examination of Claims Concerning Seurat and the Golden Number." *Gazette des Beaux-Arts* 101 (March 1983): 109–112.

House, John. "Meaning in Seurat's Figure Paintings." *Art History* 3 (September 1980): 345–356.

Minervino, Fiorella. *Tout l'oeuvre peint de Seurat*. Paris: Flammarion, 1973.

Pearson, Eleanor. "Seurat's *Le cirque*." *Marsyas* 19 (1977–1978): 45–51.

Semin, Didier. "Note sur Seurat et le cadre." *Avant-Guerre* 2 (1981): 53–59.

Thomson, Richard. "*Les Quat' pattes*: The Image of the Dog in Late Nineteenth-Century French Art." *Art History* 5 (September 1982): 323–337.

Paul Signac

Signac, Paul. *D'Eugène Delacroix au néo-impressionnisme*. Introduction by Françoise Cachin. Paris: Savoir/Hermann, 1978.

Szabo, George. *Paul Signac (1863–1935): Paintings, Watercolors, Drawings and Prints*, exh. cat. New York: Metropolitan Museum of Art, 1977.

Alfred Sisley

Angrand, P. "Sur deux lettres inédites de Sisley." *Gazette des Beaux-Arts* 78 (July–September 1971): supp. 33.

Cogniat, Raymond. *Sisley*. Paris: Flammarion; New York: Crown Publishers, 1978.

Daulte, Alfred. *Alfred Sisley*. Munich: Schuler, 1975.

Gache-Patin, Sylvie and Jacques Lassaigne. *Sisley*. Paris: Nouvelles Editions Françaises, 1983.

Nathanson, Richard. *Alfred Sisley*, exh. cat. London: David Carritt, 1981.

Thomson, Richard. "A Sisley Problem [letter]." *The Burlington Magazine* 123 (November 1981): 676.

Federico Zandomeneghi

Piceni, Enrico. *Zandomeneghi. L'uomo e l'opera*. Milan: Bramante Editrice, 1979.

Index of Artists

All of the artists who showed works in the eight original Impressionist exhibitions are listed here; ROMAN NUMERALS indicate in which shows they took part. **Bold-face** numbers refer to catalogue numbers of the works in the present exhibition; numbers in *italics* refer to page numbers on which illustrations of other works by these artists appear.

The New Painting: Impressionism 1874–1886 was produced by the Publications Department of The Fine Arts Museums of San Francisco. Editorial and production management by Ann Heath Karlstrom. Edited by Karen Kevorkian.

The book was designed by Jack Werner Stauffacher of The Greenwood Press, San Francisco, California. Display type is Kis-Janson, hand set at The Greenwood Press. Text type is Sabon, designed by Jan Tschichold. Digital composition and production by Wilsted & Taylor Publishing Services, Oakland, California. Color separations, printing and binding by BCK Graphic Arts SA, Geneva, Switzerland, on specially tinted 135-gram classe matière 3 paper.